D1318333

Marble Palaces, Temples of Art

Marble Palaces, Temples of Art

Art Museums, Architecture, and American Culture, 1890–1930

INGRID A. STEFFENSEN-BRUCE

Ingrid A. Steffensen
4/1/08

Lewisburg
Bucknell University Press
London: Associated University Presses

© 1998 by Associated University Presses, Inc.

All rights reserved. Authorization to photocopy items for internal or personal use, or the internal or personal use of specific clients, is granted by the copyright owner, provided that a base fee of $10.00, plus eight cents per page, per copy is paid directly to the Copyright Clearance Center, 222 Rosewood Drive, Danvers, Massachusetts 01923. [0-8387-5351-5/98 $10.00 + 8¢ pp, pc.]

Associated University Presses
440 Forsgate Drive
Cranbury, NJ 08512

Associated University Presses
16 Barter Street
London WC1A 2AH, England

Associated University Presses
P.O. Box 338, Port Credit
Mississauga, Ontario
Canada L5G 4L8

The paper used in this publication meets the requirements of the American National Standard for Permanence of Paper for Printed Library Materials Z39.48–1984.

Library of Congress Cataloging-in-Publication Data

Steffensen-Bruce, Ingrid A.
 Marble palaces, temples of art : art museums, architecture, and American culture, 1890–1930 / Ingrid A. Steffensen-Bruce.
 p. cm.
 Includes bibliographical references and index.
 ISBN 0-8387-5351-5 (alk. paper)
 1. Art museum architecture—United States—History—19th century.
2. Art museum architecture—United States—History—20th century.
3. Art museums—United States—History—19th century. 4. Art museums—United States—History—20th century. I. Title.
NA6695.A74 1998
727′.7′097309041—dc21 98-4527
 CIP

PRINTED IN THE UNITED STATES OF AMERICA

Contents

Acknowledgments

MANY THANKS ARE IN ORDER. FIRST AND FOREMOST I EXTEND MY GRATITUDE TO MY ADvisor, Damie Stillman, who sparked my interest in American architecture and who encouraged me throughout this satisfying but at times daunting task; and to the Art History Department at the University of Delaware for the support, academic and financial, I have received over the years. I am particularly grateful for a Luce Foundation fellowship that allowed me to conduct the research for this work. Professors William Homer and Bryant Tolles of the University of Delaware and Richard Guy Wilson of the University of Virginia, all of whom served on my dissertation committee, made valuable suggestions in their readings. I am also indebted to Mills Edgerton and James Heath of Bucknell University Press for their willingness to consider my work, as well as to the anonymous reader who made a thorough critique of my work and recommended its publication.

The debt I owe to librarians and archivists in research libraries and museums across the country is incalculable. I am most grateful for the facilities and expert assistance at two institutions: the Central Research Library of the New York Public Library with its magnificent collection and willingness to accept interlibrary loan requests; and the Avery Architectural Library at Columbia University, including its Drawings and Archives Department. I am deeply appreciative of the largely anonymous but invaluable assistance of the reference librarians at both institutions. The collections of the New-York Historical Society were also graciously made available to me. Thanks go to the many archivists, librarians, and museum personnel who made my research both profitable and pleasurable: Archivist Janice Lurie and Librarian Kari Horowicz at the Albright-Knox Art Gallery; Sherry Birk, Curator of the Drawings and Prints Collection at the American Architectural Foundation; Judy Throm at the Archives of American Art in Washington, D.C.; John Smith at the Art Institute of Chicago Archives; Mary Woolever at the Ryerson and Burnham Libraries of the Art Institute of Chicago; Cindy Tripoulas, Librarian at the Baltimore Museum of Art; Deborah Wythe, Archivist at the Brooklyn Museum; the staff of the Buffalo and Erie County Historical Society; Curator of Architecture Christopher Monkhouse and *Carnegie Magazine* Editor R. Jay Gangewere at the Carnegie; Marisa Keller, Archivist at the Corcoran Gallery and School of Art; Colleen Hennessy, Archivist at the Freer Gallery of the Smithsonian Institution; Curator of American Decorative Arts Morrison Heckscher at the Metropolitan Museum of Art; Judy Turner, Archivist at the Milwaukee Public Museum; former Curator of Collections Alejandro Anreus and Librarian Edith Rights at the Montclair Art Museum; Maureen Melton, Archivist at the Museum of Fine Arts, Boston; Archivist Louise Rossmassler, Librarian Anita Gilden, and Curatorial Assistant Alison Goodyear at the Phila-

delphia Museum of Art; Registrar Steve Nowak and Associate Librarian Judy Friebert of the Toledo Museum of Art; Nancy Shawcroff at the University of Pennsylvania's Van Pelt Library Special Collections; Nancy Welch, formerly of the Wisconsin Architectural Archives at the Milwaukee Public Library; and Harold Peterson, Head Librarian at the Minneapolis Institute of Arts for his long-distance assistance. These helpful and dedicated people all made my project theirs; I cannot thank them enough.

I had invaluable help from friends who were willing to house me during my travels, without whose generosity this project could not have been accomplished: Charles Winstead in Pittsburgh; Robert Young in Boston; Sharon Clarke in Philadelphia; Marjorie Heesemann in Syracuse and Buffalo; William and Lisa O'Brien in Columbia, Maryland; Jeffrey Rogers and Erin Monaghan, both in Washington, D.C.; and Daniel and Monica Atkins in Ann Arbor, Michigan. My greatest debt is to my mother and sometime research assistant, Elsbeth Sievers Steffensen, who accompanied me on my trip to Chicago, Milwaukee, and Toledo and who made that trip both far more efficient and enjoyable.

Finally, my warmest thanks go to my family, who have encouraged and supported me throughout the years. I am grateful to my parents and grandparents who enthusiastically supported every decision I made. I think it was their unquestioning belief that I could accomplish whatever I set out to do that has led to my success. Most of all I thank my husband, Jeffrey Bishop Bruce, to whom this book is dedicated.

Marble Palaces, Temples of Art

Introduction: The Museum Age

A museum was originally a temple in which the muses were worshipped or invoked. At Athens, a hill near the Acropolis was called the Museum because of the existence on it of such a temple. It was a place for study and high contemplation. Although we have outgrown the mythology of the Greeks, their literature and their institutions have so pervaded our language and institutions that we find the germs of some of our choicest civil and social growths sunk deep into that old civilization.
—Newton Winchell, "Museums and Their Purposes" (1891)

The first purpose of a Museum . . . is to give example of perfect order and perfect elegance, in the true sense of that test word.
—John Ruskin, "A Museum or Picture Gallery" (1880)

THE ART MUSEUM IN THE UNITED STATES FROM 1890 TO 1930 REPRESENTED THE CULTURAL aspirations of two generations of Americans who sought to establish a claim to international equality in the arena of the fine arts. The institutions founded during this era proved the ability of wealthy Americans to unite in this common goal and to assemble an extraordinary collection of art in a remarkably short period of time, housed in a constellation of art museums across various parts of the country. The buildings themselves, however, represented not only the art within but all the dreams attendant upon such collections of culture. An art museum had to answer to a very difficult imperative. In the collective mind of the late nineteenth century, the art museum not only had to house paintings safely and efficiently, but it also had to communicate the importance of culture itself. From 1890 onward, the architectural language on which the members of the American museum establishment settled was one imbued with history and culture, one which in whatever milieu it found itself could speak of art and its refining and uplifting influences. That language was the monumental classical, executed with Beaux-Arts sophistication. The era 1890–1930 witnessed a great explosion in the building of art museums, nearly all of which were built in the classical idiom. The social and cultural implications of this choice, embedded in the fabric of the late-nineteenth-century urban milieu, are the subject of this work.

The nineteenth century saw both the birth and the coming-of-age of the art museum in America. The first generally acknowledged building designed to be a museum in the United States was Peale's Museum in Baltimore, built in 1814.[1] Like many institutions after it, Peale's was an *omnibus* museum with exhibits in natural history as well as art. Only a few other art museums were established in the years prior to and during the Civil War. They were small and, with the exception of the Wadsworth Atheneum, generally ventures destined not to last. In 1826, a small building was erected to house the Gallery of the Boston Athenaeum, but it was vacated only twenty-three years later.

The American Academy of Fine Arts in New York built its first gallery and school building in 1831, and this was sold a mere ten years later. The Trumbull Gallery in New Haven, the first American art museum to be built in a classical style, was erected in 1832. The Gothic Revival Wadsworth Atheneum in Hartford was built in 1844. And the very Ruskinian National Academy of Design in New York opened in 1865, only to be torn down in 1895. Although some of these institutions survive as art museums, none of them is a museum of the great size and scope of those established in the post–Civil War years of the nineteenth century.

What led to the creation of the ideal set of circumstances for the establishment of great art museums from 1870 onwards? Like the skyscraper, whose evolution as a building genre has been analyzed as a product of economic and social conditions of the late-nineteenth-century city, the art museum relies on certain economic and social conditions requiring a concentration of wealth and population. Both of these prerequisites emerged in the latter decades of the nineteenth century. The rapid industrialization of the American economy led simultaneously to increasing concentrations of wealth in single individuals, as well as increasing concentrations of population in America's burgeoning cities.[2] Not only American rural-to-urban migrants, but European immigrants also swelled the ranks of the cities, and the great disparities between the wealthy and the working poor created slum districts in the largest cities. As a result, the wealthy felt the prickings of conscience, and the first efforts at civic reform were born. One tangible result of these initial attempts at urban improvement was the founding of libraries, theaters, and museums.

The establishment of educational and cultural institutions served a dual purpose. On the one hand, their existence partially could assuage the consciences of the upper class that they were improving the cultural life of the cities and thereby the lot of the lower classes and the urban population at large. As H. Wayne Morgan points out, "didactic observers praised the 'elevating' tendencies of music and painting."[3] This was the proffered rationale for the founding of educational institutions that could provide such uplifting material. More obviously, however, such institutions responded to the sense of cultural inferiority that Americans felt in comparison to Europe. These institutions were all based on European precedents and culture. Wealthy Americans still looked to Europe for guidance in the fine arts, even as the United States was beginning to equal and sometimes surpass European countries as an international military and economic power. As Morgan notes, "Nationalism played a large part in establishing cultural bases. Americans hoped to replace Europe in the arts, just as they wanted to supersede her in industrial growth and political freedom."[4]

The first two of the truly great art museums of this country were both founded in 1870, five years after the close of the Civil War: the Museum of Fine Arts, Boston, and the Metropolitan Museum of Art in New York. The impulses behind the establishment of these institutions, as well as the many that followed afterward, are exemplified in the speech made by William Cullen Bryant upon the founding of the Metropolitan Museum of Art. He believed that New York constituted the "third great city of the civilized world,"[5] yet in 1869, there was no art museum in New York—nor indeed the country— that could serve as a repository for important works of art. It was felt that New York simply could not compete culturally with European cities that were not nearly as large or as wealthy as New York but far surpassed any American city in cultural advantages. Prominent and wealthy New Yorker George Fisk Comfort, speaking after Bryant, put forth the matter more blatantly, issuing this challenge:

In the year 1776 this nation declared her political independence of Europe. The provincial relation was then severed as regards politics; may we not now begin institutions that by the year 1876 shall sever the provincial relation of America to Europe in respect to Art?[6]

This question hit one of the most sensitive late-nineteenth-century American nerves: the fear that Americans were wealthy but not nearly as civilized as Europeans. The establishment of art museums would go far in calming that fear.

Bryant also struck a chord with those who believed that the furthering of the arts was a duty of the wealthy and that patronage in this area would improve the quality of life in the city and its residents in general:

The influence of works of art is wholesome, ennobling, instructive. Besides the cultivation of the sense of beauty—in other words, the perception of order, symmetry, proportion of parts, which is of near kindred to the moral sentiments—the intelligent contemplation of a great gallery of works of art is a lesson in history, a lesson in biography, a lesson in the antiquities of different countries.[7]

The factors thus motivating the establishment of art museums are clear. In order to overcome American inferiority in the arts, art museums were a necessary and highly symbolic achievement, one which, with the great and newly found wealth of its capitalist elite, was relatively easy to accomplish. Art museums would also provide an antidote to the increasing power of vice in the cities, aggravated by congestion and the flood of immigrants.

A pressing order of business for any aspiring art museum was housing. Nearly all museums began their lives in temporary galleries and some of them in private homes, while permanent quarters were being built. The great and vexing question of what the museum building should look like elicited a wide variety of stylistic answers between the Civil War and 1890, as museums and their architects wrestled with the problem. American architects naturally sought an "American" solution which would fit their patrons' budgets and tastes, and in general, they did not seek to emulate specific European precedents. Many of the most prominent European art museums were housed in former palaces; the Louvre in Paris was the primary example of the tendency. Others, such as the grand Neoclassical buildings of the Prado (1784–1811, by Juan de Villanueva), the Altes Museum in Berlin (1823–30, by Karl Friedrich Schinkel) and the British Museum (1823–47, by Sir Robert Smirke) were government projects of a scale far too large to be contemplated by American institutions of the early- and mid-nineteenth century.[8] American architects, therefore, adapted currently popular styles to museum use. During the 1840s, the Gothic Revival of Andrew Jackson Downing predominated, the most prominent example of which is the Wadsworth Atheneum in Hartford. As the century progressed, the influences of Ruskin began to permeate the answers to style with buildings from P. B. Wight's National Academy of Design building and Frank Furness's Pennsylvania Academy of Fine Arts to the original buildings of the Museum of Fine Arts, Boston, and the Metropolitan Museum of Art all taking up this style. Subsequently, the influence of the Richardsonian Romanesque superseded that of the Ruskinian High Victorian Gothic, as exhibited in museum buildings in Chicago, St. Louis, and Cincinnati. It was not until 1890 that the classical idiom was settled upon. When this stylistic revolution occurred, however, it remained the dominant mode for several generations, during an era when art museum buildings proliferated across the country. Why this was so and what the architecture of the museum buildings

meant to architects in their emerging profession, museum officials in their search for the perfect form of the museum, and nineteenth-century society at large is the subject of the following chapters.

This study attempts to place the art museum building in its social, cultural, urban, and architectural-historical context. If the art museum represented culture—and there can be little doubt that to late-nineteenth-century America it did—then the appearance of its building takes on an importance far beyond a simple architectural exercise. That this was, indeed, the case is evidenced by the great concern expressed by a wide variety of people over the form the art museum should take. Architects, museum professionals, and the popular press all took a great interest in the building of art museums. The present work comprises an investigation of the meanings of the art museum to these groups and will reveal a number of important facets of the meaning of the art museum to the people who built them.

The first chapter investigates the three largest and most influential art museums of the period, in Boston, New York, and Chicago, in order to determine why the monumental classical mode came to be preferred over earlier styles. The second chapter explores a previously neglected subject: how the enormously influential World's Columbian Exposition and fairs in general came to have an important impact on the architecture and the social functioning of the art museum. The third chapter defines the relationship between the art museum and the city through an analysis of what the location of the museum within the urban milieu meant to the urban fabric and how the development of the City Beautiful movement changed attitudes toward urban land use. The fourth chapter looks at how the art museum, in combination with civic improvement plans inspired by the City Beautiful movement, came to be adopted by Progressive civic reformers as a weapon against urban moral and social decay. The fifth and final chapter investigates the issues of Beaux-Arts training, architectural competitions, and the art museum plan in order to ascertain how the creation and selection of art museum plans played a vital part in the development of the architectural profession in America. A brief conclusion brings the era of the monumental classical art museum to a close through a glimpse at art museum architecture after 1930. It discusses the legacy of the era of the great art museum in terms of classically styled art museums built during the modern period and in terms of the lessons imparted by the great classical art museums to the museum establishment of today.

In order to establish a relationship between buildings and culture, I have applied to this work a methodology that encompasses a wider range of materials than many architectural histories. In assembling the material for this work, I have traveled to the majority of the museums represented in this text. Examination of the materials available at these institutions made me realize that, for those building museums, there was a great deal more at stake than the academic question of style. I saw that certain conclusions could be drawn through an investigation of recurring tendencies, such as the relationship between the art museum and the international exposition of the late nineteenth and early twentieth centuries or the preoccupation with morality and civic reform expressed by those involved with art and art museums. I have culled my material from the wealth of comments made about museums in local newspapers; from pamphlets and articles printed by museums at the time of the opening of their new buildings; from the professional press both museological and architectural; from the growing body of literature involved with urban studies and civic improvement; and occasionally from comments made by architects, museum trustees, and patrons themselves. The intensive manner in which I pursued my research explains in part the idiosyncrasy of choice involved in the individual museums presented in this text. Limited by time,

funds, and distance, as well as the resources of a particular museum, I chose to represent museums for which I had substantial research materials available to me. Other museums are not included because thorough architectural histories of their buildings have recently been published. The extent of my research indicates, however, that my general conclusions concerning style and motivation would hold true for other museums built during this period but not extensively covered in the present work. My approach to the architecture centers around a belief that, although history cannot be recreated in any absolute sense, it can be partially understood through an investigation of and rather strict adherence to what people wrote and said about their surroundings and their times. I believe also that, of the arts, architecture in particular has an especially enduring and meaningful relationship to the era that created it; and setting it into its time and relating it to events and beliefs of its era expands our understanding both of the buildings and of the period and people that created them.

1

Establishing a Style: Boston, New York, and Chicago

My requirement of "elegance" [for a museum] contemplates chiefly architecture and
fittings. These should not only be perfect in stateliness, durability, and comfort, but
beautiful to the utmost point consistent with due subordination to the objects displayed.
　　　　　　　　　　　—John Ruskin, "A Museum or Picture Gallery" (1880)

THE GENESIS OF THE THREE LARGEST AND MOST INFLUENTIAL ART MUSEUMS IN THE
United States took place during a time of stylistic exploration in architecture, before a
monumental classicism was settled upon with near unanimity as the style of choice for
the art museum building. Therefore, the stylistic vicissitudes of the art museums of
Boston, New York, and Chicago provide important keys to the understanding of the
development of this building type. The post–Civil War period of the 1870s found New
York and Boston among the leading cities of the country: New York in terms of popula-
tion and wealth, and Boston in terms of long-established cultural traditions. The time
was propitious for the founding of art museums in these cities. Chicago was nearly a
decade behind New York and Boston in the founding of its art museum in 1879, for
Chicago was still a raw young city, with the Great Fire of 1871 halting the pace of growth
of philanthropic institutions. The institutions, however, that were born in these three
cities have a great deal in common with their building histories, and as both the cities
and the museums were among the wealthiest and most powerful in the country, they
were also the most visible, the most watched, and probably the most influential in the
museum and architectural communities. For the purposes of this investigation, what
these three institutions most importantly share is an architectural history that takes a
dramatic turn by 1900 from smaller High Victorian Gothic or Richardsonian Ro-
manesque buildings to large, classically styled, and Beaux-Arts-influenced "temples of
art." An examination of these museums' early building histories and the reasons for
their change by 1900 into entirely different styles of buildings will introduce some of
the larger issues of this work and will reveal much about the philosophy of the institu-
tions, their relationships with their home cities, and the statement their architecture
might have made—for an art museum stood for "culture" in the city.

Any discussion of the Museum of Fine Arts, Boston, or New York's Metropolitan
Museum of Art as either building or institution requires a brief examination of Lon-

16

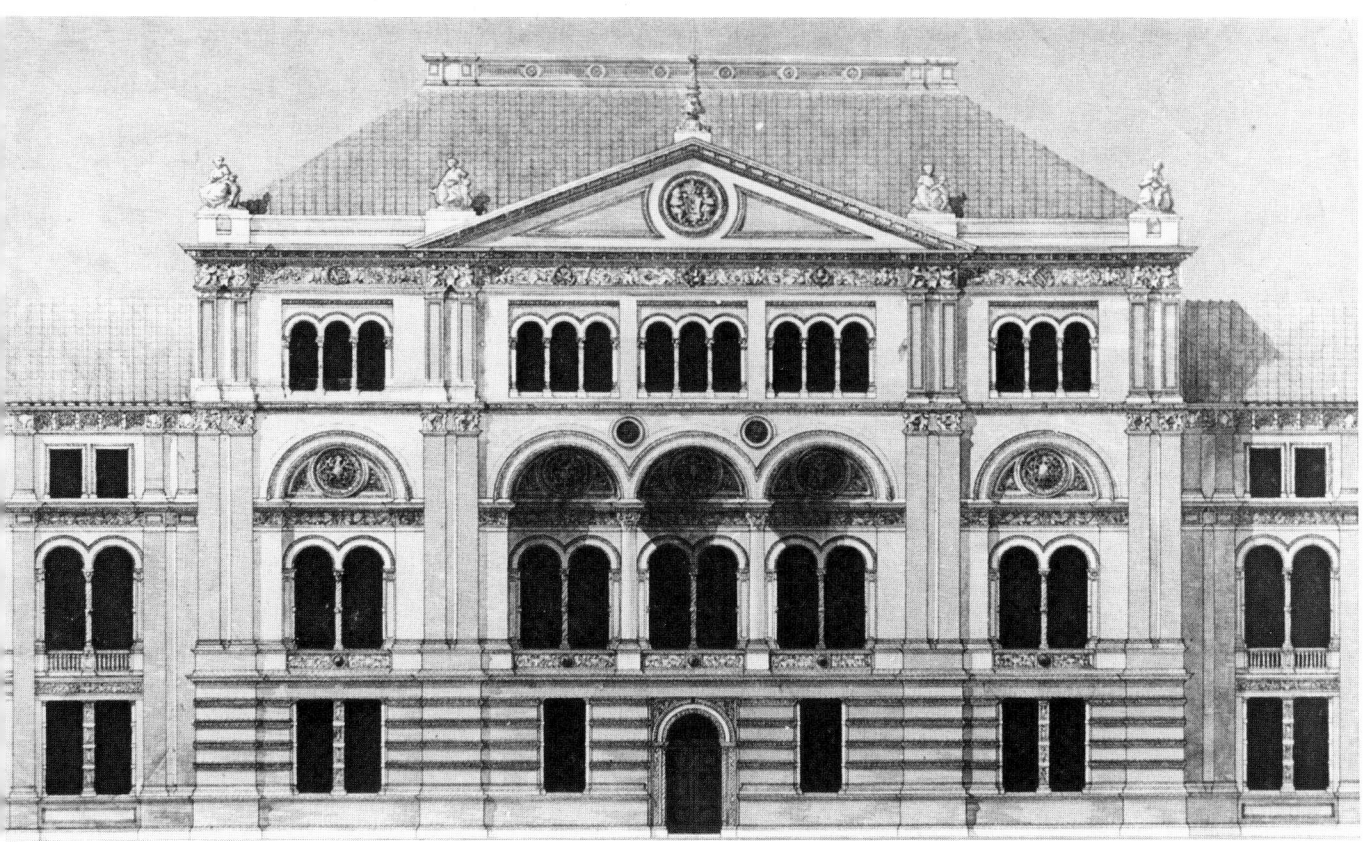

Francis Fowke. South Kensington Museum, lecture theatre facade, London, 1867–69. By courtesy of the Board of Trustees of the Victoria & Albert Museum.

don's South Kensington Museum, now known as the Victoria and Albert Museum.[1] As will be demonstrated, both Boston and New York's museums were founded with the notion of being a smaller, American version of the South Kensington. As this idea determined much about the museums as institutions as well as dictated to an extent how their buildings would look, the origin of these ideas must be briefly discussed.

The South Kensington Museum began as a collection of plaster casts purchased at the Great Exhibition of 1851 for what would later become the Royal College of Art. In 1852, it became a "Museum of Practical Art" and subsequently in 1857 a "Museum of Ornamental Art."[2] After the institution was named the South Kensington Museum and declared a success, the British Parliament in 1860 appropriated money to build permanent quarters for the museum to be designed by Captain Francis Fowke of the Royal Engineers, who was succeeded by Aston Webb in the 1890s. Thanks to the influence of William Morris, John Ruskin, and others, the current vogue in England was on the application of the arts to industry and architecture, as was indicated by the early names of the South Kensington. The aims of the museum were also influenced by this ethos, as it was defined by the museum's early officials, who were interested in reviving the use of mosaics in glass and in ceramic, tile, terra-cotta, and mural painting. The museum's architect, Fowke, even became head of a museum department, the Museum of Construction and Building Materials. Fowke's building, which made extensive use of such new materials as cement, iron, and terra-cotta, was itself an exercise both in archi-

tecture and engineering, as well as a concrete demonstration of the educational mission of the museum.

The philosophy of the South Kensington Museum, therefore, was based on the application of the arts to manufacture, industry, and architecture. The museum would house the finest examples of the fine and decorative arts, as well as architecture, and these exhibits would educate and influence not only the students at the museum's school but also the general public. Toward this end, the museum building was to be an educational influence in itself; thus, tile, mosaic, mural painting, and terra-cotta were incorporated into the decoration of the building both within and without. The terra-cotta ornamentation, for example, was a tangible symbol of the philosophy that fine art could be incorporated into mass-produced goods. On the exterior, terra-cotta proliferated with panels designed by Godfrey Sykes. The Lecture Theater facade (1867–69), which dominates the quadrangle, exhibits a typically Victorian eclecticism, with some influence from Ruskin and his preference for northern Italian Gothic polychromy and foliate forms and some influence from early Renaissance architecture. The buff-colored terra-cotta contrasts with the red brick of the walls to provide the polychromed effect, which is enhanced by mosaic work in the pediment. The large terra-cotta columns of the central triple-arched motif, also designed by Sykes, are elaborately decorated with bands of figures encircling the shafts and vines or branches twining up the length of the shafts; the capitals also incorporate foliate forms. The overall architectural effect, however, is not Gothic but early Renaissance. This effect is created by the central triple-arched motif over a rusticated first floor and a small-scale, repetitive arcade running through the attic story, the entirety surmounted by a classical cornice, balustrade, and pediment.

Although the American art museums of the 1870s retained more of the Gothic Revival influence from an earlier generation, the architecture of the South Kensington Museum would prove, in the case of the Museum of Fine Arts, Boston, to be as influential as the educational philosophy of the British museum would be to the Metropolitan Museum in New York. To monitor the changing extent of the influence that the South Kensington Museum held over American art museums is also to witness the change and growth of the American museums both as institutions and as architectural statements. New York's Metropolitan Museum of Art and the Museum of Fine Arts, Boston, the United States' earliest major art museums, were also those most heavily influenced by the London museum.

The Museum of Fine Arts, Boston, by Sturgis and Brigham

New York's Metropolitan Museum of Art and Boston's Museum of Fine Arts vie for primacy of establishment as the earliest major art museum in this country. With Boston dating its act of incorporation to February of 1870 and New York dating its to April of the same year,[3] Boston may claim to be the earlier, and its first permanent building expressly designed for the purpose of housing the museum collections predates the Metropolitan's both in design and construction. The museum opened a competition for the design of a building in June of 1870, which was won by the firm of John H. Sturgis and Charles Brigham. The original Museum of Fine Arts building, located on Copley Square, was influenced largely by the South Kensington Museum and, as built, was the first major terra-cotta-embellished building in this country.[4] As Margaret Henderson Floyd discusses in her article on the building, not only did the founders of the Boston museum overtly express their desire to create a South Kensington Museum in Boston, but the highly symbolic use of terra-cotta was also a means of identifying with the British institution.[5]

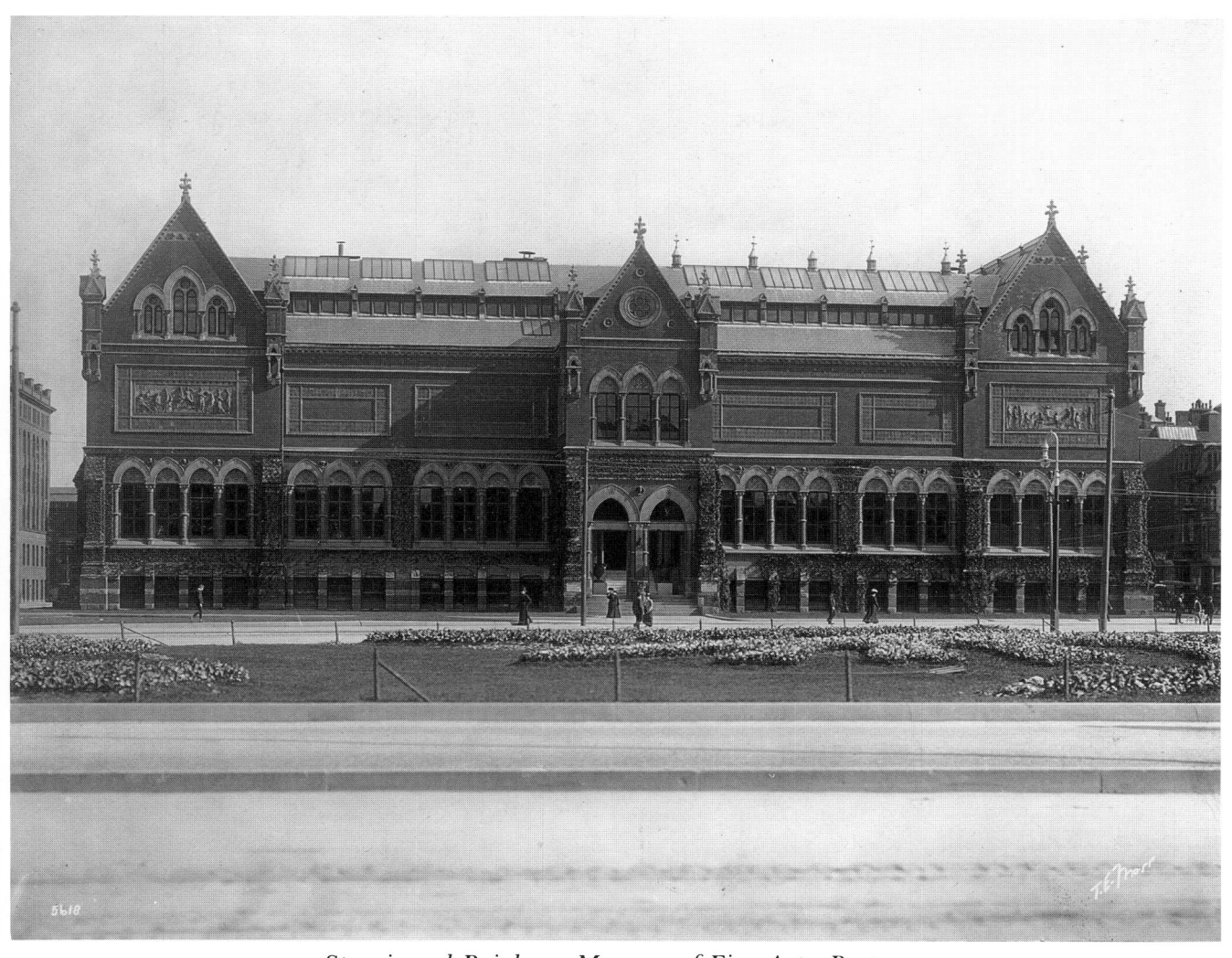

Sturgis and Brigham. Museum of Fine Arts, Boston,
1870–76. Courtesy, Museum of Fine Arts, Boston.

Both the design of the ornament and the building itself were inspired by English sources, especially because, as Floyd points out, the anglophilic John Sturgis had been living in England since 1866 and was motivated by his training—with architect James K. Colling, who had himself published books on Gothic ornamentation—and his personal preference for the Gothic Revival generally and John Ruskin's ideas specifically. The highly influential architectural writings of John Ruskin, such as *The Seven Lamps of Architecture* (1849) and *The Stones of Venice* (1853), advocated the Gothic style, particularly northern Italian Gothic with its structural polychromy and abstract foliate ornamentation. In his writings, Ruskin specifically approved of terra-cotta ornamentation as well.[6] Sturgis was closer to the architectural forefront in Europe than most of his American contemporaries; hence, the use of terra-cotta on the Boston museum building's Ruskinian Gothic design was at the cutting edge of American architectural production. As Floyd points out, the Boston museum's west facade (the first portion of the building to be completed) bears a strong resemblance to Deane and Woodward's University Museum at Oxford (1855–59), that most directly Ruskin influenced of English buildings.[7] Characteristic in the Boston museum of the style advocated by Ruskin are the pointed-arch arcades, the steep, finialed gables, and the polychrome combination of the terra-

cotta with the red brick, red and buff-colored tiles, and the granite of the basement. Typical, too, of Italian Gothic and Ruskin's preferences is the application of these details to a flat- or plain-wall surface. Adding further to the Gothic quality of the exterior are the buttresses going up to the first floor and the dwarf columns just below cornice level that support ornamental pinnacles. The museum was behind the styles of Europe in that it relied only on Ruskin and the Gothic, whereas English architecture was already beginning to move away from the Gothic by the 1870s, as can be seen in the lack of pointed arches on the South Kensington.[8]

In 1880, when the Copley Square building was still quite new, the museum was very proud of its standing at the architectural forefront with its use of terra-cotta. A long overview of the museum and its collections in *American Architect and Building News*, asserted that the museum

> was for a long time the most prominent example of terra-cotta construction in this country, holding, in this respect, much the same position as the . . . South Kensington, and even now there are few buildings of equal extent in which it forms so large a portion of the structure.[9]

That this decoration did not long stay in favor either with the museum officials or with the public became a part of the impetus for architectural change when a new museum was built, as will be demonstrated. The original style of the building was maintained throughout several building campaigns, however. The first completed portion of the building of the Museum of Fine Arts was dedicated in 1876. A subsequent addition opened in 1879, and the building in its final form opened in 1890. Only a decade later, the Boston museum would follow the examples of the museums of New York and Chicago and abandon their Ruskinian Gothic building in Copley Square in favor of a new, monumental classical building on the Back Bay Fens.

The Metropolitan Museum of Art, New York, by Calvert Vaux

Unlike the Boston museum, the New York institution never abandoned its original site, so its building as it now stands is a palimpsest of American architecture covering the period from 1872 until the present, from Vaux and Olmsted to Roche and Dinkeloo. At the outset, its history is intimately linked to the history of Central Park, where it came to be located. From the beginning, provisions were made in Central Park for the placement of various educational institutions within its boundaries. The original competition for the park called for a site to be designated for an exhibition or concert hall, and in Olmsted and Vaux's winning design (1858), the old arsenal building was to be a museum. In 1859, a law was passed that allowed bequests for the purpose of establishing museums within Central Park, and the park commissioners felt at the time that "institutions of this kind are desirable and would be fitly placed on the park."[10] It is, therefore, hardly surprising that in 1870, when the museum was legally incorporated and the trustees began looking for a permanent home, negotiations began almost immediately for a Central Park site for the building.[11] Because the park commissioners had control—both monetary and aesthetic—over buildings erected in Central Park and because both Olmsted and Vaux were on the Board of the Department of Public Parks,[12] the appointment of Calvert Vaux as architect of the Metropolitan Museum of Art was practically inevitable.[13] Vaux's design of 1872, the first portion of which was not completed until 1880, is in a style that harmonizes with the other incidental architecture of Central Park and was as typical of the period as the original Museum of Fine Arts, Boston. Like the Sturgis and Brigham building, the primary influence on the design

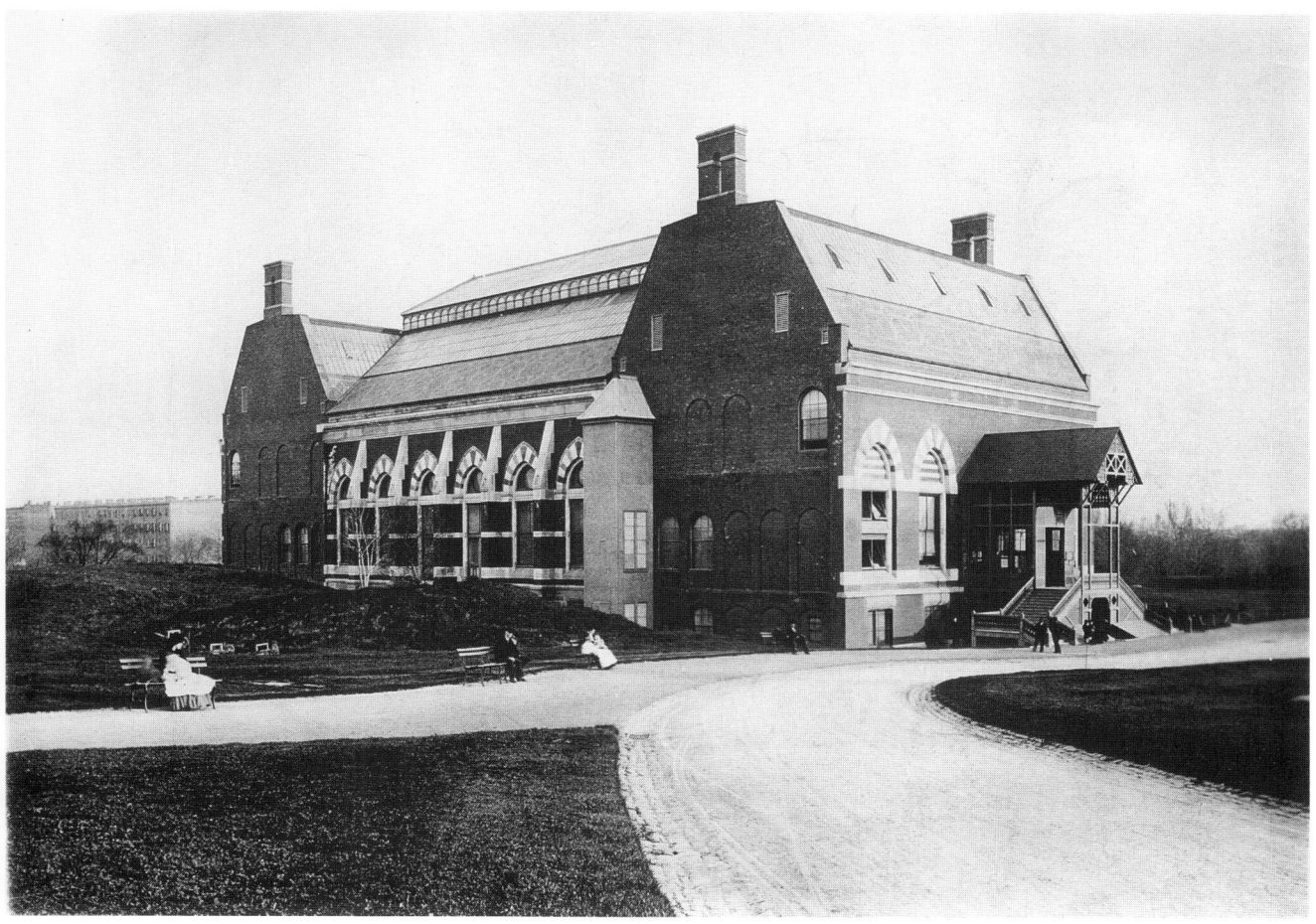

Calvert Vaux. Metropolitan Museum of Art, New York, 1872–80. Courtesy, The Metropolitan Museum of Art.

is the English picturesque; Vaux and his partner Jacob Wrey Mould were both born and trained in London. Mould had been a student of Owen Jones, and both Vaux and Mould, as Morrison Heckscher points out in his history of the museum building, "brought to America a deep-seated commitment to the Gothic Revival" style of Ruskin.[14] This building, too, followed Ruskin's preferences for successions of pointed arches and structural polychromy applied to a plain-wall surface, including both the voussoirs over the windows and the geometrically patterned tiles on the roof. Vaux added a highly picturesque wooden entrance reminiscent of his designs for the rustic and pastoral Dairy building or the (demolished) Mineral Springs Pavilion in Central Park. Perhaps, in the eyes of the museum officials, this design was inappropriate for an art museum, for it did not last long.[15]

Neither did Vaux's role as architect of the museum last. Museum officials found Vaux difficult to work with, so subsequent additions to the original museum block were handled by architects chosen from within the museum's ranks.[16] The second wing of the museum (1884–88) was begun just after the first one was finished, and the architect, Theodore Weston, was one of the founders and a trustee of the museum. With classicism on the rise, the High Victorian Gothic style chosen by Vaux for the museum was abandoned, and Weston adopted a Roman-arched style that, nevertheless, carried on the

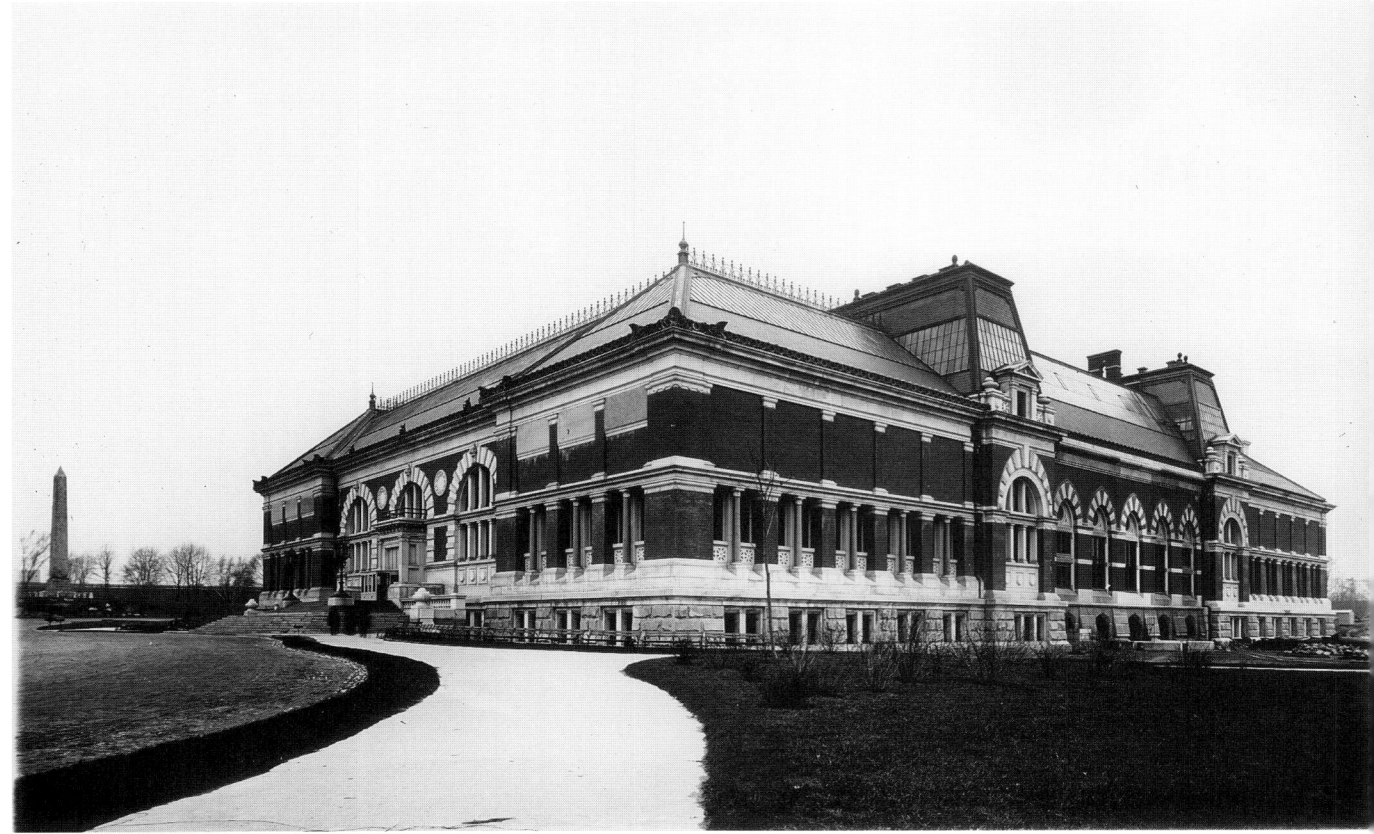

Theodore Weston. Metropolitan Museum of Art, New York, second wing, 1884–88. Courtesy, The Metropolitan Museum of Art.

polychromed voussoir idea of the original. He moderated the transition between old and new via the use of tall, narrow projecting pavilions with high mansard roofs and pedimented dormers, all perhaps intended to recall the Louvre of the 1850s. The new wing was thus an odd mix of formality and the picturesque, a result perhaps not unexpected from a civil engineer whose first and only design project was the museum's new wing. The covered wooden entrance gave way to a more elegant entrance centered on three of the large arches, and the angular, picturesque roofline gave way to a lower, broader sweep of roof. The red brick building material was continued, and Vaux's portion remained highly visible and uncomfortably integrated.

The third wing (1890–94), essentially a mirror image of the second, was carried out by yet a third architect, Arthur Tuckerman, who had been Weston's associate on the previous extension. By 1894, the shape of the museum had reached a turning point; it was a self-contained rectangular block, enclosing four small courtyards, and not easily to be augmented in any direction. It was at this juncture that the influence of events in Chicago would effect a change in the architecture of the museum in New York and produce a classical facade for the picturesque heart of the Metropolitan's original building.

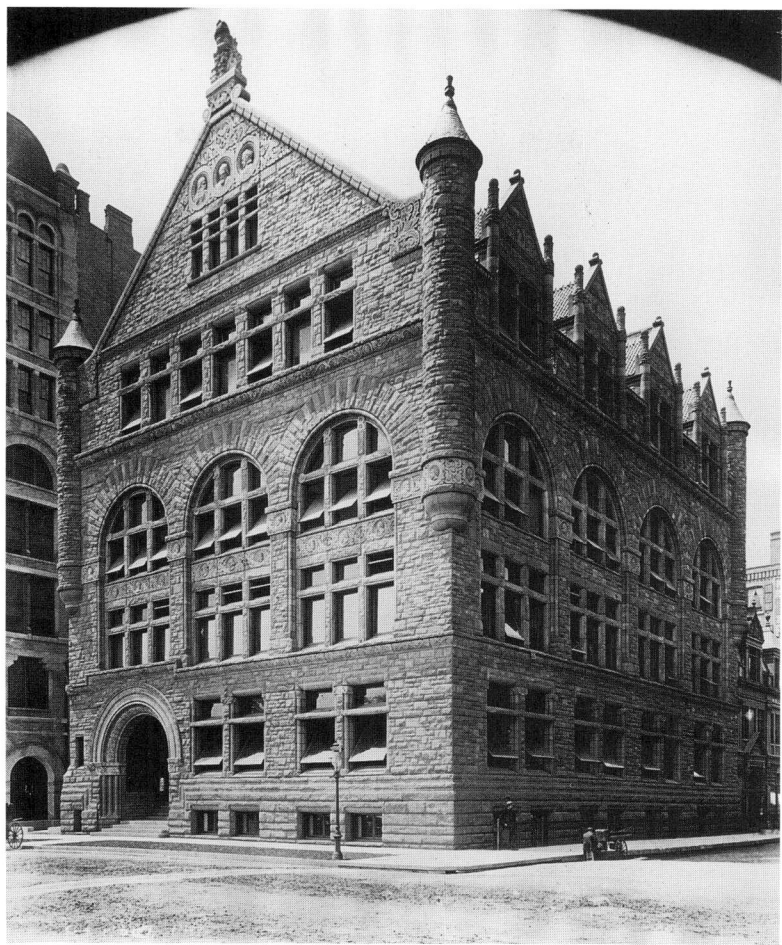

*John Wellborn Root. Art Institute of Chicago,
1886–87. Courtesy, Chicago Historical Society.*

The Art Institute of Chicago, by John Wellborn Root

Incorporated in 1879 as the Chicago Academy of Fine Arts, the Art Institute of
Chicago had a later start than its East Coast peers. It occupied two temporary homes
before building its first permanent structure expressly designed for its purpose in 1886
and completed in 1887.[17] The architects for this building were Daniel H. Burnham and
John Wellborn Root, but it is generally Root who is credited with the Richardsonian
Romanesque look of the building.[18] Typical of the Romanesque style used by Root was
the Art Institute building's foursquare massing; its dark, richly textural, monochrome
ashlar masonry; and its simplified, round-arched forms with the exaggerated voussoirs.
The style as exemplified by its eponymous practitioner, Henry Hobson Richardson,
posed a study in contrast to the picturesque flights of fancy of the High Victorian
Gothic. Its most famous exemplar was Richardson's well-known Marshall Field Whole-
sale Store (1885–87) in Chicago, with which Root would have been very familiar. Unlike
the massive blockiness of Richardson's building, however, Root's Art Institute of Chicago
had some picturesque features, vestiges from the previous generation of architectural
eclecticism. Root's design incorporated small turrets fastened to each corner and a row
of gables running down the long side of the building. Although the building from the

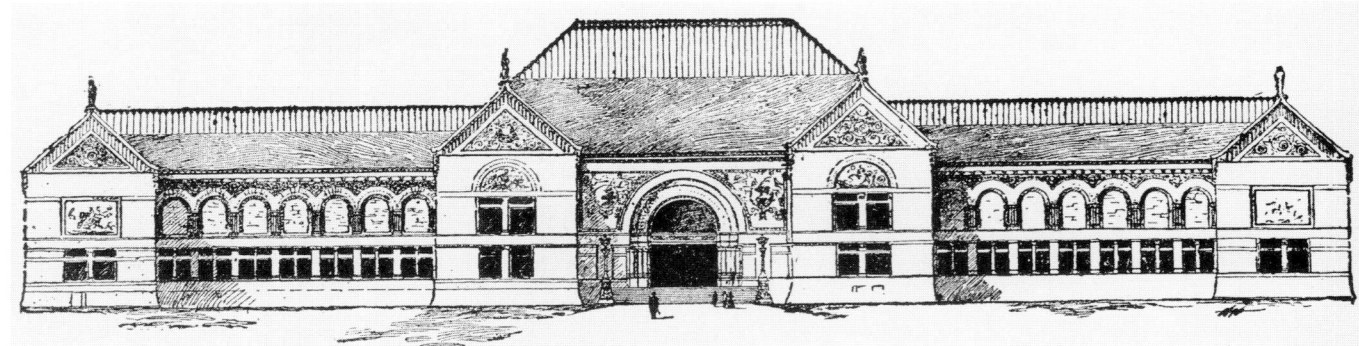

*John Wellborn Root. Art Institute of Chicago. Pro-
jected design, 1890. From Harriet Monroe,* John
Wellborn Root, *1896; photograph, courtesy of the
Art Institute of Chicago.*

cornice down was simple, massive, and unified, the roof line, composed of the turrets'
conical roofs, steep gables, and finials, exhibited a broken quality that was already be-
coming unfashionable by the late 1880s.

Still, the original Art Institute building was well liked upon its completion, Montgom-
ery Schuyler calling it an "admirable building,"[19] and the *American Architect and Building
News* writing that its "general outline [is] decidedly pleasing."[20] The unknown author
of the latter comment pointed out what he saw as a defect of the building, that the
building's appearance "is certainly not that of one's preconceived ideas of an art build-
ing, since it might with equal good judgment be taken for a club-house or even a
produce-exchange."[21] Indeed, this quality was planned in order to keep the building a
salable property; appropriately, the building was purchased by the Chicago Club when
the Art Institute sold it. That an art museum should *look like* an art museum was a
primary concern of the next generation of museum builders, and the architects of the
new Art Institute building addressed this issue with elements borrowed from a Beaux-
Arts language that insisted on appropriateness of architectural expression, as will be
shown.

The Art Institute of Chicago, by Shepley, Rutan, and Coolidge

Like the museums in Boston and New York, the Art Institute of Chicago has a
building history that begins with a structure very different in style from the classical
monument it built in 1893—still its signature facade. With a population that nearly
doubled during every decade of the latter half of the nineteenth century, Chicago
maintained an urban pace even quicker than that of New York and far outdistancing
that of Boston. With a speed commensurate with its population growth, Chicago's art
museum compressed its building's transformation into less than a decade. The building
designed by Root was completed in 1887, and the first portion of its new building was
completed in 1893. Spurred on by the defining event of fin-de-siècle American art and
architecture, the World's Columbian Exposition, the Art Institute's 1893 building was
among the first permanent architectural expressions of the fair that was often credited
with changing the face of American architecture and the urban milieu for more than
a generation.[22]

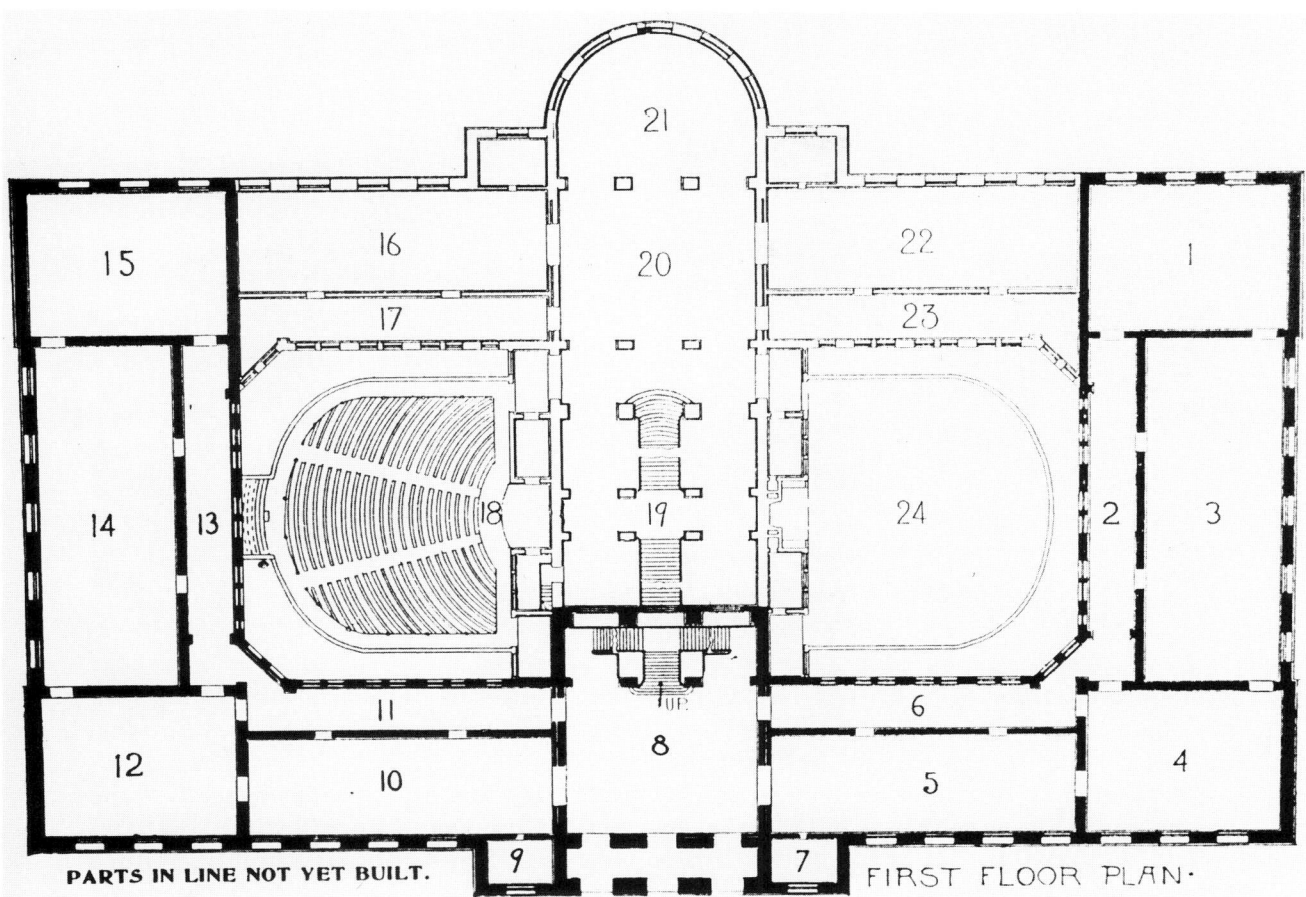

Shepley, Rutan, and Coolidge. Art Institute of Chicago. Plan, 1891. Courtesy of the Art Institute of Chicago.

Situated on a corner lot on Michigan Avenue, two doors down from Adler and Sullivan's Auditorium Building (1886–89), the Art Institute's original building was quite small and had limited room for future expansion. Only four years after moving into their new building, the trustees realized that the lack of space was already a problem and that the building would soon be inadequate for the needs of the museum and school.[23] It was not long after the building's opening in 1887 that the Institute's benefactors seized an opportunity to erect a new building on a prime site only a little north of the original location, but in a piece of parkland on the waterfront of Lake Michigan.

Like the Metropolitan Museum in New York, which was founded at a meeting of the Union League club, the Art Institute of Chicago also had close ties to one of the city's men's clubs, which served as a meeting place and intellectual proving ground for the power elite.[24] The Chicago Commercial Club maintained its ties to the Art Institute into the twentieth century. Its members provided much of the financial support that allowed the Institute to expand physically. In 1890, once Chicago had been determined as the site for the World's Columbian Exposition, the Commercial Club held a meeting debating: "Has Chicago not reached that period when special attention should be given to the founding of art galleries and museums? Will the World's Columbian Exposition be of any benefit to this city in that direction?"[25] The answer must have been a resound-

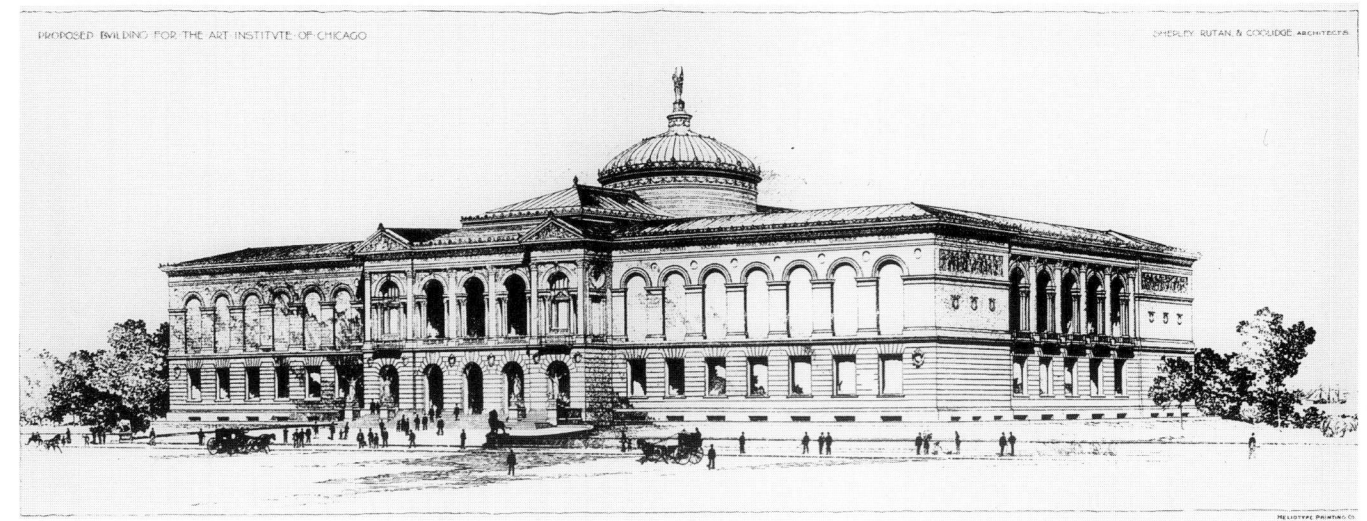

Shepley, Rutan, and Coolidge. Art Institute of Chi-
cago. Projected design, 1891. Courtesy, Shepley Bul-
finch Richardson and Abbot.

ing "yes" on both counts, for the Club appointed a committee to discuss with the Exposi-
tion directorate the possibility of erecting a permanent building for a museum that
would serve temporary Exposition functions.

After lengthy negotiations among the Commercial Club, the Art Institute, and the
Exposition company,[26] it was agreed that the Art Institute would supply $300,000 and
receive $500,000 from the Exposition company toward the erection of a building which
would house the Exposition's art department during the fair and the Art Institute's
collections afterward. Not entirely coincidentally considering the nepotistic nature of
the Chicago cultural elite, Burnham and Root, the Institute's previous architects, were
already at work on plans for the Exposition when the trustees asked the firm for designs
for their art building. Root's design (1890), presented less than two months before
his untimely death, was, not surprisingly, for a very large, imposing Richardsonian
Romanesque museum.[27] Although more refined than the Institute building of only
four years earlier, the design remained firmly in the Romanesque idiom, which was to
be swept away by the classicism of the Exposition.

Root's design was not destined to be built, however, not only because of his death but
because the site of the fair was moved south to Jackson Park in February of 1890. In
1891, the Art Institute negotiated with the city of Chicago for the right to use the site
occupied by the Illinois Inter-State Industrial Exposition building (1873) in the Lake
Front Park. Root's design was conclusively abandoned when Burnham and the architects
involved in the designs of the Exposition buildings decided on a consistently classical
look for the fair. The Fine Arts Palace that resulted from these decisions will be exam-
ined in the next chapter. As for the Art Institute, a variety of architects prepared designs
which were presented to the building committee. The Trustees' *Minutes* mention, along
with Root, Solon S. Beman, Healy and Millet, Charles B. Atwood (designer of the Fine
Arts Palace at the Exposition), and the Boston firm of Shepley, Rutan and Coolidge.[28]
After considering these designs, the building committee invited Atwood and Shepley,
Rutan, and Coolidge to submit studies of plan and exterior in competition. The Boston
firm of Shepley, Rutan, and Coolidge was chosen; Atwood's competition drawings do
not survive.

It is ironic that Root's plan for the Art Institute, still steeped in the Richardsonian Romanesque tradition, was superseded by a design executed by Richardson's own successor firm. George Foster Shepley (1860–1903), Charles Hercules Rutan (1851–1914), and Charles Allerton Coolidge (1858–1936) had all worked in Richardson's office until his death in 1886, whereupon the three formed their own architectural firm.[29] Though none of the three had attended the Ecole des Beaux-Arts in Paris, they absorbed that method of designing from Richardson, who had received his training there. After Richardson's death, however, they began to downplay the Romanesque style of his architecture in favor of classical design.

The plans developed by Shepley, Rutan, and Coolidge for the 1891 Art Institute competition show a building very close in concept to the building that was actually executed.[30] The outside walls enclose a large, simple rectangular block, within which the museum's galleries form a square figure "8" plan, with the two center sections thereby created occupied by a library on one side and a lecture hall on the other. The plan is united by a centrally axial "Grand Hall," broken along its broad spine by a large double staircase in the center and a semicircular exhibition room terminating the far end. On the exterior, the design is elegantly classical, a blind-arcaded *piano nobile* being

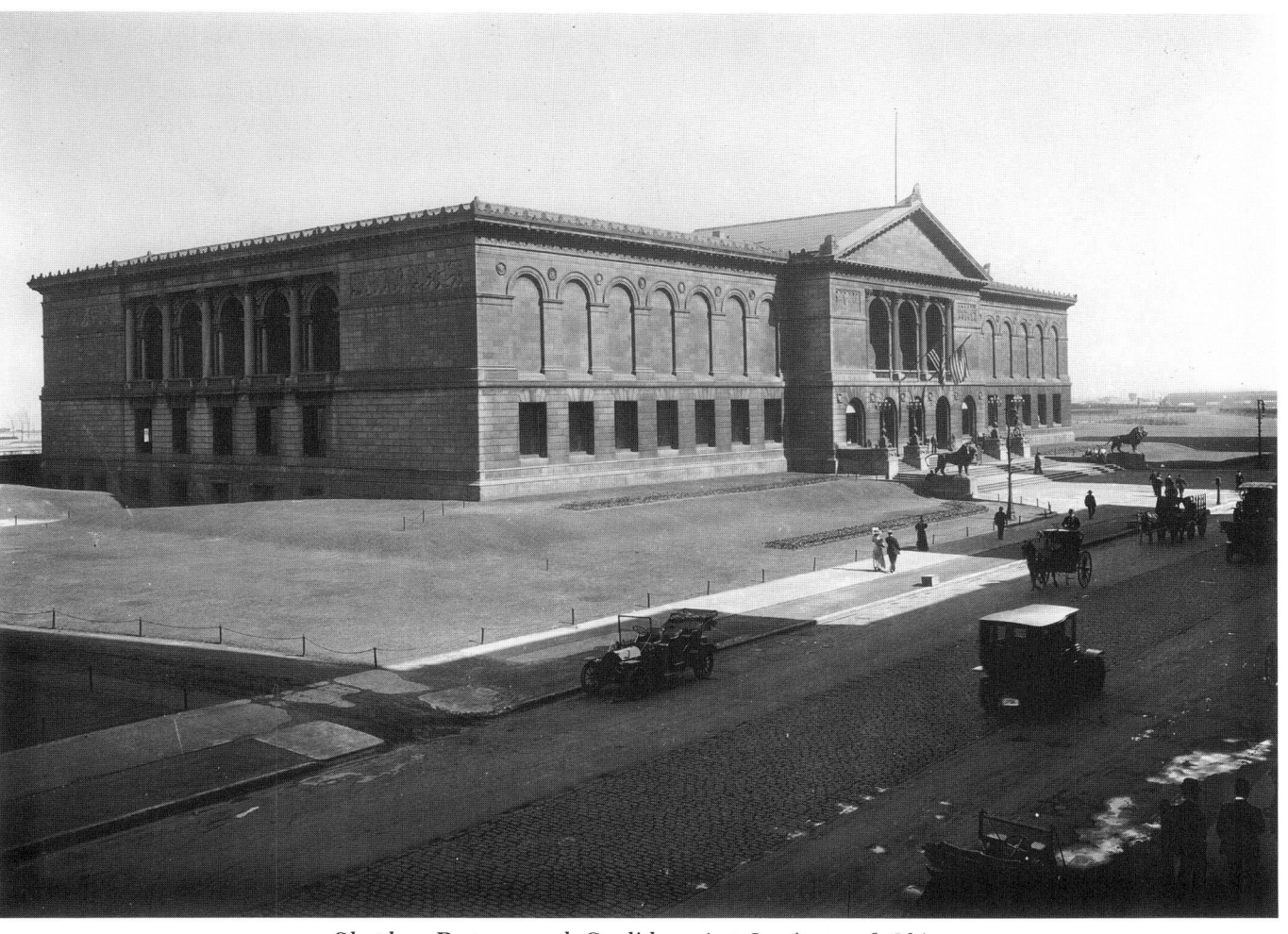

Shepley, Rutan, and Coolidge. Art Institute of Chicago, 1891–93. Courtesy of the Art Institute of Chicago.

set on a high, rusticated ground floor and a large dome topping off the roof. The design finally adopted was not greatly different from the competition design, but it was refined and some of the extraneous details reduced. The dome was eliminated (as probably too costly), and the front entrance was simplified to a single, large, pedimented pavilion set over the arcaded, rusticated ground story. To emphasize further the authentically classical aspect of the building and perhaps to act as a symbol of the art inside, portions of the Panathenaic Procession, reproduced from the Parthenon, were set into the walls around the Art Institute. Also acting as a symbol of the purpose of the building were the names of artists inscribed on the architrave running around the perimeter of the building.[31] This convention, perhaps most famously used by Henri Labrouste on the Bibliothèque Sainte-Geneviève in Paris (1838–50),[32] would become a favored device of American museum architects and was contemporaneously being employed by Ernest Flagg on the facade of the Corcoran Gallery of Art in Washington, D.C. The Art Institute's roster features most prominently the names of ancient Greek artists (Ictinus, Praxiteles) on the north side and Italian Renaissance artists from Leonardo da Vinci, Michelangelo, and Raphael to Titian, Correggio, and Tintoretto on the entrance front. These are certainly the most appropriate names to feature on a building whose style was derived both from ancient and Italian Renaissance architectural sources.

The Art Institute building, like so many other museum buildings of the era, was built in phases. The first campaign comprised the Michigan Avenue (main) facade and the two side galleries connected to it, so the plan of the completed portion in 1893 looked like a modified U, but from the entrance front the building appeared complete. Reaction to the building in both the professional and popular presses was favorable, and the trustees must have been pleased because Shepley, Rutan, and Coolidge and their successors continued to be employed as architects for the Institute for ten further projects, including the originally planned lecture hall and library.[33] In the *Architectural Record*'s "Great American Architects Series," Russell Sturgis called the central motif "really fine in conception" and the proportions of the elevations "notably good," though he found fault with some of the ornamentation.[34] The local press waxed poetic about the new building, seeing it as a great step in the progress of culture in Chicago. "The magnificent palace on the Lake Front," stated the *Inter Ocean* under a headline reading "Art Palace Opened/Grace and Beauty," is "a palatial edifice worthy of being the home of art in its noblest and most divine sense."[35]

Although there were no complaints about the Art Institute's old Romanesque building, as it had had no time to go out of style, there were expressions of relief in the local newspapers about the demise of the structure that the new building replaced, the 1873 Industrial Exposition building. Designed by William Boyington in 1873, the old Exposition building was a rambling glass, iron, and brick structure of an agglutinative design, topped with two large lanterns of vaguely Second Empire style. As it was being demolished, one observer discussed the architectural improvement of the Art Institute's building replacing the Exposition building, despite its historic nature: "Soon the old Exposition Building will have disappeared from the lake front and in the place of the big ramshackle structure will rise a palace for art, more enduring than a 'historic barn' and a fit reminder in years to come of the great Columbian Exposition."[36] Another critic was more vocal about his relief at the substitution: "The beautiful facade [of the Art Institute] will adorn a street which formerly has been disfigured by the old Exposition building."[37] The authors of these newspaper articles seemed to be very conscious of the progress of culture in Chicago and saw the Art Institute as a harbinger of cultural superiority in a city aware of its shortcomings in that area. The same writer who was worried about the "disfiguring" Exposition building claimed that the Art Institute

would "stand as a monument of what has been accomplished and a prophecy of the position art will yet hold in this empire of the West."[38]

As would happen in Boston upon the completion of the new Museum of Fine Arts, other observers of the Chicago urban milieu were conscious of the Art Institute's effects on the looks of the city and hopeful that it could become part of a new Chicago City Beautiful (even though the term itself had not yet been coined). One critic noted that, with the completion of the Art Institute building, Chicago would have a new urban showpiece: "That Chicago will have a place to take friends hereafter other than the stockyards is an accomplished fact."[39] Another writer noted that the architectural development of the area near the Art Institute had the potential to become a cultural and architectural center of the city: "What with the neighboring Public Library Building [also a classical design by Shepley, Rutan, and Coolidge], and others of a partly public nature, the locality will become one of the striking features of the city, architecturally considered."[40] Although the City Beautiful movement was not officially born until after the Exposition, Chicagoans were already expressing City Beautiful thoughts in relation to the classical building erected for the Art Institute.

In 1893, Chicagoans had much more of which to be proud than the new Art Institute structure. As the site of the World's Columbian Exposition, Chicago had a chance to prove that it was no longer "Porkopolis," but a city to contend with those of the East Coast as far as art and culture were concerned.[41] The World's Fair of 1893 provided the perfect forum for showing outsiders, particularly the eastern cultural establishment, that Chicago was capable of being a rival on the highest level. One local chauvinist claimed that the "Columbian exposition must have opened the eyes of the whole country to the fact that the eastern centers of culture, of art and literature, were quite left behind in actual aesthetic achievement as well as rivaled or exceeded in business quality by this swiftly growing metropolis."[42] This was why there were urgings at the outset to make the proposed Art Institute a showplace, as in the following statement made by the Director of the World's Columbian Exposition Executive Committee concerning the building's finances: "The committee should appropriate whatever is necessary to build the finest Art Palace in the world. . . . It is the only thing which will be left to Chicago after the Fair and we should be liberal."[43]

Although the relocation of the Exposition site to Jackson Park made the Art Institute building untenable for use as the Exposition's Art Palace, the Exposition company did not renege on its promise to provide the Institute with funding for the construction of a new building. Instead, the Directors of the Exposition passed a resolution wherein they determined that it was "desirable that some permanent memorial building, commemorating [the] World's Columbian Exposition . . . should be constructed" and that the Art Institute was a likely prospect for such a building.[44] The Exposition company therefore provided the Institute with funds for the building, with the agreement that the building would be available for the use of the Exposition.[45] It is also interesting to note that the Exposition directors required that before they gave any money to the Institute, the plans had to be submitted to and approved by the Exposition's Grounds and Buildings Committee. As the fair buildings had been determined to be classical, the related "memorial" building had one further reason to be in the classical style.[46] The building, therefore, did take part in the Exposition, as housing for perhaps the loftiest cultural undertaking of the Exposition.

The overarching goal of the fair was the summation of all human progress up to 1893, including technology, agriculture, the arts, and even the state of knowledge. The latter was the goal of the sessions of the World's Congresses which were held in the Art Institute building. The congresses assembled covered such disparate interests as

economics, government, labor, women's issues, education, fiction writing, architecture, philosophy, evolution, religion, and history (during which congress Frederick Jackson Turner gave his famous address, "The Significance of the Frontier in American History").[47] As one observer proudly noted, through the congresses, "a vast step was taken toward the unity of feeling throughout the vast human race."[48] In the eyes of many Chicagoans, the Art Institute must have retained a certain cachet not only from the fair itself but from the intellectual endeavors that took place inside, for the building "was for six months the rostrum of the greatest minds of every land on earth, that had listened to the eloquence and thought of the best, endowed minds of the day."[49] The fair was without a doubt one of the greatest milestones in the development of Chicago's urban character. The Art Institute building, as the only permanent building erected in connection with the fair, held a special place in the minds of Chicagoans, who regarded the fair with great civic pride.

Not only did the Art Institute benefit from the fair in acquiring its building and a reputation for intellectual excellence, but its collections benefited materially as well. After the fair, the Institute became the recipient of an unusually large collection of architectural casts, donated to it by the French government. These casts were representative copies of the holdings of the Palais du Trocadéro in Paris (designed by Davioud and Bourdais for the Exposition of 1878) and were shown as part of the art exhibits at the World's Columbian Exposition, intending to represent the history of French architecture with examples of Romanesque, Renaissance, and contemporary French work. After the fair, the casts were given to the Art Institute, endowing it with what was probably the largest such collection of casts in the United States. This collection enabled the Art Institute to offer, among its other art school courses, an architecture class, with the Trocadéro casts as study material. The trustees were very proud of this acquisition, noting in the *Annual Report* that the "collection of casts thus secured is unsurpassed in its kind, either in quality or extent, and its presence in Chicago almost insures the permanence and success of the school of architecture which we have already ventured to found."[50]

The donation of the Trocadéro casts would seem to make the architectural change in Chicago both complete and lasting. The East Coast, Beaux-Arts trained architects brought the French architectural tradition to Chicago via the fair and, peripherally, to the Art Institute, a lasting reminder of the fair. Not only the fleeting vision of the fair, and the lasting monument of the Institute, but the course of the training of future Chicago architects was put in the hands of the classicists via the casts that had come to rest in that repository of official art and culture, the art museum. As one champion of the classical style wrote, the "magnificent new Art Institute building . . . should make a home for a great school of architecture. May it exert a powerful influence on the architecture of the West."[51]

The Metropolitan Museum of Art, New York, by Richard Morris Hunt

The architecture of the World's Columbian Exposition had an effect not only on the architecture of the West but also on that of the East. The Metropolitan Museum of Art in New York adopted the monumental classical style that had been the keynote of the Chicago fair for its new facade upon the return of Richard Morris Hunt from the fair. This change in architectural style reflected an essential change that was occurring in the institutional philosophy of the museum: from a philosophy borrowed from the South Kensington Museum and closely identified with the Metropolitan Museum's

Richard Morris Hunt. Metropolitan Museum of Art, New York. Plan, 1895. Courtesy, The Metropolitan Museum of Art.

original High Victorian Gothic building of the 1870s to a more "high" art aesthetic that matched its new Beaux-Arts look by the turn of the century.

The Metropolitan's original building had pleased no one from the start and was becoming increasingly less satisfactory as time passed. The museum's *Annual Report* noted in 1879, before the Vaux wing had even opened, that the "exterior of the building has been much criticized."[52] Once the museum had actually moved in, the *Annual Report* noted with displeasure that the interior of the building also left a great deal to be desired: "The peculiarities of the building, its form and arrangement, required extraordinary labor and expense to fit it for the reception of the Museum's collections."[53] A later critic would call it "a rather gaunt and rather monotonous piece of Victorian Gothic."[54] The harshest criticism of all was delivered by a writer in a Midwestern paper: "The building of the Metropolitan Museum is oh! so ugly, so brutally ugly, and so incomparably coarse in every detail."[55]

By 1894, architectural tastes had changed to the extent that the museum building looked thoroughly antiquated, and at the same time, more space was desperately

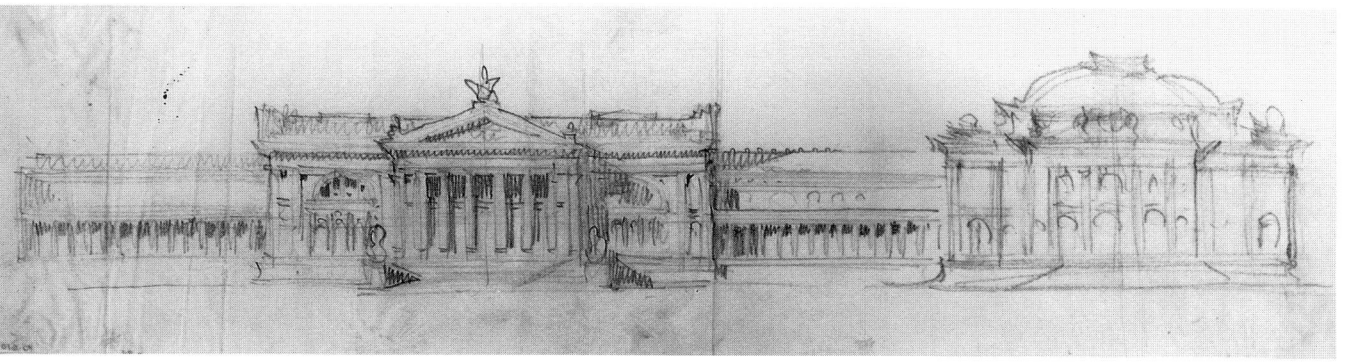

Richard Morris Hunt. Study for the Metropolitan Museum of Art, New York. 1894–95. The Prints and Drawings Collection, The Octagon Museum. Courtesy, The American Architectural Foundation (80.6105).

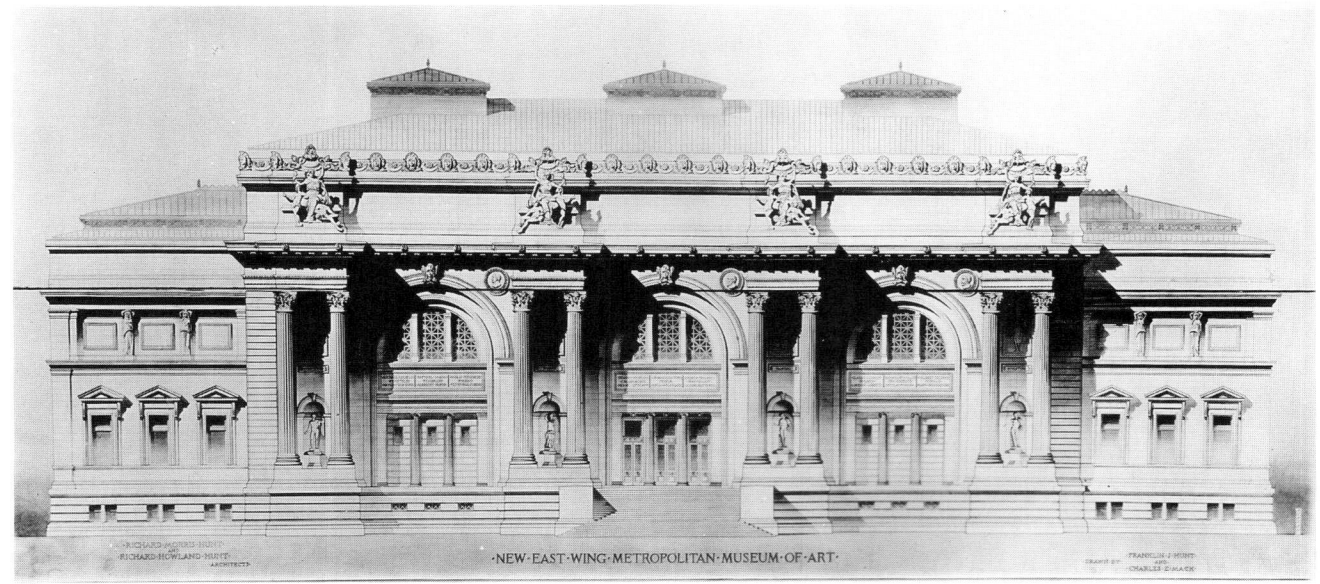

·NEW·EAST·WING·METROPOLITAN·MUSEUM·OF·ART·

*Richard Morris Hunt. Metropolitan Museum of Art,
New York. Fifth Avenue facade, 1895–1902. Cour-
tesy, The Metropolitan Museum of Art.*

needed. Richard Morris Hunt had just returned from the enormous success of the
1893 World's Columbian Exposition in Chicago, where as a sign of his professional
stature, he had been given the design of the Court of Honor's keynote structure, the
Administration Building. In 1893, Hunt was also given the distinction of being the
first American to receive the Queen's Gold Medal from the Royal Institute of British
Architects.[56] Hunt had been involved with the Metropolitan from its founding and was
a trustee and architectural advisor to the museum. That he had been passed over three
times for the opportunity of designing what was an important architectural opportunity
must have been extremely frustrating for the acknowledged leader of the profession.
In a rare moment of impatience, Hunt had turned down the request to be on the
building committee for the Weston addition, writing: "When the design of the original
building was adopted I alone formally protested, & it was not until this building was
well nigh completed that the Board recognized that I was right."[57]

When Henry Marquand, president of the museum after 1889 and former client of
Hunt,[58] convened a building committee in 1894 with Hunt as its chair, the time was
finally ripe for Hunt to begin work on correcting the "mistakes" of previous building
campaigns. That he would have done so with almost missionary zeal is suggested by
the words of one of his former students, Henry Van Brunt: "The battle of styles was
. . . waged all over the architectural field. . . . Hunt, with all the martial gallantry of his
nature inspired the classic camp with ardor. The Gothic side was championed by the
strongest and best equipped men in the profession."[59] Until his death in July of 1895,
Hunt worked on a grand scheme for the museum, including the Fifth Avenue facade
or east wing to be built immediately, as well as a plan for the future so vast and ambitious
that it could have taken the next century to build. The Beaux-Arts-trained and
classically-inclined architect devised a plan for the museum that would supersede and
entirely overwhelm the High Victorian Gothic structure and usher the museum into
the great age of classical museum buildings.

Hunt's plan would have completely enveloped the old building within a series of

interlocking galleries, halls, and courtyards, so that from the exterior, no sign of the original High Victorian Gothic mélange would be visible. The portion immediately provided for would have been an appropriate entrance to such a complex: a grand hall dominated on the interior by three great saucer domes and a long, sweeping staircase leading to the heart of the museum. Within the museum complex would have been a library, an auditorium, cloisters, a chapel, and innumerable galleries for the exhibition of paintings and sculpture. The plan is a dazzling display of Beaux-Arts grandeur; Hunt's great hall is a tantalizing foretaste of what might have been. This portion, delineated before his death and faithfully carried out by his son, is of a sophistication of design heralded by the architecture of the World's Columbian Exposition.

Hunt experimented with a variety of different designs before arriving at the final one. His design process can be followed by an examination of his preliminary sketches now at the American Architectural Foundation. What he discarded is as interesting, if not more so, as what he eventually adopted. What survive are mostly sketches for the main facade, which may thus be fairly compared to the present Fifth Avenue facade. Because they are not dated, the order in which Hunt conceived these ideas is difficult to ascertain; nevertheless, they are telling. For example, it might be argued that, compared to the old building, Hunt's new entrance is grand and imposing; yet, it appears from his sketches that most of his other ideas were even more impressive, nearly to the point of grandiloquence. One such sketch shows a very large, pedimented entrance portico with eight columns, flanked by arches. Next to it on the same sketch is a similar, hexastyle portico with attic, topped by a large saucer dome. Another sketch borrows heavily from French precedents, showing a pedimented entrance pavilion flanked by long, colonnaded wings ending in pavilions with high, Second Empire style roofs, similar to the parts of the Louvre on which Hunt had worked with his *patron,* Hector-Martin Lefuel, in 1854–55.[60] There are still more sketches, all of which experiment with long colonnades, large pedimented porticoes, and domes.[61] That Hunt relinquished these favorite Beaux-Arts expressions of architectural magnificence in preference to the much simpler design he eventually adopted showed restraint—and possibly a concern for not overwhelming the visitor with too much palatial majesty.

Instead, the Fifth Avenue facade of the Metropolitan Museum of Art achieves its effects through simplicity and excellence of proportion and manages to be both grand and inviting. The device of the linked columns framing the triple arches proved to be so effective that it was borrowed, with modifications, by the two other most successful Beaux-Arts buildings in New York City: the New York Public Library (1897–1911) by Carrère and Hastings and Grand Central Terminal (1907–13) by Warren and Wetmore and Reed and Stem. The design was greeted with applause from all corners. "His success . . . has been really brilliant. The Fifth avenue front of the Museum of Art is . . . the best classic building in the country," noted the architectural press,[62] and the architectural critic A. D. F. Hamlin called it one of the only buildings of "first rate importance" to have its designs exhibited at the New York Architectural League Exhibition in 1899.[63] The museum officials, too, were happy with the appearance of the building, labeling it a "monument to the great architect" Hunt and pointing out that the new wing now provided the museum with a "suitable" entrance and staircase.[64]

The public, as represented by the newspapers, also approved of the new edifice, calling it a "structure of splendor" and noting that "all that the artist and architect can do is shown in the new structure" and that the new portion "has not only added to the architectural beauty of the Museum, but . . . it has made possible a harmonious arrangement of the art objects."[65] One journalist especially noted the great difference of effect between the new portion of the building and the old: "The contrast between

the monumental grandeur of the new edifice and the commonplace, purely utilitarian style of the old is a startling one. It seems like passing from a temple to a railway station."[66] During an age with a growing infatuation with classicizing architecture, the appearance of the old Metropolitan building was clearly no longer considered appropriate.

That Hunt's design for the new wing of the Metropolitan Museum marked a departure from the original style of the building is incontestable. That it also marked a philosophical departure for the museum as an institution may be deduced by following the Trustees' *Annual Reports* from the museum's inception through the erection of the new wing. Like the Museum of Fine Arts, Boston, the founders of the Metropolitan Museum had hoped to establish a South Kensington-style museum on American soil. The museum's second *Annual Report* states this goal outright:

> The Trustees of the Museum purpose to establish an institution which, at some distant day shall combine the functions of the British National Gallery and the Art Departments of the British Museum and the South Kensington Museum. They desire, in the first place, to collect and publicly exhibit adequate examples of the ancient and modern schools of painting and sculpture, and, secondly, to provide as large and complete a collection as possible of objects which, without coming within the class just mentioned, derive their chief value from the application of fine art to their production—in short, a representative Museum of Fine Art applied to Industry."[67]

The legislative act of incorporation, passed in 1870, mentions that the purpose of the museum is "encouraging and developing the study of fine arts, and the application of arts to manufacture and practical life."[68] Even Richard Morris Hunt, present at the meeting at the Union League of New York that resulted in the establishing of the museum, mentioned that "it is our [the Society of Architects] aim to have, at no very future period, a museum similar to the Kensington Museum in London."[69]

In its early years, the museum did attempt to establish itself as a museum like the South Kensington. In its physical manifestation, the New York museum had a vague family resemblance to its more famous parent, adopting as it did the High Victorian Gothic idiom. Although the Metropolitan Museum building lacked the Boston museum's terra-cotta ornamentation, it did adopt one of the most telling physical characteristics of the famous London museum, namely the polychromy. Far more importantly, the museum attempted to carry out the philosophy of the South Kensington—the application of the fine arts to industry. From the beginning, it was important to the trustees that the artisan's life should encompass the beautiful or artistic: "The earnest examination given to [the collections] on free days by men of the working classes, is one of the most gratifying indications of their usefulness."[70] The ideological concern of the trustees that the industrial worker should become acquainted with art was particularly indebted to the likes of John Ruskin and William Morris, who both held that the division of labor typical of the modern industrial system was dehumanizing and claimed that "art is man's expression of his joy in labour."[71]

Toward the goal of becoming a "Museum of Fine Art applied to Industry," the museum dedicated a great deal of its public space in the original Vaux building—a large hall on the lower floor—to an industrial art collection. By 1880, the *Annual Report* noted the formation of classes for instruction in the industrial arts. The next annual report voiced the concern that "if American industrial art is to rank with that of European countries, it can only be by having educated artisans."[72] To help in the production of such workers, the museum offered, in 1881, classes in "Carriage Drafting," "Decoration in Distemper" and even "Plumbing." By 1885, the trustees felt they could congratulate

themselves on the success of the museum's effect on taste and artistic production, noting that the "relation between art education and the commercial prosperity of a country is as direct as the relation between man's demand for food and agricultural employments."[73]

The height of the museum school's success and popularity was reached during the mid- to late-1880s, when the school enrolled over 300 students in classes from "Architecture and Draughtsmanship" and a "Mechanical Class" to fine arts classes in "Color, Composition, Free-hand Drawing, and 'The Life,'" and "Sculpture Modeling." This partial list of class subjects indicates that the tendency of the museum school by this time was away from the strictly industrial or practical classes meant for local workers toward a curriculum meant for the aspiring "fine" artist, almost always of a higher social standing than the "artisan" who was originally intended to benefit from the museum and its classes. Despite the shifting emphasis away from the industrial arts and toward the fine arts, Henry Marquand, future president of the museum, could insist in 1888 that "the object of the Trustees [is] to provide instruction for the industrial classes. This building is as much intended for the humblest artisan in wood and metals as for the most luxurious patron of the fine arts."[74]

A mere five years later were to see the demise of these intentions. It is hardly coincidental that the abandonment of the industrial-art agenda coincided with the Beaux-Arts extravaganza in Chicago, the World's Columbian Exposition. It was in 1893 that a *Report of the Committee on Schools* found that

> the work done in the Museum Schools had . . . gradually ceased to have any relation to the Museum itself. They had ceased to make any use of the collections . . . and consisted for the most part of classes in drawing and painting such as could just as well been established anywhere else.[75]

This led to the reorganization of classes, with "advanced" students taught by artists of conspicuously "high" art tendencies, such as John LaFarge and Edwin Blashfield, who could not be less industrially inclined. Classes continued in painting and sculpture, but enrollment was down to 137 students with the industrial bent of the school having given way to traditional fine arts instruction.

The change in the philosophy of the museum's school can explain in part the change in the look of the museum building. The High Victorian Gothic aesthetic originally promoted by Ruskin glorified the unknown artisan who worked on the Gothic cathedral and incorporated motifs from nature which he gathered from firsthand experience. The result was an "honest" architecture; i.e., it sprang from tradition and the untutored local craftsman.[76] By re-creating the look of this architecture in various public buildings, including museums, the mid-nineteenth-century architects, artists, and theorists hoped to recreate a time when the "humble" workman took pride in his handiwork, which was a kind of art. This would be, they presumed, an antidote to the mind-numbing repetitiveness of mid-nineteenth-century industrialism. By espousing the beautiful in places like the South Kensington and Boston and New York's museums, it was also hoped that art could be brought into the industrial aesthetic, hence, the kind of classes at the Metropolitan that brought local workmen into the museum to teach them practical skills, as well as an appreciation of the beautiful. In the end, it was hoped that this influence would beautify the goods made for mass consumption, as well as improve the taste of the average consumer household.

By the end of the century, however, Americans had rediscovered the Renaissance. Wealth and artistic production had reached such a high level in the United States that both artists and patrons felt a kinship with fifteenth-century Italy.[77] A new professional-

ism was a necessary accompaniment to this rise in artistic production. It was essential to provide training for artists and architects who were to produce the kind of classical architecture, with the art to adorn it, that could compete with the glory that was the Renaissance. This atmosphere encouraged a more academic approach to art, with systemized training adapted from the Ecole des Beaux-Arts with its *ateliers, patrons,* and tiered competitions. Richard Morris Hunt, a product of the French school, was the first to bring both the style and the system to architecture in the United States. He helped to create the atmosphere that resulted in the Metropolitan Museum of Art's choosing to adopt a classical facade for its High Victorian Gothic building.

This same atmosphere, however, also shifted the emphasis away from a delight in the non-academic artisan's product and an interest in raising the standard of industrial art toward an expectation of a highly finished, classical product in both art and architecture. The Metropolitan Museum's school responded to the shift in emphasis and the new needs by reducing and eventually abandoning the classes whose focus was practical skills and art-as-applied-to-industry. These classes were replaced with those that focused on drawing and modeling, especially from life. The best students competed for the Lazarus Traveling Scholarship (established in 1892), which in 1899 was juried by a committee composed of artists and architects of the highest professional standing and academic tendencies: Edwin Blashfield, Will Low, Charles McKim, H. Siddons Mowbray, and Walter Shirlaw, among others.[78] This system of juried competitions was especially derivative of the French system of fine arts training. It was only appropriate that a museum with such a school should also have a building that was worthy of emulation by the students it was teaching.

It is indicative of the change in ideals that when the new wing by Hunt was opened in 1902, Frederick Rhinelander, president of the museum, gave a speech accepting the new building on behalf of the trustees, in which he ascribed the museum's origins to French influences rather than British ones. Neglecting entirely the influence of the South Kensington Museum, Rhinelander spoke of John Jay writing a letter from Paris, "the centre of the world of art," to encourage the establishment of a museum in New York. Rhinelander thought it significant that "the thought of a museum like this should come across the ocean from France. That capacity for art development so characterizes the French, that we owe much to them for the enrichment of this museum."[79] In the course of thirty years, then, the Metropolitan Museum of Art in New York City had undergone a fairly complete transformation of both building and philosophy that resulted in a rejection of Ruskinian ideals and an adherence to Beaux-Arts ones instead.

The Museum of Fine Arts, Boston, by Guy Lowell

The history of the building of the Museum of Fine Arts, Boston, parallels that of the Metropolitan Museum of Art in its essentials. The two institutions were founded within months of each other, and each built its first building in a style which would soon fall out of favor, so when the opportunity presented itself, both adopted the classical style which had established itself as the *sine qua non* of important public architecture during the 1890s. In the 1870s, the Boston museum had considered itself to be on the architectural forefront in its use of terra-cotta ornamentation. In 1899, only a decade after the completion of the final portion of its original building, however, the museum had purchased new land on its present site on the Fenway with the intent of building an entirely new structure and abandoning the old. The various reasons given for the building of a new museum structure are indicative not only of the tremendous growth

of the institution but of changes in the idea of what a museum should be and, ultimately, what it should look like.

The *Annual Report* of the Trustees printed the official reasons for desiring a new building away from Copley Square. The reasons given were simple and logical: an ongoing need for more space inside the building, lack of space for future expansion, tall buildings erected next to the museum blocking its light and the light of future additions, and the same tall buildings causing a fire hazard by their proximity.[80] These needs led the trustees to purchase lands adjacent to the Back Bay Fens, a marshy area useless for real estate that Frederick Law Olmsted had developed as a park. Not only the generous acreage—the museum purchased twelve acres between Huntington Avenue and the Fenway—but the land's proximity to the park ensured the trustees that the museum would be free of the encroachments of tall commercial buildings such as had been erected at Copley Square, both because of the predominantly residential area near the Fens and also because of legal height restrictions and setbacks provided for the area.[81]

Apart from the lack of space, other problems indicated the need for a new building to the museum's trustees and directors. The interior courtyard arrangement and too-small windows of the Copley Square building were found unsatisfactory for lighting the collections that were not under skylights; the interior design could not easily accommodate division into different departments. There was simply not enough storage space, resulting in a majority of the collections being crowded together in tight spaces, publicly exhibited regardless of suitability or quality. One review of the new building commented, "It is safe to say that we shall discover some things which were really in the old building, only so obscured, or so mixed up with plaster casts that we did not know them for treasures."[82] As Benjamin Ives Gilman, Secretary of the museum, pointed out, when the original building was designed,

> there were no collections to house, or only the smallest, and no exacter knowledge of the requirements of their administration. A building was therefore demanded and supplied, first of all to make a dignified and appropriate appearance, and only in the second place to serve as a functional museum.[83]

When the new building on the Fenway was designed, it looked very different from the old Ruskinian Gothic, terra-cotta-encrusted building. Although a museum cannot afford to build a new building simply because the style of its building is no longer current, it is apparent that by the turn of the century, the 1876 building had long fallen out of favor stylistically. By 1905, the influential museums in New York and Chicago, as well as others across the country, had already built their classicizing buildings, and it was time for the venerable Boston institution to follow suit. This was done, it appears, with great relief. As the museum's *Bulletin* readily admitted, the

> criticisms it [the Sturgis and Brigham building] has encountered refer not to the disposition and proportion of masses and openings, but to the quantity, quality, and color of the terra-cotta ornament. This was made in England in a fashion not now in favor. It has, moreover, not withstood our climate.[84]

In fact, as the author of this complaint points out, by 1888, i.e., within twelve years of the first building's dedication, "faith in the architectural possibilities of terra cotta had waned, and the Dartmouth Street and Trinity Place extensions of the building, designed by the same architect and carried out by his successors, are bare of any."[85] Not only did the terra-cotta ornament shed its foliage in bad weather and fall out of favor archi-

tecturally, but it was also heartily disliked by the public, as appears in this newspaper excerpt:

> It is a fine thing to think of our having a newer and better museum, without the stamped Johnnie-cake ornament, as Hunt used to call them. An old Boston wag used unkindly to say that if architecture were frozen music, the Art Museum must be 'Yankee Doodle.'[86]

The scorn heaped upon the building by lay observers could only have fueled the desires of the Boston museum's administration and Trustees to build a new museum in the most correct of "modern" tastes.

Architectural fashion had turned away from the Boston museum's original influences, the South Kensington Museum and British Ruskinian Gothic, both of which had also fallen out of favor by the turn of the century. One author who extolled the new building pointed out what he perceived as the futility of the Ruskinian ethos, when he said that the new museum exhibited a

> tendency toward restraint, logic and style. The front is thus in contrast with the highly colored Victorian façade of the present building in Copley Square, a reminiscence of the taste of 1875, when one read Ruskin and sincerely believed that an array of pointed arches and variegated stonework would reproduce the spirit of Gothic architecture.[87]

The author seems to believe that the earlier disposition toward Ruskinian Gothic was charming but naive and best discarded as architectural taste matured.

Likewise, the institutional philosophy of the South Kensington Museum was no longer held to be the ideal for the modern museum. Another critic, praising the new arrangement of the Boston museum, compared it to the South Kensington, and asked, concerning the British institution: "Is there any place in the world where so many fine objects produce so much weariness and afford so little pleasure?"[88] Clearly, it was felt that the new building represented progress on many fronts.

Because of the deficiencies of the Sturgis and Brigham building as a functional museum building, the design of the new building was approached with years of preliminary study. A building committee was appointed in 1902, and it took the unusual and unprecedented step of employing an architect—R[ichard]. Clipston Sturgis, nephew of John Sturgis—to study the needs of the museum and propose a general scheme for the building, at which point his employment would cease and the museum would either hire an architect to furnish the actual plans or hold a competition for the same purpose. Not only did Sturgis and his consulting architect, Edmund M. Wheelwright, devote nearly three years' study to the problem, but the museum also undertook a series of publications on museum buildings in general, in a four-volume set entitled *Communications to the Trustees Regarding the New Building* (published 1904–06). The first of these volumes published a variety of essays on the subject of the museum building, including Benjamin Ives Gilman's thoughts on "The Monument and the Shelter" and "On the Distinctive Purpose of Museums of Art." In the first, Gilman called for a building that considers first the functional needs of the museum, but he also asked, at the end, that it might be "a Shelter to rival a Monument in beauty."[89] In Gilman's longer essay was another intimation that the South Kensington philosophy was no longer considered the ideal. He maintained that an art museum's essential difference from other types of museums is that its mission is *not* educational.[90] To the contrary, he stated that "to conceive of fine art as model, or lesson, or training is not only to ignore its essential nature, but to contribute to the perpetuation of that ignorance."[91] This idea is diametrically opposed to the South Kensington idea that the great benefit of the art museum would be to bring beauty to industry by teaching craftsmen the lessons of art.

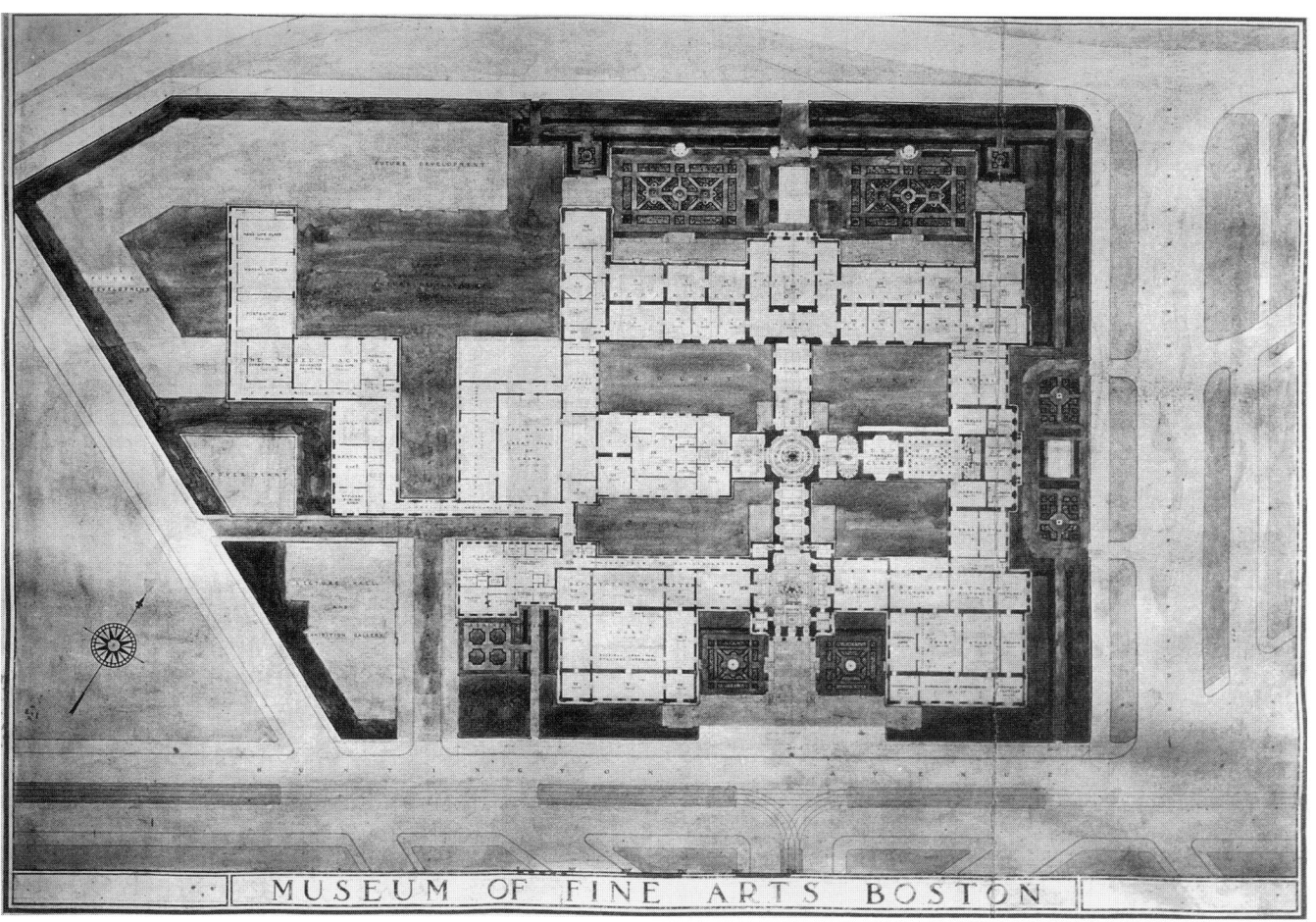

R. Clipston Sturgis. Museum of Fine Arts, Boston.
Projected plan, 1905. Report on Plans Presented
to the Building Committee, *1905. Reproduced*
courtesy of the Trustees of the Boston Public Library.

The second volume of the *Communications* contains a debate on the value of casts, as
well as essays by European authors on museum building arrangements and lighting. In
order to gather as much relevant information as possible, the architects and the director
of the museum undertook a trip to Europe between January and April of 1904, where
they visited over one hundred European museums. Their findings were reported in
the third volume of the series, and their conclusions echoed Gilman's; namely, what
was needed was not a monumental exterior but a workable museum. To that end, the
fourth volume is a report of a scientific experiment conducted with a temporary gallery
erected on the Fenway land, in order to determine the best window and skylight ar-
rangement for the lighting of pictures and statues.

Finally, architect Sturgis drew on these years of study to produce the *Report on Plans
Presented to the Building Committee* (1905) wherein he presented his recommendations.
The basic plan was for a one-story building (actually two stories, with the exhibition
floor as a *piano nobile*), separated into departments, where only the best of the museum's
collections would be shown, and a circulation plan that would allow a visitor to choose
to see one department without having to traverse others. Essentially, Sturgis's plan
resembles an open square with a Greek cross of corridors running through its center.

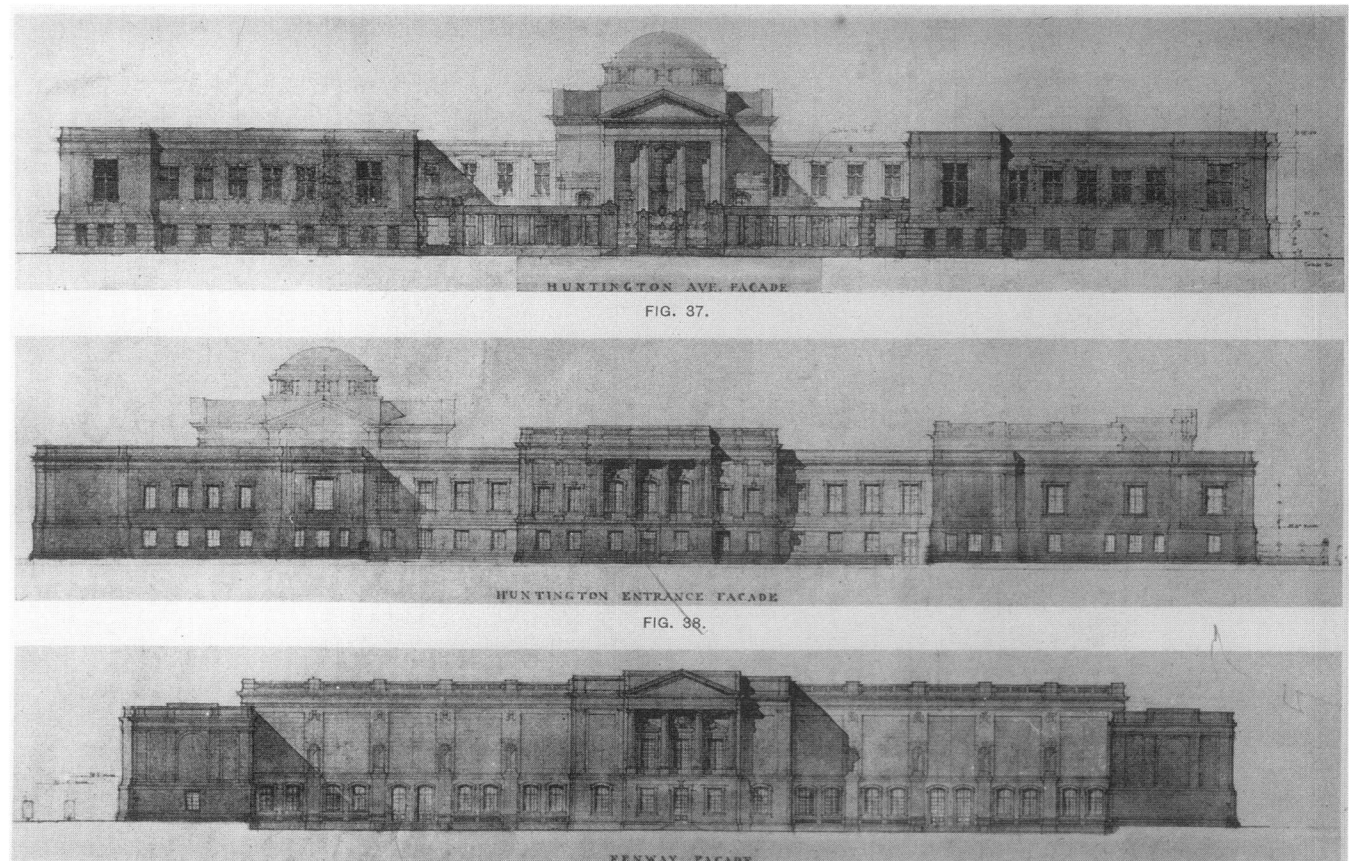

FIG. 37.

FIG. 38.

R. Clipston Sturgis. Museum of Fine Arts, Boston. Projected elevation, 1905. Report on Plans Presented to the Building Committee, *1905. Reproduced courtesy of the Trustees of the Boston Public Library.*

The entrance was to be recessed between two of the departments on each corner of the square and a rotunda marking the center crossing. Published in Sturgis's *Report* are not only plans but also elevations, which show a classically styled building with rusticated basement and *piano nobile,* a commanding front entrance with pedimented portico, and a large, low saucer dome dominating the whole.[92]

Despite Gilman's urgings for a nonsymmetrical building that allowed its needs to dictate its form, what Sturgis provided was a symmetrical, axially arranged, and highly formal building design. Even he claimed to be dominated by the desires of the trustees, lamenting that the "practical considerations of the plan . . . have possibly governed the exterior too rigidly."[93] Whereas the new museum's arrangement represented progress in the display and organization of exhibition materials, the language of plan and elevation were the same as the classical architectural language established over a decade and a half before. As will be shown, the final form of the building adhered to this pattern, and later additions to the museum would be even more monumental than the original portions.

Once Sturgis's report was received, the museum officials decided not to hold a competition and instead hired a young local architect, Guy Lowell, to work up specific plans

and elevations, following the recommendations of the various reports. Lowell was probably chosen because Chairman of the Building Committee, Samuel Warren, in a memorandum to the Committee, suggested that the architect chosen be one from Boston (for reasons of civic pride and simple geographic convenience) who was *not* particularly well-known or experienced, so that he might have "sufficient humility of mind to be guided . . . by the views of the Building Committee and the Museum Staff."[94] It is interesting to note that, whereas Lowell had no previous experience with museum buildings, a thesis he completed at M.I.T. was for a "Design for an Art Museum and Reading Room in a Small Town," the style of which he describes as "classical Graeco Roman," a term which could also later be ascribed to his design for the Boston museum.[95] It is possible—though by no means proven—that Lowell made the building committee aware of this student project in order to demonstrate his qualifications as architect for their building.

Lowell's position with the Museum of Fine Arts Building Committee was a difficult one, for he had to contend with clients who had defined their needs over a period of years and had acquired a full set of plans and elevations devised by Sturgis. The young architect was explicitly told that the building committee was "not willing to consent to

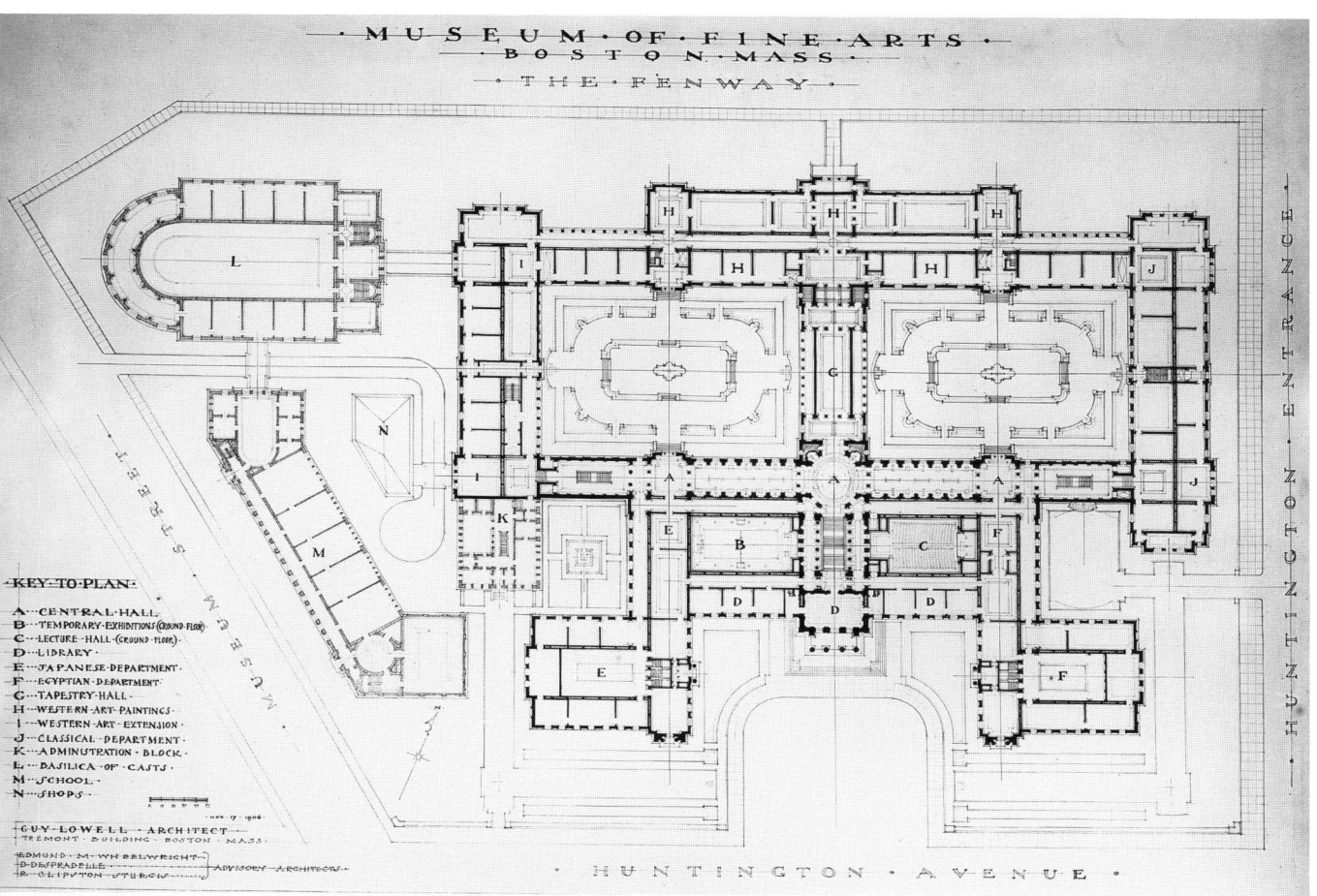

Guy Lowell. Museum of Fine Arts, Boston. Plan, 1907. Museum of Fine Arts Bulletin, 1907. Courtesy, Museum of Fine Arts, Boston.

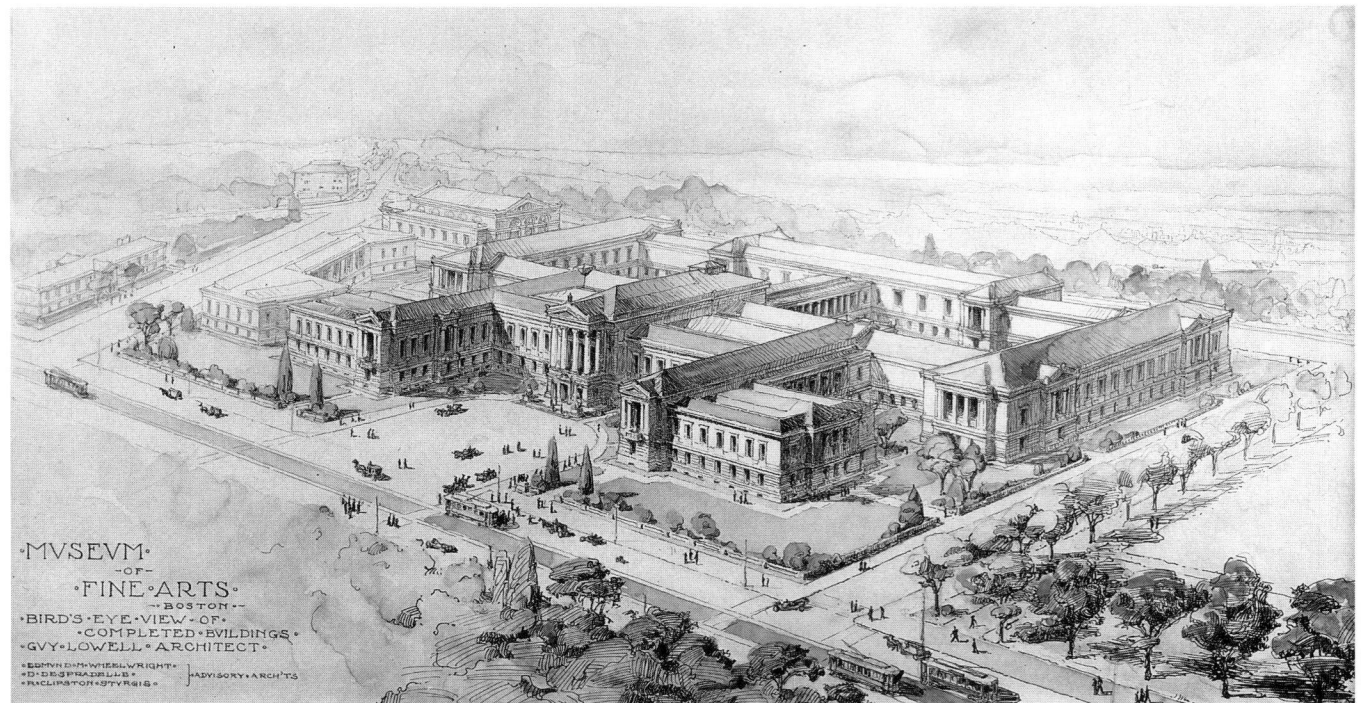

Guy Lowell. Museum of Fine Arts, Boston. Perspective, 1907. Museum of Fine Arts Bulletin, *1907. Courtesy, Museum of Fine Arts, Boston.*

a revision of its scheme of needs".[96] In order to keep Lowell in line, it seems the Committee appointed Sturgis, Wheelwright, and Désiré Déspadrelle, a professor of architecture at M.I.T., as consulting architects. Moreover, Sturgis disapproved of Lowell and told him so.[97] Nevertheless, Lowell managed to provide the museum with a building that satisfied both the museum professionals and the general public.

Lowell's plans were published in a special number of the museum's *Bulletin,* which contained detailed explanations of the building's design. The *Bulletin* articles make it clear that those within the museum thought that their new building constituted an important departure from previous museum buildings and that the scientific study devoted to the project made the building more than just a building—it was a triumph of logical thinking and a scientific advance in the field of museology.[98]

Despite the repeated emphasis on the scientific approach, however, the resultant look of the building differs little from other monumental classical buildings of the same period. Lowell's plan, like Sturgis's, is highly axial and symmetrical, and as presented in the *Bulletin,* showing future expansions, it is strongly flavored by the Beaux-Arts tendency to ceremony and grandeur; also see Chapter 5 for a discussion of the methodology of the Ecole des Beaux-Arts. In fact, Lowell was a *diplomé* of the Ecole des Beaux-Arts in Paris,[99] and a comparison of the plans of the Boston museum and Richard Morris Hunt's grand scheme for the Metropolitan Museum of Art in New York reveals many similarities: a recessed forecourt, a grand stairway, an entrance that takes the visitor under one or more domes, a division of space by long halls that establish axial and subaxial relationships, and a number of formally treated, enclosed courtyards. Designed a decade later, Lowell's facade is a great deal less flamboyant than Hunt's, but the exterior of the Museum of Fine Arts is still classical and grand. It is ornamented

with a pedimented, Ionic porch over the main entrance, pedimented corner pavilions with columns *in antis*, and a rusticated basement supporting a high *piano nobile,* all executed in granite. On the interior, the treatment is grander still, with a long ceremonial staircase leading through a hall with Ionic column screens into a large coffered rotunda, later to be decorated with murals by John Singer Sargent.[100]

In the tradition of the era, Lowell adopted a scholarly approach for the project, a method inculcated by his French training and possibly reinforced by some insecurity over a commission of such size. The facade employs a rather severe order, and that Lowell resorted to the "authority" of antique architecture is attested by a letter to Gilman wherein he requests two works on the history of ancient architecture: Luigi Canina's *L'Architettura Antica* (1845) and Friedrich Adler and Ernst Curtius's work on the excavations at Olympia (1897).[101] Although Lowell did not copy directly from these works, that he requested them showed that he was interested in producing scholarly, authentically-inspired, classical architecture.

The museum's *Bulletin* was almost apologetic about the grandeur of the exterior. After all, the "new building was not deliberately planned as an architectural monument, but inevitably became one from the dignity of its purpose and the necessary amplitude of its extent."[102] It must be remembered that however much the museum officials claimed to be looking for a "modern" solution to their needs, there was really only one style that could, at that point, answer for such a building. For the professionals of that time as well as the laymen, the only proper style for a museum was the classical. As stated in the 1907 *Bulletin,* the museum's

> exterior should convey the positive assurance that that which is to be seen within shall be of the best that men have imagined and have wrought with their hands. For such a conception the architectural style at once suggested is the classical, freely interpreted. Likewise, there is only one possible material for an important museum building—stone. For in Boston it would scarcely be acceptable to build the Museum even of armored concrete, which is so rapidly asserting itself over other permanent building material . . . the only admissible material for the principal front is cut granite.[103]

Once again, it is made apparent that no matter how "modern" and "scientific" the museum wished the building to be, architecturally there was only one acceptable approach to style.

Although the museum generally received more publicity in the professional press for its new arrangement of a museum into separate departments than for its architecture, the *Architectural Record* approved of the building itself, calling its facade one of great "beauty and dignity."[104] The newspapers gave the building a great deal of press and were overwhelmingly enthusiastic about the appearance of the "temple of art": "The building itself is an architectural adornment of which any community might well feel proud" stated one of several papers that featured the museum's opening on a full-page spread.[105] Another newspaper claimed that

> art and architecture are both served in the noble new building of the Museum of Fine Arts, on Huntington avenue . . . art, for it constitutes one of the most superb homes for painting and sculpture in the world, and architecture, for it is of that branch of art a beautiful expression.[106]

It is clear that the lay public approved of the new, grand museum building and found it greatly preferable to the old Copley Square building, which could hardly be termed grand or magnificent in comparison to the classical building on the Fenway.

The museum's most typical expression of Beaux-Arts grandeur, the large, ceremonial, interior staircase leading to the rotunda, received full approval from the press. One paper printed an apologia for this space-consuming feature:

> The spacious stairway is a much-mooted feature in museum architecture; but in this instance, at least, it seems to prove its own excuse for being, not alone in the article of beauty, but as characteristic of a building that aspires to combine in itself the several museum types of storehouse, shelter and monument and to be at once a place to visit and a workshop. It sounds the keynote of the whole structural idea, that of ample welcome, broad accommodation for all sorts and condition of men and women.[107]

The author appears to feel that the long, broad, processional stair is an appropriate *democratic* expression for a museum for the people, as well as being beautiful per se. In only one generation, this opinion would undergo a complete transformation when Philip Youtz, director of the Brooklyn Museum, removed the front stairs from his building because they were *not democratic enough.* In the first decade of the twentieth century, however, this feature endeared the museum to the people of Boston, to the extent that they felt that the building itself became an adornment to the city.

In 1908, a well-illustrated, full-page article in a Boston newspaper on "The Best Group of Buildings in the United States" claimed that Copley Square, where the old museum had been and where Trinity Church and the Public Library still are, used to be the architectural pride of Boston. Now, however, the Back Bay area containing the new museum, Harvard Medical School, the Symphony Hall, the Gardner "palace," and the Boston Opera House was now what the "proud Bostonian . . . elects as the show district of the city." The article, written as the museum was under construction, praised the museum as a "fit companion to the magnificent structures which, one by one, have been going up in the Fenway district in the last 10 years." Cited as an authority is the sculptor George Gray Barnard, who was quoted as saying about the museum's design:

> The lines are very chaste and graceful inside and outside. I am convinced that this new museum building has no equal in the world in the manifest intelligence of its purpose and manner in which that purpose is being carried out by the architect.[108]

This article firmly establishes the Museum of Fine Arts as part of a vision of a Boston City Beautiful at the height of interest in the idea of the City Beautiful, a movement which sought to recreate, unify, and beautify the modern city through the use of classical architecture placed within grand city plans in the Baroque style (and which will be examined in Chapter 3). Although the museum building was not part of a specific plan to beautify the new Back Bay area, the title of the piece—"The Best Group of Buildings in the United States"—posits a City Beautiful out of the existence of these classically styled buildings. The Boston museum could only participate in this concept of the City Beautiful in its new classical garb; the old, Ruskinian Gothic, Copley Square building could not have done so.

Delighted as Boston seemed to be with the appearance of the new museum, there were complaints that perhaps the building was too severe, too "chaste." One critic, for example, called it "a little cold, a trifle cheerless."[109] This fault was soon to be remedied, for only part of the museum had been constructed by 1909, and additions were soon to follow. The next building campaign, resulting in a facade more conspicuous than the original, began only three years later when ground was broken for the Evans wing in 1912; it opened in 1915. As one paper pointed out even before the museum began any construction, the Fenway frontage of the museum was "an even grander opportu-

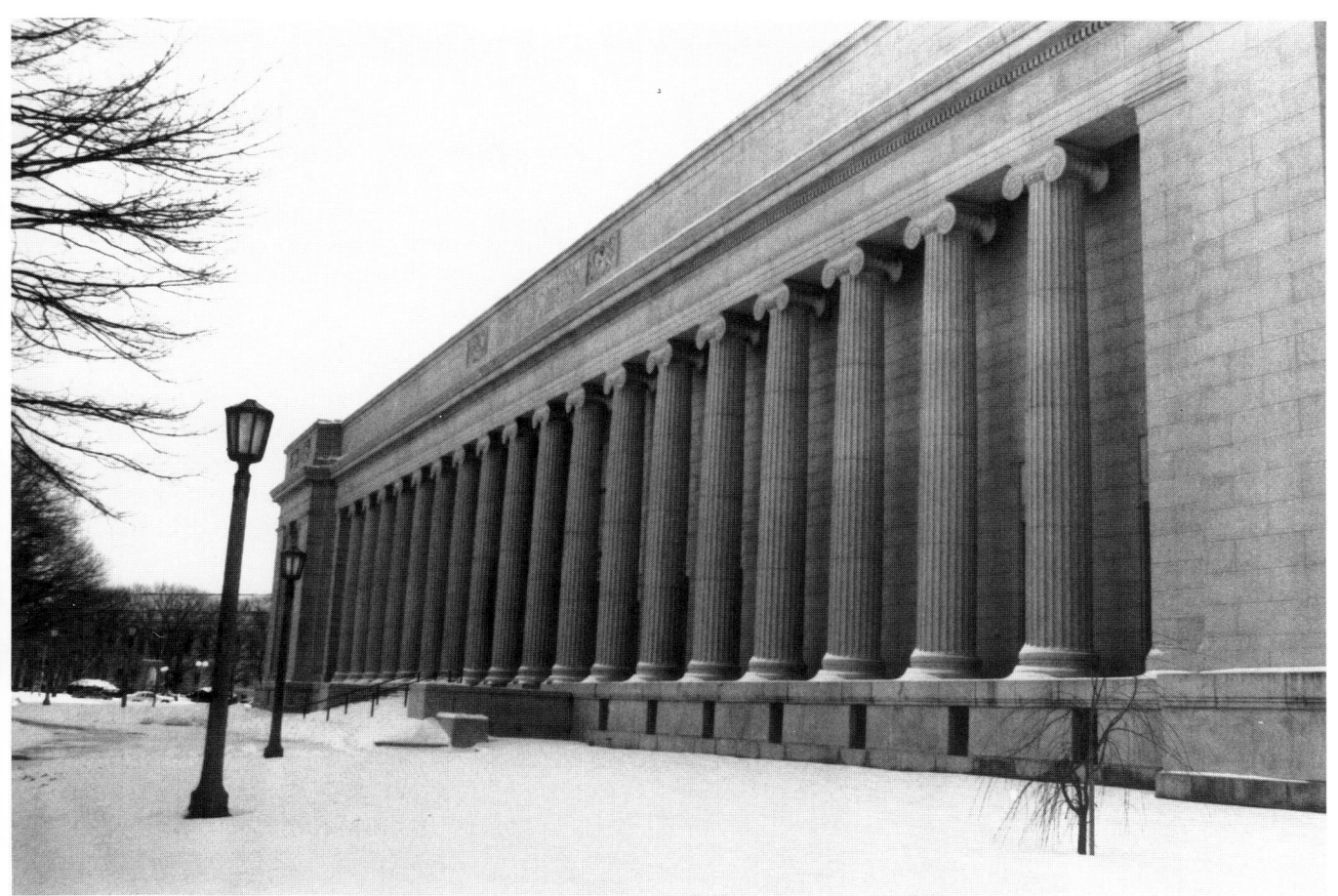

*Guy Lowell. Museum of Fine Arts, Boston. Evans
Wing, 1912. Photograph: author.*

nity for effects to be seen from the distance with a frontage of greater length."[110] Lowell took full advantage of the opportunity to create what is really a far more memorable front for the museum where it faces the Back Bay Fens and a fuller embodiment of the Beaux-Arts ideals of the time.

The Fenway facade consists of a fifty-foot-high Ionic colonnade of twenty-two fluted columns, framed by two slightly projecting pavilions at either end, each containing two more Ionic columns *in antis*. With this addition, Boston's Museum of Fine Arts joined the reigning stylophily of museum builders in the United States. One Boston paper, upon publication of Lowell's plans, astutely noted the family relationship to the similarly colonnaded Toledo Art Museum and Albright Art Gallery in Buffalo.[111] This same paper found the colonnade, and its departure from the design of the Huntington Avenue front, justified in light of the situation on the Fens and the fact that the colonnade would be visible from a distance and should, therefore, be more architecturally imposing. The hope was—and Lowell's published sketches depicted it this way—that the Fenway where it ran by the museum, and the land opposite, would be altered and improved so that the colonnade would be reflected in a water-filled basin. This integration of architecture, landscape, and water effects illustrates well Lowell's Beaux-Arts training and provide, in the words of an admirer, "a consummation devoutly to be wished."[112]

Perhaps the most appreciative description of the Evans wing comes from a guide to the museum, revised in 1924 to include this encomium on the new facade:

> The majestic Fenway front . . . is one of the most exquisite specimens of proportion and simplicity of line that can be seen in this city. The situation, too, is most favourable for this impression of stable, peaceful beauty. It is seen across an open space, with water and trees in the most effective spots in the landscape, and the possibilities of changing lights and shade in the columns and spaces are infinite. It is a never failing pleasure, as one drives by, to turn one's eyes in the direction of this embodiment of dignity and grace, a very perfect specimen of the daily ministry of good architecture in the life of the city.[113]

This description summarizes all the hopes that architects, trustees, directors, and the public held for the museum around the turn of the twentieth century: that the building would be classical, dignified, and beautiful; that it would enrich the civic life of its home city; and that it would complement other public spaces with its nobility of both architecture and intent. The new building, designed by classical architect Guy Lowell, satisfied these goals in a way that the picturesque, Ruskinian Gothic of the Copley Square building never could.

The histories of the Chicago, New York, and Boston art museums sound many of the keynotes of late-nineteenth- and early-twentieth-century culture. As architecture, they spell out changing attitudes toward architectural style and constitute a reconsideration of what sort of style is appropriate for a public repository of culture such as the art museum. Museums, however, are far more than just buildings, and such issues as what their institutional philosophies and missions were, how those goals could be expressed through architecture, and what the buildings symbolized for the city at large can be measured by public reaction, professional response, and cultural atmosphere, as well as by events. In Boston, New York, and Chicago, early museum buildings were supplanted by classicizing buildings, and that in every case this led to an architectural "improvement" was acknowledged alike by those outside the museum management and those within. In each case, however, there was far more at issue than style alone. The Art Institute of Chicago participated in the sea change of American architecture through its involvement in the World's Columbian Exposition, aligning itself not only architecturally with the Fair's mission but also intellectually with its participation in the World's Congress and its establishment of a school with help from the government of France, whence the American Beaux-Arts trainees had come. The new Fifth Avenue facade of the Metropolitan Museum of Art in New York represented a triumph of Beaux-Arts aesthetics over those of the picturesque, High Victorian Gothic; and the philosophy of the museum management, reflected in the museum school, revealed an emphatic shift in attitudes toward the purpose of art when it changed from a South-Kensington inspired philosophy to one based on "high" art and academic training. In Boston, the new building was developed under strictly scientific lines, after a great deal of study of museum practices and museum architecture. Boston's Museum of Fine Arts heralded a new era of museum professionalism and helped, in part, to redefine the city's premiere cultural locale from Copley Square to the Fens area.

The museums of Boston, New York, and Chicago established and maintained the monumental classical style as the dominant style for the art museum in the United States, and museums across the country followed suit. Other important cultural issues introduced by these three major art museums repeated themselves in the histories of other museums as well. The following chapters will examine in greater detail some of these issues which define yet further the relationship between the art museum and late-nineteenth- and early-twentieth-century American culture. These issues include the

museum's place in city planning and its relationship to the City Beautiful movement and American urban Progressivism, as well as the relationship between museums and the increasing professionalization of architects, urban planners, and museum professionals. The following chapter will focus specifically on the cultural phenomenon of the great expositions, from 1876 to 1915, and the relationship between these fairs and art museums, for Chicago was neither the first nor the last American art museum to be influenced by the occurrence of a fair.

2

The Art Museum as Fair Spectacle

And, after all, the greatest thing was the total, glittering, murmurous, restful, magical, evanescent Fair itself, seated by the blue waters, wearing the five crowns, served by novel boatmen, and with the lap so full of treasure that as piece by piece it was held up, it shone, was wondered at, and was lost again in the pile. This amazing spectacle will flash for years upon the inward eye of our people, and be a joy of their solitude.
—Alice F. Palmer, "Some Lasting Results of the World's Fair" (1893)

Late-nineteenth- and early-twentieth-century America loved a fair. They were places to gather and see all the latest that technology, industry, agriculture, art, and architecture had to offer. In this, the American fair was not much different from the fairs held in Europe, where the concept originated and flourished with as much success as in the United States. A unique development in the United States, however, was the tendency of large fairs to be held in cities across the country, rather than exclusively in one major metropolitan center, as it was in Europe, where a British fair of international consequence was always held in London and a similarly important French fair was always held in Paris. In the United States, major expositions were held in cities from New York and Philadelphia on the East Coast to Chicago, Buffalo, and St. Louis in the Midwest, to San Francisco in the West. Although many regional fairs of lesser importance were held in many other cities, from Boston to New Orleans and from Charleston to Portland, the most influential fairs with the highest attendance were those of a more national and even international scope.[1]

Many, if not most, of the major expositions of national and international scope held in the United States between 1876 and 1915 share an unusual and previously unheralded result: art museums were built to hold the art exhibits of the fair that, unlike the majority of exposition buildings, remained permanently after the fair as physical reminders of the former glory of the event. Some of these buildings were originally conceived as permanent, whereas others were converted into permanence at a later date. The conclusion, however, remains the same: there is an undeniable link between the cultural phenomenon of the American fair and that of the American art museum. Certainly, the fairs influenced the look of these buildings for the housing of exposition art departments, for the art building was planned concomitantly with the other fair buildings and needed to harmonize with them architecturally. That the art museum should partake of the mass spectacle of the fair also indicates a broader, more democratic, cultural approach the museums were taking. Finally, the placement of the perma-

48

nent buildings within the impermanent setting of the fair required thought as to the eventual location within the urban fabric—the major fairs were all urban events—and the relationship of the museum to the city. Though not all, indeed even not most, large American art museums were built in conjunction with a major exposition, that several important ones have ties with these defining events merits investigation and should help deepen our understanding of the complex cultural phenomenon of the art museum itself.

The Crystal Palace Exposition, London, 1851

Once again, reaching an understanding of this particular cultural phenomenon requires turning to England and investigating the original world's fair, London's Exposition of 1851, and the spectacular ferrovitreous structure built to house it, Joseph Paxton's Crystal Palace.[2] The very first industrial exposition, according to some sources, took place in 1761 in England—appropriately, the birthplace of the Industrial Revolution.[3] France also regularly held industrial expositions on a larger scale in the late eighteenth century and into the early nineteenth century, but these early expositions were essentially regional events. Their goals were simply to show industrial products in order to increase sales. It was not until the great London fair that the event took on international importance.

London's Exposition of 1851 had its beginnings in the annual exhibitions of the Society of Arts, which, beginning in 1847, showed "select specimens of British Manufactures and Decorative Art."[4] These shows became so successful that, with the encouragement of Prince Albert, President of the Society of Arts, an exhibition based on the French pattern but international in scope began to be planned for the National Quinquennial in 1851 (i.e., the fifth anniversary of the annual exhibitions of the Society of Arts). The result was the enormous, revolutionary, and highly influential building of the Crystal Palace, the home of the first major international fair which was to spawn many others in both Europe and the United States. The original idea of the fair was a chance for England to show off to the world its cultural and technological superiority while inviting other countries to compete with their exhibitions as they might. In part, the fair was an indication of growing international trade as we know it today.

For the purposes of this paper, there were several important and novel aspects of this fair that were to become an integral part of exhibitions in the United States. First, the Exposition was conceived as an enormous international spectacle with the general populace exhorted to attend. The final attendance figure was staggering, with 6,039,195 visitors having seen the Crystal Palace and its contents during the six months it was open.[5] Although the concept of the exposition was to increase awareness of advances in industrial manufacturing, and the event was certainly meant to pay for itself if not turn a profit, the exhibits themselves were not for sale. They were meant to be spectacle only, and the general goal was educational rather than lucrative. In fact, once the fair closed and it was determined that the event was indeed profitable, the surplus was dedicated to educational purposes, namely, the purchase of the land that would become home to the South Kensington Museum. A number of the exhibits from the exposition were donated to that newly formed institution. At the Crystal Palace, then, public entertainment and education converged upon one location and event.

The second important innovative aspect of the Crystal Palace Exposition was the inclusion of art among the various exhibits. Earlier fairs had concentrated exclusively on manufactured products. The Society of Arts conceived of the 1851 exposition as

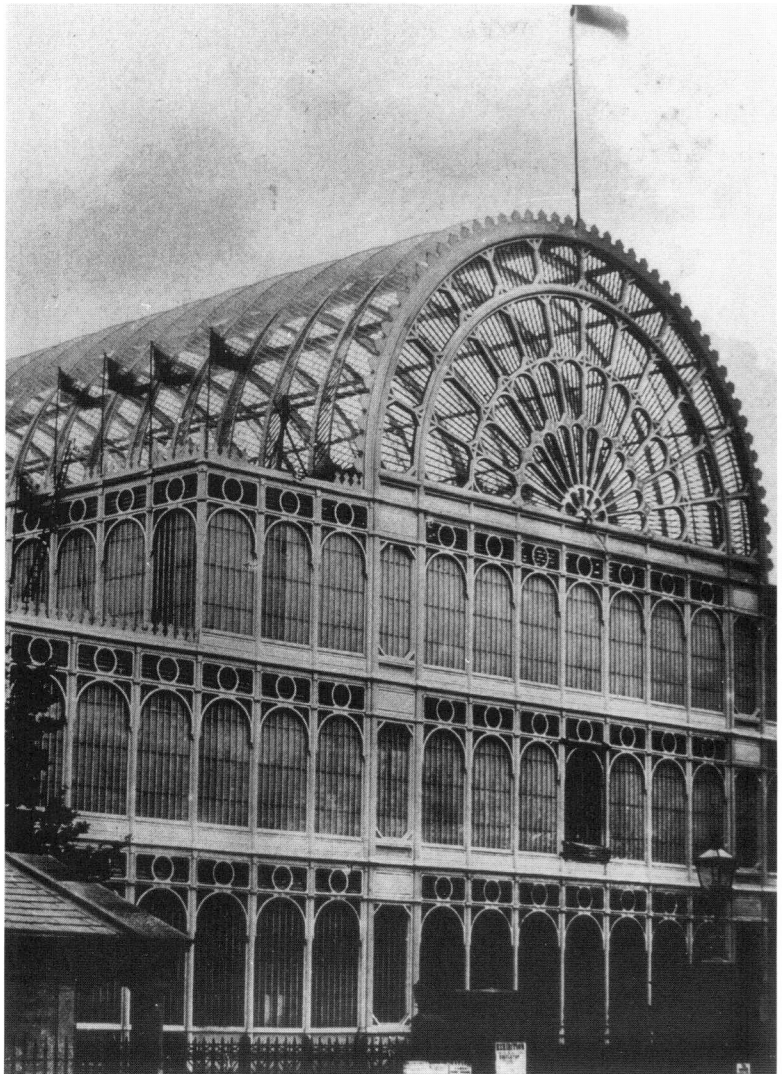

Joseph Paxton. Crystal Palace, London, 1851. By courtesy of the Board of Trustees of the Victoria & Albert Museum.

one which would display "Manufactures and Decorative Art," but this concept was delineated by Prince Albert into four categories: raw materials, machinery, manufactured products, and sculpture and plastic art.[6] The original idea for the latter category was the displaying of the art that decorated the manufactured products, i.e., to keep the exposition within strictly decorative art boundaries. The inclusion of sculpture, however, brought the displays into the realm of "high" art, despite the fact that there are few critics who would call the frankly salacious statuary, which tended to the unclothed female, "high" art. Nevertheless, such sculptural works as *The Circassian Slave Exposed in the Market, Andromeda Exposed to a Sea Monster, The Lion in Love,* and Hiram Powers's famous *Greek Slave* in the American section were, whether lacking in artistic value or not, intended to be "high" art and not decorative art.[7] The London exhibition brought art into the event in a tentative way; later fairs were to expand the art exhibits into one of the major spectacles of the exhibitions.

The third and final aspect of importance for this investigation is the fact that a special building was erected for the purpose of housing these exhibitions of art and industry. Based on Joseph Paxton's earlier designs for greenhouses, his Crystal Palace was constructed of glass, iron, and wood in a modular design that allowed it to be quickly manufactured and assembled. Both its enormity and its repetitive, crystalline appearance amazed and enchanted visitors of every ilk. Although the design of the building was to have immediate influence on, for example, the New York Crystal Palace Exposition of 1853, this stylistic influence was soon to wane. It is the fact of special planning for and designing of temporary structures to house the exposition that would become the norm for these events. In the United States as in France, the concept of exposition shelter would eventually develop into a series of separate buildings to house the various departments of the expositions. It is also of tangential consequence to note that the Crystal Palace, like some of the American exposition buildings to be discussed, was so greatly admired that, instead of disappearing after the event for which it was constructed, its proponents fought to have it reerected, in its entirety—even enlarged—in Sydenham, in South London, where it was to remain until it was destroyed by fire in 1936. These festive, celebratory exposition structures, meant to be impermanent, would have a great permanent impact on the citizens and their cities where the fairs were held, particularly in the United States.

As already mentioned, the most direct and immediate influence of the London Crystal Palace Exposition of 1851 on the United States was the organization of the New York Crystal Palace Exhibition of 1853.[8] Proposed by Horace Greeley, who was favorably impressed with the London exposition, the New York Exhibition of the Industry of All Nations was located at Reservoir Square (now Bryant Park) and resembled the London Crystal Palace in its ferrovitreous construction. After an international competition in which Paxton, Leopold Eidlitz, and James Bogardus participated, the design of the building was entrusted to Georg J. B. Carstensen and Charles Gildemeister. Essentially based upon Paxton's original, the New York Crystal Palace took its cue from its smaller, square site and was in the shape of a Greek cross with a dome over the crossing. Perhaps the most significant contribution to fair culture, and certainly of the greatest importance for this study, was the New York fair's inclusion among its industrial exhibitions not only of a collection of sculpture, as at the London fair, but also of a picture gallery. This was the first picture gallery to be included in any world's fair, and it was a highly influential one inasmuch as art departments were to be a permanent and important part of all subsequent expositions in the United States.

The Philadelphia Centennial Exposition, 1876

The United States International Exhibition held in Philadelphia in 1876 and known as the Centennial Exposition is of paramount importance to the history of American art museum architecture for two reasons.[9] First, one of only two permanent buildings designed and erected for the exposition (compared to 247 large and small impermanent ones) was Memorial Hall, the structure designed for the housing of the fair's art exhibits. Second, Memorial Hall was among the first American public buildings of any sort to be designed in the Beaux-Arts manner.[10] These two occurrences were harbingers of art museums built in conjunction with expositions of the future, as well as art museums built for their own sakes.

As at the New York Crystal Palace Exposition, the committee in charge of the exposition layout held a competition for the designs of the exhibition buildings. First prize

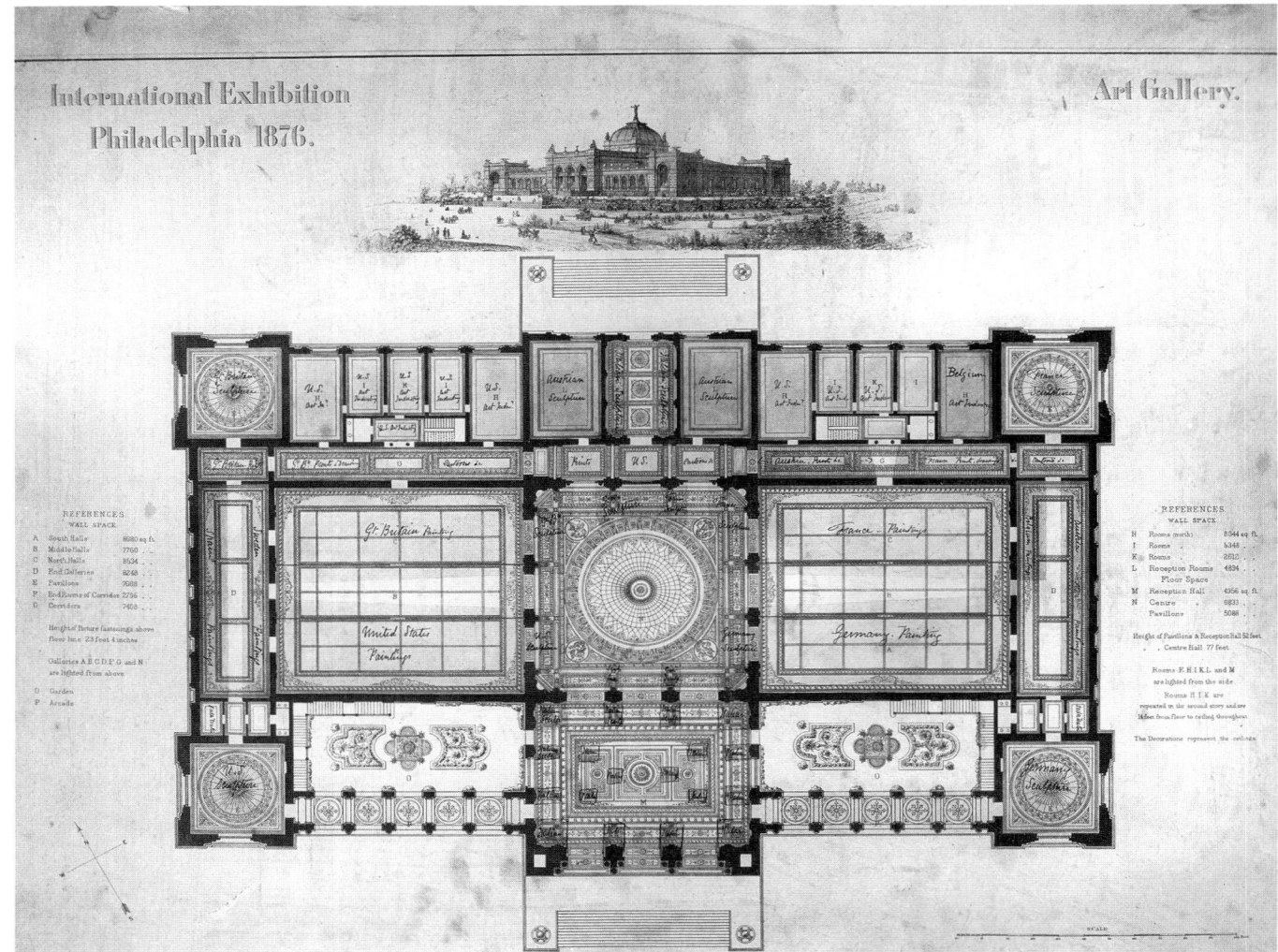

Hermann J. Schwarzmann. Memorial Hall, Centennial Exposition, Philadelphia. Plan, 1874–76. Courtesy City Archives of Philadelphia.

went to Collins and Autenreith of Philadelphia, but the jury recommended instead the unpremiated project by Calvert Vaux and George Kent Radford.[11] Their entry was for a large, iron and glass, High Victorian Gothic structure. All of the entries proved untenable, however, and the building committee instead hired the young Bavarian immigrant Hermann J. Schwarzmann as engineer. He eventually provided the designs for the two permanent buildings, Horticultural Hall and Memorial Hall. Whereas Horticultural Hall was a typically Victorian conservatory decorated in a picturesque "Moorish" style with horseshoe arches and structural polychrome, Memorial Hall was built in the "modern Renaissance" style, as Schwarzmann himself termed it.[12] The plan of the building formed a simple rectangle surmounted by a large ferrovitreous dome placed over the center with four corner pavilions and two central pavilions to provide a logical division of space into large central halls surrounded by corridors running along the exterior walls. On the exterior, the building, constructed entirely of stone, conformed to a highly formal, Beaux-Arts conception with the plan expressed on the exterior by the discrete

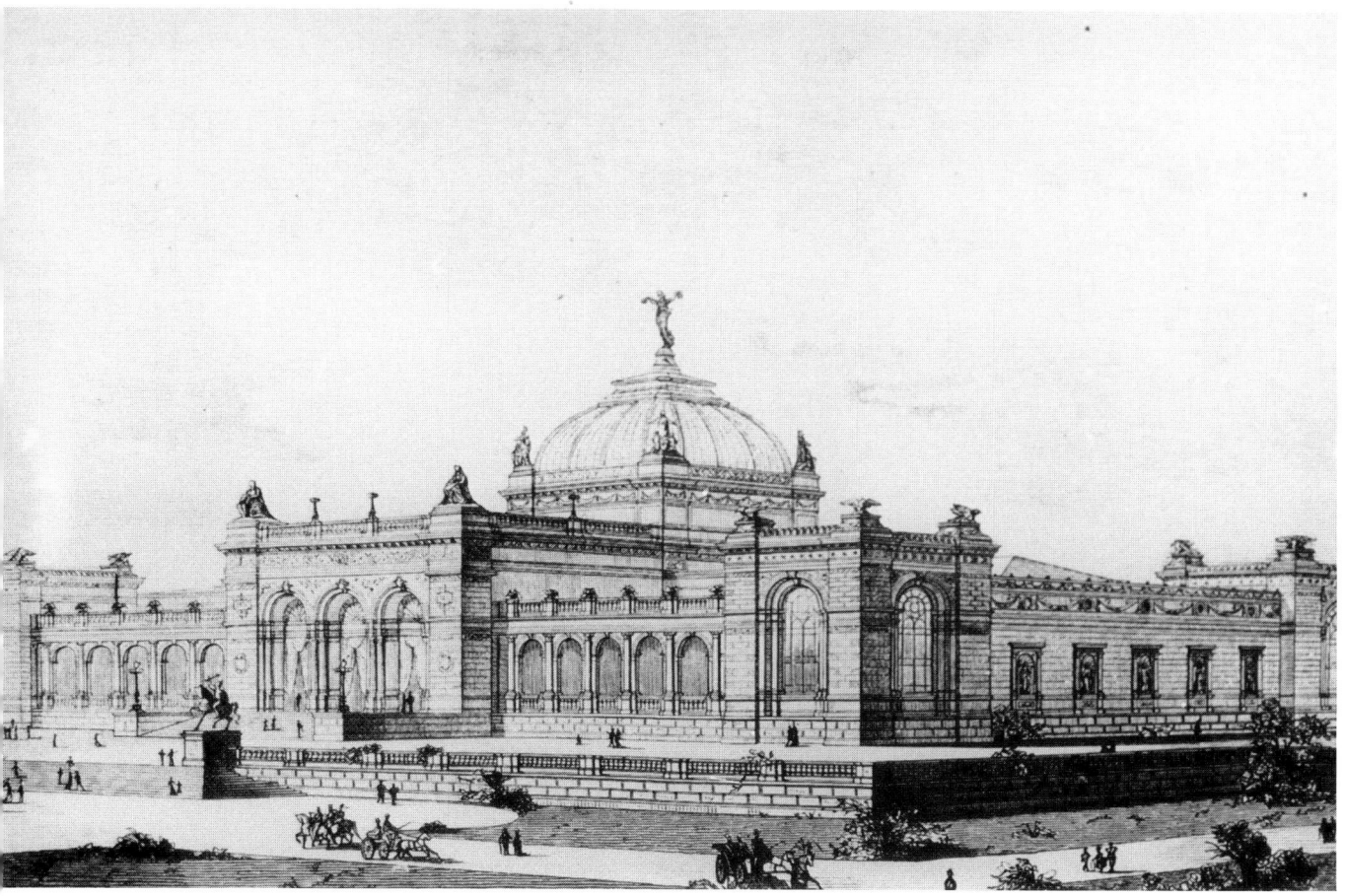

Hermann J. Schwarzmann. Memorial Hall, Centennial Exposition, Philadelphia, 1874–76. Deutsche Bauzeichnung, 1876. *Courtesy Deutsche Bauzeichnung.*

masses of the corner and central pavilions. The entrance pavilions greeted the visitor with a triple-arched porch, and the corner pavilions echoed this motif with a single arch on each of their two sides. On the two main facades, the entrance pavilions were connected to the corner pavilions by open arcades practically unique in the country.[13] Each corner on the roof of each pavilion was decorated with sculpture, as were the four corners of the dome and the pinnacle of the dome. This decoration, which included eagles and allegorical figures of Science, Art, and Columbia, provided the building with a festive silhouette.

As John Maass points out in his book on the Centennial, Schwarzmann, who had little experience as an architect, borrowed his design directly from a competition design for the 1867 Prix de Rome project at the Ecole des Beaux-Arts in Paris.[14] This competition called for *Un Palais pour l'Exposition des Beaux-Arts* in the year of the second Paris International Exposition, a logical category for Schwarzmann's appropriation. The non-premiated project by Nicolas-Félix Escalier was the one Schwarzmann adapted to design Philadelphia's Memorial Hall. The essential elements of the plan and the design of the facade were borrowed with little alteration. Schwarzmann's principal innovation was the substitution of glass and iron for the material of the dome, thereby providing toplight-

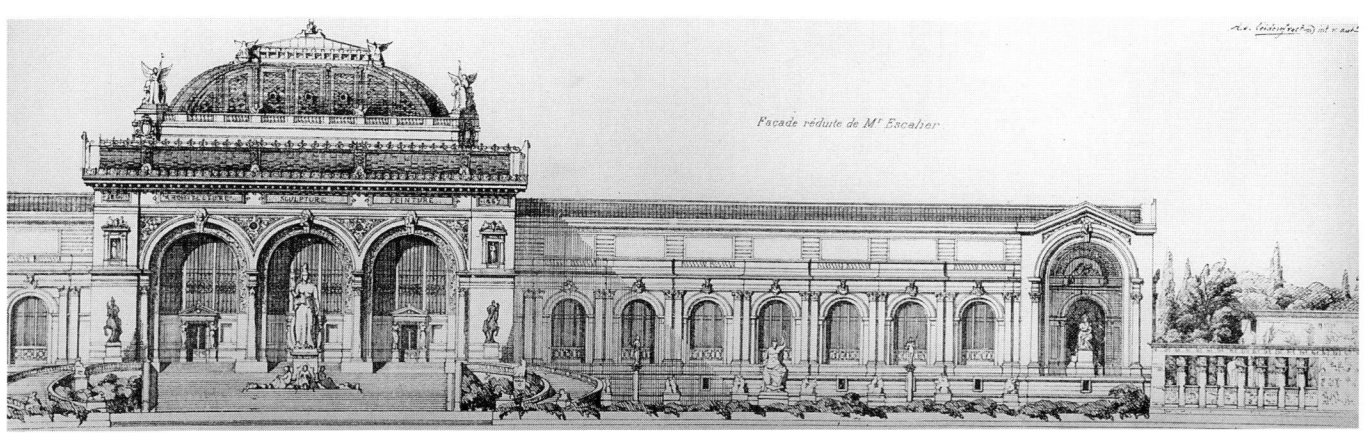

Nicolas Felix Escalier. "A Palace for the Exhibition of the Fine Arts," Prix de Rome Project, 1867. Plan. Croquis d'Architecture, *1867. New York Public Library.*

Nicolas Felix Escalier. "A Palace for the Exhibition of the Fine Arts," Prix de Rome Project, 1867. Facade. Croquis d'Architecture, *1867. New York Public Library.*

ing in the largest and most elaborate of the exhibition spaces, the central sculpture hall.[15]

Memorial Hall introduced to the United States the Beaux-Arts method of planning and design at a time when all other buildings designed for housing art were small and distinctly unclassical. Memorial Hall was by far the largest building in the country for housing art, and it housed the first great international exhibition of art in the country. Response to the invitations to exhibit were so overwhelming that a second, temporary building had to be erected behind Memorial Hall to hold all the entries. In all, 3256 paintings and drawings and 627 works of sculpture were exhibited.[16] The exposition's effect on the awareness of art and of the desirability of public displays of art was revolutionary. The great era of museum building followed shortly on the heels of the Centennial Exposition, and more measurably, its influence on art exhibitions at future expositions was decisive. As one commentator on the World's Columbian Exposition of 1893 noted, "While the display of art at the Centennial Exposition was not its strongest feature, it served . . . to give impetus to professional education, and for that reason, apart from the question of merit, it is and will be remembered."[17] Every major exposition that took place in the United States after the Centennial Exposition in Philadelphia included an art exhibition as a major attraction among its various departments. Also, all of these expositions followed the Centennial's lead in providing a separate building for housing the art at the fair.

There are some caveats in judging the influence of Memorial Hall as architecture, however. Although it is without a doubt the first classical, Beaux-Arts-influenced building for housing art in the country, and it certainly preceded the great era of classically styled art museum buildings, it cannot be said to have had a direct influence on art museum buildings being planned, designed, or built in the United States during the period immediately following the Centennial Exposition. That distinction belongs to the architecture of the 1893 World's Columbian Exposition. During the period between these two expositions, a number of museums were built in decidedly nonclassical styles. Frank Furness's remarkable High Victorian Gothic Pennsylvania Academy of Fine Arts was designed and built concurrently with Memorial Hall. It was also in the 1880s that building campaigns continued the picturesque eclecticism of the Museum of Fine Arts, Boston, and the Metropolitan Museum of Art in New York City. During the same decade, Richardsonian Romanesque museums were built in several major cities. In Chicago, the first Art Institute building was designed by John Root and built 1886–87. In St. Louis, the original Museum of Fine Arts building was designed by Peabody and Stearns and built 1879–81 (as will be discussed below). In Cincinnati, the first portion of the Cincinnati Art Museum, designed by James W. McLaughlin, opened in 1881.[18] Although Memorial Hall was a harbinger of changes to come, it cannot be argued that it had an immediate influence on museum architecture in America. It might further be argued that the later museums that were built in a Beaux-Arts manner probably did not draw their influence from Memorial Hall. It was never mentioned as a prototype (whereas other American and European buildings often were), and its almost Baroque exuberance and picturesque skyline were perhaps somewhat too provincial or overdone by the time the 1890s had arrived. Certainly, although the triple-arched entrance motif would be used again (though it was not an innovation, either), Memorial Hall's most distinctive feature, the transparent dome, was never to be repeated by an American art museum of the period of this study.

Memorial Hall did serve as a lasting reminder of the country's first truly international exposition, and it also served a continuing function as a building for housing art. After the Centennial was over, the building was given to the Pennsylvania Museum (later the Philadelphia Museum of Art), which at that time, like Boston's and New York's muse-

THE METROPOLITAN MUSEUM OF ART IN 1892.

howing the Projected Fifth Avenue Facade, 800 Feet Long, and Giving a General Idea of the Building
Where Works of Art Will Be Exhibited at New York's Big Fair.

The above sketch shows what the Metropolitan Museum of Art in Central Park will look like when it is enlarged to c
and other art exhibits at New York's international exposition in 1892. It exhibits the southerly extension recently ad
from Seventy-ninth street, and a projected façade upon Fifth avenue, extending from just above the northerly line of Eight,
southerly line of Eighty-fifth street. It has a frontage of about eight hundred feet and an approximate depth of six h
pleted structure will have a floor surface of 706,000 square feet, equivalent to sixteen and a quarter acres.

It has been found desirable to have only two exhibiting floors in a large permanent museum, which must accom
people. This does not admit of the architectural treatment that would be possible under unrestricted conditions.
lacking in accented sky lines or dominating towers is largely atoned for by simplicity and dignity in the treatment of wal
The design is incorporated in the memorial drawn up by Mr. Hewitt. Mr. Theodore Weston, of No. 31 Broad street, is t

*Theodore Weston. Metropolitan Museum of Art, New
York. Projected expansion, 1890. New York Herald,
12 January 1890. Courtesy, The Metropolitan Mu-
seum of Art.*

ums, was patterned on the South Kensington Museum in London. Memorial Hall was
the home for the Pennsylvania Museum until the present building, a Greek temple
serving as the terminus for the Benjamin Franklin Parkway, was completed in 1928.
The building was restored in 1958–69 and now houses offices for the Fairmount Park
Commission and sundry recreational facilities. Its legacy to other buildings and other
expositions will be examined in the following pages.

The World's Columbian Exposition, Chicago, 1893

Arguably the single most influential event in the history of American fin-de-siècle
culture was the World's Columbian Exposition held in Chicago in 1893. The very fact
of the debate over its influence on American architecture and urban planning alone
would indicate its importance. Whether the Columbian exposition was a product or a
producer of culture, a trendsetter, or merely a cultural barometer is unimportant. What
matters is that it was widely touted and perceived as the greatest cultural and social
event America had ever seen and that its architecture and planning were perceived as
the greatest innovation in the approach to public buildings and urban design this coun-
try had yet seen. The Columbian Exposition has been credited as the origin of the
classical architectural revolution in the United States and as the birthplace of modern
urban planning, specifically the City Beautiful movement. Both of these elements play
a part in the development of the American art museum, as will be investigated in later
chapters of this work. Volumes have been written on the history, development, and
influence of the Columbian Exposition.[19] What will be examined closely here is the

history and design of the Fine Arts Palace at the Exposition and its place in the development of American art museums, both as buildings and as institutions.

Even while the exposition was still in its earliest planning stages, it was apparent that the event would have an important effect on the art institutions of the fair's venue. In 1890, New York vied with Chicago for the privilege of hosting the fair. A great deal of the argument took place in the newspapers, with Chicago calling New York "the meanest city in America,"[20] and New York claiming that Chicago had no cultural traditions, whereas New York was the only location that would assure an internationally successful exposition. Although in the end, superior boosterism and fund-raising guaranteed Chicago the honor, proponents of New York as host city to the fair presented some strong arguments to the Senatorial Committee that was to make the official decision. Orating in front of the committee, Chauncey Depew claimed that for a fair to be successful on an international scale, it must be held "at the metropolis of the country" and that New York was unquestionably the "financial and commercial metropolis" of the United States.[21] Former mayor of New York Hewitt gave another speech that outlined some of the specific advantages that New York held as a fair site over Chicago. An important part of his argument was that Central Park would make an admirable site for the fair, made even more desirable by the existence of the Museum of Natural History and the Metropolitan Museum of Art. Hewitt stated that the New York legislature would "undoubtedly" grant up to ten million dollars for expanding the museums so that they could house some of the fair's exhibitions.[22]

This part of his argument was so important that a sketch of the Metropolitan Museum of Art, expanded to meet the needs of the proposed exposition, was the only illustration accompanying the full-page article on the argument in the *New York Herald*. The sketch by Theodore Weston, architect of the first addition (1884–88) to Calvert Vaux's original museum, shows a building many times the size of the modest museum that existed at that time. Weston's proposed additions would have made the Metropolitan Museum the largest in the country with an eight-hundred-foot-long facade on Fifth Avenue punctuated by three pavilions along its length. The central pavilion would have had a columned portico and wide steps leading to the entrance. Although the illustration is small and difficult to read, it appears that the building would have been executed in a restrained French Second Empire style, as its pavilions were capped with high mansard roofs. The caption under the illustration indicates that the museum would "contain pictures, statuary and other art exhibits at New York's international exposition in 1892."[23]

The implication of Hewitt's argument and the illustration of the expanded museum is that one of New York's most important assets was the art that was in its museum and that Chicago was inferior as a venue for the fair because it did not have as prominent an art museum or the same capability to expand it (as it did not have the space). Hewitt summed up his arguments with nine points, one of which stated that the great art works that resided in New York were potent reasons for holding the fair there:

> There are in New York, in public and private collections, priceless works of art, which could not be made available elsewhere, because of the risks involved in transportation, but which will be accessible here and go far toward insuring the success of the exhibition.[24]

The importance of the New York argument is in its insistence that the art museum provided an important asset for the fair and that the fair was conversely an ideal opportunity for New York to expand its art museum, as did, indeed, happen in Chicago.

Once Chicago had been determined as the venue for the fair, the New York idea that

a permanent art building might be gained from the exposition, as had happened at the Philadelphia Centennial Exposition, also occurred to organizers of the fair in Chicago. The Art Institute's *Annual Report* for 1891 stated that the

> idea appears to have suggested itself in several quarters at the same time that the holding of this fair might furnish an opportunity to secure a permanent art museum building for Chicago, since the former world's fairs in other cities and countries have each left behind them one or more memorial buildings.[25]

Thus, the direct influence of expositions like the London Crystal Palace and the Philadelphia Centennial can be posited. The permanent, larger home for the Art Institute of Chicago that was erected as a result of the World's Columbian Exposition has already been examined in the preceding chapter. As has been noted, the Art Institute did not end up serving as the Art Palace for the exposition. The separate building that was erected for this purpose, however, is an important building for several reasons. The Fine Arts Palace of the World's Columbian Exposition was an integral part of the highly influential architecture and planning of the fair, and it was the most widely acclaimed single building at the fair. Designed to be fireproof and semipermanent, it was so highly admired by architects and the public alike that it was eventually rebuilt in permanent materials for use as a museum for objects donated to Chicago from the exposition. The Fine Arts Palace, especially in conjunction with the simultaneously built structure for the Art Institute, probably exerted a greater influence on American art museums than any other single building or event.

Chief of Construction for the World's Columbian Exposition, Daniel H. Burnham, was the person responsible for the general organization and look of the fairgrounds. Although he did not design any of the buildings, he brought together the assemblage of architects who created the White City, managed to control the disparate personalities and styles, and meld the aggregate into the classical unity that was the White City. After Burnham, the most influential architect of the fair was the little-known Charles Bowler Atwood (1849–95), whom Burnham hired as Designer-in-Chief. Born in 1849 in Millbury, Massachusetts, Atwood studied at Harvard and joined the office of Ware and Van Brunt in Boston to study architecture. After a short time practicing on his own, Atwood joined the design firm of Herter Brothers in New York as the head of its architecture department.[26] In 1891, Burnham had lost his partner, John Root, and was looking for someone to help him with both his private practice and his appointment as Chief of Construction for the fair. Upon receiving recommendations from the architects William Ware and Bruce Price, Burnham hired Atwood for his own office but soon transferred him to full-time work on the fair.[27] Atwood's work on the World's Columbian Exposition was to be his most important as well as almost his last important work, for he appears to have been an erratic personality, and Burnham would later tell his biographer, Charles Moore, that Atwood had been a drug user.[28] His death in 1895, according to the information given by his doctor to the newspapers, of "a complication of nervous and brain disorders," was attributed to overwork at the fair.[29]

That Burnham hired Atwood to replace Root is one very important indication of the shift toward classicism that was manifested in the fair's eventual appearance. Burnham's former partner, Root, had worked in a Richardsonian Romanesque mode and had already completed designs in that genre for the Art Institute building and for a highly fantastical and picturesque main building for the fair, as well as an eclectic congeries of incidental buildings.[30] Burnham would later be able to explain the classicism of the fair with the rationale that when Richardson died, the Romanesque style died with him (and Root shortly thereafter):

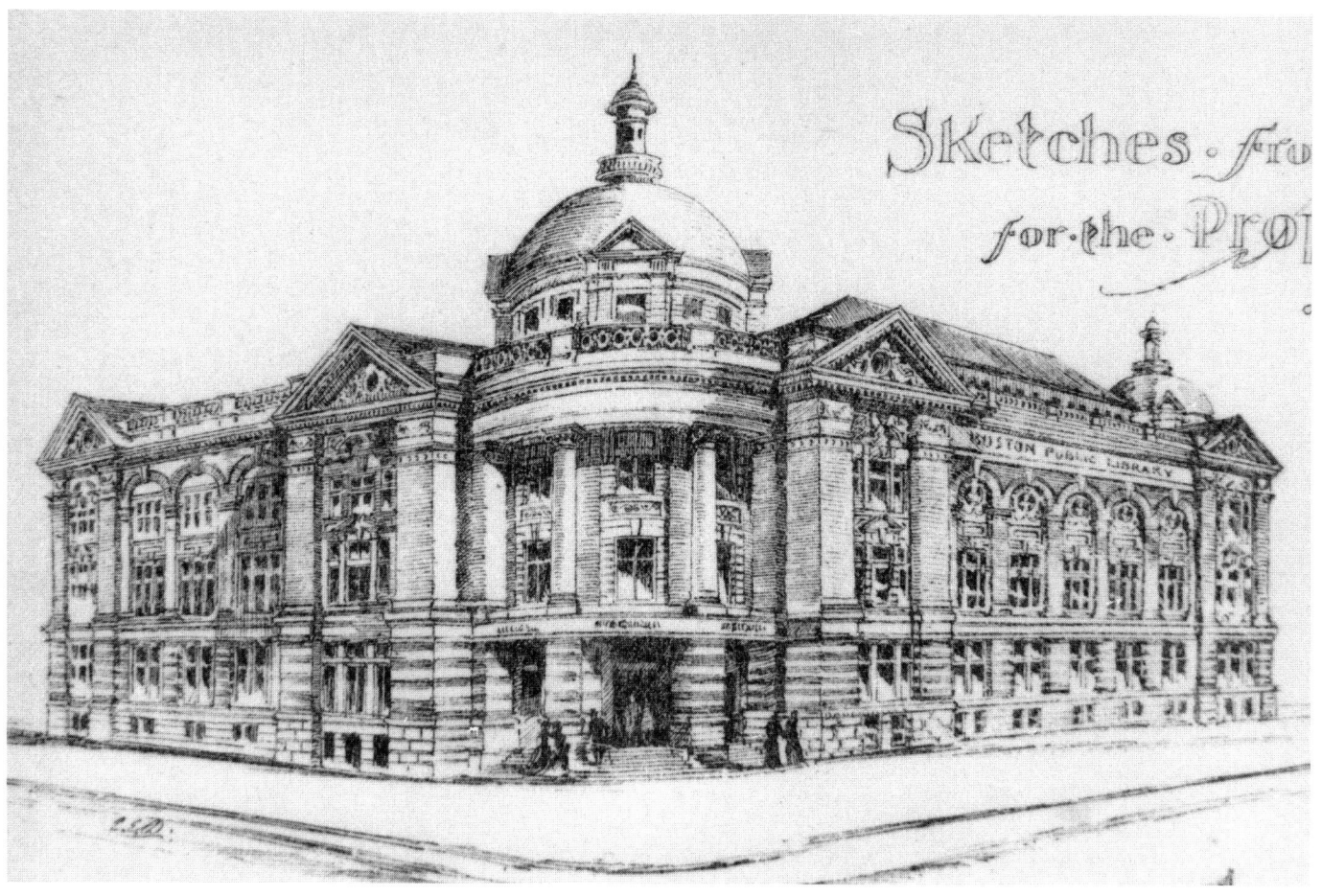

Charles Atwood. Boston Public Library. Competition design, 1884. American Architect and Building News, 1884. Avery Architectural and Fine Arts Library, Columbia University in the City of New York.

H. H. Richardson had the lead in architecture up to the time of his death, *about three years before our meetings begun [sic] in Chicago.* His art died with him. He had mastership and made vital the style he used. By 1890 however, no one any longer cared for his *sort* of work.[31]

The death of Root and his replacement with Atwood clinched the classical stylistic unity of the fair, for Atwood was part of the changing course of architectural fashion during the last decade of the nineteenth century.

One of the key monuments signaling the change toward classicism was McKim, Mead, and White's Boston Public Library (1887–95), the competition for which had originally been won by Atwood himself in 1884 with a monumental, classical design. Atwood's submission was the only premiated design to use classical rather than Richardsonian Romanesque or other revival elements.[32] Its most prominent feature was a high dome-topped, round, corner pavilion, flanked by arcaded wings featuring pedimented pavilions, all atop a rusticated basement.[33] The library trustees decided that none of the designs from the competition was suitable, and Atwood's design was relegated to oblivion. This was actually a blessing; Atwood's design is awkward and provincial, especially

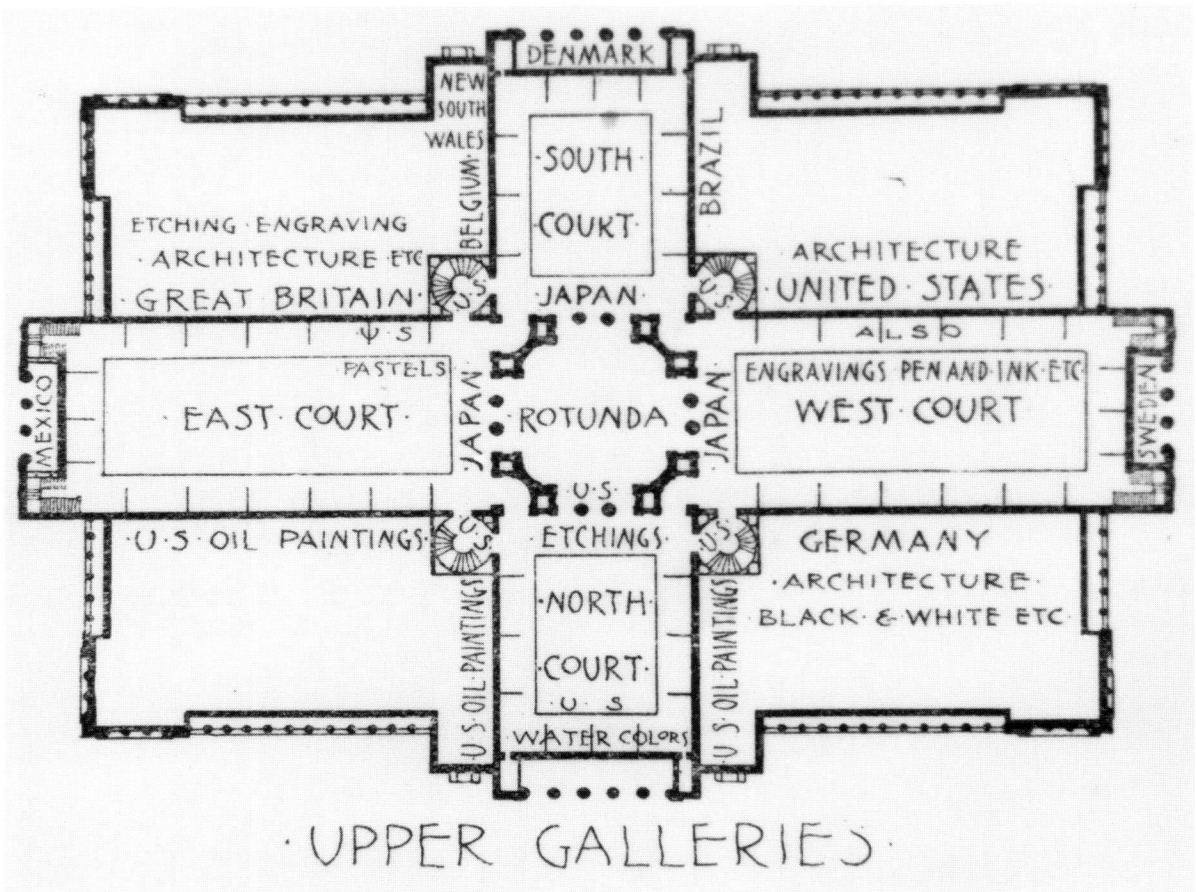

Charles Atwood. Fine Arts Palace, World's Columbian Exposition, Chicago, 1893. Plan. American Architect and Building News, *1893. Avery Architectural and Fine Arts Library, Columbia University in the City of New York.*

in comparison to McKim's elegant composition. The Boston Public Library competition, however, would prepare Atwood for creating the monumental classicism of the Chicago fair.

Atwood's position as Designer-in-Chief for the fair was an ambiguous one. Although he was given a great deal of responsibility and one of the major buildings of the fair—the Fine Arts Palace—to design, he seems to have remained a somewhat minor character among the assemblage of architectural stars who designed the Court of Honor buildings.[34] This was probably because of his relative lack of success in getting buildings constructed to his designs during the earlier part of his career. Strangely enough, however, he had more experience with the classical style than most of the other Court of Honor architects. It was thanks to Atwood that the Court of Honor was adorned with the proper milieu of terraces, bridges, balustrades, and incidental buildings. As Burnham said of him: "He did the Fine Arts, the Peristyle and all of the architectural details of the great terraces, bridges and approaches. More of the actual beauty of the Fair was due to him and his associated work with Codman than to any one else."[35] In all, Atwood designed nearly one hundred structures for the fair, including the Fine

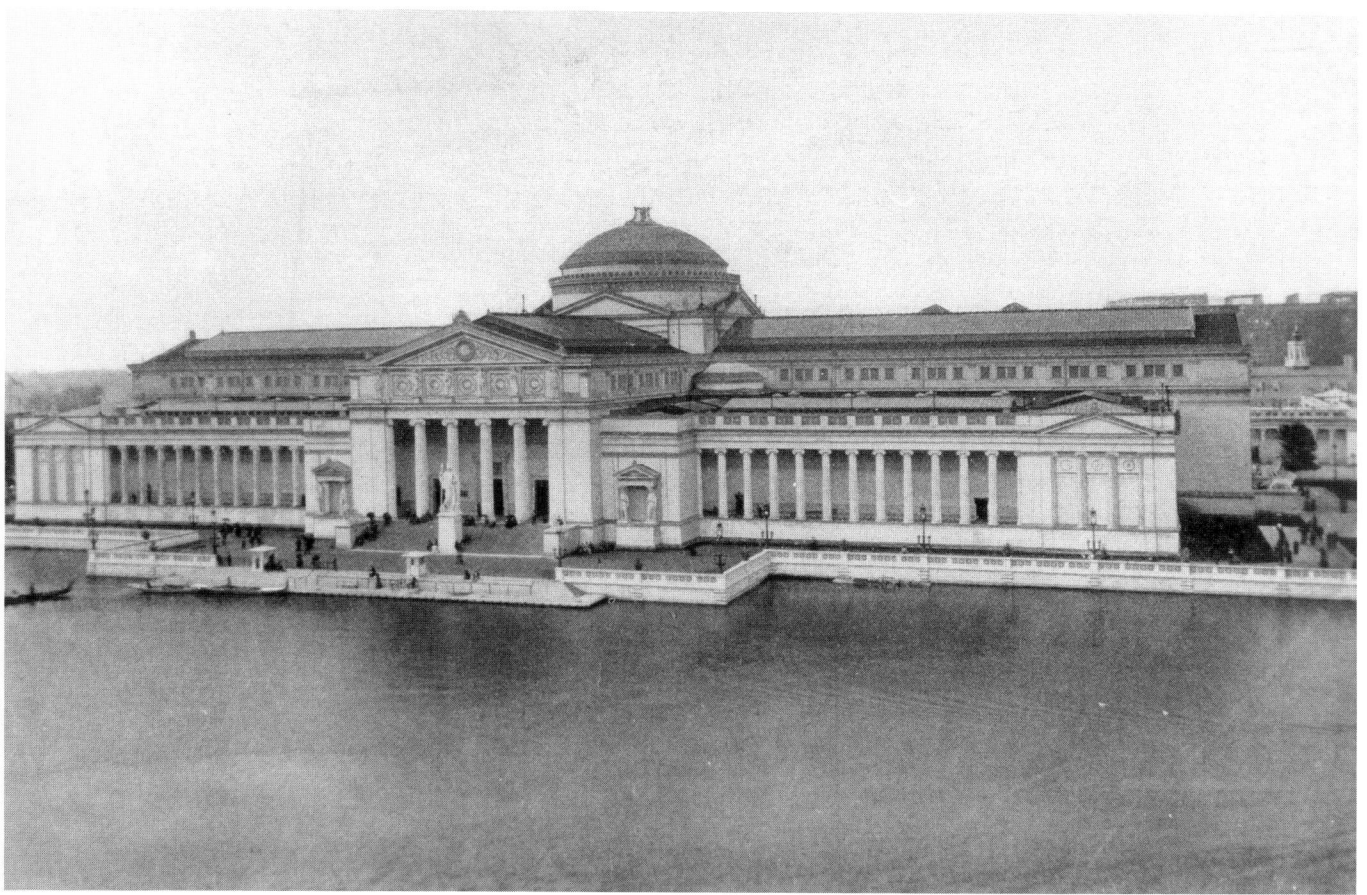

*Charles Atwood. Fine Arts Palace. World's Columbian
Exposition, Chicago, 1893.* Columbian Album,
1893. Collection of the author.

Arts Palace; the Dairy, Forestry, and Anthropological buildings; the Peristyle forming
the end of the Court of Honor; the Casino; the Music Hall; the railroad Terminal
Station; and a wide variety of such miscellaneous structures as sheds, warehouses, shops,
public restrooms, barns, flagstaffs, entryways, and the like.[36]

Atwood's Fine Arts Palace would become one of the showpieces of the fair. Although
Burnham originally offered the designing of the Fine Arts Palace to the firm of Burling
and Whitehouse, they "did not seem to grasp the work aright,"[37] and so that particular
plum, the only fair building to be built in semipermanent form (the walls were brick;
only the exterior covering was staff), was given to Atwood. Atwood's style was very much
in the vein of American fin-de-siècle classicism. Rejecting the individualistic picturesque-
ness of the previous generation, architects of Atwood's generation preferred to rely on
the authority of the past to secure a more assured and educated look for their buildings.
Burnham would say of him upon his death that Atwood was "a great user of books,
and constantly referred to the measurements made by scholars, and to the drawings
and comments of masters of our art."[38] This was very much the case with Atwood's
design of the Fine Arts Palace, to the extent that he was even accused of plagiarism.

The basic plan of the Fine Arts Palace consisted of a cross superimposed over a
rectangle with a dome over the central crossing, forming a rotunda within. The four
arms of the cross and the rotunda formed five sculpture courts on the interior. On the

exterior, the cross was made the predominating feature by giving the arms of the cross the highest elevations. The corners of the rectangle, nestled in the arms of the cross, were minor exterior projections subordinate to the overriding cross motif. These minor axes were expressed on the exterior by lower volumes. On the interior, these four corners contained the large gallery spaces. The building was perfectly symmetrical. Both front and rear facades were identical, and each could be referred to as an "entrance" facade—one for the land approach and one for the water.[39] The exterior was dominated by the entrance pavilions, which were projecting, pedimented, Ionic tetrastyle porticos *in antis*. To either side of the pavilions extended the low volumes of the galleries, decorated with a blind colonnade. The two major motifs of the building— pediments and domes—were expressed fugally. The largest pedimented porticos were on the entrance axis and similar but smaller pedimented portico motifs wrapping around the corners of the building. There were yet smaller pediments surrounding the drum of the dome. The dome motif, too, was repeated; there were four smaller domes serving as transitions between the arms of the cross and the galleries. To soften the transition between the entrance pavilions and the galleries, smaller corner volumes were introduced to either side of the entrances with caryatid aedicules copied from the Porch of the Maidens on the Erectheum. To complete the building's encyclopedic approach to scholarly architectural classicism, Atwood introduced sections of the Parthenon frieze to decorate various portions of the building and reproductions of the Choragic Monument of Lysicrates to flank the northerly (land) approach to the building.

Atwood, fond as he seems to have been of a scholarly approach to his designs, chose to adapt his design from the same Ecole des Beaux-Arts Prix de Rome competition as Schwarzmann had used for the Memorial Hall at the Philadelphia Centennial. The premiated 1867 design for an exposition art palace by Emile Bénard does have many of the same basic elements as Atwood's design. By Atwood's own admission, it is Bénard's project from which he took his design for the Art Palace's central motif, the entrance pavilion. Atwood, however, changed and simplified Bénard's design to make it more refined and less ostentatious and Baroque in conception. He also directly tapped the original ancient Greek sources by turning to the Erectheum and using not only its

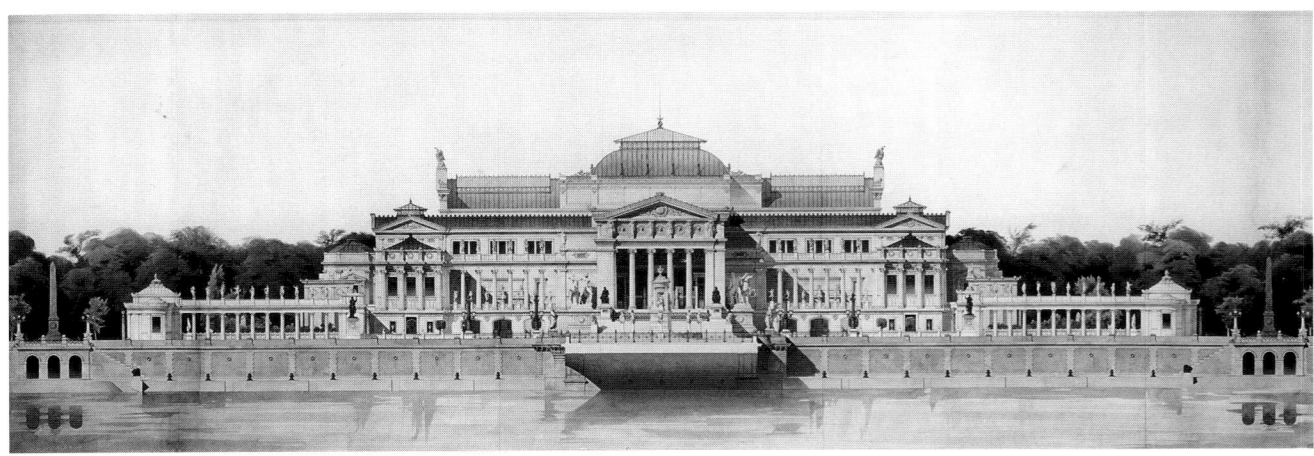

Emile Bénard. "A Palace for the Exhibition of the Fine Arts," Prix de Rome project, 1867. Paris, Ecole Nationale Superieure des Beaux-Arts.

Porch of the Maidens but also its pure Ionic order for his building. According to Atwood, he sent someone to Boston to measure the plaster casts from the Erectheum in order to make sure of the proportions.[40] The main difference between his own and Bénard's design, as Atwood pointed out, was his use of a shallow saucer dome atop the Greek cross design, rather than Bénard's high, square dome. Also, the plan of Atwood's building was of an entirely different conception from Bénard's, which was a more open design incorporating many interior courtyards.

Because of Atwood's reliance on both contemporary French and ancient Greek designs, a charge of plagiarism was leveled at him by unnamed architects and reported in the newspapers. Atwood's response was recorded in the article that reported the charge, and he simply admitted to borrowing the central motif from the Prix de Rome design (though he did not care to correct the reporter on the mistaken name and date of the design as reported in the paper). He claimed that he did no more than any other architect might do in choosing to execute a Greek building with a "tetrastal [*sic*] portico in antis" and using Bénard's design as the best example. He defended the charge of plagiarism by pointing to the originality of his design, which combined Bénard's design with a dome:

> I claim that my design is as original as anything in architecture can be and a great deal more original than some architectural work that no one thinks of challenging . . . The difference between me and some other architects is that I know what to take and what to leave and how to combine things that come from different sources.[41]

Atwood's attitude was typical of architects who worked in the classical mode during this period. They all accepted that they were not going to arrive at entirely new forms; rather, they were juggling old ones to create new admixtures. As one critic was reported to have said vis-à-vis the Art Palace: "To be sure [the building] has a dome, and the Greek architect knew nothing of domes, but surely, . . . had they known them they would have built in just this fashion."[42] Indeed, one unknown writer was so convinced by the dome on the Fine Arts Building that, upon Atwood's death in 1896, he wrote that the building had "the flattened dome so characteristic of the buildings of the Greeks"![43]

Aside from the brief aspersion on Atwood's professional character, the building received almost universal acclaim, as did its designer.[44] The building seems always to have been spoken of in superlatives. Burnham himself called it the most beautiful building he had ever seen[45] and wrote that Atwood "stands on the page of history as the greatest architect of our times, as St. Gaudens so justly stamped him."[46] It was probably also the sculptor Augustus St. Gaudens to whom Burnham was referring when he wrote of "one of the most eminent artists of our day" seizing him by the shoulders and saying: "Do you realize the rank of Atwood's Art Building among all the structures of the world? . . . There has been nothing equal to it since the Parthenon."[47] The architect Henry Van Brunt wrote that the building was "an artistic organism delicately poised, in which use and beauty find themselves in a condition of perfect harmony."[48]

This enthusiasm for the restrained classicism of the Fine Arts building extended to the more general public as well. One newspaper item claimed it was "the noblest piece of architecture in America" and said also that "of all the mighty structures of the fair it alone is generally acknowledged to be supreme and perfect."[49] The author of one of the more massive histories of the exposition, *The Book of the Fair*, praised the building as "a gem of the purest water" and pointed to its fitness as a building to house art because of the cataloguelike nature of its architectural decoration:

[The building is] enriched by every device of decorative sculpture which could be consistently recalled by historic art, so that when completed it should be fit to enshrine the figures and groups in marble and bronze, the paintings in oil, water color and fresco [etc.] . . . It was a part of the scheme to make the numerous statues, friezes, and other decorations, in the round and in relief, replicas of the greatest masterpieces of Greek and Renaissance art, so that the building itself should be a museum.[50]

This concern for making the exterior of the building *look like* a museum was important to most museum architects of this period. As already mentioned, the Art Institute building had the names of artists inscribed into a frieze at the cornice level and, like Atwood's building, had copies from the Parthenon's Panathenaic Procession frieze incorporated into the building. By making the building an encyclopedia of architecture and sculpture, Atwood not only made the building's purpose clear; he also made the building itself a lesson in architecture, a sort of museum-within-a-museum.

That the building should comprise a lesson in architecture on the exterior was also appropriate, as architectural exhibits were a part of what the Art Palace contained. There, the lesson in classical architecture continued the theme of the exterior of the building, for displayed in the upper galleries and in the rotunda were architectural drawings and models, many of classical architecture or in a classical style. There were drawings after antiquity, such as Dwight Blaney's *Arch of Titus, Rome,* John J. Bissegger's *Choragic Monument,* or Reinhardt Dempwolf's *Detail of restoration of cornice of the Temple of the Sun, Rome.* There were also designs by both established and rising Beaux-Arts architects, such as Richard Morris Hunt, Carrère and Hastings, and McKim, Mead, and White. Designs were even displayed for other Beaux-Arts museums: Ernest Flagg's *Study for an Academy of the Fine Arts, New York,* which was the inspiration for the Corcoran Gallery of Art in Washington, D.C.; and Shepley, Rutan, and Coolidge's *Art Institute of Chicago.*[51] Thus, a dialogue between the building and its exhibits was established and held in a classical language. As Henry Van Brunt wrote of the architecture at the fair in general, it

would present to the profession here an object-lesson so impressive of the practical value of architectural scholarship and of strict subordination to the formulas of the schools, that it would serve as a timely corrective to the national tendency to experiments in design.[52]

The Fine Arts Palace and the exhibits it contained served as an "object-lesson" of the merits of the classical idiom.

The instructional aspect of the building was a very important one. Naturally, it was hoped that the entire fair would be educational, improving all those who came.[53] No building could so elevate the mind and the appreciation for culture as the Fine Arts building, or so it was hoped. Alice Palmer noted that the "teachability of the common American is almost pathetic. One building was always crowded—the Fine Arts Building; yet great pictures were the one thing exhibited with which Americans have hitherto had little or no acquaintance."[54] One widely held belief was that all those who entered the Art Building would come away with an increased sense of the "art idea," i.e., an immediately improved understanding of art and its importance. The director of the Art Institute of Chicago, William M. R. French, wrote that

the influence upon the millions of people who floated through the art galleries without any particular intention [is not] to be underrated. An intelligent person could hardly visit the Fair without bringing away the idea more or less distinctly recognized, that the fine arts are of considerable importance. I consider this diffusion of the art idea the greatest service of the Fair.[55]

Others felt that if the visitors simply came to the fair and saw the buildings, they would improve their minds and become better, more cultivated people. As Professor William James of Harvard wrote, the fair "is esteemed such a revelation of beauty. People cast away all sin and baseness, burst into tears and grow religious, etc. under its influence!"[56] Ideally, this educational aspect would be a part of all art museums, but the Fine Arts Palace could claim even more of this influence because it partook of a hugely popular spectator event, the World's Columbian Exposition. That it was acceptable, even desirable for art and a museum-style building to be involved in a public— even commercial—spectacle was to change part of the outlook of museums in general in the United States. Their goals, partially as a result of the success of the fairs, would be twofold. Their buildings would have a festive look and a popular appeal; yet, at the same time, present educational and instructional displays for the non-art-educated visitor.

The Fine Arts Palace had been built out of semipermanent materials in order to be fireproof. This was the same motivation that prompted the Philadelphia Memorial Hall to be built of permanent materials. No country would send its priceless national art treasures unless it could be assured that the building that would house these works would be fireproof. Part of the general precautions taken for these buildings was that the structure should also be separated by distances fire could not easily bridge, even in the high winds that often blew through Chicago. The Fine Arts Palace had the added safety of being located on the water's edge. Although this isolation was partly a matter of fire prevention, it certainly added to the romance of the building, set apart from all the others. Additionally, the fact of the building's fireproof construction meant that when the Exposition closed and a conflagration did indeed destroy the rest of the fair's buildings on July 5, 1894, the Fine Arts Palace was the only building remaining after the fair (unless one include the Art Institute miles away to the north). It had been hoped all along that the building would remain as a memorial to the fair. As the author of *The Book of the Fair* noted:

> Among those who have beheld this edifice, of itself a work of art, their pleasure was not impaired by regret that within a few brief months it was doomed to demolition; for here was no ephemeral structure, but one with walls of brick; . . . one which after the close of the Fair would remain as among its monuments, to be used for museum purposes and for the safe keeping of the many valuable exhibits presented to the management.[57]

This is precisely what did happen. The fair closed in late October of 1893, and by the beginning of December, the art had been removed and all the space within the building had been allotted to various exhibits comprised of donations made to the fair. The space under the rotunda was to be a Memorial Hall of the Exposition, including a model of the exposition grounds; and the rest of the building was to be given over to exhibits on anthropology, zoology, botany, geology, and technology.[58] Marshall Field donated $1,000,000 toward the museum; hence, its new name was the Field Columbian Museum. Over time, the museum dropped the "Columbian" association as well as the name. The building was abandoned in 1920 when the Field Museum moved to its own permanent museum building in Grant Park, designed by the firm of Graham, Anderson, Probst, and White. It is not inconsequential to note that nearly three decades later, Atwood's design was still influential enough that the new Field Museum building was essentially based on the Fine Arts Palace, without the dome and somewhat further simplified.

By the 1920s, the former Field Museum building had fallen into disrepair, as more than thirty years had passed since its erection. The building's staff exterior had nearly

disintegrated when a group of concerned Chicagoans rallied to save the building. In 1923, it was still possible for the Chicago Chapter of the American Institute of Architects to claim that the Fine Arts Palace was "the second most beautiful building in the world," after the Parthenon.[59] The plea worked, and in 1926, the Museum of Science and Industry received its charter; by 1940 the entire restoration was complete. This was accomplished by replacing the staff exterior with stone and restoring it faithfully to its former grandeur. The exterior work was supervised by the same architectural firm that designed the Field Museum: Graham, Anderson, Probst, and White, D. H. Burnham's successor firm. The interior was finished as plainly as possible, without ornamentation. That a building originally designed to be temporary should still stand a century later is testament to the power of its design.

Charles Atwood's Art Palace would have further influence in several respects. Art buildings designed for future American fairs would also be built in permanent materials or, like Atwood's building, become so well liked that they would eventually be rebuilt permanently. Secondly, an examination of art museums built in the decade after the Columbian Exposition reveals a strong family resemblance to Atwood's art building, as, for example, McKim, Mead, and White's Brooklyn Museum and Ferry and Clas's Milwaukee Public Library and Museum. The architecture of the latter has a particularly festive appeal. Not only did Atwood's building exert influence upon the look of particular buildings, but present and future patrons were also to be affected by the classical atmosphere of the fair. John J. Albright, benefactor of the Albright Art Gallery in Buffalo, visited the fair and six years later gave the city of Buffalo a museum to be built in conjunction with the Pan-American Exposition. Similarly, Andrew Carnegie had already provided Pittsburgh with a combination library, music hall, and art and natural history museums, the designs for which were secured in 1891 when he came to the fair and had this to say of its architecture:

> Every one who was privileged to spend days and evenings in windings in and out, through and among the palaces of the White City, and especially to saunter there at night when footsteps were few, has the knowledge to treasure up that he has seen and felt the influence of the greatest combination of architectural beauty which man has ever created.[60]

Carnegie was afterward motivated to expand the Carnegie Institute's building fourfold in size, in a style as magnificent, classical, and "Aladdin"-like (to use Carnegie's own word) as was the style employed at the Chicago fair.[61]

Perhaps one of the most interesting aspects of the Art Palace was its popularity with the average fairgoer and its perceived accessibility to the general populace, including the working class. As mentioned previously, it was hoped that the educational aspect of the building and its exhibit would be widely influential. This naturally depended on the building being entered by as many people as possible—people of all sorts and classes, who needed only to afford the fifty-cent general admission to the fair. Although the Columbian Exposition's art building was not the first to house an art exhibit for the general fairgoer and although the nature of exposition in general was spectacular, the Art Palace's wide appeal presaged the great American era of public art museums. So successful was the Columbian Exposition's art building that the two biggest fairs to take place after Chicago—in Buffalo and in St. Louis—spawned permanent art museum buildings as part of the exposition architecture. The White City of Chicago was to influence the way they looked, as well as the sheer fact of their existence.

Two smaller fairs that took place within five years of the Chicago fair provide an interesting interlude between examinations of the Chicago and the Buffalo and St. Louis fairs. The first was the 1895 Cotton States and International Exposition of At-

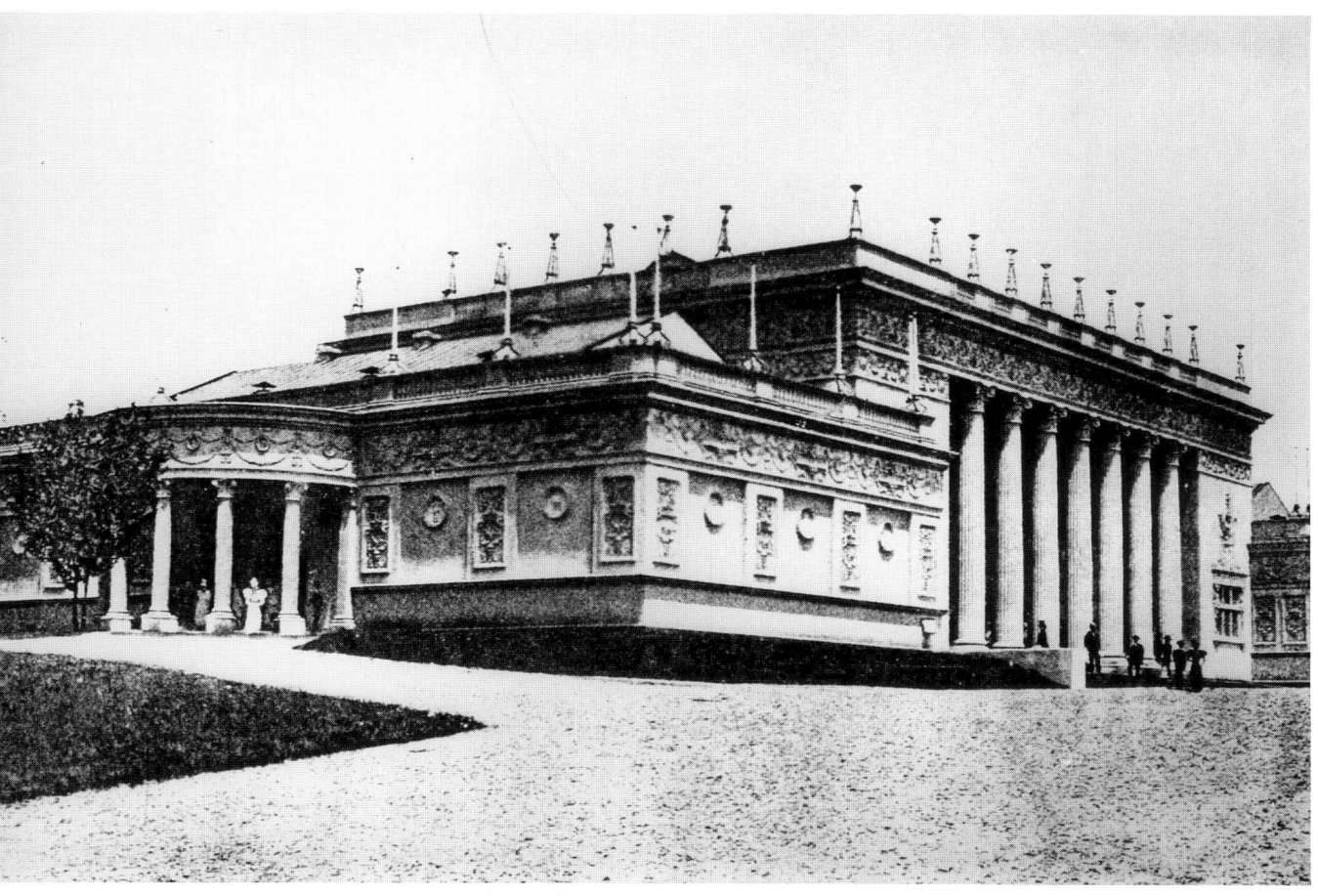

W. T. Downing. Fine Arts Building, Cotton States and International Exposition, Atlanta, 1895. The Cotton States and International Exposition and South, Illustrated, 1896. New York Public Library.

lanta.[62] Despite its name, it was primarily a regional event whose importance here lies in its Fine Arts building. Obviously influenced by the Chicago fair, whose images must still have been very strong in 1895, the Cotton States' Fine Arts building, designed by W. T. Downing, was in a classical style. It featured an entrance dominated by seven (an unusual and "incorrect" number) giant Corinthian columns *in antis,* above which was an elaborate frieze, a simple cornice, and a flat roof.[63] The central portion of the building was flanked by lower galleries, windowless by necessity. Whereas Atwood had decorated the windowless galleries of his art building with a blind colonnade, Downing applied a variety of panels, friezes, and medallions, all embellished with designs in relief. The awkward and provincial effect was heightened by Gothic pinnacles applied in a series above the cornice line. Nevertheless, it is clear that the desired effect was one of monumental, classical grandeur in the vein of the Chicago fair.

The second smaller fair to take place between the Chicago fair and the Buffalo Pan-American Exposition was the Tennessee Centennial and International Exposition held in Nashville in 1897.[64] The architectural showpiece of this fair was the replica of the Parthenon intended to house the fair's fine arts exhibits. In Nashville, the organizers of the fair took the scholarly approach to architectural design to its logical conclusion.

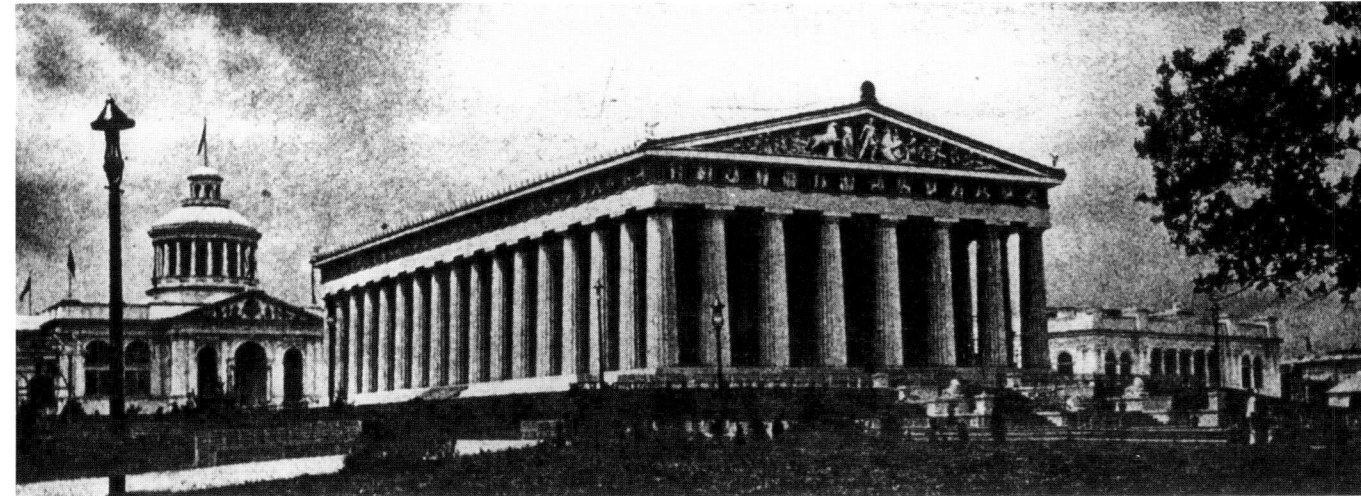

*W. C. Smith. "Parthenon," Tennessee Centennial and
International Exposition, 1897.* Official History of
the Tennessee Centennial Exposition *1898. New
York Public Library.*

As the *Official History* of the exposition states, "In size it is, in detail it is believed to be, a recreation of what Ictinus built and Phidias adorned. All the best authorities were carefully studied [and] . . . religiously followed by the accomplished architect in charge [Captain W. C. Smith]."[65]

The idea for recreating the most potent symbol of ancient Greece was to promote the notion that Nashville was the Athens of the South. The "perfect city" of the exposition (and Nashville, by extension) "should have for its central feature a brilliant palace for Fine Arts, fashioned after the Parthenon, thus . . . giving to the nineteenth century an echo of Greece's supremest triumph."[66] The inescapable conclusion, however, is that the fair organizers hoped to do the Chicago fair's fine arts building one better by making their building a duplicate of the acknowledged "most beautiful building in the world." The Nashville Parthenon was later rebuilt and still stands as a reminder of the Tennessee Centennial and an architectural study piece writ large.

The Pan-American Exposition, Buffalo, 1901

The next great fair in the United States after the enormous popular success of the Columbian Exposition was the Pan-American Exposition, which took place in Buffalo in 1901 and was intended to celebrate visions of Pan-American unity. The architects involved in the planning and designing of the fairgrounds and buildings were naturally very conscious of the effects and influences of the Chicago fair. John Carrère, the Chairman of the Board of Architects for the Pan-American Exposition, noted that the White City "was a lesson which had already awakened in this country a better understanding and appreciation of monumental architecture and a broader interest in art."[67] In 1901, the architectural critic Marianna Griswold Van Rensselaer cited the White City as the main impetus for architectural improvement of the preceding decade: "Everywhere in our country more desire for architectural excellence is manifested than was shown ten years ago, and the right way to achieve it is better understood."[68] It is clear

that the architects for the Buffalo exposition were painfully aware of the influence of the White City and felt the pressure of a famous forebear. They therefore decided to make a deliberate turn away from the austere white classicism of the Chicago fair and make instead a "Rainbow City." Carrère wrote that the architects had "the desire to avoid reminiscences of the Chicago Exposition" and chose, therefore, "to develop a picturesque ensemble on a formal ground plan."[69] The approach the architects used to differentiate their product from that of Chicago was to emphasize deliberately the temporary and festive nature of the event. The resultant architectural scheme was based on a more flamboyant architectural style than Chicago's—"Free Renaissance" with a Spanish influence, rather than Chicago's stricter classicism—and colored enthusiastically with every hue of the aforementioned rainbow.[70] The result, as reported by one visitor, was "panoramic, festal, even gay."[71] Charles Caffin, the eminent critic of architecture and urban planning, described the architectural effect thus: "It is not vulgar fooling but an elegant 'comedy of manners.'"[72]

In great contrast to this brilliantly colored, flamboyant spectacle were the permanent buildings erected in connection with the exposition. There were two such structures: the New York State Building, later to become the permanent home for the Buffalo Historical Society; and the Albright Art Gallery, intended to be the temporary home for the art exhibits at the exposition and later to become the permanent home for the Buffalo Fine Arts Academy and its art gallery. The architectural contrast between the Albright Art Gallery and the temporary exposition buildings it was originally intended to complement is particularly instructive because the architectural firm that designed the Albright Art Gallery was also responsible for several of the temporary, "Spanish-American Renaissance" buildings at the fair. That the architects, the firm of Green and Wicks, could work in these very different styles and prefer an exuberant style for the exposition buildings and a highly classical, restrained Greek style for the permanent building is indicative of contemporary attitudes about the art museum and what constituted a proper style for such an edifice.

The inception of the original portion of the Albright Art Gallery was entirely the effort of its eponymous founder, John J. Albright. Having taken an active interest in the art matters of Buffalo, Albright wrote a letter in January of 1900 to the Board of Directors of the Buffalo Fine Arts Academy declaring his intention to donate to the Academy all the money needed to provide it with a "permanent and suitable home."[73] As plans had already been made for the holding of the Pan-American Exposition in Buffalo in 1901, Albright intended that the building should serve as the art building for the exposition and, he thought, be made a "prominent feature" of the Exposition.[74] This use of the building was facilitated by the fair's location adjacent to Delaware Park, with some of the parklands included in its extent. Albright made it a condition of his gift that the gallery should be located within this Frederick Law Olmsted-designed park. With this location, the building could be built of permanent materials yet complement the impermanent fair buildings. Thus, when the original plans for the fairgrounds were laid out, the Albright Gallery was considered a part of the layout, and no other art building was planned.

The proposition of a permanent art gallery to be built in conjunction with the fair was received with great enthusiasm among the local newspapers, one of which declared:

> The glories of the Pan-American Exposition will pass, but out of it all, and independent of it, Buffalo is to receive a group of permanent structures, of great beauty and of lasting credit to the city. . . . Chief in importance is the Albright Art Gallery, a classic building of white marble.[75]

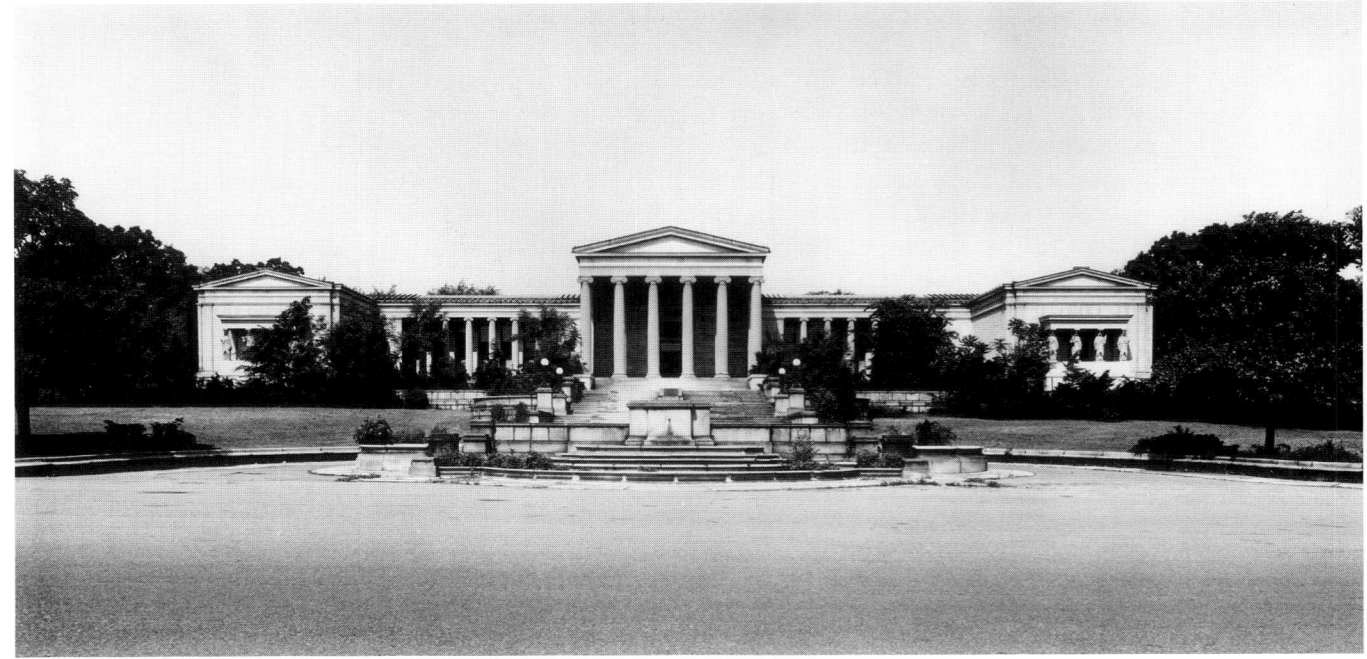

Edward B. Green. Exterior, Albright Art Gallery, Buf-
falo, NY, 1900–1905. Photograph: Greenberg-May
Inc. (view from Delaware Park, June 1960). Photo-
graph courtesy of the Albright-Knox Gallery Archives,
Buffalo, NY.

Throughout the year 1900, confidence was expressed in the completion of the building
in time for the exposition. Green and Wicks, the architects of the building, went on
record in a Buffalo newspaper in July of 1900 that the building would "undoubtedly"
be complete in time.[76] Problems arose with obtaining the marble, however, and though
there were some who still expressed faith late in the year that the building could be
ready for the Exposition's May first opening, Edward Green had already maintained
as early as March of 1900 that it was possible the building would not be ready:

> Architectural works of art cannot be reared in a hurry. It takes time and care. Some of the
> Pan-American officials have said we could finish the gallery, if we tried, before the Exposition
> was dedicated. If it were to be a ten-story mercantile building, perhaps we might. They do
> not understand what it means to build a beautiful marble structure like the gallery.[77]

By the end of the year, there was no doubt that the building could not be ready in time,
and plans were made in late December for the erection of a fireproof brick building
to house the art exhibits of the fair.

The temporary building for the art at the exposition was located within the bounds
of Delaware Park and just around the lake from the Albright gallery. In order to allow
the hanging plan to remain the same, the temporary art building was built with the
same interior arrangements and dimensions as the Albright Art Gallery with the same
central statuary hall as its main feature.[78] This replacement building was also designed
by Green and Wicks, and its appearance, like that of the other temporary fair buildings,
was indicative of the architectural philosophy and expectations of architects and patrons
of the time. Whereas the temporary art building was built with a plan identical to the

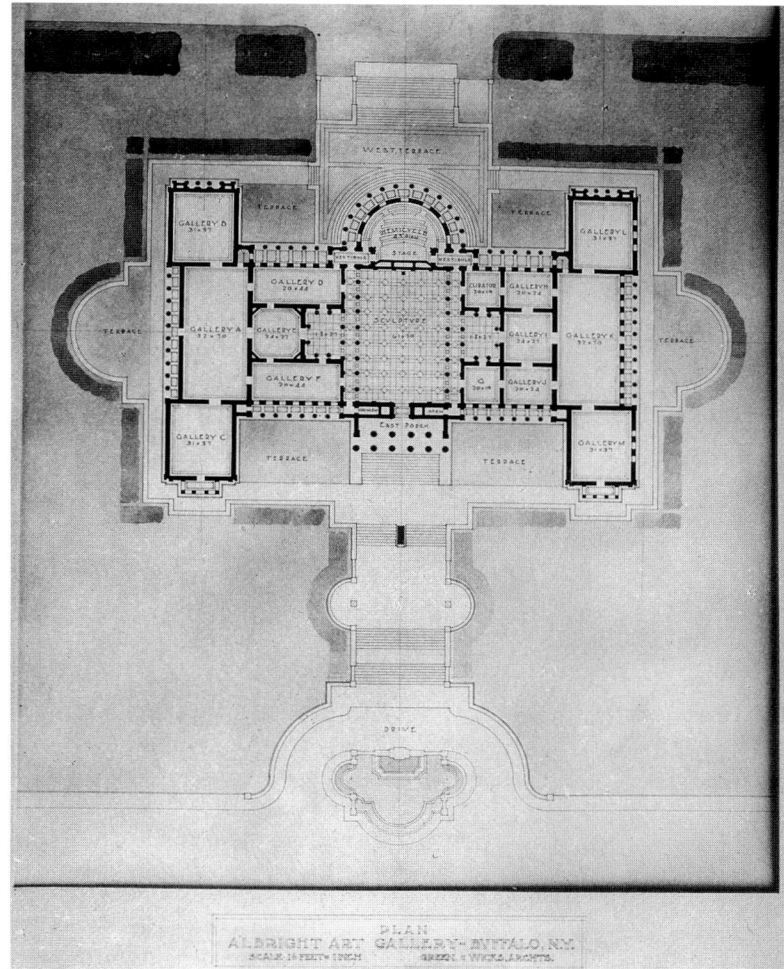

*Edward B. Green. Original architect's drawing show-
ing floor plan of Albright Art Gallery, Buffalo, NY,
ca. 1902. Photograph courtesy of the Albright-Knox
Gallery Archives, Buffalo, NY.*

classical Albright Art Gallery, its exterior was in the same style as the other fair buildings, i.e., Spanish Renaissance, with its details "resembling those of the palace in Palma, on the island of Majorca."[79]

Green and Wicks were also responsible for two of the major exposition structures, the Machinery and Electricity Buildings. As the architects themselves explained, the Machinery Building was based in its general form on the "mission style" brought to California and Mexico by the Spanish missionaries in the seventeenth and eighteenth centuries. They felt, however, that early Mission style was too simple and somber and needed "enlivenment, ornament, and color" in order to suit exposition purposes.[80] They therefore added to the simple, plain-wall, arcaded volumes of the Mission style towers, domes, columns, and an abundance of Spanish Baroque ornamentation. The effect was highly picturesque, and to be added to it was the color scheme provided by the exposition planners. The coloring of the Machinery Building consisted of green for its base color, with red, yellow, and green introduced in the doorways, corner pavil-

ions, and towers. Green and Wicks's Electricity Building was likewise picturesque with architectural details similar to the Machinery Building but with light yellow as its base color and gray and green as its accent colors.

Carrère pointed out in his description of the fair's layout that a festive, ornate, colorful approach to the exposition architecture could be considered appropriate because of the impermanent nature of the buildings. The equivocal nature of this approach for a turn-of-the-century classical architect is revealed by the fact that the buildings were laid out on a highly formal, axial plan—as formal as that used at Chicago's Columbian Exposition. In fact, some of the architects for the Pan-American Exposition had designed major buildings at the Chicago fair, namely, R. S. Peabody of Peabody and Stearns and George Shepley of Shepley, Rutan, and Coolidge. Moreover, most of the architects who designed the flamboyant Spanish structures at Buffalo were accustomed to designing in the classical style: Carrère, whose firm had been given the commission for the New York Public Library; George Cary, who designed the classical New York State Building at the fair; and Green and Wicks, who were working on the design for the Albright Art Gallery at the same time that they were working on the exposition buildings.

These various facts point out several essential truths for the turn-of-the-century architectural establishment. Whereas it might be sanctioned to make the fair buildings picturesque in style, they were still to be restrained by a formal, highly axial ground plan. Second, a permanent structure must not be so frivolous; thus, the only permanent buildings erected in connection with the fair were strictly classical. George Cary, designer of the picturesque Ethnological Building, was the architect selected for the New York State Building, which would pass into the hands of the Buffalo Historical Society upon the closing of the fair. In the competition for the building, Cary received the first prize just above a submission by Green and Wicks.[81] His building's lakefront portico was a small-scale copy of the Parthenon, as the Tennessee Centennial's art building had also been. In contrast to the colorful exposition architecture, the New York State Building's "pure white walls and classic lines made it a thing of conspicuous beauty under the dark foliage of the trees."[82] Even the language used by the reporters in the local press pointed to the desirability of the classical mode for a building that was to remain as a memorial to the fair: "Harmony and good taste mark the execution of the plans of the architect."[83]

A similar conception of architectural fitness applied to the designing of the Albright Art Gallery. John Albright had been to the Columbian Exposition in 1893 and must have been impressed by the architecture he saw there (as who had not been?), because when Charles McKim and others started the American Academy in Rome shortly after the Chicago fair, Albright was one of the Academy's incorporators.[84] It seems likely that Atwood's Art Palace—as well as its European precursors—had a strong influence on both Albright's thinking and Edward B. Green's designing. When Albright offered the financial support to make the new gallery possible, he stipulated that "a home [for the Buffalo Fine Arts Academy] should be exclusively devoted to art and in its architecture and surroundings should of itself represent the nature of its occupancy."[85] How should this be done? Albright made this clear by requiring that the building be of white marble; hence, a classical design was inevitable. This was, logically, what Green provided, with what seems to be a direct acknowledgment of Atwood's Art Palace in his use of the Ionic order taken from the Erectheum and two caryatid porches from the same that had also been incorporated into Atwood's design. A further connection is even suggested by the fact that the artist who so admired Atwood and his building—Augustus St. Gaudens—was the same artist who executed the caryatids for the Albright Art Gallery.

Edward Green was chosen as the architect for the gallery even before Albright's announcement of his donation. The choice was a logical one, for Green was a member of the Board of Directors of the Academy. When the newspapers announced Albright's gift, it was made apparent that Albright and Green had already been at work on the design of the building: "Mr. Green told of the many trips he had made under Mr. Albright's direction to inspect various art buildings throughout the country in order to gather the best ideas of the foremost architects to be at disposal here when the building is designed."[86] Of the art museums in existence in the United States in 1900, only Chicago had much to offer Green in the way of classical buildings, and it seems that he combined the efficiency of the Art Institute of Chicago with the beauty of the Columbian Exposition Fine Arts Palace.[87] Just such a comparison was made by the *Academy Notes* during the building's inaugural year, 1905, where it was pointed out that the

> beautiful Art Palace of the Columbian Exposition at Chicago was not at all well adapted for its purpose . . . [and the] Art Institute [of Chicago] is not a handsome structure, in so far as its exterior is concerned, though it fairly fits its situation. The Albright Art Gallery had the beautiful exterior as well as the intelligently planned interior.[88]

The plan of the Albright Art Gallery was highly developed and complex. Its basic outline was H-shaped, and its most distinctive feature was the sculpture hall that was perpendicular to the main entrance and ran through the depth of the building. This hall probably took its inspiration from Flagg's Corcoran Gallery, which also had a sculpture hall as its most prominent feature. The sculpture hall terminated at the entrance to the hemicycle-shaped stage, which was articulated on the exterior by a colonnaded exedra. Flanking the sculpture hall was a series of small, interlocking galleries that led to larger galleries running along the sides of the building. On the exterior, the dominating volume of the sculpture hall was expressed by a pedimented Ionic portico, flanked by the recessed, colonnaded main body of the building, each end terminating in smaller projecting pavilions (expressive of four corner galleries) decorated with the caryatid porches. As mentioned previously, the order of the building was taken from the Erectheum, just as the Buffalo Historical Society across the lake provided the complementary features of the Parthenon. The whole was surrounded by carefully planned steps and terraces. These terraces were beautifully designed, for they echoed fugally the volumes of the building. Where the portico and hemicycle projected to the front and rear, the terraces were rectilinear and skimmed the edges of the building closely. On the sides of the building, which were composed of plain, rectangular masses, the terraces expanded into semicircular shapes that echoed the shape of the rear portion of the building.

The Albright Art Gallery was extraordinarily well received by all observers, including the popular press, the architectural press, and the museum establishment. The popular press went into poetic ecstasies over the building and its classical appearance. One reporter called the gallery "stately, majestic, chaste, a Greek temple set like a gem in Buffalo's parklands, with the foliage-fringed lake as a background, a marble palace consecrated to the worship of the beautiful."[89] The professional press, too, admired the building, noting its intrinsic beauty as well as its fitness as a repository for the beautiful, echoing Albright's request for a building that "should of itself represent the nature of its occupancy." An article in *Art and Archaeology* marveled:

> Surely such a perfect building should hold one's attention for a while and lift one out of the busy life in which one lives. It should be capable of preparing one's mind for the glorious art within its walls, and place one in something of the attitude of mind and spirit in which that art was wrought.[90]

The idea of the function of an art museum building as a symbol for what it held inside is quite similar to that expressed by others writing about Atwood's similarly Greek Art Palace.

The building was admired by other museum professionals not connected to the Albright. The business manager of the Carnegie Institute in Pittsburgh, a friend of the first director in the new Albright building, Charles M. Kurtz, wrote to Kurtz: "I understand your new building will be about ideal."[91] Even other artists admired the building. Robert W. Vonnoh, the painter, wrote to Kurtz: "You are to be envied as it [the building] is the most artistic production of its kind this side of the water. It breathes purity & I know it will be a constant source of high inspiration to you."[92] Vonnoh's reference to "purity" probably subscribes to the notion of the Greek tradition as one without artifice and without, as his generation would have seen it, precedence. Like its probable inspiration, the Albright Art Gallery building enjoyed the universal admiration bestowed upon Charles Atwood's Fine Arts Palace at Chicago, with the one difference being that Green's building was also praised for its suitability for displaying art, whereas Atwood's had received some complaints about its practicality.

Where the Columbian Exposition demonstrated that an art building could be a popular spectacle and partake of a festival atmosphere, the Pan-American Exposition showed that gaiety in architecture should only be taken so far and that a proper dignity had to be maintained, despite the public nature of the building. Like the Chicago fair, the goal of the exhibitions was to provide inspiration and instruction to the visitors: "The ideals had in view at the inception of the Exposition included a wish to elevate art by the picture it would present, and thus educate, uplift and benefit the millions who were to see it."[93] The architecture that was to house the art was to maintain this high seriousness of purpose, even if it was also to be part of the spectacle. As one newspaper reporting its praises of the building noted, "We must be restrained, as were the artists in shaping the beautiful pile, . . . [and mind] the Greek motto of 'naught in overplus' which seems to have governed the builders of the classic temple from first to last."[94] The suitability of the Greek temple form was affirmed in Buffalo, and the style's many proponents not only praised the look of the building but argued that Greek architecture was the only proper form because the Greek temple

> became the treasure house in which were deposited the most precious objects evolved from artistic endeavor. Thus, the temple of one age became the museum of another, and its form seems most appropriate for that of the art gallery. The Greek temple design is most adaptable for the proportion and dignity befitting this purpose.[95]

In terms of an architecture suitable for sheltering art, the exposition at Buffalo constituted a reaffirmation of what had been stated in Chicago in 1893. The language thus created would continue to be spoken at the next important international fair to be held in the United States.

The Louisiana Purchase Exposition, St. Louis, 1904

Only three years after the Pan-American Exposition, the next international exposition was ready to take place in Missouri. The art museum built in connection with the Louisiana Purchase Exposition in St. Louis in 1904 can be considered the culmination of nineteenth-century art-museum-and-exposition collaborations. At St. Louis, as at Buffalo and Chicago, the onslaught of planning for an exposition resulted in the building of a permanent art museum. Unlike the art buildings at Buffalo and Chicago, the

St. Louis Art Museum was planned with enough time to allow it to be finished for the exposition and to serve its temporary function as the exposition's art palace. For the first time, the art museum and the exposition conjoined fully in creating both a temporary spectacle for a popular spectator event and a permanent art institution for the host city of the fair.

A number of parallel ideas and occurrences can be discerned among the three major expositions—Chicago, Buffalo, and St. Louis—and the art buildings erected in conjunction with them. Perhaps the most interesting coincidence is the recurring involvement of two men who were inextricably a part of the three fairs: Halsey C. Ives and Charles M. Kurtz. Halsey Ives was director of the departments of fine arts at all three expositions; Charles Kurtz was his second-in-command at Chicago and St. Louis and became director of the Albright Art Gallery upon the close of the Louisiana Purchase Exposition. Although it cannot be argued that either of these men had a direct influence on the architecture of the art buildings at all three fairs, they did shape the art exhibits that took place inside, and they provided yet another element of continuity that links the art, architecture, and cultural importance of the art galleries at the three fairs.

Halsey Ives, however, was directly involved in the building and planning of the art building for the Louisiana Purchase Exposition. He was not only the director of the art department but also the director of the St. Louis Museum of Fine Arts, the institute for which the permanent portion of the art building was to be built. Ives had had a long

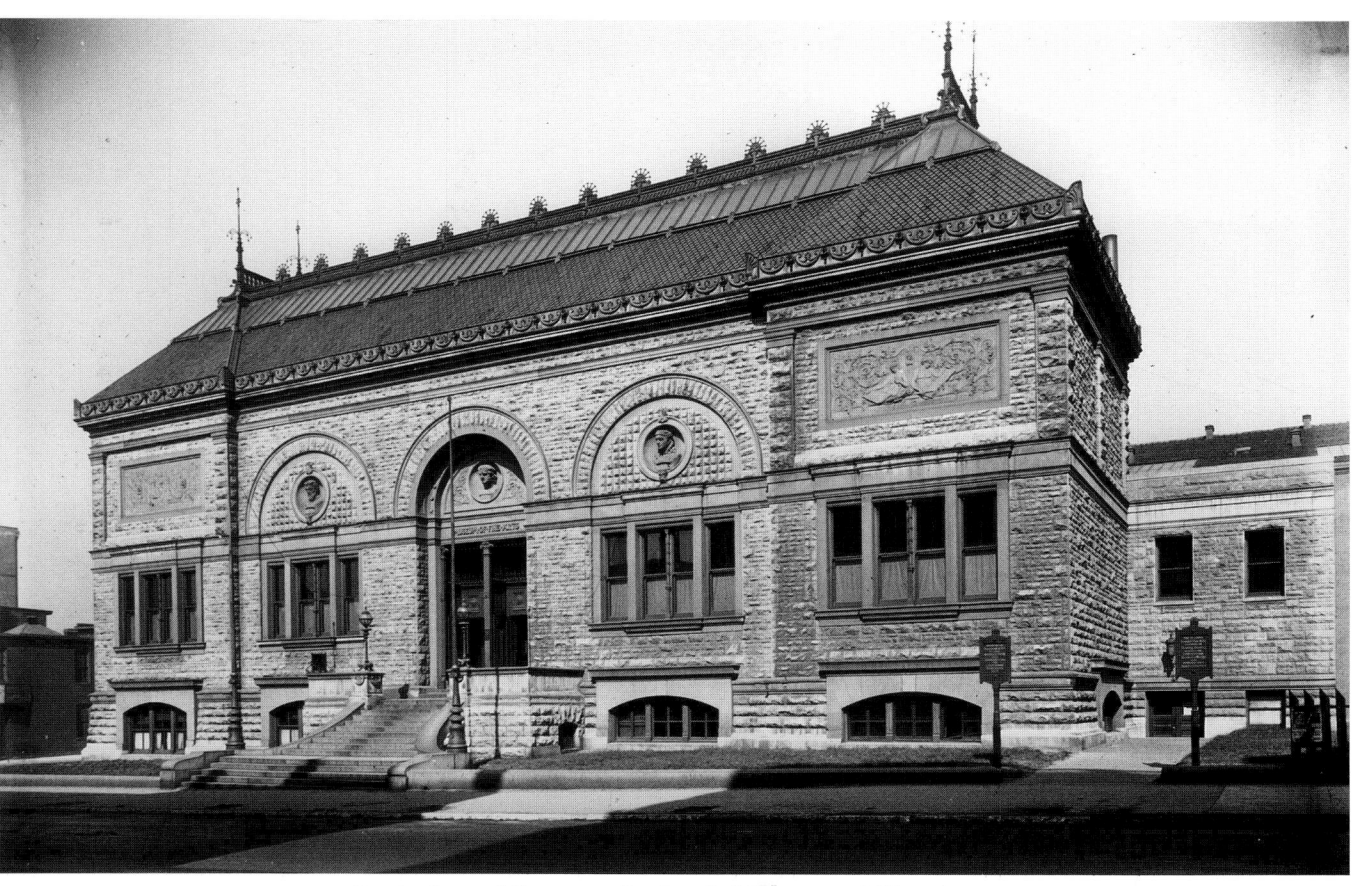

Peabody and Stearns. St. Louis Museum of Fine Arts, 1879–81. Photograph courtesy of Missouri Historical Society, St. Louis.

history with the St. Louis museum; he had been present at (and before) its inception in 1879 and watched its first building being constructed. Designed by Peabody and Stearns in 1879 and dedicated in 1881, the first St. Louis Museum of Fine Arts building was small and, like the Art Institute of Chicago's first building, influenced stylistically by the Richardsonian Romanesque. Like the Chicago institution, too, the St. Louis museum was built in the rapidly expanding downtown and quickly ran out of space for the art and tolerance for the changing neighborhood, which was becoming progressively more industrial.[96] When Forest Park was chosen as the Louisiana Purchase Exposition site, plans came together for constructing an art palace that would later serve as the museum's new home, for the park was where the museum officials had already planned to locate their new building.

The fan-shaped ground plan for the exposition was positioned on a hilltop so that the crest of the hill was also the central point of the fan from which all of the fair buildings radiated. The central feature was Cass Gilbert's Festival Hall, which was executed, like the Pan-American buildings, in "Free Renaissance" without the Spanish flavor. A great domed structure larger than the dome on St. Peter's, it presided over the fan-shaped "Cascade Gardens" and was flanked by the quarter-mile-long, colonnaded "Terrace of the States." Like the Buffalo fair buildings, Festival Hall was really Baroque

Cass Gilbert. St. Louis Art Museum, 1901–4. Avery Architectural and Fine Arts Library, Columbia University in the City of New York.

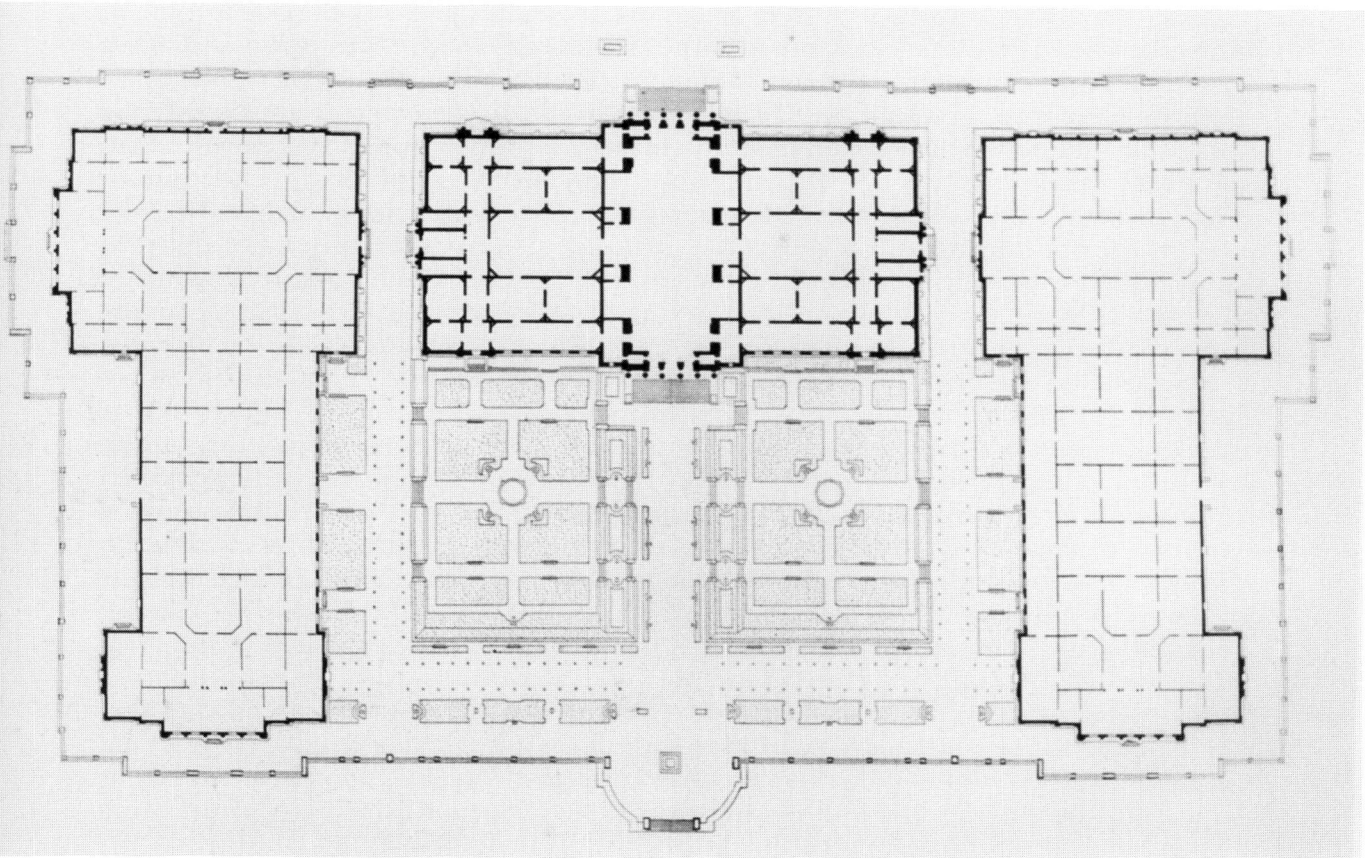

Cass Gilbert. St. Louis Art Museum, 1901–4. Plan.
Avery Architectural and Fine Arts Library, Columbia
University in the City of New York.

in conception, with an enormous arched entrance and a great deal of statuary sur-
rounding and embellishing it. The architects involved in the plan and design of the
fair were once again extremely conscious of the influence of the Chicago fair. As Kurtz
was to write, the

> magnificent central scheme includes in one view the two particularly impressive features of
> the Court of Honor at Chicago. The Festival Hall is the equivalent of the Administration
> Building at one end, and the Colonnade recalls the lovely Peristyle at the other end of the
> Grand Basin at the Columbian Exposition.[97]

Gilbert's design for the art building, however, differs as much from his Festival Hall
as did Green and Wicks's Albright Art Gallery from their Machinery Building. Once
again, as a contemporary wrote, the "festive and ephemeral nature of exposition archi-
tecture tends to loosen the bonds of restraint which should be felt in designing a
permanent structure."[98] Whereas the temporary fair buildings in both cases were flam-
boyant, highly imaginative designs, the St. Louis museum shares with the Albright
gallery a much more sober conception, based strictly on scholarly, archaeologically cor-
rect, ancient designs. Gilbert himself referred to the design of the art building as
"Graeco-Roman," as it incorporated Greek motifs with the predominating Roman bath
form expressing the central sculpture hall in the interior.[99] As both Schwarzmann and

Atwood had done, Gilbert received inspiration from Ecole des Beaux-Arts Prix de Rome designs. Specifically, the Roman bath form (based on the Baths of Caracalla) was derived from the Prix de Rome competition for 1900, won by Paul Bigot, which called for a thermal bath on a hillside.[100] The Greek details on the exterior, such as the key motif just under the cornice, were also of scholarly derivation, for Gilbert relied in part on a book published by Frank Bacon about the architecture at Assos.[101] The museum presented a simple front dominated by a Corinthian, hexastyle, unpedimented portico over which the Roman bath form predominated. This central feature was flanked by simple, low wings which enclosed the various galleries. These galleries were typical of Beaux-Arts planning in that their interlocking plans form strong principal, secondary, and even tertiary axes and cross-axes.

So great was the contrast between the art gallery and Festival Hall that Gilbert was motivated to screen the art gallery completely from the "vulgar gaze"[102] of the rest of the fairgrounds by the Festival Hall composition. The architect apparently felt so strongly about this that he threatened to sue the exposition company in order to receive the commission for Festival Hall.[103] Whereas Gilbert did not want the art museum to be a part of the overall composition of the fair, most critics thought that the positioning of the building was unfortunate, as did Montgomery Schuyler, who wrote that "it seems a pity . . . that it should have been hidden to make a local holiday."[104] This was the only criticism of the art building itself, of which the architectural press generally approved. Schuyler called it "substantial and dignified . . . of a classic severity."[105]

Like Shepley, Rutan, and Coolidge's Art Institute of Chicago building and similar to the Fine Arts Palace at Chicago and even the Albright Art Gallery, the exterior of the St. Louis Art Museum building had a pedagogical agenda. The sculpture planned and later executed for the building constituted an encyclopedia of artists and architects throughout history, from Phidias and Ictinus to Brunelleschi and Leonardo da Vinci, to Richard Morris Hunt and Augustus St. Gaudens.[106] The building was, therefore, not only indicative of what it contained and "looked like" a museum, but it was also an instructor of the history of art, a museum-within-a-museum.

Cass Gilbert was very conscious of making the museum a palace strictly for the fine arts. He strove not only to make it look like such a palace but also to plan it so that it should only accommodate the fine arts. In so doing, he opposed the museum's director, Halsey Ives, who had studied at the South Kensington and retained the mid-nineteenth-century interest in the decorative and industrial arts.[107] Although Ives fought Gilbert's conception of the museum's purpose, Gilbert won out eventually, largely on the argument of architectural appropriateness, a concern that guided almost all of Gilbert's contemporaries. In defense of his building, Gilbert was to write: "A white marble building is always a source of pride in a community, and it would be very fine to see it up there on the hill among the trees after the Exposition is over."[108] A beautiful temple dedicated to the arts yet memorial to the spectator event of the Exposition was what Gilbert wanted and so did enough of those in power that this was exactly what was achieved. As such, the St. Louis Art Museum was the culmination of the great period of exposition art-museum architecture at the turn of the century.

The Panama-Pacific Exposition, San Francisco, 1915

Although St. Louis most certainly represents the apex of exposition art gallery architecture, the St. Louis Art Museum was not the last permanent art palace to result from an exposition. The Fine Arts Palace of the Panama-Pacific Exposition, although

it resembled previous art palaces and seemed to carry on the same tradition, was no longer a part of that tradition, but a commentary on it. The last of the great Beaux-Arts exposition art galleries, it is the grand exit of that line yet already outside of it. Like its predecessors, it remains to this day as a memorial to the era of the great expositions.

The Panama-Pacific International Exposition was organized to celebrate the completion of the Panama Canal in 1914.[109] After 1906, it was also conceived as a way to promote San Francisco's recovery from the great earthquake and fire. The fair took place on undeveloped land on the San Francisco Bay, both in and near the Presidio. The layout of the fairgrounds was accomplished by the unique device of creating one enormous building to be subdivided negatively into courtyards with each courtyard to be developed independently by a different architect.[110] The architects of the three major courts were well known for their Beaux-Arts compositions: McKim, Mead, and White; Henry Bacon; and Louis Christian Mullgardt. The "Tower of Jewels," the fair's literal high point, was designed by Carrère and Hastings. The architectural leitmotif that was to harmonize the different buildings was that favorite Beaux-Arts device, the dome, so that the fair came to be called the "City of Domes."

The architect of the Fine Arts Palace for the exposition, Bernard Maybeck, was at once a traditional Beaux-Arts classicist and a highly individualistic stylist.[111] Technically, he was a member of the Beaux-Arts establishment inasmuch as he had studied at the French Ecole and worked for the Beaux-Arts firm of Carrère and Hastings in New York before settling in California. He was also, however, a true eccentric, as William Jordy describes him.[112] This is a particularly strange combination, for classicism and the Beaux-Arts approach do not generally allow for individualism beyond certain prescribed boundaries. This admixture accounts for the peculiarities of the Fine Arts Palace at the Panama-Pacific Exposition.

Once again, the building which was to house the art exhibit was to be of fireproof construction and, therefore, separate from the main structure and less temporary than all the other buildings. In a competition at the office of the fair's Architectural Commission, Maybeck came up with a design that so impressed all of the other architects that he was given the architectural plum of the fair. Maybeck's design called for a large domed rotunda as the focal point for a gently curving colonnade—or peristyle, as it was called—that both screened and mirrored the curved gallery itself. All elements, as at Chicago and Buffalo, were reflected in a lagoon. The rotunda was an open structure supported by six arches, each flanked by paired Corinthian columns. The whole composition was treated in the traditional Beaux-Arts fashion with a formal basin of water, landscaping, terraces, urns, and a great deal of statuary. This description of the superficial elements of the building, however, belies its utter strangeness and its departure from true Beaux-Arts classicism.

The Beaux-Arts approach is one of great seriousness of purpose and complete belief in its program, its monumentality, its symbolism of power and good taste, and its supremacy over history; its very timelessness is its essence. Maybeck turned this effect of timelessness on its head and produced instead a structure that bespoke sadness, decay, and (to appropriate Joyce, who would have appreciated the subversion of tradition) the ineluctable modality of existence. The architect himself said that the "keynote of a Fine Arts Palace should be that of sadness modified by the feeling that beauty has a soothing influence."[113] He aimed for just such a mood by recalling Roman ruins (via Piranesi's engravings) and slightly overgrown gardens. He achieved the effect by dissolving the hard edges of the composition with sculpture placed in untraditional locations, as at the corners of the sarcophagi blocks on the top of the colonnade, where female figures appear to mourn at the corners, their bent heads disappearing into the sarcophagi.[114]

Bernard Maybeck. Fine Arts Building, Panama-Pacific Exposition, San Francisco, 1915. Historic American Buildings Survey, Library of Congress.

He also intended that the "foliage should be high and romantic, avoiding all stiff lines," in order to intensify the effect of dissolution and decay.[115]

The building's effect on contemporary viewers was twofold. It was popular with fair-goers, but it was also evocative of sadness, just as Maybeck had intended. Thus, in the contemporary history of the fair, Frank Morton Todd's *The Story of the Exposition*, the building is described in these words:

> The theme itself we might attempt to state as the mortality of grandeur and to describe as having some affinity with our eternal sorrows over the vanity of human wishes. . . . A cloister enclosing nothing, a colonnade without a roof, stairs that ended nowhere, a fane with a lonely votary kneeling at a dying flame, fluted shafts that rose, half hid in vines, from the lush growth of an old swamp, . . . all these things were in the picture.[116]

This effect is a far cry from the serene yet celebratory buildings created to house art at previous expositions. Maybeck's Fine Arts Palace, however, was to become so beloved that it, like Atwood's Palace, was to be saved from demolition and rebuilt with permanent materials over fifty years later in 1967.

The Panama-Pacific Exposition was the last of the exuberantly optimistic, typically American fairs.[117] In the words of one historian, it was the "last collective outburst of this sort of naive optimism."[118] The architecture of the fair was also the last such "collective outburst." Although the San Francisco fair partook of the same Beaux-Arts classicism of the previous American fairs, as did even Maybeck's Fine Arts Palace, it was a last gasp for that kind of exposition architecture. Maybeck's structure served as a commentary on the fleeting nature of the fair, as well as on the architecture itself. It was also a harbinger of the demise of that particular style for expositions. Although there were to be other minor expositions after the Panama-Pacific, the next great fair to be held in the United States was the New York World's Fair of 1939, where the architecture was strictly "modern" and functional, committed to representing "truthfully" the structure and temporary nature of the buildings.[119]

The heyday of Beaux-Arts exposition architecture had lasted for forty years, and however temporary were the buildings themselves, their influence left a permanent mark both on city planning and on art museum architecture. In essence, every major exposition of the period left behind an art gallery as a memorial, whether intended or not. The similarities of these structures to each other meant that the influence upon museum architecture was large and widespread. They were all monumental, classical, yet restrained. They were all isolated buildings, placed in open, parklike spaces that nevertheless maintained a formal relationship with the pseudourban creation of the fairgrounds. They each partook of the spectacular nature of the exposition, bringing art to the masses. Finally, they were all greatly admired by the public and by other architects. These elements contributed to a self-perpetuating tradition within exposition architecture, as well as to the developing tradition of museum architecture in general. The next chapter will investigate the influence of these expositions on city planning, particularly the placement of the art museum within the urban fabric. The exposition not only changed the way Americans looked at art and architecture but also the way they saw the urban fabric itself.

3

The Museum as Urban Cultural Locator: Art Museums, Municipal Parks, and the City Beautiful Movement

> For, I take it, the great groundswell of human behavior heaving in a big city has music to it, and just as surely does the city's architecture express it. As men are, so they build—unconsciously, but inevitably.
>
> —Charles H. Caffin, "Municipal Art" (1900)

THERE WERE MANY CONDITIONS PRESENT IN LATE-NINETEENTH- AND EARLY-TWENTIETH-century American culture that helped determine what an art museum would look like. The influence of Beaux-Arts training, the search for an alternative to runaway eclecticism, and as previously discussed, the importance of expositions all led the search for style to rest in the classical mode. The temple or palace form for the museum became a cultural signifier for what took place inside the walls of the museum, namely, "art" and "culture." An equally important signifier for the position of the museum within American culture, however, was the physical location of the museum within the urban fabric. *Where* the museum was located was as important as what it *looked like*.

In some ways similar to a skyscraper, a museum requires a certain set of conditions in order to come into existence. Indeed, some of the conditions required to produce a museum are the same as those needed for skyscrapers. An urban milieu is essential, along with a well-developed financial base. There must be a dense concentration of people to provide the museum with supporters, visitors, and art. There must be an economy wealthy enough and well-established enough to have the surplus money and interest to invest large sums in the business of culture. If the museum requires an urban setting, its placement within the city takes on a great significance, for all real estate use within a city is significant.

Just as the course of the nineteenth century saw great changes in the idea of the appropriate style for a museum, so did it also witness the evolution of city planning and the placement of the museum within the urban fabric. The essence of this evolution, as it will be traced in this work, comprises a sea change in the general attitude about the relationship between art museums and municipal parklands. From the mid-nineteenth century to the turn of the twentieth century, many, if not most, art museums were

built on municipal parklands. Toward the end of the nineteenth century, a developing awareness of the necessity of comprehensive city planning developed and reached its peak in the early decades of the twentieth century. This new awareness determined that the placement of a museum should be part of a comprehensive city plan. Brought about by the City Beautiful movement, the change in the approach toward locating the art museum left a permanent mark on the look of many cities and determined where several important museums would be located and what their surroundings would look like. Although only one museum—the Philadelphia Museum of Art—was actually built in conjunction with a comprehensive city plan, comprehensive city planning that included the museum was held out as an ideal and often affected the way a museum's location was decided and its surroundings treated. The result in many cases left an indelible impression on the urban fabric.

Because many important museums were founded in an earlier era, however, they came to be located in city parks. This was the case because city planning in anything like the modern sense really did not exist in the United States in the early nineteenth century. Those in a position to decide relegated parklands for museum use because the existence of the city park was relatively new and the concept of proper use was only beginning to be developed. It was the municipal parks movement at which the first tentative attempts at comprehensive city planning were born. In order to investigate why so many museums found their homes in parks in the nineteenth century, one must first take a brief look at the parks movement itself, for it ends up having a strange and strained relationship with the museums that began to be built so abundantly within the confines of the parks the movement had created.

Frederick Law Olmsted and the Municipal Parks Movement

Nineteenth-century American landscape architecture was the precursor of the City Beautiful movement, and Frederick Law Olmsted was the father of both nineteenth-century landscape architecture and the urban parks movement.[1] As it happened, large museums were built in nearly all of Olmsted's most important parks. It is thus particularly instructive to examine first how Olmsted felt about the purpose of the park within the city, before examining the eventual uses to which his parks were put. Frederick Law Olmsted (1822–1903) was born during a pivotal period in the history of American urbanization.[2] At the time of his birth, there were only a handful of cities in the United States of any consequence—Boston, New York, and Philadelphia were among the prominent ones—and the population of the United States was still predominately rural. By the time he reached the peak of his career in the latter half of the nineteenth century, increasing industrialization, immigration, and centralization had produced many large cities with all the attendant problems of the large city: overcrowding, slums, poverty, disease, etc.[3] Olmsted, a romantic who shared Thomas Jefferson's idealization of the rural life of America, was particularly shaped by what he saw as the destruction of the rural way of life and the concurrent multiplication and expansion of the cities. Although Olmsted was a proponent of any open space within the urban enclave, he restricted the term *park* for use only to denote very large tracts of land set aside for the public enjoyment of rural landscapes.[4] Olmsted wrote: "I reserve the word park for places with breadth and space enough, and with all other needed qualities to justify the application to what you find in them of the word scenery."[5] This definition required that the municipal park be rural: an escape from the city and not so much an adjunct to it. Despite the fact that this rural quality was achieved with much artifice and manipulation

of the natural topography, Olmsted's parks were, as Alan Trachtenberg observes, a "therapy," a "city upon a hill within the city of destruction, a celestial place amid Vanity Fair."[6]

The park as physical "therapy" and as antidote to the urban milieu is precisely how Olmsted conceived of Central Park, for example. In his plan for the park, he wrote that he intended to make two classes of improvements:

> one directed to secure pure and wholesome air, to act through the lungs; the other to secure an antithesis of objects of vision to those of the streets and houses, which should act remedially by impressions on the mind and suggestions to the imagination.[7]

Both of these goals—fresh air and rural scenery—are the "antithesis" to urban reality, as it was perceived by Olmsted. Although it would be incorrect to argue that Olmsted was entirely anti-urban, it is fair to state that his conception of the park was as an antidote to urban problems. They were conceived as "breathing" spaces to counter the unhealthy crowding of the city. It is possible—though perhaps controversial—to argue that the parks themselves were anti-urban in their purpose and design.

The Olmsted park achieved its salubrious effect and its rural quality by a kind of denial of its existence within the urban fabric. In such parks as New York's Central Park or Brooklyn's Prospect Park, Olmsted, with his associate Calvert Vaux, created a world separate, even isolated from the urban surroundings. In contrast to the gridiron street pattern surrounding the parks and creating their boundaries, the paths and roads within the parks curved and meandered gently, creating an impression that there was no urgency in arriving at any destination. In contrast to the stone and brick buildings within the gridiron of the city, much of the incidental architecture of the parks was wooden and rustic. Olmsted's parks created views, scenery full of pastoral effects with idyllic lakes, gently rolling fields, and bosky woods. In the midst of the most expensive real estate in the country, Olmsted's parks created illusions of spaciousness through a luxurious, rural use of space. In New York's Central Park, Olmsted used the ingenious device of burying the cross streets used by city traffic so even that concession to urban requirements would be hidden. Even the formal and axial promenade or mall is placed nonaxially and unsymmetrically within the romantic irregularities of the rest of Central Park.

Central and Prospect Parks in New York represent Olmsted's earlier essays in urban landscape design. They were large, isolated parks set in the heart of the city. Olmsted's later ideas developed the concept of a citywide parks system, consisting of both large and small parks connected by a parkway system. The most outstanding example of a citywide park plan and the one of which Olmsted was most proud was Boston's "Emerald Necklace." Although its linking of various parks and its creation of parkways comprised a more substantial recognition of the needs of the city, the individual elements of the Boston system were planned in the same mode as his earlier designs. Parks like the Back Bay Fens recreated a naturalistic feeling via meandering paths, native plants, and picturesque bodies of water.

Olmsted's park designs were to be enormously influential, spawning an entire generation of naturalistic park designs, such as those of landscape architects H. W. S. Cleveland and Charles Eliot and other parks in other cities across the country, many of them not as sensitively and ingeniously designed but Olmsted-inspired in any case. It was Olmsted's approach to the city that spawned the first forays into planning the entire urban environment, as well. Although his parks were highly influential, his creation of the parkway and conception of the city as a unit which could and ought to be comprehensively

planned were even more influential to future generations of city planners. This is how he served as the father of the City Beautiful movement, which would eventually take a far more formal approach to open spaces within the urban milieu.

Central Park and the Metropolitan Museum of Art, New York

In the mid-nineteenth century, New York was the largest and fastest growing city in the country. Nowhere could a better case be made for a city in need of recreational open spaces, and by the 1850s, this fact was apparent to even the most rabid urbanite. In 1853, an act was passed authorizing the acquisition of land for a "Central Park," and a competition for its design was thrown open in October of 1857. The result of that competition was Olmsted's first, most famous, most influential, and arguably most important park design: the "Greensward" plan. In collaboration with Calvert Vaux, Olmsted proposed a comprehensive plan for the enormous, wooded tract of land that took advantage of natural features in order to create a predominantly rural character for the park. As noted above, Olmsted wished to procure a place within the city that would provide healthy air and rural scenery for city dwellers who could not travel to the Adirondacks, for example, where wealthy urbanites went for escape. He felt that the preservation of a rural character was particularly important because he prophesied—with uncanny accuracy—that the city would continue to grow until some day "the whole island of New York would, but for such a reservation, before many years be occupied by buildings and paved streets; [and] millions upon millions of men were to live their lives upon this island."[8]

Despite the emphasis on the park's rustic qualities, however, some buildings were planned to intrude upon the park's precincts from the beginning. Aside from picturesque gazebos, refreshment stands, and the like, the Olmsted and Vaux plan for the

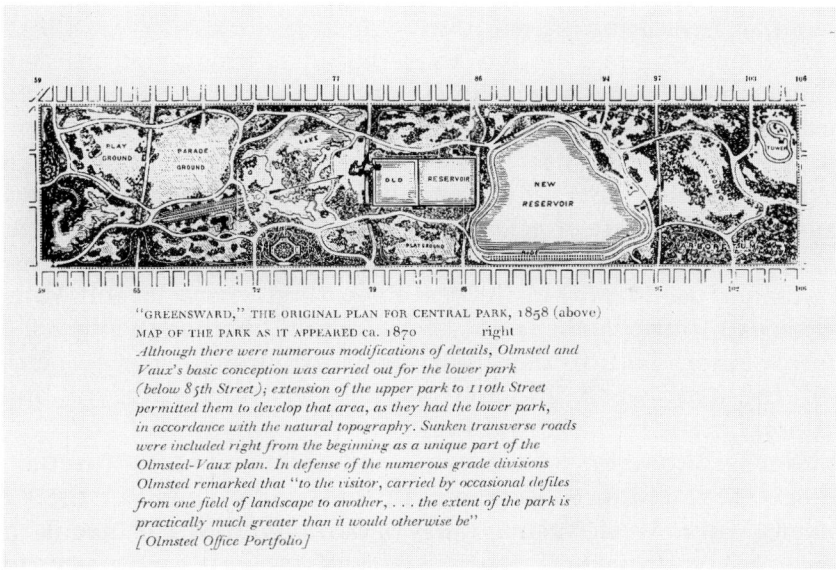

"GREENSWARD," THE ORIGINAL PLAN FOR CENTRAL PARK, 1858 (above)
MAP OF THE PARK AS IT APPEARED ca. 1870 right
Although there were numerous modifications of details, Olmsted and Vaux's basic conception was carried out for the lower park (below 85th Street); extension of the upper park to 110th Street permitted them to develop that area, as they had the lower park, in accordance with the natural topography. Sunken transverse roads were included right from the beginning as a unique part of the Olmsted-Vaux plan. In defense of the numerous grade divisions Olmsted remarked that "to the visitor, carried by occasional defiles from one field of landscape to another, . . . the extent of the park is practically much greater than it would otherwise be"
[Olmsted Office Portfolio]

Frederick Law Olmsted and Calvert Vaux. "Greensward" plan for Central Park, New York, 1858. National Park Service, Frederick Law Olmsted National Historical Site.

park included the designation of the old arsenal building in the park as a museum. A music hall combined with a conservatory was also planned to be located near Fifth Avenue. In 1859, just a year after the "Greensward" plan was adopted, a law was passed that provided for gifts and bequests for museums, galleries, and the like to be under the jurisdiction of the park board. This act paved the way for the establishment of the Metropolitan Museum of Art in Central Park, and by 1871, the museum had received its charter; both five hundred thousand dollars and the land had been granted to the museum in the bill of appropriations for the Public Parks.[9] State legislative authority had been given to the city to erect the building, but the original plan was that a building should be erected that would house both the Museum of Natural History and the art museum. The site was to be Manhattan Square, the present location of the Museum of Natural History, outside the boundaries of the park. The trustees of the Metropolitan Museum managed to persuade the Central Park Commissioners, however, that the two museums needed two separate buildings, and they asked for another park location to be granted them.[10] Thus, in 1872, the commissioners dedicated the present location occupied by the Metropolitan Museum for the erection of the new building.

Olmsted and Vaux explained in 1865 that they were not necessarily in favor of erecting large buildings in a park but that the designation of the arsenal building as a museum was made as a matter of convenience: because it was already there and would "probably, if retained, be found to be of sufficient value to be converted into the nucleus of a museum." They cautioned, however, "this illustration is presented with no purpose of favoring the introduction of large structures of this character within the limits of a public park."[11] At the time that the museums of natural history and art were seeking a location for their new home, the park's commissioners debated thoughtfully about land usage within the park. They observed that the

> architectural development is thus far mainly of a character that is required for the immediate comfort and pleasure of the visitor to the Park itself, and little of it can be styled grand or magnificent, the aim being to secure, wherever possible, quiet, unobtrusive effects that will harmonize with the character of the scenery.

This is certainly what Olmsted and Vaux intended for the incidental buildings of the park. The commissioners also discussed the wisdom of building the "more extensive architectural structures necessary for museums of natural history and of art" and decided that in order for New York to maintain a "proper relation with the great movement of the age in the interest of science and art," such buildings must be allowed—however cautiously—within the precincts of the park.[12] At the time of the establishment of the Metropolitan Museum within Central Park, then, Olmsted and Vaux had given an equivocal approval to the existence of such buildings within their park design, and the park's commissioners had decided that such institutions had a place there. In response to this decision, of course, the Metropolitan Museum of Art was, indeed, established inside the boundaries of Central Park.

As discussed earlier, however, one caveat for the Metropolitan Museum of Art was that the building's design was to be placed in the hands of one of the Central Park designers, Calvert Vaux. What resulted was a building with the needs of any large public institution but with a look akin to some of the other rustic, incidental park architecture. Communicating through his design, Vaux made it clear that any building that was to intrude upon the park's scenery must not interrupt its bucolic effects. The museum's relationship to its surroundings changed drastically, however, when Richard Morris Hunt designed the Fifth Avenue facade for the museum. How this later portion

of the museum responded to City Beautiful ideals will be examined in proper order in the following pages.

Prospect Park and the Brooklyn Institute of Arts and Sciences, New York

Before the onset of the City Beautiful movement, Frederick Law Olmsted would design and see to completion numerous municipal parks. In a pattern that mimicked the sequence of events that took place in New York City, other museums would find their way into several of Olmsted's most important parks. Perhaps because of his experience with Central Park, Olmsted approached the issue of a museum to be built on the grounds of Prospect Park in Brooklyn with a keener sense of the invasion it might become and made better provisions for such an occurrence. Olmsted and Vaux began designing Prospect Park in 1865 and submitted their proposal to the Brooklyn commissioners in 1866.[13] In their proposal, they suggested that a wholly separate parcel of land be designated expressly for the purpose of erecting educational institutions. This parcel of land was already held by the park commissioners but was separated from the

Frederick Law Olmsted and Calvert Vaux. Plan for Prospect Park, Brooklyn, New York, 1866. National Park Service, Frederick Law Olmsted National Historical Site.

greater body of Prospect Park by Flatbush Avenue, a thoroughfare too important to be eliminated or rerouted and too large to bury, as had been done at Central Park. This circumstance made the amputated portion of land undesirable as parkland in the eyes of the landscape architects, because it could not present an illusion of rural peacefulness.[14] By suggesting that the commissioners retain this portion for buildings like museums, Olmsted and Vaux accomplished a two-part goal. First, the principal part of the park would not be encroached upon by such buildings. Second, they provided a space for educational institutions. As they wrote in their proposal, they believed in such institutions—they just did not want them in their parks:

> We have before shown the impropriety, as a general rule, of placing edifices, which are not strictly auxiliary to the primary purpose of a park, within its boundaries, and this illustration is, of course, presented with no purpose of favoring their introduction but rather to show that they ought in some other way to be provided for in season.[15]

Therefore, in the particular case of Prospect Park, the landscape designers can have had no objection when a museum was built on the open space provided for just such a contingency.

Although Olmsted and Vaux must have been pleased that the Brooklyn Institute of Arts and Sciences would not be built within the main precincts of their park, the builders of the museum were equally pleased to be within a parklike location as they perceived it. In 1889, the proper official steps were taken to secure the more than forty acres that would provide a home for the Brooklyn Institute as well as the Brooklyn Botanical Gardens. It seemed particularly appropriate to most of the participants that the museum's site should be on the summit of a "stately hill." As one of the park commissioners noted, "No better place could be selected than the one chosen, here, with its magnificent view, and time will justify the selection."[16] The museum's *Year Book* concurred, stating that the location "is the most desirable site for a large public building in the city of Brooklyn. A large building located upon the site will be one of the most commanding structures in the State."[17] Not only did many observers feel that the museum's location in a parklike setting atop a hill was appropriately attractive and commanding, but those involved in the establishment of the museum also felt that it was appropriate that the land on which the museum would be built should be publicly held. If the museum were built on public land, they reasoned, it would "therefore belong the more to the people. The citizens of Brooklyn—men, women, and children alike—will feel that these museums are theirs by right, and that they are in duty bound to cherish them."[18] The notion that a museum ought to be on public land—whether or not the museum itself was publicly owned and operated—informed the choice of location of other art museums, as well.

Delaware Park and the Albright Art Gallery, Buffalo

The Albright Art Gallery in Buffalo's Delaware Park was just such a case. Olmsted and Vaux began the designing of Buffalo's park system in 1868, shortly after they had submitted their designs for Prospect Park.[19] The heart of their design was the 350-acre Delaware Park, which employed a number of devices similar to those in Central and Prospect Parks. There were sunken transverse roads, a picturesque lake, open meadows, meandering paths, and wooded areas. An important part of the landscape architects' plan was the creation of smaller parks all linked to each other and to Delaware Park via broad, shaded parkways. The term *parkway* had been coined by Olmsted and Vaux

Frederick Law Olmsted and Calvert Vaux. Plan for Delaware Park, Buffalo, 1868. National Park Service, Frederick Law Olmsted National Historical Site.

for their plans for Brooklyn, but the parkways in Buffalo were the first of their parkways to be built. The concept of the parkway was to ensure that everyone in the city would be within a reasonable distance of some portion of the whole park system and that getting to the actual parks "would thus be more park-like than town-like."[20] It should be noted that Olmsted's conception of the parkway as "more park-like than town-like" was very different from the parkway or boulevard idea adapted by the City Beautiful planners and proponents of the next generation. Although Olmsted's plans incorporated a whole-city view, the purpose of his parks and parkway systems remained as the escape from the city or providing an antidote to the city. In an essential way, the Olmsted park system denied the life of the city.

It is almost a certainty that Olmsted would have deplored the erection of the Albright Art Gallery in the heart of Delaware Park, overlooking the shore of the picturesque lake he had created by the damming of Scajaquada Creek. By 1900, however, Olmsted's health was on the decline, and he could not have protested. In any case, the gallery's patron, John J. Albright, felt that the location was not only ideal but necessary and an appropriate response for the city to match his own generous offer. In the letter in which Albright communicated his gift to the Buffalo Fine Arts Academy, he stipulated that his gift came with only two conditions. One required that the academy should maintain the building he donated. The other condition was that

> consent be obtained to locate the building in the park . . . Such a building should be of white marble and therefore, should be remote from other buildings for all time and so removed from all risk of injury because of the proximity of manufacturing plants, apartment houses or any other use of adjacent property as might tend to impair the effect of the structure. I do not know how this condition can be met in our growing city unless the site be within the public park. I am advised that such a use can be properly sanctioned by the authorities.[21]

That his building would be classical appears to be taken for granted. That such a building requires open spaces, free of other architectural intruders, was, for Albright and many of his contemporaries, a *sine qua non*. His reasoning further appeared to be that his request was logical in view of his own generosity to the citizens of Buffalo and that there was no reason the building should not be located in the park.

The local newspapers agreed that the site specified by Albright was "admirable" for many reasons. One article cited fire safety, freedom "from the many menaces and dangers of downtown locations," and the accessibility and popularity of the park itself: "The park is the mecca of the masses, the paradise of the people. The Albright Gallery will make it all the brighter."[22] In response to both the gift and the choice of location, the Mayor of Buffalo enthused: "It is magnificent. . . . The City certainly will do whatever is needed, promptly and joyfully. All that will be asked, through the plans as developed, will be a small, small token of the City's appreciation of the liberality of Mr. Albright."[23] Apparently, it occurred to no one that the building would itself be an intrusion upon the rural scenery of the park. To the contrary, all observers seemed to find that the finished museum was an ornament to the park—or even, conversely, that the park was an ornament to the museum. At the gallery's dedication, one reporter wrote that "Nature [was] at her loveliest to do honor to the occasion."[24] Another article waxed poetic, claiming:

> There is a noble harmony in the Art Gallery and its environment that would have delighted our Yankee Plato, Emerson, who says that 'the pleasure that a noble temple gives us is only in part owing to the temple. It is exalted by the beauty of sunlight, the play of the clouds, the landscape around it.' . . . And so our beautiful Gallery is exalted by its ideal setting.[25]

Whatever the park's designers may have felt about large buildings in their park in 1868, by 1900 the public felt that the park site for the art gallery was both beautiful and appropriate.

The Back Bay Fens and the Museum of Fine Arts, Boston

Many of the same arguments that were employed in New York, Brooklyn, and Buffalo were also employed in determining the site for another museum that was built adjacent to an Olmsted park: the Museum of Fine Arts, Boston, on the Back Bay Fens. The Back Bay Fens were a small part of the overall plan for the Boston municipal park system, which Olmsted was hired to design in 1878.[26] He considered the entire Boston park system to be the most important project of his career, because it embodied his thinking about the creation of a "green necklace," or citywide parks system, connected by a series of parkways that would provide all city dwellers easy access to the delights of nature. Using Olmsted's own definition, Franklin Park was the only park that met his definition of a true park, one which was large enough to provide rural scenery. The Boston system included in its extent a number of smaller parks (in the generic sense), among which were the Back Bay Fens. The Fens were salt marsh, a swampy portion of

Frederick Law Olmsted. Plan for Back Bay Fens, Boston, 1879. National Park Service, Frederick Law Olmsted National Historical Site.

the man-made Back Bay area that resisted real estate development and had actually become a noisome health hazard. Olmsted devised a remarkable plan that would at once be a sanitary improvement, a recreation of the salt marsh, and an attractive park. The resultant design incorporated typical Olmsted features. There were two curving parkways bordering either edge of the park, the major one on the eastern border becoming the Fenway; there were trees lining the roads; and there were footpaths and bridlepaths to accommodate various kinds of traffic. The recreation of the salt marsh was an unusual extension of Olmsted's belief in natural scenery but necessary for the sanitary improvements he had planned. The plan was obviated by 1910 when changes in Boston's flood-control system diverted fresh water into the Fens. A number of improvements were then suggested, among which were those proposed in conjunction with the Museum of Fine Arts in 1912.

In the case of the Boston museum and the Fens, the park itself remained inviolate. The 1899 decision to locate the new building next to the Back Bay Fens was, however, consciously made because of the park and what proximity to the park meant to the museum building. The museum's original setting in Copley Square was seen as undesirable because of the proximity of other buildings, particularly tall ones which blocked the museum's light and created a fire hazard. Building near the newly developed park allowed the museum to purchase acreage generous enough to allow for future expansion. As one approving newspaper noted, "There is no danger of any structure ever being erected near it."[27] The building codes established for park frontages also meant that the museum would never be surrounded by commercial buildings or even by residences of less than a certain value.[28]

Perhaps because of the proximity to the Olmsted park, the museum seemed to fancy itself an extension of the park—something of a park in and of itself. The special number of the museum's *Bulletin* that was published on the occasion of the opening of the new building claimed that the grounds of the museum were "conceived as a park to be made available and beautiful as the means can be set apart or may be contributed . . . the charms of a garden will be the prelude and may be interludes of every Museum visit."[29]

When the Evans wing was built 1912–15, the museum seemed to participate even more in the park. As several observers noticed, architect Guy Lowell's plans responded to the vista of the park by taking on a more imposing appearance than the front entrance—a departure thought wholly appropriate for the location on the park. One newspaper stated that the grandeur of the Evans wing was "demanded by the situation and surroundings."[30] The architect's drawings, as published in various Boston newspapers, showed the Evans facade reflected in a formal water basin that actually would have been located across the Fenway in the park. These drawings responded to a plan devised by landscape architect Arthur A. Shurtleff and proposed in 1912 by the Boston Park Commissioners to improve the Fenway approach to the museum. Shurtleff's plan extended Jersey Street to the Fenway to create a semicircular drive in front of the Evans wing. The curving Fenway would also have had to have been straightened in order to create a symmetrical plan. The space thereby created would then have been filled with a reflecting basin. At the height of the interest in the City Beautiful, this plan was received with enthusiasm for the grand effects it would create. The *Globe* wrote that "a very stately foreground will be provided for the new building,"[31] and the *Evening Transcript* prophesied that "if carried out [it] will be one of the most impressive combinations of architectural and landscape harmony to be found anywhere."[32]

Although it appears that park officials and the public alike were pleased with such a plan, there can be little doubt that Olmsted would have disapproved of a plan that invaded the park with formal drives for the sake of a building that was actually outside the park. The straightening of the Fenway was also contrary to the Olmsted preference

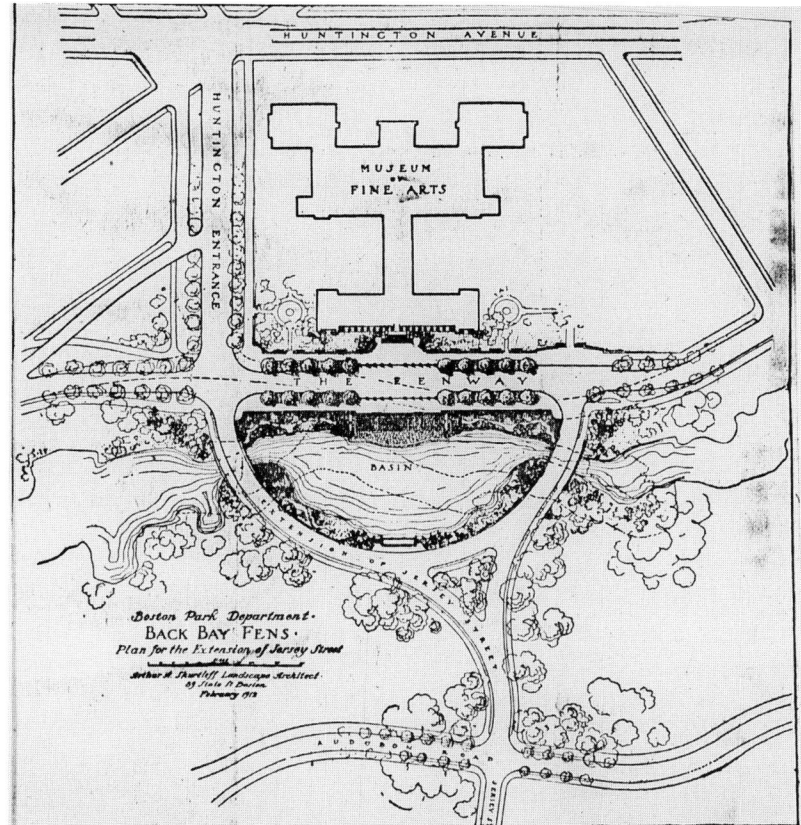

*Arthur Shurtleff. Plan for improvement of the Fenway
at the Museum of Fine Arts, Boston, 1912.* Boston
Transcript, *17 October 1913. Courtesy, Museum of
Fine Arts, Boston.*

for gently curving, irregular drives, and the subsuming of the importance of the park
to the building would doubtless have been in opposition to Olmsted's declared purpose
for parks: the enjoyment of nature, and the "recreat[ion] of the mind from urban
oppressions."[33]

In fact, we know precisely how Olmsted felt about such buildings as museums finding
their way into his parks. Although the original plan for his first park, Central Park,
included the designation of the old arsenal as a museum building, he soon after cau-
tioned that that particular example should not be construed as "favoring the introduc-
tion of large structures of this character within the limits of a public park."[34] In 1872,
Olmsted and Vaux formulated their particular guidelines for including a structure
within a park. Their opinion was that any building that could be otherwise accommo-
dated should not be erected in the park; conversely, only those buildings that materially
contributed to the enjoyment of the park should be included.[35] Structures they thought
did belong included bridges, shelters, seats, and refectories, all preferably of a rustic
design. Olmsted's mature opinion on larger, more formal, City Beautiful-style structures
within park precincts is well summed up in the following exchange:

> "Are not fine buildings, statues, monuments, great additions to a park?"
> "Nay, they are deductions from it."
> "Do they not add greatly to the value of the . . . Park?"

"Nay, they take much from its value as a park. They would be worth more to the city if they were elsewhere."[36]

It is clear that the founder of the municipal park movement would have been greatly displeased with the placement of large, classical museum buildings within his parks. Yet this very occurrence happened consistently; Olmsted's parks were not, however, singled out exclusively for this kind of intrusion.

Municipal Parks and Art Museums

There were a number of other museums that came to be located in municipal parklands. Cincinnati's art museum was an early example. The city of Cincinnati gave to the art museum there "a very commanding site of twenty acres in Eden Park, the surface of the ground being 350 feet above the level of the Ohio River," where construction of the museum began in 1882.[37] The desirability of a hilltop location was to be affirmed by the Brooklyn Institute a decade later. Similarly, the Carnegie Institute was located on nineteen "picturesque"[38] acres at the main entrance to the recently established Schenley Park. Schenley Park was conceived in the vein of an Olmsted park by the public works director Edward Bigelow and carried out by British landscape architect William Falconer, who gave Schenley Park the same curved paths and scenic vistas of an Olmsted park.[39] Although the Institute was not actually located on a significant rise, one observer wrote about it as if it were: "The great structure rises over the Oakland plain, and seems to be the incarnation of all that is best and noblest in our life here below."[40]

The St. Louis art museum also came to be located in a park, albeit in conjunction with the Louisiana Purchase Exposition of 1904 being held in the same location. The land in Forest Park on which the museum was built became so identified with the art museum that it soon came to be known as "Art Hill." The art department's circular notes that near the museum building, "many large forest trees have been left standing, which will add much to the beauty of the general effect."[41] It was thus contrived that the land surrounding the museum should appear as rural and parklike as possible, despite the use of the grounds for the Louisiana Purchase Exposition. After the exposition, the temporary buildings were removed, and the museum remained in isolation at the top of the hill.

As one final example, the Cleveland Museum of Art also came to be built within the precincts of a municipal park. The location selected for the museum in 1908 was in Wade Park on a hill overlooking a lake.[42] This site was proclaimed as "a magnificent setting" by one critic,[43] and its relation to the park and lake is reminiscent of the situation of the Albright Art Gallery in Buffalo.

The examples just enumerated by no means comprise an exhaustive list of museums built in municipal parks during the late-nineteenth and early-twentieth centuries. Nearly all museums built during this period were built in or near some kind of urban park, large or small.[44] The question is: why? That a large, classically-styled museum building would be an encroachment on the naturalistic scenery of a park must have been obvious to all, yet there were no public outcries when it was suggested that a museum should be built in a city park. To the contrary, by all measures, the public was delighted with the "temples of art" that cropped up in parks across the country. There were a number of reasons why this sequence of events repeated itself almost often enough to become a rule. First, there was the factor of convenience. Museums needed space and safety, and many argued that they needed to be free from tall neighbors to

reduce the risk of fire. They also needed light. In an age when artificial lighting for museums was still in an early developmental stage, most museums were skylighted for the provision of light for their exhibits. A park was an obvious place to find open spaces. It was also easy for city officials to give such land away, so the museum could cheaply find a home. Not inconsequentially, the patrons and trustees of most museums were well connected with city officials (when they were not one and the same). It was easy, too, for a museum to argue that it was providing a tangible public benefit and that, in exchange for the cultural benefits it would provide, the donation of space by the city would be a small sacrifice to make.

A park location was not only a matter of convenience; the architectural aesthetics of the time demanded it. A spreading, two-story, white marble, classical building must be set in an open space in order to look properly dignified. Many museums were termed "temples," and the obvious connection to be made was with actual temples, which were set in the Greek countryside; or, in the case of the consummate templar example, the Parthenon, set on a hill overlooking the surrounding city. Linked to both aesthetics and conceptions of culture and the city, another reason the museum seemed appropriately located in a park was that it could be removed—physically and spiritually—from the commercial center of the city. To give one example, a description of the Art Institute of Chicago called it a "structure of pure classic outline that stands on the lake front, apart from the sordid commercial sky-scrapers."[45] As another example, Ernest Flagg argued against large windows being introduced on the ground level of his Corcoran Art Gallery. "I fear," he wrote, "it will give it the air of a shop front and greatly reduce the monumental character of the building."[46] Finally, the small art museum in Montclair, New Jersey, was also located in a small park, and when the museum's patron purchased some adjacent land for the museum, a canny observer pointed out that this would "isolate the Museum from possible future objectionable development. Such seclusion is conducive to the purpose of fostering the specific sense of institutional value."[47] For the late nineteenth century, the museum and the commercial district could not exist peaceably side by side, for they were of two separate and conflicting worlds. The park provided a place away from the business center of the city for the museum to accomplish its own cultural business.

The trustees of the Metropolitan Museum of Art in New York, as yet another example, found their institution to be wonderfully appropriate in its park location. They thought of their museum as "an addition to the attractions of that popular and delightful place of resort [Central Park]."[48] In 1880, James Wenman, President of the Department of Parks and a trustee of the museum, would admire the beneficial location of the museum "within this beautiful Park, removed from the noise and shadows of this great city, the commercial center of the Western Hemisphere, and within easy access of the great mass of its population."[49] Both park and museum officials concurred, therefore, that although the museum ought to be within reach of the city, it should not be *in* the city or *of* the city but removed from it, in the park. Why? Because a museum would not be appropriately located if it were in the commercial heart of the city; it should, rather, contrast with it. On the occasion of the opening of the north wing of the Metropolitan Museum in 1894, one speaker delineated the contrast between the city and the museum, calling the city's skyscrapers "temples of Mammon," but the museum, in its "inspiring" surroundings of the park, an "oasis."[50] This contrast, often explicitly stated, was what fueled the belief of many museum builders—donors, architects, museum management, and even city officials—that the museum building ought to be placed at a remove from the commercial part of the city. That this contrast should be framed within strong moral terms is also an important factor in the erection and

placement of museum buildings, as shall be further examined in the following pages. As for the need to place the museum in such an appropriately separate spot, where better—and easier—was there to be found a relatively isolated and spacious location for a museum building than in the park?

The placement of art museums within municipal parks was an obvious, even simplistic, solution to the needs of the museum and the self-imposed difficulties of placing a classical building in an urban setting. Although this approach to land use represented a great departure from the Olmstedian construct for park usage, it was neither the best solution nor the final one for cities ambitious to have their classical temple of art and their park, too. The approach to city planning—or lack of it—that allowed museums to encroach upon municipal parkland was to be overtaken by a more comprehensive approach to both the urban fabric and the museum's place within that fabric. The newer ideals that began to affect city planning and art museums appeared around the time of the World's Columbian Exposition and later became known as the City Beautiful movement.

The City Beautiful Movement

Much has been written about the City Beautiful movement and its true origins.[51] For the purposes of this paper, it is unimportant whether or not the World's Columbian Exposition was actually the origin of the City Beautiful movement. What matters is that those involved in the movement afterward, including its most important practitioners and proponents, believed the Chicago fair to be the starting point and first exemplar of the City Beautiful. Writing in 1905, Charles Zueblin, one of the most prominent City Beautiful advocates and critics, claimed authoritatively that the White City "furnished the spectacular example of the construction of a great temporary city on a single scale in accordance with a comprehensive plan."[52] He pointed directly to the Columbian Exposition as "the standard for the aesthetic and material reconstruction of Washington, Boston, and Harrisburg, as it will be of cities generally when the newer citizenship has learned the art of city making."[53] Certainly, the Court of Honor first exhibited in tangible form what such a city could look like. Most importantly, it gave Daniel Burnham, the City Beautiful's father and most important and influential practitioner, his seminal and guiding experience in city planning. He firmly believed that the White City was the germ of the city planning movement and that the idea, implanted in the minds of the country's citizens, caused them to agitate for comprehensive city plans everywhere. He directly attributed the first great accomplishment of the city planning movement, the McMillan plan for Washington, D.C., to the Chicago fair.[54] All of Burnham's subsequent plans, as well as the plans composed by his followers, would contain elements of the White City.

Chicago's White City set the standard for City Beautiful-style city planning. The important elements were the grouping of buildings, planned to be harmonious in style; the formal, classical architecture; the formality of the composition and the setting, including such incidental structures as balustrades, lampposts, etc.; the collaboration of different experts—landscape architect, engineer, architect, sculptor, and painter; the carefully planned transportation routes, including not only pedestrian and vehicular thoroughfares, but the railroad station and seagates; and the unification and celebration of all elements of the urban fabric. Although the White City was a uniquely American product, its primary inspiration was European, most especially Parisian. The White City and the City Beautiful movement took their cues both from Beaux-Arts precepts

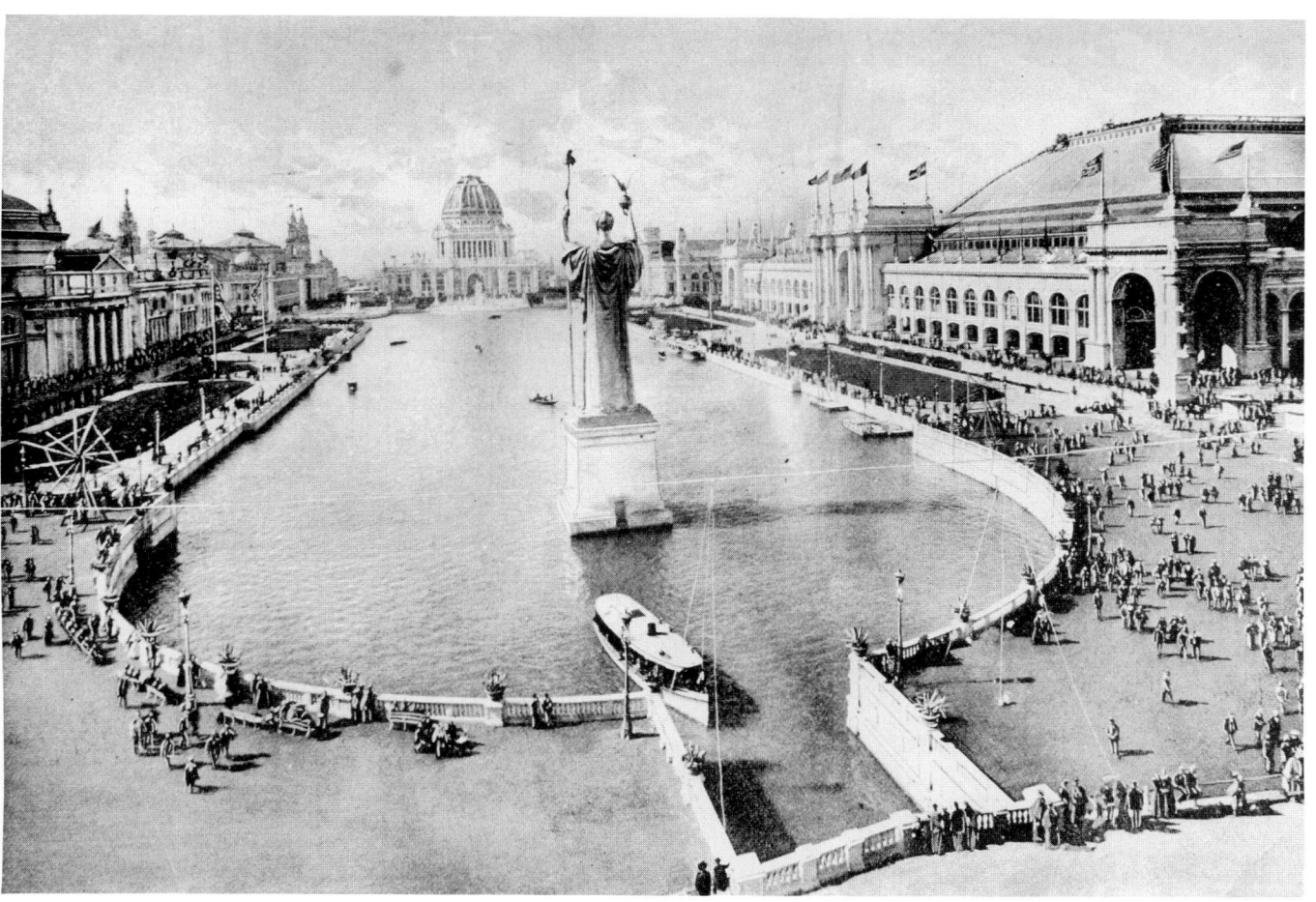

Court of Honor, World's Columbian Exposition, Chicago, 1893. Columbian Album, 1893. Collection of the author.

writ large and directly from Baron Haussmann's Paris, the Paris of wide boulevards and formal building codes, monumental public buildings like Garnier's Opéra, and sculpture-adorned public squares and grand boulevards like the Place de L'Etoile or the Champs-Elysées.

The City Beautiful movement was to have a great effect on a number of cities, as well as on several important art museums. The movement, which demanded a more comprehensive approach to city planning, forced a reexamination of the practice of dropping an art museum into a city park. Instead, the City Beautiful required that an art museum, like all large, important public buildings, be incorporated into civic life and woven into the fabric of the city. This attitude spells out a much more celebratory approach to the city, one that provides a special place within the city for the museum, rather than a place apart where it stands beautiful but isolated. The City Beautiful would make the museum of the city, rather than merely in it. This would be accomplished by including the museum in areas like civic centers, the cultural, political, and economic heart of the city and creating boulevards that would lead to the museum and celebrate the visitor's approach. Often, these improvements were created ex post facto, indicating interest in participation in the City Beautiful even when a comprehensive

city plan was not possible. Such involvement would include surrounding the museum not with trees and rolling expanses of grass but with esplanades, terraces, plazas, fountains, balustrades, and sculpture.

In 1911, at the height of the City Beautiful movement, a debate on the use of municipal parkland was held at the third annual National Conference on City Planning. This debate, spearheaded by Frank Miles Day's speech, "The Location of Public Buildings in Parks and Other Open Spaces," shows clearly the changed attitude toward museums and their locations. Day and other speakers all agreed that great caution should be exerted when considering erecting a public building within a park. Their attitude was in some respects not greatly different from Frederick Law Olmsted's mid-nineteenth-century attitude: in chastising Buffalo for having "deprived Delaware Park of a large part of the charm it once possessed by the simple process of erecting a beautiful building in it," Day harks back to the Olmstedian view of the unassailability of the park.[55] He also suggests an alternative to the Olmsted park and the jarring effect a classical building has on it:

> It would be unreasonable to set up as our ideal for all parks under all circumstances the natural type. . . . A formal treatment of many a park area, though in this country we are rather prone to sniff at it, would give us a finer, a more reasonable, and a less expensive solution than would an attempt to coax unwilling nature into an imitation of herself. . . . I mention the formal type because no such dissonance between it and its related buildings is felt as is necessarily felt in the naturalistic type.[56]

Day posits an alternative to the Olmstedian rural park: a formal open space that could be both park and home to monumental public buildings. Another debater made a suggestion along similar lines that proposed encircling large parks with such monumental buildings, thereby providing "a transition between the wildness and freedom of the park to the fixed formal lines of the adjoining streets."[57] Both suggestions adhere to City Beautiful tenets by employing comprehensive city planning ideals and by encouraging the location of monumental public buildings within carefully planned formal spaces.

The Mall and the Corcoran and Freer Galleries of Art, Washington, D.C.

The country's original City Beautiful plan made possible just such an arrangement for museums. Major Pierre Charles L'Enfant's 1792 plan for Washington was based on the highly formal axial arrangements of the gardens of Versailles. His father had been a painter there, and he had grown up with its long vistas, sunburst designs, and formal landscaping.[58] L'Enfant's plan for Washington incorporated all of these elements, and the centerpiece was the Mall. It was an urban space unlike any in the country: a large, highly formal, open space about which the monumental government buildings were to be arranged. Although the process took many generations, the capital city's government and memorial buildings were built around the green centerpiece. Chief among them were the Capitol Building, the President's House, and the Washington Monument. These buildings, although not designed by L'Enfant, were executed in the spirit of his designs for the Mall, and they gave the surrounding areas a special cachet.

Thus it was that in 1891, when Washington's first art gallery, the Corcoran, needed to build a new home, the trustees chose a site only a few blocks away from the original building, but fronting on the portion of the Mall directly behind the Executive Mansion. There can be no doubt that the site offered the dual attraction of an open green space and the associational grandeur of the other monumental buildings—of which

the Corcoran was to be a conspicuous example in white marble. The desirability of the location and the appropriateness of the new gallery for that location were pointed out by the president of the board of trustees of the gallery, Dr. James C. Welling, at the cornerstone-laying ceremony:

> We rejoice to have obtained [a site] so eligible, because of its close adjacence to the spot originally selected by Mr. Corcoran, and because it is in still more sensible touch with all that is most typical of this national capital. In the very shadow of yonder marble shaft . . . ; full in sight of the Executive Mansion; . . . with the domes of the Capitol and of the National Library in front of us . . . we shall here erect a palace.[59]

A century after the implementation of L'Enfant's plan, the Mall had become a valued site for the kind of classical architecture that had once again come to the stylistic forefront.

The Mall had suffered many indignities over the course of its first century, however. As the nineteenth century progressed, many incursions were made upon the precincts of a Mall, which for some time looked unnecessarily large for the city. A railroad station and tracks ran right through one end of it; and shacks and warehouses had been built indiscriminately on various areas of it. Perhaps strangest of all, in 1851, Andrew Jackson Downing had imposed a romantic landscape design upon the whole with parts of it actually implemented. Another notable incursion on the Mall was the original Smithsonian building, designed by James Renwick in a picturesque Romanesque-Gothic style.

Around 1900, with the impetus of the Chicago fair's example, interest grew in having the Mall improved and restored to the original intentions of its designer. To this end, a Senate committee chaired by Senator McMillan appointed the Senate Park Commission consisting of Daniel Burnham, Charles McKim, and Frederick Law Olmsted, Jr. All three had been intimately involved in the World's Columbian Exposition, Olmsted working under his father. They supplemented that experience by traveling to Europe and visiting the great cities there: Rome, Venice, Paris, Frankfurt. On their return, they worked on a comprehensive plan for the city of Washington that concentrated on restoring L'Enfant's scheme to its intended grandeur. The resulting proposal, the 1902 *Report of the Senate Committee . . . on the Improvement of the Park System of the District of Columbia*, was probably the defining document of the City Beautiful and city planning movements. It defined a scheme for improving the Mall area by removing all extraneous structures—Renwick's original Smithsonian Institution building was intended to be among them—and taking the Mall to its logical extension of four full axes, to be properly terminated by classical memorials. The plan included formal reflecting pools, terraces, and balustrades for the Washington Monument, formal tree-lined promenades, and elegant sweeps of green lawn.

For the purposes of this study, one of the McMillan plan's most important provisions was allowance for the expansion of the Smithsonian Institution. The plan stated that "areas adjoining B street north and south, averaging more than four hundred feet in width from the Capitol to the Monument, afford spacious sites for buildings devoted to scientific purposes and for the great museums."[60] The plan thus established uniform sight lines for buildings erected on the Mall; it also specified "the general style of architecture adopted when the Capitol and White House were built," i.e., the classical style that the World's Columbian Exposition had once again made fashionable.[61] When beginning in 1914 the Smithsonian Institution undertook the building of its first art museum in conjunction with the patron and donor of the building, Charles Lang Freer, the proposed building was located on the Mall, precisely on the lines established by Daniel Burnham and the Senate commission. Freer chose as architect his friend Charles

Capital Park and Planning Commission

THE McMILLAN PLAN : 1901 - THE MALL

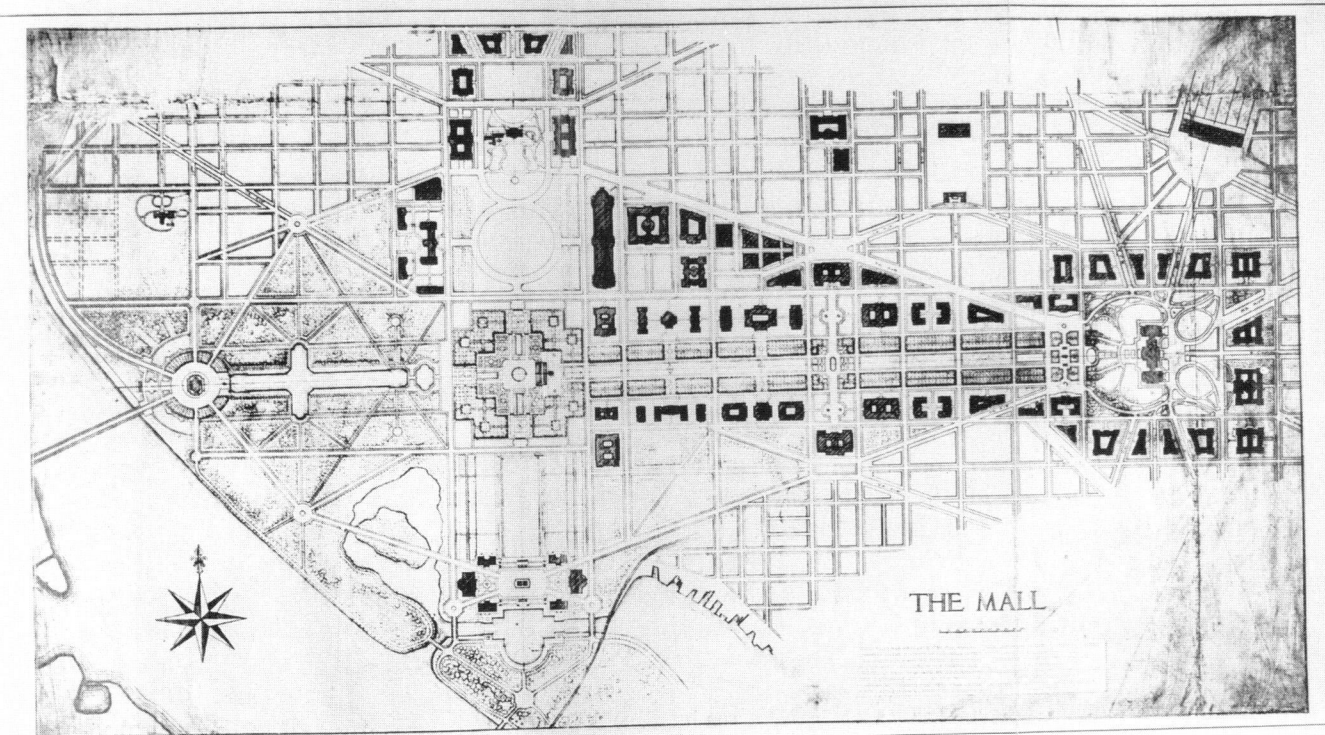

THE MALL

1901—THE MALL.—The McMillan Commission of 1901 prepared a plan providing for a return to the spirit of the original L'Enfant plan, including a great avenue from the Capitol to the Washington Monument. The plan also recommended the and the Arlington Memorial Bridge, and the removal of the railroad tracks from the Mall. The new Union Station, the Lincoln Memorial, and a large number of other buildings in the area have been located in general accordance with this pla

National Capital Park and Planning Commission. McMillan Plan design for the Mall, Washington, D.C. 1902. Plans and Studies: Washington and Vicinity, *1929. Avery Architectural and Fine Arts Library, Columbia University in the City of New York.*

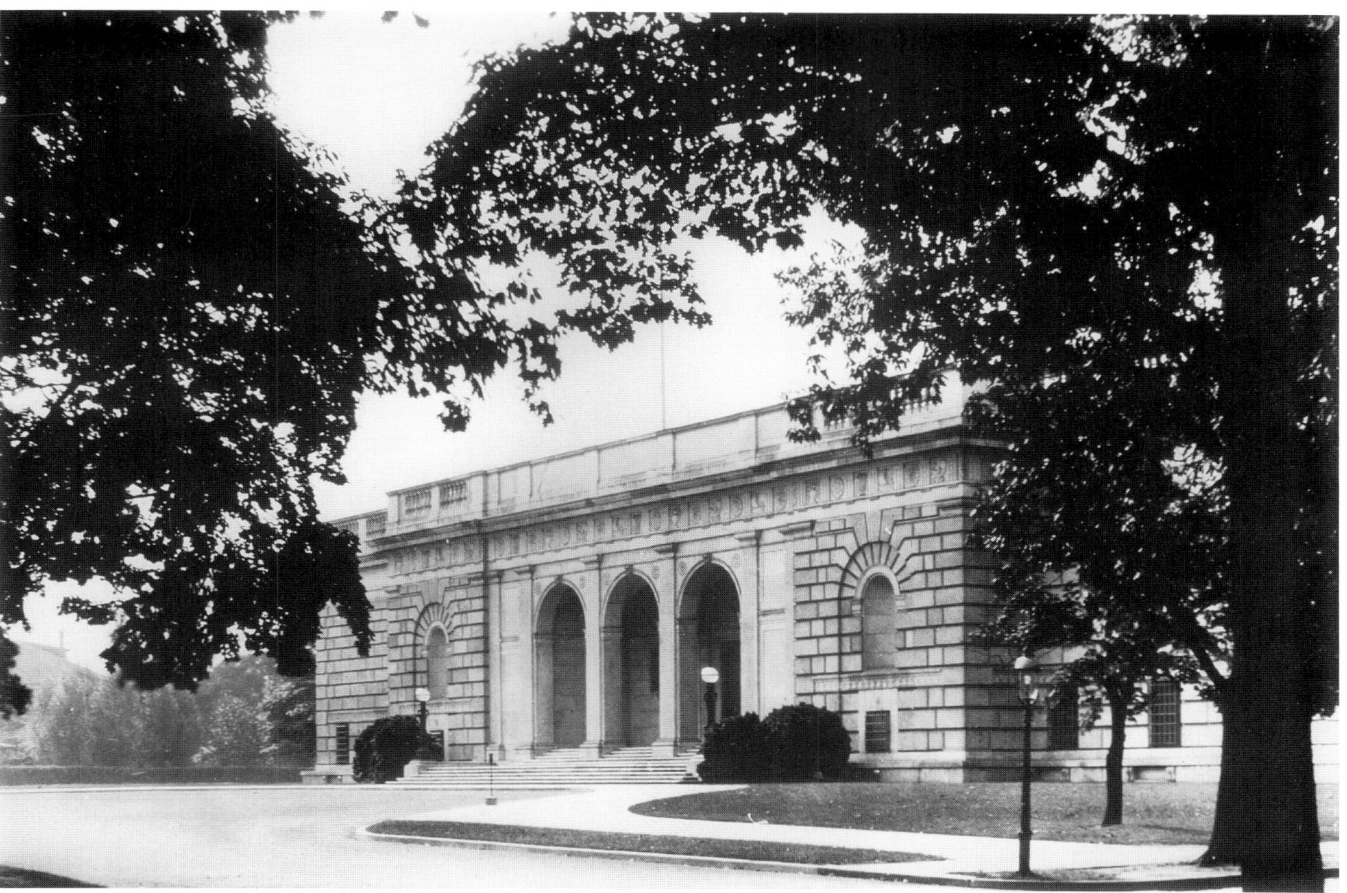

Charles Platt. Freer Gallery of Art, Washington, DC, 1914–19. Freer Gallery of Art Building Records. Courtesy of the Freer Gallery of Art, Smithsonian Institution, Washington, D.C. Photographer: Richard Southall Grant.

Platt. Between 1916 and 1921, Platt was also on the Commission of Fine Arts, which oversaw the development of buildings on the Mall. Sympathetic to the goals of the McMillan plan, he designed a beautifully restrained building. It was a low, block-shaped edifice of rusticated granite everywhere but the highly finished triple-arched portico. The decoration was simple; under the cornice was a wave-patterned frieze, and above the cornice, a richly designed balustrade.[62] The restrained elegance of the building and its adherence to the McMillan plan guidelines is reminiscent of the cooperative spirit that imbued the White City with such a great sense of harmony. As one newspaper noted, the Freer gallery did, indeed, add to the general effect of the buildings on the Mall:

> the style of architecture is eminently suited for an art gallery and makes a splendid addition to Washington's public buildings, which, it is hoped, will some day make the vista from the Capitol in the Monument known as the Mall, the most beautiful thing of its kind in the world.[63]

The Freer Gallery of Art thus was both conceived and perceived as an integral part of the City Beautiful plan for Washington.

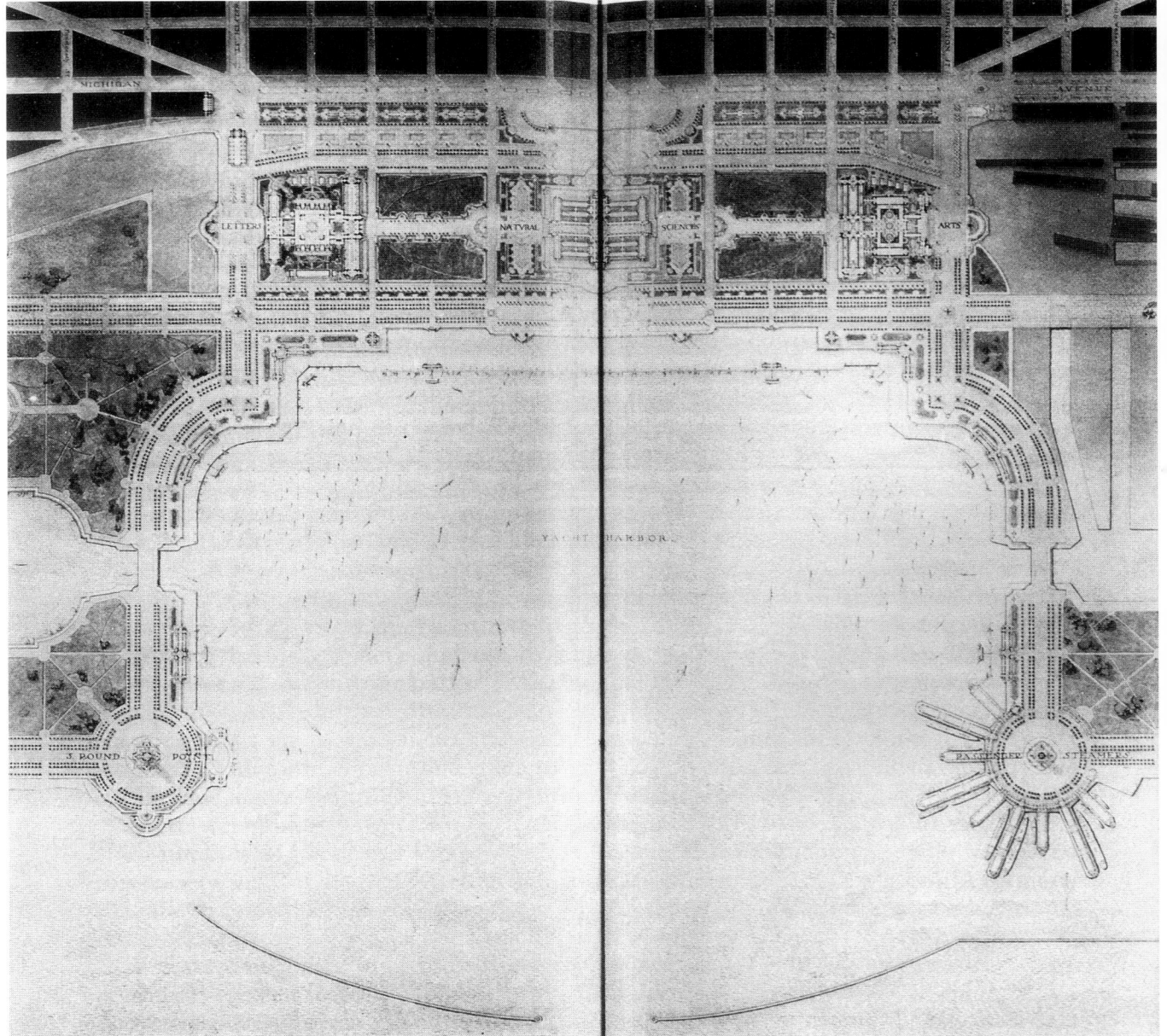

*Daniel Burnham. Plan for Grant Park, Chicago,
1909. Daniel Burnham,* Plan of Chicago, *1909.
Courtesy of the Art Institute of Chicago.*

The Plan of Chicago, *Grant Park, and the Art Institute of Chicago*

Another of Daniel Burnham's city plans was to address the special needs of museums within the city fabric and come up with a solution similar to that of the Washington Mall: a specially designated, formally designed park set aside for the particular use of museums. Although the museum complex was not to come to fruition, the plan provided architects and planners alike with an ideal to strive for. This was Burnham's 1909 *Plan of Chicago,* developed in collaboration with Edward H. Bennett, who would himself

go on to become one of the foremost practitioners of city planning. The *Plan of Chicago* can be directly attributed to the impulses generated by the World's Columbian Exposition.[64] The White City had shown in pointed and poignant contrast the comparative dilapidation of Chicago, which some then called the "Black City." The contrast compelled Burnham and Charles Atwood, who was still working with him, to propose that the site of the fair and the Lake Michigan shoreline to the north be preserved as a permanent park connecting the southern part of the city with the commercial district. Although received with enthusiasm in some influential quarters, the plan was not implemented and was allowed to languish for several years. After the impressive success of the plan for Washington, however, the idea was again taken up by the Chicago Commercial Club, which eventually formed the Chicago Plan Commission and sponsored the publication of the *Plan of Chicago* in 1909.

Much has been written about Burnham's plan.[65] Its principal accomplishments are seen today along two separate lines, though Burnham probably did not see it that way. The first was the accommodation of every kind of traffic and transport. Burnham devised new, improved, and consolidated waterways, railways, and highways; major routes and bypasses; and radial and concentric boulevards that would carry efficiently every kind of traffic, from industrial cargo to suburban commuters. This aspect of the plan may have resorted to typical European precedents, but it was highly practical and as such has been lauded by most modern critics. The development of a metropolitan park system extended the earlier work of Olmsted and Cleveland and could only be seen as commendable. The other aspect of the plan has been perceived as overly grandiose, if not megalomaniacal, and remains firmly in City Beautiful, not City Practical, terrain.[66] This portion involved the creation of a grand civic center and other groupings of monumental public buildings, a museum group among them.

Burnham saw museums as an integral part of the City Beautiful. In the *Plan of Chicago* he pointed to them as part of the international City Beautiful movement:

As a part of this movement arises the impulse to express in concrete form the feeling of loyalty to and pride in the city; and this feeling finds expression in parks and pleasure grounds, in monuments and fine public buildings, in institutions of art and learning.[67]

Burnham was able to combine his belief in the importance of such institutions with his enthusiasm for "the orderly arrangement of fine buildings and monuments" in his proposal for Grant Park.[68]

The scheme for Grant Park, which was to have comprised a strip of land along Lake Michigan in the very heart of the Loop, would have created a center of learning par excellence and a City Beautiful of unparalleled grandeur and elegance. Burnham combined Grant Park with the new harbor for the city in an enormous, symmetrical design. The harbor and park arrangement was the centerpiece of the whole Chicago plan and would have provided the city with an impressive seagate and a multipurpose recreational area. As delineated in the beautiful, subtle pastels of Jules Guèrin, the Grant Park area would have comprised a large harbor embraced by two large "arms" of formal promenades, planted with shade trees and terminating in "round points" decorated with fountains. The park itself, fronting on the harbor, would have had the monumental Field Museum (once housed in the Columbian Exposition's Art Palace) at the center of the composition, surrounded by elaborately planned terraces, fountains, and landscaping. It would have been flanked by the Crerar Library to the south and the new Art Institute complex to the north. Connecting the three would have been formal walkways traversing large sweeps of green lawn, thereby creating much the same impression as the Washington Mall. The scale, as in many of Burnham's "big plans," would have been

very large. Grant Park would have spanned nearly the entire width of the Loop from one river to the other.

As for the Art Institute itself, Burnham somewhat cavalierly announced that it was in the way of the proposed widening of Michigan Avenue and, therefore, could be demolished and reconstructed in accordance with his designs.[69] The building itself would not be all that different, architecturally speaking, from the 1893 Shepley, Rutan, and Coolidge building; Burnham's plan also depicts a classical, but domed, building. What was more important to Burnham was the building's participation in a complex grouping of educational buildings. It seems that everything Burnham planned had to be a group or complex, for even the art museum itself was not immune. Like the entire Grant Park complex, but on a smaller scale, it was to consist of "a gallery of the fine arts, together with a school of art, comprising lecture halls, exhibition rooms, ateliers, and general administration quarters." In order to complete the City Beautiful atmosphere and make the group competitive with the most impressive European prototypes, the complex was to be augmented by "open-air loggias and gardens, the whole group being akin to the great art museums and schools of Europe."[70] Burnham also drew parallels with the Museum of Fine Arts, Boston, and the surrounding Back Bay area, with the presumably dual intention of showing that such a group was possible, as well as rousing the Chicago booster spirit, which in general could not bear comparisons with Eastern cities. What would make Chicago even better was that this group was to be planned and organized by experts, rather than simply occurring serendipitously, as had happened in Boston.

The Grant Park plan embodied all of the grand City Beautiful ideals: it combined architectural grandeur and a grouping of buildings with educational-recreational purposes, all to be harmonized with terraces, colonnades, and the like and to be linked in the minds of the citizens with the fabric of the city itself. Burnham is well worth quoting on this:

> The assembling in Grant Park of three monumental groups so as to form one composition offers opportunity for treatment impressive and dignified in the highest degree. It is such opportunities which when properly utilized give to a city both charm and distinction, because of the satisfaction which the mind obtains in contemplating orderly architectural arrangements of great magnitude both in themselves and in relation to the city of which they thus become an integral part.
>
> Economy, as well as effectiveness, dictates the adoption of a group plan; for the buildings have kindred uses, and should express relationship both in their architecture and also in their landscape settings. Indeed they may well be bound together by porticoes to protect the visitor against sun and rain; and such porticoes would offer abundant means of adornment by statues, paintings, and commemorative inscriptions. One has only to recall the impressiveness of the Peristyle at the World's Fair to understand the value of the colonnade as an adjunct to buildings beautiful in themselves.
>
> The landscape setting of the Grant Park group offers opportunities of the highest order. The broad terraces need for their relief the green of trees and the judicious use of parterres; and the walks and driveways, if well located, will give the sense of unity, while at the same time adding to the convenience of the visitor.[71]

There can be no doubt that the art museum can be found at the very heart of the City Beautiful enterprise. As an institution, it embodied the kind of high cultural aspirations that the urban cultural elite sought to incorporate in their vision of the twentieth-century American city. As architecture, it provided an ideal opportunity for grand City Beautiful expressions: great buildings, grouped together, surrounded by

formal parks and adorned with colonnades, terraces, fountains, and statues. Together, the institution and its building would exert a moral and artistic uplifting influence. The advantages of such a group, Burnham wrote, "cannot be overestimated; for art everywhere has been a source of wealth and moral influence. . . . The influence of this training in raising the standard of public taste and in creating demands for better physical conditions must be manifest."[72] The museum and the City Beautiful would thereby become part of a self-fulfilling prophesy; the creation of the museum group would help to establish the City Beautiful, as well as perpetuate the ideals by which it was built, while enabling the citizens to appreciate what had been done for them and making them want more of the same.

The Grant Park scheme as an architectural monument to learning was never implemented. The Art Institute remained where it was and obtained additional space via a bridge over the railway. Some impressive improvements did come about because of Burnham's plan, namely, the landfill development of Grant Park and the creation of the harbor and Buckingham Fountain. An educational center of sorts was created out of the grouping of Shedd Aquarium, Field Museum, and Adler Planetarium, though without the architectural grandeur and cohesiveness of Burnham's scheme.[73] The impetus created by Burnham and his great plans for the World's Columbian Exposition, Washington, and Chicago proper did spur on other cities and city planners to commission City Beautiful plans centering on museums, some of which were eventually carried out in part or in whole. Probably the best known of these is the creation of the Benjamin Franklin Parkway in Philadelphia and the grouping of educational institutions around it, culminating in the new Philadelphia Museum of Art building.

The Benjamin Franklin Parkway, the Philadelphia Museum of Art, and the Rodin Museum

Although the idea of a parkway connecting the center of the city of Philadelphia with Fairmount Park had been agitating for years, the fruition of the idea came only at about the same time as Burnham's plan for Chicago.[74] Spurred on by the Washington plan, the Fairmount Park Art Association joined forces with city officials to create a great boulevard, the Benjamin Franklin Parkway. The parkway would become home to a cluster of educational institutions and would terminate in the new art museum building that had been dreamed of for years. Following the spirit of the times, which insisted on the advice of experts, the Art Association hired a team of architects to create a plan for the parkway. The group consisted of Paul Cret, Clarence Zantzinger and his partners Charles Borie and Milton Medary, and Horace Trumbauer. The construction of the parkway commenced in 1909, and in 1911, Zantzinger, Trumbauer, and Borie were appointed by the Fairmount Park Commission to design the new art museum. Cret would go on to design the Rodin Museum, one of the group of buildings to be built on the parkway, along with the Free Library, the Franklin Institute, the Academy of Natural Sciences, and the Municipal Court. The drawings of the parkway prepared in 1917 by the French landscape architect and city planner Jacques Gréber—whose drawings evoke the same pastel delicacy as Jules Guèrin's drawings for the *Plan of Chicago*—are some of the most spectacular of the genre and served as a great persuader for the plan, one of the most elaborate of the City Beautiful era to be carried out so completely.

There is no doubt that the climax of the Benjamin Franklin Parkway plan is the art museum. It serves as the terminus to the parkway—that function further emphasized because the parkway could not be carried all the way to City Hall—and dominates the

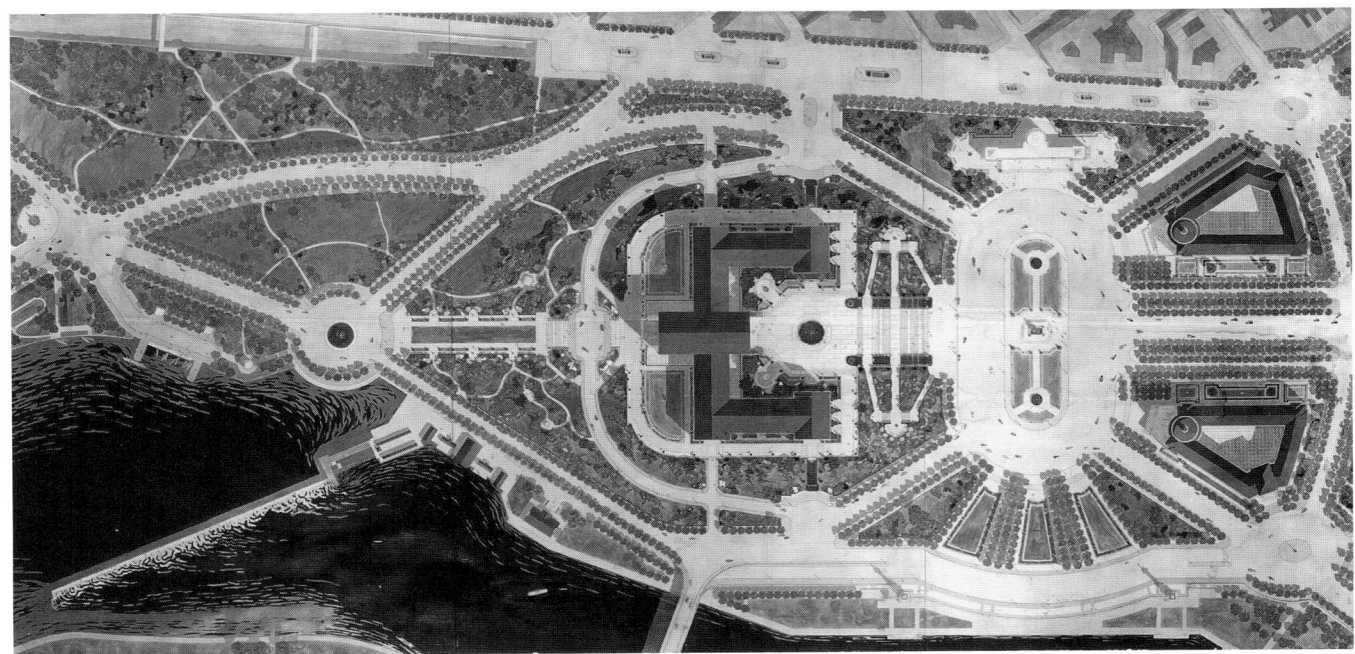

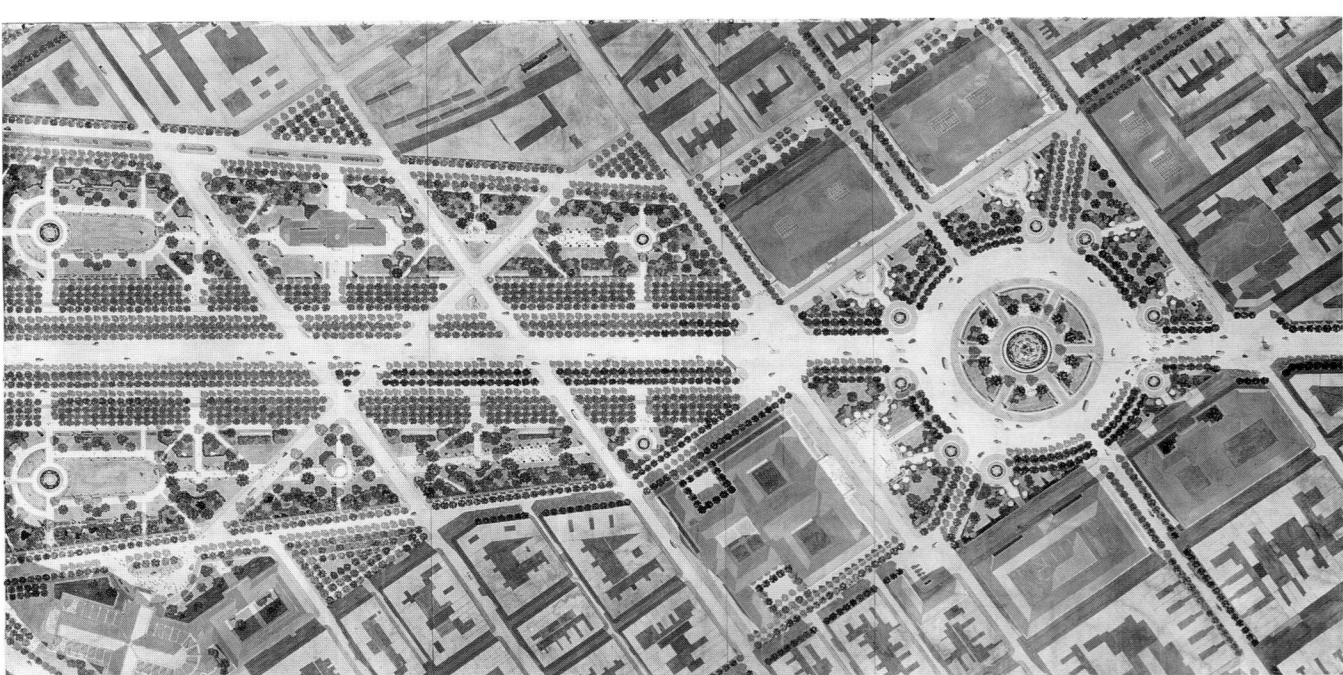

Jacques Gréber. Plan of the Benjamin Franklin Park-
way, Philadelphia, c. 1917. Courtesy, the Philadelphia
Museum of Art Archives.

composition by virtue of its tremendous bulk and its placement on a sizeable hill.
This favorite device of museum builders during this period here reached its ultimate
expression, as king of the summit being paid homage to by one of the grandest boule-
vards ever to be constructed in this country. Not surprisingly, Zantzinger, Trumbauer,

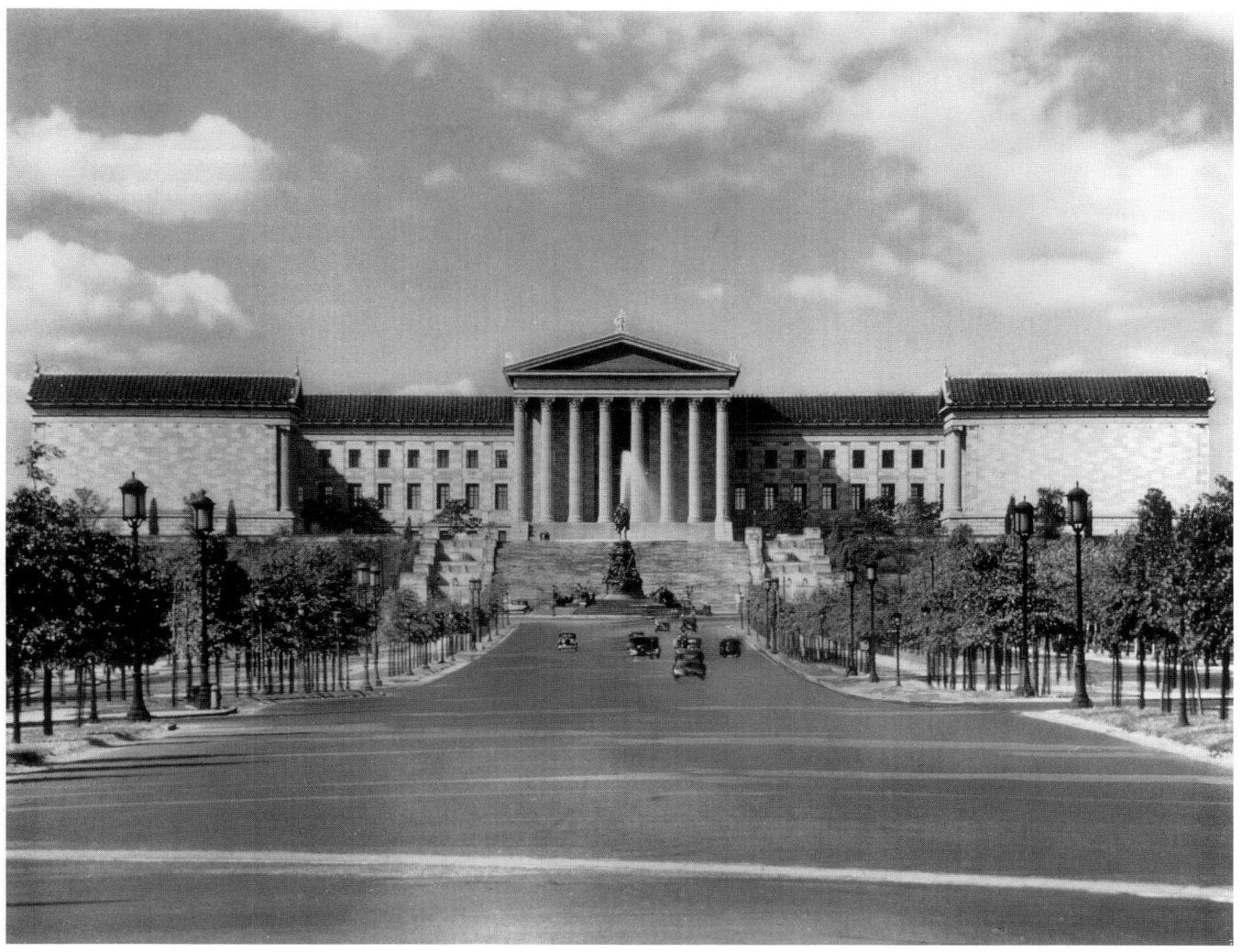

*Zantzinger, Trumbauer, and Borie. Philadelphia
Museum of Art. 1911–28. Official photo, 1933.
Courtesy, the Philadelphia Museum of Art.*

and Borie chose as a suitably monumental style an adaptation of the Greek temple;
thus, they followed the noble line begun by Charles Atwood at the World's Columbian
Exposition and continued by Edward Green at the Albright Art Gallery in Buffalo.
When the museum's design reached its final form in 1917, it consisted of a large Greek
temple form with two very large arms extending from either side, forming a courtyard
in their embrace. Each of these arms terminated in temple fronts as well. With its myriad
templelike forms, the structure was intended to resemble the Athenian Acropolis, but
all enclosed as a concession to the exigencies of a museum. The architects adopted the
very latest information known about Greek architecture and carried it out to the letter;
there was polychrome sculptural decoration and not a single straight line on the build-
ing.[75] As one man from the construction company proudly claimed, "In this building
. . . we have been able to 'out-Greek the Greeks.'"[76] Construction began after World
War I in 1919, and the building first opened to the public nine years later in 1928.

Public reception of the museum building was mixed. The costs of erecting the struc-

ture had escalated during the course of the many years of planning and construction, and progress on the building was slow. By the time 1928 had arrived, many were disillusioned by the laborious and expensive requirements of the City Beautiful. Nevertheless, when the expense and delay were forgotten, the popular press was generally enthusiastic both about the building and the parkway improvements. The area was often photographed and appeared in the newspapers in novel "airplane views." One paper claimed that the "new museum will give Philadelphia one of the finest buildings of its kind in the world."[77] A more poetically inclined journalist wrote: "As the building lifts itself to its full height and gazes down, with a smile, upon the city, the city itself seems to fall at its feet in adoration and to pronounce it most beautiful and most worthy."[78] Without referring to the City Beautiful program, the author of that encomium was certainly aware of the integral relationship between the city and the museum. She refers to the effect of the building on a hill as an answer to all those who were "skeptical and cantankerous" about the project, describing the museum upon the summit "with the city a dream-city in the distance, and the magnificent bulk of the building breaking like a wave of light against the sky."[79]

Other newspaper articles praised the Benjamin Franklin Parkway plan itself. One 1927 article gave a brief history of the parkway's development and concluded, "Its immense possibilities for further development as one of the noteworthy and ornate urban highways of the country are manifest to every one."[80] The frequently photographed area was often illustrated in the newspapers, with captions like "Athens? No, this is our own Art Museum on the Parkway"[81] and "Destined to Be One of the Finest Driveways in America . . . The vacant spaces on each side will some day be filled with beautiful public buildings designed in harmony with the Art Museum."[82] Indeed, this goal was actually to be fulfilled by the construction of the Rodin Museum, among other buildings. By the time construction had begun on the small museum devoted to works by the French sculptor Auguste Rodin, yet another journalist could claim, "We are now on the way toward a realization of the long-cherished desire to make this avenue one of the beauty spots of Philadelphia."[83]

The Rodin Museum was the result of the generosity of wealthy Philadelphian Jules Mastbaum, a collector of the sculptor's work, who in 1926 offered to build a museum to house his collection, to be built on the parkway at his own expense.[84] Mastbaum's reasoning appears to have followed John J. Albright's in assuming that the least the city could do in return for his generous offer would be to provide space for his donated building. In Philadelphia, however, the space Mastbaum desired was one already planned as a formal park intended to house public institutions, as had been suggested by City Beautiful planners like Frank Miles Day. Mastbaum originally called on Jacques Gréber to design the proposed museum, and Gréber asked Paul Cret to collaborate with him on the project. The resulting composition included a faithful reproduction of the facade of the Château D'Issy at Meudon, through which visitors passed in order to arrive at the small but elegant building by Cret. Though Gréber and Cret both harbored modernist tendencies, they tempered their modernism with a Beaux-Arts classicism more palatable to conservative Philadelphians and more in harmony with the general tone of the Parkway. Thus, Gréber's garden designs were deemed "worthy of Le Nôtre,"[85] and Cret's design for the building was reminiscent of the Petit Trianon at Versailles.[86] The formal reflecting pool in front of the main facade enhances the classical effect and harks back to the same device employed on the Washington Mall. Whereas the crisp planarity of the building is suggestive of modernist ideals, the overall effect is emphatically formal and classical.

The Rodin Museum was opened to the public in 1929 to both professional and

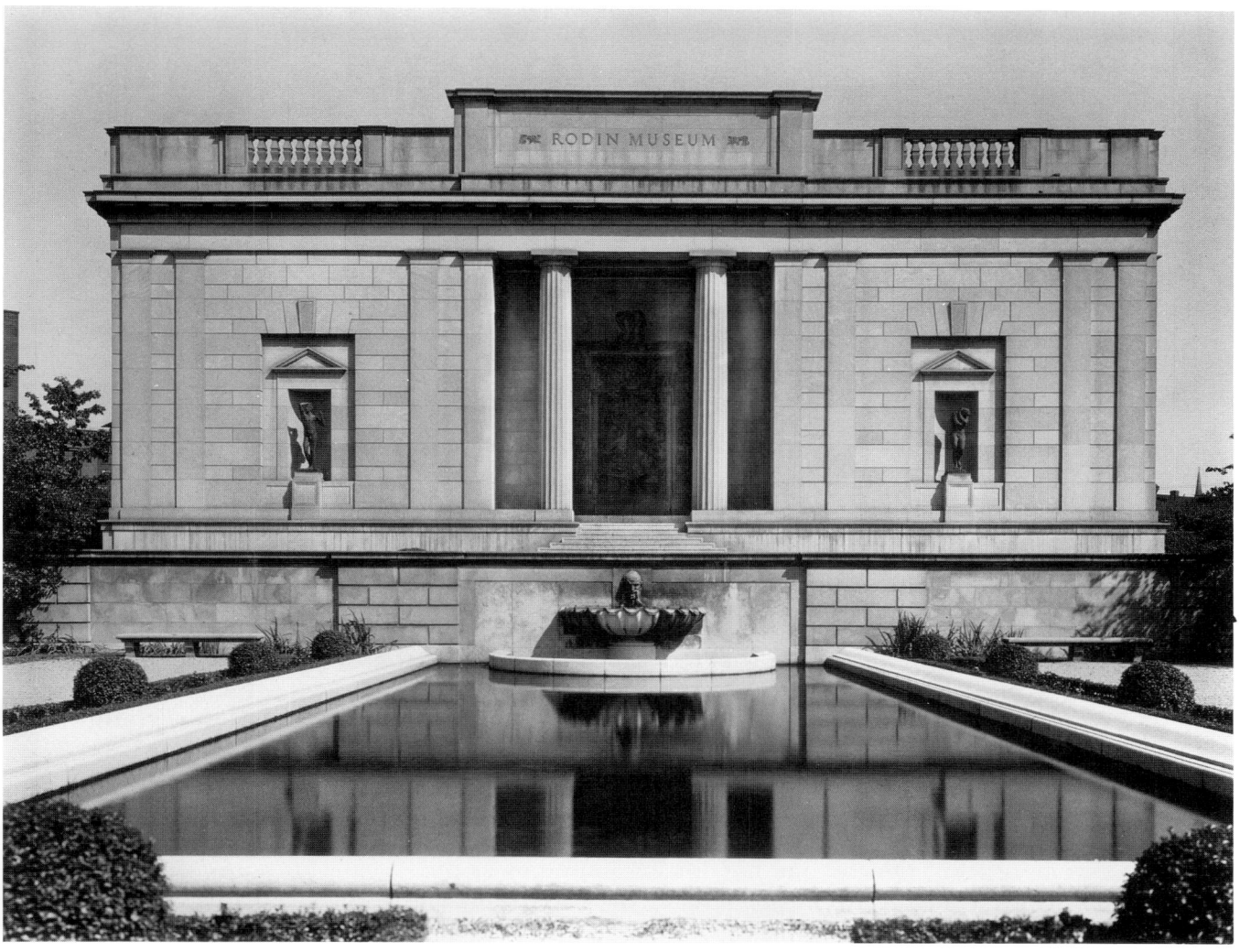

Paul Cret and Jacques Gréber. Rodin Museum, Philadelphia, 1926–29. Courtesy, Rodin Museum.

popular acclaim. An article in *Architecture* noted that Rodin "has been singularly happy in the sites chosen for collections of his work" and admired the proportions of the building and the careful attention to detail.[87] The popular press, generally more given to enthusiasm, printed such comments as, "It is a jewel which shines like the jewel upon the breast of a woman in Philadelphia."[88] Like the journalist who wrote with similar poetry about the museum of art, this observer instinctively relied on the integral connection between the city and the museum brought about by the city plan.

Cret had been involved with the plans for the parkway at the beginning, but his involvement in World War I, when he returned to serve his native France, interrupted his participation. On his return, he resumed interest in Philadelphia's City Beautiful, and concurrently with his plans for the Rodin Museum, he developed a radical plan for the improvement of City Hall Square. This project provides an interesting sideline to the relationship between the City Beautiful and the museum because of the insistence upon conformity that it indicates. Like Burnham's Grant Park scheme for his *Plan of Chicago*, Cret called for the demolition of a large and important building, but Cret's

temerity went even further than Burnham's. In collaboration with Harry Sternfeld, Cret produced a "Report on Improvement of City Hall Square," wherein he proposed the demolition of all of the City Hall building, save the tower.[89] The site would then have become an open square and traffic round point. To give Cret his due, William Penn's original plan for the city called for the square to be open. Cret's argument, seconded by at least one newspaper editorial, was that the sentimental attachment to the building was directed primarily at the tower and the statue of Penn and that "even with the collaboration of time, the Public Building will never become good architecture."[90] Although the plan has some of the earmarks of the City Practical in its emphasis on improved traffic circulation, there can be no doubt of its City Beautiful intentions. Cret proposed that civic buildings be erected all around the square, thus creating a civic center; furthermore, the circular road and tower ("like the Campanile of St. Mark's in Venice . . . marking the center of the city"[91]) would provide a proper terminus for the parkway at that end. Closure and symmetry for the grand parkway project would thereby be provided for: circular roadways would define each end of it, and a properly chastened architectural monument would echo the crowning glory of the museum on the hill. Thus, in Philadelphia, as in Chicago, the museum can be found at the heart of the City Beautiful enterprise, with city planners as interested in the location and design of museums as in the city plan itself.

The Montclair, New Jersey, Improvement Plan and the Montclair Art Museum

Whereas the plans for Washington, Chicago, and Philadelphia were all on a grand scale, the City Beautiful movement had a more intimate, yet also more popular, aspect to it, as well. This part of the movement might be termed grass roots in that it affected people living in small towns and concerned itself with such small-scale improvements as flower gardens and street signs.[92] This aspect of the movement meshed with museums in several aspects. On the one hand, such museums as the Toledo Museum of Art in Ohio involved themselves in this level of the City Beautiful by holding art classes and advocated the planting of flower gardens.[93] This could be looked upon as an instance of the grand-scale City Beautiful (the museum) concerning itself with the small-scale (neighborhood beautification). In one unusual circumstance, however, the influence went the other way, and a small town concerned itself with an overall city plan of the large-scale type. This interesting case was Montclair, New Jersey, which produced what was very likely the first small-town art museum in the country and the first art museum in the state of New Jersey.

Montclair was a special case. Whereas all the museums of this study are urban institutions (university art galleries have been excluded as an altogether separate case worthy of its own study), the Montclair Art Museum is located in a small suburban town.[94] Its arrival at the point of the establishment of an art museum can be explained by the town's wealth and location only twelve miles west of New York City, as well as its special status as home to several important late-nineteenth-century artists, most prominently George Inness. Thus, its existence was primarily indebted to New York. By the early twentieth century, New York had become a city capable of spinning off a suburb independent and wealthy enough to sustain its own art museum. At the same time, the town became caught up in the excitement of the City Beautiful movement and entertained the idea of improving the town via a plan created by an expert. The museum and the town plan came together in 1909 when William T. Evans offered his collection of American paintings to the Montclair Municipal Art Association and city planner John Nolen

*John Nolen. "Civic or Town Center," Montclair, NJ,
1909. John Nolen,* Montclair: The Preservation of
its Natural Beauty, *1909.*

published his improvement plan, as commissioned by the Montclair Civic Association,
in *Montclair: The Preservation of Its Natural Beauty and Its Improvement as a Residence Town.*
Although, in the end, the museum did not end up where Nolen had intended it to be,
the plan for Montclair included provisions for the art museum, and Nolen's incorpora-
tion of the museum into the heart of his plans for Montclair once again indicates the
importance of the museum to the City Beautiful, even on the small town level.

John Nolen (1869–1937) was one of the founding fathers of the American planning
profession.[95] Graduating from Harvard in 1905 in the newly established course of
landscape architecture, he established a practice in the new field of city planning shortly
thereafter. By 1909, when he published the plans for Montclair, he had already de-
signed plans for Charlotte, North Carolina; Savannah, Georgia; and Roanoke, Virginia,
(all 1907); and San Diego, California, (1908). He also had published plans for the *State
Parks for Wisconsin* (1909) and, in collaboration with Frederick Law Olmsted, Jr., a plan
for a civic center for Milwaukee, Wisconsin. Nolen's career spanned the first four dec-
ades of the twentieth century, and his profession saw many changes over the course of
those years. At the beginning of his career, Nolen was deeply influenced by the City
Beautiful approach to town planning, as may be evidenced by a speech he gave at the
fourteenth annual National Conference on City Planning—as late as 1922—entitled

"The Place of the Beautiful in the City Plan."[96] Although Nolen mistakenly called the early City Beautiful movement a superficial effort at decoration achieved by planting geraniums, his conclusions were basically those formed by the comprehensive city plans of the early, Burnham-inspired City Beautiful, namely, that a city plan "makes the beautiful in cities possible."[97] He illustrated his point with many of the same examples so dear to the hearts of the earlier City Beautiful proponents: Versailles, the Avenue de L'Opéra in Paris, and L'Enfant's plan for Washington. Nolen concluded that beauty in a city is achieved with architecture, sculpture, and landscaping, but that it is not possible without a city plan. American cities and towns, he claimed, "must be beautiful. The city itself should be a work of art."[98] In 1909, however, the distinction between the City Beautiful and the City Practical had not yet been drawn, and that Nolen's plan for the town of Montclair should incorporate the beautiful was not even in question.

The plan for Montclair did call for a great many practical improvements, particularly in traffic circulation, just as had Burnham's *Plan of Chicago*. Nolen proposed the elimination of certain dangerous at-grade railroad crossings, as well as the erection of a new, more commodious, and attractive railroad station. A "six corners" street intersection would be widened, creating a plaza to provide safer and easier traffic circulation, and very much as Burnham had suggested for Chicago, he proposed a town bypass of sorts, a "circuit or pleasure drive" for improved traffic circulation around the town. This appealed to the Commission, which likened the circuit drive to Vienna's Ringstrasse.

The heart of Nolen's plan for Montclair was the creation of a "Civic or Town Center." He pointed out that although Montclair had a substantial population of more than 20,000, it had no real town center. He proposed to remedy the lack with a New England-style "green square or Town Common," around which would be grouped the town's public buildings: the schools, library, churches, a new town hall, public baths and a gymnasium, the post office, and "a Casino or Garden for music, theatrical performances and art exhibitions."[99] Once again, Nolen's scheme resembles Burnham's, with the grouping of public and educational buildings on an open space. The obvious difference is the scale and a concomitant lessening of formality, considered appropriate for a small town. This proposal was at the head of the list of the Commission's recommendations; the Commission then went on to recommend that Nolen's proposed town common provide the site for the new Montclair art gallery.

In 1909, the collection of paintings for the museum had already been donated, and Mrs. Henry (Florence Rand) Lang had provided substantial monies for a building fund to house that collection and create a gallery for Montclair. The Art Commission saw the tandem donations as a serendipitous opportunity to take advantage of Nolen's plan for Montclair. Following Nolen's suggestion for the type of building to occupy the planned common, the Commission proposed that the art gallery should front on the common. An observer pointed out that the "need for such a Common is emphasized by Mr. [William T.] Evans' proposal [of the donation of his art collection which formed the germ of the museum], for there seems to be no other entirely adequate site for such a gallery."[100] There was universal agreement that the gallery would make the town an even more desirable place in which to live and visit. The Art Commission wrote that it "will add greatly to the attractiveness of the Town and will make it unique among residential suburbs."[101] The donor Evans also believed that Montclair, "enriched by Art," would thus be "rendered even more attractive as a select residential town."[102] The deep meaning associated with the project by the ideals of the period was defined by the sculptor Lorado Taft, in a 1920 lecture at the Montclair Art Museum, entitled "Beauty in the Home Town." He claimed that the proposed common would have brought "the greatest and most valuable returns in the future to Montclair—would

make not only a more beautiful town, but better Americans of its citizens."[103] Thus, even in a small town, urban City Beautiful ideals concerning the importance of the museum within the comprehensive city plan held true.

In Montclair, as in Chicago, the museum was not to take its place in the plan as designed by the expert. Despite Nolen's repeated assurances that the proposed improvements were economically viable and that "beauty pays," the town voted down the beautification process as too expensive, for they feared debt and higher taxes.[104] The City Beautiful guru Charles Mulford Robinson lamented the defeat but wrote hopefully that Nolen's plan had given the town a "Vision" which would help the town grow "into municipal comeliness and strength."[105] Robinson's prophesy came true to a certain extent. Montclair did widen roads and intersections, extend other roads, and build a new railroad station. The town common, however, did not come about, and the Montclair gallery was built in a primarily residential location away from the heart of the town. It may be that the impetus for the museum's erection began with the plan, as the Art Commission claimed in the published plan. By 1914, Montclair did have a lovely, small, classical art gallery designed by Albert R. Ross and later completed by the firm of Goodwillie and Moran. Montclair residents looked forward to its completion still believing it would partly comprise a City Beautiful for Montclair. The *Montclair Times* reported in 1912:

Albert R. Ross. Montclair Art Museum, NJ, 1912–14. Photo: author.

With the establishment of the art gallery and museum there will be formed another unit in what will probably be one of the finest groups of buildings devoted to educational purposes in any town the size of Montclair in the United States.[106]

The repeated linking of the art museum to the improvement of the town and its citizens in general indicates once again the importance of the art museum to the City Beautiful enterprise, even at the small-scale end of the movement.

The Plan of Minneapolis *and the Minneapolis Institute of Arts*

One final example will secure the connections of the art museum to the City Beautiful movement. By the early twentieth century, the art museum movement as well as the City Beautiful movement had moved westward.[107] Chicago was the largest city in the Midwest and the first to establish an art museum, but the tremendous growth of the region soon produced cities large and wealthy enough to support art museums and a concern for urban aesthetics. The City Beautiful movement left a greater impact on the younger and, therefore, more impressionable cities of the Midwest and West. Minneapolis was a prime example of the boom in Midwestern cities. In 1860, there were less than 6000 inhabitants of the city; by 1910, there were over three hundred thousand.[108] The city's leading citizens had established a Society of Fine Arts as early as 1883, and by 1910, the art society and the school established under its auspices were in need of a new and permanent home.[109] A donor offered the Society the gift of a ten-acre tract of land in a residential area away from the heart of the city with the stipulation that five hundred thousand dollars had to be raised for a building fund. In the fall of 1911, the Society's board opened an invitational competition, which was won in 1912 by the firm of McKim, Mead, and White. The grand scheme called for in their plans consisted of a very large, rather severely classical building with a large entrance portico on the front of the building, large galleries and formal courtyards composing the main portion of the building, and an enormous hemicycle hall, enclosing another courtyard at the rear facade. Only about one-seventh of the plan was actually built, with the entrance facade and portico reaching completion in 1915. Despite its doomed fate, the plan was the presumed future of the building for many years.

The architects' plan was still the guiding image of the museum in 1917 when the Minneapolis Civic Commission published its *Plan of Minneapolis,* which had been written by Andrew W. Crawford of Philadelphia but prepared by city planner Edward H. Bennett.[110] Born in England, Bennett had studied in France at the Ecole des Beaux-Arts, graduating in 1902. He had worked with Daniel Burnham for seven years, including work on the 1905 plans for San Francisco and Manila, and he was listed as coauthor of the *Plan of Chicago.* He was thus fully indoctrinated with grand manner City Beautiful ideals, which were fully expressed in his 1917 plan for Minneapolis. Like Burnham and Nolen, Bennett, too, devoted a great deal of his study to improved transportation and road systems. The Minneapolis art museum figured prominently in the plan, as well. An entire chapter was dedicated to the museum and a proposed extension of Sixth Avenue which would connect the museum to the rest of the city. The Sixth Avenue extension is really at the heart of the *Plan of Minneapolis,* for Bennett saw it as one of the "two great axes of the city," at the intersection of which he planned to create a large Civic Plaza. This plaza resembled in general terms the *Plan of Chicago* Civic Center, with which Bennett, as coauthor of that plan, would have been very familiar.[111] The Sixth Avenue scheme also resembled that of the Benjamin Franklin Parkway in Philadelphia, for the Civic Plaza was intended to be the great boulevard's focal point at the

Edward Bennett. Sixth Avenue approach and the Minneapolis Institute of Arts, 1917. Edward Bennett, Plan of Minneapolis, *1917. Courtesy of the Art Institute of Chicago.*

center of the city, as City Hall would have been in Philadelphia, and the museum, located on a rise, would have been the focal point of the avenue near the boundary of the city limits.[112] The Minneapolis plan illustrated the Philadelphia scheme, describing the Philadelphia museum and parkway as a fait accompli in order to persuade Minneapolitans that such a scheme was feasible. The Minneapolis museum was also to be on a continuation of the Sixth Avenue Parkway, which would lead to Lake Harriet, and thus, like the Philadelphia museum, serve as a formal entrance to a municipal park system. The terminus of Sixth Avenue at Lake Harriet was to be a formal roundpoint with classic pavilions framing a lake vista, as well as a ceremonial entrance to the lake-park system of the city.

One of the most important arguments presented by the Minneapolis plan for the extension of Sixth Avenue to the museum was that the institution's location was not central enough and, therefore, also not democratic enough. This attitude illustrates a central difference between the City Beautiful approach to museum locations and the approach of the earlier generation, which put the museum in a "rural" municipal park. Although Bennett had stated that educational institutions ought to be "somewhat aloof from the turmoil of the downtown center,"[113] he nevertheless wished the museum to be accessible to the largest number of people. Its location was "not in touch with the ebb and flow of the daily life of the city." According to the *Plan of Minneapolis,* this was

not as it should be, for "Art is not a thing to be enjoyed only on Sundays and half-holidays, but should be an everyday experience. It is not intended for the enjoyment of the few, but, as Italy shows, is the rich heritage of the many." The Sixth Avenue extension would thus bring the museum "into direct and intimate relationship with everyday Minneapolis."[114]

Italy was not the only European example provided to show how the plan should be accomplished. The creation of a great highway in Minneapolis would be the proper descendant of earlier European examples:

> Unter den Linden, Berlin, is a suggestion of Sixth Avenue Extended where its width is 200 feet; and the Champs Elysées, Paris, where that width is increased to 250 feet. The opportunity is here. We should know all that the makers of these world-famous Boulevards knew. We are their heirs and the heirs of all the ages.[115]

By using these examples, it becomes clear how Sixth Avenue was to achieve its effects: by cutting diagonally through the city, by widening to a grand and spacious width, by planting large shade trees, and by using vistas ending with columned facades and a great deal of sculpture in order to create architectural magnificence. The gorgeous illustrations of the avenue, rendered by Jules Guèrin, show an elegant, cosmopolitan city very much in the same league as Paris.

The area around the art museum was to receive special treatment. The plan was arranged around the way the museum would appear when finished to McKim, Mead, and White's specifications. There was to be a small park in front of the museum named Washburn Park. Bennett gave it a highly formal treatment by creating a semicircular drive in front of the museum, which Sixth Avenue would meet at an angle. The ground created by the hemicycle would, he pointed out, provide an ideal opportunity for monumental sculptural decoration. The illustration portrayed a large obelisk at the intersection of the hemicycle and the avenue and the semicircular plaza receiving a formal treatment of grassy sweeps of lawn, formal paths, and evenly planted shade trees. This composition was to be the highlight of the entire Sixth Avenue scheme, as the plan made clear:

> The construction of the Sixth Avenue Extension will make the location of the Institute of Arts the summit of the greatest highway of the city. It is thus physically, as well as figuratively, true to call the location of the Museum the summit of this Avenue.[116]

Bennett emphasized the importance of the museum building by arranging the roads around the museum so that "the three chief motifs of the building are each located so as to end vistas."[117] A City Beautiful place of honor was the end of a vista; Bennett's placement of the Minneapolis Institute of Arts at such a location indicated the great importance of the art museum, as architecture and as institution, to the City Beautiful program.

The City Beautiful Movement and the Metropolitan Museum of Art, New York

It is fitting to conclude this chapter with a return to New York City and the Metropolitan Museum of Art in Central Park. The museum was located within the boundaries of the park during a period when there was no true city planning, and a park seemed like a good place to put a museum. When the museum underwent a change in architecture, from High Victorian Gothic to Beaux-Arts classical, it also responded to the new

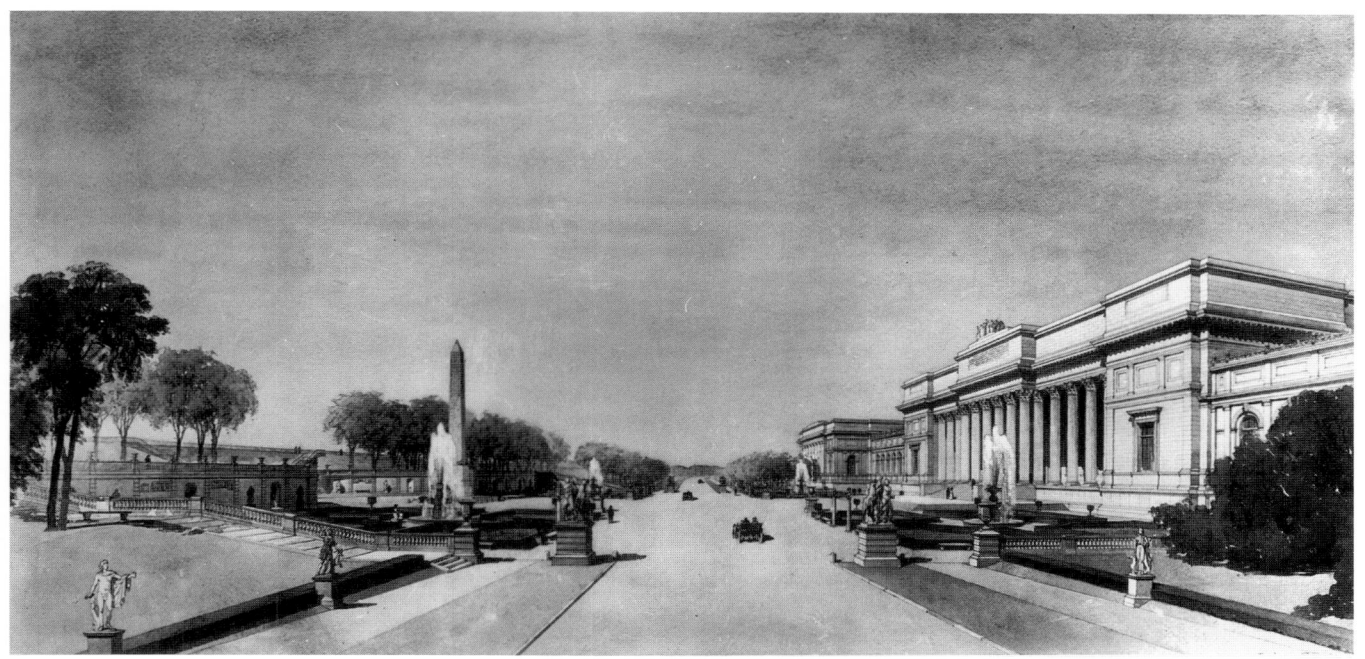

*McKim, Mead, and White (drawing by Jules Crow).
Proposed western facade of the Metropolitan Museum
of Art, New York, 1907. Museum of the City of New
York, 90.44.1.855. Gift of McKim, Mead, & White.*

City Beautiful ideals and became more of an integral part of the city. Richard Morris Hunt, fresh from the planning revelations of the Columbian Exposition, placed the new Fifth Avenue facade at the end of Eighty-Second Street, thereby providing New York City with one of its rare City Beautiful-style vistas (the two other most notable ones, Grand Central Station and the New York Public Library, were also built during this period). A critic in the *Architectural Record* approvingly noted the setting which Hunt used "to so brilliant account," recalling in the building and its site "a distinct reminiscence of Paris."[118] By placing the new facade directly on Fifth Avenue, Hunt also put the museum in a more direct relationship to the life of the city. He placed the museum building squarely in the ethos of the City Beautiful movement.

During the course of the decade following Hunt's death, New York would make further attempts to participate in the City Beautiful movement, attempts made futile by the resolute grid of the city. In 1907, the New York Public Improvement Commission came out with its improvement report, which featured, like so many City Beautiful plans, a civic center built around City Hall.[119] Although the widening of Fifth Avenue was about the only improvement to result from the report, the very existence of the report indicated an interest in City Beautiful ideas. As it grew, the Metropolitan Museum of Art would figure prominently in arguments about municipal improvements. After Hunt's death, McKim, Mead, and White became the architects for the museum, charged with carrying out Hunt's plans. The firm carried out extensions to the north and south of the entrance hall and designed a master plan that featured an extension to the west into the park, creating a facade congruent in proportions and importance to the Fifth Avenue front of the building.[120] The unexecuted western addition was designed in 1907 in the best City Beautiful style. A beautiful drawing signed by Jules Crow shows the

proposed facade facing an elegant esplanade and terraces decorated with balustraded stairs, a fountain, and an obelisk.[121]

McKim, Mead, and White's extensions along Fifth Avenue that did get built generated some controversy, however. In a drawing by Vernon Howe Bailey published in the New York *Sun* in 1913, the museum's two new wings were shown in exaggerated perspective so that they seemed to stretch along Fifth Avenue for a great distance. The article accompanying the illustration reported the controversy surrounding the new south wing (the north extension had already been built). Critics, the paper reported, objected to "every enlargement of the Metropolitan upon the score that the building is encroaching too much upon the public playground."[122] The article specifically recorded the objection of sculptor Gutzon Borglum, who complained that the proposed extensions "walled up" Fifth Avenue. Borglum's own proposition, created in response to the growth of the museum, demonstrates to what disastrous lengths the idea of the City Beautiful could be taken when directed by insensitive hands.

In 1912 when his plan was made public, Borglum was a member of the Park Rehabilitation Committee. His proposal for "saving" Fifth Avenue from the museum consisted of an enormous arts complex to be erected in the center of Central Park, atop the old Croton reservoir behind the museum. The complex would comprise seven large build-

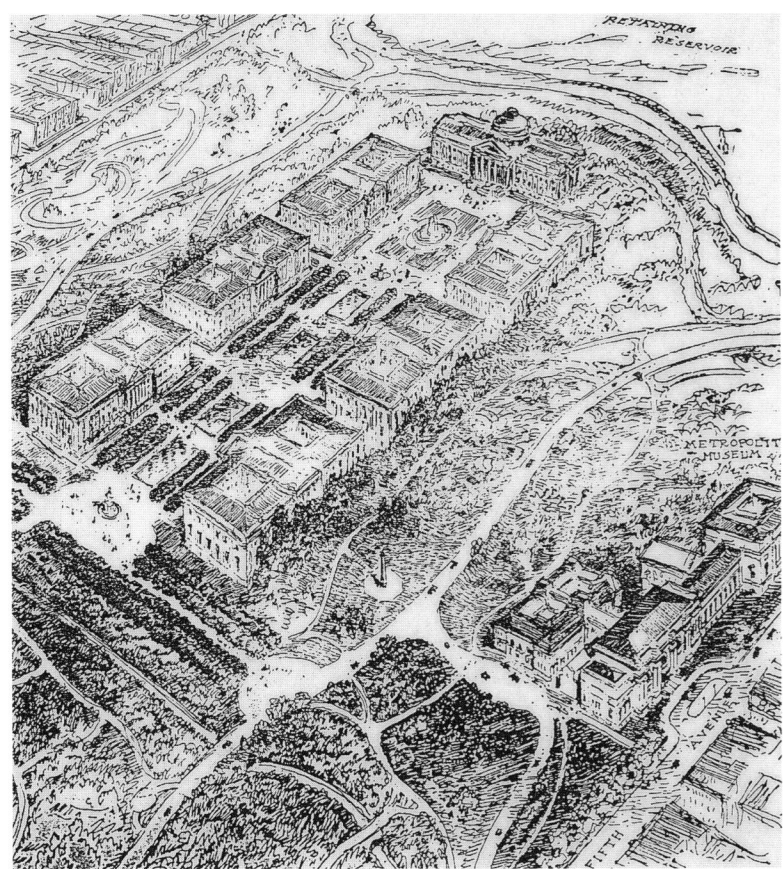

Gutzon Borglum (drawing by Vernon Howe Bailey). Proposed arts complex, Central Park, New York, 1912. New York Sun, *10 March 1912. Collection of the New-York Historical Society.*

ings grouped around a formal garden court, and the dimensions of land to be taken up by the complex were of incredible proportions. Although Borglum suggested that the buildings and courtyard could be sunken within the reservoir walls, thereby not encroaching upon park lands, the drawing, also by Vernon Howe Bailey, showed a large and inappropriate complex within the bounds of the park. The extent of the proposed complex made the Metropolitan museum as it then stood appear diminutive. Borglum called himself an ardent park protectionist, but his megalomaniacal suggestions were City Beautiful ideals run amok, for they emphasized the creation of monumental architecture, unified planning, and the creation of cultural resources to the detriment of open parkland and even common sense. It comes as little surprise to read that the Mount Rushmore sculptor was often at odds with the Park Commissioner, and it was still less surprising that nothing came of his proposition.

The history of the Metropolitan Museum of Art encompasses both the early history and the mature development of the City Beautiful in the United States. Its placement in the first Olmsted-designed municipal park heralded a brief but indelible age of locating art museums within parks. The museum's change to a Beaux-Arts facade reflected the changing attitude toward city planning that was brought about by the City Beautiful movement. Although many of its ideals were ridiculed by the later "City Practical" planners, the City Beautiful movement attempted to bring museums into closer relation with the city generally by placing them in smaller, more formal parks and connecting them to the life of the city with specially designed boulevards. Although Borglum's proposal presents an extreme example, his scheme also helps illustrate why many of the City Beautiful plans were not implemented to the degree desired by their progenitors: they were imposing and expensive, and above all, they required a degree and concentration of power not possible in the free-form democracy of the developing American city. The partnership briefly formed by the City Beautiful movement and the art museums of more than a few cities affected not only the way the cities and the museums looked but the way urban denizens thought about the museum. The City Beautiful helped to give the art museum a mission of reform and improvement not only aesthetic but moral and spiritual. How the museum and the urban reform movement—closely linked to the desire for improvement manifested by the City Beautiful movement—made use of each other will be the subject of the next chapter.

4

The Art Museum as Urban Moral Influence

To great cities resort not only all that is eminent in talent, all that is splendid in genius, and all that is active in philanthropy; but also all that is most dexterous in villany, and all that is most foul in guilt. It is in the labyrinths of such mighty and crowded populations that crime finds its safest lurking-places; it is there that vice spreads its most seductive and fatal snares, and sin is pampered and festers and spreads its contagion in the greatest security. My friends, it is important that we should encounter the temptations to vice in this great and too rapidly growing capital by attractive entertainments of an innocent and improving character.

—William Cullen Bryant, speaking at the Union League (1869)

The right function of every museum, to simple persons, is the manifestation to them of what is lovely in the life of Nature, and heroic in the life of Men. . . . A Museum, primarily, is to be for *simple* persons. Children, that is to say, and peasants.

—John Ruskin, "A Museum or Picture Gallery" (1880)

At almost the same time that the father of the modern skyscraper, Louis Sullivan, intoned through his buildings that "form ever follows function," the great boom of classical art museum buildings was at its height, as if to contradict Sullivan's edict with their monumental architecture. Is this such a great contradiction? Perhaps not, if one consider that function is not scientifically determinable. Consider the art museum building. Although its ostensible function is the safe and convenient housing of works of art, there can be no doubt that the late-nineteenth- and early-twentieth-century arbiters of culture determined that the function of a museum entailed a great deal more than that. They would have said that the function of an art museum also included a kind of mental preparation for the viewing of the art inside; that the building, through its architecture, must also educate about the art of architecture, in some cases even the history of art; and that the look of the building should be a symbol of its function. All this has been discussed in previous chapters. But a review of a miscellany of sources—from the annual reports of museum trustees and the publications of the museums themselves, to newspaper articles, the proceedings of charity organizations, City Beautiful tracts, and the writings of urban reformers—indicates that a museum's function could also include being a spiritual and moral benefactor to the dwellers of the urban

area it served. How this was to be done involves the cooperation of thought processes of City Beautiful proponents and Progressive urban reformers.

The City Beautiful Movement and the Progressives

The City Beautiful movement arose as one response to the newly perceived problems of the urban environment at the turn of the twentieth century. The movement posited the comprehensive city plan as a solution to the aesthetic disarray of the late-nineteenth-century American city. It was proposed that classically styled architecture would enhance the atmosphere of the city and serve as a cultural signifier of "Civilization." As classical monument and as educational institution, the art museum served as an ideal icon of the goals of the City Beautiful movement. That the art museum was an integral part of the City Beautiful movement is amply documented through the literature of the movement, especially in the comprehensive plans engendered by the likes of Daniel Burnham, John Nolen, and Edward Bennett. The City Beautiful movement, however, with its emphasis on both physical and psychical improvement, comfortably slid into the Progressive movement in general, which aimed at urban reform not through grand-manner, comprehensive city plans, but through the improvement of the lot of both the average city dweller and especially the urban poor. The improvement of the situation of the urban poor was to be accomplished, in the Progressive ideology, via moral, religious, educational, and civic enlightenment. The art museum, both as institution and as architectural monument, had a vital role to play in the ideology of the Progressive urban reformer in all of these areas. In the eyes of the urban reformer, the art museum could uplift the urban denizen both morally and spiritually through the educational influence of the art it contained, as well as through the physical appearance of a well designed museum building. As art institution and as architecture, the art museum was both a practical device and a hopeful symbol to the turn-of-the-century interest in urban improvement.

The Plight of the City and the Progressive Response

The last decade of the nineteenth century awoke many to the rapidly worsening problems of the American city. The cities had grown phenomenally during the course of the nineteenth century, and the attendant ills of urban blight had grown commensurately. For the first time, Americans became aware of the effects of urban decay, particularly the slums, and began to write about what they perceived as the evil progeny of urban congestion: crime, alcoholism, prostitution, etc. An indication that even the government was interested in the problem was the 1894 report on *The Slums of Baltimore, Chicago, New York, and Philadelphia*.[1] This study accumulated information and statistics on the comparative numbers of liquor saloons and arrests; the proportions of men to women, native to foreign-born residents, literate people to illiterate ones; and the comparative earnings, rents, and health of slum dwellers versus the population of the city at large. The compiled information, scientifically organized into tables, revealed what the authors must have been expecting: that arrests and incidents of alcoholism were higher in the slums, that there were more immigrants in the slums than elsewhere, that illiteracy was higher and health poorer, and that the concentration of people per dwelling and acreage was appallingly high. This labor commissioner's report was primarily a statistical compilation.

The first significant contribution by an American individual to urban studies was Adna Ferrin Weber's 1899 book *The Growth of Cities in the Nineteenth Century*, which investigated for the first time, with a scholarly and objective eye, the causes and effects of urbanism, and possible remedies for its problems.[2] Weber looked first at the tremendous relative growth of American cities, which he correctly attributed to the rapid growth of transportation, industrialization, centralization, and commerce, pointing out that in the century between 1790 and 1890, the percentage of Americans living in urban conditions had increased from 3.35 percent to 29.2 percent, or about tenfold. In later chapters, Weber discussed "The Physical and Moral Health of City and Country," using an application of Social-Darwinist theories to argue that although insanity and suicide rates are a great deal higher in the city, "it is the concentration of population in cities which best promotes the process of bringing capable men to the front . . . the cities are the instruments of natural selection."[3] Although Weber prints the inevitable statistics on the higher percentages of saloons, prostitutes, crime, illegitimate births, and suicides and a lower percentage of churches in the city than in the country, he argues earnestly that the city is not necessarily a hotbed of immorality and vice but that these evils are "the penalty paid for progress."[4] Adopting an attitude contrary to his earlier Social-Darwinist stance, Weber concludes the study with suggestions for remedying the problems of the city with socialistic answers—"laws along the line of *personal welfare*."[5] He believes in private philanthropy as well as public supervision and legislation: "Not only complete drainage, paving, water-supply, inspection of food, etc., are required from the municipality, but also small parks, playgrounds, public baths and laundries, and a variety of other institutions."[6] With these suggestions, Weber falls squarely within the philosophy of the Progressive movement which was just then being born.

Toward the end of the nineteenth century, the Progressive movement transformed Populism into a movement more palatable to the upper-middle and middle classes.[7] Originally concerned with wresting power away from the big trusts and suspicious of labor organizations and urban bossism, the movement became transformed when it reached a more popular level. Progressivism fostered a sense of middle-class Protestant guilt and personal responsibility, inspired by the exposure of corruption and social ills by the muckrakers and eventually resulted in the urban reform movement. One of the most prominent and visible results of this movement would be the famed example of Jane Addams and Hull House in Chicago. Early civic reform was at least partially motivated by a kind of chauvinism, which implied that the European immigrants who were crowding the cities were themselves at fault for the conditions under which they lived. Poor moral and spiritual conditions were also often blamed, and the movement aimed its energies at the abolition of saloons, prostitution, and other similar urban vices. Nevertheless, Progressive urban reformers had a genuine desire to improve the lot of the urban poor, once they had been made aware of their situation.

The plight of the urban poor was not brought to middle-class consciousness by a statistician like Adna Weber, however. This feat was accomplished by the famous muckrakers Lincoln Steffens, Ida Tarbell, Upton Sinclair, and Gustavus Myers, whose specialty was the shocking exposure of the wretched conditions of the nation's slums. Possibly no exposé of slum living was quite so brutal as Jacob Riis's photography and one of the original muckraking works, his *How the Other Half Lives* (1890). With words and pictures, Riis, an immigrant himself, portrayed the truly horrific conditions of tenement life, where large, predominantly immigrant families shared single, windowless rooms, and whole tenement buildings lacked heat or plumbing.[8] The haunted, tragic faces of the people in his pictures and the squalid conditions in which they were found were eloquent arguments for urban reform.

Environmental Determinsim and the Urban Milieu

Riis, like most early reformers, was a believer in environmental determinism. He sincerely believed that the root of the social ills of the slum was slum conditions: over-built, ramshackle, filthy tenements and the streets they crowded. "In the tenements," Riis wrote in *How the Other Half Lives,* "all the influences make for evil."[9] The environment of the tenements, one of "actual darkness, moral and physical,"[10] could not help but pro-duce "young vagabonds, the natural offspring of such 'home' conditions."[11]

Other reformers echoed Riis's notions. A contemporary article entitled "Morality and Environment" asked:

> Must not the environment of the man—the things he hears and sees; the atmosphere of vice and virtue in which he lives—so control, govern or direct his thought as to gradually shape his brain, till the brain-product is in harmony with his surroundings? . . . Take, for example, a boy brought up in the slums around Tompkins Square, in New York City. From his earliest childhood he is of necessity familiar with all manner of wickedness; the best dressed women of his neighborhood are fallen women; the boys who have the most money to spend are those who lead vicious lives; the brightest house is the saloon. . . . Can a child spend his life amid such environment without being, both in body and brain, affected by it? For a child to grow up virtuous in such a locality is little less than a miracle.[12]

It was this sincere belief in the effect of the environment that led to the commensurate belief that improving the environment in which the poor lived would inevitably improve the lives of the people who lived there. The playground and parks movement was a natural offspring of this belief, which would also eventually extend its tenets to include the improving effect of the art museum.

Like Frederick Law Olmsted and his philosophical heirs, Riis believed wholeheartedly in the restorative powers of the park. Olmsted thought that the open spaces and natural scenery of his parks would have a calming effect on the "rough element of the city."[13] From 1860 until his death, however, Olmsted advocated large parks of a rural nature, whereas the new generation, constituting Riis and his fellow urban reformers, agitated for small parks and playgrounds to be cut into the dense fabric of the tenements. Riis argued for such parks so successfully that some tenement districts actually had small parks and playgrounds built in their precincts. Riis proudly wrote in *How the Other Half Lives* that the transformation "of Tompkins Square from a sand lot into a beautiful park put an end for good and all to the Bread and Blood riots."[14] Indeed, many Progressives saw the park as a way to improve the physical, hence moral, environment of the city. One parks and playgrounds advocate stated it this baldly: "Foul air prompts to vice, and oxygen to virtue."[15] Even park officials believed in the benefits parks could "confer on the masses, morally and physically."[16] A City Beautiful planner like Daniel Burnham revealed his philosophical kinship with the reformers when he argued for a Chicago lakefront park proposal with the assertion that "when a citizen is made to feel the beauty of nature, when he is lifted up by her, to any degree, the state, of which he is a part, is benefited thereby."[17] One indication of the importance of this concept and of the importance of art museums to the agenda of the urban reformers is the sugges-tion of one religious official, the Rev. Gustavus Bierdemann of Toledo, Ohio, that an art museum constitutes a "Winter Park for the community. When other sources of amusement and instruction are cut off from them by nature, they can always find the beautiful and wonderful things of nature in the museum."[18] The connection made between the art museum and the park is that of a mutual effect upon the physical and emotional health of the populace. The idea that an art museum could have as improving

an effect as the park was a fundamental aspect of the relationship between art museums and the Progressives.

The Art Museum, the City Beautiful Movement, and the Progressives

The art museum figures into the ideology of the Progressive era partly because the goals of the City Beautiful and those of the Progressives meshed so well.[19] The Progressive urban reformers had a vision of the city improved that contained many of the same elements as the plans promoted by architects and city planners of the City Beautiful. The Progressive concerns with morality, religion, education, health, and cleanliness complemented the concerns of the City Beautiful advocates. Both wanted the city to be a better place for all of its residents to live; both hoped to accomplish this via physical improvements. Both were motivated by the same interest in civic improvement and kept as their goal a vision of the city as it was described by Charles Mulford Robinson, one of the foremost City Beautiful advocates. Like many of the Progressives, Robinson likens the City Beautiful mission to a religious experience, namely the vision of St. John:

> The new day for cities has its . . . promise . . . in the light that, glancing on the dew-bathed flowers and grass of the people's parks, studs them with jewels as sparkling and as precious to a city as were the gems in the prophet's vision of the new Jerusalem.[20]

Compare this vision to that of one of the more histrionic reformers of urban evil, the Reverend Josiah Strong:

> The first city was built by the first murderer, and crime and vice and wretchedness have festered in it ever since. But in to the last city shall enter nothing that defileth, neither shall there be any more sorrow nor crying, for the former things shall have passed away. Shelley said: "Hell is a city much like London," but the city redeemed is, in the vision of the revelator, the symbol of *heaven*—heaven on earth—the Kingdom fully come.[21]

It is thus not only the Progressives who were motivated by a consideration of morality and religion; even the architecturally oriented City Beautiful concerned itself with these spiritual matters. Interestingly enough, both ideologies concerned themselves with achieving urban spatial order, and St. John's vision of the New Jerusalem, the heavenly city, was one of a supremely well-ordered, rationally designed urban environment.[22]

As one example of the relationship between the two movements, which eventually adopted each other's goals, methods, and concerns, consider the stated goal of a series on the City Beautiful in the *Bulletin* of the Brooklyn Institute of Arts and Sciences beginning in December of 1908. The articles printed in the *Bulletin* would, it was hoped,

> indicate in what ways in the future development of New York City unsightly, unwholesome and immoral conditions may be avoided and in what places the appearance, the healthfulness and the moral tone of the city may be improved.[23]

The City Beautiful in this instance is intimately related to the moral and spiritual aspect normally adopted by the Protestant urban reformers. Both movements related the appearance and physical environment of the city to the moral and spiritual well-being of the inhabitants. One reformer, indeed, endowed the physical condition of the city with such importance that nothing less than the moral health of the entire nation was at stake:

After all, though men make life, it is cities which make men. Whether our national life is great or mean, whether our social virtues are mature or stunted, whether our sons are moral or vicious, whether religion is possible or impossible, depends on the city.[24]

As a highly visible physical symbol, the museum would prove to be as useful a tool for the urban Progressive reformers as it was for the City Beautiful proponents, on both physical and spiritual counts.

Art as Moral and Spiritual Uplift

Museums assumed a primary importance for the Progressive impulse to improve the urban denizen morally, spiritually, and socially. Every aspect of the museum came to be transformed, if one were to believe the literature and commentary of the times, into weapons against urban decay. Both the art that was inside and the architecture of the museum itself could be perceived in this manner. This could occur because of the nearly universal idea that every soul longed for beauty and that beauty itself had a spiritually restorative effect. This belief pervades much of the reform literature of the time and filtered down into the popular press and even the literature associated with the museums. It was this belief that beauty could provide moral uplift that allowed museums to partake so thoroughly of the Progressive-based urban reform movement.

An excellent example of this belief is furnished by one of the many publications that resembled Riis's in the shocking revelations provided to the reader about the conditions of tenement life in the city. Helen Campbell's *Darkness and Daylight; or, Lights and Shadows of New York Life* (1895) provided highly descriptive vignettes to enlighten the reader about the horrors of the slums. Like her fellow muckrakers, Campbell inserted true-life anecdotes and personal stories to foster a sense of intimacy, immediacy, and guilt. Campbell went on, however, to recite some examples of the inroads being made by urban reform programs. In a section of her book entitled "Taming the Little Vagabonds," she detailed the effects accomplished by the Fresh Air Fund and the Flower Missions. The Flower Missions provided potted plants to the children of the tenements and cut flowers to crippled and ill children, as well as prisoners. Campbell's stories "proved" the healing effects of beauty when she described how "little savages of the district carr[ied] a plant more carefully than they did the baby entrusted to their care;"[25] or when she related the tale of the intractable and somewhat terrifying "Long Sal," imprisoned in the "Tombs" of Ryker's Island, a "thief, drunkard, fighter, and general disturber of the peace," who turned around her life as the result of the influence of a "baby geranium." So powerful was its effect that "she is no longer a terror, nor is she alone in the experience which bears witness to what power dwells in beauty."[26]

Not solely beauty as it generally resided in nature but especially beauty as it was embodied in the arts—painting, sculpture, architecture—was believed to have an uplifting effect. Stories abounded that described how a work of art could change a poor person's—especially a child's—life. One story, told at the opening reception of the Montclair Art Museum in New Jersey, recounted the experience of Larry, an "Irish lad" in Chicago, who enjoyed the pictures hung in his school by the Public School Art Society so much that when he had to change schools, he "sat for days in listless gloom." When asked why, he said that he was homesick for his old school, because "the pictures we had there, . . . they made the hours bright." This anecdote was proof of just "how instinctive is the love of beauty."[27] It also "proved" that art had a positive effect on poor and immigrant urban youth.

The arts were also considered to be uplifters of society in general—not only of individuals. The "positive power of art" was an article of faith for many writers and observers of the period. An eloquent argument was presented by one author who lauded the artistic success of the Panama-Pacific Exposition in San Francisco in 1915:

> Consider how in any age or land where the expert expression of beauty—which is art—is not honored and practiced: houses are ugly, clothes are worse, utensils, tools, furniture and all so-called "decorations" are inadequate, unshapely, and inferior, and cities are mean and gray, and life itself is sad, and slow, and stupid. And then consider how all these conditions are reversed when art is honored and practiced with love and devotion. Add to these reflections the further one, already stressed above, that life in these United States will from now on be profoundly modified and influenced in all directions by the artistic beauty of the Panama-Pacific Exposition, and layman and critic will agree that art is a practical, immediate interest, and not an esoteric cult for high-brow men and women's clubs.[28]

The idea that art was a powerful influence for good in all aspects of life was a convincing persuader for the usefulness of art museums to a community.

A more specific example of how the art museum itself, as repository of such life-improving beauty, could improve the conditions of the urban poor was provided by one of the "friendly visitors" sponsored by Associated Charities, a Protestant, Progressive organization. The "friendly visitor," as the name implied, regularly visited a poor family; the idea was that the refining influence of an upright, middle-class woman would inspire the poor, immigrant family to cleanliness, good manners, thrift, and other desirable virtues. In one anecdote, the friendly visitor and the art museum changed the life of one unmanageable boy:

> There are visitors who keep to their own simple and natural ways with their poor as they do with their well-to-do friends. One of these visitors, an artist, took an unruly boy from one of her families to the Art Museum. In the same charming spirit with which she entertains her society friends, she cultivated the artistic imagination in this boy. When he went home, he could not begin again slashing up the furniture with his pocket-knife or beating his younger brother; for on every pine chair and table, as well as on his brother's jacket, arose visions of a soldier's camp-fire at sunset, of a cardinal in his crimson robe of state, of three boats sailing out into the moonlight. He soon became a good boy.[29]

Like the story about the boy in Chicago, this story is another "proof" that art, and the experience of the art museum, had the moral power to reform and uplift the lives of the urban, immigrant poor. Although the tone adopted by some of these reformers sounds saccharine and somewhat repugnant today, they sincerely believed that their efforts could cure what they saw as laziness and moral weakness and that providing a better environment as well as education and spiritual uplift could raise the poor out of their degradation (as they saw it) and improve their lot in life.

Art Museums, Religion, and "Temples of Art"

The urban reform movement was founded upon a religious ethos mainly Christian and Protestant. Many critics and observers of urban life at the turn of the century noted and bemoaned the lack of churches in the city. Statistics comparing the number of churches to the number of saloons were frequently cited as evidence of moral decline in the city. Many religious movements of the period attempted to remedy this deplorable lack; such movements included the Sunday school movement, the heyday of the Young

Men's Christian Association, and the great expansion of the charity organization move-ment.[30] Nevertheless, critics like the Rev. Josiah Strong or Benjamin Flower, the latter in *Civilization's Inferno* (1893), ranted about the spiritual decay of the city and lamented the spiritual doom of the average city dweller, prophesying the nearly inevitable damna-tion of the slum denizen.[31]

During this perceived spiritual crisis, the art museum began to form a curious rela-tionship with the religious aspect of the urban reform movement. In a sense, the art museum came to be seen as an accessory to religion. On a formal level, the institutions received their blessings from religious officials; on a more informal or subconscious level, the museum was seen as an appropriate place to transfer aesthetic feelings into religious ones. The idea was that art was spiritual and divinely inspired; hence, the contemplation of art could improve one's spiritual self. This idea was constantly rein-forced by the references to the Greek architecture of many museums through their appellation as "temples of art."

At most museum dedicatory exercises, religious officials were present to give their benediction upon the institution and its new building. Many of them commented on the divine nature of art and the assistance the museum could give to the religious life of the community. One eloquent example was provided by the Bishop of Toledo at the opening of the Toledo Museum of Art. His invocation read in part:

Edward B. Green. Toledo Museum of Art, Toledo, 1909–12. Photo: author.

In Thy wonderful creation Thou didst erect the first and most perfect temple of sublimest beauty and grandeur and madest all the arts to minister therein, that by the things that are visible we might clearly see and understand the invisible things of Thy being and majesty, Thy eternal power also and divinity.[32]

The metaphor of God as first architect is a very old one; Byzantine icons have portrayed God with a compass, as architect of the world. In Toledo in 1912, the bishop extended the metaphor to call God the first painter and sculptor as well. The bishop's prayer put the religious stamp of approval upon both the building—which at Toledo very much resembled a Greek temple—and the art it contained. Similarly, at the dedication of the new Minneapolis Institute of Arts building, the Rev. John Bushnell blessed the "fair temple" designed by McKim, Mead, and White, praying:

May it [the museum] be an abounding source of true enlightenment and inspiration to all who may share its privileges and grant that with all its purposes of earthly good accomplished, it may be so ordered of Thee in all things as to lead the hearts of Thy children through its paths of beauty from nature up to Thee Who art nature's ever glorious and adorable God.[33]

It is clear that both of these religious officials hoped that the museum would be an aid to religion. Their line of reasoning was logical and direct. Art imitates nature, and nature is God's creation; hence, the study of art can be transformed into a religious act. A sermon given at a Congregational church around the time of the opening of the Toledo Museum of Art made specific the relation between God and art. The title of the sermon, "The Message of Art and Its Relation to Religion," indicates the line of reasoning taken by the pastor, George Wallace. He claimed that "one of the mightiest means of teaching religion is through paintings." This was because "God is the greatest artist in the world, and the great artist merely puts before man on canvas that which he knows that God has put in to the world." As for the art museum, the citizenry of Toledo, he said, "should thank God for any influence that will help uplift men in a city where there is so much to pull them down. . . . People absorb art and in doing so are made better citizens."[34] Wallace made the direct connection between museums, art, and urban reform. Another pastor in Toledo, the Rev. George Gunnell, went so far as to say that those who had been present at the opening night of the museum, "came away with an impression of the holiness of beauty."[35] If the art within was holy, then the museum could act in much the same manner as a church, the great moral guide of the city.

Not only religious officials saw the museum as an accessory to the religious life of the community. In 1896, at the laying of the cornerstone of the Brooklyn Institute of Arts and Sciences, the director of the Institute spoke on "The Purposes of the Institute." The museum, he said,

should prove of inestimable value to other agencies for education and inspiration in our midst. . . . As science and art are "the handmaids of religion," it should have its influence in strengthening every religious organization in our city, and in deepening the religious life of every human soul.[36]

Lay observers, too, sometimes saw the opening of an art museum as an event of quasireligious significance. On the occasion of the opening of the Carnegie Institute in Pittsburgh, one local weekly paper published the following enthusiastic revelation:

Truly Pittsburg's [sic] Promised Land is in plain sight. For twice forty years there had been weary wandering through the wilderness of utilitarianism behind pillars of smoke by day and

of fire by night. But the Pittsburger of the present can stand upon the Schenley Park Pisgah and look confidently to the new era wherein men shall come from afar to receive the benefits here available; to be perfected in music and in painting and in the sciences; to sit, in fact, at the feet of the once contemned and smoky Gamaliel, and to learn that, through Carnegie, good can and has come out of this Nazareth of mills and workshops.[37]

Very much like the religious officials who saw the museum as an aid to religion, so did other hopeful reformers, both within the museum community and without, believe that the art museum could bring the visitor nearer to God through the study of art, and thus ultimately create better citizens through such revelations.

The belief that a trip to the art museum could foster a closer relationship with religion was frequently emphasized by the oft-repeated notion that the classically styled art museum constituted a "temple of the arts." The concept was further strengthened by the many references made to the process of "worship" that occurred on the visit to the "temple." Thus, in Buffalo, the "Greek temple" of the Albright Art Gallery was described as "a marble palace consecrated to the worship of the beautiful."[38] Another observer defined the building's "lofty purpose—to become a temple of art, in which the gospel of beauty shall be perpetually exemplified and the spirit of art shall find its truest, best expression."[39] Similarly, upon the opening of the new building of the Museum of Fine Arts, Boston, one journalist described the appropriate reverence with which one should approach and enter the museum:

There is fine reverence for the high and pure spirit of art in it all and one feels that this is, properly speaking, a temple of art, rather than a museum—a place wherein the spirit of worship is more appropriate than the spirit of curiosity which is satisfied with a momentary sensation.[40]

Although the term *temple* was the one most frequently used to describe the museum building, and thus a pagan rather than a Christian term, the language used in conjunction with that term—*worship, reverence,* and *gospel*—indicated the connection in many minds between (Christian, primarily Protestant) religion and the art museum.

Art Museums and Sunday Openings

Perhaps no other issue concerning the art museum aroused so much controversy and religious fervor as that of the Sunday opening. Whether or not to keep the museum open on Sundays was an issue hotly debated in many cities: Boston, New York, and Washington, among them. Boston newspapers reported fervent debates when the Museum of Fine Arts made its decision to open on Sundays.[41] In May of 1891, the Metropolitan Museum of Art in New York opened the museum on Sunday for the first time. The decision alienated a number of the museum's supporters, to the extent that a fifty thousand dollar bequest was withdrawn.[42] The issue up for debate was whether or not a visit to the museum constituted an appropriate excursion for Sunday, a day relegated to religion. At the time, stores were never open on Sundays and naturally saloons were not either. There was more than simply the issue of museum opening at stake. The issue had a great deal to do with class demarcations, for the working class did not have Saturdays free, and therefore, Sunday was the only day on which they could visit a museum.

The problem was extensively discussed in relation to the World's Columbian Exposition in Chicago, which included the Fine Arts Palace among the exhibits. Traditional

and conservative religious elements argued that the fair was a secular event and, there-fore, should be closed on Sundays. Many, including some religious officials, contended that Sunday above all days was when the fair should be open, so that members of the working class could attend. As historian of the fair Reid Badger points out, "the thinly disguised attitude that lay beneath these arguments for keeping the fair open was that the working classes were in the greatest need of spiritual and educational lessons."[43] Perhaps so, but the earnest desire of many supporters of the Sunday opening was simply that the broadest variety of people could come to enjoy the fair without penalty and that to deny them any benefits—whether educational or simply recreational— they might gain would be inhumane. At a feast commemorating the completion of the construction at the fair, one speaker spoke eloquently on behalf of Sunday openings:

> Humanity and Christianity demand that the laboring element shall have a chance of seeing the exposition without suffering pecuniary loss. Education demands that all shall be allowed to absorb knowledge. True religion does not bar any gates that lead to the harmless acquire-ments of benefits, and benefits which broaden civilization, heighten ambitions, and strengthen purposes should not be denied. The demands for an open Sunday fair come from all sides. And in the name of God, of peace, and of religion these demands should be granted.[44]

The argument that the working classes had the most to gain from Sunday openings was repeated during controversies over other museums' opening their doors on Sundays. Certainly, the concept that the study of art could be part of a religious experience bolstered the arguments of those who were in favor of Sunday openings at the fair, for one of the major attractions of the fair was the Fine Arts Palace.

The appealing combination of pseudoreligion through art and kindness to the work-ing class informed the 1897 opening of the Corcoran Gallery of Art in Washington, also in that year newly opened on Sundays. The trustees marked the inauguration of the new building with the new rule—as if they were confirming in concrete terms the enlightened architecture of the building with an enlightened approach to its clientele. A journalist commented that, had the Sunday opening been tried ten years earlier, "such an innovation would have been received with cries of indignation [as had indeed happened in New York only six years earlier], and a dire fate would have been predicted for the men who countenanced it." Instead, the move was received with praise on behalf of the "much-exploited 'laboring class.'" This observer took great pleasure in reporting the following anecdote as proof of the great good of opening the gallery on Sundays:

> A little girl, some twelve years old, frail and thin, with big, hungry eyes, showing in her tidy dress unmistakable evidence of that poverty known as decent, grasping the hand of a middle-aged man, her father evidently, who was somewhat ill at ease in his well-brushed Sunday clothes, but whose face wore a holiday air, stood entranced before that very creditable picture, "A Swedish Holiday."
> "Oh, dad," said the wee maiden, with a long sigh of pleasure, "why did you never bring me here before?"
> The man smiled a bit sourly. "'Cause tain't never been opened of a Sundays before. Church's good enough for we workin' people. We don't need pictures; them's only fer rich folks."[45]

Despite the condescending tone audible to the modern ear, the commentary makes clear that the author genuinely thought that the Corcoran's policy was a good idea. Not only was the Sunday opening the right thing to do for the working class, and not only did some religious officials sanction art as a path to God, but as a "much traveled gentleman" visitor to the Corcoran remarked, "This is the most educating thing in the world."[46]

Art Museums, Universal Education, and Progressive Era "Socialism"

The educational aspect of museums was naturally one of the most appealing qualities of those institutions in the eyes of Progressive urban reformers. Although religion was very important to them, the period also saw the great era of public school reform. Education for all was one of the most important goals of the Progressives, because they believed that education was the key to lifting the urban poor out of poverty and making them prosperous, participating citizens. The pedagogical function of museums was one seized upon by many museum supporters who wished to confirm the value of the museum in an era so concerned with universal education. An early history of the Baltimore Museum of Art states that "it must be recognized that a museum of art is essential to any educational system which aims at the full development of the individual."[47]

City Beautiful proponent Charles Zueblin praised the cooperation between museums and other educational institutions in a statement that defined the museum as an educational institution:

Not the least of the contributions of the best public libraries to the diffusion of a fraternal sentiment is the growing co-operation between library and public school and museum, whereby the ablest educators of the community are uniting in the unification of the best public educational institutions in the service of the people.[48]

As Zueblin's observation makes clear, however, perhaps the most important part of the educational conception of the museum was not alone that it was educational but that it constituted education for the masses. This aspect is naturally related to the idea that the museum should be open to people in all walks of life, including the laboring poor.

In his work, Zueblin praises socialism as a cooperation between private and collective interests for the improvement of the city.[49] Although a true, government-sponsored socialism was not generally espoused by the urban reformers, a socialistic atmosphere emerged in which the emphasis was on improvement for the benefit of the "masses." That the goals of nineteenth-century socialism and the City Beautiful movement could easily unite was heralded by a book predating the City Beautiful movement, Edward Bellamy's *Looking Backward—If Socialism Comes, 2000–1887*. Written as fiction, the book employs a Rip Van Winkle device for its hero, a Bostonian from 1887 who awakes in the year 2000 to find a thoroughly socialist system in place. Its most noticeable physical result is the very first thing with which the hero becomes acquainted. When he will not believe that he has awakened in the year 2000, he is shown the view of the city. What he sees, instead of the Boston of 1887 that he knew, is

a great city. Miles of broad streets shaded by trees and lined with fine buildings . . . stretched in every direction. Every quarter contained large open squares filled with trees, among which statues glistened and fountains flashed in the late afternoon sun. Public buildings of a colossal size and architectural grandeur unparalleled in my day, raised their stately piles on every side.[50]

Beautiful architectural surroundings and a great deal of public art were essential to Bellamy's conception of the socialist city. A certain amount of this notion was adopted by turn-of-the-century urban reformers of both the City Beautiful and the Progressive ilk.

The socialist attitude as it was exemplified by the Progressives was more of a social or cultural attitude than a governmental one. That is, for most Progressives, the extent to which they embraced Socialism really encompassed only a more enlightened sense of

"democracy," which included the poor and working classes. Socialist- or democratically-minded proclamations about art for the masses abound in City Beautiful publications, in literature published by and about museums, and in reform literature as well. For example, a 1902 City Beautiful article in *Century Magazine* reflected upon the growing tendency toward municipal improvement as proof of "the development of a more beautiful life for the people at large. The love of the beautiful probably exists in every human being, and, in some shape, strives for expression."[51] If the beautiful was for everyone, then so was art, and by extension, the museum as well. As early as 1896, Ernest F. Fenollosa upheld a democratic ideal for the museum, for which he eloquently argues in a piece entitled "Art Museums and Their Relation to the People":

> Beauty [is] no monopoly of the few, but the heritage of all mankind. . . . Art should therefore be the highest and most popular concern of the State. . . . Art education in our public schools, in our civic life, is a duty we owe especially to the poor, the children of the laboring classes. It is for them that we found our art museums.[52]

Fenollosa maintained that art education was absolutely necessary for educating the poor. The alternative, he wrote, was an "arctic winter of evil social condition which stunts us into pygmy firs."[53]

The idea that the art museum could help the poor and remedy "evil social conditions" arose quite early in the great era of museum building. Even before most of the great museums were built, Frederick Law Olmsted and Calvert Vaux wrote in 1866, concerning such educational institutions as museums, that they believed a system of popular education was not only desirable but that it represented a "saving to the tax payers through a reduction of taxes for courts, police, prisons and poorhouses."[54] When the Brooklyn Institute of Arts and Sciences was established in the portion of Prospect Park designated for the purpose by Olmsted and Vaux, the museum's founders stated their hopes that the museum would serve as an educating and uplifting influence for those in need of charity, the poor:

> The masses of people in our great cities need mental and moral elevation. Many are already reached by beneficent and intelligent charities. But the ways of charity are infinite, and who will say that fine works of art, collections in natural history, exhibitions of applied science, may not be a source of help, when all other influences have failed.[55]

Likewise, in 1888, in a speech inaugurating the new Metropolitan Museum of Art building in New York, Henry Marquand declared, "From these halls will spread into homes, into workshops, factories, commerce, the refining influences of art, . . . knowledge of beauty and desire to possess it. Here the poor will be happy."[56]

Art Museum Architecture as an Expression of Democracy

In Boston, too, as Neil Harris points out in his article on the founders of the Museum of Fine Arts, the museum was built around a desire to provide art education not only for the social elite but for a more popular audience as well, and it was to serve broadly educational functions via the purchase and exhibition of reproductions, including casts.[57] When the museum's new building opened in 1907, many observers praised the thought that went into making the design of the building "democratic." In an article in a popular journal, the *Atlantic Monthly*, the museum was praised because its plans "primarily represent the novel idea that an art museum should serve, not the student

but the general public."[58] This statement probably refers to the separation within the museum of the choicest examples of the collection being given prominence to the casual visitor, and the study collections—previously always on display—being relegated to the basement floor study areas. The idea that the architecture itself was democratic was repeated by a journalist who admired the great staircase of the main hall, writing that "it sounds the keynote of the whole structural idea, that of ample welcome, broad accommodation for all sorts and condition of men and women."[59] The idea once again seems to praise the museum's emphasis on the casual visitor, elevating him or her over the specialist and scholar who must *descend* to see the study collections, whereas the uneducated visitor makes the grand *ascent* to the collections, housed in the museum's *piano nobile*.

The idea that the architecture of a museum could represent the democratic philosophy of the institution it housed was repeated by critics of the Toledo Museum of Art. An article in *Art and Progress* commented that the building was "so . . . appropriately designed that it conforms perfectly to democratic requirements. It is above all an institution for the people by the people."[60] Similarly, when the president of the Art Institute of Chicago, Charles Hutchinson, spoke at the dedication of the Minneapolis Institute of Arts building, he urged the trustees to conduct the museum "along the broad lines of democratic culture. You will make everyone who enters its doors feel at home."[61] In this interpretation of the museum's physical embodiment, the act of entering the building is transformed into a civic, democratic act, and once again the idea is that the building itself is designed with "democratic requirements" in mind.

One more indication of the perceived relationship between the architecture of art museums and fin de siècle interests in democracy is the favored style for art museums: a "purified" Greek style. Charles Atwood first explored the style for the Fine Arts Palace at the World's Columbian Exposition. His lead was followed most actively by Edward Green in art galleries at Buffalo, Toledo, and Dayton. Temple forms abounded in the genre, from Boston to Minneapolis, however, and the attraction of the style had a great deal to do with its perceived appropriateness to the function of the art museum, which was one of high seriousness of purpose. There can be little doubt, however, that yet another facet of the appeal of the style had to do with its symbolic representation of one of the most potent symbols of democracy for Americans: ancient Greek civilization. The frequent references to art museums as "temples of art" cannot have been separated from a broader concept of democracy engendered by the advent of the Progressive movement.

The idea that the museum was an essential participant in American democracy may also account for the extensive and frequent newspaper coverage of museum events, especially the building and opening of new museums or new museum structures. The "fourth estate" in the United States was always very concerned with democracy and keeping the public of all classes informed. The newspapers reveled in the muckraking of the Progressive era, exposing the corruption of big business and city government. It comes as no surprise, therefore, to read a statement made by a member of the press that explains the relationship between democracy, museums, and the press. In Toledo, a member of the press made a speech concerning "The Press and the Museum," wherein he explained,

> The special mission of the press is to give the museum a broader application: to put the minds of the people in touch with their opportunity and to arouse them to the significance of the opportunity, so that the institution shall become the right of every man, woman and child in the community, without regard to their station in life. The ideal condition will have been reached when the humble people will have been placed in touch with the highest concep-

tion of the brightest minds in the world. It is the ambition of the press of Toledo to make the museum of art the heritage of the people.[62]

It is presumably thanks to this attitude that there was ample coverage of and commentary about museums in the press at the time and that from the newspapers we can come as close as possible to gauging the attitude of the general public toward the museum.

The idea of the museum as a democratic institution was a very important one to many museum officials as well. The keynote address at the inauguration of the new Toledo Museum of Art building was delivered by the Chicago museum's ubiquitous president Hutchinson. The subject of his speech was "Art and Democracy," and it concentrated on the essential points embraced by proponents of museums as instruments of social reform. These points were, namely, that "There is nothing more democratic than beauty. There is nothing more closely allied than beauty and Art."[63] In order to prove his point, Hutchinson repeated the religious notion that "the true mission of Art is to discover and represent the ideal" and that "God teaches and leads us through our imagination."[64] He discussed the history of art in ancient Greece (once again, a potent symbol of democracy), declaring that we should learn from the Greeks that art should be "the fusion of the ideas of the beautiful and the good."[65] Finally, he made the logical circle complete by reasoning that as "Art aims to express the ideal," it can therefore serve as "instruction [for the] people."[66] Hence, the Toledo museum, with the collection of art within its walls, serves as a "magnificent building for the pleasure and education of your citizens."[67] The museum building should be a place as democratic as the city park "where every citizen from the highest to the humblest shall feel at home. Let them come here and use its galleries as freely as one breathes the air and enjoys the sunshine in your parks."[68] As the Toledo Museum of Art subsequently made as part of its mission the education and involvement of the schoolchildren of Toledo, it seems that they took to heart the exhortations of the president of the Chicago art museum. Thus, the very architecture of the Toledo museum was felt to embody the democratic ideals of universal art education.

There were many writers who felt that art education was necessary to save society from not only aesthetic but also social ills. Consider again the journalist who wrote that in a society without art, "life itself is sad, and slow, and stupid." It was thought by many that the art museum was "a place from which will emanate aesthetic and educational influences capable of producing a strong and enduring reaction against the vulgar and clamorous tendencies of the day—influences that only beauty can generate."[69] The reasoning seemed to be that if the museum could reach out to as broad a spectrum of people as possible, then its influences toward the beautiful could not but help to affect these people and improve their lives and hence the atmosphere, even the quality of citizenship, of the entire community. As was written about the Toledo Museum,

> Few people realize how extensively the museum has entered into the intellectual life of the city. Its influence permeates the school; it reaches out for the uplifting of countless homes; it enters the shops and factories, contributing to the education and directing the profitable pleasures of a great host of people to whom, consciously and unconsciously, it is an actual need: it is a great constructive element in our civilization, making daily better men and women and through them conferring its blessings upon the children—in a word, creating, year after year, a better citizenship.[70]

We thus arrive at the heart of the position of the art museum in the ideology of the related goals of the City Beautiful and urban Progressive reform. Both movements attributed to the museum, not only as receptacle of art but also as structure and as

architecture, the power to exert order over chaos, to give the urban milieu a beneficent, socially stabilizing overseer. This power was considered particularly potent when combined with a city plan, but even without one, the art museum as good architecture was seen as powerful facilitator for urban social and moral reform.

The Educational Institution as Urban Reformer

The museum as institution was endowed with such improving and reforming powers with great frequency. President McKinley himself espoused such a belief, which he expressed during his visit to the Carnegie Institute upon its opening in 1897. He said that "library study" and the "cultivation of art," made possible by the institution endowed by Andrew Carnegie, "make a better citizenship, and in so doing constitute an impregnable bulwark for law and order."[71] In contrast, therefore, to the perceived eroding effect on morals and citizenship that a saloon or brothel would have, the museum was perceived as an institution, like the church, with an ability to positively effect an orderly, law-abiding citizenry. In a similar vein was the proclamation of the City of Buffalo, thanking John Albright for his generosity in establishing the Albright Art Gallery. Signed by the mayor of Buffalo, the resolution stated that "the City of Buffalo appreciates that the establishment of such an institution is a most potent factor in the betterment of mankind and is destined to aid greatly in the ultimate improvement of our citizenship."[72] Once again, elected officials appeared to perceive the museum as a beneficent influence on a presumably impressionable citizenry, somewhat akin to a passive police force. Inspiring good behavior, it was hoped, the museum could by its very existence improve the morals and hence the citizenship of those who visited within its walls. During a time of great trepidation about the fate of the city, a time when the fear of rioting and anarchy was a genuine one, the hope that an art museum could make better citizens and even contribute to law and order must have been highly seductive.

City Beautiful Planning and the Slums

It was not only the art museum as an institution that provided urban reformers with such hope. The architecture and concomitant urban planning of the City Beautiful were also perceived as aids to better urban citizenship. As has already been shown, the art museum took a vital part in the City Beautiful program through both architecture and planning. The belief that good architecture could uplift the community is integrally related to the belief in environmental determinism espoused by the likes of Jacob Riis. Whereas the tenement houses of the slums provided a negative influence, good architecture could provide a positive one. Riis's *How the Other Half Lives* is suffused with the belief that bad architecture—in the form of crowding, lack of necessary conveniences, and poor maintenance—fosters poor social conditions and depresses positive human behavior. For example, Riis uses the image of the decay of a once-proud house (i.e., a single-family home turned into a tenement) as a symbol of the physical and moral decay of the people living inside. Once the house was well-maintained and lovely, but now the steps are worn away, and the "broken columns at the door have rotted away at the base." The house may once have been the residence of a happy family, but now "dirt and desolation reign in the wide hallway, and danger lurks on the stairs."[73] The language Riis uses to describe the tenement houses consistently links bad buildings to bad human beings. In Riis's vernacular, it seemed that the tenements *caused* alcoholism, crime, un-

employment, and disease. The overriding message is of the powerful influence of physical surroundings to affect directly the behavior of those who must come in constant contact with it.

The perhaps obvious solution to curtailing the evil influences of the tenements was their eradication. Riis ardently campaigned for the razing of the infamous tenement housing in the New York City area known as the Bend. He succeeded to the extent that the Bend became a park in 1897. In his approach to the cure for slum areas, Riis actually had a great deal in common with City Beautiful proponents, who may have preferred to discuss and plan grandiose civic centers, but who were also forced to consider the problem of the slums.

As the City Beautiful movement held up as its greatest model for urban improvement the Paris of Napoleon III and Baron Haussmann, so did Riis. He ended *How the Other Half Lives* with this lamentation: "New York has its St. Antoine, and it has often sadly missed a Napoleon III to clean up and make light in the dark corners."[74] Haussmann, Riis, and American City Beautiful proponents all advocated a similar bulldozing approach to slum districts. Daniel Burnham's *Plan of Chicago* is an excellent example. In this seminal City-Beautiful treatise, Burnham sets forth the urban planning techniques of Baron Haussmann as the best possible model. "Paris," he wrote, "has reached the highest stage of [urban] development."[75] He provides an overview of Paris's urban history, pointing out that by Napoleon Bonaparte's time, the heart of the old city consisted of "dirty, crowded, ill-smelling, narrow, winding streets, the hotbeds of vice and crime."[76] Like Riis and other environmental determinists, Burnham saw the crowded, irrational plan of the slums and downtown districts as a direct cause of urban moral and social decay. It was Georges-Eugène Haussmann, under Napoleon III, however, who "accomplish[ed] the great work of breaking through the old city, of opening it to light and air, and of making it fit to sustain the army of merchants and manufacturers which makes Paris to-day the center of a commerce as wide as civilization itself."[77] How was this accomplished? By the same methods that Burnham so ardently advocated: "by cutting new streets and widening old ones, by sweeping away unwholesome rookeries, and by opening up great spaces in order to disengage monuments of beauty and historic interest."[78] It is clear that Burnham saw the City-Beautiful style city plan, with its broad avenues and formal parks, as an obvious and necessary solution to the problems of the slums, those "hotbeds of vice and crime."

It should also be pointed out that another point of similarity between Burnham and Haussmann was one of the reasons for which the creation of wide boulevards seemed so desirable. For Napoleon Bonaparte and his successors, a clear danger was presented by the irregular and narrow streets of old Paris. During times of revolution and popular uprisings, these streets could and had been barricaded by its outraged denizens. A boulevard a hundred feet or more in width is practically impossible to barricade; it is fruitless to attempt if the street cuts through the city from one side to the other, so it would have to be barricaded twice in order to be blocked off effectively. Also, a wide street provides a second advantage to the power in charge: troops can be moved easily into and through a city made accessible by the swath of a broad boulevard. They cannot, on the other hand, be maneuvered through the narrow, winding streets typical of ancient and unsupervised urban development. Haussmann's style of city planning presented a tactical solution to an actual military threat dealt with in the past by rulers of France.

It should be noted that Daniel Burnham and his American contemporaries faced a similar threat, not as extensive as the French Revolution, certainly, but just as real and threatening to upper- and middle-class Americans accustomed to and desirous of order.

The late nineteenth century saw a number of urban uprisings that turned into riots and engendered violence, and Burnham's Chicago had faced the worst of them. Violence had erupted in eastern cities following the national rail strike of 1877, and numerous walkouts and strikes resulted in violence thereafter, culminating in the infamous Haymarket Square bomb explosion.[79] These incidents proved to planners like Burnham that there was a clear and present danger from rioters, and they proposed an architectural solution, as Haussmann had for Paris. By clearing out the slums and replacing the irrational plans and congested areas with broad streets and rational, orderly urban planning, City Beautiful planners hoped to eradicate the perceived threat posed by the slums. As Jacob Riis himself attempted to prove, the clearing of a tenement district in New York was, according to his view of things, the solution and the end to the "Bread and Blood" riots.

Burnham does in fact briefly consider the problem of Chicago's urban poor and their slums. He describes one slum district as in need of "thorough transformation." There, he writes, the air is contaminated with the smoke and soot produced by railroad yards and river traffic. Garbage collectors and tanneries increase the vile odors, and the operation of the coal docks adds to the dust and noise. He makes a brief—and somewhat denigrating—allusion to the largely immigrant population that must live "amid surroundings which are a menace to the moral and physical health of the community."[80] Too long a residence in the slums, he warns, will require the wholesale removal and relocation of "men and women so degraded by long life in the slums that they have lost all power of caring for themselves."[81] He proposes that the intolerable conditions be improved via "remorseless enforcement of sanitary regulations which shall insure adequate air-space for the dwellers in crowded areas, and absolute cleanliness in the street, on the sidewalks, and even within the buildings."[82] But first and above all, Burnham recommends the best solution he knows: "The remedy is the same as has been resorted to the world over: first, the cutting of broad thoroughfares through the unwholesome district," thereby inevitably eliminating great swaths of it, as had been done in Paris and as Riis had also advocated for the tenement districts in New York.[83] Whereas today this bulldozing approach seems simplistic and perhaps even ludicrous as a remedy to the causes of poverty, to turn-of-the-century urban planners attacking the problem for the first time, the solution seemed logical.

City Beautiful Planning as Urban Reformer

When in possession of an environmentally deterministic vision, a reformer must believe that the simple elimination of a "bad" environment will necessarily improve the physical and moral outlook of the local residents. This philosophy was what might be called negative environmentalism. It went hand in hand with the converse, positive environmentalism, which was a belief that replacing a bad environment with a good one could lead to spiritual and physical improvements.[84] There are many indications that proponents of urban reform—physical or social—believed in this positive environmentalism; i.e., they espoused good architecture and urban planning as agents capable of providing positive social benefits. They believed, first, that the order and logical clarity of a well-designed city plan could itself bring about harmony and order among the citizens who lived there.[85] Advocates of city planning and the City Beautiful held up their favorite device, the monumental grouping of public buildings, as a potent agent of civic harmony. Edward Bennett, close associate of Daniel Burnham and one of the most important of the early city planners, referred to the grouping of public

buildings as a beneficent influence capable of conferring order upon a disorderly society. A plan for several centers of public and semipublic buildings within a city would, he claimed, "have the advantage of reasonable concentration, a plan that will be of public benefit and will wield the influence so paramount in these days of orderly and harmonious arrangement."[86] Bennett posited the very clarity of a city plan and the grouping of monumental and well-designed public buildings as an instrument of urban social reform.

Another City Beautiful advocate would take Bennett's concept one step further by arguing that the unification of architecturally imposing public buildings into civic centers would also help construct a unity of feeling among urban denizens, especially those most in need of becoming unified with the established culture of the cities, namely, the immigrants and the working class. As previously discussed, the immigrant population was of great concern to urban reformers and City Beautiful advocates alike. The huge influx of European immigrants, especially from southern and eastern Europe, was most frequently blamed for the creation of the slums and the attendant problems of crime, alcoholism, and other vices seen as the causes of moral decay and urban social decline. Riis, Burnham, and others advocated the obliteration of tenement districts in order to rid the city of the ills created by the tenements and the immigrants who peopled them. On the positive side of the solution, these same reformers hoped to replace the slums with broad streets and decent buildings. On a grander scale, they also saw the grouping of civic buildings as a possible influence toward unifying the immigrant population with the city at large. Milo Roy Maltbie, an advocate of the City Beautiful, argued in a 1904 article on "The Grouping of Public Buildings" that the creation of civic centers could actually increase the patriotism of the lower- or working-class population and thereby improve their behavior and attitude toward civic involvement. Not only that, but they could also override the influence of corrupt city politics and bossism, the hated target of the most urgent efforts of Progressive urban reformers. A civic center, Maltbie writes,

> arouses civic pride and patriotism. They give the city character, dignity, and expression. Here is something which the masses can appreciate and enjoy, something which expresses power, greatness, and ideality, and to which they can point with pride. It is not too much to say that one important reason why politics is so perverted is that the city appears to the great masses of the people only through the policemen—as a restrictive power, and not as a constructive and vitalizing force. Being so distant and apparently so unrelated to their interests, they oppose any seeming attempt to increase the police power, and indifferently bestow their suffrages upon the politician who sends them turkeys upon Thanksgiving Day, who pays their rent when hard pressed, and attends the funeral when the baby dies. Yet these very masses are most easily influenced by visible improvements of a constructive character, and their patriotism is quickly and often permanently aroused by civic progress.[87]

Maltbie here formulates a strong argument for the erection of great civic centers: they could overcome the corrupting influence of the bosses to whom immigrants were so susceptible. Noble architecture arranged in a monumental city plan, he contends, could counteract the nefarious politicians vying for the favor of the masses who have too little civic pride to withstand the immediate and personal benefits provided them by the bosses.

Daniel Burnham had already argued the benefits of city parks to immigrant integration. As early as 1896, he claimed that the establishment of his proposed lakefront park would constitute "a long step towards cementing together the heterogeneous elements of our population and towards assimilating the million-and-a-half of people who are here now but who were not here some fifteen years ago."[88] In 1904, Milo Maltbie

pointed out that the small urban parks already established had provided a great benefit. "How much greater," he argued, "would be the uplifting influence if the public and semi-public buildings . . . were grouped in and about these parks, and the city government thus brought close to the citizen and expressed concretely?"[89] Thus, both open spaces in the shape of parks and the monumental grouping of public buildings were seen as a way to foster a feeling of unity toward the city among the urban immigrant population. As has been discussed in the previous chapter, museums were of central importance to these same groupings; thus, through their involvement in the ideal of City Beautiful, public building groupings within formal urban parks, museums were to have taken part in the unifying effect on immigrants and all other urban residents of great public architecture and city planning. Had this been the case, the City Beautiful would easily have met the goals propounded by Progressive urban reformers. The arguments for civic beauty in the shape of beautiful public buildings as an influence of urban reform even went beyond a sense of order imposed by a city plan; architecture itself was put forth as a medium for spiritual uplift in the soul of the city dweller.

Monumental Architecture as Urban Reformer

During the twin eras of Progressivism and the City Beautiful, architecture was endowed with the qualities of both a cultural barometer and a social influence. On the one hand, many social observers believed that the quality of a society's architecture was an indicator of how far that society had progressed culturally (for "culture," read "high" culture). As Charles Zueblin put it, "the ideals of a people soon find expression in their architecture."[90] It then follows that city planners who hoped to elevate the quality of architecture in urban areas despaired of doing so until the society in general was better able to appreciate and hence demand better buildings: "Our cities will scarcely put on the garment of beauty and wear it with an air of ease and accustomedness until our people gain that real culture which shows itself in the appreciation of the fitness of things."[91] On the other hand, the pervasive belief in environmental determinism made most observers believe that the reverse also held true; that is, that good architecture would of itself educate and even uplift those who were exposed to its influences. Thus it was that Maltbie, the proponent of civic centers, would speak of the "ennobling influence" a beautiful building exerts.[92] There can be no doubt that what is referred to during this period as "good" or "beautiful" architecture is the academic classicism that was the darling of all City Beautiful proponents.

Art Museum Architecture as Spiritual and Moral Influence

What does this particular aspect of Progressive era ideals concerning architecture have to do with art museum architecture? A great deal if one were to believe quite a number of observers and writers about the museum buildings themselves. As has already been discussed in depth, the art museum had an integral relationship with the ideology of the City Beautiful and the advent of City Beautiful-style planning. The museum was a public or semipublic building that was given architectural prominence via the adoption, almost exclusively, of the monumental-classical style. As a monument to culture, it fit in perfectly with City Beautiful ideals and the need of those reformers of the physical urban milieu to provide an architectural focus to the sprawling cities and to endow a sense of magnificence to a mainly utilitarian architectural atmosphere.

In return, City Beautiful planners gave the art museum special consideration in their comprehensive city plans, bestowing upon them the distinction of prominent placements within formal parks and at the termini of great boulevards. For Progressives more interested in moral and spiritual concerns, however, the museum as architecture also had a great deal to offer. According to numerous sources, the art museum building, if well designed, could exert a powerful influence for good through its very existence in the urban milieu.

A potent example of this belief is provided in 1896 by a commentator on the new Corcoran Art Gallery in Washington. The author of the article on the Corcoran in the *Illustrated American* states at the outset her belief in the powerful influences exerted by architecture. She delineates, in almost evangelical terms, both the "bad" and the "good" in this case:

> In Washington, perhaps more than in any city of the United States, two things have been conclusively proven: the value of noble architecture, and, through the medium of some builded monstrosities, the evils which must arise from merely political influence in the choice of architects. Of these latter evils it is scarcely necessary to speak. They speak for themselves in tones of brazen insolence, crying aloud their transcendent ugliness to the confusion of art-loving architects and the shame of right-minded men.[93]

In the vernacular of this author, it is presumably also not necessary to speak of the horrible effects such architecture could have on those not educated enough to know the difference between good and bad architecture and, therefore, open to the evil influences of those architectural "monstrosities." Fortunately, in the eyes of this particular observer, there did exist the corrective influence of noble buildings, including the Corcoran in their number: "Among these buildings which lend dignity and symmetrical beauty to our chaotic conglomeration of palaces and hovels, marble mansions and wooden shanties, is the new Corcoran Gallery of Art."[94] This description of the gallery building endows the building itself with a power to induce order in chaos, with chaos necessarily defined as an undesirable factor in aesthetic terms, if not an actual evil in moral terms. The power attributed by the author to the building—and by extension to its architect, Ernest Flagg—goes even deeper. She evokes the issue of appropriateness in order to help define the beneficent influences of the very appearance of the building:

> The design of Mr. Flagg seems to have been, first and foremost, to preserve unbroken that massive dignity and grave imperiousness which so well become a building whose main object is at once to inspire by its very exterior reverence for beauty and the desire for culture.[95]

This interpretation of the gallery's architecture defines appropriateness in a slightly different way from those who were concerned mainly with the rather simpler question of style. Instead, the conception of appropriateness—or the function of the museum building—extends to the spiritual and improving influence of the building itself. That is, the building's very existence in its physical form is imbued with the spirit of the art it contains. Its architecture, like all other art, was to uplift through beauty and provide societal unification through an agreement as to what culture was.

This conception of the positive moral and spiritual influence of the architecture of the art museum was adopted by numerous other writers about art museum architecture, from before the turn of the century in Washington, D.C., to several decades later in Toledo and Boston. As late as 1924, the author of a guidebook to the collections of the Museum of Fine Arts, Boston, would write that the "majestic Fenway front of the Museum" was the very "embodiment of dignity and grace" and attest to the power of

"the daily ministry of good architecture in the life of the city."[96] Like the critic of the Corcoran Gallery building, this admirer of the Boston museum building uses language evocative of religious experience—through a charged word like *ministry*—that suggests the spiritual uplift provided by the building to the urban milieu itself.

Other observers were yet more forceful and specific in their assessment of the powers embodied in and radiating from a beautifully designed museum building. The Attic severity and purity of Edward Green's museum architecture in particular seemed to evoke this response. Reactions to the Albright Art Gallery and the Toledo Museum of Art were especially suffused with the concept of the spiritually ennobling influence of fine architecture. In Buffalo, the appeal of the Greek style was explained by resorting to the academic authority of a professor at Yale. He stated that Greek art satisfies our desire for beauty completely because it is not defined by "mere sensuous beauty," but rather is "tempered by intellectual and moral qualities that make it noble and elevating to him who becomes imbued with its spirit."[97] The art gallery building itself seemed to have taken on this very spirit of Greek art as defined by the Yale professor, for a description of the building and the supposed goals of the architects defines the building's influence in several strata of human experience—the artistic, religious, and civic:

> It was kept in mind that an art gallery should represent a stride toward the ideal; that it should be so impressive in its dignity that men should approach it with a certain feeling of reverence; with a feeling calculated to intensify the appreciation of responsibility and duty as citizens having personal participatory interest in the structure and its contents.[98]

Once again, the language of the description sounds a quasireligious note, but the implication is that the reverence inspired by the building will improve the citizenship of those who come into its presence.

That merely looking at the building could inspire such noble thoughts was echoed by a newspaper journalist, who wrote that such was the building's power that

> From the rush and sordidness of daily life, from the din of the factory, from the smoke and ugliness of our business streets, one comes before this building, and feels the refreshing, uplifting influence which never fails when beauty penetrates our lives.[99]

The harsh contrast described between the realities of urban life and the cultural oasis of the art gallery underscores the hopes that urban reformers held for the influence of the museum. That the beauty of the collections, embodied in the beauty of the building enshrining them, could uplift the spirit of the urban dweller who was ordinarily mired in the depressing influences of urban industry, congestion, and all its attendant evils was the greatest charge given to the museum building's design and architecture.

One last example should suffice to demonstrate the great hopes pinned on art museum architecture by progressive-thinking individuals. In Toledo as in Buffalo, the architecture of Edward Green inspired a great deal of thought about the function of art museum architecture in the life of the city. The experience of several generations of art museum builders during the heyday of art museum growth led one commentator in the *American Architect* to state that "it is now generally conceded that a museum of art should be something more than a building affording wall space on which to hang pictures."[100] Although this belief would undergo a complete reversal in only the next generation, the statement explains decades of observations concerning art museum buildings. For architects, museum builders, and many observers of the period, the function of an art museum building went far beyond the housing of art. Indeed, the

art museum, as institution and as architecture, represented some of the greatest hopes
fostered by late-nineteenth- and early-twentieth-century Americans for the future of
their society, especially its urban component. The museum, they hoped, would

> play its part in influencing the minds of those who gather to see the works of great painters
> and sculptors. It must unconsciously draw them away from the commercial life about them
> and lift them to an intellectual plane in harmony with the spirit in which those pictures
> were executed.[101]

Another observer of the function of the museum building claimed that not only
should the building have an influence on those who come to see the art inside but also
upon those who merely happen to see the building as they conduct their daily business:
"The facade of the building should be a work of art in itself, a fitting introduction to
the treasures within, and a source of inspiration to the passerby."[102]

That the museum could be appropriated as such a potent symbol for many of the
hopes of the late nineteenth and early twentieth century is thanks to its involvement in
so many different aspects of the culture. The art museum building cradles some of the
most deeply meaningful and culturally charged products of human civilization: paint-
ing, sculpture, architecture, and the decorative arts. Because it is also a highly visible
public building, its importance to the city reverberates throughout the history of atti-
tudes toward the city. Art and museums were such highly adaptive symbols—because
what they stand for is necessarily nebulous and chimerical—that they could serve the
needs of a variety of groups seeking the answers to deeply troubling questions: namely,
the health of the city, spiritual, moral, religious, and civic. The search for order and
meaning in the confusing fabric of the emerging modern American city found comfort
in the authoritative look of the museum, as well as in the institutionalization of culture.

Thus it was that the museum—both building and institution—could be perceived as
a weapon in the fight to shore up order and morality in the city. Acquaint as wide a
public as possible with the spiritually and morally uplifting influences of art, it was
thought, and the city in which that public resides must turn away from the pernicious
influences of modern urban life and turn instead toward the refining influences of art.
The art inside the museum as well as the beautiful architecture of the museum could
positively infect the mind of the viewer inside and even the passersby outside to the
extent that the urban environment would be both improved and improving. Could the
existence of the monumental classical art museum within an improved city plan actually
have attained these desired improvements among urban denizens, the fondest hopes
of both City Beautiful advocates and Progressive urban reformers would have been
fulfilled.

5

Plans, Competitions, and Architectural Professionalism

The principles taught [at the Ecole des Beaux-Arts] are the principles of good taste. One is taught a knowledge of the resources of art, and mastery of its technique. Her atmosphere is not congenial to the growth of sentimentalism, one hears little about the picturesque. The teachings of Ruskin and Turner are foreign to her methods. Her standards of art are of a higher type. Art is regarded as the highest effort of the intellect of man, the measure of his superiority over all created matter.
—Ernest Flagg, "The Ecole des Beaux-Arts" (1894)

Architects generally dislike competitions and deprecate the system. For the pangs of disappointed expectation are more poignant and are longer remembered than the satisfactions of success, and they seem more uncalled for. . . . The fact that nobody likes competitions may accordingly be discounted. It signifies nothing. It is no proof that they are not a good thing for the client, for the community, and even for architects themselves.
—William Ware, "Competitions" (1899)

THUS FAR, THE MUSEUM HAS BEEN STUDIED IN A VARIETY OF CONTEXTS. THE CHOICE OF THE classical style has been examined and its ramifications investigated; the urban, cultural, and historical contexts of the museum have been explored; and finally, some of the sociological meanings of the museum have been unearthed. There is one vitally important aspect of the architectural development of the American art museum that has yet to be covered: the genesis, meaning, and influence of the museum plan. The plans generated by American architects for art museums provided the language through which all the other important aspects of the museum came to be expressed. These plans, produced by the first generations of professionally trained architects and heavily influenced by the French Beaux-Arts method of architectural design production, were how style was defined and applied to the museum structure. They were integral to the museum building's relationship to the urban plan, and they were the means by which the desired order and clarity of structure was gained to provide the kind of moral and artistic influence it was desired that an art museum should have.

The museum plans thus produced were icons of the emerging profession of architecture in America. In the decade of the 1890s, the architectural competition was a defining issue of the profession. During this early period in the development of the monumental classical museum building, the competition was the museum establish-

ment's preferred method for obtaining plans for their new buildings. After a number of controversial competitions, however, the profession asserted itself to the extent that the use of competitions began to abate; when they were employed, they were more strictly and responsibly organized. Perhaps one of the more interesting results of this change is that, although it may have represented a victory for those in the architectural profession, the abatement of the tradition of the competition did not result in any substantial differences in the look of the museum plan. Rather, the plans developed by architects for museums selected without the formality of the competition, nevertheless, retained the same Beaux-Arts grandeur of those plans generally submitted for competition purposes. With or without the competition, the influence of the Beaux-Arts method of architectural design production continued throughout the period and extended beyond the period of this study, even into the modern period. Hence, an evaluation of the tradition of the grand plan for the art museum covers a long period and follows the development of the architectural profession in America during one of the most crucial periods of its existence. Of further significance is the fact that many of these plans provided for expansion into the distant future. The resultant manner in which these plans were either followed or disregarded provides a reflection of both the changing museum establishment and the changes in the general rubric of architectural "fashion" or "taste" during the first two decades of the twentieth century, leading eventually to the abandonment of the Beaux-Arts approach in favor of a more "modern" one. The architectural plan mirrors the rise and fall of a particular genre of museum building and provides clues to both the original success and the eventual failure of the Beaux-Arts program for the American architectural profession.

The nineteenth century saw a revolution in the American architectural profession. At the beginning of the century, there was not one native-born American architect who could be described as professionally educated and trained. There were no schools of architecture in the country, and most buildings were produced via adherence to pattern books and slowly evolving, essentially vernacular traditions. For the first half of the nineteenth century, as American architecture progressed from the Federal style through the Greek and Gothic Revival styles, the architect responded to the changing dictates of fashion through the use of such published pattern books as A. J. Downing's 1850 *The Architecture of Country Houses,* which stressed the picturesque mode. It was Richard Morris Hunt who reversed this tradition and introduced both a systemized method of architectural training in this country via his own *atelier* and his highly influential students and a coagulation of the profession via his involvement, as founding member and later as president, of the American Institute of Architects. These two aspects combined to bring about a change no less than revolutionary in the establishment of the American profession in architecture.

The Beaux-Arts System

Hunt embarked upon his career by traveling to Paris and enrolling in 1846 at the most renowned and respected architectural training ground in the world, the Ecole des Beaux-Arts, which was at the apex of its importance and influence in the middle of the nineteenth century. He remained in Paris for nearly a decade, only returning to the United States in 1855. During his stay in France, he absorbed completely the Beaux-Arts method of architectural design and the official French predilection for classical grandeur in architectural style, particularly as exemplified by Hunt's *patron,* Hector Martin Lefuel, architect, with Visconti, of the New Louvre. Upon his return to the

United States and his establishment of residence in New York, Hunt set up his own *atelier* and transmitted the French style of training to one of the most influential generations of architects to enter practice in the country.[1] Thus, Hunt's preferred method of instruction, which he learned at the Ecole in France, was to have a domino effect on the profession in the United States. The body of art museum plans produced beginning in 1890 and continuing for decades thereafter was one tangible result of his influence. Hunt's own work in museum architecture was among them.

It would therefore be particularly profitable to investigate briefly the Beaux-Arts method of teaching and manner of designing with its concomitant emphasis on the plan, for doing so should provide a key to understanding the plans produced by American architects, including Hunt himself. The Ecole system of training was a tiered system in which advancement came only through the execution of a series of projects. A "first mention" for a project advanced the pupil to each subsequent level, from aspirant to second class to first class, until the final level was reached: the Prix de Rome winner, of which there was only one a year. This winner—always a French native—was sent, at the government's expense, to Rome to study the architecture of antiquity first-hand. The actual training of each student at the school was received through connection with an *atelier* and its *patron*, who oversaw the aspiring architect's projects and critiqued them. It was in the *atelier* that the student actually learned the practical aspects of architecture; but he (always male in Hunt's time) also learned theory and history from the lectures given at the Ecole. All training was in preparation for the competitions, or *concours*, in which the students were asked to prepare designs for buildings whose programs or requirements were assigned to them. There were basically two types of *concours*: the *esquisse*, or sketch, finished after twelve hours, and the *projet rendu*, or rendered project, which was submitted after a few months and was, therefore, much more polished. Most of these competition programs were for public buildings, from small schools and railroad stations for the second class and museums and theaters for the first class, in preparation for the final competition, the Prix de Rome, which was always for a very large, very grand public building. This was a logical progression, for the Prix de Rome winner was hired after his tenure in Rome by the government to execute government projects which were by their very nature large, grand, and, of course, public. It was a natural outcome of this influential school's system that architectural competitions for such large commissions as art museums became popular in the United States.[2]

There was a great deal more to the system, however, that had its effects on the architectural profession as it developed in this country. One of the most important aspects is that the Ecole, part of the French Academy, had its philosophical basis in a rationalist doctrine that all of the arts, including architecture, were based in reason and that they were, therefore, eminently teachable. Thus evolved the tiered teaching system which was emulated so widely in the United States. The other important aspect had to do with style: the academy, hence the Ecole, and specifically the school of architecture, was historically conservative and traditional with a stylistic preference for classicism of three kinds: ancient, Renaissance, and French sixteenth century. The fact that academicians were the jurors of the Ecole competitions and were generally members for life contributed to the conservative aspect of the system, as did the usual progression of a Prix de Rome winner to *patron* of an *atelier* himself. These aspects combined by the mid-nineteenth century to establish a fairly recognizable Ecole style of design, which had less to do with style itself than with the method used to produce a certain finished product. That is, an architect with Ecole training had been inculcated with a certain method of designing that was encouraged by the pedagogy of the Ecole system. The most important and most recognizable aspect of this method was the importance

attached to the plan, the Ecole style or method being essentially plan-generated.

The primacy of the plan was probably the most important lesson taught at the Ecole.[3] An *esquisse* was always begun with a plan; the final form of the building grew up from the plan. In the argot of the Ecole, the importance of the plan was due to the primacy attached to the *parti,* or the generating idea or program of a building, whereas the composition of the plan was the uniting of the ideas or functions of the various spaces within a building into a logically functioning plan that provided for proper circulation. The *parti* was the ideational force behind the plan. It generated the plan, which produced the general appearance of the building. Ernest Flagg, writing shortly after his own experience at the Ecole, tried to impress upon his readers just how important the plan was:

> As the *parti* is most clearly shown upon the plan, the plan becomes the chief consideration, and upon it is lavished by far the greatest study and care. For the same reason the plan is the chief consideration of the jury; it is scarcely an exaggeration to say that in making awards the plan counts for nine points out of ten.[4]

The Ecole method for the development of the plan was also distinctive. A Beaux-Arts plan was distinguished by highly axial arrangements, often disposed in long hallways grouped around very large courtyards. Frequently, the complexity of the *parti* resulted in interlocking patterns of circulation. The spaces formed within were highly ceremonial with some halls extending for almost inconceivably long distances. The progress of circulation was also ceremonial with great prominence attached to colonnades, stairways, and an elaborate path leading to the heart of the building, the space that answered the function of the building (e.g., the actual auditorium within a theater building). The traditionally recognized sequence was the *cour d'honneur,* or forecourt; the *corps de logis,* or principal block; and the garden. The exterior appearance of a building was always to have a precise congruence with the plan, once again to emphasize the primacy of the plan. The third dimension of the building was also developed with stacked and hierarchical axes, usually pyramidally arranged. The exterior, too, was to be properly laid out with large terraces, courtyards, and gardens and frequently embellished with statuary, fountains, and other incidental ornamentation. The Ecole system encouraged very large buildings, requiring complex programs. The Prix de Rome projects were generally for enormous, often multifunctional buildings: a college, an *hôtel* for a wide variety of purposes, palaces of justice, libraries, etc. One important aspect of the teachings of the Ecole was that the resultant building should look like what it was, that is, in some manner relate its function through its architecture. Although this is a somewhat nebulous concept, it had a great influence upon American art museum architecture, as has already been discussed.

The distinctive method inculcated by the Ecole des Beaux-Arts for the development of the grand plan had a great impact on the profession of architecture in the United States as well as on the architecture of and the means of its selection for American art museums after 1890. Transmitted by Richard Morris Hunt and subsequent American architects of great influence, the method had a tremendous effect on the plans and designs created for art museums, which were ideal candidates for the Beaux-Arts treatment. Museums were a favored subject for Ecole *concours,* and it has already been pointed out that actual Ecole student projects for museums had been appropriated by American architects for museum plans, as in the example of Memorial Hall at the Philadelphia exposition in 1876. Its author, H. J. Schwarzmann, however, was not an architect by training and, therefore, logically resorted to fairly straightforward copying.

Later American architects, in competition for art museum commissions, had actually been trained at the French school firsthand or had received its methodology second-hand and were capable of developing Beaux-Arts programs using their own ideas and *partis*. First within the context of the competition and later without it, Beaux Arts-style plans were to dominate art museum architecture for several generations.

The atmosphere of the competition, such an integral aspect of the Ecole system, was not unfamiliar to Americans of the nineteenth century and perhaps appealed to their sense of democratic fair play. A design for the New York Crystal Palace had been solicited by means of a competition in 1852. The plan for Central Park had been selected through a competition in 1857. Museum competitions were also not unknown prior to the era of the great monumental classical art museum. The Sturgis and Brigham design for the Museum of Fine Arts, Boston, for example, had been selected through a well-publicized competition in 1870. Between the Boston museum's original competition in 1870 and its decision not to hold a competition for its new building designed in 1907, possibly more museum designs were a result of competitions than were not. During the decade of the 1890s, art museum competitions reflected the growing influence of the Beaux-Arts method and the ever-increasing competence and professionalism of the architects. In order to document these changes, it is possible to follow art museum competitions from the 1891 competition for the Carnegie Institute in Pittsburgh to one of the last grand-manner competitions, that of 1911 for the Minneapolis Institute of Arts.

The Carnegie Library Competition, 1891

The competition held in 1891 for the Carnegie Library (as it was then usually called) elicited a response from an unprecedented ninety-seven architects, and the wide variety of styles exhibited by the competitors attested to the as yet unresolved stylistic quandaries of American architecture. The program, or *parti*, was an extremely complex one, calling not only for a library but also for a music hall and two museums, one for natural history and one for art. Although it has been suggested that the attempt to concentrate so many functions into one building was indicative of a residual provincialism,[5] the result was a problem that presented itself in much the same manner as many Ecole *concours*. It should then come as no surprise that of the many competitors, the winning firm of Longfellow, Alden, and Harlow was the only one with a wide experience in the French method of architectural composition. Alexander Longfellow had actually studied both at M.I.T., where the first American school of architecture was established along the lines of the Ecole method, and at the French school itself. His approach was solidified during his tenure in the office of H. H. Richardson, himself a product of the Ecole des Beaux-Arts. Frank Alden had also studied at M.I.T. and worked as a draftsman under Richardson; and Alfred Harlow, another graduate of M.I.T., had worked for the firm of McKim, Mead, and White.[6] The firm thus was able to handle with facility the complicated needs of the structure with a plan that provided relatively easy access to all functions of the building and a clear reading of these spaces. The music hall, for example, was easily identifiable from the exterior by its rounded shape signifying the auditorium, its dual towers, and its separate entrance. The architects themselves described the use of the semicircular form as one which allowed "an expression of the individual character of the building."[7] The music hall was appended to one end of the main, H-shaped block of the building that housed the library. This most important portion was dignified with its own entrance at the much more subdued front that would

Longfellow, Alden, and Harlow. Carnegie Library,
Pittsburgh, 1891–95. Plan. Dedication Souvenir,
1895. Courtesy, Carnegie Library of Pittsburgh.

indicate the serious purpose of the library. In order to clarify and make more "legible" the separate functions within the building, the end of the building with the music hall had prominent musicians' names inscribed on the frieze, whereas the main block housing the library displayed the names of famed literary figures. The two museum galleries were housed on the second floor in the projecting wings flanking either side of the main library block. These wings had minor entrances, advertising their functions by the names of scientists and artists over their respective entrances. Thus, the plan was not only well articulated, but was assisted in legibility by the labeling of the exterior: in the words of the architects, "a useful and instructive form of decoration."[8]

Although the logical layout of the plan seems to have had its influence in the Beaux-Arts training of its architects, the style of the building expressed the vestigial influences of the Richardsonian Romanesque. Its towers, providing the building with a picturesque silhouette, were particularly reminiscent of Richardson, most especially of his nearby Allegheny Courthouse in downtown Pittsburgh.[9] Longfellow, Alden, and Harlow introduced stylistic motifs, however, that indicated a concern with participating in the rising classicism embodied by the likes of McKim, Mead, and White. There were, in fact, strong suggestions of the influence of that firm's famed Boston Public Library. The long, low, classical silhouette of the main library portion of the building distinctly resembles the Boston library, as does the main library stair hall. In a similar vein, the Florentine Renaissance motifs of the arched windows with arched tracery and roundels in the spandrels above, the inclusion of balustraded balconies, and the rustication of the first floor all presage the classicism that was to be fulfilled by the additions made to that

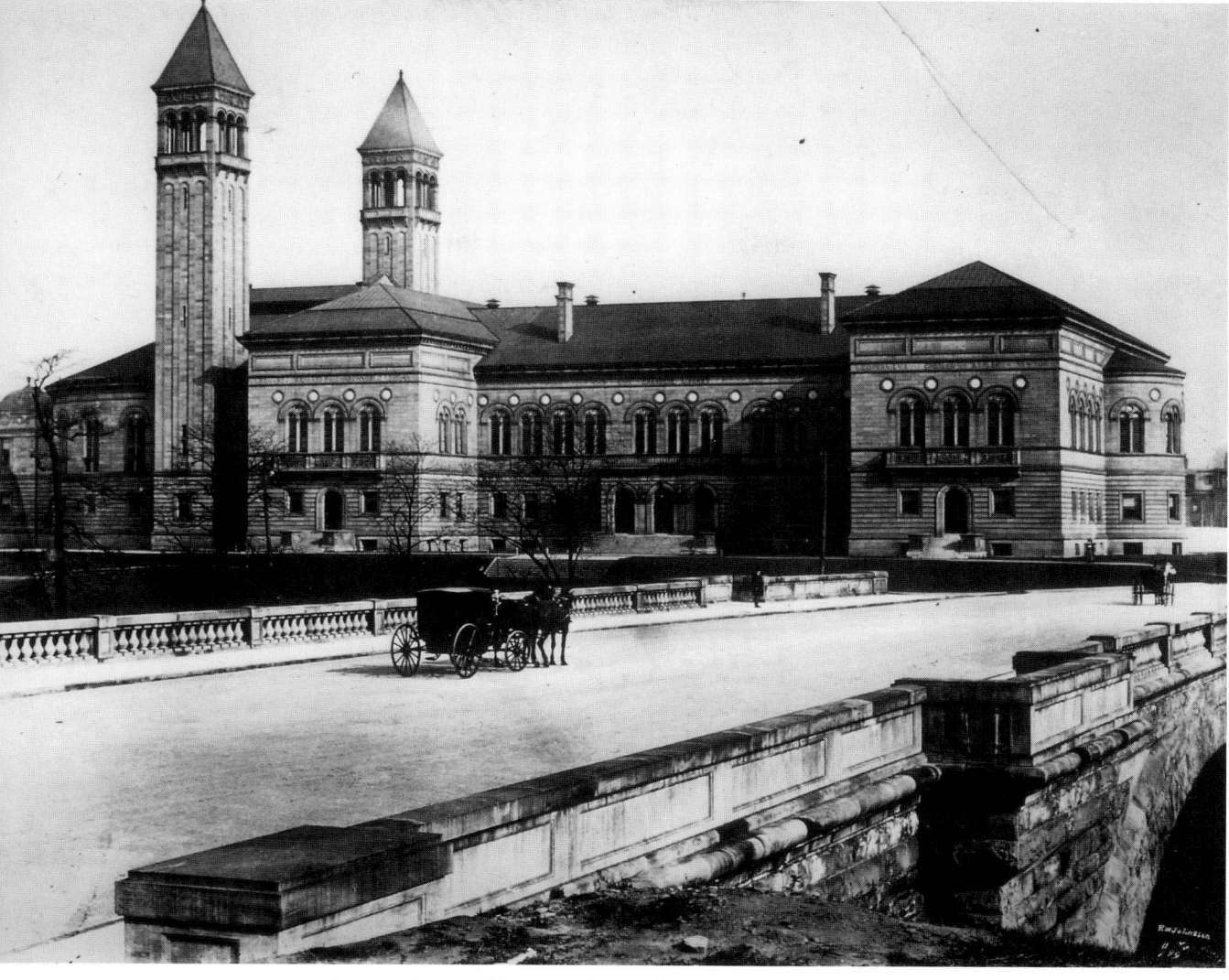

Longfellow, Alden, and Harlow. Carnegie Library, Pittsburgh, 1891–95. Courtesy, Carnegie Library of Pittsburgh.

building within a decade.[10] The result, as Margaret Henderson Floyd notes in her recent work on Longfellow, Alden, and Harlow, is a "design that balanced on the razor's edge between two distinct epochs, as no other major building would do."[11]

The state of the architectural profession was indicated not only by the building chosen for the Carnegie Library, but also more inclusively by the many designs not selected for the commission. As with any competition, the entries not chosen are as telling, if not more so, than the one that was. The submissions for the Carnegie competition came not only from Pittsburgh but also from such eastern cities as New York and Baltimore.[12] These designs, too, indicated a profession still hesitating on the stylistic brink before plunging headlong into the classical mode. Several entries included a classically-designed block very similar to the library portion of the Longfellow, Alden, and Harlow design and similarly derivative from the Boston Public Library. Both the submission by the New York firm of Arne Dehli and J. Howard Chamberlain and that by the Pittsburgh

*Arne Dehli and J. Howard Chamberlain. Competition
design, Carnegie Library, Pittsburgh, 1891.* Ameri-
can Architect and Building News *35, 5 March
1892. Courtesy, Carnegie Library of Pittsburgh.*

*Frank Irving Cooper and William Welles Bosworth.
Competition design, Carnegie Library, Pittsburgh,
1891.* American Architect and Building News
*35, 5 March 1892. Courtesy, Carnegie Library of
Pittsburgh.*

John Appleton Wilson. Competition design, Carnegie Library, Pittsburgh, 1891. American Architect and Building News 35, 5 March 1892. *Courtesy, Carnegie Library of Pittsburgh.*

PERSPECTIVE VIEW

George Palliser. Competition design, Carnegie Library Pittsburgh, 1891. American Architect and Building News 35, 23 April 1892. *Courtesy, Carnegie Library of Pittsburgh.*

*William E. Greenawalt. Competition design, Carnegie
Library, Pittsburgh, 1891* American Architect and
Building News *36, 21 May 1892. Courtesy, Carne-
gie Library of Pittsburgh.*

firm of Frank Irving Cooper and William Welles Bosworth incorporated this feature,
giving them both a family resemblance to the winning entry, at least from one side.
The submissions also included some widely varying styles, the most farfetched of which
was a sixteenth-century, Flemish palace by John Appleton Wilson of Baltimore. Others,
like George Palliser of New York and William E. Greenawalt also of New York, incorpo-
rated oversized and impractical Italian bell towers as the focal point of their designs.
These features of eye-catching gigantism—improbably soaring towers, overwhelmingly
large domes, a profusion of glittering ornament—were likely over-enthusiastic bids for
attention in a competition of such importance. As Floyd points out, of the published
plans (which were presumably the most capably handled), Longfellow, Alden, and Har-
low's most ably incorporated the various functions of the building into one smoothly
integrated—and not overly elaborate—plan.[13]

In order to place the Carnegie competition plan into the history of the development
of the museum plan, it must be observed that one of the most significant aspects of the
plan is that, although Longfellow, Alden, and Harlow's plan for the Carnegie Library
seems to be Beaux Arts-influenced in its functional logic and exterior legibility, it lacks
the sweeping grandeur, the interlocking axes, the ceremonial progressions, and the

sheer immensity of scale properly belonging to a true grand-manner, Prix de Rome-style, Beaux-Arts plan. Rather, the Carnegie Institute plan was practical and practicable; that is, it was relatively easily completed as planned, in one building campaign. Unlike the typical Prix de Rome project, the Carnegie library was comprehensible on a human scale and attainable in terms of economic and physical viability. The vast scale of the true Beaux-Arts project would not be taken up by American architects, despite their presumable ability to do so, until after the advent of the World's Columbian Exposition in Chicago, the event which made all things seem possible no matter how fantastic the scale. In the short time before that event, however, there was one other strongly Beaux Arts-influenced art museum and competition worthy of consideration, yet executed in the same relatively modest scale of the Carnegie Library—the Corcoran Gallery of Art.

The Corcoran Gallery of Art Competition, 1892

The competition for the design of the new Corcoran Gallery of Art was one of the competitions that gave rise to complaints among architects of unfair practices, these complaints eventually leading to a revision of the process. For a long time prior to the actual competition, the museum's eventual architect, Ernest Flagg, was in contact with the trustees of the museum. As early as October of 1891 when the possibility of erecting a new building was only just being officially decided among the trustees,[14] Flagg had approached one of them about showing him some of his drawings originally meant for a new National Academy of Design building, which he thought would suit the Corcoran equally well. In order to bring his qualifications to light, Flagg mentioned that he had "for the last three years been studying [the problem], in Europe."[15] It was certainly to Flagg's advantage to call his study at the Ecole des Beaux-Arts to the trustee's attention, for it was still an important professional distinction. According to an unpublished manuscript written by Flagg, he had worked on the design while in Paris and, in his own words, while "making the drawings I had the criticism of my *patron* M. Paul Blondel."[16] In order to adapt this design to the needs of the Corcoran, Flagg remained in contact with the gallery trustees through the first half of 1892, showing his drawings to other trustees and conferring with the gallery's curator, Francis S. Barbarin, on the changes he made to his designs the better to accommodate the needs of the gallery.[17]

Despite this close contact between architect and prospective patron, the trustees of the Corcoran decided in June of 1892 to invite three local architectural firms to submit plans in competition for the design of the new gallery building: Paul J. Pelz, Hornblower and Marshall, and W. Bruce Gray, each of whom received two hundred dollars in compensation.[18] Unsolicited plans were also submitted by Robert Stead, A. B. Noerr, Frank B. Mayer, and a partnership with the names of Head and Wood. Although no drawings survive, extensive descriptions submitted by the respective architects do, as do plans by two of the architects other than Flagg, published in *American Architect and Building News*. Of the invited competitors, Paul J. Pelz claimed that the irregularity of the site precluded an academic approach—which probably meant in his language a symmetrical design—and he therefore advocated an entrance on the corner of the building to be highlighted by a rounded tower surmounted by a dome.[19] The style Pelz appeared to have used is, in his own word, Renaissance, and he referred to columns flanking the entrance, segmental pediments on the corner tower, pavilion, and statuary niches. W. Bruce Gray also appears to have used classical motifs in the preparation of his design, for his brief description refers to cornices, balustrades, architraves, marble columns at the entrance, marble panels over the windows, and a dome to crown the

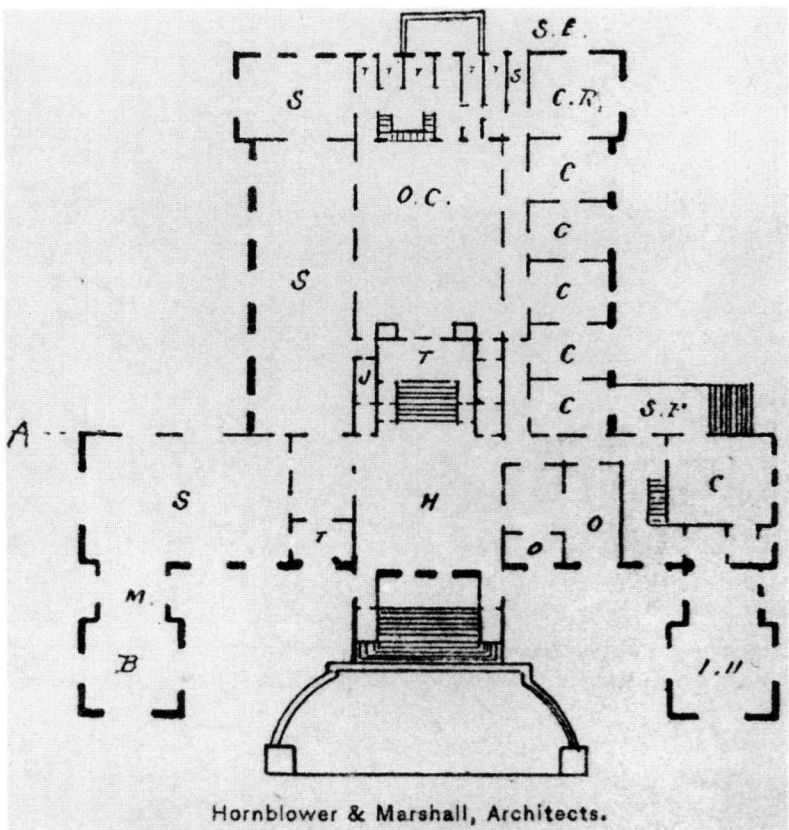

Hornblower & Marshall, Architects.

*Hornblower and Marshall. Competition plan, Corco-
ran Gallery of Art, Washington, DC, 1892.* Ameri-
can Architect and Building News *43, 27 January
1894.* Avery Architectural and Fine Arts Library, Co-
lumbia University in the City of New York.

structure.[20] A description of Gray's plan outlines it as a symmetrical building in the
form of a cross with a stairway at the center and a dome over the crossing.[21] Hornblower
and Marshall, the only invited competitors for whom an actual plan survives, submitted
the most professionally handled description and design other than Flagg's.[22] Their plan
for the building ignores the irregularity of the trapezoidal plot at the intersection of
New York Avenue and Seventeenth Street and proposes a symmetrically disposed struc-
ture fronting on Seventeenth Street. Its main facade was in the shape of a shallow U
with a monumental exterior staircase as the centerpiece. There was to be an entrance
portico supported by columns,[23] and the architects' written description defines the
silhouette of a classical building: simple and low, with no apparent roofline. It was the
architects' contention that the appearance of their building "unmistakably indicates
its purpose."[24]

It was this plan which most appealed to the author of the review of the competition
drawings in *American Architect and Building News.* He thought that Hornblower and
Marshall's plan had its "chief attraction" in the relation of the building to the street;
unlike Flagg's plan, theirs was to be set back fifty feet from the street, thereby allowing
for "green grass, and broad effects and effective, generous steps."[25] This critic also
approved of the circulation patterns of the plan and the "simple and refined" exterior

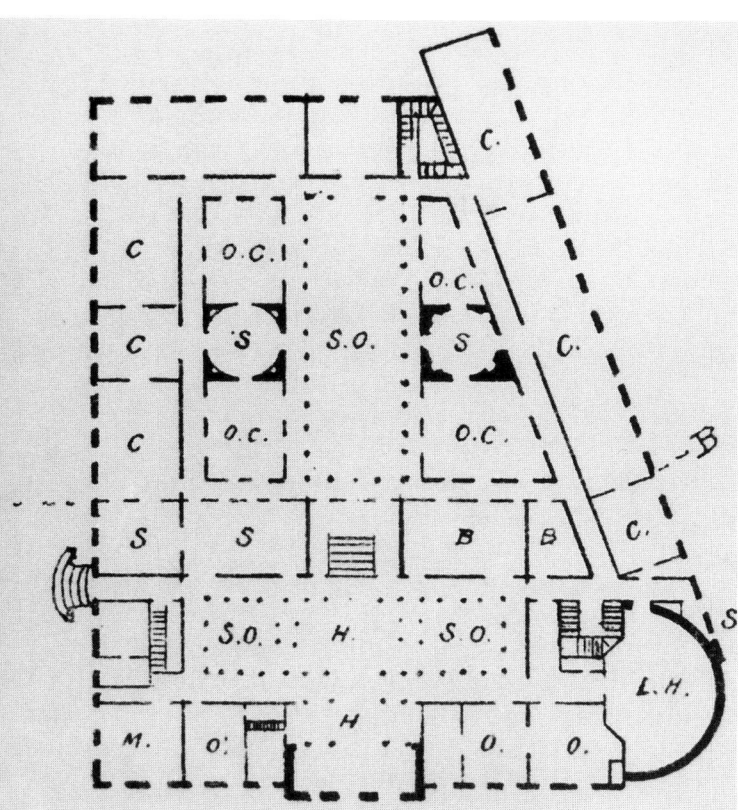

Ernest Flagg. Competition plan, Corcoran Gallery of Art, Washington, D.C. 1892. American Architect and Building News *43, 27 January 1894. Avery Architectural and Fine Arts Library, Columbia University in the City of New York.*

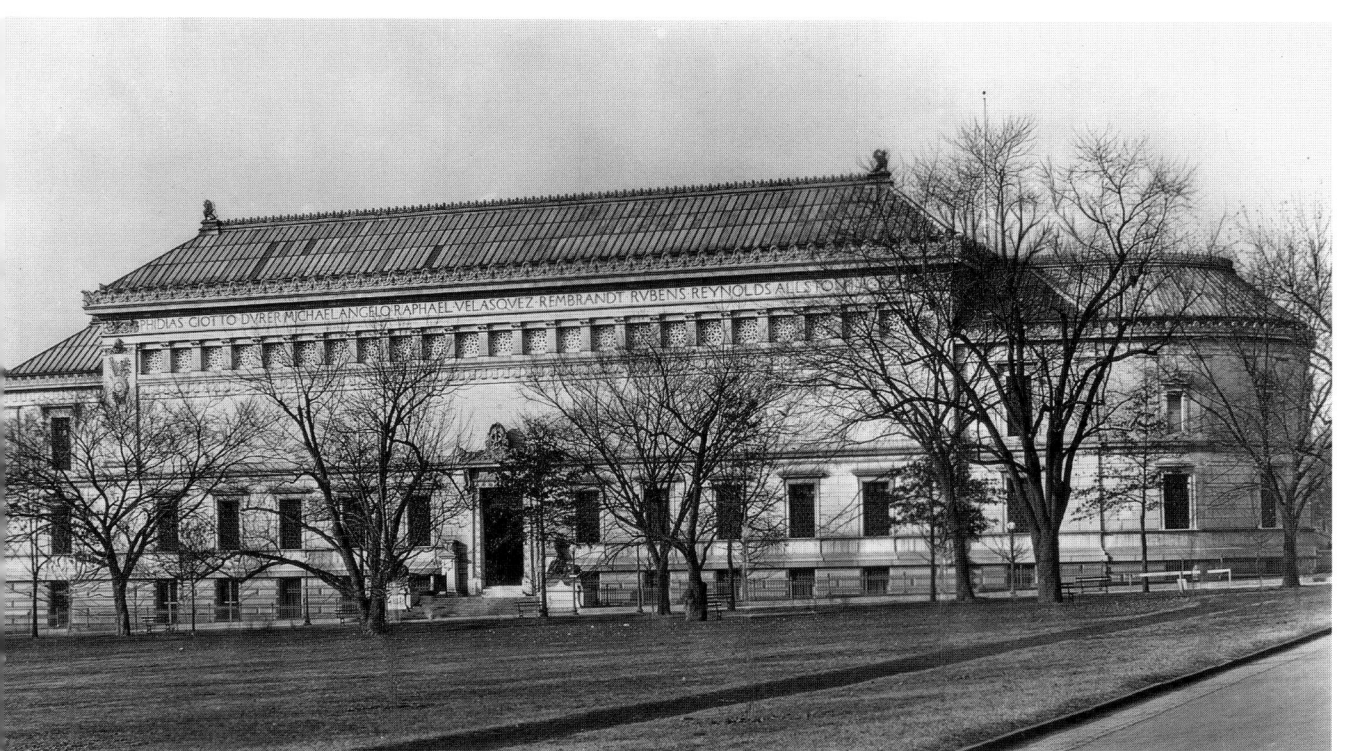

Ernest Flagg. Corcoran Gallery of Art, Washington, D.C. 1892–97. Courtesy of the Corcoran Gallery and School of Art Archives.

appearance. There was no doubt that had the author of this review been a judge of the Corcoran competition, Hornblower and Marshall's plan would have triumphed. In contrast to the scheme he preferred, the author criticized several aspects of Flagg's plan. He claimed the columns in the main statuary hall would interfere with the actual viewing of the sculpture and that the rooms grouped around the main hall could only be accessed through the hall, making circulation patterns confusing and problematic. It is clear, however, that Flagg's plan makes better use of the relatively small plot of land relegated to the building, providing the Corcoran with a tightly organized, compact building. He also knew what the trustees wanted. As the disgruntled author of the article rightfully maintained, it is impossible not to perceive Flagg's obvious advantage over his rivals: "As might have been expected, Mr. Flagg, who was admitted to the competition and who had full knowledge of the problem, was awarded the building."[26] The situation thereby created was certainly one persuasive reason for a reevaluation of the competition and the eventual creation of standardized regulations for the conducting of competitions.

There were other compelling reasons to standardize both the competition and the professionals who could qualify simply to enter. It was not only the architects who suffered from a lack of regulation in this area, because a reading of some of the unsolicited entry descriptions for the Corcoran competition immediately indicates that those deciding the outcome of the competition were unfairly imposed upon by some truly incompetent submissions. One description, interesting for the ideas it elaborated—e.g., "a *home* of art should . . . combine the influences of the garden with other expressions of beauty"—was submitted not by an architect but by an artist, Frank Mayer of Annapolis.[27] He sent what he termed an "incomplete drawing" and offered to develop it more completely if the trustees so desired. The description clearly indicates that Mayer had no background as an architect and submitted a rather amateur drawing. Surprisingly, perhaps even worse was the submission by architects Robert Head and Waddy B. Wood. The typewritten description is riddled with abominable misspellings, grammatical errors, and sloppy, handwritten corrections, and the excuses provided for the quality of the work indicate a poor plan at best: "Our limited time explains our unfinished basement plans, and the bad coloring on the Facade and some of our other work which was done at night."[28] It is not surprising that when the American Institute of Architects approved a standard set of rules for competitions, among them was one requiring participants to adhere to a minimum standard of professionalism.

Fortunately for the officials at the Corcoran, they had at least one, and likely more than one, competent entry from which to choose, and they decided upon Flagg's entry as the one best suited to their needs and taste. Both the plan and the style of Flagg's building were the most directly Beaux-Arts influenced.[29] Like Longfellow, Alden, and Harlow at Pittsburgh, Flagg had to contend with a complex program that called for both a school and a museum to be housed in one building. He was able to integrate classrooms, an auditorium, a two-story sculpture hall with grand stairway, galleries, and various offices with virtuosity into the rather cramped and irregularly shaped plot. Also like the Carnegie building, the functions of the building are clearly legible to the passerby: the rounded corner houses the auditorium, and a discreet entrance on New York Avenue marks the students' entrance. The high volume and blank walls of the sculpture hall and galleries signal their function; and if that were not enough to identify the purpose of the building, Flagg also "labels" the building with artists' names.[30] As Flagg pointed out, echoing the directive of the Ecole method, he wished "above all to give it the appearance of an art building."[31] The beautiful, crisp handling of the details also reveals Flagg's French training, in the professionalism of execution.

A letter in the Gallery's archives sheds an interesting light on the trustees' seeming preference for the use of Beaux-Arts classicism for their building. In 1891, the Washington architect Robert Stead, presumably solicited for his advice, suggested to one of the trustees that the best way to get a design for the new building was to hold an invitational competition with the invitees to be paid $500 for their participation. What is most interesting about Stead's letter is his proposed list of invitees. They (perhaps somewhat naively) included some of the era's most prominent architects to be had anywhere. First on his list was Charles Garnier, famed architect of the Paris Opéra, followed by Richard Morris Hunt and the firm of McKim, Mead, and White.[32] Stead also suggested that William Ware, then the head of the School of Architecture at Columbia, should be asked to judge the competition. With this combination of competitors and judge, Stead was creating a wholly Beaux-Arts milieu. The architects he suggested used Beaux-Arts methods, and Ware, one of Hunt's pupils, headed the first American school of architecture, at M.I.T., established on Beaux-Arts lines in 1868. This epistle suggests that the trustees had as a desideratum for their new building an up-to-date Beaux-Arts style and approach. Although they did not actually invite any of the architects on Stead's list, they did choose as architect for their building the most Beaux Arts-influenced of the competitors, an architect who was fresh out of the French school and thoroughly indoctrinated with its methods.

Like the Carnegie Institute building, Flagg's building was designed using Beaux-Arts methods of composition but was not on the scale of a Prix de Rome competition. Although Flagg was fresh from the Ecole and designed a building of monumental appearance, complex program, and a high cultural seriousness, he nevertheless gave the Corcoran a plan with a human scale, one that was erected with relative speed and ease, attainable with the budget the gallery had available. Furthermore, although the plan called for a grand statuary hall (which Flagg consistently referred to as the "Parthenon Room"[33]) and a splendid, ceremonial staircase, the building's plan did not have the kind of multiple axes; long hallways forming open, airy courtyards; and ceremonial progression of *cour d'honneur, corps de logis,* and garden all typical of the grand-manner Ecole des Beaux-Arts *parti.* Instead, Flagg kept realistically to the scale and degree of architectural elaboration called for by the immediate needs and budget of the institution.

The World's Columbian Exposition and the Beaux-Arts Plan

The advent of the World's Columbian Exposition changed this rather considerate approach among American architects. The grandiose building programs provided by architects for museums after the fair of 1893 seemed to be a direct response to the extravaganza created on the shores of Lake Michigan. Indeed, there appears to be a direct correlation between the first exercise—however academic and temporary—in large-scale city planning in this country and the exceedingly large-scale museum plans produced directly afterward in cities as far apart as New York and Milwaukee. The White City had been designed very much along the lines of Beaux-Arts principles. As if to highlight the relationship, the main grouping of buildings was called the Court of Honor, the *cour d'honneur* of the Beaux-Arts methodology. The complex program and ceremonial hierarchy were also much like the *parti* of the Prix de Rome *concours;* the only distinguishable differences were that this project was actually built, and it comprised a series of buildings rather than just one. The cooperative effort that went into the designing; the insistence upon conformity, as in the uniform cornice line and the

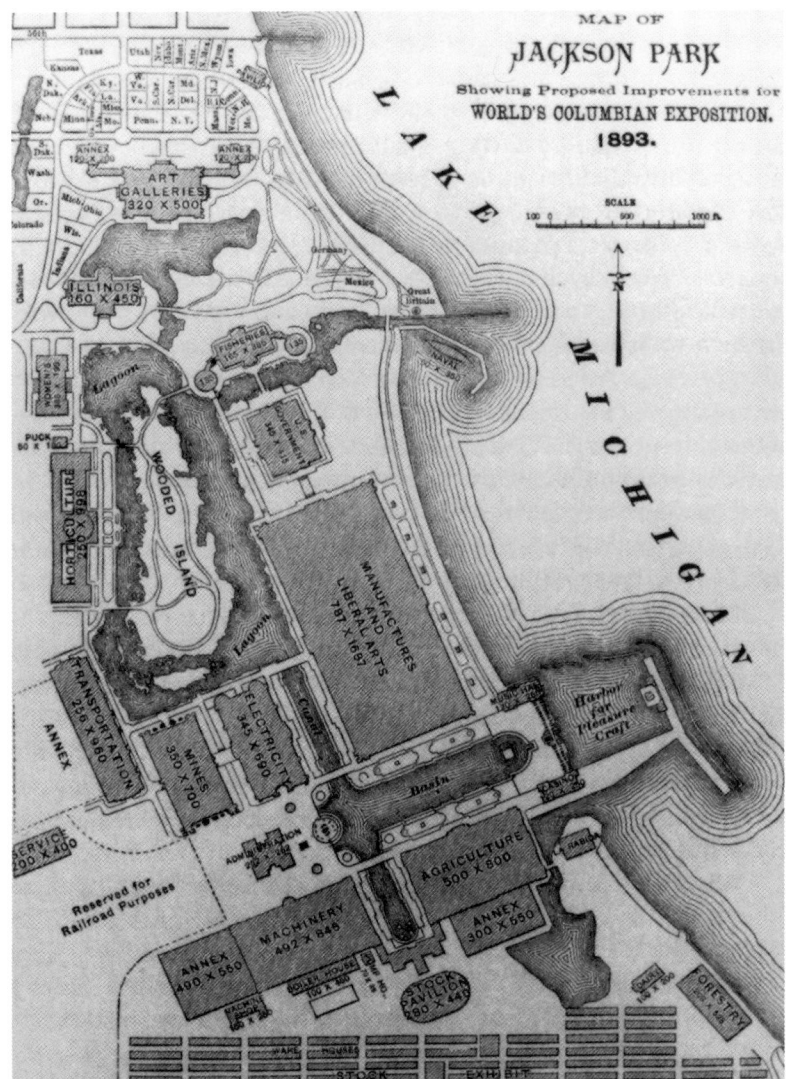

Court of Honor, World's Columbian Exposition, Chicago, 1893. Plan. Daniel Burnham, Plan of Chicago, 1909. Courtesy of the Art Institute of Chicago.

monochromy; and an overall interlocking congruence of the buildings all suggested a Prix de Rome project writ large.[34] Also very much like a grand Ecole project was the attention paid to the incidental ornamentation and the careful designing of the surrounding open spaces: plazas, terraces, water basin, walkways, etc. Finally, the sheer enormity of the scale of the White City was a waking dream of the usual lot of theoretical Prix de Rome contrivances. The familiar emphasis on the highly axial arrangement, the correlating minor axes created by the interrelationships of the buildings, the ceremonial or celebratory (ranging on the pompous) aura, and the culmination of the buildings in the domed structure of the Administration Building all hearken to the directives of the French school. This should hardly come as a surprise, as the major buildings were designed by America's first Ecole-trained architect, Richard Morris Hunt, given the composition's centerpiece, and such other Beaux-Arts architects as

George Post and Henry Van Brunt, students of Hunt, and the firm of McKim, Mead, and White.

It was the World's Columbian Exposition that opened the floodgates to the displays of technical virtuosity exhibited in the great museum competition plans. That the great fair was the starting point and the catalyst is once again proven by the fact that whereas these same architects, trained in Beaux-Arts methods either first- or secondhand, must have been just as capable of producing such grand plans before the fair as after, they did not do so until after the experience of the fair opened both their eyes and the eyes of their prospective patrons to the possibilities presented by the event. Suddenly, following directly on the heels of their participation in or witnessing of the fair, American architects produced plans for museums that rivaled the creations of French Ecole students competing for the Prix de Rome. Although they must have been just as capable of doing so prior to the fair, it was the fair that enabled the production of such plans and their acceptance both within the architectural community and the museum establishment.

The Brooklyn Institute of Arts and Sciences Competition, 1893

The competition most directly following the fair and showing perhaps its greatest influence was that held in 1893 for the Brooklyn Institute of Arts and Sciences, won

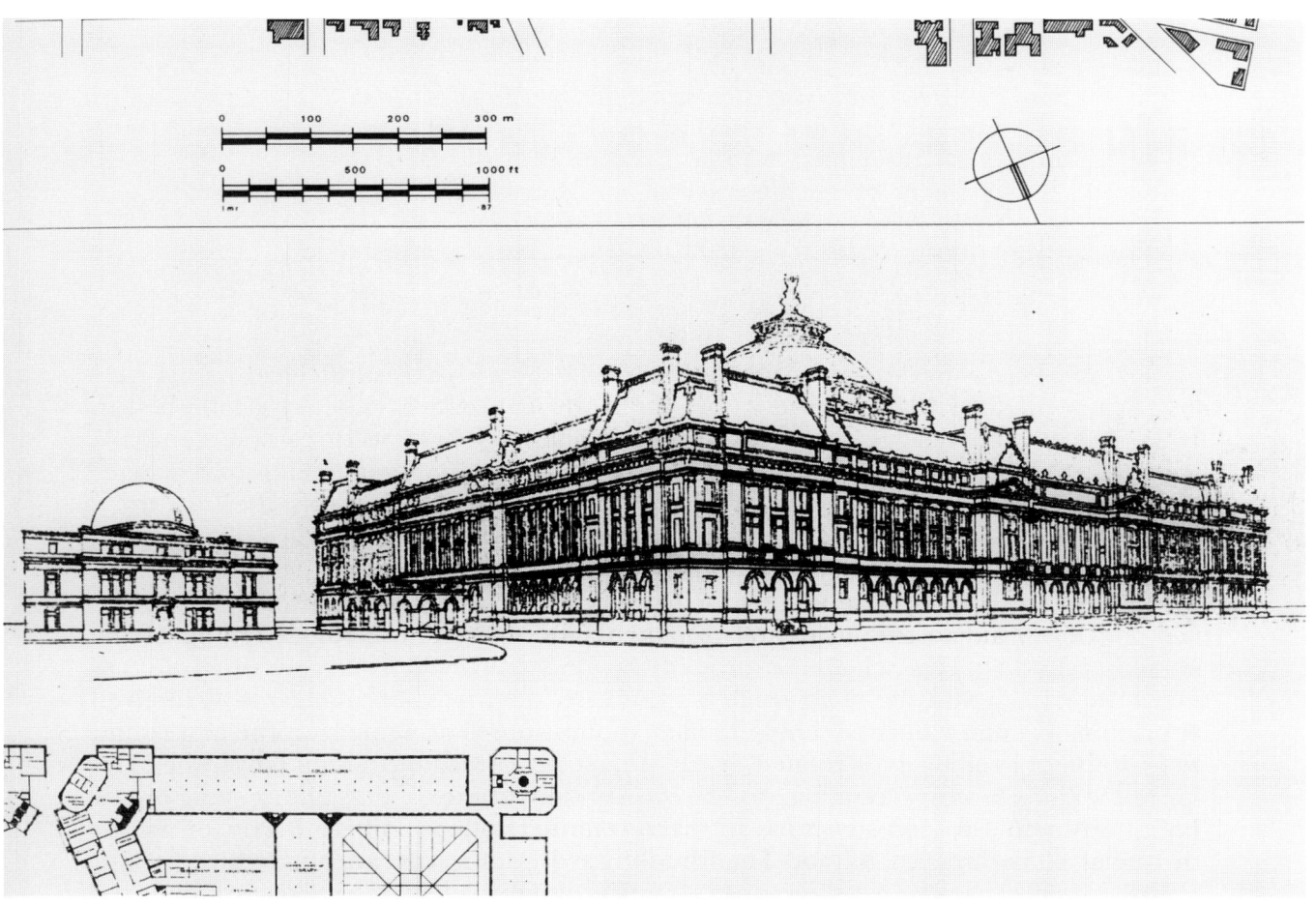

James Cromwell. Competition design, Brooklyn Institute of Arts and Sciences, New York 1893. American Architect and Building News *41, 12 August 1893.* *Avery Architectural and Fine Arts Library, Columbia University in the City of New York.*

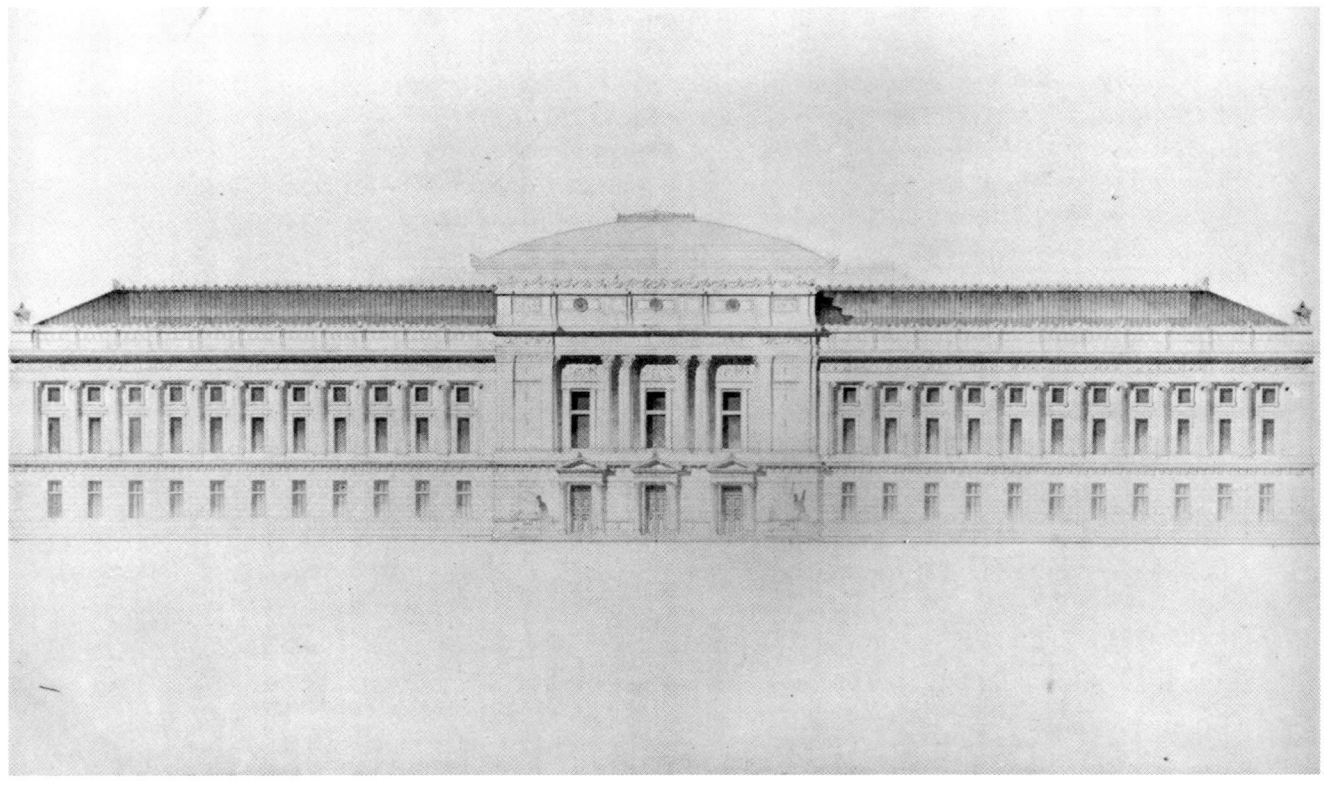

Albert Brockway. Competition design, Brooklyn Institute of Arts and Sciences, New York, 1893. Catalogue of the Third Annual Exhibition of the Department of Architecture of the Brooklyn Institute of Arts and Sciences, *1894. Avery Architectural and Fine Arts Library, Columbia University in the City of New York.*

by fair architects McKim, Mead, and White. The Brooklyn Institute had a relatively long history before 1893, having its origins in an Apprentices' Library established in 1823. The educational organization grew apace, offering books, lectures, and eventually scientific exhibitions until 1889 when its President, Franklin Hooper, announced plans to form both an art department and an architecture department within the Institute.[35] When it was decided to solicit plans for a new building, the architecture department, led by architectural critic A. D. F. Hamlin, devised a two-tiered competition in which the preliminary competition was a student exercise for which only sketches were solicited, and the formal competition was for the winners of the first round as well as five invited architects. This scheme is distinctly reminiscent of the two types of Ecole *concours:* the *esquisse* and the *projet rendu.* In this case, the first-round entrants were given approximately one month to complete their submissions. The winners of the first round were younger architects: William Boring, Albert Brockway, and James Cromwell. The invited architects were, according to the competition circular, Louis DeCoppet Berg of J. C. Cady and Co., John Carrère of Carrère and Hastings, Albert Parfitt of Parfitt Brothers, William B. Tubby, and Stanford White of McKim, Mead, and White.[36]

Probably because of the advice and assistance of knowledgeable professionals in the architecture department, the competition circulars made clear the requirements of the

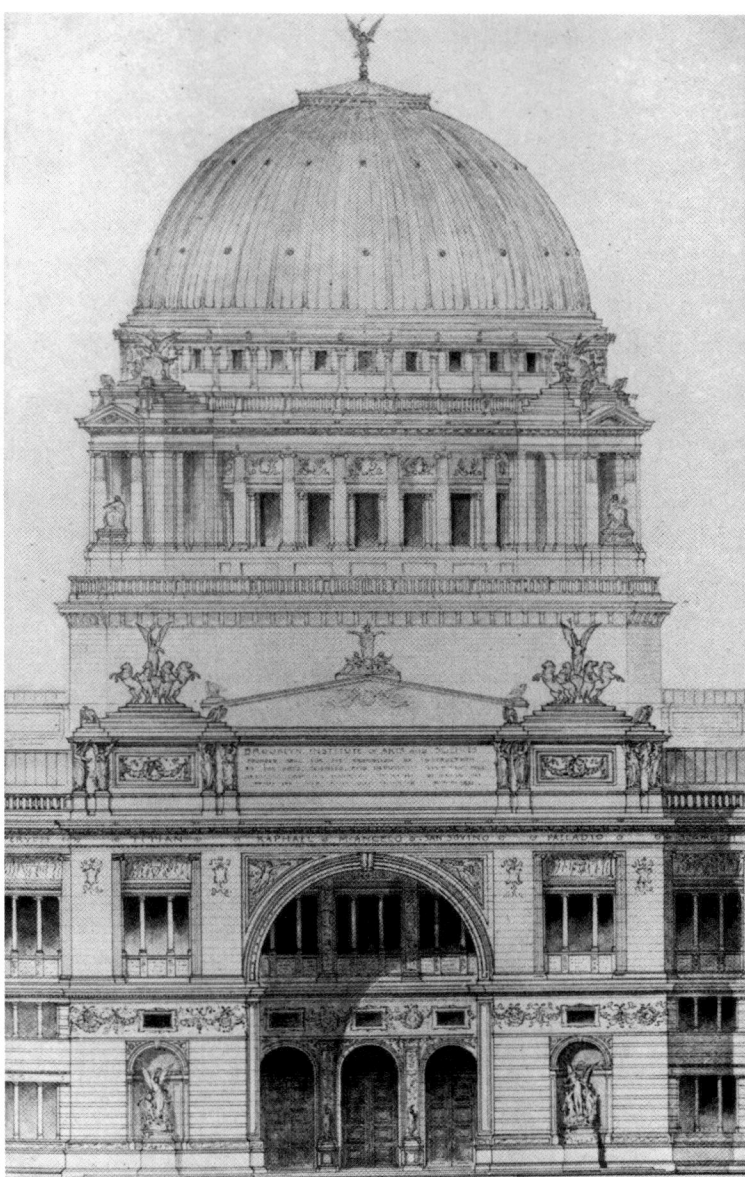

Parfitt Brothers. Competition design, Brooklyn Institute of Arts and Sciences, New York, 1893. Catalogue of the Third Annual Exhibition of the Department of Architecture of the Brooklyn Institute of Arts and Sciences, *1894. Avery Architectural and Fine Arts Library, Columbia University in the City of New York.*

program, from instructions as to the scale and type of paper to be used for the submissions to the location and the plot of land, the size of the completed building, the square footage required by the various departments of the museum, and specifics like an auditorium to seat three thousand, lecture rooms, exhibitions halls, and the like. More importantly for the resultant look of the building, the circulars specified both the general plan of the building and the style. The program stated that "the Trustees have . . .

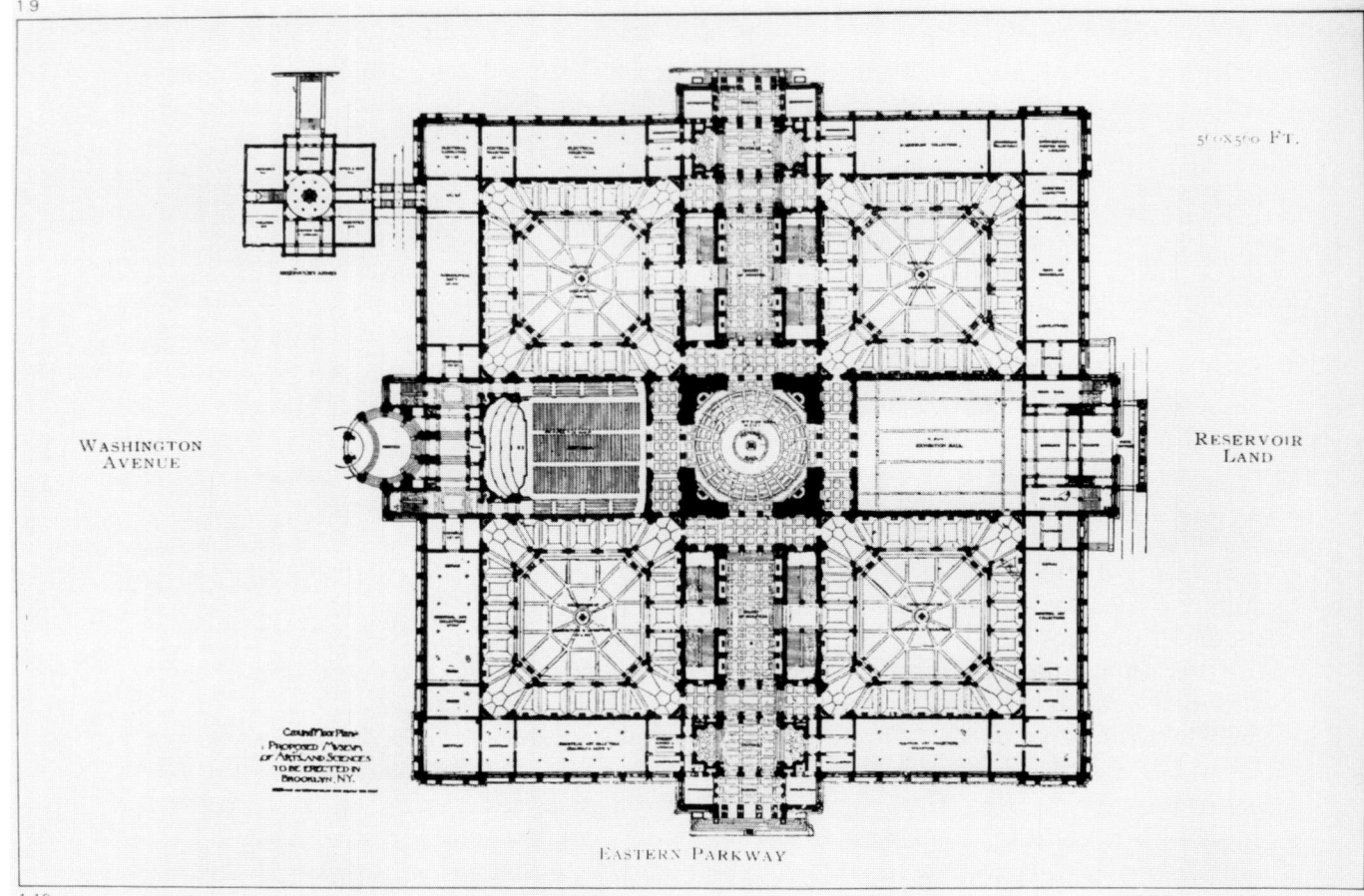

McKim, Mead, & White. Brooklyn Institute of Arts and Sciences, New York, 1893. Plan. Courtesy of the Brooklyn Museum.

imagined a rectangular block with interior cruciform arms enclosing four open courts. But this conception of the building is in no way binding to the competitors." Furthermore, even the stylistic preferences were specified:

> The proposed Museum should be simple, dignified and monumental in its proportions and architectural treatment, and freely classical in its general style, but not necessarily and rigidly formal in its use of classic motives.[37]

If it were not clear enough from these directives that the trustees were after a certain kind of building, the further specification that "there should be one [staircase] of conspicuous size and importance from each of the main entrances or vestibules" must necessarily have indicated the desire for a classical, formal, and ceremonially organized building, precisely what would be provided by architects steeped in Ecole des Beaux-Arts traditions and encouraged by the advent of the White City.

Of the unsuccessful entries, there exist a representative selection of plans and elevations that show just what kind of response this competition, begun in the aftermath of the World's Columbian Exposition, elicited. Certainly none of the participants, neither the trustees who came up with the program nor the architects who responded to it,

can be accused of making any "little plans." The size of the completed building, as specified in the competition circular, was to have been worthy of a Prix de Rome competition. McKim, Mead, and White's plan, for example, was to have contained over 500,000 square feet of space within a building whose exterior sides were to measure 560 feet each. This was approximately what the program specified; the other competitors responded with plans of similar gigantism. James Cromwell's plan, published in *American Architect and Building News*, resembles closely that of McKim, Mead, and White and the description provided by the trustees.[38] It is in the shape of a giant square, divided into three courtyards (rather than four) by a T-shaped arrangement of hallways and galleries. The largest single space, the auditorium, finds its place in the central crossing, over which the elevation depicts a great dome. Cromwell's plan definitely reflects Beaux-Arts precedents. It has a distinct ceremonial and hierarchical progression defined by a "Grand Vestibule" behind the main entrance, which then leads into a grand stairhall, which in turn fronts the auditorium, behind which is the cloistered courtyard. The exterior is classical in detail but is distinctly behind in architectural fashion, as it employs a steeply pitched Mansard roof atop the otherwise long, low, classical bulk of the building.

For one of the other student submissions, there exists a front elevation but no plan. Albert Brockway's design was the most severely classical of the lot, taking the cue for its general silhouette from the Boston Public Library but substituting Ionic columns for the other building's arcaded front.[39] To the long, low mass of the building Brockway added a central pavilion of great simplicity, without grand stairs or even a portico: merely two sets of coupled columns *in antis* above the rusticated ground floor entrance.[40] Without an extant plan, it is unclear what the shape of the building would have been, but it is probable that Brockway followed the suggestions of the trustees, creating a cross within a square. There appears to be a very shallow saucer dome over the center of the building. This feature is the weakest element of the design, for the dome is too shallow even to be seen from the ground. Although Brockway's design is classical and restrained, it lacks the exuberance of the Beaux-Arts classicism of the World's Columbian Exposition and likely also the appeal of that style for the judges of this competition.

The central portion of the front elevation of the Parfitt Brothers' submission also remains to us in published form. This design definitely reveals the influence of the architecture of the fair; its most prominent feature is a high dome that bears a family resemblance to the dome on the White City's Administration Building, especially in its use of a high, colonnaded drum. Also in the same spirit as the fair, the Parfitt design is lavishly embellished with sculpture, including niches containing statuary groups flanking the entrance and a quadriga surmounting the entrance pavilion. Using the familiar device of labeling the architrave with famous artists' names, the Parfitts indicate their affinity with Renaissance architects Michelangelo, Sansovino, Scamozzi, and Palladio, perhaps hoping for some of their glory to be attached to the design. Once again, the plan of the building can only be assumed to be similar to that suggested by the trustees, the sole indication being the large dome which would presumably be located over the crossing.

The winning design by McKim, Mead, and White naturally followed the suggestions of the museum's trustees. As A. D. F. Hamlin indicated upon selection of the design, their plan "most nearly fulfilled the requirements of the Trustees, both in artistic merit and practical qualities."[41] The plan followed precisely the suggestion of a cruciform shape contained within a square and forming four courtyards. This particular form had a long history in Ecole des Beaux-Arts practices, for the Ecole emphasis on symmetry and axial arrangements made the cross-within-a-square plan an obvious and favored

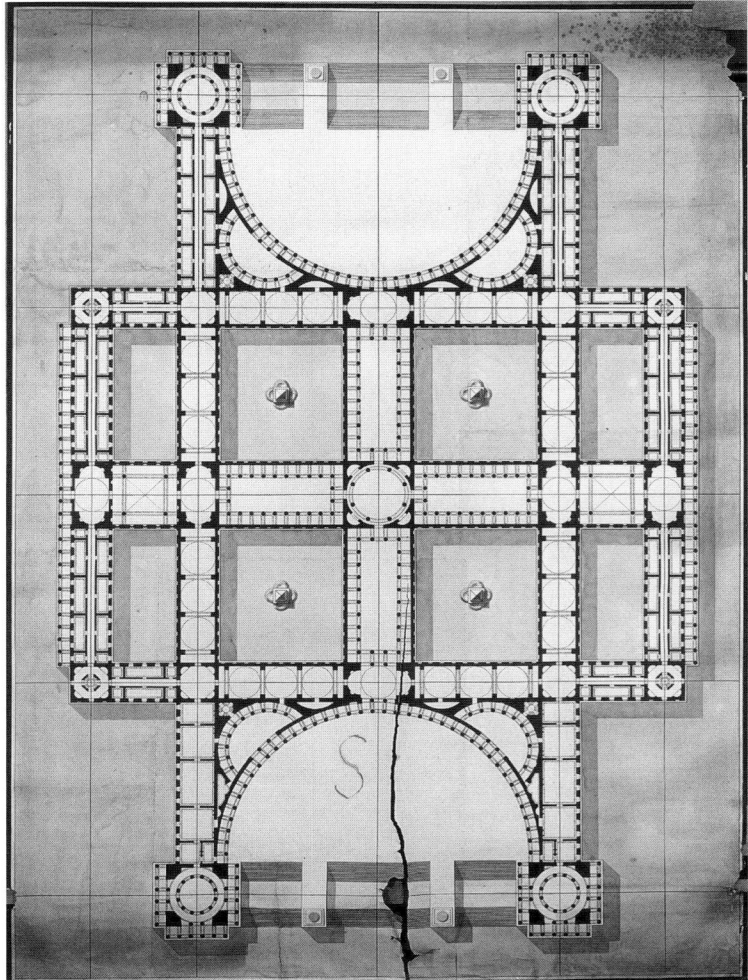

*J.-N.-L. Durand. Plan for a museum, Prix de Rome
project, Ecole des Beaux-Arts, 1779. Paris, Ecole Nat-
ionale Superieure des Beaux-Arts.*

solution. The plan goes as far back as the eighteenth century, having been used by the
visionary Boullée and subsequently adopted by the most prominent of the Beaux-Arts
theorists and pedagogues, J.-N.-L. Durand. Durand's 1779 plan for a museum, in fact,
incorporates just such a form, albeit within an even grander scheme. Nevertheless, the
heart of his plan is a cross within a square, enclosing four courtyards. This form was
to reappear in numerous Grand Prix projects at the Ecole for buildings as disparate
as a Covered Fair (A.-F. Peyre's 1762 Grand-Prix winner), a Supreme Court (both the
winner, Henri Labrouste, and the project by F.-L. Lepreux used the form for the 1824
Grand-Prix competition), and a City Hall (the 1839 Grand-Prix winner Hector Lefuel,
Hunt's future *patron*).[42]

McKim, Mead, and White's adoption of this plan was prompted by the suggestions
of the museum's trustees in the competition circular, but their adaptation was highly
sophisticated and used all the Beaux-Arts techniques at their disposal. The multifunc-
tional requirements—like those at the Carnegie and the Corcoran—called for the em-
ployment of Ecole methodology in the segmentation of the *parti* into diverse functions

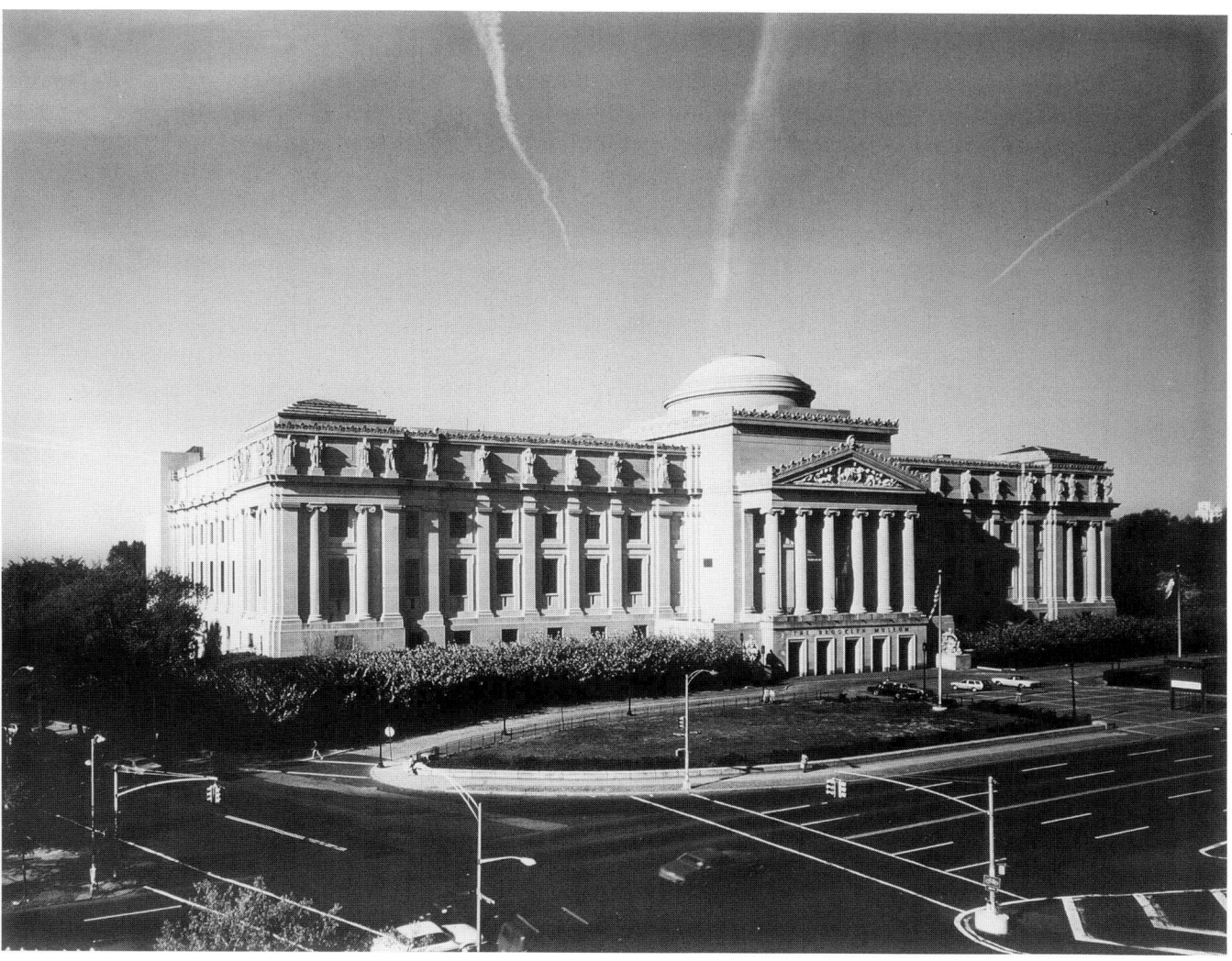

*McKim, Mead, & White. Brooklyn Institute of Arts
and Sciences, New York, 1893. Photograph, 1985.
Courtesy of the Brooklyn Museum.*

that were yet integrated into a harmonious whole. This they accomplished by following the ceremonial progression of a typical Prix de Rome plan. The main entrance draws the visitor in; it consists of a grand exterior stairway that draws the visitor not only in but up to the *piano nobile* and through a series of spaces that progresses from vestibule, to grand exhibition hall, to the climax of the central rotunda. This central space would then enable the visitor to make a series of choices: left to the auditorium, right to a large exhibition space, or straight ahead to another hall that could also lead one to a contemplation of the open and spacious courtyards. This progression follows the *cour d'honneur-corps de logis*-garden progression of the Ecole method, if one allows the courtyards to function as garden spaces. Finally, the sheer abstract beauty of the plan, with its dominant axes formed by the central cross and its interlocking, secondary axes formed by the surrounding hallways of the exterior square recalls those of the Grand Prix *concours*. The cloistered courtyards form a series of squares-within-a-square and repeat the overall motif of the building. It might also be noted once again that the scale of the plan was in keeping with those products of the French school.

Considered in the third dimension, the building was also arranged in hierarchical, pyramidally arranged volumes. Like the motif of the square in the plan, the dome was the fugally repeated motif of the exterior. In a beautifully orchestrated progression, the corner pavilions were capped simply with low, stepped roofs and shallow pyramids to be topped with quadrigae (not executed). Small domes accentuated the meeting of the arms of the cross with the surrounding square at the building's entrances, and the whole composition was to be crowned by the large, shallow dome marking the crossing of the interior halls. In the original conception of the building, all of these domes were to be saucer domes, carefully articulated with stepped bands around the lower circumferences.[43] It was this feature in particular that most specifically reflected the influence of the firm's own work at the World's Columbian Exposition. A comparison of the Brooklyn Institute design to that of the Agriculture Building at the fair reveals similarities other than the appearance of the domes. Like the Brooklyn Institute, the Agriculture Building was composed of long, low, simple masses. Its horizontality was emphasized by the dominant cornice line and low attic above it. At the fair, this cornice line united the Agriculture Building with the other buildings around it. In the Brooklyn building, the same cornice emphasizes the classical, horizontal mass of the building and provides a unifying guide for the visitor's eye to the overpowering scale of the building

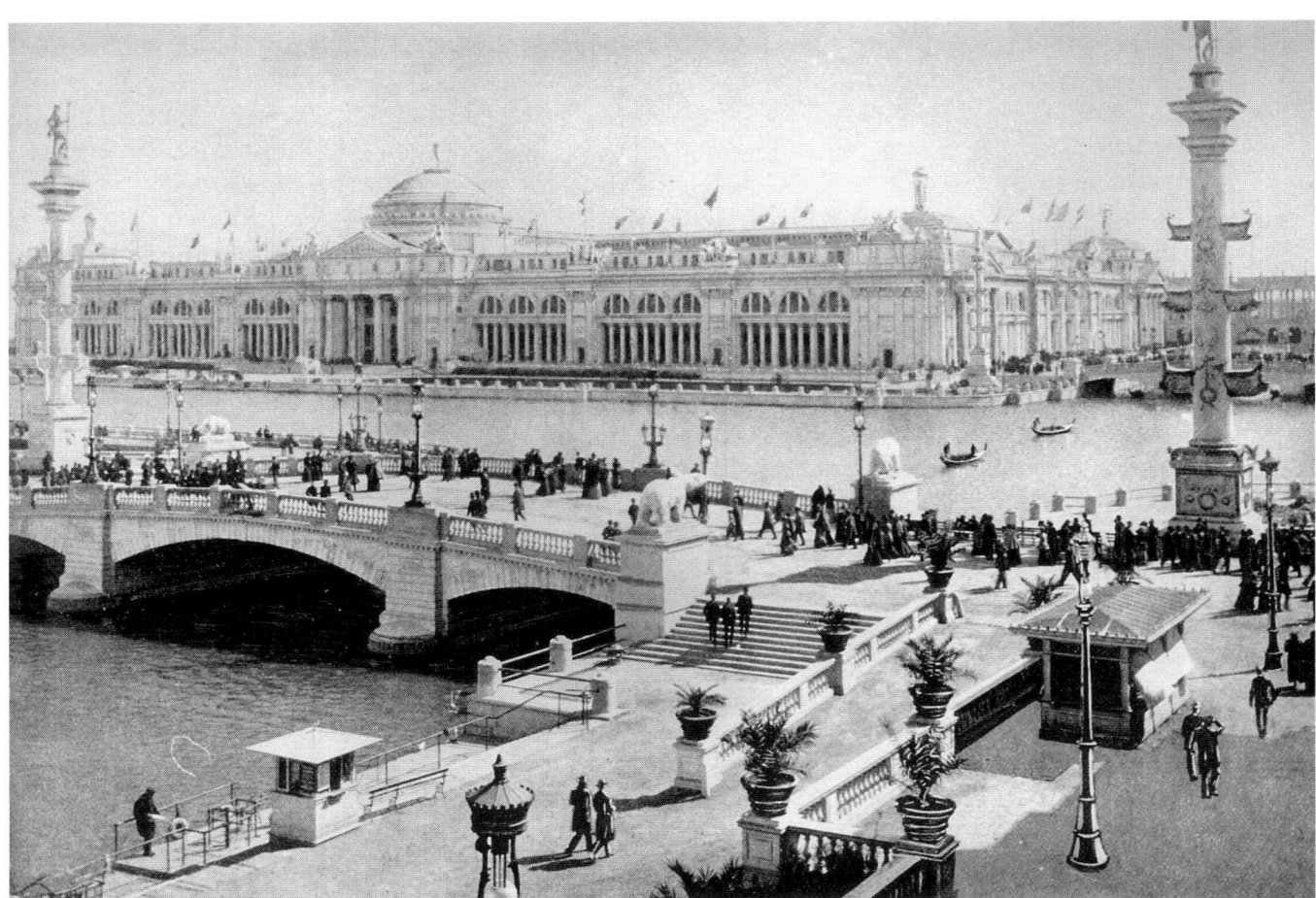

McKim, Mead, & White. Agriculture Building, World's Columbian Exposition, Chicago, 1893. Columbian Album, *1893. Collection of the author.*

in the relatively modestly scaled milieu of Brooklyn. Other similarities between the Brooklyn and the Chicago buildings are the corner pavilions, topped by similar pyramidal motifs at both locations, and the giant order of the pilasters applied to their height, belying the buildings' several stories and giving the appearance of a unified vertical elevation. The portico at Brooklyn is more prominent than the one on the Agriculture Building and has six freestanding columns rather than four, but both serve as prominent, dignified entrance motifs. Not to be overlooked is the similarity of the grand, even vast, scale of the two buildings. Although the architecture of the Agriculture Building masked a single, enormous interior exhibition space and the Brooklyn Institute was divided into smaller spaces as was usual for classical architecture built using traditional load-bearing construction, the scale of each was almost unprecedented in the American experience.[44] It is almost a certainty that the fair allowed the architects to think on such a grand scale.

The style of the building also incorporates some influences from the fair. The Brooklyn Institute's exterior appearance was not as severe as that of the Boston Public Library, which was reminiscent of the Neo-Grec, with its clean, bold massing and spare ornamentation. Rather, the Brooklyn museum incorporates some of the exuberance of the fair, not only in scale, but in ornamentation: the grand portico, the multiplication of domes, and above all, the preponderance of sculptural decoration. The firm's depiction of the museum shows pediment sculpture on the porticos, quadrigae atop all four corner pavilions, winged figures perched on the domes, and a lengthy series of Attic figures illustrating in three dimensions the famous names that only a year or more previously would have remained in simply incised inscriptions only (as at the Boston library). Francis L. V. Hoppin's beautiful perspective drawing of the museum shows four freestanding columns, surmounted by statues and wrapped in garlands, decorating the grounds of the museum, much as such columns had been scattered about the fairgrounds of Chicago. By incorporating some of the festive and celebratory features of the fair with generally classical proportions and a formal Beaux-Arts plan, the architects were able to satisfy the request of the trustees that the building be both "dignified and monumental in its proportions" yet not "rigidly formal in its use of classic motives."

The influence of the Columbian Exposition went even further. As has been discussed, the museum plans conceived by architects before the fair, as at Pittsburgh and Washington, were relatively easy to execute. This was no longer the case with grand-manner plans like the one produced by McKim, Mead, and White for Brooklyn. The fact that the architects' plan was unattainable within the scope of the usual five-to-ten-year timespan was not entirely the fault of their own visionary grandeur. The trustees were well aware that the building they wanted would take many years, more money than they actually had, and numerous building campaigns to finish. Like city planner Daniel Burnham, however, both architects and patrons decided to make big, long-range plans with the optimistic confidence that they would be followed—indeed, deemed worthy of following—by successive generations. The Brooklyn Museum embarked on its construction shortly after the competition was decided and completed the first portion, the west wing, in 1897. The central portion, with the staircase and entrance portico, was complete in 1904; the east wing, in 1906; and the first (and only) courtyard was enclosed by 1925. Nearly three decades after the competition, only about one-sixth of the total plan was completed. Shortly thereafter, modern aesthetics as well as modern economics led to the total abandonment of the original plan, never to be taken up again. It is perhaps a tribute to McKim, Mead, and White's plan that it survived and was followed for so long, but its demise seems inevitable by the advent of modernism. The long time frame required by these plans, set within the short time frame of changing architectural

fashion, spelled doom for these gargantuan undertakings. The portions that remain, like that at Brooklyn, stand like isolated puzzle pieces, clues to the ambitions of an earlier era.[45]

The Milwaukee Public Library and Museum Competition, 1893

The ascendancy of the Beaux-Arts plan and the ubiquity of the classical style are attested to by other museums and their competitions. McKim, Mead, and White brought the fair architecture to New York, but close to Chicago, the fair encouraged architects who had only witnessed the event to participate in its classicism and its grandeur through their submissions to another competition, that held for the Milwaukee Public Library and Museum in 1893 and won by the local architectural firm of George Ferry and Alfred Clas. It was perhaps inevitable that the Milwaukee institutions, only ninety miles from Chicago, should seek a design that would reflect some of the glory of the World's Columbian Exposition. Like all of the other buildings mentioned in this chapter so far, the putative Milwaukee building was to house a multitude of functions. Milwaukee, like Chicago, was a rapidly expanding city in the late nineteenth century, and its cultural institutions were growing with commensurate speed. By 1890, both its public library and its public natural history museum had outgrown their facilities and were desirous of erecting new ones. The respective boards of trustees of the two institutions conferred and decided that a single building could be erected to house both of them. In the newly scientific spirit of the era, the two boards appointed a committee to investigate the issue of the building's design with the result that the committee advised "the erection of two practically independent structures, connected only toward the street, so that they may present the appearance of a unified whole."[46] The committee's report also considered in depth the kind of facilities the new building should have. Among the special rooms to be provided for in the library portion of the building, there were to be several rooms for the study and display of art, including one for the display of copies and engravings with tables to accommodate the study of large portfolios and space to allow for copying and a toplighted gallery "for the exhibition of separate paintings, engravings and other art objects under the best possible conditions."[47] Thus, the building was intended to house a natural history museum, a library, and art galleries. The program for the building was, therefore, quite similar to the Carnegie Institute, which also housed these three functions, and the Brooklyn Institute, which was to house a kind of omnibus museum, containing exhibits in natural history, science, and art. That most of these multifunctional institutions have since dropped one or more of their functions—the Brooklyn building now only houses art and the Milwaukee building now functions solely as a library—is incidental; what they were intended to be at the time of their designing and erection is what matters.[48]

The Columbian Exposition was at its height when the competition was thrown open in September of 1893 with the publication and dissemination of the "Instructions to Architects" flier.[49] Taking their cue from the specific nature of the Brooklyn Museum competition instructions (the investigating committee had visited Brooklyn in 1890 and it is possible that the Milwaukee officials kept an eye on the competition that was taking place earlier in 1893), the trustees of the two institutions enumerated their desires in this circular. It should be kept in mind that the joint report published in 1890 was also available to any competitor desirous of acquainting himself with the needs of the two institutions. In the "Instructions to Architects," the specific requirements of the building included the materials preferred (all were various types of stone); the facilities to be

provided, including a skylighted gallery for the putative art exhibitions; and, as had been done at Brooklyn, intimations of the style preferred by the trustees. They asked that the "building should be of a pure style of architecture, befitting its uses, and impressive to the eye by beauty of proportion and harmony of lines rather than by showy ornament or eccentric features."[50] This statement is a clear summons to the kind of classicism that was exhibited at the Chicago fair and contains echoes of the Beaux-Arts teachings that were used to produce it.

The desire for a "pure style of architecture" could only be responded to through the use of the scholarly approach taught at the Ecole and by Richard Morris Hunt especially—a scholarly approach that defined classicism as the only "pure" style. Henry Van Brunt, once a pupil of Hunt, recalled that he and his fellow students "were instructed to make our plans on rigidly scholastic lines, and the vertical developments in the elevations we were taught to study in strict classic form."[51] That by "pure style" the Milwaukee trustees meant "classical" seemed to have been generally understood by the competitors, for nearly all of the designs published in the newspapers during the much-watched contest were classical.[52] Because of the great excitement generated in Milwaukee by the competition, more than twenty-five of the seventy-four submissions were illustrated, either in elevation or perspective, in the local newspapers, thereby providing a more than usually complete idea of the scope of the contest. Two influences emerge very clearly: that of McKim, Mead, and White's Boston Public Library and that of the Chicago fair's architecture in general.

Designs by William M. Kenyon of Minneapolis; R. C. Spencer Jr. of Chicago; the Boston firm of Andrews, Jaques, and Rantoul; and the Detroit firm of Nettleton and (Albert) Kahn are clearly adaptations of the Boston library building.[53] All four of these designs exhibit long, low silhouettes with shallowly pitched roofs and the arcaded windows used so successfully by McKim, Mead, and White. The great influence of the Boston building appears to have been superseded by the popularity of the architecture of the fair, however, because most of the competition designs incorporate the more flamboyant brand of classicism practiced there. The influence of the Columbian Exposition was not lost upon observers, who noted in a local newspaper "the extraordinary

Andrews, Jaques, and Rantoul. Competition design, Milwaukee Public Museum and Library, 1893. The [Milwaukee] Sentinel, *3 December 1893. Courtesy of the Milwaukee Public Library.*

NETTLETON & KAHN DETROIT.

Nettleton and Kahn. Competition design, Milwaukee Public Museum and Library, 1893. The [Milwaukee] Sentinel, *3 December 1893. Courtesy of the Milwaukee Public Library.*

effect of the World's Fair architecture on the designs. A majority of the architects have adopted some of the striking features of the buildings of the White City."[54] Specific motifs drawn from some of the Court of Honor buildings appear a number of times, as the architects ransacked the ideas of the fair architects in order to produce a building that would endow Milwaukee with some of the glory of the Columbian Exposition. For example, the Spanish Renaissance towers that adorned Peabody and Stearns's Machinery Hall found admirers in the designs by J. E. O. Predmore of Chicago and John A. Moller of Milwaukee, whereas the entrance motif of Van Brunt and Howe's Electricity Building, consisting of a pair of more classical towers flanking a pedimented temple front with projecting portico also reappeared, somewhat modified, on the submission by Gordon and Helliwell of Toronto.[55] The low saucer dome of McKim, Mead, and White's Agriculture Building was appended onto several submissions, including the winning design by Ferry and Clas of Milwaukee and a submission by a young Frank Lloyd Wright (which proves that almost no one was immune to the magic of the fair).[56] Other indications of the influence of the fair were the consistent uses of decorative sculpture; prominent, horizontally emphatic cornice lines; and in general a more exuberant classical mode than was exhibited by such prefair buildings as the Boston Public Library, the Carnegie Institute's original building, and the Corcoran Gallery.

The most original submission was Ernest Flagg's. The greatest difference between Flagg's plan and all of the other published plans was that Flagg's edifice was expressed in protruding and receding volumes, whereas all the other competitors formed the exterior massing of their buildings with one main volume. This tendency reveals a too-assiduous copying of the fair buildings, which were all necessarily formed in this manner because each of them enclosed one large, hangarlike interior space. Flagg's published perspective shows a U-shaped building embracing a recessed forecourt into which pushes the volume of the entrance hall and a double set of curved exterior staircases. Although this very French design is nearly baroque in its play of contrasting positive and negative spaces, it is the only one to recognize that the Milwaukee building was to

W. D. KIMBALL'S DESIGN FOR THE LIBRARY MUSEUM

J. E. O. FREDMORE, CHICAGO.

J. E. O. Predmore. Competition design, Milwaukee Public Museum and Library, 1893. The [Milwaukee] Sentinel, *3 December 1893. Courtesy of the Milwaukee Public Library.*

DESIGN OF JOHN A MOLLER, MILWAUKEE.

John A. Moller. Competition design, Milwaukee Public Museum and Library, 1893 (The [Milwaukee] Sentinel, *16 November 1893). Courtesy of the Milwaukee Public Library.*

Gordon and Helliwell. Competition design, Milwaukee Public Museum and Library, 1893. The [Milwaukee] Sentinel, *3 December 1893. Courtesy of the Milwaukee Public Library.*

Ferry and Clas. Competition design, Milwaukee Public Museum and Library, 1893. The [Milwaukee] Sentinel, *16 November 1893. Courtesy of the Milwaukee Public Library.*

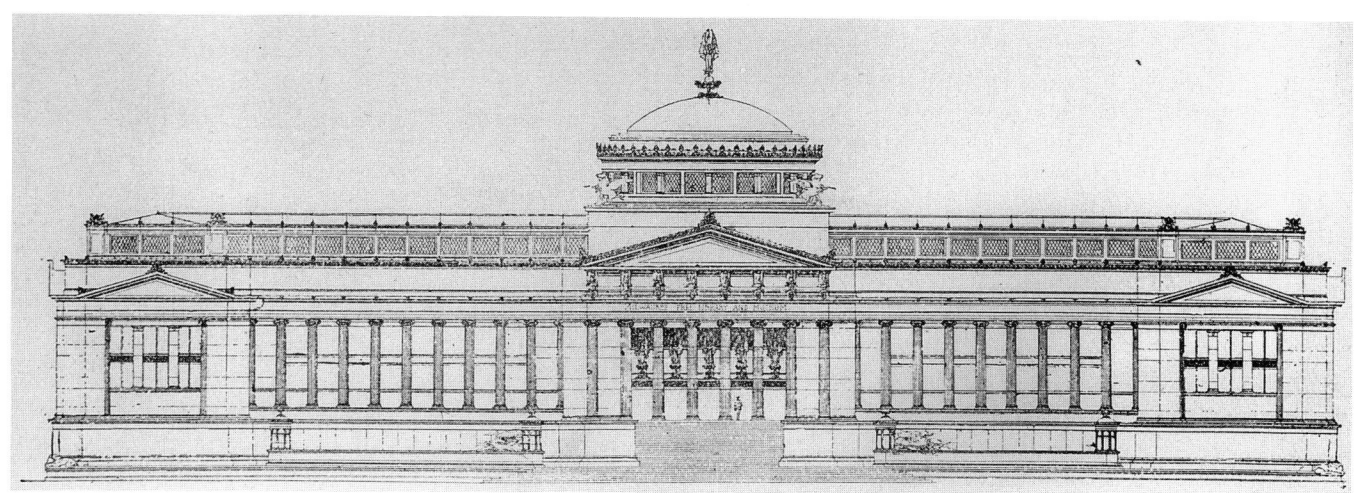

Frank Lloyd Wright. Competition design, Milwaukee Public Museum and Library, 1893. Courtesy of the Art Institute of Chicago.

PRINCIPAL FLOOR PLAN.

Ernest Flagg. Competition design, Milwaukee Public Museum and Library, 1893. Inland Architect and News Record *23. Courtesy of the Art Institute of Chicago.*

be built using traditional load-bearing construction and therefore could be subdivided into discrete volumes.

Despite the originality of Flagg's design, it is clear that the library and museum officials were interested in a design that had its origins in the Chicago fair. This is made particularly apparent by the interest they expressed in having Charles Atwood, designer of the Fine Arts Palace at the fair, submit a design for the competition.[57] Atwood never entered the competition, however, nor did any of the actual fair architects who worked in the classical mode.[58] In order to choose the most academically correct design, the museum and library officials invited Professor William Ware, then head of the school of architecture at Columbia University, to serve as consultant and judge (with the trustees to make the final decision by vote). Their choice of judge asserts their interest in adhering to the best classical and Beaux-Arts standards, considering Ware's training and his involvement in establishing the Ecole teaching methodology as de rigueur in American schools.

Ware obliged by narrowing down the field of competitors to five: Nettleton and Kahn; Milwaukee architect H. C. Koch; Ferry and Clas; Andrews, Jaques, and Rantoul; and Boring and Tilton.[59] Although Ware did not single out any one design as the very best, he referred to the design by Ferry and Clas as the one for which the plan was least objectionable and he commended the elevation as "one of the best, if not the very best of them all, elegant and sufficiently dignified."[60] The primary sources for the Ferry and Clas library and museum building are, appropriately enough, a museum and a library: the Louvre and the library at the University of Leipzig. The German antecedent seems particularly appropriate for a city with a large German population. In any case, the Ferry and Clas design is a well-handled one in which the rusticated basement floor is in good proportion to the *piano nobile*, the five-part rhythm of pavilions and wings is in particularly nice harmony, and the detailing of the Corinthian colonnade, arched windows, inscribed cornice, and balustrade are professionally executed. Perhaps the design's greatest fault lies in its adoption of the saucer dome, which is somewhat small in proportion to the corpus and appears as something of an afterthought.

In comparison, H. C. Koch's design combines many of the same elements as the Ferry and Clas design and achieves much the same feeling. Koch, too, employs an inscribed cornice line, decorative sculpture, a balustraded parapet, and a rusticated basement which supports a *piano nobile*. Here, however, the upper floors are not well unified, as they lack the device of the colonnade which distinguishes the upper floors from the lower in the Ferry and Clas design. Although Koch also uses a colonnaded pavilion to distinguish his grand entrance, the lack of end pavilions makes such a long facade seem indecisive in comparison to the balanced facade of the winning entry.

Ware qualified his report by mentioning problems he saw in each design, suggesting that much of the problem arose from a lack of specificity in the "Instructions to Architects." The trustees voted to award the commission to Ferry and Clas on the fourth of January, 1894. Upon the announcement of the trustees' decision, however, there were suddenly cries of "unfair!" from some of the other participating architects, primarily from Koch, whose plan finished in second place.[61] Koch declined his five hundred dollars prize money and sought to secure a court injunction preventing the trustees from paying Ferry and Clas for their entry. Koch's accusations were not the least of those brought against Ferry and Clas, Ware, and the officials in charge of the competition. Particularly because the winners were a local firm, it was assumed that favoritism was a part of the decision; but it was also alleged that Ware, a New Yorker, had shown favoritism toward architects on his final list who were thought to be personal friends of his.[62] Other arguments maintained that Ferry and Clas's entry should have been

disallowed because Ferry had attempted (unsuccessfully) to submit a revised floor plan after the close of the competition and before Ware's arrival.[63] A formal protest against Ware's report was also submitted by ten of the competitors in the form of a petition.[64] As Ware would later point out in a lengthy article on competitions,

> Just as, after an election, there are always more people gratified than disappointed, so after a competition there are necessarily many more people disappointed than gratified. Only the winner is satisfied with the way the system works, and even he is not eager to risk it again.[65]

Yet another objection to Ferry and Clas came about well after the decision had been made, this time asserting that their building could not be constructed for the five hundred thousand dollars specified by the trustees, and because the architects would not provide a bond to insure that amount, it was argued, Ferry and Clas should be disqualified.[66]

A variety of editorials appeared in Milwaukee newspapers concerning the fairness of the competition. One claimed that the competition was practically a model of fairness, asserting that Ware had no knowledge of the authorship of the plans he chose; this assertion appears to have been true, as the published version of his report referred to the plans by number only.[67] Another editorial claimed that Ware did see the names of the competitors before making his decisions; hence, the competition was grossly unfair.[68] A much more interesting criticism of the competition was presented by architect N. S. Patton to the Chicago chapter of the American Institute of Architects only a month after the competition was decided. Patton wrote that for years architects had agitated to have "experts" judge competitions in the interests of fairness and a knowledgeable judgement. The Milwaukee library and museum officials had done precisely that in soliciting William Ware for his advice; but it was apparent that Ware's report satisfied few, including Patton, who dissected Professor Ware's report point by point. He faulted Ware for basing his conclusions on what he perceived the interior arrangements of the plan ought to be and claiming that the "Instructions to Architects" was not specific enough, whereas Patton asserted to the contrary that "the instructions were unusually explicit."[69] Patton claimed that Ware chose to ignore the layouts of the plans and judged the entrants solely by exterior appearance:

> In the mind of the expert, the arrangement of a good plan is a matter of accident, and he proposes to award the prizes not in accordance with the results before him, but on his estimate of the skill of the designers, as shown by their avoiding what is desirable.[70]

Patton chastised Ware for what he saw as placing emphasis on the elevation rather than on the plan, truly a reversal of dearly held Ecole des Beaux-Arts tenets. He concluded that Ware's perusal of the plans must have been cursory and superficial and argued that, in the future, such an important decision should not be subjected "to the whim of any one man."[71] Patton's was one of the most cogent arguments against Ware's involvement, but it must have been difficult for the trustees in Milwaukee to imagine any judge more qualified than Ware; they were, finally, satisfied with his recommendations.

Nevertheless, the flurry of controversy over the competition was not the least of Ferry and Clas's problems. Once they had been irrevocably engaged to do the work and had even completed some of it, the museum and library officials reneged on their promised 5 percent commission, reducing it to 3.5 percent.[72] It was no wonder that in the last decade of the nineteenth century, many architects viewed the competition "as a sort of nightmare, as an incubus or vampire, stifling the breath of professional life, and draining its blood."[73] An 1894 article written by the well-established architect Leopold Eidlitz

attempted to demonstrate the problems of competitions by reciting an argument he
had had with a doctor friend. He claimed that having the average building committee
choose an architectural design from a series of competition entries was like the architect
telling the doctor how to practice medicine.[74] Eidlitz maintained that such building
committees were easily swayed by colorful drawings, large models, and glib promises
about low cost and high technology and that they were, moreover, "bent upon employing
architects in whom they have a personal interest."[75] It might have been assumed that
the employment of a knowledgeable judge such as Ware would preclude such problems,
but in the case of Milwaukee, it was not enough. It would take another two decades
before the profession, under the aegis of the American Institute of Architects, formu-
lated a set of guidelines for the competition.

Until then, the preference of any architect who could manage it was the system of
outright appointment. Naturally, the architect who had prestige and a high reputation
could garner his business in this manner. Thus it was that other major art museums
during this period of developing professionalism were designed without the formality
of the competition. With or without the competition, however, the grand Beaux-Arts
plan, executed along the lines of a Prix de Rome contest, claimed ascendancy over the
future of the American art museum building. Like the plan for the Brooklyn Museum,
other plans for museums were designed that encompassed great swaths of land and
leaps of the imagination and would require generations of commitment to the plan as
well as a great deal of money and ongoing building campaigns if they were to be
completed.

The Master Plan for the Metropolitan Museum of Art, 1895

Only shortly after the Columbian Exposition which kindled the architectural ambi-
tions of architects and museum officials alike, Richard Morris Hunt envisioned a master
plan for the Metropolitan Museum of Art in New York the scope and complexity of
which could rival the best of the Prix de Rome winners. As has been previously dis-
cussed, Hunt disliked the High Victorian Gothic style of the original museum building
but had had to tolerate it for two decades. For Hunt, the irony of his position on the
board of trustees of the museum and his helplessness as he watched the building being
constructed must have amounted to insult. When in 1894 the architectural future of
the museum was finally entrusted to Hunt, he responded with a plan that would not
only completely envelop the original building but would also occupy the entire plot of
land assigned by the city of New York to the museum.[76] Hunt's master plan is firmly
entrenched in Ecole des Beaux-Arts tradition, both in its individual elements and its
unifying progression, or *parti*. In his essay on Hunt and the museum, Morrison
Heckscher notes the similarities between Hunt's plan and that of several specific ante-
cedents, such as Henri Labrouste's Grand Prix winner for 1824, a design for a Supreme
Court, and Honoré Daumet's 1855 Grand Prix winner, a Conservatory of Music and
Oratory.[77] Hunt's design has suggestions of both; two chapels he proposed to jut into
open courtyard spaces very much resemble similar features of Labrouste's plan, and
the rhythm that would have been created in Hunt's plan by the large volumes of en-
trance hall, library, and auditorium, connected by long, low wings is reminiscent of
similar rhythms created in Daumet's great plan. These devices were common to many
Ecole designs, however, and it is the overall flavor of Hunt's design that recalls the
teachings of the French school.

Most essentially, the ceremonial progression created by Hunt for the Metropolitan

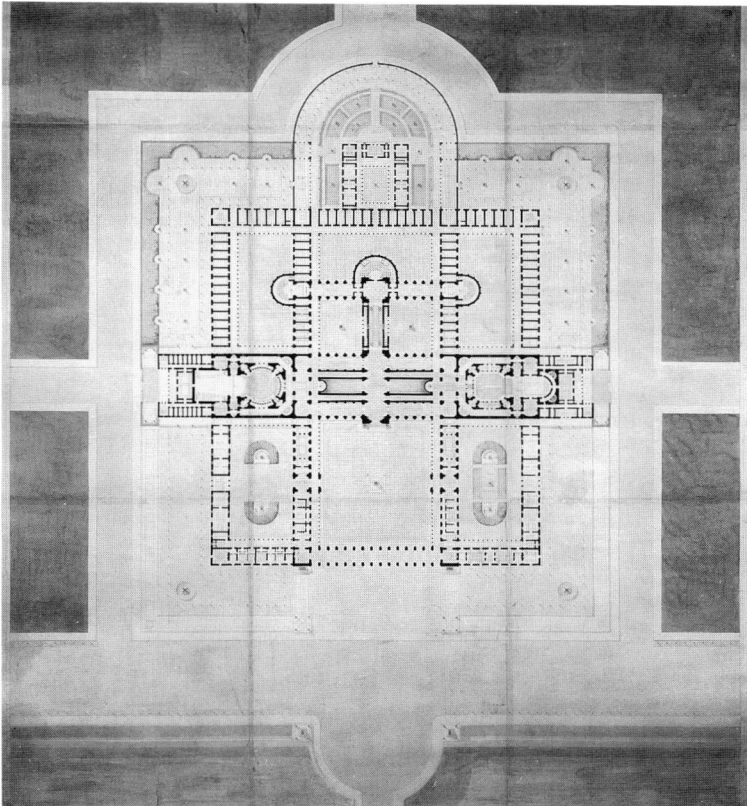

*Honoré Daumet. "A Conservatory of Music and Ora-
tory," Prix de Rome Project, Ecole des Beaux-Arts,
1855. Paris, Ecole Nationale Superieure des Beaux-
Arts.*

Museum adheres to the Beaux-Arts method. The *cour d'honneur* is marked by the shal-
lowly recessed main entrance hall whose grandeur would prepare a visitor for the slow
progression through the building and appreciation of the art contained therein. The
corps de logis is created by the functional galleries, emanating outward from the large
central block of the original building and culminating in a series of interlocking, open
squares formed by the halls and containing open courtyards. The end of the progres-
sion, appropriately enough, was the garden, in this case all of Central Park, which is
drawn into Hunt's plan by a rear entrance composed of a recessed, semicircular court
whose pedigree extends back to Boullée and Durand. The interlocking squares and
axiality of Hunt's plan are essential to the French emphasis on the plan, and it is clear
that in this case the design for the museum is plan generated. The third dimension (no
studies survive) would also have been hierarchically arranged, with the largest volumes
on the exterior expressing the library, auditorium, and main entrance, the appearance
of height gradually diminishing as the northern and southern extremities were reached.
Finally, the sheer abstract beauty of the master plan as prepared by Hunt puts his work
clearly in the same exalted family as the Prix de Rome competitors. The main difference
between them and Hunt is that Hunt was at the very end of his distinguished career,
and this plan was a paean to the career that had begun so auspiciously in the Paris
Ecole four decades earlier.

Despite Hunt's death prior to the approval of the plans, his champions saw to it that

at least the first portion of his design was executed. The main entrance and the hall that connected it to the original building was completed and opened to the public in 1902. Like McKim, Mead, and White's design for the Brooklyn Institute, the grand plan envisioned by Hunt was adhered to for several building campaigns before its abandonment. In later building campaigns, McKim, Mead, and White extended the Fifth Avenue facade along the lines suggested by Hunt, but the entire scheme never materialized and was abandoned, like that for Brooklyn, with the advent of modernism and the more pressing exigencies of modern finances. The existing fragments of these museums in Central and Prospect Parks stand as eloquent reminders of a past whose hopes for the future were relinquished by its descendants.

The Master Plan for the Museum of Fine Arts, Boston, 1907

None of the grand Beaux-Arts plans created by architects during this period came to fruition in more than a fragment. The optimism of the period was applied to museum plans as hopefully as to the great city plans, however; and Guy Lowell's design for the Museum of Fine Arts, Boston, was as sweeping in its vision as Hunt's and nearly as impossible to execute. The choice of architect in the case of the Metropolitan Museum was nearly moot; Hunt had been connected to the museum for the length of his own career. To subject him to a competition would have been both absurd and insulting; additionally, the desired designs were not for a whole new building (as much as Hunt wanted it to appear that way), but for an addition. In the case of the Boston museum, however, the choice of an architect was almost as well researched and debated as the requirements of the plan. As has been previously discussed, the museum embarked on a study of museum buildings which considered all the needs as stated by its own departments and conducted a broad study of museums in the United States and Europe. Architect R. Clipston Sturgis was hired in 1902 to consolidate these needs into a prototype of a plan for the museum, but he was explicitly told that once his job had been fulfilled, the museum would be free to hire another architect directly or to hold a competition from which Sturgis would be barred.[78]

The issue of a competition was one much in the collective mind of the building committee for the museum. As early as 1899, when the museum had only just purchased the lands on the Fenway, architects wrote to the museum and even petitioned it with requests to hold a competition or be invited to one. These requests came from such notable architects as Charles Coolidge of Shepley, Rutan, and Coolidge, who—in an indirect reference to McKim, Mead, and White—complained that a Boston architect should at least have a chance at designing such a prominent Boston building.[79] The museum even received a petition in 1900 signed by a dozen architects, requesting that the museum hold a competition for its new building design.[80] In response to this pressure to sponsor a competition, one of the trustees wrote to Charles McKim in 1901, requesting the names of the five best Boston architects in McKim's judgement, with the idea of holding an invitational competition.[81] Another idea entertained by the building committee was for a competition in which a number of architects were to be invited to compete, but the preliminary stage of the competition was to consist of an interview or series of interviews. The architect would be expected to answer questions "which would draw out his appreciation of the peculiar nature of [the] problem, his willingness to work it out in collaboration with us, . . . his general idea of what such a building should be like, and so on."[82] After the interview, the architect or firm would then be asked to prepare drawings. This idea in itself suggests the inappropriateness of a competition for the temperament and mentality of this particular building committee.

It was, therefore, despite the urgings of architects who wished to compete for the commission of the museum design that in the end it was decided to hire an architect outright. Samuel Warren, chairman of the Building Committee, was especially against the idea of a competition, primarily because he wished the museum to have the maximum degree of control over the finished product as was possible. To this end, he suggested that an architect be hired who first filled the needs of the Committee in respect to his malleability; that is, they were looking for someone competent yet without too much experience. As Warren stated:

> Anyone who thinks he knows our needs better than we do ourselves, or who would propose to force us into an exterior not in every way suited to our uses, because it is the sort of building he would like to construct, is not for us. We want a helper and not a master. I would rather take the risk of a lack on the side of experience than on that of amenability to our requirements.[83]

Although this statement does not express a great faith in the profession, the kind of close working relationship the building committee desired to cultivate with their architect was one for which a direct hiring, rather than a competition, was conducive. In Guy Lowell they found a perfect candidate. Only recently an Ecole des Beaux-Arts *diplomé*, Lowell was well trained but not greatly experienced. Whether or not the building committee members were aware of it, an architect with Beaux-Arts training was precisely the person to execute their designs. To a degree greater even than any of the Ecole *concours*, the Museum of Fine Arts building was plan-generated; Sturgis and a number of the museum personnel had been working out the most desirable *parti* for three years before Lowell was hired. Much as in the manner of a student competition, Lowell had to create a concrete plan following the intricate but highly specific program set forth for him by his client. Not only were the requirements for the plan specific, but they were also multifunctional like earlier museum programs. To be incorporated into the design were not only the various galleries and administrative spaces, but a library, the school of art, and even a hall of casts. That Lowell's final plans look like a Prix de Rome competition entry should hardly be surprising.

Like the plans for the Brooklyn Institute and the Metropolitan Museum, Lowell's vision for the Museum of Fine Arts optimistically encompassed a good deal of the future, for once again only a relatively small portion of the proposed edifice could be erected at once (though more than had been erected at either New York institution). The overall scheme was as thoroughly Beaux-Arts in its organization and progression as either of its New York forebears. Its deeply recessed forecourt, flanked by two large wings, made a ceremony of entrance, continued and emphasized by the grand, ceremonial staircase the visitor encountered after passing through the vestibule. This portion formed the *cour d'honneur;* once visitors had progressed up the staircase, they reached the rotunda, which could be equated with a traffic *rondpoint,* or what Lowell referred to as a "distribution center" to the *corps de logis*.[84] There visitors would have to make a choice as to which portion of the museum to visit. The museum was logically subdivided into smaller circuits visitors could make and then return to the rotunda without having to travel through portions of the building they did not wish to see. This was the organization the building committee desired, but Lowell achieved it using traditional Ecole methods. The plan unfolds itself in the familiar fashion: a major axis crossed by minor ones, a series of larger and smaller courtyards formed by the loosely interlocking hallways. Like Hunt's plan for the Metropolitan, Lowell's plan has an abstract beauty in its symmetry and even disposition of solids and voids, both on the building's exterior and in its interior courtyards. As he had been taught at the Ecole, Lowell designed the building to look like a museum and a cultural icon via his use of forms and architectural lan-

guage. He felt he had done so successfully when he wrote that the building's "purpose as a great public institution is evident."[85]

So wed was Lowell to the Beaux-Arts design process and method that despite the fact that the museum's consulting architect, R. Clipston Sturgis, had come up with a plan and a set of elevations that were published as the *Report on Plans Presented to the Building Committee,* Lowell's plans really bear very little resemblance to them. Lowell's final plan retained some of the general suggestions of Sturgis's arrangements, namely in the retention of the public exhibition spaces all remaining on one floor and the overall division into departments so desired by the museum personnel. A comparison of the plan devised by Sturgis, who was not an Ecole trainee, during his three years' cooperation with the museum staff with Lowell's plan, however, reveals the telling imprint of a recent student of the Ecole des Beaux-Arts. Sturgis's plan is not entirely symmetrical, and although it, too, contains a number of interior courtyards, the bulk of the building in plan is comprised not of the long, elegant, interlocking hallways of Lowell's plan but of larger blocks connected by short, comparatively stubby halls. The functions of the two plans are much the same; Lowell was not at liberty to change the program, but he brought it to fruition with a *parti* of an elegance and symmetry that bear the imprimatur of his Beaux-Arts training.

Lowell's vision of the museum fared better than any of the other museum plans of the grand type. He was young when he was first hired and remained the architect for the museum through several building campaigns. A comparatively large portion of the museum was executed according to his plans, somewhat modified in the details but the same in essence. The two large courtyards, however, were never completed along the lines Lowell envisioned. The Museum of Fine Arts as it now stands is the most complete fulfillment of a grand-manner Beaux-Arts plan, for both the Huntington Avenue and Fenway facades appear as Lowell designed them. Unlike visitors to the Metropolitan, however, who still experience Hunt's entrance as a preparation for the grand progression through the museum, visitors to the Boston museum must now forgo the ceremonial progression from the Huntington Avenue forecourt, up the grand staircase, and to the rotunda; sadly, they must enter instead via a side parking lot.

Competitions and the American Institute of Architects

Despite the Boston museum's seeming lack of faith in the architectural profession and especially in the competition, the era of the Prix-de-Rome style museum plan was not to end without one last competition in the traditional style. The 1911 competition for the Minneapolis Institute of Arts was conducted on lines that showed evidence that architects and museums alike had learned from the vicissitudes of previous competitions. Professional observers, such as William Ware, who by 1900 had supervised as many as thirty competitions, had experienced the best and worst that the competition brought out in all of its participants and had devoted a great deal of thought to the problem. In 1899, not long after his experience with the Milwaukee Public Museum and Library, Ware outlined the problems and benefits of the competition and stated his recommendations for the fair conducting of competitions. In a lengthy article in *American Architect and Building News,* he discussed the benefits of competitions as allowing young architects to have a chance at prominent commissions, lessening the vagaries of individual patronage, protecting the public from the whims of individual architects, and stimulating the profession at large. In order to make the competition as painless as possible for all elements involved, he suggested that only sketches should be

solicited, every competitor should be compensated for his outlay, and a professional advisor should attend all facets of the procedure, from the writing of the program to the judging. Ware insisted that with careful attention to procedure, the competition could be a satisfying process for all involved:

> It seems plain that the advantages [of the competition] are sufficiently real and important to account for and justify its continued existence. Since, then, we cannot reasonably expect to do away with competitions, and on the whole should not desire to, it is gratifying to find that with a little care and pains it is practicable materially to enhance their advantages and almost entirely to get rid of their most objectionable features.[86]

Coming from one with such wide experience, Ware's arguments made a great deal of common sense. It is therefore not surprising that the architectural profession would eventually adopt the spirit of Ware's suggestions in its professional guidelines.

By 1909, the American Institute of Architects had authorized its "Circular of Advice and Information" on competitions, a set of requirements prerequisite to the participation of any member of the Institute in a competition. This set of guidelines follows with close adherence to Ware's suggestions but with the authority of the Institute to ensure compliance: "Members of the American Institute of Architects do not take part as competitors or jurors in any competition the program of which has not received the formal approval of the Institute."[87] The Institute required that an architect should act as advisor to write up the program, choose the competitors, and conduct the competition. It also required that at least one practicing architect should be on the jury but preferred that a majority be architects and that some members of the jury should be selected by the competitors themselves. Furthermore, the Institute stated its preferences concerning the type of competition it considered optimal: a limited, invitational competition, requiring the minimum number of simple drawings for which each competitor should be compensated. The Institute also sought to protect the prospective builders by urging that only architects of proven ability be allowed to enter the competition. With the establishment of these guidelines, the assurance that competitions would be conducted in a professional manner was finally secured for the profession at large. The competition for the Minneapolis Institute of Arts was to prove the efficacy of these guidelines, for the profession regarded that competition as a model of fairness and propriety.

The Minneapolis Institute of Arts Competition, 1911

When in 1910 the Society of Fine Arts in Minneapolis was ready to undertake the process of building its new home, it was decided to secure the design for its building via competition. With careful adherence to the new rules established by the American Institute of Architects, the building committee organized the competition with the help of an expert advisor, Warren P. Laird, a Professor of Architecture at the University of Pennsylvania. They also selected an expert panel for the jury, which consisted of William M. R. French, Director of the Art Institute of Chicago, architects Paul Cret and Walter Cook, and J. H. Gest. The tone of the competition was particularly legitimized and elevated by the participation on the jury of Walter Cook, an early Ecole des Beaux-Arts trainee and President of the American Institute of Architects in 1912. In adherence to the preference of the A.I.A. for limited competitions, five firms were invited to compete, each to be compensated $1000 for their participation, except for the winner, whose

prize was the commission itself. The terms of this competition were highly praised in the professional journal, *The Western Architect:* "Only those of the profession can, perhaps, appreciate the credit that is due this Committee for the care with which it outlined its program, adhering, as it did, strictly to the rules of the A.I.A."[88]

Considering the professionalism with which the competition was conducted, it is not surprising that the Minneapolis Institute was able to attract some of the most distinguished architectural firms of the time to compete. The five invitees were the winning firm of McKim, Mead, and White; Carrère and Hastings of New York; Pell and Corbett of New York; Shepley, Rutan, and Coolidge of Boston; and Hewitt and Brown, the hometown concession from Minneapolis, advised by Walter McCornack. According to Paul Cret, the Minneapolis Institute was even more to be commended for the selection

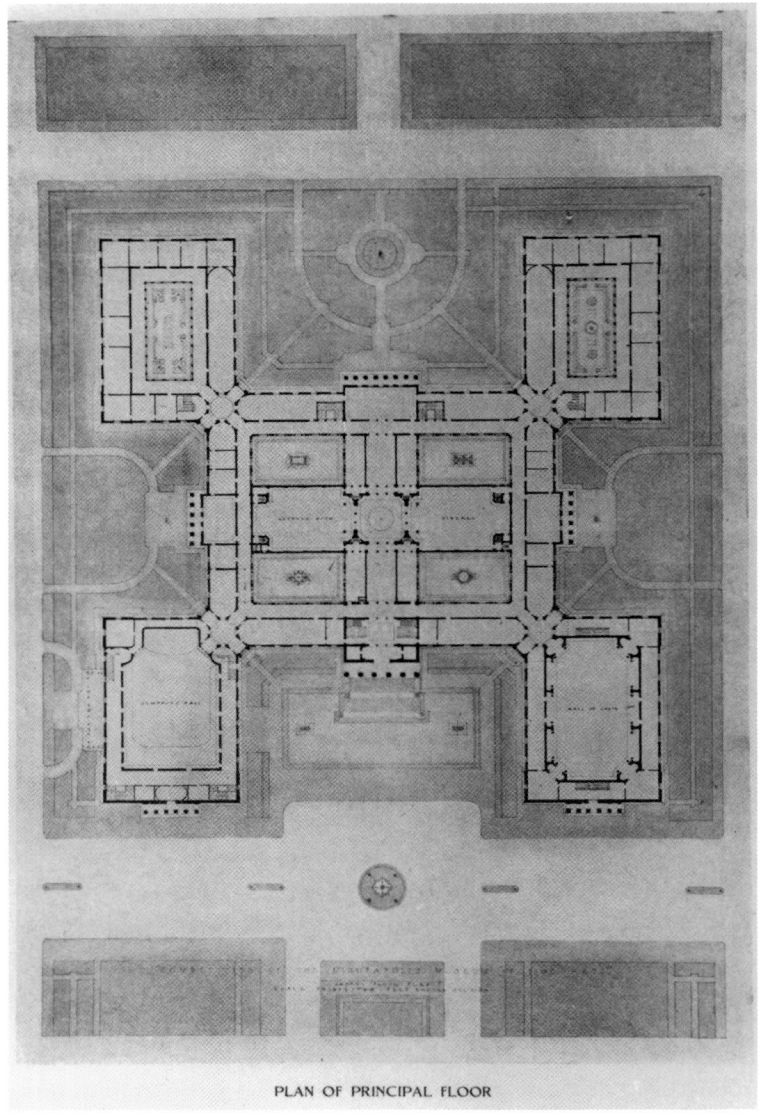

PLAN OF PRINCIPAL FLOOR

Shepley, Rutan, and Coolidge. Competition design for Minneapolis Institute of Arts, 1911. Plan. Architectural Review *1, 1912. Courtesy of the Art Institute of Chicago.*

VOL. I, NO. 5 THE ARCHITECTURAL REVIEW PLATE XLI

FRONT ELEVATION

SIDE ELEVATION

SECTION
DESIGN SUBMITTED IN COMPETITION FOR A MUSEUM OF FINE ARTS, MINNEAPOLIS, MINN.
SHEPLEY, RUTAN & COOLIDGE, ARCHITECTS

Shepley, Rutan, and Coolidge. Competition design for Minneapolis Institute of Arts, 1911. Elevations and section. Architectural Review *1, 1912. Courtesy of the Art Institute of Chicago.*

of the architects for "their special fitness and previous experience with similar buildings."[89] McKim, Mead, and White had already designed the Brooklyn Institute; Carrère and Hastings had recently completed work on the New York Public Library; Shepley, Rutan, and Coolidge had designed the Art Institute of Chicago building; and Walter McCornack, advising Hewitt and Brown, had been of assistance with the problem of the design for the Museum of Fine Arts, Boston.[90] The choice of architects is particularly telling in the matter of style, for they were all well known for their architecture in the classical, Beaux-Arts manner. Such monuments to classicism as the Brooklyn Institute, the Boston Public Library, the New York Public Library, and the Art Institute of Chicago served as icons of the names of the architects. The selection of the architects made the question of style moot: a classical, Beaux-Arts-designed building was precisely what these architects were going to submit, as all of the firms practiced in that idiom. The instructions to the architects did not discuss style beyond a requirement of Bedford limestone for the exterior of the building and "ornament simple and restrained."[91]

The competition program called for a large, three-story building of a minimum of 225,000 square feet to be built in stages, integrating in its design exhibition galleries, a gallery of architecture, a school (in the preliminary stage to be housed in the basement), library, lecture hall, symphony hall to seat twenty-five hundred, and administrative spaces. The program, therefore, harks back to the multifunctional buildings envisioned by previous institutions from the Carnegie Institute, which incorporated library, museums, and music hall, to the Museum of Fine Arts, Boston, which in the overall plan by Lowell included a school, library, and hall of casts. Although the competition entries each incorporated these aspects of the program into their plans differently, the results have a generic resemblance to each other in their Beaux-Arts planning and their classical exterior elegance.[92]

The submission by Shepley, Rutan, and Coolidge surpasses their Art Institute of Chicago design in its complexity of plan and grandeur of style. The design incorporates some of the ideas used by Lowell at the Boston museum, for the different functions of the museum are segregated by individual circuits. At the heart of the complex plan is a cruciform shape containing the library and lecture room, surrounded by a rectangle creating four small courtyards. At each corner of the large rectangle sprouts another small rectangle, two of which house the symphony hall and the architecture gallery or hall of casts and two of which are comprised of hallways surrounding two more courtyards for the housing of offices or more exhibition space. The plan, like all good Beaux-Arts plans, is bilaterally symmetric and unfolds in a series of axes and cross-axes formed by the interlocking series of hallways. On the exterior, the central cruciform ends in four hexastyle Corinthian porticos, each recessed in a deep forecourt and each leading to the very center of the building, a rotunda space like that devised by McKim, Mead, and White at Brooklyn and Lowell at Boston. It is a plan of great elegance and much more highly developed, in terms of Beaux-Arts methodology, than the Art Institute of Chicago.

Carrère and Hastings's entry is as complex and formal as may be expected of the architects of the New York Public Library. Like their library, the plan for the Minneapolis Institute is highly articulated. It is a simple rectangle, bisected by the large "Architectural Hall" of casts which forms two courtyards within the main rectangle. Into the courtyards project two smaller halls, in much the same fashion as the chapels projected into courtyards in Hunt's plan for the Metropolitan. These halls were to provide space for temporary exhibits. The main body of the plan is composed primarily of long corridors providing access to exhibition rooms. At the rear of the building, the halls widen to accommodate the library and reading room, between which, at the rear and center of the building, is the very large and grand symphony hall, reminiscent in cross section and elevation, with its dome and vestibule, of Garnier's Opéra. The major fault of this plan lies in the interruption of the library facilities by the auditorium. Nevertheless, the plan is in the best Beaux-Arts tradition, with its highly articulated interior spaces expressed by discrete volumes on the exterior, as had been done at the New York library.

Both the designs by Pell and Corbett and Hewitt and Brown exhibit similar tendencies taken to the extreme. The articulation of exterior volumes, reflecting the varying functions of the space within, is in both submissions rather overdone. The plans of each incorporate the familiar features of open rectangles crossed by hallways to form courtyards; recessed forecourts; and separate provisions for the symphony hall, lecture hall, and library. On the exterior, they are both rather pretentious, and it is perhaps not surprising that neither of these submissions was successful.

The winning design by McKim, Mead, and White is the most compactly elegant of

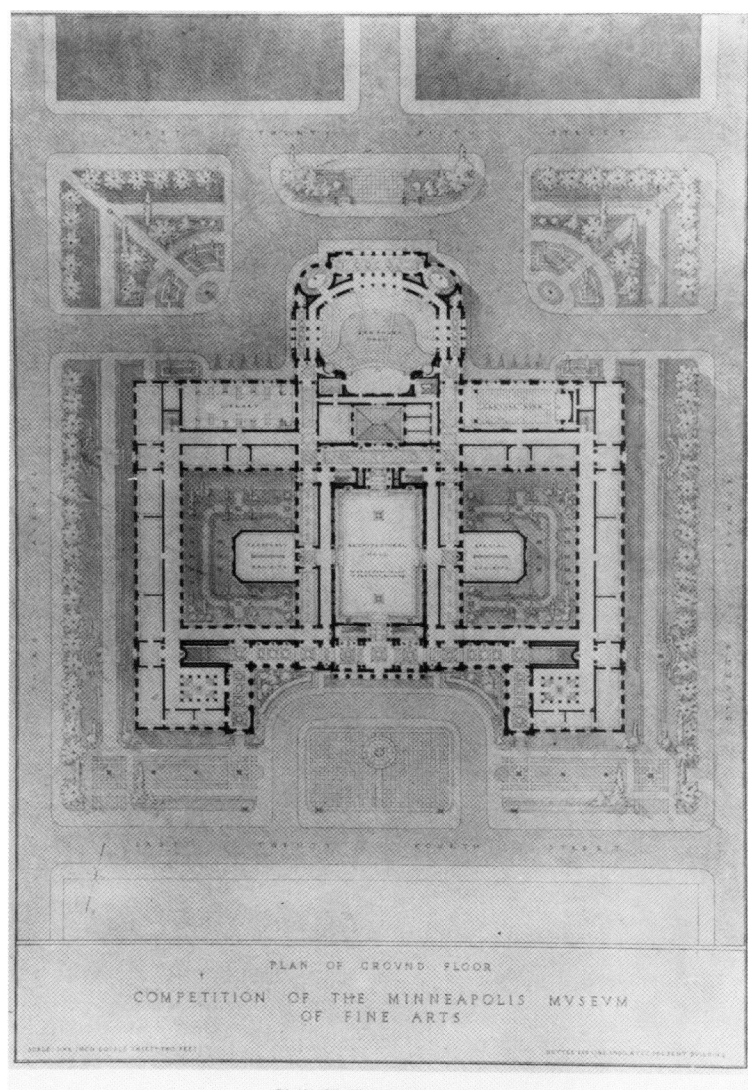

PLAN OF PRINCIPAL FLOOR

Carrère and Hastings. Competition design for Minneapolis Institute of Arts, 1911. Plan. Architectural Review *1, 1912. Courtesy of the Art Institute of Chicago.*

the submissions, both in plan and elevation. The plan is the simplest of all of them, despite the fact that it, too, manages to include courtyards and cross axes and other favorite Beaux-Arts devices. The overall design of the plan consists of yet another open rectangle bisected by a long hall forming two open courtyards. The center hall opens into the main entrance with a simple hexastyle Ionic portico; the facade was to be simple, articulated only by the entrance and two shallowly projecting end pavilions. The sides of the main rectangle of the plan are formed by the "Orchestra Hall" on one side and the "Architectural Hall" on the other. At the far end of both of these large halls, separated by hallways, are rooms with semicircular apses, very similar to the feature incorporated by Hunt in his plan for the Metropolitan. In Minneapolis, one of the semicircular spaces was to be the lecture hall and the other the library. The rear end

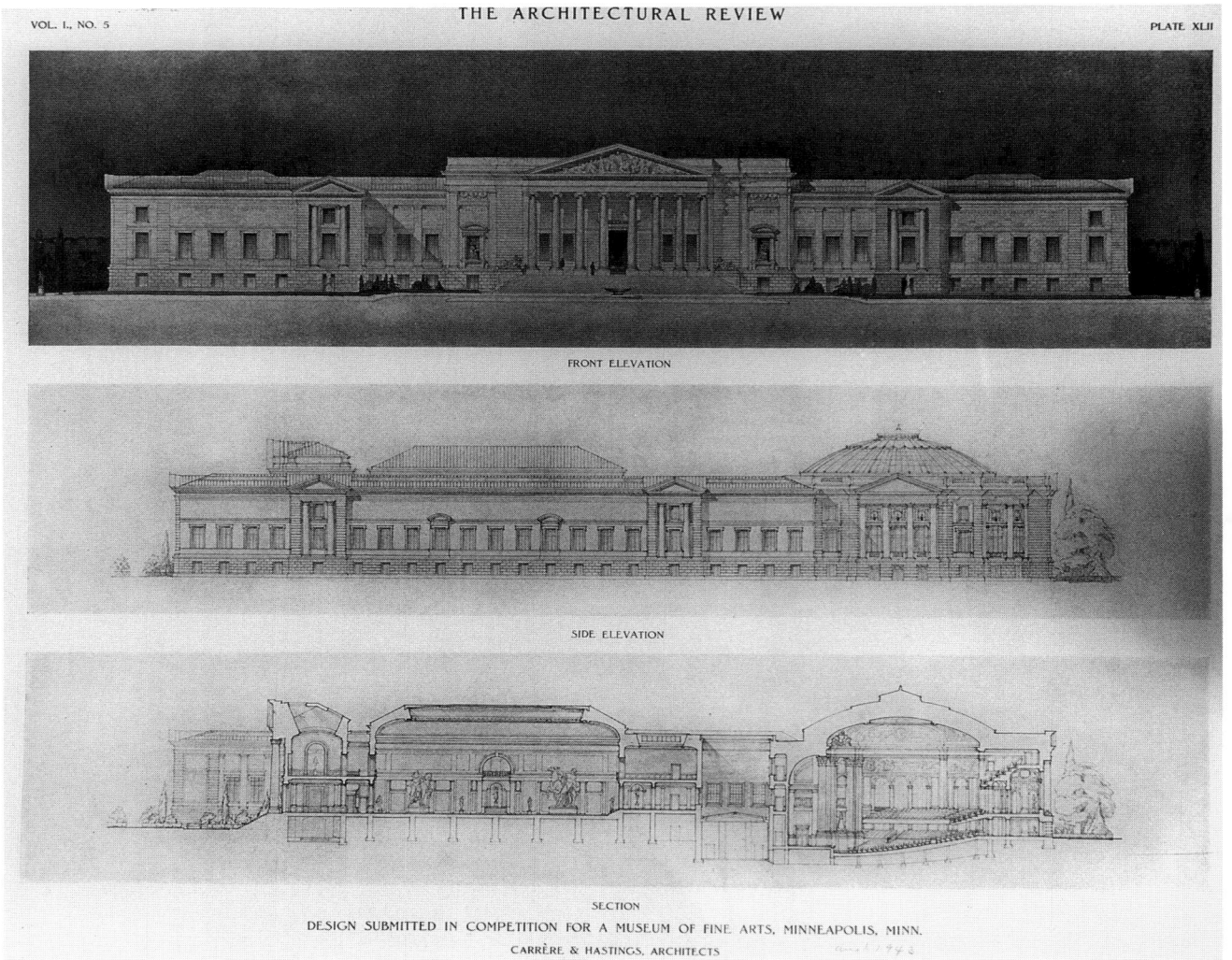

THE ARCHITECTURAL REVIEW

Carrère and Hastings. Competition design for Minneapolis Institute of Arts, 1911. Elevations and section. Architectural Review *1, 1912. Courtesy of the Art Institute of Chicago.*

of the building was to have the unusual feature of a very large semicircular hall springing from one of the end pavilions and ending in the other, like a rainbow. This was termed a "promenade gallery" and was to house some of the art exhibits. The semicircular space formed within this hall was to be a third courtyard, treated in a formal manner to suggest an Italian garden.[93] The traditional Beaux-Arts progression through the

Pell and Corbett. Competition design for Minneapolis Institute of Arts, 1911. Plan. Architectural Review *1, 1912. Courtesy of the Art Institute of Chicago.*

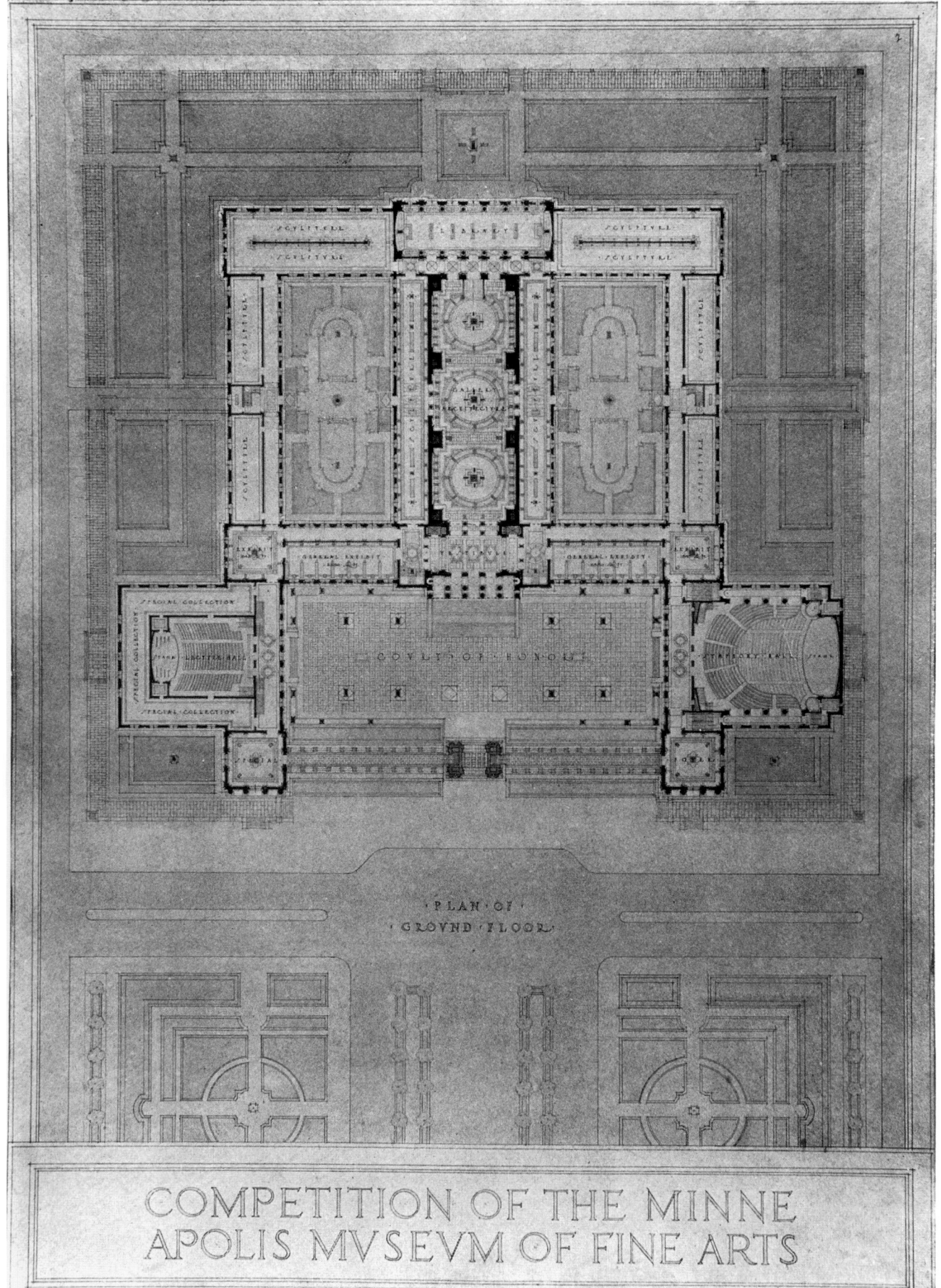

PLAN OF PRINCIPAL FLOOR

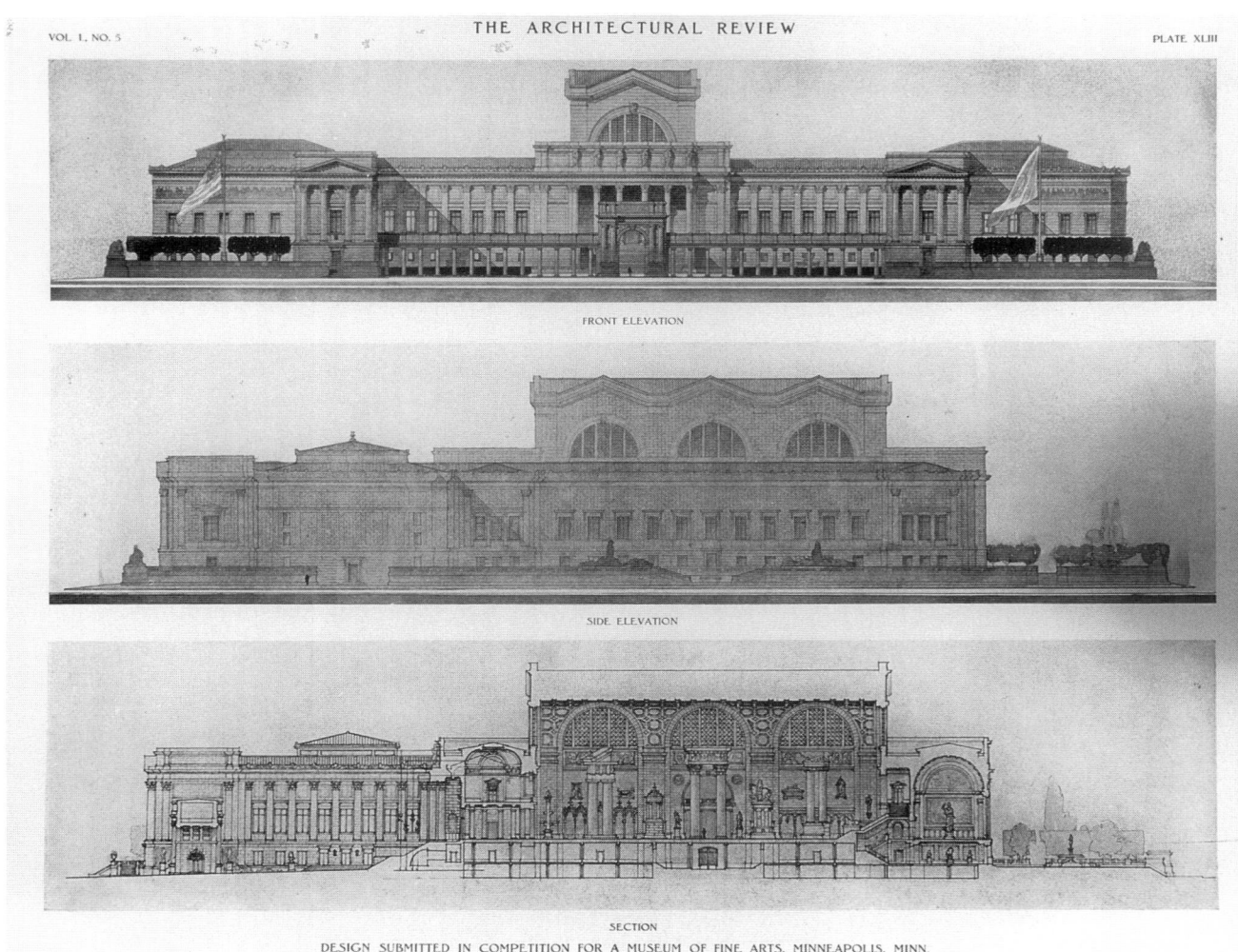

Pell and Corbett. Competition design for Minneapolis Institute of Arts, 1911. Elevations and section. Architectural Review *1, 1912. Courtesy of the Art Institute of Chicago.*

building is very much in evidence. The ceremonial entrance consisted of a progression up the exterior stairs, through the portico, the vestibule, and a large, formally treated entrance hall. From the hall, the visitor could choose to go either right or left through the galleries or straight ahead through a grand columned hall that ended in a broad interior staircase like that at the Boston museum. At the end of the progression through the main body of the building, there was either the leisurely progression through the semicircular promenade or an inspection of the formal gardens inside the courtyard. The design is a masterful combination of traditional Beaux-Arts technique with innovative design features. William M. R. French, Director of the Art Institute of Chicago and a member of the jury, appraised the design:

PLAN OF BASEMENT FLOOR

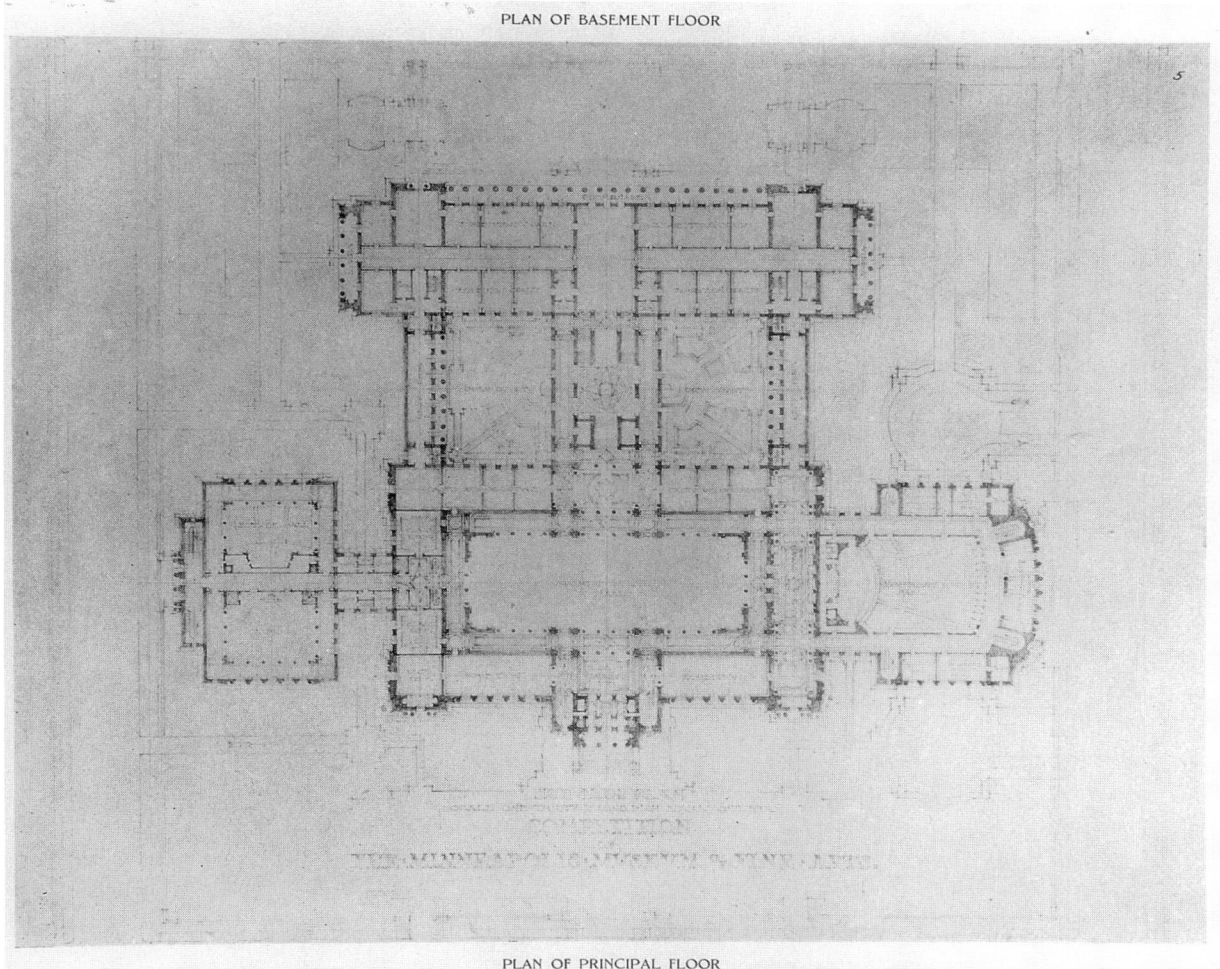

PLAN OF PRINCIPAL FLOOR
DESIGN SUBMITTED IN COMPETITION FOR A MUSEUM OF FINE ARTS, MINNEAPOLIS, MINN.

Hewitt and Brown. Competition design for Minneapolis Institute of Arts, 1911. Plan. Architectural Review *1, 1912. Courtesy of the Art Institute of Chicago.*

The ultimate building, with the main staircase and its approach, the great architectural cast gallery, the symphony hall, and the grand apsidal range of sculpture and picture galleries (which constitutes the most striking peculiarity of the design) must produce a grand and impressive effect, quite equal to the most important museums of the world.[94]

The plan is a fitting finale to the period of the grand-manner art museum competition in the United States.

Like all the other grand plans conceived during this period, that for the Minneapolis Institute was never completed as planned. Only the central section of the facade between the two end pavilions was ever completed according to the final, revised, McKim, Mead,

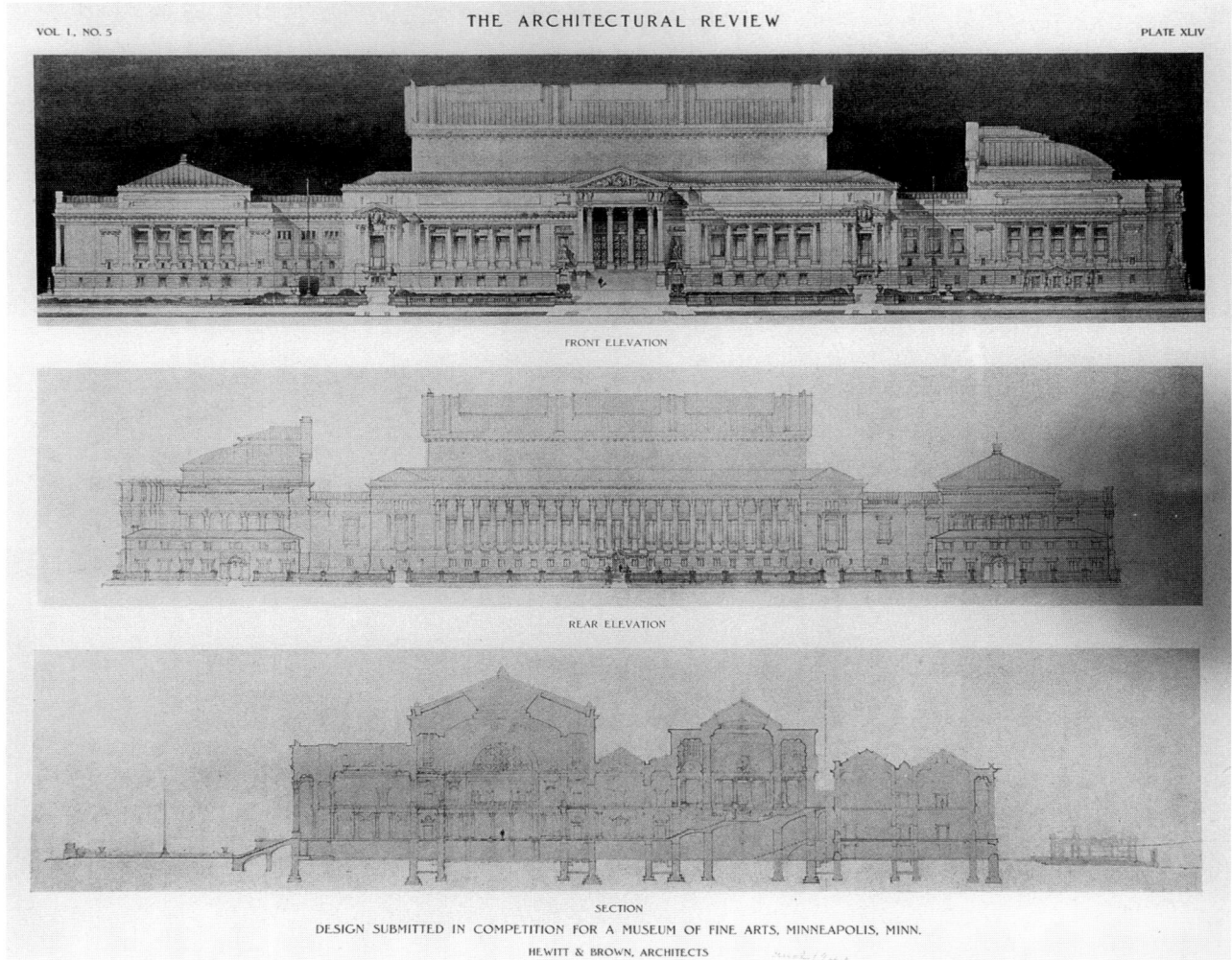

FRONT ELEVATION

REAR ELEVATION

SECTION
DESIGN SUBMITTED IN COMPETITION FOR A MUSEUM OF FINE ARTS, MINNEAPOLIS, MINN.
HEWITT & BROWN, ARCHITECTS

Hewitt and Brown. Competition design for Minneapolis Institute of Arts, 1911. Elevations and section. Architectural Review *1, 1912. Courtesy of the Art Institute of Chicago.*

and White design. Because this plan was conceived toward the end of the era of monumental museum buildings, it was abandoned earlier in its career than many of those begun in the late 1800s. The first section was completed in 1915. When an addition to the building was planned in 1926, another architect was hired to design it (a move which infuriated the firm of McKim, Mead, and White but one to which they had no legal recourse[95]), and the grand plan as envisioned by McKim, Mead, and White was abandoned forever.

McKim, Mead, & White. Competition design for Minneapolis Institute of Arts, 1911. Plan. Architectural Review *1, 1912. Courtesy of the Art Institute of Chicago.*

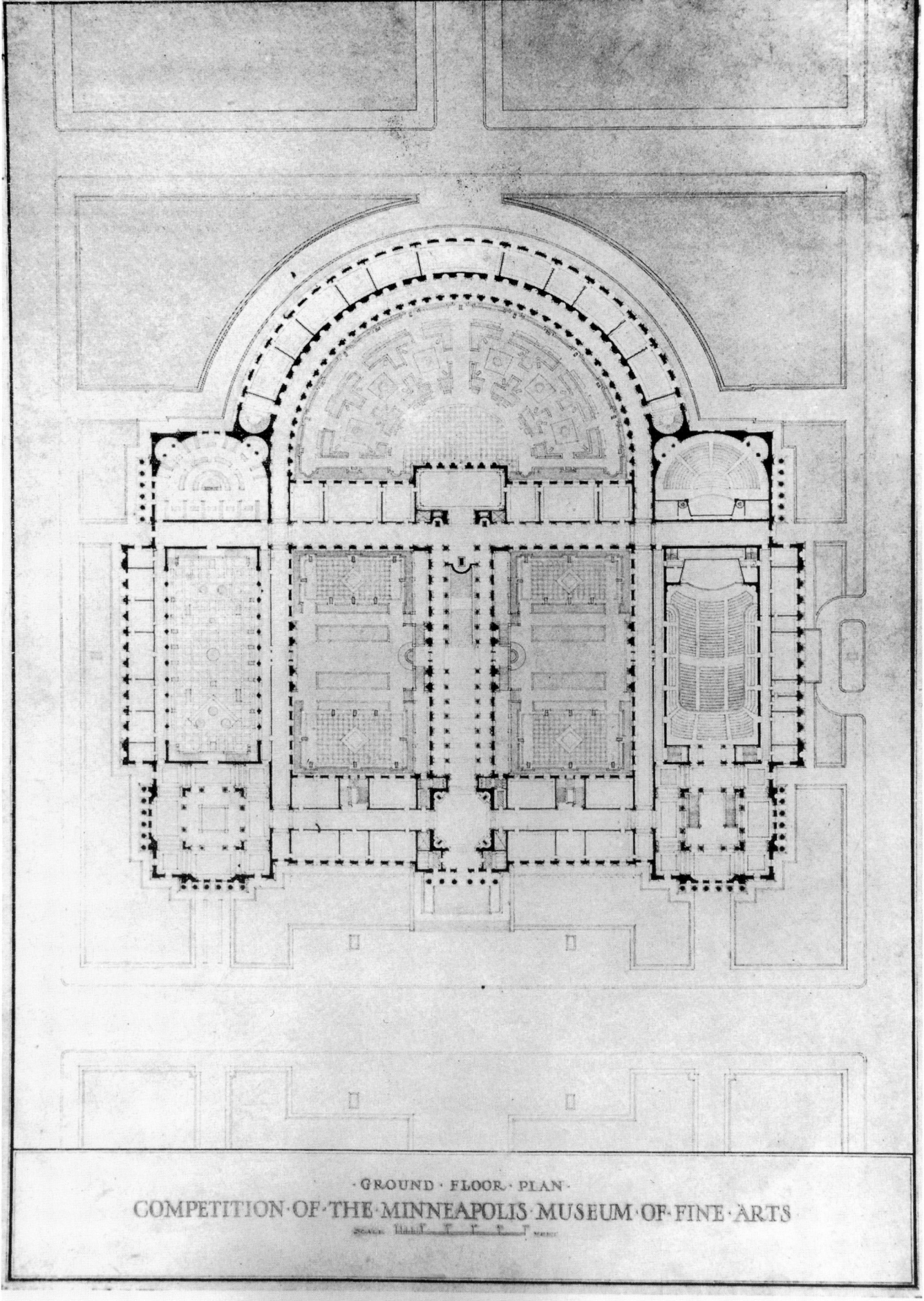

·GROUND·FLOOR·PLAN·
COMPETITION·OF·THE·MINNEAPOLIS·MUSEUM·OF·FINE·ARTS

PLAN OF PRINCIPAL FLOOR

McKim, Mead, & White. Revised design for Minneapolis Institute of Arts, 1911 (Architectural Review *1, 1912). Courtesy of the Art Institute of Chicago.*

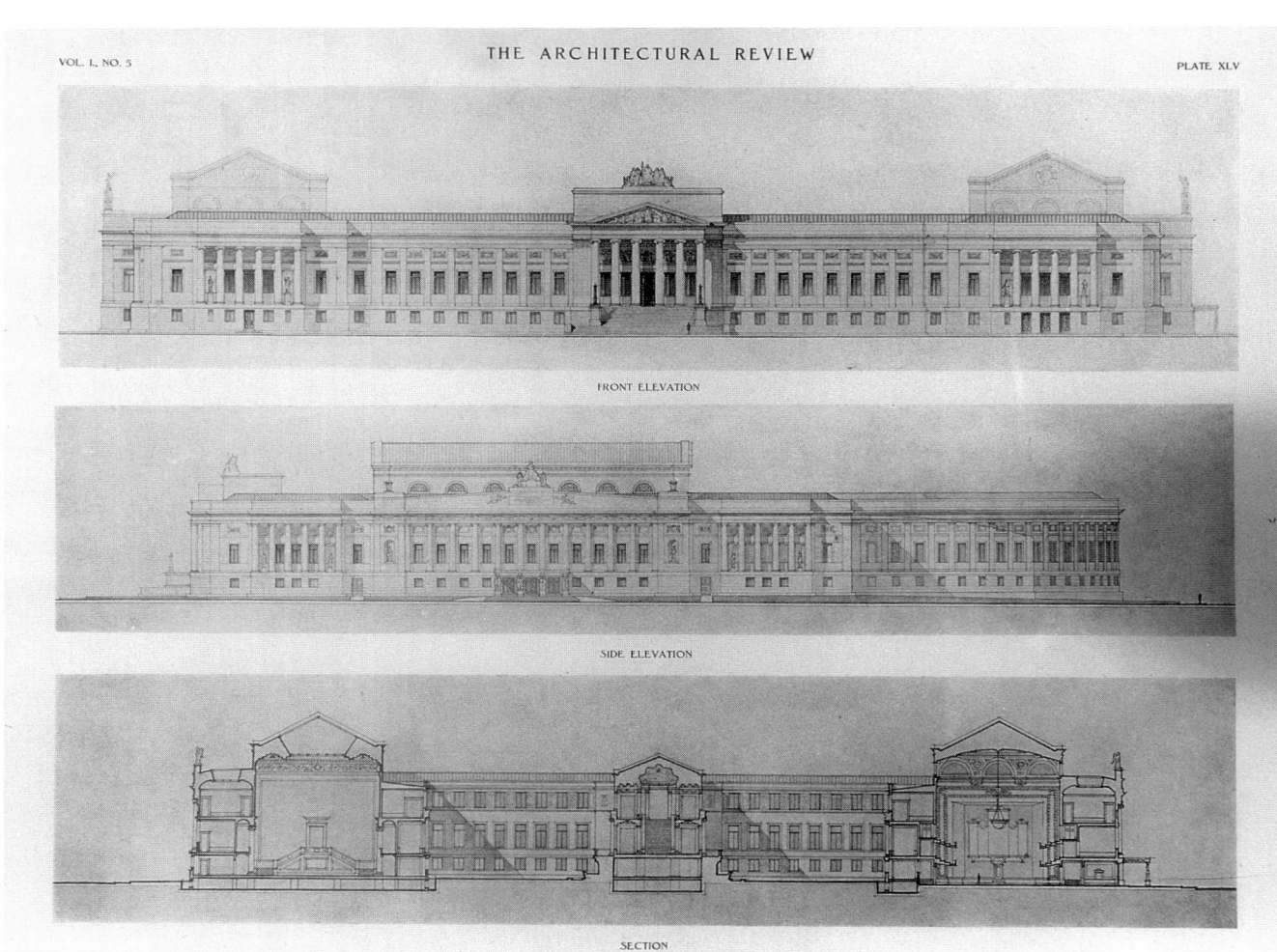

McKim, Mead, & White. Competition design for Minneapolis Institute of Arts, 1911. Elevations and section. Architectural Review *1, 1912. Courtesy of the Art Institute of Chicago.*

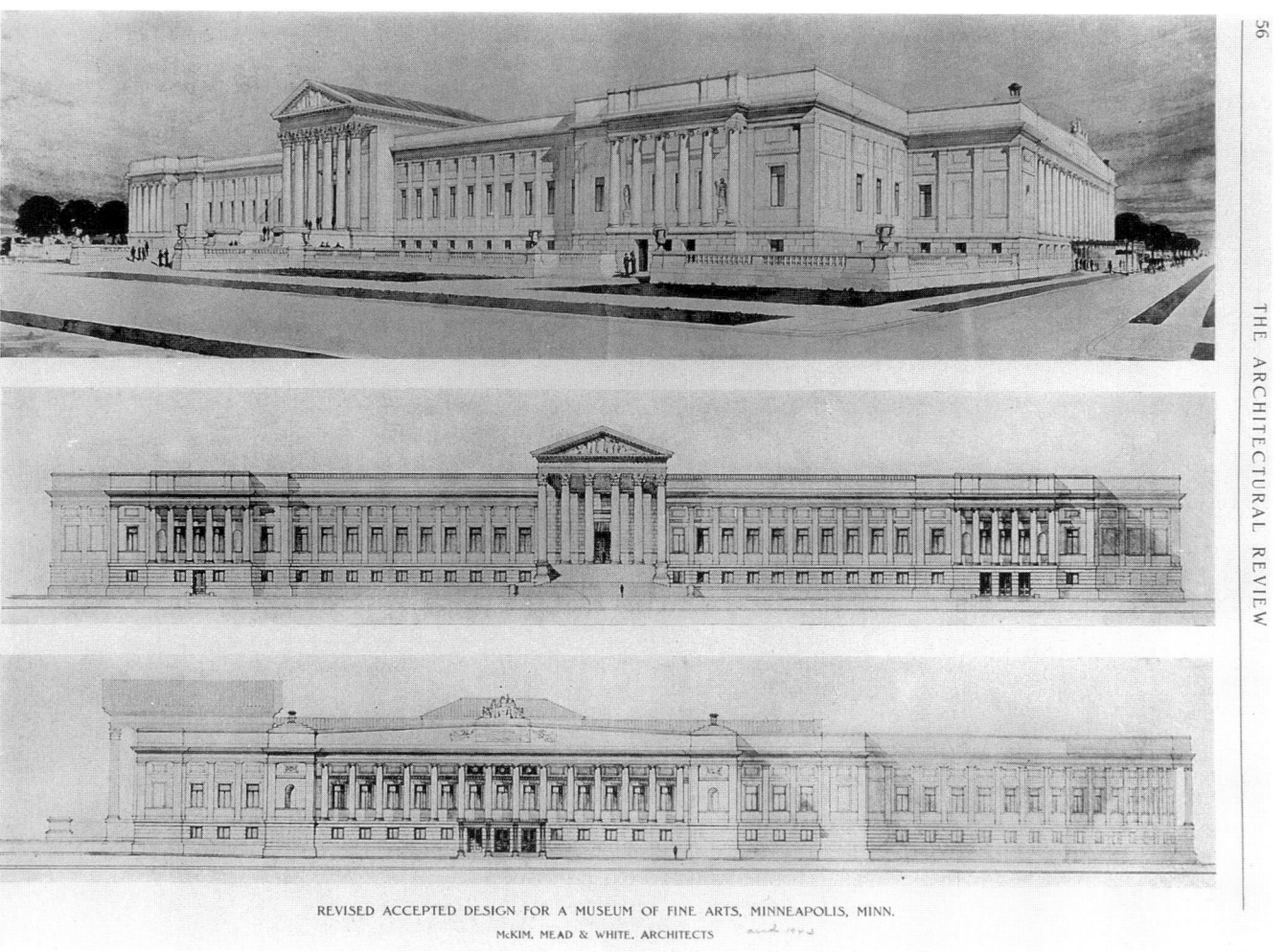

REVISED ACCEPTED DESIGN FOR A MUSEUM OF FINE ARTS, MINNEAPOLIS, MINN.
McKIM, MEAD & WHITE, ARCHITECTS

The Master Plan for the Baltimore Museum of Art, 1925

Although the plans solicited for the Minneapolis museum constituted the last art museum competition conducted in the grand style, there were several plans executed during the 1920s and even afterward which attest to the continuing adherence to the Beaux-Arts ideal. One of these was the plan developed by John Russell Pope for the Baltimore Museum of Art. The Baltimore museum had been established in 1914, and its holdings were at first stored in borrowed space in the Peabody Institute, until in 1922, a private residence on Monument Street was lent to and then purchased by the Museum, serving as its first space open to the public.[96] The museum's present location, six acres of Wyman Park, was donated by Johns Hopkins University. The construction of a permanent home for the museum was undertaken in 1924 when the Trustees managed to introduce a referendum on the local ballot for the loan of one million dollars to build the museum. The city charter required the hiring of a local architect, and in 1925, Howard Sill was chosen as architect of the museum with John Russell Pope named as associate architect.[97] Only one month after accepting the commission,

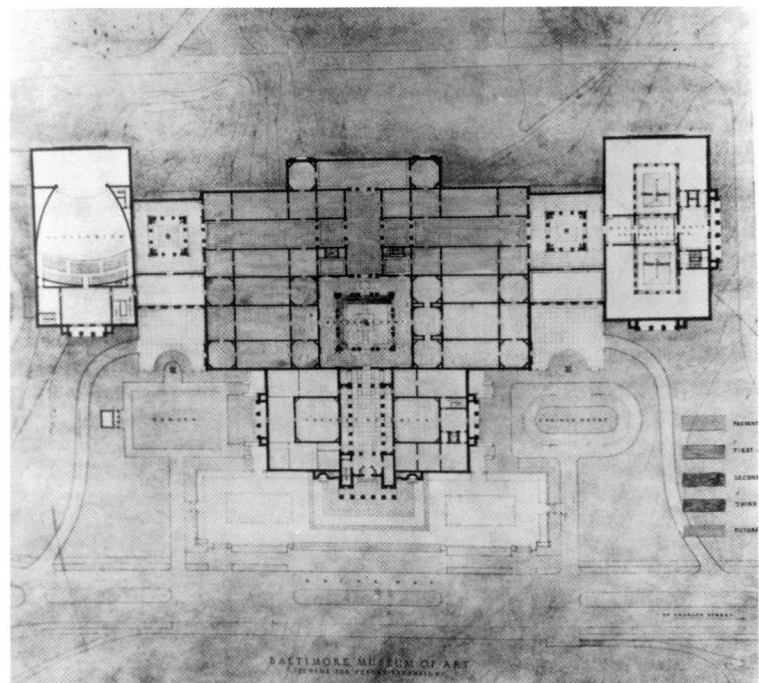

*John Russell Pope. Master plan for Baltimore Museum
of Art, 1925. The Baltimore Museum of Art.*

however, Sill was stricken by illness, and Pope took over the design of the museum. Like
his architectural predecessors—Hunt; McKim, Mead, and White; Lowell—Pope was
steeped in the Beaux-Arts tradition, having been trained not only at the famous school
but also at Columbia and the American Academy in Rome under Charles McKim
himself. Thus, when the design of the Baltimore Museum fell into his hands, he pro-
duced for the Baltimore Museum not merely a plan for immediate construction but a
grand vision for the distant future as well.

The original portion to be constructed by the museum was only to encompass ap-
proximately one-eighth of the museum's eventual size, but it was also intended to be a
complete, if small, operating museum on its own. This portion, begun in 1927 and
completed in 1929, consisted of a compact, self-contained rectangular unit that included
the main entrance—present and future—and a central, grand, columned sculpture hall
in the tradition of the Parthenon Room of Flagg's Corcoran Gallery. This was flanked
on each side by a series of galleries. In plan, these galleries resembled the typical
hallways surrounding open courtyards of many of the earlier plans in the grand tradi-
tion; in this case, however, Pope knew that such space could not be spared in the first
phase of construction; thus, what would have been open courtyards in the usual Beaux-
Arts fashion became functioning galleries at the Baltimore museum. In the master
plan, however, this first portion was to be only the introduction to a vast museum
complex that included at least four times the gallery space of the first section, a "Garden
Court" nearly half the size of the original structure, and auditorium and decorative art
and architecture wings each the size of the originally planned building. Although lack-
ing the spacious looseness and open courtyards of earlier Prix de Rome-style plans, the
organization and progression of the overall plan are undoubtedly Beaux-Arts influ-
enced. The grand plan of the museum's future was to have been laterally symmetrical,

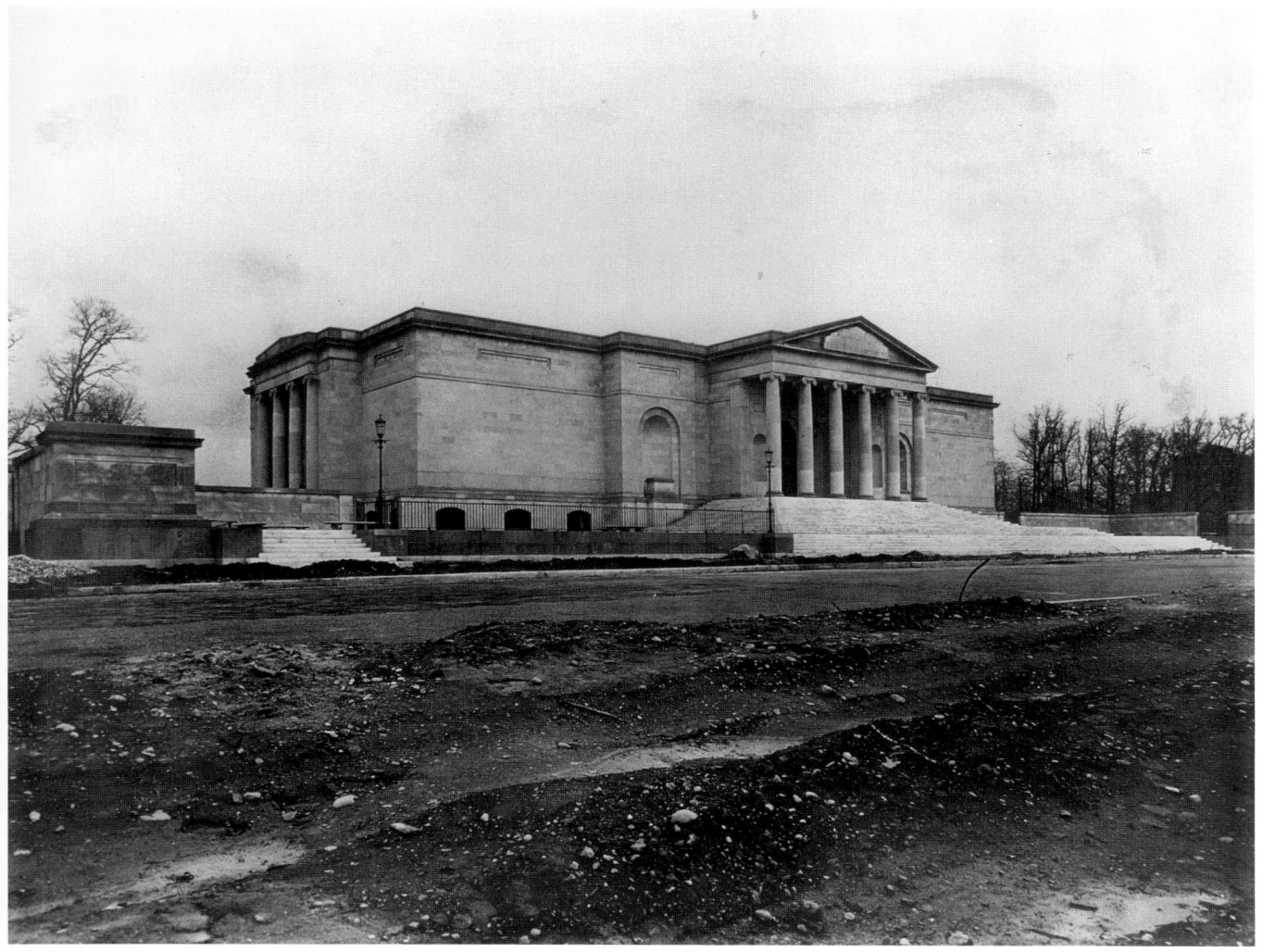

John Russell Pope. Baltimore Museum of Art, 1925–29. The Baltimore Museum of Art.

organized in a series of interlocking galleries, the intersections of which were to be accented by small, octagonal rooms. The main galleries at the heart of the building were to be punctuated by open garden courtyards, and direction was to be provided by long hallways given architectural importance by column screens.

In the fashion of its predecessors, the progression through the building would have been a dramatic unfolding of the architectural and exhibited treasures of the museum. Visitors would begin ascending to the entrance from the sidewalk; there were several sets of steps before even reaching the main entrance, in order to "elevate" visitors to a proper state of mind. Upon entering, visitors would encounter a small vestibule and then the grand sculpture hall of the first portion of the building, leading them into the vast complex that was to be the future of the museum. This, in turn, would lead them into a large garden court from which they could make a leisurely circuit of any number of galleries to their right or left, or they could proceed into the crossing of the large, column-screened hallways, passing through smaller garden courts along the way that would bring them to the farthest reaches of the building: either the auditorium or the decorative arts and architecture wing. The orderly and ceremonial progression through

the building was once again typical of grand-manner Beaux-Arts planning, as was the abstract, one-dimensional virtuosity of the plan as it was executed on paper.

Pope's grand plan suffered the same fate as its exalted ancestors. The portion of the building to be constructed in 1927 was completed in 1929 as designed by Pope; the rest, after the onset of the Great Depression and Modernism, was abandoned. Once again, the initial optimism for the architectural future of the museum failed in the sight of modern exigencies, just as the Beaux-Arts program eventually failed the architectural profession, by and large. That it did not entirely disappear is evidenced by the continuance of the Beaux-Arts classical tradition in such a building as Pope's National Gallery long after modernism had proclaimed the obsolescence of its approach. Another indication of the durability of the Beaux-Arts approach was the modernists' continued reliance on the plan and the strict adherence to function that had been emphasized for so long by the Beaux-Arts methodology.

The Rome Prize in Architecture Competition, 1929

Young architects trained in the Beaux-Arts approach to planning embarked on careers that were to be changed by the onset of Modernism, but the Beaux-Arts tradition lingered in their training despite the increasingly simplified approach to exterior design and ornamentation. An excellent example may be provided by the designs for a museum by a young architect at the very end of the period of reigning classicism. B. Kenneth Johnson, twenty-two years old in 1929, had studied at the University of Illinois and received a B.F.A. in architecture from Yale University in 1928. He won the competition for the Rome Prize in Architecture with his designs for an "Institute of Fine Arts." The competition program posited a wealthy patron of the arts donating a large sum of money to the government in order to endow and build the institute. The program gave the following suggestions and requirements:

> It is proposed that the building shall serve as a national headquarters for matters connected with the Fine Arts and as a clearing house for art matters, and shall house as well the editing office of an important and scholarly general magazine devoted to the fine arts. The architecture should be of a monumental and dignified nature, using fine material, to comport with the adjoining governmental and institutional buildings of a national character.[98]

The program further goes on to describe the location for the building as one that sounds very much like the Mall: "an entire block . . . on an important boulevard which runs along one side of a broad formal parkway." It also lists the complex requirements of the building, which include "a monumental vestibule offering dignified approach to the stairs," an auditorium, a conference room, a library, an exhibition gallery, a studio or drafting room, and sundry offices and physical facilities.[99] The program recalls the national character and multifunctional needs of a Prix de Rome competition at the Ecole des Beaux-Arts in Paris. Indeed, the competition and prize were in exact equivalence to the French Prix de Rome, for the winner would spend three years studying architecture in Rome. Johnson's response, executed nearly four decades after the first grand Beaux Arts-style art museum competition in the United States, embraces fully the Beaux-Art precepts so wholeheartedly adopted by the American architectural profession and promulgated by its schools. Johnson's design calls for a building perfectly square in plan with a vestibule as monumental as anything for which the authors of the program could have hoped. His entrance is composed of eight monumental columns *in antis,* behind which the visitors would find themselves in a vestibule that ran the

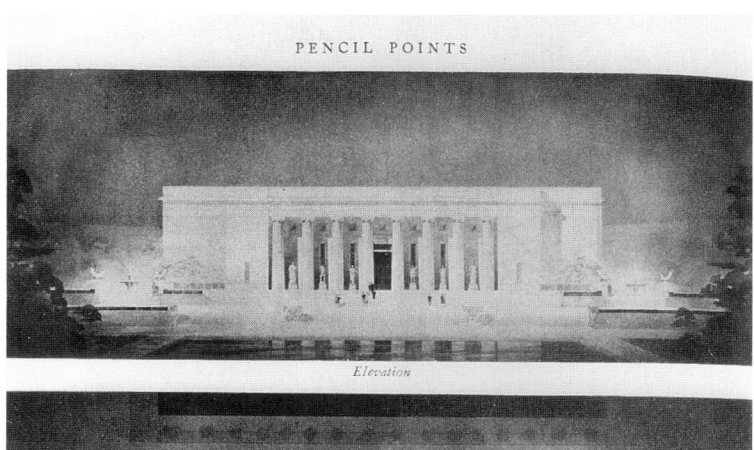

Elevation

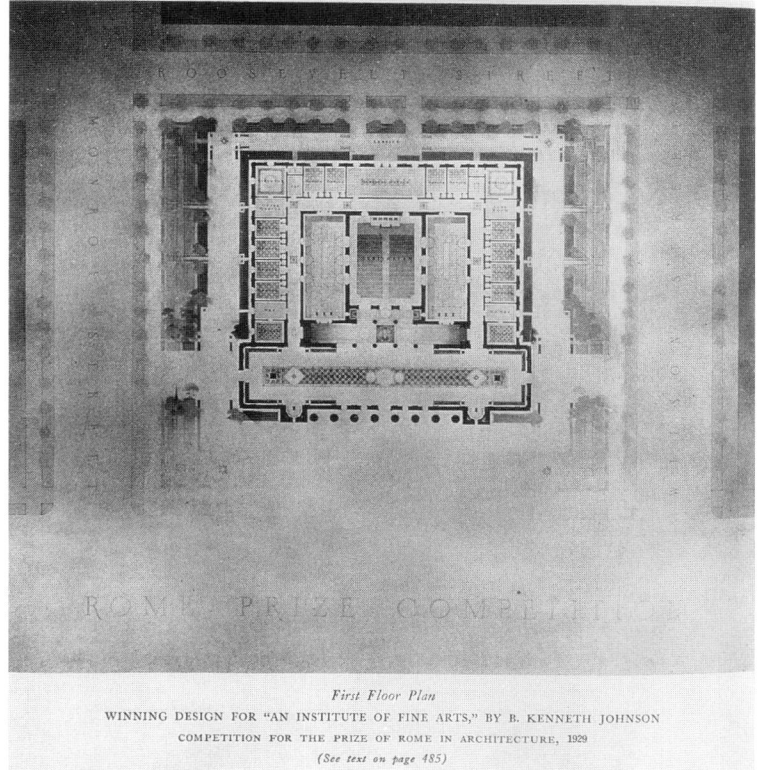

First Floor Plan

WINNING DESIGN FOR "AN INSTITUTE OF FINE ARTS," BY B. KENNETH JOHNSON

COMPETITION FOR THE PRIZE OF ROME IN ARCHITECTURE, 1929

(See text on page 485)

[486]

B. Kenneth Johnson. Competition design for Rome Prize in Architecture, 1929. Pencil Points *10, July 1929. Courtesy of the Art Institute of Chicago.*

full width of the building. A column screen at the rear of the vestibule separates the monumental double staircase to the second floor. The rest of the plan forms a **C** behind this vestibule with the offices housed in the hallways formed by the **C** and the main spaces of auditorium and exhibition galleries finding their place in the center of the building. The plan is simple and compact, and the exterior style shows the reductive approach toward ornamentation of increasing modernism. The columns and a continuous cornice line are the only decoration on an otherwise plain-walled box. Despite these concessions to modern design, the style is monumental and classical, and the design is plan-generated and accomplished through a Beaux-Arts approach to organization. It

should come as little surprise that this design was chosen as the winner by a jury on which sat John Russell Pope, the last great American Beaux-Arts classicist and soon to be designer of a National Gallery much in the vein of the "Institute of Fine Arts" in Washington posited by the Rome Prize competition for 1929.

Art museum plans and competitions played a central role in defining the American architectural profession from 1890 until 1930. Throughout the period, the art museum provided a forum for the exploration of the Beaux-Arts ideals American architects had learned at home and abroad. Through competitions, the emerging American architectural profession was able to express itself and prove its competence in the face of European domination of the field. The competition was a battlefield for the young profession, enabling it to feel its bounds as well as increase its strength. In the end, the profession was able to mold the event of the competition into one which acknowledged the respectability and importance of the profession.

With the advent of modernism, the Beaux-Arts tradition was pronounced obsolete. The grandiose visions of an earlier era had long failed for the museums with plans executed by architects whose training and beliefs had embraced the French methodology. Beaux-Arts ideals had had to be abandoned in favor of more practical—and decidedly more prosaic—architectural modes. For generations, however, grand plans had provided an expression of a uniquely American confidence in the ability to create culture and history from scratch, enhanced by an optimistic belief in the stability of the future and its adherence to the goals of the past. Although the modernists may have believed the Beaux-Arts tradition to be dead and buried, its precepts lingered like ghosts in the fragments of the museums it created, only to be resurrected by later generations.

Like the City Beautiful plans of the same era, which they resembled so strongly in miniature, the sweeping plans concocted by architects for museums were also the means through which the social and cultural goals of an era could be expressed. Their logical clarity, ceremonial spaces, and axial arrangements were a measure of the same confidence that was held by city planners in their ability to shape urban spaces both exterior and interior, present and future. As emblems of an American cultural vision, the art museum plans from 1890 to 1930 are unsurpassed; their only fault lay in their unattainability in the face of twentieth-century urban and economic realities.

Conclusion: The Death and the Legacy of the Monumental Classical Art Museum

> The museum requires a highly specialized type of architecture in order to fulfill the function of exhibiting objects to the public. Few museum buildings in America are adapted to their purpose. As a result most museum architecture is actually more of a handicap than an asset to the institution it is supposed to serve. The fault lies not with architects but with museum directors and trustees who do not have a grasp of the nature of the museum as an institution. Consequently they are unable to furnish architects with an intelligible list of requirements. Left to their own devices the architects produce monuments which record in perpetuity our entire ignorance of the aims of the institutions we direct.
>
> —Philip Youtz, "Museum Architecture," (1936)

IN THE FOUR DECADES BETWEEN THE TRIUMPHANT BIRTH AND THE SLOW BUT EVENTUAL death of the monumental-classical art museum, the number of art museums that came into existence in the United States amounted nearly to an explosion. Between 1814—the erection of the first museum building in the United States, Peale's Museum in Baltimore—and 1890, only a few more than a dozen art museums of significance were built in this country; whereas during the period between 1890 and 1930, more than fifty art museums had been built, from major buildings to minor galleries, and that number does not include university art galleries.[1] During the latter period, the monumental classical style predominated to the exclusion of all others. It even eradicated some of the earlier ventures in High Victorian Gothic or Richardsonian Romanesque styles, as at Boston, New York, and Chicago.[2] Although most of these art museums have had subsequent modern additions appended to their classical cores, the period from 1890 to 1930 left most major urban areas with art museums all having a generic resemblance to each other, with the result that the classical style and a location within a municipal park came to serve as signposts for the art museum. By 1930, however, the love affair between museums and classical architecture was coming to a close, as museum officials began to search for another architectural idiom that would better serve their physical and ideological needs, as well as their pocketbooks. They pondered, too, the question of location, eventually determining that a museum should be more like a shop, to which a maximum number of passersby are attracted, than an isolated monument within a park. The changes in attitude toward museum architecture, its function, and its location can be documented in the professional literature which was rapidly multiplying in the modern era of museology.

At the height of the popularity of the classical style for the art museum, at a time

when such a style was the only one in use for museum buildings in this country, it was possible for an observer to make the following remarks concerning the Great Hall of Richard Morris Hunt's Metropolitan Museum of Art in New York:

> The emptiness and fine architecture add enormously to the dignity and repose of the museum, and although many protest against the waste of space and the subdued lighting, it is surely right that a great and wealthy museum should allow itself the luxury and dignity of such a hall, which is an excellent preface to the beautiful collections to come, or a resting place after a visit.[3]

That such an entrance hall was somehow "right" was part of the ethos of the architecture, influenced as it was so heavily by the Ecole des Beaux-Arts and the American need to prove cultural fitness by European standards. Furthermore, the salient point of this remark is the implicitly understood belief that an appropriate function of museum architecture was a kind of mental preparation, or elevation, for the experience of viewing the art the building contained. The creation of an appropriately dignified—not to say imposing—atmosphere was considered, if not essential, then a worthwhile exchange for the space and money it consumed. That the space, atmosphere, and appearance thereby created should sacrifice exhibition facilities was not entirely to be regretted, for although the exhibition of art objects was an important function of the museum building, it was not the only one. Monumentality and dignity were proper functions of a museum building, enhanced by the properly dignified location within a park. That this was so was repeatedly evidenced by the great joy architects and museum officials alike seemed to take in the creation of monumental steps, entrance facades, vestibules, and rotundas in art museums located in municipal parkland across the country. The great proliferation of columns alone would attest to this "function" of the museum building to serve as a cultural monument in and of itself.

This belief naturally came to an end with the advent of architectural modernism and was assisted by the increasingly "modern" or functionalist approach of museum directors and curators. The professional literature had greatly increased over the first decades of the twentieth century, as those involved with museums gradually organized themselves both as a profession and as something of a science. As the field of museum work came increasingly to be considered a legitimate profession—and not merely a playground for wealthy dilettantes—so the study of the ideal functioning of a museum came more and more under scrutiny. New methods of classification for the exhibit of objects had recently been developed which separated objects not only by their medium—painting, sculpture, or decorative arts—but first by country and then by period. This approach to the organization of exhibits is so commonplace now as to seem prerequisite, but the revelation of this method brought about a revolution in museum exhibits in the first decades of the twentieth century. The interest growing among architects and museum officials alike in perfecting the design of the museum building according to its function also effected an eventual revolution in museum architecture.

Toward the end of the period of dominance of the great classical art museum, there were critics who had begun to doubt the wisdom of the monumental form of museums. Upon the completion in 1924 of the Field Museum of Natural History in Chicago, essentially a copy of Charles Atwood's Fine Arts Palace at the World's Columbian Exposition of 1893, Richard Bach, a well-known arts advisor and at one time librarian of the Avery Architectural Library at Columbia University, questioned the role played by museum architecture in relation to the function of the museum itself. Adapting Le Corbusier's dictum that a house was a machine for living in, Bach wrote that the mu-

seum was "a complex educational machine," whose function was "the finding, preparing or acquiring, exhibiting, protecting and demonstrating of material."[4] The architect, he wrote, must respond to these needs as well as the new theories of museum work in order to create the museum of the future. Bach asked:

> Will such revision of theory bring with it a new interpretation of design? Must a museum be a temple or a basilica or a palace in appearance? Will the future museum be a humbler appearing, harder working institution, looking its part, and perhaps situated in a crowded district?[5]

These questions struck at the foundation of the beliefs an earlier generation had taken for granted about museums, i.e., that they should indeed look like a temple or palace in order to appear properly dignified and to signal the importance of the art they contained and that a location apart from the congested business areas and factories was essential to maintaining that same dignity. Bach questioned the very monumentality of the structure, denying its necessity:

> It [the Field Museum building] is a monumental structure, awe-inspiring as to size and splendor. Is that an advantage in museum buildings? Or does it add another monumental pile to the city's list of fine buildings which too few citizens enter? Not in criticism do we write this, but as a question based upon museum theory, for it is obvious that museums . . . should be admired more within, as to their contents, than without, as to their appearance.[6]

Therein lay the heart of the modern approach to museum architecture: its function was no longer to entertain notions of dignity or monumentality. The "function" of a museum building to prepare and elevate the mind of the visitor through impressive— and what an earlier generation also thought of as instructive—architecture was no longer considered appropriate. Bach prophesied correctly that "in the future—and within a generation's time—architects will so conceive museum buildings that the last thought that could be associated with them will be that of 'monument.'"[7]

What were theorists of the museum building of the future looking for instead of the architectural monument? Henry Kent, Secretary of the Metropolitan Museum of Art, defined the theories of the moment in a 1932 article in the *Architectural Forum*. He complained that recently built museums—those erected prior to 1932—"still present façades in a classic style, and courts of honor, monumental staircases, and architectural embellishments in a manner of buildings designed for other purposes under earlier social and economic conditions."[8] What is instead needed, he asserted, is a museum architecture that responds to the needs of the modern museum. He defined those modern needs as having been brought about by the adoption of the German system of classification, that of arrangement of exhibits by country and period. The results of this system were, to him, manifold. First, exhibits were to be given colorful "period" settings. This resulted in the need for a harmony between the architecture of the building and the objects displayed in it. In Kent's words, "to show German styles in a building in the Italian or French manner was, to say the least, unnecessary."[9] What was needed, he implied, was an architectural nonstyle:

> It is to be hoped that with the coming of the new or "modern" style of building, which concerns itself with its own problems without copying some by-gone style, the fashion which has been followed in this country of making all public buildings reminders of the classical or some other period may give way to a better studied solution of the problem of appropriateness.[10]

In the name of harmony for the exhibited objects, here was a call for the abandonment of the classical mode and the adoption of the "modern."

The most important effect of the new classification methods, however, was the concomitant need for flexibility in the museum plan. If, for example, the Gothic art department is neatly sandwiched in between the Romanesque and Renaissance departments, and then a wealthy patron donates a large collection of Gothic art to the museum, the Gothic department will have to expand and thereby push the others into different spaces. Therefore, what is needed is a highly flexible floor plan, such as Kent pointed out had been the development in contemporary office and factory buildings. Kent was clearly calling for the museum establishment to adopt architectural modernism when he wrote:

> One does not have to be a student of architecture . . . to understand what would be the result in a museum building if the same principles of adaptability were applied to the solution of its needs. With unitization, with steel, movable partitions, new substitutes for old materials, . . . etc., the museum of today could be built so as to allow growth and change economically, so as to allow classification its perfect work, and so as to give opportunity for effective exhibition. The floor spaces of such a building would not be hampered by party walls and fixed partitions, its divisions of space would be changeable at will, . . . and its decorations would be neutral.[11]

This description of the ideal museum building excludes the classical buildings of the previous generation utterly. Their appearance relied entirely on traditional load-bearing construction—or the illusion of it. This entailed heavy masonry walls, the proliferation of columns, and construction in stone. The unit-based flexibility called for by Kent could only be achieved with the steel-frame construction used for skyscrapers and factories, precisely the favored method of construction for the modernists. Kent abrogated the monumental-classical museum building with this eloquent dismissal:

> To spend space and money on monumental halls, which are unusable, staircases which no one mounts, and solid partitions which have no structural necessity—in fact to build a house in an old style when a new one is clearly indicated—is not to have learned what is required, and to have missed the most obvious lesson of museum experience.[12]

This ringing endorsement of modernism in museum architecture is all the more eloquent when it is considered that Kent, as Secretary of the Metropolitan Museum of Art, lived every day with the largest, grandest, and possibly most expensive of the monumental halls built during the previous era. Kent's call to modernism sounded one of the death knells for the grand, classical art museum building.

Perhaps no event is more emblematic of the failure of the Beaux-Arts program for the museum establishment in the 1930s than the removal of the great exterior staircase at the Brooklyn Institute.[13] For two decades, the grand stairs had provided access to the main entrance of the building, which in the best classical tradition was through a large portico on the *piano nobile*. Climbing the stairs was intended to be a slow, ceremonial progression which would elevate visitors both mentally and physically in preparation for their visit to the museum. Toward the end of the 1920s, however, environmental damage was beginning to make the steps a safety hazard, and as if to emphasize the need for an alternative entrance, visitors had long abjured the climbing of the steps in preference to entering the museum through a warren of passages in the basement.[14] In 1934, the Brooklyn Institute's new Acting Director, Philip Youtz, pressed for changes in both the museum's appearance and its mission. In a tangled series of events, Youtz

asked the firm of McKim, Mead, and White to create a new entrance to the museum, and when none of the firm's solutions pleased him, he was able to effect the complete removal of the stairs in the spring of 1934. By August of the same year he had hired architect William Lescaze, who had recently completed work on the most modern and functional building yet built in the United States, the PSFS skyscraper in Philadelphia (1929–32). Lescaze took over the transformation of the entrance and lobby of the Brooklyn building, and the result was a direct entrance off the street into the basement of the building and through a lobby designed in the most up-to-date modern fashion.

The redesigning of the Brooklyn Institute's main entrance constitutes one of the most potent emblems of the new approach to museum architecture. Philip Youtz, Director of the museum, outlined an entire modern philosophy of museum architecture shortly after this reorientation of the Brooklyn museum building. "Museum Architecture," a paper read by Youtz to the Association of Art Museum Directors in 1936, provided both a rationale for the changes at the Brooklyn Institute and a call to modern architecture and a functionalist approach for the museum building of the future. Youtz defined the problem of museum architecture strictly as one of function, and that function was the display of objects for the public. In order to achieve this directive, the museum building, Youtz argued, must first of all be located

> where it can be seen by a maximum number of people passing by for work or pleasure. Some day all museums will have show windows which will excite the curiosity of those who pass and tempt them to enter. Accessibility and propinquity are as vital to museum attendance as collections or exhibitions. Parks are usually poor locations for museums because people visit these open spaces chiefly for the pleasure of being out of doors and because trees and plants tend to conceal any building from view.[15]

Whereas Ernest Flagg abjured ground floor windows for the Corcoran Gallery because he did not wish the building to resemble a shop front, Youtz argued precisely for what Flagg despised. Also, the previous period's favored location of a park for the art museum was challenged once again. For the Brooklyn Museum, naturally, the matter of location was moot; but Youtz could and did change the Brooklyn building to comply with another of his directives concerning modern museum architecture: entrances, he announced, "must be at street level."[16] The main galleries should also be located on the ground floor: "The old practice of placing main galleries on an upper floor . . . is essentially bad planning."[17] With these statements and in the name of functionalism, Youtz completely justified the changes to the facade of the Brooklyn Institute to which the original architects so strenuously objected as impairing the dignity of the building.

Youtz was also a firm advocate of modern architecture for the museum building. In his speech, he echoed the assertions of Henry Kent's article, written four years earlier. He maintained that the interiors of museums "should be perfectly plain without architectural ornament or design."[18] It logically follows that one must banish "all such architectural stock in trade as nitches [*sic*], pilasters, cornices, monumental doorways, vaulted or coffered ceilings, etc."[19] Furthermore, Youtz argued, all nonfunctional features within the museum should be eliminated:

> Monumental stairs occupy an excessive amount of space and are dangerous in case of crowds . . . Sculpture courts, so dear to the heart of every museum architect, are in most cases the worst possible places to exhibit sculpture because of their colossal scale and bad lighting . . . Colonnades, arcades, rotundas and domes are all useless architectural liabilities which destroy the functional value and living quality of a museum building.[20]

As to the exterior of the building, Youtz claimed he made no dictates concerning style; rather, he said, that was the province of the architect, who ought to create an exterior design "appropriate" to the functional requirements of the interior. Since, however, Youtz specifically recommended the use of steel-frame construction and curtain walls on the exterior to allow for maximum flexibility, it is clear that he was calling for a modern functionalist approach for the exterior as well as the interior only answerable by the most recent developments of European modernism in architecture.

How did American architects respond to these various dictates? As with any adjustment in style and any movement in history, theory was ahead of fact, and the adjustment to modernism was gradual and overlapped with buildings whose appearance still clung to classical tenets. The transition was partially accomplished by museums whose attempts at modernism were similar to the moderate modernism of Rockefeller Center in New York (1928–40). The skyscrapers of Rockefeller Center, in comparison with the "pure" European modernism of Howe and Lescaze's PSFS building, were executed in a sleekly stylized idiom, part modern in outline and part Art Deco in decorative embellishment.[21] The aesthetic of the Rockefeller Center buildings—spare, modern-looking silhouettes, decorated at street level with shallowly incised Art Deco figures and motifs—reappears in several art museums, among them Edward L. Tilton and Alfred Morton Githens's Museum of Fine Arts, Springfield, Massachusetts, (1931–33) and the Wichita Art Institute, Kansas, by Clarence S. Stein (1929–35). The Springfield museum

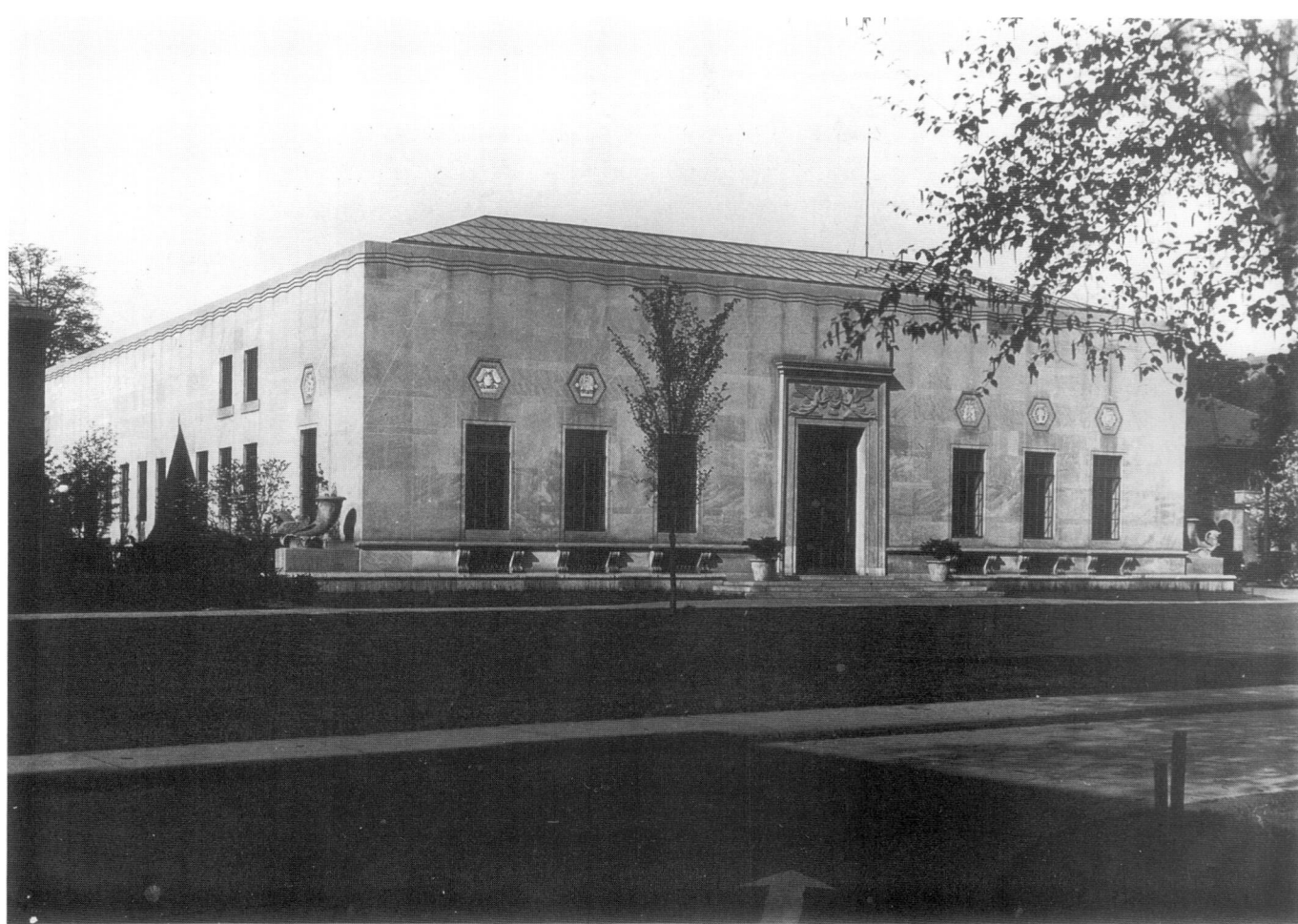

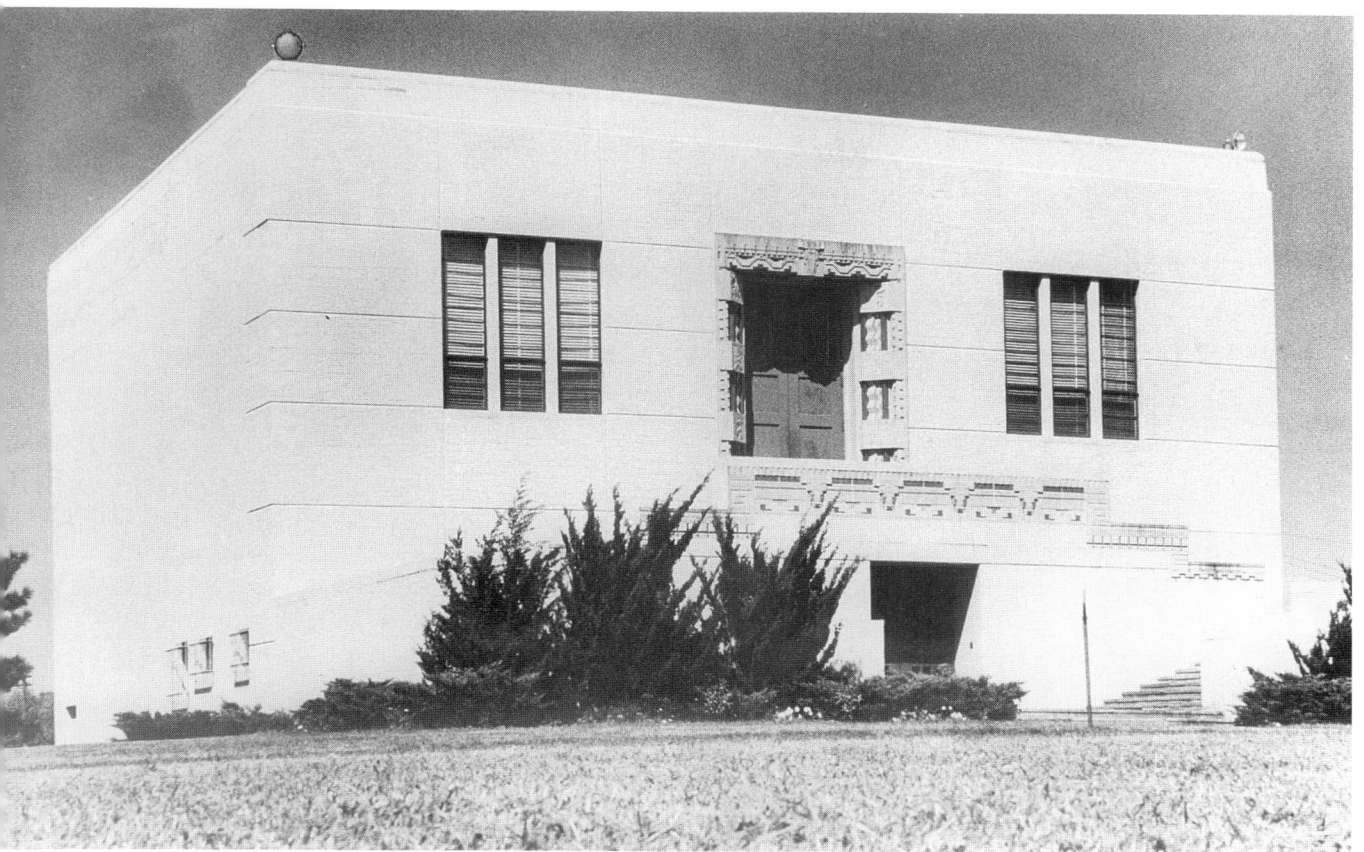

Clarence S. Stein. Wichita Art Institute, 1929–35.
Courtesy of the Wichita Art Museum.

presents a plain facade punctuated only by windows, doors, and small, incised, hexagonal panels over the windows. The pared-down aesthetic of the facade looks modern but the decoration introduced by the panels over the windows and a triple row of incised waves instead of a cornice keep the design from being as completely barren of decoration as a truly modernist design, and the placement of the decorations is distinctly reminiscent of classical design. Even closer to the aesthetic of Rockefeller Center is Clarence Stein's Wichita Art Institute. The main blocks of the building are kept clean and discrete, like the slabs of the Rockefeller buildings. The exterior decoration is also very like that of Rockefeller Center, for the very good reason that sculptor Lee Lawrie executed both. The Wichita museum's exterior decoration is kept to isolated, geometric panels, which contain stylized human figures separated by bands of shallowly incised geometric patterns. Both museums represent a kind of compromise style between wholehearted adherence to the precepts of European modernism and the remaining desire not to relinquish Beaux-Arts classicism completely.

ward L. Tilton and Alfred Morton Githens.
ringfield Art Museum, Springfield, MA, 1931–33.
urtesy of the Connecticut Valley Historical Museum,
ringfield, Massachusetts.

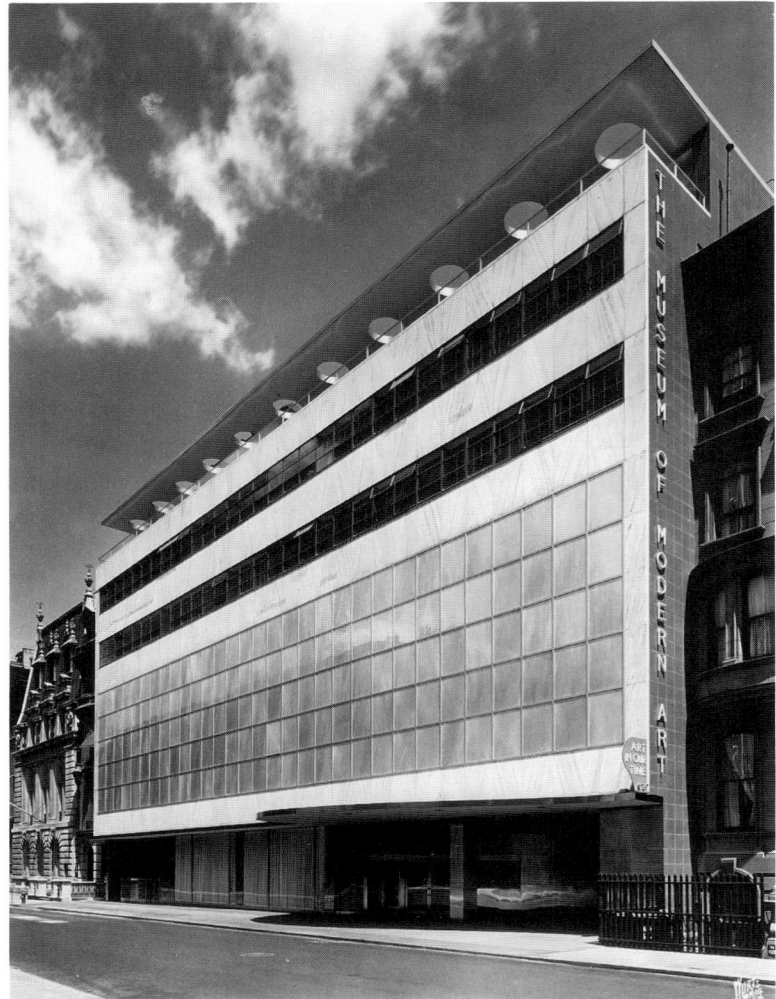

Edward D. Stone and Philip L. Goodwin. Museum of Modern Art, New York, 1933–39. Photograph by Richard Wurts, Courtesy The Museum of Modern Art, New York.

The true landmark of modernism in art museum architecture was, of course, the Museum of Modern Art in New York. Founded in 1929, the Museum of Modern Art was "an aggressive tastemaker," as Helen Searing points out in *New American Art Museums,* influencing not only museum architecture but all modern architecture with its 1932 touring show, "International Exhibition: Modern Architecture."[22] The show and its companion volume, *The International Style: Architecture Since 1922,* set forth the principles of modern style like "a cookbook, a set of do's and don'ts: regularity, flat roofs, horizontality, free plans and the use of screens."[23] The exhibit seemed to make all other styles look not only obsolete but even somehow morally wrong, as the rigor and zeal of the modernist agenda seemed to imply. As Searing puts it, "The museum, as every other building type, would be transfigured by this vision of the new, the good, and the beautiful."[24] It is possible to draw a parallel between the reform mission of the City Beautiful architects with a similar agenda followed by the modernists. Both desired to

effect social as well as aesthetic reform through architecture; only the language through which they hoped to achieve their goals was radically different.

In direct response to the modernists' edicts, the Museum of Modern Art's trustees first commissioned Howe and Lescaze to create designs for their building in 1930.[25] Lescaze's various designs for the museum began as reminiscent of his current work for the PSFS skyscraper, with a tall, thin mass on the corner serving the elevators and stairs, and a large slab for the main exhibition spaces balanced over a cantilevered entrance motif. Subsequent designs included a famous and daring constructivist scheme of nine stacked rectangular blocks set at right angles, alternating short and long sides; and finally, in 1931, a reversion to the single-slabbed skyscraper. Although Lescaze's designs were never executed, the Museum of Modern Art's building was eventually designed in the International style by architect Edward Stone and museum trustee Philip Goodwin in 1939. It contains all the requisite ingredients: a flexible floor plan created by steel-skeleton construction, glass curtain walls arranged in a grid and stretched taut over the surface of the building, and no suspicion of ornament in the traditional sense. Both the show and the building itself helped to establish the International style as the "approved image of the 20th century."[26]

Seconding New York's endorsement of the International style as the preferred style for such important public buildings as museums was the 1939 competition for a Smithsonian Gallery of Art in Washington.[27] Conceived, in part, as a modernist antidote to the monumental National Gallery of Art, this museum was to house contemporary works of art, and its program stressed a strict adherence to functional necessities and flexibility of space. The competition attracted a large number of up-to-date modern submissions, and the winner, the entry by Eliel Saarinen, Eero Saarinen, and Robert F. Swanson, was foremost among them. Their design balanced a long, low horizontal mass which echoed the classical buildings on the rest of the Mall with a tall, unornamented slab which marked the auditorium functions. With all the earmarks of the International style—the plain, unadorned masses, the horizontality emphasized by ribbon windows and flat roofs, the open, flexible floor plan—the proposed Smithsonian Gallery of Art would have thumbed its nose at its monumental classical neighbors and joined the Museum of Modern Art in the call for modern architecture for the art museum. Unlike the Modern, however, the Smithsonian Gallery was not to be built, doomed by a lack of funding.

However the modernists—architects and the museum establishment alike—may have felt about the art museums produced by the period 1890–30, the buildings existed in just about every major urban area in the country. Modern additions may have been built onto them en masse, but their principal facades remained monumental and classical and in most cases became signatures of the museums themselves. Today, almost every museum places a photograph of the front of the building on its brochures; these classical facades serve in many cases as the identifying emblem of the museum. The legacy of the era is palpable and impossible to ignore; its buildings are large, prominently placed within the privileged spaces of municipal parks, and imposingly decorated with colonnades, porticos, domes, sculpture, rotundas, and grand staircases. In a very important sense, these buildings still perform their originally intended function of serving as a proud emblem of cultural and civic pride in the urban milieu.

Naturally, there are other legacies as well. First, there was the continuing legacy of the tradition itself. Despite the visual proclamation of the triumph of modernism trumpeted by the Museum of Modern Art, monumental classicism did not die with that peal. John Russell Pope's National Gallery of Art in Washington, D.C., of 1938–42, for example, was built in the grand tradition of the turn-of-the-century American art

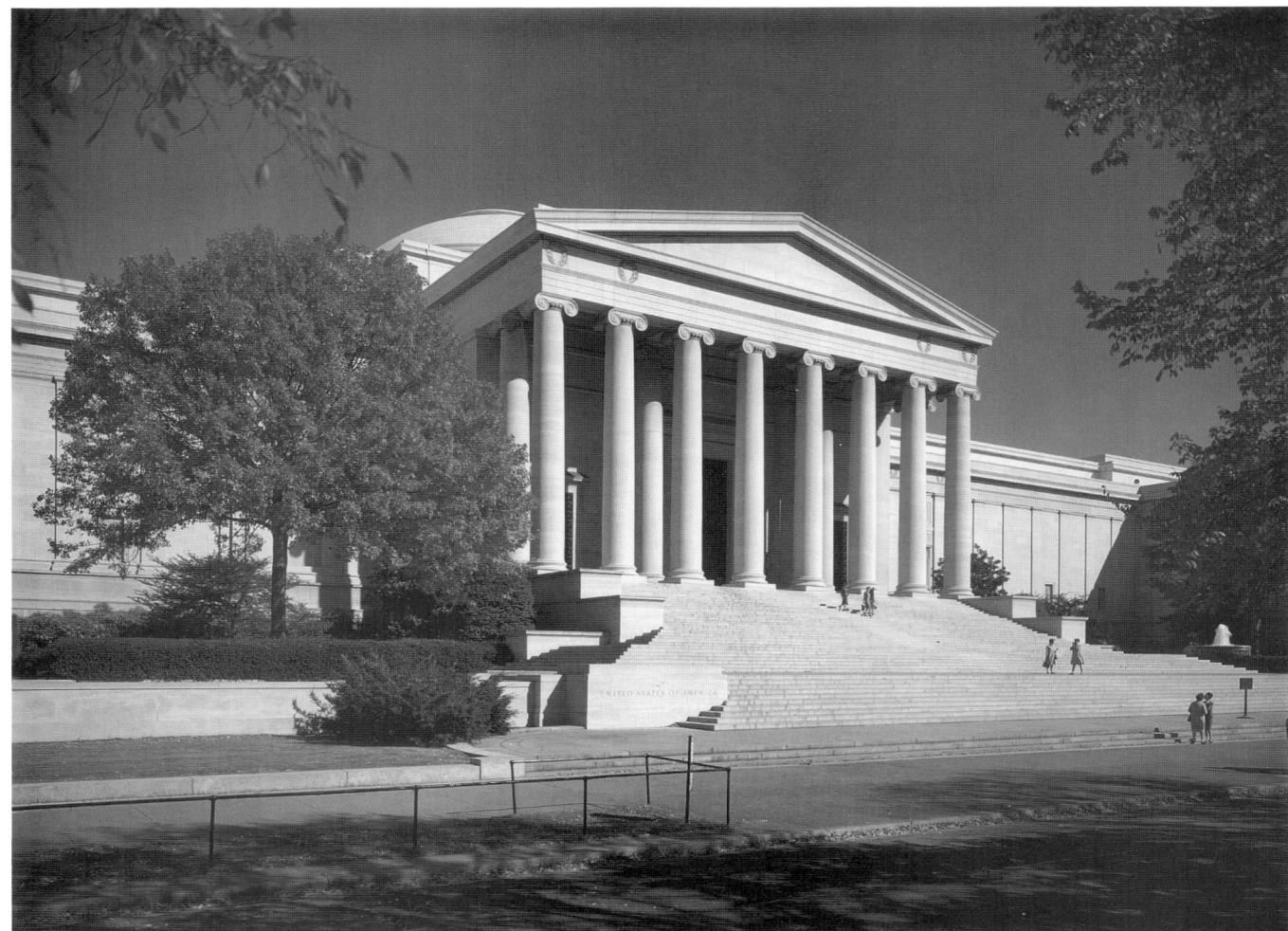

John Russell Pope. National Gallery of Art, Washington, D.C., 1938–42. Board of Trustees, National Gallery of Art, Washington, DC.

museum.[28] Once again, one may find Beaux-Arts planning, grand interior spaces, and solemn progressions through lengthy hallways, as well as the appearance of traditional load-bearing construction. Even the location of the museum building in the privileged space of the Mall harks back to the monumental-classical and City Beautiful traditions upheld by this post-Museum of Modern Art structure.

There are other lasting legacies of the period as well. The return of the most recent generation of art museum architects and museum officials to some of the precepts of the classical art museum is a recognition of the real accomplishments of those structures. A prime example is the Metropolitan Museum of Art in New York. When Kevin Roche of Roche and Dinkeloo made his alterations to the front entrance of the Metropolitan in 1970, he recreated the feeling of the monumental exterior staircases of a century before. The steps rise slowly, in stages, and although they lack the rich ornamentations of a true Beaux-Arts-styled staircase, they have the same form. More importantly, the steps at the Metropolitan have become a part of life in New York City, an urban gesture that was also an important part of Beaux-Arts ideology. The steps still serve as a ceremo-

nial preparation for entrance to the museum, but they are also filled on a sunny day with tourists and workers eating lunch, and they serve as a meeting spot and even as spectator seating for everything from mimes to ragtime bands. The contrast between the entrance of the Metropolitan and that of the Brooklyn museum is a startling one, for it points to some of the most valuable aspects of Beaux-Arts architecture. It garners affection; it has appeal; people now and a century ago respond to it emotionally.

There are other functional lessons taught by the Beaux-Arts era of museum design and relearned by the present generation. Henry Kent and Philip Youtz argued against interior architectural ornamentation and for flexible partitioning of the galleries, and modern museum architecture adopted these dictates as absolute truths. Now, one hundred years after the very height of the monumental-classical art museum with its permanently determined galleries and architectural decorations, museums have begun to return to these aspects so maligned by the modernists. In 1988, the Art Institute of Chicago opened its Daniel F. and Ada L. Rice Building, designed by the Chicago archi-

Hammond, Beeby and Babka. Roger McCormick Memorial Court, within the Daniel F. and Ada L. Rice Building of the Art Institute of Chicago, 1988, view from the north. Courtesy of the Art Institute of Chicago.

tectural firm of Hammond, Beeby, and Babka.[29] Its architecture takes inspiration from the original Shepley, Rutan, and Coolidge building. Its interior focus is the Roger McCormick Memorial Court, a two-story sculpture court in the classical tradition with heavy piers on the first story supporting a Doric colonnade on the second. The top-lighted, skylighted galleries recall the original solution to museum lighting before the advent of reliable electric illumination. Although the construction of the skylights and the regulation of the interior climate is state-of-the-art technologically, the building is low and spreading and looks as if it were built using traditional load-bearing construction. Furthermore, just like the newly renovated nineteenth-century European galleries at the Metropolitan Museum of Art that opened in 1993, the galleries in the Rice building have fixed walls rather than flexible partitions. Curators have apparently found that once such partitions are in place, it is too cumbersome and troublesome to move them. The plan of the Rice addition, too, develops axially and cross-axially with stairs and sculpture court providing the ceremonial progression through the building so essential to the Beaux-Arts plan. As an argument for the classical look of the new building, James N. Wood, director of the Art Institute, proposed classical architecture as an appropriate means of expressing democratic or populist goals:

> We've learned that people from all backgrounds and social levels want to participate in great institutions. They don't want to have institutions scaled down to a common denominator; they don't want to remove the monumental facade and the grand staircase. Maybe it's less intimidating for people to come in right off the street, possibly through the back door. It's certainly easier—but in a sense, it's also condescending.[30]

The director of the Art Institute of Chicago has come full circle to return to the notion of the art museum and its classical architecture as a means of expressing democracy both through the institution and its physical appearance as a building. Although the reform agenda espoused by the City Beautiful advocates—and later taken up in a different form by the modernists—is missing, the late-twentieth-century museum establishment thinks no less deeply about the role of the museum in the life of the city and the role of architecture in the life of the museum than did the museum establishment one century earlier. In doing so, it has returned to some of the same architectural conclusions that its grandparents held.

In the closing years of the twentieth century, it has become clear that there will never be one ideal solution for the physical form or style of the art museum. For this we may be grateful. We can also be grateful, however, for the noble and impressive buildings left to us by an earlier generation that believed an art museum should be a civic monument to a social, cultural, and architectural ideal. It is thanks to that generation and its optimistic beliefs in the power of art and classical architecture to produce better cities and citizens that we may delight in the impressive facades and grand spaces of the museums that survive as testaments to the efforts and ideals of those who produced them.

Appendix

THIS APPENDIX HAS BEEN CREATED AS A REFERENCE GUIDE TO THE MUSEUMS REPRESENTED in the text. Each entry, arranged alphabetically by name, contains a brief history and description of the building, including architect(s), construction dates, and defining issues surrounding the building. The final paragraph contains a brief annotated bibliography indicating the most important sources for the history of each museum, both as institution and as architecture. The impermanent buildings created exclusively for an exposition—namely, the Fine Arts Palaces for the World's Columbian Exposition and the Panama-Pacific Exposition—as well as the 1876 Memorial Hall for the Centennial Exposition are not represented here. They are amply covered in the chapter devoted to exposition architecture and their influence on museums (chapter 2). The museums included in the appendix follow:

Albright Art Gallery, Buffalo, New York
Art Institute of Chicago, Chicago, Illinois
Baltimore Museum of Art, Baltimore, Maryland
Brooklyn Institute of Arts and Sciences, Brooklyn, New York
Carnegie Institute, Pittsburgh, Pennsylvania
Corcoran Gallery of Art, Washington, D.C.
Freer Gallery of Art, Washington, D.C.
Metropolitan Museum of Art, New York, New York
Milwaukee Public Library and Public Museum, Milwaukee, Wisconsin
Minneapolis Institute of Arts, Minneapolis, Minnesota
Montclair Art Museum, Montclair, New Jersey
Museum of Fine Arts, Boston, Massachusetts
Philadelphia Museum of Art, Philadelphia, Pennsylvania
Rodin Museum, Philadelphia, Pennsylvania
Saint Louis Art Museum, Saint Louis, Missouri
Toledo Museum of Art, Toledo, Ohio

ALBRIGHT ART GALLERY, BUFFALO, NEW YORK (NOW ALBRIGHT-KNOX ART GALLERY)

The Albright Art Gallery in Buffalo had its beginnings in the Buffalo Fine Arts Academy, founded in 1862 as both a school of the fine arts and a forum for the exhibition of art in Buffalo. The Academy occupied temporary, rented spaces during the rest of the nineteenth century. It was not until 1900 that philanthropist John J. Albright offered to donate enough money to the Academy to provide it with a specially designed, permanent home. Albright's only stipulations were that enough money should

be raised to provide the gallery with operating expenses and that the city of Buffalo should provide the land for the gallery on the grounds of Delaware Park, Buffalo's Olmsted-designed municipal park. Albright and the Academy directors thought that the gallery could be finished in time to serve as the art exhibition space for the upcoming Pan-American Exposition to be held in Buffalo in 1901. The exposition, an event popular during the late nineteenth and early twentieth centuries, served as a forum for industrial progress but also incidentally exhibited the most recent developments in (officially sanctioned) art. Construction of the Albright Gallery, which was not completed until 1905, took too long for it to participate in Buffalo's exposition, but the structure was designed with this purpose originally held in mind.

Edward B. Green, a director of the gallery and a confidant of Albright, was naturally chosen as architect of the building in collaboration with his partner, William S. Wicks. Green's design was a compendium of Greek architecture, with the columns of the lakefront portico copied from the Erectheum and not one but two decorative copies of the Porch of the Maidens from the Erectheum with caryatids executed by Augustus St. Gaudens. The facade of the land approach is dominated by a grand semicircular colonnade, and more colonnades embellish the sides of the building. This stylophily was typical of the period and designated the building as a "temple" of art, as the Albright Gallery and others like it were frequently termed. Upon the 1905 opening of the gallery, Buffalo residents were delighted with the classical structure, as was evidenced by the admiring response to it in the local press. The original building served its purpose until 1962 when International style architect Gordon Bunshaft was hired to execute a stark glass-and-steel addition to the gallery, which served as an eloquent architectural contrast to the Greek temple form of the original.

The architectural history of the Albright-Knox Art Gallery is covered briefly in John Douglas Sanford, *The Gallery Architects: Edward B. Green and Gordon Bunshaft* (Buffalo, N.Y.: Buffalo Fine Arts Academy, 1987); as its title suggests, it also covers Bunshaft's celebrated 1962 addition to the gallery. The history of the Academy as an institution is chronicled in *100: The Buffalo Fine Arts Academy, 1862–1962* (Buffalo, N.Y.: Buffalo Fine Arts Academy, 1962); much can also be gleaned from the early volumes of the institution's *Academy Notes,* which was first published in 1907. For the Pan-American Exposition, the best contemporary source is *Pan-American Art Hand-book: Sculpture, Architecture, Painting* (Buffalo, N.Y.: David Gray, 1901). A scholarly work on the fair may be found in Joann Marie Thompson, "The Art and Architecture of the Pan-American Exposition" (Ph.D. diss., Rutgers University, 1980).

ART INSTITUTE OF CHICAGO, CHICAGO, ILLINOIS

Like its predecessors in Boston and New York, the Art Institute of Chicago began in a modest structure designed in a style that was to be superseded by its present classical building. Founded in 1879 as the Chicago Academy of Fine Arts, the first specially designed home for the Art Institute was designed in 1886 and completed in 1887. The architects were Daniel H. Burnham and John Wellborn Root, but it is generally Root who is credited with the Richardsonian Romanesque look of the building. Probably influenced by Richardson's best-known work, the Marshall Field Wholesale Store (1885–87) in Chicago, Root's Art Institute was similarly massive, with dark, richly textural, monochrome ashlar masonry and simplified, round-arched forms with exaggerated voussoirs.

The Art Institute quickly grew out of its space, and with the onslaught of planning and construction for the World's Columbian Exposition that would take place in Chi-

cago in 1893, it was decided that a new art building would be erected to house the art for the exposition and serve as a memorial to it, as well as a new home for the Institute. The vicissitudes of the planning for the fair did not allow the use of the new building for the fair as intended, but it was constructed in time for the exposition and did serve some exposition functions before it became the permanent new home for the museum. The Institute's connection to the World's Columbian Exposition is of great significance, for the event magnified the influence the architecture of the Institute was to have.

Designed by the Boston firm of Shepley, Rutan, and Coolidge in 1891 and completed in 1893, the new Art Institute building was among the earliest museums to return to the classical style. The design displays a rather more tentative classicism than the exuberant but ephemeral architecture of the fair. The plan was comprised of a rectangular block, decorated simply on the exterior with a blind arcade atop a rusticated *piano nobile*. The entrance pavilion consisted of a pedimented, triple-arched porch over the arched doorways set into the *piano nobile* and reached via a modest flight of exterior stairs. Although the structure lacks the Beaux-Arts flamboyance of the fair architecture and its subsequent progeny, it clearly turns away from the architectural eclecticism of the previous generation and sets classicism as the new standard. The reproductions of the Panathenaic Procession from the Parthenon emphasize the adherence to the classical idiom. Whereas many museums took up the Beaux-Arts manner of the fair, there was also a continuous line of museums, especially those designed by Edward B. Green in New York and Ohio, which would maintain a more severe Attic style.

An excellent architectural history of the Shepley, Rutan, and Coolidge Art Institute building is Linda S. Phipps, "The 1893 Art Institute Building and the 'Paris of America': Aspirations of Patrons and Architects in Late Nineteenth-Century Chicago," *The Art Institute of Chicago Museum Studies* 14 (1988):28–45; the rest of the same issue also provides a chronology of the Art Institute's history as an institution, an article on the history and cultural significance of the lions flanking the Institute's entrance, and two more articles on the architectural history of the institute, bringing it up to 1988. An insightful look into the social atmosphere that led to the creation of the Art Institute, among other educational and cultural institutions, is provided by Helen Lefkowitz Horowitz, *Culture and the City: Cultural Philanthropy in Chicago from the 1880s to 1917* (Chicago, Ill.: University of Chicago Press, 1976).

BALTIMORE MUSEUM OF ART, BALTIMORE, MARYLAND

Perhaps because of the proximity of Washington, D.C., and the existence of the then mostly private Walters art collection, Baltimore's art museum was founded well over a generation later than most of the major East Coast art institutions. Incorporated in 1914, the museum first borrowed space from the Peabody Institute for the housing of its accessions and only found exhibition space in a private residence in 1923. In 1924, a city referendum was passed, authorizing a million-dollar loan for the construction of a municipal art museum in Wyman Park, the land for which had been donated by Johns Hopkins University. The city charter required that the architect should be a Maryland resident, and Howard Sill, who had been involved with the designing of the Baltimore Courthouse, was chosen, with John Russell Pope named as associate architect. Only a month after accepting the commission, however, Sill was paralyzed by a stroke and rendered unable to complete the designs. Pope was then put in charge of the project and listed Sill as associate architect out of courtesy. Construction of the building began in 1927; the first portion was open to the public in 1929.

Prefiguring his most famous building, the National Gallery of Art in Washington,

D.C., Pope's design for the Baltimore Museum of Art was a serenely classical monument executed with a maximum degree of restraint and care, to the extent that there are some who call Pope's classicism academic to the point of sterility. In any case, the design continues the tradition of monumental classical museum buildings from the preceding generation, with its pedimented, hexastyle Ionic portico reached by a ceremonial progression up an exterior staircase. Niches which were to contain sculpture flank the portico, and the carefully orchestrated receding volumes of the front of the building gracefully turn the corner of the structure to introduce the shallow porticos on the sides.

Like earlier museum plans executed by such architects as Richard Morris Hunt for the Metropolitan Museum; McKim, Mead, and White for the Brooklyn Institute of Arts and Sciences; or Guy Lowell for the Museum of Fine Arts, Boston, Pope designed a monumental scheme for the future of the Baltimore Museum that was never executed. His plan depicts the executed portion of the structure as merely the entrance to an enormous museum complex in the grandest Beaux-Arts tradition. The Great Depression and the onset of architectural modernism, however, precluded the construction of any of Pope's design beyond the first building campaign.

No architectural history per se of the Baltimore Museum of Art has been written, but Steven Bedford, who is presently writing a dissertation on Pope at Columbia University, is author of an article entitled "Museums Designed by John Russell Pope," *Antiques* 139 (April 1991): 750–63. A history of the institution may be found in the museum's periodical publication: Kent Roberts Greenfield, "The Museum: Its First Half Century," *Baltimore Museum of Art Annual* 1 (1966). For further information on Pope and museum design, see National Gallery of Art, *John Russell Pope and the Building of the National Gallery of Art* (Washington, D.C.: National Gallery of Art, 1991).

BROOKLYN INSTITUTE OF ARTS AND SCIENCES, BROOKLYN, NEW YORK (NOW THE BROOKLYN MUSEUM, NEW YORK, NEW YORK)

The Brooklyn Institute of Arts and Sciences traces its origins to an 1823 Apprentice's Library, a resource for working-class youth to improve their minds and characters and learn about developing technology. Its first building was erected in 1825; in 1841, it moved into space offered by the Brooklyn Lyceum, and its broadening educational mission led to its name change to the Brooklyn Institute in 1843. As the city of Brooklyn grew, so did its Institute. In 1890, it was once again renamed the Brooklyn Institute of Arts and Sciences with the goal of constructing a separate building worthy of the goals of the sixteen different departments in science, natural history, and fine arts that the Institute had formed.

By 1889, the Institute secured land that was a part of Olmsted-designed Prospect Park—not in the heart of the rural park but in a portion set aside expressly for such educational institutions. In 1893, the Institute's Department of Architecture devised a competition to obtain the design for the proposed new building. Responding to the growing interest in civic beautification obtained through classical architecture that was epitomized by the World's Columbian Exposition held in Chicago in 1893, the competition program specified the classical style. The winner of the competition, the firm of McKim, Mead, and White, provided the Institute with a grand scheme for a monumental building to be built in successive stages. The plan was based on a square about five hundred feet on each side with a cross in the center forming four interior courtyards in its arms. The style of the building was greatly indebted to the architecture of the World's Columbian Exposition, with its unifying, high-level cornice line, giant-order pilasters supporting sculpture, hexastyle Ionic portico, and one great and four smaller

saucer domes enlivening its silhouette. The huge scale and bold, sculpture-enriched classicism were to serve as icons of civic progress in Brooklyn.

Construction began in 1895, and the first portion of the building was completed in 1897. Subsequent building campaigns completed other sections of the building between 1899 and 1926, which marked the end of the adherence to the McKim, Mead, and White designs. Despite thirty years' fidelity to the original vision of the building, less than a quarter of the plan was ever built. Philip Youtz, who became director in 1934, tried to bring the renamed Brooklyn Museum into the twentieth century both philosophically and architecturally with institutional and structural changes. He hired William Lescaze, architect of the PSFS skyscraper in Philadelphia, to redo the entrance to the museum. In 1934, the great stairs were removed, and the basement became the new ground-level lobby, redesigned in the latest modern style. The changes constituted a decisive turn away from the grandeur of the Beaux-Arts era.

An excellent architectural history of the Brooklyn Museum may be found in Leland Roth, "McKim, Mead & White and The Brooklyn Museum, 1893–1934," in *A New Brooklyn Museum: The Master Plan Competition,* ed. Joan Darragh (New York, N.Y.: Brooklyn Museum, 1988), 26–51. Darragh's essay in the same volume continues the architectural history of the museum beyond McKim, Mead, and White. For further information on the development of Prospect Park, see Albert Fein, ed., *Landscape into Cityscape: Frederick Law Olmsted's Plans for a Greater New York City* (Ithaca, N.Y.: Cornell University Press, 1967).

CARNEGIE INSTITUTE, PITTSBURGH, PENNSYLVANIA (NOW THE CARNEGIE)

The architectural history of the Carnegie Institute building from 1890 to 1907 bridges the change in taste toward the end of the nineteenth century from Richardsonian Romanesque to Beaux-Arts classical. The Institute was intended to be an omnibus of human knowledge, similar in concept to the Brooklyn Institute of Arts and Sciences. Owing its existence to its eponymous founder, Andrew Carnegie, the Institute's original 1895 building was of modest size and housed under one roof a library, music hall, museum of natural history, and art gallery. Selected via competition in 1890–91, the architects of the Institute were the members of the Boston firm of Longfellow, Alden, and Harlow. The building combined Richardsonian influences with an early Renaissance style, featuring Brunelleschian windows on the main block of the library and two attenuated campanili flanking the music hall. These towers especially recall the influence of Richardson, whose Allegheny County Courthouse (1884–88) was nearby in downtown Pittsburgh.

When Andrew Carnegie donated a great deal more money in 1905 to expand the institute, Alden and Harlow (Longfellow had left the firm by this time) made plans to expand the building fourfold in size and alter considerably its exterior appearance. The new facade, completed in 1907, was both more classical and more flamboyant with a distinctly French Beaux-Arts flavor. This change in style probably suited Carnegie, who had visited the 1893 World's Columbian Exposition in Chicago and was greatly impressed with the architecture there. The new entrance facade was decorated with four large sculptural groups in the Beaux-Arts tradition, representing music, art, science, and literature. The interior also reflected the change of taste in the lush decoration of the new music hall foyer with its lavish use of polychrome marble inlay and gilding, as well as the grand entrance stairway with murals depicting the *Apotheosis of Pittsburgh* by John White Alexander.

The location of the museum in Oakland, a section of Pittsburgh that was coming into its own around the turn of the century, is telling of the urban concerns of the era.

When Carnegie offered his gift of the building of the Institute, the city offered in return fourteen acres at the entrance to Schenley Park, a rural-picturesque park modeled on the Olmstedian ideal. The picturesque quality of the first building suited its location at the edge of an Olmsted-style park. When the Institute expanded, it reached out instead toward the developed part of the area, in a gesture responsive to the growing interest in the City Beautiful spurred on the by the Columbian Exposition. The Institute became the heart of a cultural center developing in Oakland with the University of Pittsburgh on one side and Carnegie-Mellon University on the other.

The most recent architectural consideration of the Carnegie building is contained in Margaret Henderson Floyd, *Architecture after Richardson: Regionalism before Modernism—Longfellow, Alden, and Harlow in Boston and Pittsburgh* (Chicago: University of Chicago Press, 1994), 203–11 and 215–31. See also Floyd's "Longfellow, Alden & Harlow's First Carnegie Library and Institute," *Carnegie Magazine* 61 (January-February 1993): 23–30 which does not cover the later additions made to the building. For an earlier look at this subject, see James D. Van Trump, "The Past as Prelude: A Consideration of the Early Building History of the Carnegie Institute Complex," *Carnegie Magazine* 48 (October-November 1974): 346–60. A brief look at the history of Schenley Park, at whose entrance the Carnegie is located, may be found in R. J. Gangewere, "Schenley Park," *Carnegie Magazine* 53 (Summer 1979): 20–28. A more thorough examination of Pittsburgh's parks is Barbara Judd, "Edward M. Bigelow: Creator of Pittsburgh's Arcadian Parks," *Western Pennsylvania Historical Magazine* 58 (January 1975): 53–67. An excellent look at Pittsburgh may be found in Franklin Toker, *Pittsburgh: An Urban Portrait* (University Park, Pa.: Pennsylvania State University Press, 1986).

CORCORAN GALLERY OF ART, WASHINGTON, D.C.

The first building for the Corcoran Gallery of Art was designed by James Renwick—also architect of the Smithsonian "Castle"—and was the first major public building in this country to be designed in the French Second Empire style. The reason for the choice of this style is indicative of the cultural aspirations of Americans during this period. William Wilson Corcoran, whose collection the gallery was to house, had visited the Louvre in 1855 and wished his collection to become the basis of an American Louvre. Because of Corcoran's strong belief in states' rights, the building was seized by the government during the Civil War, and the gallery was not open to the public until 1874. Typical of the Second Empire style were the plasticity of the volumes formed by the central and corner pavilions, the high Mansard roofs over the pavilions, the alternating triangular and segmental pediments, the coupled columns and pilasters, and the exuberant use of ornamental carving and sculptural decoration.

Because the gallery soon ran out of space and could not expand, it was decided in 1891 to purchase the land at Seventeenth Street and New York Avenue where the gallery now stands. The architect, Ernest Flagg, was selected via a competition of dubious integrity, although a close inspection of the competition materials indicates that Flagg's design was probably the best. Constructed from 1892 to 1897, the Corcoran was one of the earliest museums in the country to be built in the monumental classical vein and one of the most truly Beaux-Arts examples of the genre. Having only recently returned from Paris and the Ecole des Beaux-Arts, Flagg drew upon several French Neo-Grec antecedents, notably Labrouste's Bibliothèque Ste-Geneviève—especially in the inscription of artists' names on the frieze under the cornice—and for the school wing, the highly appropriate influence of Felix Duban's Quai Malaquais front of the Ecole des Beaux-Arts itself. The ingenious solution of placing the hemicycle auditorium

at the odd angle created by Seventeenth Street and New York Avenue probably also owes a debt to French design, namely the Haussmann era apartment houses in Paris, which often had to deal with sharply-angled streets. The imposing white marble exterior and the elegant interior with grand staircase and two-story skylighted "Parthenon" atrium made a big impression on the popular press, which regarded it as the most beautiful and up-to-date art gallery in the country.

In 1925, Charles Platt, having already designed the Freer Gallery of Art on the Mall, designed the addition to the Corcoran made possible by the bequest of William Clark. Platt's addition nearly doubled the size of the building but seamlessly maintained Flagg's style. Platt was a likely candidate for the addition, because he had a predisposition toward the classical style, as is indicated by his service on the Commission of Fine Arts between 1916 and 1921. It seems likely that his experience with the Freer may have influenced his work at the Corcoran.

For a thorough architectural analysis of the building with a detailed look at the Neo-Grec sources and influences, see Mardges Bacon, *Ernest Flagg: Beaux-Arts Architect and Urban Reformer* (New York: Architectural History Foundation and Cambridge: MIT Press, 1986), 77–89. The history of the institution, from its beginnings in the present Renwick Gallery to 1976, is covered in *Corcoran* (Washington, D.C.: Corcoran Gallery of Art, 1976). The essay by Davira Spiro Taragin also includes a brief history of William Wilson Corcoran's life. The Corcoran Gallery and School of Art Archives are a particularly rich and well-organized resource.

FREER GALLERY OF ART, WASHINGTON, D.C.

Despite the Freer Gallery of Art's relatively late completion date, it was only the second museum of art to be established in the nation's capital after the Corcoran, and it was the first art gallery to be erected under the aegis of the Smithsonian Institution. The gallery was proposed and funded by its eponymous founder, Charles Lang Freer, in order to house his collections of American paintings and Asian art, which he intended to bestow as a gift to the nation. Already a friend of Charles A. Platt, Freer commissioned the architect to design the gallery on the Mall in 1913. Because of wartime delays, it was not open to the public until 1923.

As is indicated by his service on the Commission of Fine Arts between 1916 and 1921, Platt was concerned about the architectural integrity and the future of the Washington Mall, only recently rescued from aesthetic oblivion by the first and most successful City Beautiful campaign, the McMillan or Senate Park Commission Plan of 1901. It was, therefore, only natural that Platt should adhere to the classical style preferred by the McMillan Plan, as well as the sightlines for the Smithsonian Institution on the Mall established by the plan. With a spirit similar to the one that imbued the White City at the 1893 World's Columbian Exposition with such a sense of harmony, Platt created a low, classical block with a strongly unifying cornice line, which emphasized the relationship of the building to the Mall rather than calling attention to the individuality of the building itself.

Platt's design is highly subtle and refined. The Gallery's plan consists of a simple rectangular block enclosing an interior courtyard. The exterior is completely—yet in a genteel rather than an aggressive manner—rusticated, except for the smooth finish of the entrance pavilion, which is distinguished by a triple-arched, recessed portico, flanked by niches. From this pavilion, the main bulk of the building recedes only shallowly. The structure's elevation was also kept extremely simple, with only a series of basement-level windows to mark the level of the main floor and an incised wave motif

decorating the cornice line; rusticated arches relieve the sides of the building from monotony. The composition is completed by a balustraded parapet. The overall effect of the building is very different from its rather more showy neighbors on the Mall, particularly its nearest neighbor, the Romanesque-Gothic "Castle" designed by James Renwick and also the grand classical buildings there. From the exterior, the Freer conveys an impression of solidity and repose; indoors, it creates a world apart.

Keith N. Morgan, *Charles A. Platt: The Artist as Architect* (New York: Architectural History Foundation and Cambridge: MIT Press, 1985) 162–70 provides an overview of Platt's oeuvre and a chapter devoted to "Museums and Schools" covers the Freer. A recent book provides a history of the gallery and its collections: Thomas Lawton and Linda Merrill, *Freer: A Legacy of Art* (Washington, D.C.: Freer Gallery of Art, Smithsonian Institution and New York: Harry N. Abrams, Inc., 1993).

METROPOLITAN MUSEUM OF ART, NEW YORK, NEW YORK

Founded in 1870 in the same year as the establishment of the Museum of Fine Arts, Boston, the Metropolitan Museum of Art in New York is one of the oldest continuously operating art museums in the country and among the most prominent. Architecturally speaking, it is also one of the most interesting, as its present building comprises a series of accretions from its earliest edifice to the present. The museum received the use of its land in Central Park along Fifth Avenue from the City of New York in 1870. The Park Board retained authority over the architecture of the building; its first structure, therefore, was designed by one of the designers of Central Park itself, Calvert Vaux. This original building, designed in 1872 and opened in 1880, was in a picturesque High Victorian Gothic style intended to blend into the rural surroundings of the park. It featured pointed arches, structural polychromy, and an eclectic mix of architectural forms. Throughout the remainder of the nineteenth century, the building had an uneven history as its design passed through the hands of three different architects— from Vaux, to Theodore Weston, to Arthur Tuckerman. Weston's building campaign (1884–88) attempted to modernize the style of the building by lowering the slant of the roof and incorporating large Roman arches into the design. The third addition— Tuckerman's—consisted of a mirror image of Weston's wing (1890–94).

Before the turn of the century, the museum had reached a turning point in its building history. It had evolved into a self-contained, H-shaped block, not easily extended in any direction. In response to the resurgent interest in classical architecture, the museum hired the "Dean" of American architects, Richard Morris Hunt, fresh from the success of the 1893 World's Columbian Exposition in Chicago, to make a plan for the museum. This he did in grand Beaux-Arts classical style, shaping the future of the museum into a vast complex of hallways, theaters, chapels, galleries, and courtyards. Although this plan was never realized, Hunt provided the museum with its signature facade, a triple-arched, monumental entrance with coupled columns framing each arch. Seen to completion by his son, Richard Howland Hunt, after his death in 1895, the great hall was constructed between 1894 and 1902 as the first section of the new building campaign. It consisted of a monumental space crowned by three domes, echoing the triune motif of the facade. A grand staircase connected the hall to the original building. The entrance was to be extensively decorated with sculpture in relief and in the round, a scheme which was never realized. Nevertheless, the great hall that Hunt and his son created for the Metropolitan proved to be influential for other buildings in New York and set the tone for future building campaigns at the museum, for example, the wings flanking the entrance executed by the firm of McKim, Mead, and White.

An excellent history of the museum's architecture from its beginning through the present day is Morrison H. Heckscher, "The Metropolitan Museum of Art: An Architectural History" reprinted from *The Metropolitan Museum of Art Bulletin* (Summer 1995); see also his "Hunt and the Metropolitan Museum of Art," in *The Architecture of Richard Morris Hunt,* ed. Susan R. Stein (Chicago: University of Chicago Press, 1986), 172–85. The most complete institutional history of the museum remains Winifred E. Howe, *A History of the Metropolitan Museum of Art,* 2 vols. (New York: Metropolitan Museum of Art, 1913–46). An older piece which discusses the incomplete sculptural program and their most visible remains, the rough pyramidal blocks above the coupled columns, is Albert Ten Eyck Gardner, "Those Blocks," *Metropolitan Museum of Art Bulletin* 11 (May 1953): 252–58.

MILWAUKEE PUBLIC LIBRARY AND PUBLIC MUSEUM, MILWAUKEE, WISCONSIN (NOW MILWAUKEE PUBLIC LIBRARY)

The building for the Milwaukee Public Library and Museum is one of the most obvious inheritors of the legacy of the Beaux-Arts classicism of the 1893 World's Columbian Exposition in Chicago. In 1890, the city's public library and natural history museum, both cramped for space, decided to pool their resources and erect one building to house both functions, as well as an art gallery and art study space. This omnibus approach mirrors that of such other contemporary institutions as the Brooklyn and Carnegie Institutes. In 1893 and only ninety miles from Chicago, a competition was held to obtain a design for the structure and won by the local architectural firm of George Ferry and Alfred Clas. The majority of the submissions adopted the look of the fair architecture; the winning entry was no exception. Ferry and Clas's design, little altered when constructed in 1895–97, featured the same horizontality, unifying cornice line, sculptural decoration, and saucer dome found at the fair. The dome especially was reminiscent of the dome atop McKim, Mead, and White's Agriculture Building. Belying the function of the structure as home to two different institutions, the design presented a unified exterior based on a simple rectangular volume, interrupted only by slightly projecting corner and entrance pavilions. The ground-level entrance was marked by three arches through the rusticated *piano nobile,* atop that rested a giant-order Corinthian colonnade which defined the second and third floors. The entablature included a frieze inscribed with the names of authors and scientists, and the structure was capped by a balustraded parapet and the saucer dome.

Despite the hiring of an outside expert—William Ware of Columbia University—the manner in which the competition was conducted and the fact that the winners were local architects aroused a great deal of controversy at the time, including accusations of favoritism and special exceptions. Even after the furor over the competition died down, the Public Library and Museum reneged on the promised commission to the architects and accused Ferry and Clas of producing an inferior building with structural defects. During the emergence of architecture as a profession of high standing, such problems helped to define the strengths and weaknesses of the business of architecture as it was then practiced and eventually led to the creation of standards for competitions and the conducting of architectural business by the American Institute of Architects.

A good history of the Milwaukee Public Museum, which in its first chapters chronicles the history shared with the Milwaukee Public Library, is Nancy Oestreich Lurie, *A Special Style: The Milwaukee Public Museum, 1882–1982* (Milwaukee, Wisc: Milwaukee Public Museum, 1983). Beautiful photographs as well as a brief architectural history of the museum and library structure may be found in H. Russell Zimmermann, *Magnificent*

Milwaukee: Architectural Treasures, 1850–1920 (Milwaukee, Wisc: Milwaukee Public Museum, 1987). The HABS report on the Milwaukee Public Library is also extremely informative and cites many additional sources.

MINNEAPOLIS INSTITUTE OF ARTS, MINNEAPOLIS, MINNESOTA

As urbanism spread westward in the nineteenth century in the United States, so did the desire for culture as it was then perceived. Minneapolis was a burgeoning city in the late nineteenth century, large and wealthy enough to enable the founding of the Minneapolis Society of Fine Arts in 1883. The Society's first art exhibitions, as was the case with almost every such newly established organization, took place in rented quarters. From 1889 until the Society was able to move into its permanent home, the Society and the art school it had established in 1886 were housed in the Minneapolis Public Library. Not until 1910 was the Society able to move forward in its aim to build a permanent museum structure for its collections, administration, and school. The museum came to be located on a donated ten-acre tract of land in a residential area away from the busy center of Minneapolis, and the design for the new building was obtained by an architectural competition held in 1911. The competition was won by the firm of McKim, Mead, and White in 1912. The overall scheme was executed in the manner of Ecole des Beaux-Arts competitions or Richard Morris Hunt's grand plan for the Metropolitan Museum of Art, but it was designed in a restrained classical idiom very different from the exuberant French style of Hunt's facade for the Metropolitan and rather like the firm's own subdued designs for the Metropolitan's Fifth Avenue wings.

The multifunctional program for the Minneapolis Institute of Arts building included galleries for paintings and sculpture and a grand hall for architectural casts. Its long-range goals also included space to house a library, the school, a symphony hall, offices, and an unusual semicircular "Promenade" gallery enclosing a semicircular courtyard at the rear of the building. The program, like so many grand plans of the period, provided for construction and expansion well into the future. The portion that was built immediately, between 1912 and 1915, comprised only a fraction of the entire scheme, yet in itself it was quite a large building. The 1915 building consisted of nearly the whole facade of the intended plan and was built of granite, which contributed to its rather severe appearance. The entrance motif consisted of a set of steps leading to a hexastyle Ionic portico topped with an unornamented pediment. This was flanked by two wings containing the original galleries, accented only with windows, shallow pilasters, and a simple cornice molding. The wings ended abruptly where the end pavilions were to be built; these were never completed. The firm of McKim, Mead, and White was never to work on the structure again; subsequent additions were executed first by local architects and then by the Japanese architect Kenzo Tange.

The architectural history of the Minneapolis Institute of Arts building from the beginning through 1974 is covered by Eileen Michels, *An Architectural View, 1883–1974: The Minneapolis Society of Fine Arts* (Minneapolis, Minn., 1974). The entire set of competition drawings was published by the *Architectural Review*, n.s., 1 (1912): 56 and Pls. 41–50. For further information on the firm of McKim, Mead, and White, see Leland M. Roth, *McKim, Mead & White, Architects* (New York: Harper & Row, 1983).

MONTCLAIR ART MUSEUM, MONTCLAIR, NEW JERSEY

The establishment of the Montclair Art Museum, though it is a small institution, is indicative of several important currents in early-twentieth-century American culture. The first is the ever-widening influence of large cities on their surrounding metropoli-

tan areas. By the early twentieth century, New York was a large and powerful enough city to produce a suburb wealthy enough to sustain its own art museum. Montclair, though an independent entity, is twelve miles directly west of New York and could only have produced an art museum—the first in the state of New Jersey—through its commuter relationship with New York. A second item worth noting is Montclair's addition to a growing number of small-town art museums after the turn of the century. Another important trend indicated by the existence of the Montclair museum is that of the City Beautiful movement. The town entered into the City Beautiful movement at the same time as it fostered its museum. The museum and its proposed town improvement plan came together in 1909 when Montclair philanthropist William T. Evans offered his collection of American paintings to the Montclair Municipal Art Association and city planner John Nolen published his improvement plan, as commissioned by the Montclair Civic Association, in *Montclair: The Preservation of its Natural Beauty and its Improvement as a Residence Town*. Although the museum did not come to be located where Nolen had intended it, the Civic Association credited the plan with the construction of the museum.

By 1909, the collection of paintings for the museum had already been donated, and Mrs. Henry [Florence Rand] Lang had provided substantial monies for a building fund to create a gallery for Montclair and house that collection. The small, classical art gallery, designed by Albert R. Ross, was opened to the public in 1914; the building was later completed by the firm of Goodwillie and Moran. The museum structure identifies yet another common thread in American architectural and cultural history. Like the far larger and grander museums it was attempting to emulate, the Montclair Museum is in the classical mode, though constructed of the humbler materials of brick and stucco rather than of marble or granite. The structure's facade consists of an unusual and somewhat naive arrangement. Four irregularly spaced columns (two pairs with a larger space in the center) form a screen to the recessed entrance porch; this is flanked by two pedimented wings with applied pilasters and central doorways. Columns and pilasters support a small entablature, an unadorned frieze, and cornice. The effect is charming and pastoral, as the building is set on a hill in open, primarily residential land next to a park in the green suburb of Montclair.

Robert D. B. Carlisle, *A Jewel in the Suburbs: The Montclair Art Museum* (Montclair, N.J.: Montclair Art Museum, 1982), is a history of the museum as an institution and covers briefly the various building campaigns that comprise the museum building in its present state. The City Beautiful tract created for Montclair, which features the art museum as one of its most important improvements, is John Nolen, *Montclair: The Preservation of Its Natural Beauty and Its Improvement as a Residence Town* (Montclair, N.J., 1909).

MUSEUM OF FINE ARTS, BOSTON, MASSACHUSETTS

Founded in 1870, the Museum of Fine Arts, Boston, stands with the Metropolitan Museum of Art in New York as one of the earliest major art institutions in this country still in operation. Designed for an 1870 competition won by the firm of John Sturgis and Charles Brigham, the Museum's first home was a Ruskinian Gothic building, innovative in its extensive use of terra-cotta ornamentation. Located on Copley Square, the museum formed a part of an early urban-planning enterprise, Boston's Back Bay. The structure became part of a group that featured H. H. Richardson's Trinity Church and—near the end of the museum building's existence—Charles McKim's famed Boston Public Library.

By the turn of the century, the Museum was rapidly running out of space, and the directors were concerned about fire hazards and light depletion caused by tall neigh-

bors. In 1900, anxious to move to a less crowded neighborhood, the Museum bought twelve acres of land bordering the newly created Back Bay Fens designed by Frederick Law Olmsted. The museum's building committee then embarked upon a three-year study of museum architecture and planning around the world, visiting hundreds of European museums and compiling data from these museums and from their own staff in order to determine their needs. Under the architect, R. Clipston Sturgis, a basic plan was established, which in 1906 was developed into a grand building program by young architect Guy Lowell. The principle of the plan was a division of the museum's main floor into departments that could be visited in closed circuits, wherein would be exhibited only a small, select portion of the collections. The lower floor would be devoted to curatorial departments and study rooms available to the scholar, student, or anyone desiring more specialized knowledge. The first building campaign was completed and open to the public in 1909.

The architecture of the 1909 building, although then often described as plain and unadorned, is in fact monumental, and the focal point of the plan is a grand staircase and rotunda with murals by John Singer Sargent. The granite exterior features a quatrastyle Ionic portico on the *piano nobile,* topped by a pediment decorated with acroteria; this main entrance is recessed behind wings, which form a courtyard embracing Cyrus Dallin's *Appeal to the Great Spirit.* The museum quickly moved forward in its building program, constructing the Evans Wing in 1912–15 with a monumental Ionic colonnade facing the Fenway. Of all the grand Beaux-Arts programs conceived for museums of this period, Boston's museum probably comes the closest to realizing the architectural dreams of the era.

For a detailed architectural history of the Copley Square building, see Margaret Henderson Floyd, "A Terra-Cotta Cornerstone for Copley Square: Museum of Fine Arts, Boston, 1870–1876, by Sturgis and Brigham," *Journal of the Society of Architectural Historians* 32 (May 1973): 83–103. Neil Harris, "The Gilded Age Revisited: Boston and the Museum Movement." *American Quarterly* 14 (Winter 1962): 545–66, provides a look at the reasons behind the establishment of the museum. A complete history of the museum as an institution is contained in Walter Muir Whitehill, *Museum of Fine Arts, Boston: Centennial History,* 2 vols. (Cambridge: Belknap Press of Harvard University Press, 1970). The primary source of information on the construction of the 1909 museum building is *Communications to the Trustees Regarding the New Building,* 4 vols. (Boston: privately printed, 1904–6). The Museum of Fine Arts has well-organized and well-maintained archives, which contain the complete records of the building committee.

PHILADELPHIA MUSEUM OF ART, PHILADELPHIA, PENNSYLVANIA

Presiding over the Benjamin Franklin Parkway and Philadelphia like a queen on a throne—or, as its designers intended it to be, like the Acropolis over Athens—the Philadelphia Museum of Art is one of the most notable successes of the City Beautiful movement that inspired sweeping city plans and grand public buildings during the first decades of the twentieth century. Philadelphia's Art Association began its City Beautiful project when it hired a team of architects to create a plan for the proposed parkway. The group consisted of Paul Cret, Horace Trumbauer, and Clarence Zantzinger and his partners Charles Borie and Milton Medary. Construction of the parkway, a ceremonial boulevard cutting diagonally through the grid of the city, commenced in 1909; and in 1911, the firm of Zantzinger, Trumbauer, and Borie was appointed by the Fairmount Park Commission to design the new art museum that would be the crowning glory of the plan.

After taking up and abandoning several plans between 1911 and 1915, some very grand and classical and some more "modern" and restrained, the designers chose to capitalize on the museum's location on a prominent hill to recreate the aura of the Athenian Acropolis by erecting a congeries of temple forms on the hill. Because of the exigencies of displaying art in Philadelphia weather, the temple forms were connected by galleries, creating a court of honor surrounded by three large temple-front porticoes. The designers of the museum applied the most recent scholarship on ancient Greek architecture to its historicist framework. All of the building's lines were subtly altered to replicate the effects of entasis, including the upward swell of the building and the tilting of the columns toward each other. Museum officials proudly stated that there was not a single straight line in the building. Perhaps the most visible application of recent archaeological discoveries was the museum's startling polychromy. Some architectural features and all of the terra-cotta sculpture were painted in vivid primary colors, heightened by the butter yellow of the masonry. These bright colors provided a brilliant contrast to the determinedly monochrome museums of the preceding generation and, though applied to a historicist structure, brought museum architecture into the Art Deco style, which would eventually give way to modernism.

By the time that the museum first opened to the public in 1928, frequent delays, upward-spiraling costs, and diminishing public enchantment with City Beautiful goals had marred the original shining vision of the "Philadelphian Acropolis." There were, nevertheless, many who admired the completed building, and it was Fiske Kimball's directorship of the museum that led the institution into twentieth-century museum practice, particularly with its period room installations.

The primary work to be consulted about the Philadelphia Museum of Art is the 1989 book that accompanied an exhibition on Philadelphia's City Beautiful. David B. Brownlee, *Building the City Beautiful: The Benjamin Franklin Parkway and the Philadelphia Museum of Art* (Philadelphia: Philadelphia Museum of Art, 1989) presents a detailed look at the architectural, cultural, and political climate in Philadelphia that resulted in the creation of the parkway. The book also covers the architectural history of the museum and, more briefly, that of the various institutions—both putative and constructed—of the parkway.

RODIN MUSEUM, PHILADELPHIA, PENNSYLVANIA

The Rodin Museum is an integral part of one of the most comprehensively planned and successfully executed American City Beautiful plans next to the 1901 McMillan Plan for Washington, D.C. The plan for the Philadelphia Museum of Art and the Benjamin Franklin Parkway leading to it was conceived by a team of architects hired by the Philadelphia Art Association. The group consisted of Paul Cret, Horace Trumbauer, and Clarence Zantzinger and his partners Charles Borie and Milton Medary. The construction of the parkway commenced in 1909, but was not to be completed for many years. The design of the parkway, intended to fulfill the loftiest City Beautiful ambitions, combined a grand, diagonally running boulevard with a formally designed linear park. The setting was an ideal one for the creation of a center of culture and learning in Philadelphia, the culmination of which was to be the Philadelphia Museum of Art, which would also include the Franklin Institute, the Free Library, and the Academy of Natural Sciences, among others.

The Rodin Museum took its place among these eminent institutions in 1926 when wealthy Philadelphian Jules Mastbaum, a collector of the sculptor's work, offered to build a museum to house his collection, to be built on the parkway at his own expense.

Mastbaum originally commissioned Jacques Gréber, who specialized in landscape architecture, to design the proposed museum; Gréber subsequently asked architect and fellow native Frenchman Paul Cret to collaborate on the project with him. The resulting museum, opened to the public in 1929, included a faithful reproduction of the facade of the Château d'Issy at Meudon, whose fragments Rodin had collected and reassembled at his own studio. Visitors passed through this gate to arrive at the small, but elegant, building by Cret. Though Gréber and Cret both harbored modernist bents, they tempered their modernism with a Beaux-Arts classicism more palatable to conservative Philadelphians and more in harmony with the general tone of the parkway as well. The formal reflecting pool in front of the main facade enhances the classical effect and harks back to the same device employed on the Washington Mall. Whereas the crisp planarity of the building is suggestive of modernist ideals, the overall effect is emphatically formal and classical.

The structure presents the appearance of a simple block whose most prominent feature is the recessed entrance porch, screened only by two massive, simplified Doric columns. The entrance motif is flanked by smooth ashlar masonry, ornamented with applied pilasters and aediculed sculpture niches. A restrained cornice supports a balustraded parapet, which is interrupted by an almost signlike inscribed projection over the entrance announcing the building to be the "Rodin Museum." The museum, though minuscule by the standards of such museums as the neighboring Philadelphia Museum of Art, is a small gem and indicative of a trend during the first decades of the twentieth century toward smaller, more specialized museums.

The most recent and informative work on the Rodin Museum and its location on the Benjamin Franklin Parkway is David B. Brownlee, *Building the City Beautiful: The Benjamin Franklin Parkway and the Philadelphia Museum of Art* (Philadelphia, Penn.: Philadelphia Museum of Art, 1989). For additional information on Cret, see Elizabeth Grossman, "Paul Philippe Cret" (Ph.D. diss., Brown University, 1980).

SAINT LOUIS ART MUSEUM, SAINT LOUIS, MISSOURI

Like several other major American art museums whose homes are now in a classical "palace of art," the Saint Louis Art Museum's first home was built during a period of architectural eclecticism. Erected between 1879 and 1881, the first St. Louis Museum of Fine Arts was designed by the Boston firm of Peabody and Stearns in a Richardsonian Romanesque style that was shortly to be supplanted by classicism. This first museum was small, its exterior presenting a simple rectangular block whose main feature was the triple-arched entrance to the building. As with nearly every Romanesque art museum built in the United States during the 1870s and 1880s, the St. Louis Museum's first building soon proved too small; it was also located in an increasingly industrialized area. By 1900, the museum's need for a new home and the selection of St. Louis as the venue for the 1904 Louisiana Purchase Exposition combined to produce a building for the museum that would serve as the Art Palace during the Exposition and as the new home for the museum thereafter.

Still lingering in the long shadows cast by the 1893 World's Columbian Exposition in Chicago, the Exposition architects and officials decided to create a fair that would emulate the White City in style but surpass it in scale and grandeur. The architects, including Van Brunt and Howe, Carrère and Hastings, and architect of the museum Cass Gilbert, were all practiced in the classical idiom. Construction of the impermanent fair buildings as well as of the permanent museum structure began in 1901; the Exposition opened in 1904. The focal point of the fair's fan-shaped layout was Gilbert's Festival

Hall, an enormous and flamboyantly Baroque domed structure that actually obscured the far more restrained historicist art museum. The permanent art museum comprised only a portion of the fair's Fine Arts Building. It was flanked on both sides by temporary wings that more than trebled the exhibition space. The present museum's plan is anchored by a large sculpture hall which serves as its central axis. This hall is patterned after the Baths of Caracalla and provides the facade with a high gable end featuring a large Diocletian window. A hexastyle Corinthian column screen dignifies the entrance. The sides of the building flanking the entrance are subordinate to the main hall and very simply decorated with a band of small, square clerestory windows similar to those at the Corcoran and a simple cornice. In keeping with the examples set by the Brooklyn Institute of Arts and Sciences building, for example, the exterior of the St. Louis museum was enriched with sculpture representing the great artists of ancient, Renaissance, and even modern art history: from Phidias and Ictinus to Leonardo da Vinci, Michelangelo, and Richard Morris Hunt. By 1909, the museum was open full-time to the public, and the City Art Museum had been created by a municipal ordinance.

An excellent architectural history of the museum is provided by Osmund Overby, "The Saint Louis Art Museum: An Architectural History," *Saint Louis Art Museum Bulletin*, n.s., 18 (Fall 1987): 2–37. For a much more detailed history of the involvement of Cass Gilbert in the art museum in particular and the fair architecture in general, see Sharon Lee Irish, "Cass Gilbert's Career in New York, 1899–1905" (Ph.D. diss., Northwestern University, 1985). The entry on the Louisiana Purchase Exposition in John E. Findling, ed. and Kimberly D. Pelle, assistant ed., *Historical Dictionary of World's Fairs and Expositions, 1851–1988* (New York: Greenwood Press, 1990), gives a brief history of the Exposition and provides a bibliography on the subject.

TOLEDO MUSEUM OF ART, TOLEDO, OHIO

Founded in 1901 through the auspices of the Toledo Tile Club, the Toledo Museum of Art spent its first decade of existence in converted private residences, before beginning construction of its permanent museum building in 1909. Made possible by the tandem donations of land and funds by Edward Libbey of Toledo's Libbey Glass Plant, the Toledo Museum of Art was designed by Edward B. Green of the Buffalo firm of Green and Wicks. The style of the museum followed the Hellenistic lead of Green's first building for art, the Albright Art Gallery in Buffalo. Opened to an admiring public in 1912, the original portion of the Toledo museum took the form of a simple rectangle subdivided not by axial hallways but by galleries leading from one to the other through connecting doors. Although not allowing visitors a convenient way of bypassing galleries they do not wish to see, the arrangement permits a highly compact, efficient use of space. The central axis of the building featured a sculpture court with column screens on every side, behind which was a small hemicycle lecture hall also decorated with a colonnade along its perimeter. Like many other multifunctional museum plans conceived during this period, the plan also incorporated a library and would later include a music hall. The exterior, constructed of serendipitously-obtained marble, boasts a sixteen-member Ionic colonnade supporting a simple entablature and a gently pitched roof. Like his design at Buffalo, Green's plan for the Toledo museum included a beautiful use of landscape design, which incorporated oak trees and rows of small evergreens, a reflecting pool at the front entrance, and a flight of steps interrupted by a formally planted terrace.

As was intended by the architect, the 1912 portion of the museum was ideally suited for additions, and the structure was expanded to either side with funds again donated

by Libbey in 1929. The two side wings, constructed between 1930 and 1933, expanded not only the space of the building but the mission of the institution. One wing housed a 1500-seat auditorium for musical concerts, the other, the educational branches of the museum, notably the school of design. Despite the late date and modern construction methods of the additions (the auditorium is supported by a steel skeleton), their style remained true to the original heart of the building, and the transition between the two is seamless. Even the marble was again cheaply obtained because of Depression era low prices.

The auditorium, intended to resemble an open-air amphitheater, is a particularly notable feature of the completed Toledo Museum of Art. Semicircular in shape, its interior perimeter is embellished with an Ionic colonnade, above which is a plaster shell that, with special lighting effects, reproduces dawn, dusk, and nighttime outdoors. The lobby further enhances the effect with pantiled porches protruding into the space and a second floor gallery with painted figures in Greek dress looking down upon entering visitors.

No single modern architectural history has been written for the Toledo Museum of Art, although there is a wealth of material on the construction of the building in contemporary articles published by the museum in its bulletin. See especially "The New Building," *Toledo Museum of Art News* 2 (January 1909): 90–91; "A Brief History," *Toledo Museum of Art News* 19 (March 1912): 221–25; and "The Completed Museum Building," *Toledo Museum of Art News* 64 (January 1933): 845–70. The museum's library also has a valuable newspaper clipping scrapbook, which covers both local and national coverage of the museum from its beginning through its various stages of construction.

Notes

Introduction: The Museum Age

1. The most complete listing of museum buildings in the United States remains Laurence Vail Coleman, *The Museum in America: A Critical Study*, vol. 3 (Washington, D.C.: American Association of Museums, 1939), appendix Y. The development of the museum building in America as architecture, from its beginnings to its recent developments, is covered by Helen Searing, *New American Art Museums* (New York: Whitney Museum of American Art, 1982). Less recent but nevertheless informative is Jay Cantor, "Temples of the Arts: Museum Architecture in Nineteenth-Century America," *Metropolitan Museum of Art Bulletin* 28 (April 1970): 331–54. For a more general historical view of museums, see Nathaniel Burt, *Palaces for the People: A Social History of the American Art Museum* (Boston: Little, Brown and Co., 1977).

2. Large fortunes, of course, had also been made earlier in the century, but their impact on urban society increased as the century progressed. For the development of the American city, see David R. Goldfield and Blaine A. Brownell, *Urban America: A History* (Boston: Houghton Mifflin Co., 1990); and Charles N. Glaab and A. Theodore Brown, *A History of Urban America* (London: Macmillan Co., 1967).

3. H. Wayne Morgan, *Unity and Culture: The United States, 1877–1900* (Baltimore: Penguin Books, 1971), 84. Morgan's book is a brief, general, but informative account of the culture, politics, and society of the era.

4. Morgan, *Unity and Culture*, 84.

5. Quoted in Winifred E. Howe, *A History of the Metropolitan Museum of Art*, (New York: Metropolitan Museum of Art, 1913) 1:107.

6. Quoted in Howe, *History of the Metropolitan Museum*, 1:112–13.

7. Quoted in Howe, *History of the Metropolitan Museum*, 1:111.

8. For the history of the museum as an architectural genre, see Nikolaus Pevsner, "Museums," *A History of Building Types* (Princeton: Princeton University Press, 1976), 111–38.

Chapter 1. Establishing a Style: Boston, New York, and Chicago

1. For the sake of consistency, I shall refer to the Museum as the South Kensington, as it was called by the people who are quoted in this study. The Museum came to be known as the Victoria and Albert in 1899.

2. The source used here for the basic information on the South Kensington (Victoria and Albert) Museum is John Physick, *The Victoria and Albert Museum: The History of Its Building* (Oxford: Phaidon-Christie's Ltd., 1982).

3. The standard histories for these two institutions are Winifred E. Howe, *A History of the Metropolitan Museum of Art*, 2 vols. (New York, 1913 and 1946); and Walter Muir Whitehill, *Museum of Fine Arts, Boston: A Centennial History*, 2 vols. (Cambridge: Belknap Press of Harvard University Press, 1970). For the social and cultural atmosphere that led to the founding of the Museum of Fine Arts, Boston, see Neil Harris, "The Gilded Age Revisited: Boston and the Museum Movement," *American Quarterly* 14 (Winter 1962): 545–66.

4. Margaret Henderson Floyd, "A Terra-Cotta Cornerstone for Copley Square: Museum of Fine Arts, Boston, 1870–1876, by Sturgis and Brigham," *Journal of the Society of Architectural Historians* 32 (May 1973): 84.

5. Floyd, "Terra-Cotta Cornerstone," 83. Martin Brimmer, one of the Boston museum's founders, referred to the projected museum as "a South Kensington Museum to be established here on a scale proportioned to the modest capacities of the place."

6. Floyd, "Terra-Cotta Cornerstone," 95. See also Kristine Otteson Garrigan, *Ruskin on Architecture: His Thought and Influence* (Madison, Wisc.: University of Wisconsin Press, 1973).

7. Floyd, "Terra-cotta Cornerstone," 99. See also Eve Blau, *Ruskinian Gothic: The Architecture of Deane and Woodward, 1845–1861* (Princeton: Princeton University Press, 1982).

8. Floyd, "Terra-cotta Cornerstone," 101–2, theorizes, on the basis of a rough sketch published in her article, that Sturgis originally came up with a more classically inspired design, but the Museum Committee decided instead that Gothic would be more to their liking.

9. "The Museum Building," *American Architect and Building News* 8 (30 October 1880): 206.

10. Frederick Law Olmsted, Sr., *Forty Years of Landscape Architecture: Central Park*, ed. Frederick Law Olmsted, Jr. and Theodora Kimball (Cambridge, Mass.: MIT Press, 1973), 472.

11. Several sites were considered before the present location was settled upon. Originally, the museum was to share a site with the natural history museum. When this situation no longer seemed feasible, the museum asked the parks department to reserve Reservoir Square (now the location of the New York Public Library and Bryant Park). Finally, realizing that even this site might be limiting in the future, the executive committee of the museum and the park commissioners settled on what was called Deer Park, the museum's present location. See Howe, *History of the Metropolitan Museum*, 1:150–53; and Metropolitan Museum of Art, *Annual Report of the Trustees of the Association, from 1871 to 1902*, Second *Annual Report* (1872).

12. According to the chronology of Olmsted, *Forty Years of Landscape Architecture: Central Park*, Olmsted and Vaux were appointed to the newly organized Board of the Department of Public Parks in May of 1870, resigned in November of the same year, and were reappointed in November of 1871. From May to October 1872, Olmsted was President of the Department, in the absence of Commissioner Stebbins.

13. For a thorough discussion of the building history of the Metropolitan Museum from the beginning until the erection of Richard Morris Hunt's Fifth Avenue facade, especially the complicated machinations that resulted in a long succession of architects, see Morrison H. Heckscher, "The Metropolitan Museum of Art: An Architectural History" reprinted from *The Metropolitan Museum of Art Bulletin* (Summer 1995); see also his "Hunt and the Metropolitan Museum of Art," in *The Architecture of Richard Morris Hunt*, ed. Susan R. Stein (Chicago: University of Chicago Press, 1986), 172–85. See also Paul R. Baker, *Richard Morris Hunt* (Cambridge: MIT Press, 1980), 441–49.

14. Heckscher, "The Metropolitan Museum of Art," 11.

15. On the incidental architecture of Central Park, see Henry Hope Reed and Sophia Duckworth, *Central Park: A History and a Guide* (New York: Clarkson B. Potter, Inc., 1967).

16. Jay Cantor, "Temples of the Arts: Museum Architecture in Nineteenth-Century America," *Metropolitan Museum of Art Bulletin* 28 (April 1970): 332.

17. For a brief history of the original Art Institute building (with photographs of the interior), see John Zukowsky, "Centennial Remembrances: The Early Art Institute Buildings," *Bulletin of the Art Institute of Chicago* 73 (January-February 1979): 2–4.

18. On the partnership of Burnham and Root, see Thomas S. Hines, *Burnham of Chicago: Architect and Planner* (New York: Oxford University Press, 1974).

19. Quoted in Hines, *Burnham of Chicago*, 39.

20. "The Art Institute, Its Work, Its Equipment and Its Building," *American Architect and Building News* 23 (January 1888): 30.

21. "The Art Institute, Its Work," 30.

22. Whether or not the World's Columbian Exposition in Chicago really did have a great effect on American architecture and city planning has been the subject of much debate. See, for example, Dimitri Tselos, "The Chicago Fair and the Myth of the 'Lost Cause,'" *Journal of the Society of Architectural Historians* 26 (December 1967): 259–68, which suggests that the turn to the classical style was more or less inevitable, despite the assertions of many that the architecture of the fair represented a "lost cause" for the rationalism of Richardson, Root, and Sullivan. I would suggest that much of the fair architecture's importance lies in its being credited as an impetus for change by contemporary architects and critics. If Louis Sullivan hated it so much (see chapter 2, n. 44), it must have created a big impression. See also chapter 3, n. 54.

23. Art Institute of Chicago, *Annual Report of the Trustees, 1891* (Chicago: Knight, Leonard & Co., Printers, 1891), 7–8.

24. On the Chicago cultural philanthropists who founded and supported such institutions as the Art Institute, see Helen Lefkowitz Horowitz, *Culture and the City: Cultural Philanthropy in Chicago from the 1880s to 1917* (Chicago: University of Chicago Press, 1976).

25. As quoted in Linda S. Phipps, "The 1893 Art Institute Building and the 'Paris of America': Aspirations of Patrons and Architects in Late Nineteenth-Century Chicago," *Art Institute of Chicago Museum Studies* 14, no. 1 (1988): 30. This essay is an excellent account of the building history of the original 1893 Art Institute Building; the rest of the issue deals with the history of the Institute's expansion, ending with the 1988 Rice Building. See also John Zukowsky, "The Art Institute of Chicago: Constructions, Concepts, and Queries," *Threshold* 3 (Autumn 1985): 60–74.

26. For which see Phipps, "The 1893 Building."

27. The only surviving copy of Root's design is illustrated in Harriet Monroe, *John Wellborn Root: A Study of His Life and Work* (Park Forest, Ill.: Prairie School Press, 1896).

28. Art Institute of Chicago, Trustees' Minutes, 17 October 1891, Archives, Art Institute of Chicago.

29. Information obtained from Henry F. Withey and Elsie Rathburn, *Biographical Dictionary of American Architects (Deceased)* (Los Angeles: New Age Publishing Co., 1956). Shepley married Richardson's daughter, Julia, in 1886. The firm's first major commission was the first group of buildings for Leland Stanford Junior University at Palo Alto, California (1890).

30. For a thorough examination and documentation of the development of the design, see Phipps, "The 1893 Building."

31. It should be noted that John Root used a similar device on his Art Institute building with varying degrees of success. He, too, used portions of the Parthenon frieze but on the interior of his building. He also incorporated relief carvings of famous artists on the exterior of the building and topped off the peak of the front gable with a torso of an unidentified artist. The *American Architect and Building News* critic, who otherwise admired the building (see n. 19), called the carvings "simply atrocious" and wrote that "plain stone would have exemplified better the old saying about beauty unadorned."

32. On the use of the inscriptions on Labrouste's building, see Neil Levine, "The Book and the Building: Hugo's Theory of Architecture and Labrouste's Bibliothèque Ste.-Geneviève," in *The Beaux-Arts and Nineteenth-Century French Architecture,* ed. Robin Middleton (London: Thames & Hudson, 1982), 139–73.

33. Phipps, "The 1893 Building," 43.

34. Russell Sturgis, "A Critique of the Works of Shepley, Rutan & Coolidge and Peabody & Stearns," *Architectural Record: Great American Architects Series* 3 (July 1896): 26–29.

35. *Inter Ocean,* 9 December 1893.

36. "Home for Fine Art," unidentified newspaper clipping, ca. 1892, from Art Institute of Chicago Newspaper Clipping Scrapbooks, Ryerson and Burnham Libraries, Art Institute of Chicago.

37. *The Interior,* 4 February 1892, from Art Institute of Chicago Newspaper Clipping Scrapbooks.

38. *The Interior,* 4 February 1892.

39. *Sunday Herald,* Chicago, 19 November 1893, from "Miscellaneous Newspaper Clippings, Art Institute of Chicago" folder, Chicago Historical Society.

40. *The Graphics,* 26 March 1892, from "Miscellaneous Newspaper Clippings, Art Institute of Chicago" folder, Chicago Historical Society.

41. The use of "Porkopolis," a term referring to Chicago's position as—in Carl Sandburg's famous words ("Chicago," 1916)—"Hog Butcher for the World," has been traced back to 1869 by Mitford M. Mathews, ed., *A Dictionary of Americanisms* (Chicago: University of Chicago Press, 1951). Reid Badger, *The Great American Fair: The World's Columbian Exposition and American Culture* (Chicago: Nelson Hall, 1979), quotes a British visitor to Chicago during the World's Columbian Exposition, who asserts, "Since 1893 Chicago ought never to be mentioned as Porkopolis without a simultaneous reference to the fact that it was also the creator of the White City, with its Court of Honor" (pp. 114–15).

42. *Springfield Republican,* 16 February 1896, from Art Institute of Chicago Newspaper Clipping Scrapbooks.

43. Unidentified newspaper clipping, ca. 1891, from Art Institute of Chicago Newspaper Clipping Scrapbooks.

44. Art Institute of Chicago, *Annual Report of the Trustees, 1891,* 16–20. The Exposition Directory also mentioned that the Institute's location at the heart of the city would be more convenient for the World's Congresses than the actual fair site.

45. The Exposition company downgraded its contribution to $200,000 after the building could no longer serve as Art Palace on the Exposition grounds.

46. Art Institute of Chicago, *Annual Report of the Trustees, 1891,* 20.

47. See "The World's Congresses" in Badger, *Great American Fair,* 95–102.

48. *Springfield Republican,* 16 February 1896, with the reading "vast human race" uncertain, partially obscured by microfilm copy.

49. *Inter Ocean,* 9 December 1893.

50. Art Institute of Chicago, *Annual Report of the Trustees, 1892,* 10.

51. *Brickbuilder* 4 (July 1895): 156–57.

52. Metropolitan Museum of Art, Ninth *Annual Report* (1879).

53. Metropolitan Museum of Art, Tenth *Annual Report* (1880).

54. "The New Metropolitan Museum of Art," *Architectural Record* 12 (August 1902): 305.

55. Louis H. Gibson, "American Art Galleries," *Indianapolis News,* ca. 1897, from Corcoran Gallery Newspaper Clipping Scrapbooks, Corcoran Gallery and School of Art Archives, Washington, D.C.

56. On this and Hunt's other honors, see Baker, *Richard Morris Hunt,* 433–35.

57. Richard Morris Hunt to John Taylor Johnston, 10 July 1884, as quoted in Heckscher, "Hunt and the Metropolitan Museum," 176.

58. Hunt designed Marquand's New York mansion in 1881; see Baker, *Richard Morris Hunt,* 293–95.

59. Henry Van Brunt, *Richard Morris Hunt, A Memorial Address* (Washington, D.C.: American Institute of Architects, 1896), 10. Although the remark was made in reference to the early years of the A.I.A., it is relevant to the situation at the Metropolitan where Hunt had a chance to right the wrongs of that earlier era.

60. See Richard Chafee, "Hunt in Paris," in *Architecture of Richard Morris Hunt,* 34–36.

61. In order as mentioned, see sketches 80.6105 (illustrated), 80.6106 (illustrated) and 80.6107-.6108.a

(illustrated in Heckscher, "The Metropolitan Museum of Art") from the Hunt Collection, Drawings and Prints Collection, American Architectural Foundation, Washington, D.C.

62. "New Metropolitan Museum of Art," 306.

63. A. D. F. Hamlin and F. S. Lamb, "The New York Architectural League Exhibition," *Architectural Review*, n.s., 1 (March 1899): 39.

64. Metropolitan Museum of Art, Thirty-third *Annual Report* (1902).

65. "Dedicate To-Day New Hall of Art," *New York Herald*, 12 December 1902.

66. "Art Museum Opens To-Day," *The [New York] World*, 22 December 1902.

67. Metropolitan Museum of Art, Second *Annual Report* (1872).

68. Howe, *History of the Metropolitan Museum*, 1:125.

69. Howe, *History of the Metropolitan Museum*, 1:113.

70. Metropolitan Museum of Art, Seventh *Annual Report* (1877).

71. William Morris, "Art under Plutocracy" (1883), as quoted in Mark Swenarton, *Artisans and Architects: The Ruskinian Tradition in Architectural Thought* (London: Macmillan, 1989), 72.

72. Metropolitan Museum of Art, Eleventh *Annual Report* (1881).

73. Metropolitan Museum of Art, Fifteenth *Annual Report* (1885).

74. Metropolitan Museum of Art, Nineteenth *Annual Report* (1889).

75. Metropolitan Museum of Art, Twentieth *Annual Report* (1893).

76. "Go forth again to gaze upon the old cathedral front, ... examine once more those ugly goblins, and formless monsters, and stern statues, anatomiless and rigid; but do not mock at them, for they are signs of the life and liberty of every workman who struck the stone; a freedom of thought, and rank in scale of being." John Ruskin, *Stones of Venice* (1853), as quoted in Swenarton, *Artisans and Architects*, 27.

77. On the cultural phenomenon of the American Renaissance, see Brooklyn Museum, *The American Renaissance, 1876–1917* (New York: Brooklyn Museum, 1979).

78. Metropolitan Museum of Art, Twenty-ninth *Annual Report* (1899).

79. Quoted in "Mayor Low Opens New Hall of Art," *New York Herald*, 23 December 1902.

80. Trustees of the Museum of Fine Arts, *Twenty-Fourth Annual Report, for the Year Ending December 31, 1899* (Boston: Alfred Mudge & Son, Printers, 1900), 7–8.

81. Trustees of the Museum of Fine Arts, *Twenty-Sixth Annual Report, 1901*, 7. See also legal notice, "Restrictions for Park Frontages, from the Fens to Franklin Park," which prohibits commercial buildings and even residential buildings of less than a certain value from being built adjacent to park lands; this law also provides for setbacks of twenty-five feet and a height restriction of seventy feet.

82. Mary B. Hartt, "The New Museum," *Boston Weekly Review*, 13 March 1909, from Museum of Fine Arts Newspaper Clipping Scrapbooks, MSC AC2, Archives, Museum of Fine Arts, Boston.

83. Benjamin Ives Gilman, "The Monument and the Shelter," *Communications to the Trustees Regarding the New Building*, 1 (Boston: Museum of Fine Arts, 1904), 38–39.

84. "G" [Benjamin Ives Gilman?], "The Copley Square Museum," *Museum of Fine Arts Bulletin* 7 (April 1909): 14.

85. "Copley Square Museum," 14.

86. *The Boston Herald*, 23 June 1907, from Museum of Fine Arts Newspaper Clipping Scrapbooks. It is unclear to which Hunt the article refers; it was probably Richard Morris, but possibly his brother William Morris, who lived in Boston.

87. Frederick W. Coburn, "The New Art Museum at Boston," *International Studio* 33 (December 1907): 60.

88. Frank Jewett Mather, "An Art Museum for the People," *Atlantic Monthly* 100 (December 1907): 731.

89. Gilman, "The Monument and the Shelter," 40.

90. Benjamin Ives Gilman, "On the Distinctive Purpose of Museums of Art," *Communications to the Trustees Regarding the New Building*, vol. 1 (Boston, Museum of Fine Arts, March 1904), 42–53.

91. Gilman, "On the Distinctive Purposes of Museums of Art," 51.

92. R. Clipston Sturgis, *Report on Plans Presented to the Building Committee* (Boston: Museum of Fine Arts, 1905).

93. Sturgis, *Report on Plans*, 71.

94. Samuel D. Warren, "Memorandum to the Building Committee of the Museum of Fine Arts," 22 September 1902, BAG AC1 1/3, folder 2: Architect's Competition, 1895–1906, Archives, Museum of Fine Arts, Boston.

95. Guy Lowell, "Design for an Art Museum and Reading Room in a Small Town," (Undergraduate Thesis, M.I.T., May 1894) copy in Archives, Museum of Fine Arts, Boston.

96. Samuel D. Warren to Guy Lowell, 26 January 1906, BAG AC1 2/3, folder 49: Lowell, Guy, 1906–1907, Archives, Museum of Fine Arts, Boston.

97. R. Clipston Sturgis to Guy Lowell, 23 December 1905, BAG AC 1 1/3, folder 2: Architect's Competition, 1895–1906, Archives, Museum of Fine Arts, Boston: "I vigorously opposed your appointment, honestly thinking from what had been submitted ... that you were not the best man for the place."

98. Samuel D. Warren, "The Plans," *Museum of Fine Arts Bulletin: The New Museum* 4 (June 1907): 27–30. Warren sums up the scientific approach:

The experience of thirty years was reviewed, the literature dealing with museums investigated, the counsel of authorities sought, buildings at home and abroad visited, experiments instituted in the present Museum and in a temporary structure on the newly-acquired site, and the resulting data put into printed form for the information of the Trustees, and utilized in a long series of studies for the proposed building. In January, 1906, after more than three years of earnest and self-sacrificing coöperation by many minds, the scheme was decided upon which is carried out in the plans adopted by the Trustees last July, and now presented to the public [p. 28].

99. Lowell discusses the plan of the building using the word *parti* in his article, "The Museum of Fine Arts, Boston," *American Architect* 109 (29 March 1916): 201. For a review of Lowell's career up to the point of his hiring as architect for the Museum of Fine Arts, see Benjamin F. W. Russell, "The Works of Guy Lowell," *Architectural Review* 13 (February 1906): 13–40.

100. For the Sargent murals, see C. H. Blackall, "The Sargent Decorations in the Boston Museum of Fine Arts," *American Architect* 121 (29 March 1922): 240–44; and the *Museum of Fine Arts Bulletin* 19 (December 1921): 66–71, and 23 (December 1925): 66–70.

101. Guy Lowell to Benjamin Ives Gilman, 12 July 1907, BAG AC1 2/3, folder 49: Lowell, Guy, 1906–07, Archives, Museum of Fine Arts, Boston. The office records of Lowell do not survive, so such small leads are the only available clues to Lowell's design process. The books Lowell requested in his letter are Luigi Canina, *L'Architettura antica descritta e dimostrata coi monumenti* (Rome, 1845); and Friedrich Adler and Ernst Curtius, *Olympia: Die Ergebnisse der von dem Deutschen Reich veranstalteten Ausgrabung* (Berlin, 1897). Canina's work has no illustrations and covers Egyptian, Greek, and Roman architecture. Adler and Curtius's volume has engravings mainly of maps and the site. In any case, the Museum of Fine Arts is certainly not based on the Temple of Zeus at Olympia.

102. J. Randolph Coolidge, Jr., "The Architectural Scheme," *Museum of Fine Arts Bulletin: The New Museum* 4 (June 1907): 41.

103. Coolidge, "Architectural Scheme," 41.

104. "Boston's New Museum of Fine Arts," *Architectural Record* 27 (January 1910): 124.

105. *Boston Globe,* 9 November 1909, from Museum of Fine Arts Newspaper Clipping Scrapbooks.

106. *Boston American,* 31 October 1909, from Museum of Fine Arts Newspaper Clipping Scrapbooks.

107. *Christian Science Monitor,* 1 February 1913, from Museum of Fine Arts Newspaper Clipping Scrapbooks.

108. "The Best Group of Buildings in the United States," *The [Boston] Sunday Herald,* 16 August 1908, from Museum of Fine Arts Newspaper Clipping Scrapbooks.

109. Philip L. Hale, "The Boston Art Museum," *Scribner's Magazine* 47 (February 1910): 256.

110. *Boston Evening Transcript,* 15 June 1907, from Museum of Fine Arts Newspaper Clipping Scrapbooks.

111. *Boston Evening Transcript,* 4 May 1912, from Museum of Fine Arts Newspaper Clipping Scrapbooks.

112. *Boston Evening Transcript,* 4 May 1912.

113. Julia de Wolf Addison, *The Boston Museum of Fine Arts* (Boston: L. C. Page & Company, 1924): vii–viii.

Chapter 2. The Art Museum as Fair Spectacle

1. For a complete listing, with bibliographies, of important fairs both in the United States and around the world, see John E. Findling, ed., and Kimberly D. Pelle, asst. ed., *Historical Dictionary of World's Fairs and Expositions, 1851–1988* (New York: Greenwood Press, 1990).

2. There are many sources on the 1851 Exposition and the Crystal Palace. See, e.g., Anthony Bird, *Paxton's Palace* (London: Cassell and Company, 1976); Patrick Beaver, *The Crystal Palace, 1851–1936: A Portrait of Victorian Enterprise* (London: Hugh Evelyn, 1970); or "'This Cristial Exhibition,'" in John Allwood, *The Great Exhibitions* (London: Studio Vista, 1977). Another useful source is the Dover edition of the reprinted illustrated catalogue of the exposition: *The Crystal Palace Exhibition Illustrated Catalogue, London 1851: An Unabridged Republication of The Art-Journal Special Issue* (New York: Dover Publications, 1970).

3. Allwood, *Great Exhibitions,* 9.

4. Quoted in Allwood, *Great Exhibitions,* 13.

5. Allwood, *Great Exhibitions,* 22.

6. Allwood, *Great Exhibitions,* 14.

7. For illustrations of the sculpture at the Exposition, see *The Crystal Palace Exhibition Illustrated Catalogue;* and Beaver, "The Art," in *Crystal Palace,* 57–61.

8. See Findling, ed., *Historical Dictionary of World's Fairs,* 12–15, which includes an extensive bibliography on the subject.

9. For an excellent account of the Centennial Exposition, see Robert C. Post, ed., *1876: A Centennial Exhibition* (Washington, D.C.: National Museum of History and Technology, Smithsonian Institution, 1976).

10. Richard Morris Hunt's Lenox Library in New York City (1869–77) predates Memorial Hall, and Hunt actually attended the Ecole des Beaux-Arts; nevertheless, Memorial Hall is an early, important example of the Beaux-Arts influence in the United States.

11. Vaux and Radford's design was not premiated because it did not follow the competition's specification. John Maass, *The Glorious Enterprise: The Centennial Exhibition of 1876 and H. J. Schwarzmann, Architect-in-Chief* (Watkins Glen, N.Y.: American Life Foundation, 1973), 32.

12. See Schwarzmann's official description of the building in Maass, *Glorious Enterprise*, 44.

13. As Maass, *Glorious Enterprise*, 45, n. 2, points out, Independence Hall has arcades, but they are of brick and have an entirely different, more domestic feeling in style and scale.

14. Maass, *Glorious Enterprise*, 50.

15. This feature was probably appropriated by Schwarzmann from the winning design for the 1867 Prix de Rome project by Emile Bénard, which incorporated a ferrovitreous dome over the central crossing. It was Bénard's plan that would eventually serve as the inspiration (though much less slavishly copied) for Charles Atwood's Fine Arts building at the World's Columbian Exposition in 1893.

16. Post, ed., *1876: A Centennial Exhibition*, 15.

17. Hubert Howe Bancroft, *The Book of the Fair* (Chicago, 1894), 665; for more of the perceived effects of the Philadelphia fair, see Alfred T. Geshorn, "Effects of the Centennial Exhibition," *Engineering Magazine* 6 (January 1894): 423–29. Geshorn was the Director General of the Centennial Exposition.

18. See "The Cincinnati Museum, Mr. James W. McLaughlin, Architect," *American Architect and Building News* 19 (9 January 1886): 18; and Jay Cantor, "Temples of the Arts: Museum Architecture in Nineteenth-Century America," *Metropolitan Museum of Art Bulletin* 28 (April 1970): 348–49.

19. The two most complete histories of the fair are David F. Burg, *Chicago's White City of 1893* (Lexington, Ky.: University Press of Kentucky, 1976); and Reid Badger, *The Great American Fair: The World's Columbian Exposition and American Culture* (Chicago: Nelson Hall, 1979). See also the bibliography in Findling, ed., *Historical Dictionary of World's Fairs*.

20. Quoted in Badger, *Great American Fair*, 48.

21. "Arguing for the Fair," *New York Herald*, 12 January 1890.

22. "Arguing for the Fair."

23. "Arguing for the Fair."

24. "Arguing for the Fair."

25. Art Institute of Chicago, *Annual Report of the Trustees, 1891* (Chicago: Knight, Leonard & Co., Printers, 1891), 14.

26. This information on Atwood is gleaned from the following sources: Daniel H. Burnham, "Charles Bowler Atwood," *Inland Architect and News Record* 26 (January 1896): 56–57; and various newspaper clippings from the period just after Atwood's death in the Daniel H. Burnham Scrapbooks, Daniel H. Burnham Collection, Ryerson and Burnham Libraries, Art Institute of Chicago.

27. Burnham, "Charles Bowler Atwood," 56.

28. "Notes taken at a meeting held in the Office of the Commercial Club, April 26, 1908," typescript interview of Daniel H. Burnham and Edward Bennett by Charles Moore, Daniel H. Burnham Collection. It seems that Moore was too much of a gentleman to mention Burnham's allegations of Atwood's drug use; no mention of it appears in any published work on Burnham.

29. Unidentified newspaper clipping, ca. December 1895, Daniel H. Burnham Scrapbooks.

30. For an illustration of the sketch for the main building for the fair, see Harriet Monroe, *John Wellborn Root: A Study of His Life and Work* (Park Forest, Ill.: Prairie School Press, 1896), 217; for the sketches of the incidental buildings, see p. 251.

31. No. 2 of two typed pages attached to "World's Columbian Exposition Chronology Report," box 58, folder 34, Daniel H. Burnham Collection (italics Burnham's own). Burnham goes on to say, "None of us in Chicago had even faintly imitated [Richardson], except, perhaps Henry Cobb."

32. For details of the competition, see Walter Muir Whitehill, *Boston Public Library: A Centennial History* (Cambridge: Harvard University Press, 1956), 138.

33. Atwood's design as well as the second-, third-and fourth-place entries were published in *American Architect and Building News* 17 (14 February 1885), Pl. 477.

34. See Titus Marion Karlowicz, "The Architecture of the World's Columbian Exposition," (Ph.D. diss., Northwestern University, 1965), 243, n. 179.

35. Daniel H. Burnham, "World's Columbian Exposition Chronology Report," box 58, folder 34, Daniel H. Burnham Collection.

36. For a full list of buildings designed by Atwood, see Karlowicz, "Architecture of the World's Columbian Exposition," 333–34.

37. Burnham, "World's Columbian Exposition Chronology Report."

38. Burnham, "Charles Bowler Atwood," 57.

39. There were boats providing transportation within the Court of Honor and the connecting lagoon on which the Fine Arts Palace was located.

40. "Denies the Charge," *Chicago Tribune*, 15 January 1893, from Daniel H. Burnham Scrapbooks.

41. "Denies the Charge."

42. "Finest in the World," *Chicago Times*, 15 March 1893, from folder "Printed Material: clippings re: World's Columbian, undated, ca. 1891–4," Charles M. Kurtz Papers, Archives of American Art, Smithsonian Institution.

43. Unidentified newspaper clipping, ca. 1896, from Daniel H. Burnham Scrapbooks.

44. The only other accusation comes from Louis Sullivan in his generally bitter diatribe on the classicists, *An Autobiography of an Idea*, where he calls the building's design "impudently thievish." Karlowicz, "Architecture of the World's Columbian Exposition," 178–84, notes this nasty remark and covers the incident of the plagiarism accusation thoroughly.

45. Charles Moore, *Daniel H. Burnham: Architect, Planner of Cities* (Boston: Houghton Mifflin Co., 1921), 48.

46. Burnham, "World's Columbian Exposition Chronology Report."

47. Burnham, "Charles Bowler Atwood," 56–57.

48. Henry Van Brunt, "Architecture at the World's Columbian Exposition," in *Architecture and Society: Selected Essays of Henry Van Brunt*, ed. William A. Coles (Cambridge: Belknap Press of Harvard University Press, 1969), 283.

49. "Finest in the World."

50. Bancroft, *Book of the Fair*, 668.

51. See *Official Catalogue of Exhibits, World's Columbian Exposition, Department K, Fine Arts* (Chicago: W. B. Gonkey, 1893), 51–57. Other designs for art museums included Longfellow, Alden, and Harlow's *Carnegie Library and Music Hall*, the earlier portion of which was still partly influenced by the Richardsonian Romanesque style; and Charles Z. Klauder's *An Art Museum*, an unexecuted project (style unknown).

52. Van Brunt, "Architecture at the World's Columbian Exposition," 233–34. Also see Henry Van Brunt, "The Architectural Event of Our Times," *Engineering Magazine* 6 (January 1894): 430–41.

53. Whether they liked it or not. See Badger, "The World's Congress," in *Great American Fair*, 95–102, on the World's Congresses and who needed to be educated the most.

54. Alice F. Palmer, "Some Lasting Results of the World's Fair," *Forum* 116 (December 1893): 521.

55. Daniel H. Burnham, quoting William M. R. French, director of the Art Institute of Chicago, "Uses of Expositions," Daniel H. Burnham Collection.

56. Quoted in Badger, *Great American Fair*, 97.

57. Bancroft, *Book of the Fair*, 667.

58. "To Place the Curios," *Chicago Daily Tribune*, 8 December 1893.

59. American Institute of Architects, Chicago Chapter, *A Challenge to Civic Pride: A Plea for the Preservation and Rehabilitation of the Fine Arts Building of the World's Columbian Exposition* (Chicago: American Institute of Architects, 1923), 5.

60. Andrew Carnegie, "Value of the World's Fair to the American People," *Engineering Magazine* 6 (January 1894): 417.

61. Carnegie, "Value of the World's Fair," 417.

62. See Findling, ed., *Historical Dictionary of World's Fairs*, 139–41.

63. For illustrations and a history of the fair, see Walter G. Cooper, *The Cotton States and International Exposition and the South, Illustrated* (Atlanta, Ga.: Illustrator Company, 1896).

64. Findling, ed., *Historical Dictionary of World's Fairs*, 146–49.

65. "The Parthenon," in *Official History of the Tennessee Centennial Exposition*, ed. Herman Justi (Nashville, Tenn.: Brandon Printing Company, 1898), 112.

66. Justi, ed., *Official History of the Tennessee Centennial Exposition*, 112.

67. John M. Carrère, "The Architectural Scheme," in *Pan-American Art Hand-Book: Sculpture, Architecture, Painting* (Buffalo, N.Y.: David Gray, 1901), 13.

68. Mrs. Schuyler [Marianna Griswold] Van Rensselaer, "From an Art Critic's Point of View," in *Pan-American Art Hand-Book*, 25–26.

69. Carrère, "Architectural Scheme," 13.

70. See C. Y. Turner, "The Color Scheme," in *Pan-American Art Hand-Book*, 20–22. Turner's idea was to start with brilliant primary colors on the building the farthest distance from the centerpiece of the plan, the Electricity Tower, and then the colors would become lighter and "more refined," until the Tower itself was predominately of ivory-white. The base colors of some of the main buildings were brilliant: orange, "golden orange," yellow, "red quite pure," "blue-green," blue and violet, with the "emerald-green" representing Niagara Falls as the keynote color. The effect must have been startling, especially to those used to the white marble buildings that had been influenced by and built since the Chicago fair.

71. Walter H. Page, "The Pan-American Exposition," *World's Work* 2 (August 1901): 1026.

72. Charles H. Caffin, "The Pan-American Exposition as a Work of Art," *World's Work* 2 (August 1901): 1050.

73. Buffalo Academy of Fine Arts, Board of Directors' Minutes, 15 January 1900, Archives, Albright-Knox Art Gallery, Buffalo, N.Y.

74. Buffalo Academy of Fine Arts, Board of Directors' Minutes, 15 January 1900. Actually, the Buffalo Fine Arts Academy officials had discussed the notion of building a permanent art gallery in connection with the exposition as early as February 1899, nearly a year before Albright made his offer. See "Art Gallery," *Buffalo Times*, 21 Febrary 1899.

75. *Illustrated Buffalo Express*, 16 December 1900.

76. "New Art Gallery," *Buffalo Commercial Advertiser*, 14 July 1900.

77. *Buffalo Courier*, 25 March 1900; quoted in Birge Albright, "John Joseph Albright—Part II," *Niagara Frontier* 9 (Winter 1962): 99.

78. See "Art Gallery," *Buffalo Commercial Advertiser*, 29 December 1900.

79. "Catalogue of Buildings," *Pan-American Art Handbook*, 44. The editor's note to the "Catalogue of Buildings" indicates that most of the descriptions were written by the architects who designed the buildings.

80. "Catalogue of Buildings," 41.

81. See *Report of the General Managers of the Exhibit of the State of New York at the Pan-American Exposition* (Albany, N.Y.: J. B. Lyon Company, 1902), 18–32.

82. *Report of the General Managers of the Exhibit of the State of New York at the Pan-American Exposition*, 26.

83. *Buffalo Commercial Advertiser*, 7 August 1901.

84. Albright, "John Joseph Albright," 98.

85. Buffalo Academy of Fine Arts, Board of Directors' Minutes, 15 January 1900.

86. Unidentified newspaper clipping, ca. January 1900, from Eugenie Hauenstein Scrapbooks, Archives, Albright-Knox Art Gallery. Another newspaper reported that Albright had gone with Green: "Mr. Albright has made a careful study of the question, as will be seen from the fact that he and the architect who will design the proposed structure have visited all the leading galleries in this country seeking information and ideas." From an unidentified newspaper clipping, John J. Albright Scrapbook, Library, Buffalo and Erie County Historical Society, Buffalo, N.Y.

87. Aside from Chicago, there were also the Brooklyn and Milwaukee museum buildings. Both were, however, strongly influenced by the architecture at the Chicago fair. Flagg's Corcoran was likely the influence for the Albright's sculpture hall.

88. "Art Museum Notes," *Academy Notes* 1 (December 1905): 128.

89. *Illustrated Buffalo Express*, 28 May 1905.

90. Cornelia Bentley Sage, "Buffalo as an Art Center: The Albright Art Gallery," *Art and Archaeology* 4 (September 1916): 143. In all fairness it should be noted that Sage was the director of the Albright Art Gallery at that time.

91. Charles Ward Rhodes to Charles M. Kurtz, 26 October 1904, Charles M. Kurtz Papers.

92. Robert W. Vonnoh to Charles M. Kurtz, 11 November 1904, Charles M. Kurtz Papers.

93. William J. Buchanan, *Report of the Director-General of the Pan-American Exposition* (Buffalo, 1902), 8.

94. "The Albright Art Gallery," unidentified newspaper clipping from John J. Albright Scrapbook.

95. Sage, "Buffalo as an Art Center," 143.

96. For a more detailed history of the circumstances surrounding both the original founding of the St. Louis Art Museum and its move to Forest Park (as well as the museum's restoration in the 1970s), see Osmund Overby, "The Saint Louis Art Museum: An Architectural History," *Saint Louis Art Museum Bulletin*, n.s., 18 (Fall 1987): 2–36.

97. Charles M. Kurtz, *Universal Exposition Commemorating the Acquisition of the Louisiana Territory, St. Louis, U.S.A., 1904: An Illustrated Handbook* (St. Louis: Gottschalk Printing Co., 1904), 29–30.

98. Frederick M. Mann, "Architecture at the Exposition," *American Architect and Building News* 85 (2 July 1904): 5.

99. Sharon Lee Irish, "Cass Gilbert's Career in New York, 1899–1905," (Ph.D. diss., Northwestern University, 1985), 330.

100. Irish, "Cass Gilbert's Career in New York," 378–79.

101. Irish, "Cass Gilbert's Career in New York," 380.

102. Montgomery Schuyler, "The Architecture of the St. Louis Fair," *Scribner's Magazine* 35 (April 1904): 390.

103. Folke Tyko Kihlstedt, "Formal and Structural Innovations in American Exposition Architecture: 1901–1939" (Ph.D. diss., Northwestern University, 1973), 44.

104. Schuyler, "Architecture of St. Louis Fair," 387.

105. Schuyler, "Architecture of St. Louis Fair," 387.

106. For the entire list see Overby, "Saint Louis Art Museum," 10.

107. For the details of the controversy between Gilbert and Ives, see Irish, "Cass Gilbert's Career in New York," 368–77.

108. Quoted in Irish, "Cass Gilbert's Career in New York," 383. The museum was built out of limestone rather than marble because of the cost.

109. For general background on the Panama-Pacific Exposition, see Findling, ed., *Historical Dictionary of World's Fairs*, 219–26.

110. For a contemporary description of the fair's architecture, see Louis Christian Mullgardt, "Architecture of the Panama-Pacific International Exposition," in *Art in California* (1916; reprint, Irvine, Calif.: Westphal Publishing, 1988), 151–58.

111. On Maybeck, see Kenneth H. Cardwell, *Bernard Maybeck: Artisan, Architect, Artist* (Santa Barbara, Calif.: Peregrine Smith, 1977). For an analysis of the Fine Arts Palace, see "Craftsmanship and Grandeur in an Architecture of Mood: Bernard Maybeck's Palace of Fine Arts and First Church of Christ Scientist," in William H. Jordy, *American Buildings and Their Architects*, vol. 4, *Progressive and Academic Ideals at the Turn of the Twentieth Century* (New York: Oxford University Press, 1972), 275–300.

112. Jordy, "Bernard Maybeck's Palace of Fine Arts," 275–77.

113. Bernard R. Maybeck, *Palace of Fine Arts and Lagoon* (San Francisco, Calif.: Paul Elder & Co., 1915), 9.

114. Jordy, "Bernard Maybeck's Palace of Fine Arts," 298.

115. Bernard R. Maybeck, "Architecture of the Palace of Fine Arts at the Panama-Pacific International Exposition," in *Art in California*, 164.

116. Frank Morton Todd, *The Story of the Exposition;* quoted in Cardwell, *Bernard Maybeck*, 144.

117. The concurrently held Panama-California Exposition of 1915–16, designed primarily by Bertram G. Goodhue in a Spanish colonial style, was of a similar optimism. Because of the competing fair in San Francisco, a compromise was worked out between the two in which San Francisco's fair was to be the major international affair and San Diego's was intended to be a more modest regional event. On the Panama-California Exposition, see Raymond Starr, "San Diego, 1915–1916: The Panama California Exposition," in *Historical Dictionary of World's Fairs*, ed., Findling, 227–30.

118. Burton Benedict, "San Francisco, 1915: Panama-Pacific International Exposition," in *Historical Dictionary of World's Fairs*, ed. Findling, 225.

119. Whether or not Chicago's Century of Progress Exposition of 1933 can be called a major fair, it, too, featured modern architecture. Other fairs between 1915 and 1930 included the Bronx International Exposition of 1913, the Philadelphia Sesqui-Centennial International Exposition of 1926, and the Long Beach, California, Pacific Southwest Exposition of 1928. These other, minor fairs were not on a scale to compare with the 1915 and 1939 fairs.

Chapter 3. The Museum as Urban Cultural Locator: Art Museums, Municipal Parks, and the City Beautiful Movement

1. For Olmsted as the precursor to the City Beautiful movement, see "Frederick Law Olmsted and the City Beautiful Movement," in *The City Beautiful Movement* (Baltimore: Johns Hopkins University Press, 1989), 9–34.

2. For the essential work on Olmsted's life, see Laura Wood Roper, *FLO: A Biography of Frederick Law Olmsted* (Baltimore: Johns Hopkins University Press, 1973).

3. According to Zane Miller, *The Urbanization of Modern America: A Brief History* (New York: Harcourt Brace Jovanovich, 1973), between 1820 and 1860, the number of Americans living in cities increased eightfold, and the number of cities with populations of over 10,000 increased nearly tenfold. The number of cities with populations of over 100,000 increased from two to eight, and by 1869, New York City had reached a population of over one million.

4. Frederick Law Olmsted, Jr. and Theodora Kimball, eds., *Frederick Law Olmsted: Landscape Architect, 1822–1903* (reprint; New York: Benjamin Blom, Inc., 1970), 2:3.

5. Quoted in Olmsted and Kimball, *Frederick Law Olmsted*, 2:212.

6. Alan Trachtenberg, *The Incorporation of America: Culture and Society in the Gilded Age* (New York: Hill and Wang, 1982), 112.

7. Frederick Law Olmsted and Calvert Vaux, "A Review of Recent Changes . . . in the Plans of Central Park," in Olmsted and Kimball, *Frederick Law Olmsted*, 2:249.

8. Olmsted and Vaux, "A Review of Recent Changes," 248–49.

9. Metropolitan Museum of Art, *Annual Report of the Trustees of the Association, from 1871 to 1902*, First *Annual Report* (1871).

10. Winifred Howe, *A History of the Metropolitan Museum of Art*, vol. 1 (New York: Metropolitan Museum of Art, 1913), 138–40; 150–52. See also Metropolitan Museum of Art, Second *Annual Report* (1872).

11. Frederick Law Olmsted and Calvert Vaux, *Brooklyn Park Report* (1865); quoted in Olmsted and Kimball, *Frederick Law Olmsted*, 2:474.

12. Central Park Commission, *Fourteenth Annual Report* (1870), as quoted in Olmsted and Kimball, *Frederick Law Olmsted*, 2:473.

13. Frederick Law Olmsted and Calvert Vaux, "Preliminary Report to the Commissioners for Laying Out a Park in Brooklyn, New York: Being a Consideration of Circumstances of Site and Other Conditions Affecting the Design of Public Pleasure Grounds," in *Landscape into Cityscape: Frederick Law Olmsted's Plans for a Greater New York City*, ed. Albert Fein (Ithaca, N.Y.: Cornell University Press, 1967), 95–127.

14. "[T]he ground . . . east of Flatbush avenue, does not appear to us desirable to be retained for the purpose for which it has been assigned." Olmsted and Vaux, "Preliminary Report to the Commissioners for Laying Out a Park in Brooklyn," 123.

15. Olmsted and Vaux, "Preliminary Report to the Commissioners for Laying Out a Park in Brooklyn," 125.

16. "Squier Turns the First Sod," unidentified newspaper clipping, from Museum Building Box (1), "Museum: 1897–1903," 12/23/87, Archives, Brooklyn Museum, New York.

17. "The Museum Movement," *Year Book of the Brooklyn Institute of Arts and Sciences* (1893–94): 246.

18. Brooklyn Institute of Arts and Sciences, *Report Adopted by the Citizens' Committee on Museums, on the Scope and Purposes of the New Corporation* (Brooklyn, N.Y., 1890), 10.

19. For a brief essay on Olmsted's parks in Buffalo, see Charles Beveridge, "Buffalo's Park and Parkway System," in *Buffalo Architecture: A Guide* (Cambridge: M.I.T. Press, 1981), 15–23.

20. Olmsted, as quoted in Beveridge, "Buffalo's Park and Parkway System," 18.

21. Buffalo Academy of Fine Arts, Board of Directors' Minutes, 15 January 1900, Archives, Albright-Knox Art Gallery, Buffalo, N.Y.

22. "Art Gallery," unidentified newspaper clipping, ca. January 1900, from Eugenie Hauenstein Scrapbooks, Archives, Albright-Knox Art Gallery.

23. "Following His Lead," unidentified newspaper clipping, ca. January 1900, from Eugenie Hauenstein Scrapbooks.

24. *Buffalo Express*, 1 June 1905.

25. "The Albright Art Gallery," unidentified newspaper clipping, ca. 1905, from John J. Albright Scrapbook, Library, Buffalo and Erie County Historical Society, Buffalo, N.Y.

26. The complete history of Olmsted and his development of the Boston park system is in Cynthia Zaitzevsky, *Frederick Law Olmsted and the Boston Park System* (Cambridge: Belknap Press of Harvard University Press, 1982).

27. "What Boston Hopes to Have—New Building Should be Occupied by the Summer of 1909," *Boston Globe*, 15 June 1907.

28. See legal notice, "Restrictions for Park Frontages, from the Fens to Franklin Park."

29. Benjamin Ives Gilman, "The Museum Past, Present, and Future," in *Museum of Fine Arts Bulletin: The New Museum* 4 (June 1907): 46.

30. *Boston Evening Transcript*, 4 May 1912.

31. *Boston Globe*, 12 March 1912.

32. *Boston Evening Transcript*, 4 May 1912.

33. Olmsted and Kimball, *Frederick Law Olmsted*, 2:476.

34. Olmsted and Kimball, *Frederick Law Olmsted*, 2:474.

35. "To determine whether any structure on the Park is undesirable, it should be considered, first, what part of the necessary accommodation of the public on the Park is met by it, how this much of accommodation could be otherwise or elsewhere provided, and in what degree and whence the structure will be conspicuous after it shall have been toned by weather, and the plantations about and beyond it shall have taken a mature character." Olmsted and Kimball, *Frederick Law Olmsted*, 2:475.

36. Olmsted and Kimball, *Frederick Law Olmsted*, 2:472.

37. "The Cincinnati Museum," *American Architect and Building News* 19 (9 January 1886): 18.

38. *Dedication Souvenir of the Carnegie Library, Pittsburgh, Pa.* (Pittsburgh, Pa.: Carnegie Institute, 1895), 18.

39. See Barbara Judd, "Edward M. Bigelow: Creator of Pittsburgh's Arcadian Parks," *Western Pennsylvania Historical Magazine* 58 (January 1975): 53–67; and R. J. Gangewere, "Schenley Park," *Carnegie Magazine* 53 (Summer 1979): 20–28.

40. Harry M. Bitner, "Institute Monument of Magnificence," *Pittsburgh Press*, 7 April 1907.

41. "Circular No. 2 to Artists" (St. Louis, Mo., 1903), 3.

42. For a full discussion of the museum site selection, see Walter C. Leedy, Jr., *Cleveland Builds an Art Museum: Patronage, Politics and Architecture, 1884–1916* (Cleveland, Ohio: Cleveland Museum of Art, 1991), 20–40.

43. I. T. Frary, "The Cleveland Museum of Art," *Architectural Record* 40 (September 1916): 195.

44. There were some rare exceptions, e.g., the Milwaukee Public Library and Museum, which was built in the 1890s in downtown Milwaukee without any surrounding parkland whatsoever.

45. "Chicago's Art Institute," unidentified newspaper clipping, ca. 1895, from Art Institute of Chicago Newspaper Clipping Scrapbooks, Ryerson and Burnham Libraries, Art Institute of Chicago.

46. Ernest Flagg to Francis Barbarin [Curator of the gallery], 27 May 1892, Directors' Correspondence #7501, Corcoran Gallery and School of Art Archives, Washington, D.C.

47. *Montclair Times*, 3 March 1917, from Montclair Art Museum Newspaper Clipping Scrapbooks, LeBrun Library, Montclair Art Museum, Montclair, N.J.

48. Metropolitan Museum of Art, Eighth *Annual Report* (1878).

49. Metropolitan Museum of Art, Tenth *Annual Report* (1880).

50. Metropolitan Museum of Art, Twenty-fifth *Annual Report* (1894).

51. Pertinent works include: Wilson, *City Beautiful Movement;* Mel Scott, *American City Planning Since 1890* (Berkeley and Los Angeles, Calif.: University of California Press, 1969); Jon A. Peterson, "The City Beautiful Movement: Forgotten Origins and Lost Meanings," *Journal of Urban History* 2 (August 1976): 415–34; and Mario Manieri-Elia, "Toward an 'Imperial City': Daniel H. Burnham and the City Beautiful Movement," in *The American City: From the Civil War to the New Deal* (Cambridge: M.I.T. Press, 1979), 1–142.

52. Charles Zueblin, *A Decade of Civic Development* (Chicago: University of Chicago Press, 1905), 145.

53. Zueblin, *Decade of Civic Development*, 57.

54. Daniel H. Burnham, "White City and Capital City," *Century Magazine* 63 (February 1902): 619–20. Mario Manieri-Elia defends the Columbian Exposition as the source of the City Beautiful movement by distinguishing several different threads of the movement, naming Burnham's style of City Beautiful the more strictly architecturally-concerned one. William Wilson suggests that, although Burnham believes that the White City was the inspiration for the movement, it was a matter of *post hoc, propter hoc* reasoning and convenient forgetting. He points to the lapse of time from 1893 to 1902 as too long for the two events to be directly related. I would suggest that they were indeed directly related, since Burnham was in charge

of both. Wilson also argues that the term *City Beautiful* was not used widely until 1899, but must a movement have its historical name before it can exist?

55. Frank Miles Day, "The Location of Public Buildings in Parks and Other Open Spaces," in *Proceedings of the Third National Conference on City Planning* (Cambridge, Mass.: University Press, 1911), 57.

56. Day, "Location of Public Buildings in Parks," 59.

57. William W. Emmart, "Discussion of Frank Miles Day, 'The Location of Public Buildings in Parks,'" 77.

58. John W. Reps, *Monumental Washington: The Planning and Development of the Capital Center* (Princeton: Princeton University Press, 1967).

59. "The Corner Stone," *[Washington, D.C.] Evening Star*, 11 May 1894, from Corcoran Gallery Newspaper Clipping Scrapbooks, Corcoran Gallery and School of Art Archives.

60. *Report of the Senate Committee . . . on the Improvement of the Park System of the District of Columbia;* quoted in Reps, *Monumental Washington*, 119.

61. Commission of Fine Arts, *Message from the President of the United States transmitting the report of the commission of fine arts for the fiscal year ended June 30, 1914* (Washington, D.C.: U. S. Government Printing Office, 1915), 22; quoted in Keith N. Morgan, *Charles A. Platt: The Artist as Architect* (New York: Architectural History Foundation, 1985), 164–65.

62. On the influences upon and design of the building, see Morgan, *Charles A. Platt*, 162–70.

63. "Home of Art that Graces Mall," *Washington Post*, 1 August 1920, from Freer Gallery of Art Newspaper Clipping Scrapbooks, Freer Gallery of Art Archives, Smithsonian Institution, Washington, D.C.

64. Burnham himself said so: "The origin of the plan of Chicago can be traced directly to the World's Columbian Exposition." See Daniel H. Burnham and Edward H. Bennett, *Plan of Chicago* (1909; reprint, New York: Da Capo Press, 1970), 4.

65. See, in particular, Thomas S. Hines, *Burnham of Chicago: Architect and Planner* (New York: Oxford University Press, 1974), 312–45; and Manieri-Elia, "Toward an 'Imperial City.'"

66. In Paul Boyer, *Urban Masses and Moral Order in America, 1820–1920* (Cambridge: Harvard University Press, 1978), 274; nn. 48, 49, Boyer details the responses to Burnham's style of city planning by critics John Reps, Mel Scott, Vincent Scully, and George Chadwick, all of whom disliked his grandiose visions.

67. Burnham, *Plan of Chicago*, 29.

68. Burnham, *Plan of Chicago*, 30.

69. The same cavalier attitude about existing buildings prompted the McMillan group to suggest the removal of Renwick's Smithsonian "Castle." This steamroller approach was probably another reason for the eventual demise of the City Beautiful.

70. Burnham, *Plan of Chicago*, 110.

71. Burnham, *Plan of Chicago*, 111.

72. Burnham, *Plan of Chicago*, 112.

73. See Hines, *Burnham of Chicago*, 341–45.

74. The definitive account of the parkway and the museum is David B. Brownlee, *Building the City Beautiful: The Benjamin Franklin Parkway and the Philadelphia Museum of Art* (Philadelphia: Philadelphia Museum of Art, 1989).

75. On the polychrome decoration, see Brownlee, *Building the City Beautiful*, 68–70; Leon V. Solon, "The Philadelphia Museum of Art, Fairmount Park, Philadelphia: A Revival of Polychrome Architecture and Sculpture," *Architectural Record* 60 (August 1926): 97–111; "The Philadelphia Museum of Art," *Atlantic Terra Cotta*, vol. 8 (February 1927); and "Color Treatment in City Buildings," *New York Times*, 30 January 1927.

76. "Philadelphia Art Museum Example of Pure Greek Architecture," *Building Magazine*, April 1927, 11.

77. "New Art Museum Ready Next Spring," *Philadelphia Public Ledger*, 20 November 1925; from Philadelphia Museum of Art Newspaper Clipping Scrapbooks, Archives, Philadelphia Museum of Art.

78. Mary Dixon Thayer, "Art Museum, in All Its Glory, Smiles on City," *Philadelphia Bulletin*, 16 October 1926; from Philadelphia Museum of Art Newspaper Clipping Scrapbooks.

79. Thayer, "Art Museum."

80. Edmund Stirling, "Fairmount Parkway's Origin and Growth," *Philadelphia Public Ledger*, 10 January 1927; from Philadelphia Museum of Art Newspaper Clipping Scrapbooks.

81. "Seeing Philadelphia Through the Camera's Eye," *Philadelphia Public Ledger*, 28 December 1926; from Philadelphia Museum of Art Newspaper Clipping Scrapbooks.

82. *Philadelphia Inquirer*, 13 February 1927; from Philadelphia Museum of Art Newspaper Clipping Scrapbooks.

83. "More Fine Buildings for the Parkway," *Philadelphia Inquirer*, 7 May 1927; from Philadelphia Museum of Art Newspaper Clipping Scrapbooks.

84. See Brownlee, *Building the City Beautiful*, 77–80.

85. John Junius, "The Rodin Museum, Philadelphia," *Architecture* 64 (October 1931): 193.

86. Brownlee, *Building the City Beautiful*, 78. This resemblance appears to have been the result of an explicit suggestion made by Mastbaum's agent, the portrait painter Albert Rosenthal.

87. Junius, "Rodin Museum, Philadelphia," 189.

88. *New York Herald,* ca. 4 April 1930, newspaper clipping stapled to letter, Jacques Gréber to Lawrence Hills, 4 April 1930, Paul Cret Collection, Department of Special Collections, Van Pelt-Dietrich Library Center, University of Pennsylvania, Philadelphia, Pa.

89. Paul Cret and Harry Sternfeld, "Report on Improvement of City Hall Square, Philadelphia, Pennsylvania," Paul Cret Collection.

90. Cret and Sternfeld, "Report on Improvement of City Hall Square," 7.

91. "City Hall Demolition Plan," *Philadelphia Record,* 23 May 1929, from Philadelphia Museum of Art Newspaper Clipping Scrapbooks.

92. See Peterson, "City Beautiful Movement: Forgotten Origins."

93. See, e.g., "The City Beautiful Campaign," *Toledo Museum of Art News* 22 (October 1914): 266–67; and "What One Boy Accomplished," *Toledo Museum of Art News* 25 (February 1915): 303–4.

94. For a history of the Montclair Art Museum as an institution, see Robert D. B. Carlisle, *A Jewel in the Suburbs: The Montclair Art Museum* (Montclair, N.J.: Montclair Art Museum, 1982).

95. See John L. Hancock, "John Nolen and the American City Planning Movement: A History of Culture Change and Community Response, 1900–1940" (Ph.D. diss., University of Pennsylvania, 1964); and John L. Hancock, *John Nolen: A Bibliographical Record of Achievement* (Ithaca, N.Y.: Cornell University Program in Urban and Regional Studies, 1976).

96. John Nolen, "The Place of the Beautiful in the City Plan: Some Everyday Examples," *National Conference on City Planning* (n.p., 1922), 5–21.

97. Nolen, "Place of the Beautiful in the City Plan," 11.

98. Nolen, "Place of the Beautiful in the City Plan," 19. Nolen echoes Frederick Law Olmsted's claim that a park is a work of art, thereby extending the organic metaphor to the entire city, including, but not limited to, the park.

99. John Nolen, *Montclair: The Preservation of Its Natural Beauty and Its Improvement as a Residence Town* (Montclair, N.J., 1909), 36.

100. *Montclair Times,* 27 November 1909; from Montclair Art Museum Newspaper Clipping Scrapbooks.

101. Nolen, *Montclair,* 91.

102. *Montclair Times,* 27 November 1909.

103. Unidentified newspaper clipping, ca. 2 February 1920; from Montclair Art Museum Newspaper Clipping Scrapbooks.

104. Nothing ever changes! For an account of the defeat of the plan, see Park Terrell, "Montclair Beautiful," *American City* 3 (July 1910): 29–31.

105. Charles Mulford Robinson, "The Improvement of Montclair," *Architectural Record* 28 (August 1910): 141.

106. *Montclair Times,* 10 August 1912; from Montclair Art Museum Newspaper Clipping Scrapbooks.

107. In Wilson, *City Beautiful Movement,* the author concentrates primarily on the Western and Midwestern cities of Kansas City, Seattle, Denver, and Dallas.

108. For an early impression of the virtues of Minneapolis as a city, particularly its merits as a City Beautiful, see "The Minneapolis Spirit," *American City* 6 (January 1912): 398–404.

109. For an architectural history of the museum, see Minneapolis Society of Fine Arts, *An Architectural View: 1883–1974* (Minneapolis, Minn.: Minneapolis Institute of Arts, 1974).

110. Minneapolis Civic Commission, *Plan of Minneapolis Prepared under the Direction of the Civic Commission, 1917, by Edward H. Bennett Architect, Edited and Written by Andrew Wright Crawford, Esq.* (Minneapolis, Minn.: Civic Commission, 1917).

111. *Plan of Minneapolis,* 34.

112. The desirability of a location on a hill for a museum is illustrated in the *Plan of Minneapolis* with a photograph of the Albright Art Gallery.

113. Edward Bennett, "Public Buildings and Quasi-Public Buildings," in *City Planning: A Series of Papers Presenting the Essential Elements of a City Plan,* ed. John Nolen (New York: D. Appleton and Company, 1916), 106.

114. *Plan of Minneapolis,* 31–34.

115. *Plan of Minneapolis,* 30.

116. *Plan of Minneapolis,* 34.

117. *Plan of Minneapolis,* 39.

118. "The New Metropolitan Museum of Art," *Architectural Record* 12 (August 1902): 307.

119. See Harvey A. Kantor, "The City Beautiful in New York," *New-York Historical Society Quarterly* 57 (April 1973): 148–71.

120. Leland M. Roth, *McKim, Mead & White, Architects* (New York: Harper & Row, 1983), 296.

121. Illustrated in Roth, *McKim, Mead & White.*

122. *[New York] Sun,* 25 May 1913; from *Paper Cuttings of the Firm of McKim, Mead & White, Architects* [microfilm], New York Historical Society Library, New York.

Chapter 4. The Art Museum as Urban Moral Influence

1. Carroll D. Wright, ed., *The Slums of Baltimore, Chicago, New York, and Philadelphia: Seventh Special Report of the Commissioner of Labor* (1894; reprint, New York: Negro Universities Press, 1969).

2. Adna Ferrin Weber, *The Growth of Cities in the Nineteenth Century: A Study in Statistics* (1899; reprint, Ithaca, N.Y.: Cornell University Press, 1968).

3. Weber, *Growth of Cities*, 388.

4. Weber, *Growth of Cities*, 443.

5. Weber, *Growth of Cities*, 435. "Men cannot live long in close contact without acquiring a painful sense of the separateness of individual interests, of the absurdity of identifying the individual's interest with the interest of society and the consequent policy of *laissez-faire*."

6. Weber, *Growth of Cities*, 457.

7. See Richard Hofstadter, *The Age of Reform: From Bryan to F.D.R.* (New York: Alfred A. Knopf, 1966).

8. A look at Riis in the context of the reform movement is Roy Lubove, "Jacob A. Riis: Portrait of a Reformer," in *The Progressives and the Slums* (Pittsburgh: University of Pittsburgh Press, 1962), 49–80.

9. Jacob A. Riis, *How the Other Half Lives: Studies among the Tenements of New York* (1890; reprint, New York: Hill and Wang, 1957), 2.

10. Riis, *How the Other Half Lives*, 12.

11. Riis, *How the Other Half Lives*, 10.

12. Arthur Dudley Vinton, "Morality and Environment," *Arena* 17 (April 1891): 571–74.

13. Olmsted, quoted in Geoffrey Blodgett, "Frederick Law Olmsted: Landscape Architecture as Conservative Reform," *Journal of American History* 62 (March 1976): 878.

14. Riis, *How the Other Half Lives*, 123.

15. "Public Parks and Playgrounds: A Symposium," *Arena* 10 (1894): 276.

16. *Annual Report of the Department of Public Works, City of Pittsburgh* (1890), 17.

17. Daniel H. Burnham, "Lake Front Proposal, Chicago Commercial Club, 1896," box 61, folder 9, Daniel H. Burnham Collection, Ryerson and Burnham Libraries, Art Institute of Chicago.

18. "Museum a Winter Park," *Toledo Blade*, 9 February 1911, from Toledo Museum of Art Newspaper Clipping Scrapbooks, Toledo Museum of Art Library, Toledo, Ohio.

19. On the identification of the City Beautiful movement with the Progressive reform movement, see Jon A. Peterson, "The City Beautiful Movement: Forgotten Origins and Lost Meanings," *Journal of Urban History* 2 (August 1976): 415–34; and William H. Wilson, *The City Beautiful Movement* (Baltimore, Md.: Johns Hopkins University Press, 1989), especially the Introduction and Part I, "Origins and Ideology," 1–95.

20. Charles Mulford Robinson, *Modern Civic Art: or, The City Made Beautiful*, 4th ed. (New York: Knickerbocker Press, 1913), 5.

21. [Rev.] Josiah Strong, *The Twentieth Century City* (New York: Baker and Taylor Co., 1898), 181.

22. "And the city lieth foursquare, and the length is as large as the breadth: and he measured the city with the reed, twelve thousand furlongs, The length and the breadth and the height of it are equal" (Revelation 21 : 16). The New Jerusalem also was surrounded by a great wall which had three gates on each side.

23. *Bulletin of the Brooklyn Institute of Arts and Sciences* 1 (5 December 1908): 310.

24. Henry Drummond, quoted in Charles H. Wacker, "The City Plan," in *The Child in the City: A Series of Papers Presented at the Conference Held during the Chicago Child Welfare Exhibit* (Chicago: Department of Social Investigation, Chicago School of Civics and Philanthropy, 1912), 462.

25. Helen Campbell, *Darkness and Daylight; or, Lights and Shadows of New York Life* (Hartford, Conn.: Hartford Publishing Co., 1895), 307.

26. Campbell, *Darkness and Daylight*, 313.

27. "Art Museum Is Now Open," unidentified newspaper clipping [ca. 15 January 1914], from Montclair Art Museum Newspaper Clipping Scrapbooks, LeBrun Library, Montclair Art Museum, Montclair, N.J.

28. Michael Williams, unidentified newspaper clipping, ca. 27 June 1915, from Freer Gallery of Art Newspaper Clipping Scrapbooks, Freer Gallery of Art Archives, Smithsonian Institution, Washington, D.C.

29. Francis A. Smith, "Continued Care of Families," in *Proceedings of the National Conference of Charities and Correction* (Boston: Press of Geo. H. Ellis, 1895), 89.

30. See Paul Boyer, *Urban Masses and Moral Order in America, 1820–1920* (Cambridge: Harvard University Press, 1978).

31. B[enjamin]. O[range]. Flower, *Civilization's Inferno: or, Studies in the Social Cellar* (Boston: Arena Publishing, 1893); for Strong, see n. 21.

32. Joseph Schrembs, "Invocation," in *Dedication and Inaugural Addresses*, Toledo Museum of Art (n.p., 17 January 1912), 9.

33. "Inaugural Exercises," *Bulletin of the Minneapolis Institute of Arts* 4 (January-February 1915): 2.

34. "Sees in Museum of Art an Uplift and Aid to Religion," *Toledo Blade*, 15 January 1912, Toledo Museum of Art Newspaper Clipping Scrapbooks.

35. "Pastors See in Art Museum New Inspiration for City," *Toledo Blade*, 22 January 1912, Toledo Museum of Art Newspaper Clipping Scrapbooks.

36. Franklin Hooper, "The Purposes of the Institute," in *An Account of the Exercises at the Laying of the Cornerstone of the Museum Building of the Brooklyn Institute of Arts and Sciences* (Brooklyn, N.Y.: Brooklyn Institute of Arts and Sciences, 1896), 11.

37. *The [Pittsburgh] Bulletin,* 2 November 1895.

38. *Illustrated Buffalo Express,* 28 May 1905.

39. *The Buffalo Express,* 1 June 1905.

40. "To Be Opened on Monday," *The [Boston] Globe,* 9 November 1909, from Museum of Fine Arts Newspaper Clipping Scrapbooks, MSC AC2, Archives, Museum of Fine Arts, Boston.

41. See Museum of Fine Arts Newspaper Clipping Scrapbooks.

42. Metropolitan Museum of Art, *Annual Reports of the Trustees of the Association, from 1871 to 1902,* Twenty-second *Annual Report* (1892). The trustees reported that "At first a certain element of turbulence and disorder was noticeable in the attendance. Many visitors took the liberty of handling every object within reach; some went to the length of marring, scratching or breaking articles unprotected by glass; a few proved to be pickpockets, and others brought with them peculiar habits which were repulsive and unclean. With the beginning of August, however, these disorders in a large measure ceased, and toward the end of the year the change in the character of visitors on Sunday afternoons was as marked as it was gratifying."

43. Reid Badger, *The Great American Fair: The World's Columbian Exposition and American Culture* (Chicago: Nelson Hall, 1979), 97.

44. "Bade Adieu to Toil," *The [Chicago] Daily Inter Ocean,* 1 May 1893.

45. "The Stroller," *Washington Post,* 14 March 1897, from Corcoran Gallery Newspaper Clipping Scrapbooks, Corcoran Gallery and School of Art Archives, Washington, D.C.

46. "The Stroller."

47. *The Baltimore Museum of Art: A Brief Account of Its History and Aims* (Baltimore: Norman T. A. Munder & Co., 1915), 6.

48. Charles Zueblin, *A Decade of Civic Development* (Chicago: University of Chicago Press, 1905), 25.

49. Zueblin, *Decade of Civic Development,* discusses the World's Columbian Exposition as an example of what can be accomplished through a kind of cooperative pseudo-Socialism:

The White City was unique in being an epitome of the best we had done; and a prophecy of what we could do, if we were content with nothing but the best, and added to individual excellence a common purpose. The White City was the most socialistic achievement of history, the result of many minds inspired by a common aim working for the common good. . . . More than that, the Chicago World's Fair was a miniature of the ideal city. [p. 62]

50. Edward Bellamy, *Looking Backward—If Socialism Comes, 2000–1887* (London: W. Foulsham & Co., 1887), 25–26.

51. Sylvester Baxter, "The Beautifying of Village and Town," *Century Magazine* 63 (April 1902): 844.

52. E[rnest]. F. Fenollosa, "Art Museums and Their Relation to the People," *Lotos* 9 (May and September 1896): 842.

53. Fenollosa, "Art Museums and Their Relation to the People," 933.

54. Frederick Law Olmsted and Calvert Vaux, "Preliminary Report to the Commissioners for Laying Out a Park in Brooklyn, New York: Being a Consideration of Circumstances of Site and Other Conditions Affecting the Design of Public Pleasure Grounds," in *Landscape into Cityscape: Frederick Law Olmsted's Plans for a Greater New York City,* ed. Albert Fein (New York: Van Nostrand Reinhold Company, 1981), 124.

55. Brooklyn Institute of Arts and Sciences, *Report Adopted by the Citizens' Committee on Museums, on the Scope and Purposes of the New Corporation* (Brooklyn, N.Y.: Brooklyn Institute of Arts and Sciences, 1890), 5.

56. Metropolitan Museum of Art, Nineteenth *Annual Report* (1888).

57. See Neil Harris, "The Gilded Age Revisited: Boston and the Museum Movement," *American Quarterly* 14 (Winter 1962): 545–66.

58. Frank Jewett Mather, "An Art Museum for the People," *Atlantic Monthly* 100 (December 1907): 729.

59. *Christian Science Monitor,* 1 February 1913; from Museum of Fine Arts Newspaper Clipping Scrapbooks.

60. "A New Art Museum," *Art and Progress* 3 (March 1912): 516.

61. "Inaugural Exercises," 7.

62. "Friends of Art Museum," *[Toledo] Blade,* January 1904; from Toledo Museum of Art Newspaper Clipping Scrapbooks.

63. Toledo Museum of Art, *Dedication and Inaugural Addresses,* 32.

64. Toledo Museum of Art, *Dedication and Inaugural Addresses,* 35.

65. Toledo Museum of Art, *Dedication and Inaugural Addresses,* 37.

66. Toledo Museum of Art, *Dedication and Inaugural Addresses,* 40.

67. Toledo Museum of Art, *Dedication and Inaugural Addresses,* 42–43.

68. Toledo Museum of Art, *Dedication and Inaugural Addresses,* 45–46.

69. "The Museum as an Art Center," *News-Record of the Baltimore Museum of Art,* vol. 1 (November 1928), unpaginated.

70. *Toledo Museum of Art News* 4 (January 1911): 201.

71. *Pittsburg [sic] Post,* 4 November 1897, in Carnegie Institute Newspaper Clipping Scrapbooks, Carnegie Library, Pittsburgh, Pa.

72. "Resolutions Presented to John J. Albright by City of Buffalo," John J. Albright Collection, Library, Buffalo and Erie County Historical Society, Buffalo, N.Y.

73. Riis, *How the Other Half Lives,* 23.

74. Riis, *How the Other Half Lives,* 204.

75. Daniel H. Burnham and Edward Bennett, *Plan of Chicago,* ed. Charles Moore (1909; reprint, New York: Da Capo Press, 1970), 14.

76. Burnham, *Plan of Chicago,* 15.

77. Burnham, *Plan of Chicago,* 17.

78. Burnham, *Plan of Chicago,* 18.

79. Charles N. Glaab and Theodore Brown, *A History of Urban America* (London: Macmillan Co., 1967), 231; see also David R. Goldfield and Blaine A. Brownell, *Urban America: A History* (Boston: Houghton Mifflin Company, 1990), 206–7.

80. Burnham, *Plan of Chicago,* 108.

81. Burnham, *Plan of Chicago,* 109.

82. Burnham, *Plan of Chicago,* 108.

83. Burnham, *Plan of Chicago,* 108.

84. For this concept, see Boyer, *Urban Masses,* 220–32.

85. See M. Christine Boyer, *Dreaming the Rational City: The Myth of American City Planning* (Cambridge: MIT Press, 1983).

86. Edward Bennett, "Public Buildings and Quasi-Public Buildings," in *City Planning: A Series of Papers Presenting the Essential Elements of a City Plan,* ed. John Nolen (New York: D. Appleton and Co., 1916), 108.

87. Milo Roy Maltbie, "The Grouping of Public Buildings," *Outlook* 78 (September 1904): 40–41.

88. Daniel Burnham, "Lake Front Proposal."

89. Maltbie, "Grouping of Public Buildings," 41–42.

90. Charles Zueblin, *American Municipal Progress: Chapters in Municipal Sociology* (New York: Macmillan Co., 1902), 206.

91. Arthur A. Stoughton, "The Architectural Side of City Planning," in *Proceedings of the Seventh National Conference on City Planning* (Cambridge: [Harvard] University Press, 1915), 125.

92. Maltbie, "Grouping of Public Buildings," 37.

93. E. E. Newport, "The New Corcoran Gallery at Washington," *Illustrated American* 20 (26 September 1896): 426. Newport was a student at the Corcoran School of Art and probably female.

94. Newport, "New Corcoran Gallery," 426.

95. Newport, "New Corcoran Gallery," 426.

96. Julia de Wolf Addison, *The Boston Museum of Fine Arts* (Boston: L. C. Page & Co., 1924), vii–viii.

97. "The Albright Art Gallery," *Academy Notes* 1 (June 1905): 4.

98. "Albright Art Gallery," 4.

99. Carleton Sprague, "The Albright Art Gallery," *Illustrated Buffalo Express,* unidentified newspaper clipping, from Eugenie Hauenstein Newspaper Clipping Scrapbooks, Archives, Albright-Knox Art Gallery, Buffalo, N.Y.

100. "The Toledo, Ohio, Museum of Art," *American Architect* 101 (10 April 1912): 165.

101. "Toledo, Ohio, Museum of Art," 165.

102. "The Completed Museum Building," *Toledo Museum of Art News* 64 (January 1933): 846.

Chapter 5. *Plans, Competitions, and Architectural Professionalism*

1. The second American to receive architectural training at the Ecole des Beaux-Arts in Paris, Henry Hobson Richardson, had an effect about equally influential. Though his preferred style was Romanesque and not classical, he was largely responsible for the professional development and training of Stanford White and Charles McKim, who took up the banner of classicism.

2. See Richard Chafee, "The Teaching of Architecture at the Ecole des Beaux-Arts," in *The Architecture of the Ecole des Beaux-Arts,* ed. Arthur Drexler (New York: Museum of Modern Art, 1977), 61–109.

3. See David Van Zanten, "Architectural Composition at the Ecole des Beaux-Arts from Charles Percier to Charles Garnier," in *Architecture of the Ecole des Beaux-Arts,* 111–323.

4. Ernest Flagg, "The Ecole des Beaux-Arts," *Architectural Record* 4 (July-September 1894): 40.

5. James D. Van Trump, "The Past as Prelude: A Consideration of the Early Building History of the Carnegie Institute Complex," *Carnegie Magazine* 48 (October-November 1974): 346.

6. Margaret Henderson Floyd, "Longfellow, Alden & Harlow's First Carnegie Library and Institute," *Carnegie Magazine* 61 (January-February 1993): 23.

7. [Longfellow, Alden and Harlow], "The Architectural Plan," in *Dedication Souvenir of the Carnegie Library* (November, 1895), 31.

8. [Longfellow, Alden and Harlow], "The Architectural Plan," 23.

9. For the distinctive personalities and architecture of the various Pittsburgh neighborhoods, especially Oakland where the Carnegie Institute found its home, see Franklin Toker, *Pittsburgh: An Urban Portrait* (University Park: Pennsylvania State University Press, 1986).

10. For the additions to the Carnegie Institute which expanded the size of the structure fourfold and significantly altered its appearance and architectural style, see Margaret Henderson Floyd, *Architecture after Richardson: Regionalism before Modernism—Longfellow, Alden, and Harlow in Boston and Pittsburgh* (Chicago: University of Chicago Press, 1994), 215–31.

11. Floyd, *Architecture after Richardson*, 203.

12. The only sources for the competitive designs not chosen for the Carnegie Library are the illustrations to be found in *American Architect and Building News* 35 (5 March 1892); 36 (23 April; 21 May 1892), Pls. 845, 852, 856.

13. Floyd, *Architecture after Richardson*, 203.

14. Building and Grounds Committee Minutes, 12 October 1891, RG7, Corcoran Gallery and School of Art Archives, Washington, D.C.

15. Ernest Flagg to S. H. Kauffmann, 24 October 1891, Directors' Correspondence #7260, Corcoran Gallery and School of Art Archives.

16. Ernest Flagg, "The Corcoran Gallery of Art" [unpublished manuscript], Ernest Flagg Papers, Drawings and Archives, Avery Architectural and Fine Arts Library, Columbia University, New York.

17. Ernest Flagg to F. S. Barbarin, 24 May 1892, Directors' Correspondence #7496, Corcoran Gallery and School of Art Archives.

18. Building and Grounds Committee Minutes, 9 June 1892, RG7, Corcoran Gallery and School of Art Archives.

19. Paul J. Pelz, "Description of Drawings," September 1892, Directors' Correspondence #7665, Corcoran Gallery and School of Art Archives.

20. Pelz, "Description of Drawings."

21. "Exhibit of Competitive Plans for the New Corcoran Gallery of Art," *American Architect and Building News* 43 (27 January 1894): 44.

22. Hornblower and Marshall, "Description of Drawings," 31 December 1892, Directors' Correspondence #7668, Corcoran Gallery and School of Art Archives.

23. This is described in "Exhibit of Competitive Plans," 45.

24. Hornblower and Marshall, "Description of Drawings."

25. "Exhibit of Competitive Plans," 44.

26. "Exhibit of Competitive Plans," 44.

27. Frank B. Mayer, "Sends Suggestions for a new Gallery," 20 April 1893, Directors' Correspondence #7814, Corcoran Gallery and School of Art Archives. Mayer signed his written description with "Frank B. Mayer, Artist."

28. Robert Head and Waddy. B. Wood, "Description of Drawings," 5 January 1893, Directors' Correspondence #7671, Corcoran Gallery and School of Art Archives. Although Wood may have enjoyed a better reputation in the Washington, D.C., area for other work, there seems to be little excuse for the unprofessional appearance of the written description, and the excuses made within it for the quality of the submission bode ill for the appearance of the lost drawings.

29. For a detailed evaluation of the specific Beaux-Arts influences on Flagg's design, see Mardges Bacon, *Ernest Flagg: Beaux-Arts Architect and Urban Reformer* (New York: Architectural History Foundation, and Cambridge: MIT Press, 1986), 77–89.

30. Bacon covers the precedent of Labrouste's Bibliothèque Ste-Geneviève and the general stylistic influence of the Neo-Grec on Flagg.

31. Flagg to Barbarin, 28 May 1892, Directors' Correspondence #7501, Corcoran Gallery and School of Art Archives.

32. Robert Stead to C. C. Glover, 4 May 1891, Directors' Correspondence #7476, Corcoran Gallery and School of Art Archives. The two others mentioned by Stead were William Young of London and the rather idiosyncratic choice of Alfred Waterhouse.

33. See Flagg to Barbarin, 20 May 1892 and 2 April 1895, Directors' Correspondence #7492 and #8628, Corcoran Gallery and School of Art Archives.

34. As Richard Chafee points out, the *atelier* system was also a cooperative one; e.g., if one of the *atelier* members were working on the Prix de Rome competition, the whole *atelier* helped, and "if an *ancien* in the atelier brought back the Grand Prix, the *esprit de corps* was intense." Chafee, "Teaching of Architecture at the Ecole des Beaux-Arts," 92.

35. Brooklyn Institute of Arts and Sciences, Minutes of the Board of Directors, 2 February 1889, Archives, Brooklyn Museum, New York.

36. Various histories have been written about the building of the Brooklyn Museum building. These include Richard Guy Wilson, *McKim, Mead & White, Architects* (New York: Rizzoli, 1983), 178–85; and Leland M. Roth, "McKim, Mead & White and the Brooklyn Museum, 1893–1934, in *A New Brooklyn Museum: The Master Plan Competition,* ed. Joan Darragh (New York: Brooklyn Museum, 1988), 26–48. Neither of the two works agree exactly on the number and identities of the participants in the competition. One mentions only two winners of the preliminary competition, the other, three; both only mention four

invited architects. According to the first circular distributed by the Institute, there were to be five invited architects, as listed, and three winners of the preliminary competition. What happened to William Tubby— whether he ever submitted an entry—is not clear. The minutes of the board of directors discuss the entries only by number, revealing only the winners' names. See *Competition for the Proposed Museum of Arts and Sciences, to be Erected for The Brooklyn Institute of Arts and Sciences, in the City of Brooklyn, Circular No. 1* [no publ. data], copy in Archives, Brooklyn Museum.

37. *Competition for the Proposed Museum of Arts and Sciences, Circular No. 4,* copy in Archives, Brooklyn Museum.

38. *American Architect and Building News,* vol. 41 (12 August 1893), Pl. 920.

39. The front elevations of Albert Brockway's and the Parfitt Brothers' submissions were illustrated in the *Catalogue of the Third Annual Exhibition of The Department of Architecture of the Brooklyn Institute of Arts and Sciences at the Art Association Building* (Brooklyn, N.Y., 1894).

40. The triple doorways set into the rusticated ground floor resemble the front of the Brooklyn Museum once its stairs were removed.

41. Brooklyn Institute of Arts and Sciences, Minutes of the Board of Directors, 19 May 1893.

42. All are illustrated in *Architecture of the Ecole des Beaux-Arts.*

43. The master plan, which was developed in 1907, made the greatest change from the original design in the central dome. It became a much taller dome, resting on a high colonnaded drum. See Roth, "McKim, Mead & White and The Brooklyn Museum," 42–43.

44. The difference in the division of space, of course, was integrally related to the difference in construction methods. The fair buildings were built with steel skeletons, whereas the museum was built using classical load-bearing construction methods. Hence, the plans for the two buildings were vastly different; but the exterior appearances were conceived in similar veins. After all, the architecture of the fair was meant to look like load-bearing architecture as much as possible.

45. The 1986 competition held for the completion of the Brooklyn Museum and won by Arata Isozaki is the main subject of Darragh, ed., *A New Brooklyn Museum.*

46. K. A. Linderfelt and Adolph Meinecke, *Report on the Proposed Library and Museum Building for the City of Milwaukee* (Milwaukee, Wisc., 1890), 4.

47. Linderfelt and Meinecke, *Report on the Proposed Library and Museum Building,* 8.

48. The Carnegie is one of the only institutions known to the author that still maintains its multifunctional program. It is also, incidentally, the only one (again to this author's knowledge) to display a collection of architectural and sculptural casts, a turn-of-the-century practice long discredited by most other art museums. The collection at the Carnegie is, therefore, as much—if not more so—historical as art historical, but its existence gives validity to the original purposes of the parts of the building in which they are installed.

49. *Instructions to Architects for the Library-Museum Building of the City of Milwaukee* (Milwaukee, Wisc.: Trustees of the Public Library and the Public Museum, 1893).

50. *Instructions to Architects,* 15.

51. Henry Van Brunt, *Richard Morris Hunt: A Memorial Address* (Washington, D.C.: American Institute of Architects, 1896), 9.

52. There seem to be only two exceptions. One was an entry submitted by William Kenyon of Minneapolis and published in *The [Milwaukee] Sentinel,* 19 November 1893, which was Romanesque in design and rather crudely drawn. The other was a submission by Henry Ives Cobb. It was not illustrated in any of the local newspapers but was described by the same issue of the *Sentinel* as Romanesque and a close copy of his Newberry Library in Chicago.

53. These designs were all illustrated in "Plans for the Public Library and Museum," *The [Milwaukee] Sentinel,* 3 December 1893.

54. "Several More Plans," *Evening Wisconsin,* 16 November 1893.

55. All three designs were illustrated in "Plans for the Library and Museum," *The [Milwaukee] Sentinel,* 3 December 1893.

56. An illustration of Wright's entry can be found in Mark L. Peisch, *The Chicago School of Architecture: Early Followers of Sullivan and Wright* (New York: Random House, 1964).

57. This item is mentioned in John Thiel and Mary Ellen Wietczykowski, *Historic American Building Survey Report on the Milwaukee Public Library and Museum,* 13. The source is cited as an unidentified article in the *Evening Wisconsin,* which this author could not locate.

58. Once again it must be mentioned that Henry Ives Cobb was a competitor, but as his submission was in the Romanesque style, it was never given much consideration either by the press or the judges, all of the premiated designs being classical.

59. "Professor Ware's Report," *The [Milwaukee] Sentinel,* 5 January 1894. No design for Boring and Tilton appears to have survived.

60. "Professor Ware's Report."

61. For the vicissitudes of the Milwaukee competition, particularly the controversy that erupted afterward, see H. Russell Zimmermann, *Magnificent Milwaukee: Architectural Treasures, 1850–1920* (Milwaukee, Wisc.: Milwaukee Public Museum, 1987), 251–60.

62. "Trouble Is Brewing," unidentified newspaper clipping, ca. December 1893, in Wisconsin Architectural Archives, Milwaukee Public Library, Milwaukee, Wisc.

63. "Trouble Is Brewing."

64. "Only Two Plans Now," *The [Milwaukee] Sentinel,* 3 January 1894.

65. William R. Ware, "Competitions," *American Architect and Building News* 66 (30 December 1899): 108.

66. "Only Two Plans Now."

67. "Anonymous Competitions," unidentified newspaper clipping, ca. January 1894, Wisconsin Architectural Archives.

68. "The Library Competition," unidentified newspaper clipping, ca. January 1894, Wisconsin Architectural Archives.

69. N. S. Patton, "Expert Decisions of Competitions," *Inland Architect and News Record* 23 (March 1894): 13.

70. Patton, "Expert Decisions of Competitions," 14.

71. Patton, "Expert Decisions of Competitions," 15.

72. Ferry and Clas to the Joint Board of Trustees, [Milwaukee] Public Library and Museum, 23 March 1900, Archives, Milwaukee Public Museum, Milwaukee, Wisc.

73. Ware, "Competitions," 107.

74. Leopold Eidlitz, "Competitions—The Vicissitudes of Architecture," *Architectural Record* 4 (October-December 1894): 147–56.

75. Eidlitz, "Competitions," 150.

76. Morrison Heckscher, "Hunt and the Metropolitan Museum of Art," in *The Architecture of Richard Morris Hunt,* ed. Susan R. Stein (Chicago: University of Chicago Press, 1986), 179.

77. Heckscher, "Hunt and the Metropolitan Museum," 185.

78. Samuel D. Warren to R. Clipston Sturgis, 10 November 1902, BAG AC1, Archives, Museum of Fine Arts, Boston.

79. Charles A. Coolidge to Charles Loring, 30 December 1899, BAG AC1, Archives, Museum of Fine Arts, Boston. Coolidge wrote: "It is a great refection [*sic*] on the profession of the 'Modern Athens' to have all the principal buildings given to New York men without even a chance."

80. "Petition addressed to Trustees of the Boston Museum of Fine Arts," 14 February 1900, BAG AC1, Archives, Museum of Fine Arts, Boston. The petition was signed by the following: Walter Atherton, William Atkinson, J. W. Ames, Wm. Chester Chase, Herbert D. Hale, Stephen Goodman, Arthur Wallace Rice, Charles N. Cogswell, Charles Perkins, John W. Bemis, Arthur W. Wheelwright, and J. Harleston Parker.

81. Museum of Fine Arts Trustee [signature faded beyond recognition] to Charles McKim, 2 July 1901, BAG AC1, Archives, Museum of Fine Arts, Boston. There are in the Museum's Archives other letters similar to this one, requesting the names of competent architects both in and out of the Boston area.

82. Edward Robinson to Samuel Warren, 10 July 1902, BAG AC1, Archives, Museum of Fine Arts, Boston.

83. Samuel D. Warren, "Memorandum to the Building Committee of the Museum of Fine Arts," 22 September 1902, BAG AC1, Archives, Museum of Fine Arts, Boston.

84. Guy Lowell, "The Boston Museum of Fine Arts," *Architects' and Builders' Magazine,* n.s., 11 (May 1910): 315.

85. Lowell, "Boston Museum of Fine Arts," 315.

86. Ware, "Competitions," 112.

87. American Institute of Architects, "Architectural Competitions, a Circular of Advice and Information," in *A Handbook of Architectural Practice Issued by the American Institute of Architects for Use in Connection with Its Standard Documents* (Washington, D.C.: American Institute of Architects, 1920), 116.

88. "Minneapolis Art Museum Competition," *Western Architect* 18 (January 1912): 1.

89. "Minneapolis Art Museum Competition," 1.

90. Benjamin Ives Gilman, et al., to Samuel Warren, 8 August 1905, BAG AC1, Archives, Museum of Fine Arts, Boston. In this letter, a half dozen members of the staff of the museum reported to the chairman of the building committee that they had devised their own variation of the museum plan, very different from Sturgis's classical and symmetrical plan. Their plan consisted of a number of almost separate buildings connected by long, narrow corridors, which the letter describes as "an academy or an enclosed grove dedicated to the arts." This variation was asymmetrical and represents quite a progressive manner of thinking, though one perhaps unaware of architectural exigencies. Walter McCornack assisted the museum staff in making a sketch of this plan, which was never in any of its aspects adopted.

91. *Program of a Competition for the Selection of an Architect and the Procuring of a General Design for the Minneapolis Fine Arts Museum, Minneapolis, Minnesota,* (Minneapolis, Minn., 1911), 14.

92. All of the designs are illustrated in *Architectural Review,* n.s., 1 (1912): 56 and Pls. 45–46.

93. "Minneapolis Art Museum Competition," 1.

94. "Minneapolis Art Museum Competition," 1.

95. Letters documenting the controversy between the firm of McKim, Mead, and White and the Minneapolis Institute of Arts can be found in the McKim, Mead, and White Collection at the New York Historical Society.

96. For the early history of the museum as an institution, see Kent Roberts Greenfield, "The Museum: The First Half Century," *Baltimore Museum of Art: Annual I* 1 (1966): 5–13.

97. See Bennard B. Perlman, "How They Got the Building Up," *The [Baltimore] Sun,* 7 March 1989.
98. "Rome Prize in Architecture Awarded," *Pencil Points* 10 (July 1929): 487.
99. "Rome Prize in Architecture Awarded," 487.

Conclusion: The Death and Legacy of the Monumental Classical Art Museum

1. These numbers are culled from Laurence Vail Coleman, *The Museum in America: A Critical Study,* vol. 3, appendix Y (Washington, D.C.: American Association of Museums, 1939), 683–98. The numbers cited include only museum buildings devoted primarily to art and exclude university art galleries, whose numbers would swell the comparison even further. The numbers cited also include new buildings for old institutions established in the earlier period.
2. Once again, the exception is university art galleries, where architects also experimented with Neo-Georgian as an appropriate style, as at the second Fogg Art Museum at Harvard University or the Rhode Island School of Design art building.
3. Cecil Claude Brewer, "American Museum Buildings," *Journal of the Royal Institute of British Architects* 20 (April 1913): 377.
4. Richard Bach, "The Field Museum of Natural History," *Architectural Record* 56 (July 1924): 1.
5. Bach, "Field Museum," 2.
6. Bach, "Field Museum," 6.
7. Bach, "Field Museum," 15.
8. Henry W. Kent, "The Why and Wherefore of Museum Planning," *Architectural Forum* 56 (June 1932): 529.
9. Kent, "Museum Planning," 530.
10. Kent, "Museum Planning," 530.
11. Kent, "Museum Planning," 532.
12. Kent, "Museum Planning," 532.
13. See Joan Darragh, "The Brooklyn Museum: Institution as Architecture, 1934–1986," in *A New Brooklyn Museum: The Master Plan Competition,* ed. Joan Darragh (New York: Brooklyn Museum, 1988), 52–72.
14. See D. Wythe, "Summary of file 'McKim, Mead and White, DIR:PNY, 1933–36,'" Archives, Brooklyn Museum, New York.
15. Philip N. Youtz, "Museum Architecture," typescript of speech, DIR:PNY, Speeches (1936–37), Archives, Brooklyn Museum, 3.
16. Youtz, "Museum Architecture," 4.
17. Youtz, "Museum Architecture," 5.
18. Youtz, "Museum Architecture," 6.
19. Youtz, "Museum Architecture," 7.
20. Youtz, "Museum Architecture," 7.
21. The significance of Rockefeller Center and the PSFS skyscraper in terms of modernism is explored in the first two chapters of William H. Jordy, *American Buildings and Their Architects,* vol. 5, *The Impact of European Modernism in the Mid-Twentieth Century* (New York: Oxford University Press, 1972).
22. Helen Searing, *New American Art Museums* (New York: Whitney Museum of American Art, 1982), 49. For the "International Style" exhibit, see Richard Guy Wilson, "International Style: the MoMA Exhibition," *Progressive Architecture* 63 (February 1982): 92–104. The entire issue is dedicated to the fiftieth anniversary of the exhibit.
23. Wilson, "International Style," 100.
24. Searing, *New American Art Museums,* 49.
25. Lorraine Welling Lanmon, *William Lescaze, Architect* (Philadelphia: Art Alliance Press, 1987), 78–83. Lanmon illustrates all of Lescaze's various schemata for the Museum of Modern Art.
26. Wilson, "International Style," 101.
27. Travis C. McDonald, Jr., "Smithsonian Institution: Competition for a Gallery of Art, January 1939-June 1939," in *Modernism in America, 1937–1941: A Catalog and Exhibition of Four Architectural Competitions,* ed. James D. Kornwolf (Williamsburg, Va: Joseph and Margaret Muscarelle Museum of Art, College of William and Mary, 1985), 177–223.
28. See National Gallery of Art, *John Russell Pope and the Building of the National Gallery of Art* (Washington, D.C.: National Gallery of Art, 1991).
29. See Stuart Klawans, "Beaux-Arts Modernism in the Art Institute's Daniel F. and Ada L. Rice Building," *Art Institute of Chicago Museum Studies* 14 (1988): 83–98.
30. Klawans, "Beaux-Arts Modernism in the Rice Building," 97.

Bibliography

Archival Sources

A note on archival sources: It would be both fruitless and cumbersome to enumerate every single item from each archival source that proved of use for this study. Each scrapbook alone consisted of several hundred items which I read but did not cite in this work. Those items used specifically are cited in the notes. The following is a list of those depositories I visited and the general categories of sources that were of use. All published material is listed in the next section.

Baltimore, Maryland
Baltimore Museum of Art, Prints, Drawings, and Photographs, and Library
 Architectural drawings
 Assorted ephemera
 Assorted loose newspaper clippings

Boston, Massachusetts
Museum of Fine Arts, Archives
 Assorted ephemera
 Building Committee records
 Building files
 Correspondence files
 Newspaper clippings scrapbooks

Buffalo, New York
Albright-Knox Art Gallery Archives
 Assorted ephemera
 Hauenstein, Eugenie, Newspaper clipping scrapbooks
 Minutes, Board of Directors
 Miscellaneous newspaper clippings

Buffalo and Erie County Historical Society
 Albright, John J., assorted ephemera
 Albright, John J., Newspaper clippings scrapbooks
 Pan-American Exposition, assorted ephemera

Chicago, Illinois
Art Institute of Chicago Archives
 Architectural drawings
 Assorted ephemera
 Building files

French, William M. R., files
Hutchinson, Charles L., files
Minutes, Board of Trustees
Photographs

Chicago Historical Society Library
Art Institute of Chicago, assorted ephemera
World's Columbian Exposition, assorted ephemera

Ryerson and Burnham Libraries, Art Institute of Chicago
Art Institute of Chicago newspaper clipping scrapbooks (microfilm)
Bennett, Edward, Collection
Burnham, Daniel H., Collection
Burnham, Daniel H., Newspaper clipping scrapbooks (microfilm)
Burnham, Daniel H., "Uses of Expositions." Typescript manuscript, ca. 1895. (in DHB
 Collection).

Milwaukee, Wisconsin
Milwaukee Public Museum Archives
Correspondence files

Wisconsin Architectural Archives, Milwaukee Public Library
Architectural drawings
Milwaukee Public Library and Museum building, assorted ephemera, including loose
 newspaper clippings
Thiel, John, and Mary Ellen Wietczykowski. "Historic American Buildings Survey Report
 on the Milwaukee Public Library and Museum Building." Typescript

Montclair, New Jersey
Montclair Art Museum, LeBrun Library
Assorted ephemera
Assorted loose newspaper clippings
Minutes, Montclair Art Association
Newspaper clippings scrapbooks

New York, New York
Avery Architectural and Fine Arts Library, Columbia University, drawings and archives
Flagg, Ernest, papers, including scrapbook
Hunt, Richard Morris, papers, including scrapbook
Platt, Charles Adams, Drawings Collection
Rogers, James Gamble, Drawings Collection

Brooklyn Museum Archives
Assorted ephemera, including loose newspaper clippings
Building files
Directors' files
Minutes, Board of Trustees
Youtz, Philip N. "Museum Architecture" (paper read before the Association of Art Museum
 Directors, 10 May 1936). DIR:PNY Speeches, 1936–36.

New York Historical Society
Gilbert, Cass, Collection
McKim, Mead, and White Collection
McKim, Mead, and White, newspaper clippings scrapbooks (microfilm)

Philadelphia, Pennsylvania
Philadelphia Museum of Art Archives
Directors' correspondence
Newspaper clippings scrapbooks

University of Pennsylvania, Van Pelt Library, Special Collections
 Cret, Paul, Collection. Cret, Paul. "City Plan: Paper." Typescript manuscript, ca. 1920.
 ————. "The Detroit Institute of Arts." Translated by S. W. Typescript manuscript.

Pittsburgh, Pennsylvania
The Carnegie
 Architectural drawings
 Assorted ephemera
 Minutes, Board of Trustees
 Newspaper clipping scrapbooks
 Photographs

Toledo, Ohio
Toledo Museum of Art Archives and Library
 Architectural drawings
 Assorted ephemera
 Correspondence files
 Godwin, Blake-More, "Recollections," transcript from audio tape
 Knudsen, Sandra K., "The Libbey Legacy," unpublished manuscript
 Newspaper clippings scrapbooks
 Photographs

Washington, D.C.
American Architectural Foundation, Drawings and Prints Collection
 Hunt, Richard Morris, Collection

Archives of American Art
 Kurtz, Charles M., papers
 Louisiana Purchase Exposition Department of Art Papers (microfilm)

Corcoran Gallery and School of Art Archives
 Architects' competition descriptions (Directors' Correspondence)
 Building files
 Directors' correspondence
 Minutes of the Building and Grounds Committee
 Newspaper clippings scrapbooks
 Photographs
 Records of the Committee on the Laying of the Cornerstone

Freer Gallery of Art, Smithsonian Institution, Archives
 Building Records
 Correspondence central files
 Freer, Charles Lang, papers
 Newspaper clippings scrapbooks
 Photographs

Published Sources

An Account of the Exercises at the Breaking of Ground for the Museum Building of the Brooklyn Institute of Art and Sciences, September Fourteenth, 1895. Brooklyn, N.Y.: Brooklyn Institute of Arts and Sciences, 1896.

An Account of the Exercises at the Laying of the Corner Stone for the Museum Building of the Brooklyn Institute of Arts and Sciences, December Fourteenth, 1895. Brooklyn, N.Y.: Brooklyn Institute of Arts and Sciences, 1896.

Ackerman, Frederick L. "The Architectural Side of City Planning." In *Proceedings of the Seventh National Conference on City Planning.* Boston: University Press, 1915.

Adam, T. R. *The Civic Value of Museums.* New York: American Association for Adult Education, 1937.

Addison, Julia de Wolf. *The Boston Museum of Fine Arts.* 2d ed. Boston: L. C. Page, 1924.

"The Albright Art Gallery." *Academy Notes* 1 (June 1905): 3–9.

Albright, Birge. "John Joseph Albright—Part II." *Niagara Frontier* 9 (Winter 1962): 98–103.

Alexander, Mrs. J[ohn]. W[hite]. "John W. Alexander's Mural Decorations Entitled 'The Crowning of Labor." In Elizabeth Moorhead Vermorcken, *The Carnegie Institute and Library of Pittsburgh,* 30–31. Pittsburgh, Pa.: Carnegie Library of Pittsburgh, 1916.

Alland, Alexander. *Jacob A. Riis: Photographer and Citizen.* Millerton, N.Y.: Aperture, 1974.

Allwood, John. *The Great Exhibitions.* London: Studio Vista, 1977.

American Institute of Architects. *A Handbook of Architectural Practice Issued by the American Institute of Architects for Use in Connection with Its Standard Documents.* Washington, D.C.: American Institute of Architects, 1920.

Anderson, Patricia McGraw. *The Architecture of Bowdoin College.* Brunswick, Maine: Bowdoin College Museum of Art, 1988.

"Arguing for the Fair." *New York Herald,* 12 January 1890.

"Art and Daily Life." *News-Record of the Baltimore Museum of Art,* vol. 2 (April-May 1929).

Art Institute of Chicago. *Annual Report of the Trustees.* 1891–1904. Chicago: Knight, Leonard & Co., Printers, 1891–1904.

"The Art Institute, Its Work, Its Equipment and Its Building." *American Architect and Building News* 23 (January 1888): 30.

"The Art Museum Movement." *First Year Book of The Brooklyn Institute,* 1888–89, 85–97.

"Art Museum Notes." *Academy Notes* 1 (December 1905): 127–28.

"An Artistic Center." *Academy Notes* 1 (May 1906): 195–98.

"As He Is Known [R. Clipston Sturgis]." *Brickbuilder* 24 (January 1915): 25.

Bach, Richard. "The Field Museum of Natural History, Chicago, Illinois." *Architectural Record* 56 (July 1924): 1–13.

———. "The Modern Museum: Plan and Functions." *Architectural Record* 62 (December 1927): 457–69.

Bacon, Mardges. *Ernest Flagg: Beaux-Arts Architect and Urban Reformer.* New York: Architectural History Foundation, and Cambridge: MIT Press, 1986.

Badger, Reid. *The Great American Fair: The World's Columbian Exposition and American Culture.* Chicago: Nelson Hall, 1979.

Baker, Paul R. *Richard Morris Hunt.* Cambridge: MIT Press, 1980.

"Baltimore Art Museum, Baltimore, Maryland." *American Architect and Architecture* 131 (5 March 1927): 313.

Baltimore Museum of Art. *Inaugural Exhibition. Baltimore: Norman T. A. Munder, 1923.*

The Baltimore Museum of Art: A Brief Account of Its History and Aims. Baltimore, Md.: Norman T. A. Munder & Co., 1915.

Bancroft, Hubert Howe. *The Book of the Fair.* Chicago, 1894.

Barrows, John Henry. *The Parliament of Religions at the World's Fair.* New York: Funk & Wagnalls Co., 1892.

Barth, Gunther. *City People: The Rise of Modern City Culture in Nineteenth-Century America.* New York: Oxford University Press, 1980.

Baxter, Sylvester. "The Beautifying of Village and Town." *Century Magazine* 63 (April 1902): 844–51.

Beaver, Patrick. *The Crystal Palace, 1851–1936: A Portrait of Victorian Enterprise.* London: Hugh Evelyn, 1970.

Bedford, Steven. "Museums Designed by John Russell Pope." *Antiques* 139 (April 1991): 750–63.

Bellamy, Edward. *Looking Backward—If Socialism Comes, 2000–1887.* London: W. Foulsham & Co., 1887.

Bennett, Edward. *Plan of Minneapolis Prepared Under the Direction of the Civic Commission, 1917.* Edited and written by Andrew Wright Crawford. Minneapolis, Minn.: Civic Commission, 1917.

———. "Public Buildings and Quasi-Public Buildings." In *City Planning: A Series of Papers Presenting the Essential Elements of a City Plan,* edited by John Nolen. New York: D. Appleton and Co., 1916, 103–115.

Beveridge, Charles. "Buffalo's Park and Parkway System." In *Buffalo Architecture: A Guide,* intro. by Reyner Banham, et al., 15–23. Cambridge: MIT Press, 1981.

Bird, Anthony. *Paxton's Palace.* London: Cassell and Co., 1976.

Blackall, C. H. "The Sargent Decorations in the Boston Museum of Fine Arts." *American Architect* 121 (29 March 1922): 240–44.

Blau, Eve. *Ruskinian Gothic: The Architecture of Deane and Woodward, 1845–1861.* Princeton, N.J.: Princeton University Press, 1982.

Blodgett, Geoffrey. "Frederick Law Olmsted: Landscape Architecture as Conservative Reform." *Journal of American History* 62 (March 1976): 869–89.

Bluestone, Daniel M. "Detroit's City Beautiful and the Problem of Commerce." *Journal of the Society of Architectural Historians* 47 (September 1988): 245–62.

A Book of the Office Work of Geo. B. Ferry & Alfred C. Clas, Architects, Milwaukee, Wis. St. Louis, Mo.: I. Haas, 1895.

"The Boston Museum of Fine Arts." *Architects' and Builders' Magazine* n.s., 11 (May 1910): 315–22.

"Boston's New Museum of Fine Arts." *Architectural Record* 27 (January 1910): 124–25.

Bosworth, F. H., Jr., and Roy Childs Jones. *A Study of Architectural Schools.* New York: Charles Scribner's Sons, 1932.

Boyer, M. Christine. *Dreaming the Rational City: The Myth of American City Planning.* Cambridge: MIT Press, 1983.

Boyer, Paul. *Urban Masses and Moral Order in America, 1820–1920.* Cambridge: Harvard University Press, 1978.

Brewer, Cecil Claude. "American Museum Buildings." *Journal of the Royal Institute of British Architects* 20 (April 1913): 365–98.

"A Brief History." *Toledo Museum of Art News* 19 (March 1912): 221–25.

Brimmer, Martin. "The Museum of Fine Arts, Boston." *American Architect and Building News* 8 (30 October 1880): 205–22.

"Brooklyn Institute, Brooklyn, N.Y." *Architectural Review,* vol. 6 (December 1899), Pl. 78.

Brooklyn Institute of Arts and Sciences. *Report Adopted by the Citizens' Committee on Museums, on the Scope and Purposes of the New Corporation.* Brooklyn, N.Y.: Brooklyn Institute of Arts and Sciences, 1890.

Brooklyn Museum. *The American Renaissance, 1876–1917.* New York: Brooklyn Museum, 1979.

Brownlee, David B. *Building the City Beautiful: The Benjamin Franklin Parkway and the Philadelphia Museum of Art.* Philadelphia: Philadelphia Museum of Art, 1989.

Buchanan, William J. *Report of the Director-General, The Pan-American Exposition.* Buffalo, N.Y. 1902.

"A Building on the Board: A Selected Group of Drawings Showing the Progress from the Sketch to the Finished Working Drawings of the Wichita Art Institute, Wichita, Kansas, Clarence S. Stein, Architect." *Pencil Points* 10 (August 1929): 535–44.

"The Buildings of the Barnes Foundation at Merion, Pa." *Architecture* 53 (January 1926): 1–6.

Bunting, Bainbridge. "The Back Bay Area as an Example of City Planning." In *Houses of Boston's Back Bay.* Cambridge: Harvard University Press, 1967, 361–99.

Burg, David F. *Chicago's White City of 1893.* Lexington, Ky.: University Press of Kentucky, 1976.

Burnham, Daniel H. "Address before the World's Congress of Architects." *American Architect and Building News* 41 (12 August 1893): 103–6.

———. "Charles Bowler Atwood." *Inland Architect and News Record* 26 (January 1896): 56–57.

———. *The Final Official Report of the Director of Works of the World's Columbian Exposition.* 2 vols. 1894. Reprint, New York: Garland Publishing, 1989.

———. "White City and Capital City." *Century Magazine* 63 (February 1902): 619–20.

Burnham, Daniel H., and Edward H. Bennett. *Plan of Chicago.* Edited by Charles Moore. 1909. Reprint, New York: Da Capo Press, 1970.

Burnham, Daniel H., and Francis D. Millet. *World's Columbian Exposition: The Book of the Builders, Being the Chronicle of the Origin and Plan of the World's Fair.* Chicago and Springfield, Ohio, 1894.

Burroughs, Clyde H. "The New Home of the Detroit Institute of Arts." *American Magazine of Art* 18 (October 1927): 544–54.

Burt, Nathaniel. *Palaces for the People: A Social History of the American Art Museum.* Boston: Little, Brown and Co., 1977.

C., F. "Robert Dawson Evans Memorial Galleries for Paintings." *Museum of Fine Arts Bulletin* 13 (February 1915): 18–28.

Caffin, Charles H. "The Beautifying of Cities." *World's Work* 3 (November 1901): 1429–40.

———. "Municipal Art." *Harper's New Monthly Magazine* 100 (April 1900): 655–66.

———. "The Pan-American Exposition as a Work of Art." *World's Work* 2 (August 1901): 1049–51.

Campbell, Helen. *Darkness and Daylight: or, Lights and Shadows of New York Life.* Hartford, Conn.: Hartford Publishing Co., 1895.

Cantor, Jay. "Temples of the Arts: Museum Architecture in Nineteenth-Century America." *The Metropolitan Museum of Art Bulletin* 28 (April 1970): 331–54.

Cardwell, Kenneth H. *Bernard Maybeck: Artisan, Architect, Artist.* Santa Barbara, Calif.: Peregrine Smith, 1977.

Carlisle, Robert D. B. *A Jewel in the Suburbs: The History of the Montclair Art Museum.* Montclair, N.J.: Montclair Art Museum, 1982.

Carnegie, Andrew. "Value of the World's Fair to the American People." *Engineering Magazine* 6 (January 1894): 417–22.

Carnegie Library Competition Drawings. *American Architect and Building News,* vols. 35 and 36 (5 March; 23 April; 21 May 1892), Pls. 845, 852, and 856.

Carnegie Library of Pittsburgh. *Ordinances and By-Laws of the Carnegie Free Library of the City of Pittsburgh.* Pittsburgh, Pa.: Carnegie Library of Pittsburgh, 1911.

Catalogue of the Third Annual Exhibition of The Department of Architecture of the Brooklyn Institute of Arts and Sciences. Brooklyn, N.Y.: Brooklyn Institute of Arts and Sciences, 1894.

A Challenge to Civic Pride: A Plea for the Preservation and Rehabilitation of the Fine Arts Building of the World's Columbian Exposition. Chicago: American Institute of Architects, 1923.

"The Cincinnati Museum, Mr. James W. McLaughlin, Architect." *American Architect and Building News* 19 (9 January 1886): 18 and Pl. 524.

"The City Beautiful [series]." *Bulletin of the Brooklyn Institute of Arts and Sciences,* vols. 1–2 (September 1908-February 1909).

Ciucci, Giorgio, Francesco Dal Co, Mario Manieri-Elia, and Manfredo Tafuri. *The American City: From the Civil War to the New Deal.* Translated by Barbara Luigia. Cambridge: MIT Press, 1979.

Clas, Alfred C. *Civic Improvement in Milwaukee, Wisconsin: An Address Delivered before the Greater Milwaukee Association, December 14, 1916.* Milwaukee, Wisc., 1916.

Clute, Eugene. "A New Craftsmanship in Cast Stone." *Architecture* 72 (November 1935): 241–46.

Coburn, Frank W. "The New Art Museum at Boston." *International Studio* 33 (1907–8): 57–62.

Coleman, Laurence Vail. *Museum Buildings.* Washington, D.C.: American Association of Museums, 1950.

———. *The Museum in America: A Critical Study.* 3 vols. Washington, D.C.: American Association of Museums, 1939.

Competition for the Proposed Museum of Arts and Sciences, to be Erected for the Brooklyn Institute of Arts and Sciences, in the City of Brooklyn. 5 circulars. Brooklyn, N.Y.: Brooklyn Institute of Arts and Sciences, 1893.

"Competitive Designs Submitted for the Brooklyn Museum of Arts and Sciences." *American Architect and Building News* 41 (12 August 1893), Pl. 920.

"Competitive Designs Submitted for a Museum of Fine Arts, Minneapolis, Minn." *Architectural Review,* n.s., 1 (1912): 56 and Pls. 41–50.

"The Completed Museum Building." *Toledo Museum of Art News* 64 (January 1933): 845–70.

Conard, Howard Louis. *History of Milwaukee from Its First Settlement to the Year 1895.* 2 vols. Chicago: American Biographical Publishing Co. and H. C. Cooper, Jr., 1895.

Coolidge, J. Randolph, Jr. "The Architectural Scheme." *Museum of Fine Arts Bulletin Special Number: The New Museum* 4 (June 1907): 41–42.

Cooper, Walter G. *The Cotton States and International Exposition and South, Illustrated.* Atlanta, Ga.: Illustrator Company, 1896.

Cret, Paul. "The Ecole des Beaux-Arts: What its Architectural Teaching Means." *Architectural Record* 23 (1908): 367–71.

———. "Theories in Museum Planning." *Museum News* 12 (15 November and 1 December 1934): 7–8 and 6–8.

Crooks, James B. *Politics and Progress: The Rise of Urban Progressivism in Baltimore, 1895 to 1911.* Baton Rouge, La.: Louisiana State University Press, 1968.

The Crystal Palace Exhibition Illustrated Catalogue, London 1851: An Unabridged Republication of the Art Journal Special Issue. New York: Dover Publications, 1970.

Darragh, Joan. "The Brooklyn Museum: Institution as Architecture, 1934–1986." In *A New Brooklyn Museum: The Master Plan Competition.* Edited by Joan Darragh. New York: Brooklyn Museum, 1988, 52–72.

Day, Frank Miles. "The Location of Public Buildings in Parks and Other Open Spaces." In *Proceedings of the Third National Conference on City Planning, Philadelphia, PA, 1911.* Boston: University Press, 1911, 53–79.

"Dedication Ceremonies, Albright Art Gallery." *Academy Notes* 1 (June 1905): 23–31.

Dedication Souvenir of the Carnegie Library. Pittsburgh, Pa.: Carnegie Library, 1895.

Downing, A.J. *The Architecture of Country Houses.* 1850. Reprint, New York: Dover Publications, Inc., 1969.

Drexler, Arthur, ed. *The Architecture of the Ecole des Beaux-Arts.* New York: Museum of Modern Art, 1977.

Eastman, Rebecca Hooper. *The Story of the Brooklyn Institute of Arts and Sciences, 1824-1924.* New York: Brooklyn Institute of Arts and Sciences, 1924.

Eidlitz, Leopold. "Competitions—The Vicissitudes of Architecture." *Architectural Record* 4 (October-December 1894): 147–56.

"Eight Museums of the Fine Arts." *Architectural Forum* 56 (June 1932): 541–63.

"Exhibit of Competitive Plans for the New Corcoran Gallery of Art." *American Architect and Building News* 43 (27 January 1894): 44–45.

Exhibition of Drawings, Designs and Models, Illustrating the Report of the Commission on the Improvement of the Park System of the District of Columbia. Washington, D.C.: Corcoran Art Gallery, 1902.

Fein, Albert, ed. *Landscape into Cityscape: Frederick Law Olmsted's Plans for a Greater New York City.* New York: Van Nostrand Reinhold, 1981.

Fenollosa, E. F. "Art Museums and Their Relation to the People." *Lotos* 9 (May and September 1896): 841–47 and 929–35.

"The Field Columbian Museum Opened." *Inland Architect and News Record* 23 (June 1894): 48.

Findling, John E., ed. and Kimberly D. Pelle, assistant ed. *Historical Dictionary of World's Fairs and Expositions, 1851–1988.* New York: Greenwood Press, 1990.

Flagg, Ernest. "The Ecole des Beaux-Arts." *Architectural Record* 4 (July-September 1894): 38–43.

———. "Influence of the French School on Architecture in the United States." *Architectural Record* 4 (October-December 1894): 211–28.

———. "Public Buildings." In *Proceedings of the Third National Conference on City Planning, Philadelphia, PA, 1911.* Boston: University Press, 1911, 42–52.

Flower, B[enjamin]. O[range]. *Civilization's Inferno: or, Studies in the Social Cellar.* Boston: Arena Publishing, 1893.

Floyd, Margaret Henderson. *Architecture after Richardson: Regionalism before Modernism—Longfellow, Alden, and Harlow in Boston and Pittsburgh.* Chicago: University of Chicago Press, 1994.

———. "Longfellow, Alden & Harlow's First Carnegie Library and Institute." *Carnegie Magazine* 61 (January-February 1993): 23–30.

———. "A Terra-Cotta Cornerstone for Copley Square: Museum of Fine Arts, Boston, 1870–1876, by Sturgis and Brigham." *Journal of the Society of Architectural Historians* 32 (May 1973): 83–103.

Ford, George B. "The Architectural Side of City Planning." *Proceedings of the Seventh National Conference on City Planning, Detroit, MI, 1915.* Cambridge: [Harvard] University Press, 1915, 129–34.

Fox, Stephen. "The Museum of Fine Arts, Houston: An Architectural History, 1924–1986." *[Museum of Fine Arts, Houston] Special Bulletin* 15 (1992): 2–127.

Fox, Thomas. *Decorations of the Dome of the Rotunda by John Singer Sargent.* Pamphlet. Boston: Museum of Fine Arts, 1922.

Francis, David R. *The Universal Exposition of 1904.* St. Louis, Mo.: Louisiana Purchase Exposition Co., 1913.

Frary, I. T. "The Cleveland Museum of Art." *Architectural Record* 40 (September 1916): 195–211.

———. "The Dudley Peter Allen Memorial Art Building, Oberlin, Ohio." *Architectural Record* 44 (August 1918): 99–111.

G. "The Copley Square Museum." *Museum of Fine Arts Bulletin* 7 (April 1909): 14–19.

Gangewere, R. J. "The Origins of the Carnegie." *Carnegie Magazine* 61 (November-December 1992): 25–33.

———. "Schenley Park." *Carnegie Magazine* 53 (Summer 1979): 20–28.

Gardner, Albert Ten Eyck. "Those Blocks." *Metropolitan Museum of Art Bulletin* 11 (May 1953):252–58.

Garrigan, Kristine Otteson. *Ruskin on Architecture: His Thought and Influence.* Madison, Wisc.: University of Wisconsin Press, 1973.

Geerlings, Gerald K. "The Detroit Institute of Arts." *Architecture* 57 (January and February 1928): 1–12 and 65–76.

A General Outline of the Plans and Purposes of the Pan-American Exposition, May 1 to November 1, 1901, at Buffalo, N.Y., U.S.A. Buffalo, 1901.

Geshorn, Alfred T. "Effects of the Centennial Exhibition." *Engineering Magazine* 6 (January 1894): 423–29.

Gilbert, James. *Perfect Cities: Chicago's Utopias of 1893.* Chicago: University of Chicago Press, 1991.

Gilman, Benjamin Ives. "The Monument and the Shelter." *Communications to the Trustees Regarding the New Building.* Vol. 1. Boston: Museum of Fine Arts, 1904.

———. *Museum of Fine Arts, Boston, 1870–1920.* Pamphlet. Boston: Museum of Fine Arts, 1920.

———. "The Museum Past, Present, and Future." *Museum of Fine Arts Bulletin Special Number: The New Museum* 4 (June 1907): 42–47.

———. "On the Distinctive Purpose of Museums of Art." *Communications to the Trustees Regarding the New Building.* Vol. 1. Boston: Museum of Fine Arts, 1904.

Girouard, Mark. *Cities and People: A Social and Architectural History.* New Haven: Yale University Press, 1985.

Glaab, Charles N. and A. Theodore Brown. *A History of Urban America.* London: Macmillan, 1967.

Goldfield, David R., and Blaine A. Brownell. *Urban America: A History.* Boston: Houghton Mifflin Company, 1990.

Gould, E. R. L. "Civic Reform and Social Progress." *International Quarterly* 3 (March 1901): 344–58.

———. "Park Areas and Open Spaces in Cities." *American Statistical Association Publication,* 1888–89, 49–61.

Graff, M. M. *Central Park, Prospect Park: A New Perspective.* New York: Greensward Foundation, 1985.

Greenfield, Kent Roberts. "The Museum: Its First Half Century." *Baltimore Museum of Art Annual* 1 (1966): 5–63.

Hale, Philip L. "The Boston Art Museum." *Scribner's Magazine* 47 (February 1910): 253–56.

Hamlin, A. D. F. "Our Public Untidiness." *Forum* 33 (May 1902): 322–32.

Hamlin, A. D. F., and F. S. Lamb. "New York Architectural League Exhibition." *Architectural Review,* n.s., 1 (1899): 39–45.

Hancock, John L. *John Nolen: A Bibliographical Record of Achievement.* Ithaca, N.Y.: Cornell University Program in Urban and Regional Studies, 1976.

———. "Planners in the Changing American City, 1900–1940." *Journal of the American Institute of Planners* 33 (September 1967): 290–304.

Harder, J. F. "The City's Plan." *Municipal Affairs* 2 (1898): 25–43.

Harris, Neil. "The Gilded Age Revisited: Boston and the Museum Movement." *American Quarterly* 14 (Winter 1962): 545–66.

Heckscher, Morrison H. "Hunt and the Metropolitan Museum of Art." In *The Architecture of*

Richard Morris Hunt. Edited by Susan R. Stein. Chicago: University of Chicago Press, 1986, 172–85.

————. "The Metropolitan Museum of Art: An Architectural History." Reprint from *Metropolitan Museum of Art Bulletin* (Summer 1995).

Hegeman, William R. "Wanna Fight? Try Telling the 100-Year-Old Minneapolis Society of Fine Arts It Doesn't Have the Finest Arts Museum Between Chicago and Tokyo." *Twin Cities* 6 (August 1983): 23–26 and 73–81.

Hines, Thomas S. *Burnham of Chicago: Architect and Planner*. New York: Oxford University Press, 1974.

Hitchcock, Henry-Russell, Jr., and Philip Johnson. *The International Style: Architecture Since 1922*. New York: W. W. Norton, 1932.

Hoffmann, Donald. *The Architecture of John Wellborn Root*. Baltimore, Md.: Johns Hopkins University Press, 1973.

Hofstadter, Richard. *The Age of Reform: From Bryan to F.D.R.* New York: Alfred A. Knopf, 1966.

Holmes, W. H. "Shall America Have a National Gallery of Art?" *American Magazine of Art* 14 (July 1923): 349–55.

Horowitz, Helen Lefkowitz. *Culture and the City: Cultural Philanthropy in Chicago from the 1880s to 1917*. Chicago: University of Chicago Press, 1976.

Howe, Winifred E. *A History of the Metropolitan Museum of Art*. 2 vols. New York: Metropolitan Museum of Art, 1913–46.

"Inaugural Exercises." *Bulletin of the Minneapolis Institute of Arts* 4 (January-February 1915): 2–23.

Instructions to Architects for the Library-Museum Building of the City of Milwaukee. Milwaukee: Trustees of the Public Library and the Public Museum, 1893.

Johnson, Rossiter. *History of the World's Columbian Exposition Held in Chicago in 1893*. Chicago, 1897.

Jordy, William H. *American Buildings and Their Architects*. Vol. 4, *Progressive and Academic Ideals at the Turn of the Twentieth Century*. New York: Oxford University Press, 1972.

————. *American Buildings and Their Architects*. Vol. 5, *The Impact of European Modernism in the Mid-Twentieth Century*. New York: Oxford University Press, 1972.

Judd, Barbara. "Edward M. Bigelow: Creator of Pittsburgh's Arcadian Parks." *Western Pennsylvania Historical Magazine* 58 (January 1975): 53–67.

Junius, John. "The Rodin Museum, Philadelphia." *Architecture* 64 (October 1931): 189–96.

Justi, Herman, ed. *Official History of the Tennessee Centennial Exposition*. Nashville, Tenn.: Brandon Printing Company, 1898.

Kantor, Harvey A. "The City Beautiful in New York." *The New-York Historical Society Quarterly* 57 (April 1973): 148–71.

Kent, Henry W. "Museums of Art." *Architectural Forum* 47 (December 1927): 581–600.

————. "The Why and Wherefore of Museum Planning." *Architectural Forum* 56 (June 1932): 529–32.

Kimball, Fiske. "Planning the Art Museum." *Architectural Record* 66 (December 1929): 582–94.

Klawans, Stuart. "Beaux-Arts Modernism in the Art Institute's Daniel F. and Ada L. Rice Building." *Art Institute of Chicago Museum Studies* 14 (1988): 83–98.

Kriehn, George. "The City Beautiful." *Municipal Affairs* 3 (1899): 594–601.

Kurtz, Charles M. *Universal Exposition Commemorating the Acquisition of the Louisiana Territory, St. Louis, U.S.A., 1904: An Illustrated Handbook*. St. Louis, Mo.: Gottschalk Printing Co., 1904.

Lamb, Frederick S. "Municipal Art." *Municipal Affairs* 1 (1897): 674–88.

Lanmon, Lorraine Welling. *William Lescaze, Architect*. Philadelphia: Art Alliance Press, 1987.

Lears, T. J. Jackson. *No Place of Grace: Antimodernism and the Transformation of American Culture, 1880–1920*. New York: Pantheon Books, 1981.

Leedy, Walter C., Jr. *Cleveland Builds an Art Museum: Patronage, Politics, and Architecture, 1884–1916*. Cleveland, Ohio: Cleveland Museum of Art, 1991.

Linderfelt, K. A., and Adolph Meinecke. *Reports on the Proposed Library and Museum Building for the City of Milwaukee*. Milwaukee, Wisc.: Milwaukee Public Library and Museum, 1890.

Loring, Charles G. "A Trend in Museum Design." *Architectural Forum* 47 (December 1927): 579.

Lowell, Guy. "The Museum of Fine Arts, Boston." *American Architect* 109 (29 March 1916): 201–2.

Lurie, Nancy Oestreich. *A Special Style: The Milwaukee Public Museum, 1882–1982.* Milwaukee, Wisc.: Milwaukee Public Museum, 1983.

M., L. "A New Art Museum." *Art and Progress* 3 (March 1912): 516–22.

Maass, John. *The Glorious Enterprise: The Centennial Exhibition of 1876 and H. J. Schwarzmann, Architect-in-Chief.* Watkins Glen, N.Y.: American Life Foundation, 1973.

———. "Memorial Hall 1876." *Architectura* [Berlin] 2 (1972): 127–52.

Maltbie, Milo R. "The Grouping of Public Buildings." *Outlook* 78 (September 1904): 37–48.

Mann, Frederick M. "Architecture at the Exposition." *American Architect and Building News* 85 (2 July 1904): 5–6.

Mather, Frank Jewett. "An Art Museum for the People." *Atlantic Monthly* 100 (December 1907): 729–40.

Maybeck, Bernard R. "Architecture of the Palace of Fine Arts at the Panama-Pacific International Exposition." In *Art in California.* 1916. Reprint, Irvine, Calif.: Westphal Publishing, 1988, 151–58.

———. *Palace of Fine Arts and Lagoon.* San Francisco, Calif.: Paul Elder, 1915.

McDonald, Travis C., Jr. "The Smithsonian Institution Competition for a Gallery of Art." In *Modernism in America, 1937–1941: A Catalog and Exhibition of Four Architectural Competitions.* Edited by James D. Kornwolf. Williamsburg, Va.: Joseph and Margaret Muscarelle Museum of Art, College of William and Mary, 1985, 177–223.

McKelvey, Blake. *The Urbanization of America, 1860–1915.* New Brunswick, N.J.: Rutgers University Press, 1963.

Metropolitan Museum of Art. *Annual Reports of the Trustees of the Association, from 1871 to 1902.* New York: Metropolitan Museum of Art, 1903.

Michels, Eileen. *An Architectural View: 1883–1974.* Minneapolis, Minn.: Minneapolis Society of Fine Arts, 1974.

Middleton, Robin, ed. *The Beaux-Arts and Nineteenth-Century French Architecture.* London: Thames & Hudson, 1982.

Miller, Zane. *The Urbanization of Modern America: A Brief History.* New York: Harcourt Brace Jovanovich, 1973.

The Milwaukee Sentinel. Illustrations of competition drawings for the Milwaukee Public Library and Museum. 16 and 19 November and 3 December 1893.

"Minneapolis Art Museum Competition." *Western Architect* 18 (January 1912): 1.

"The Minneapolis Museum of Fine Arts." *American Architect* 107 (21 April 1915): 245–48.

"The Minneapolis Spirit." *American City* 6 (January 1912): 398–404.

"The Model City." *World's Fair [Louisiana Purchase Exposition] Bulletin* 3 (February 1902): 30–31.

Monroe, Harriet. *John Wellborn Root: A Study of His Life and Work.* Park Forest, Ill.: Prairie School Press, 1896.

Moore, Charles. *Daniel H. Burnham: Architect, Planner of Cities.* Boston: Houghton Mifflin Co., 1921.

Morgan, H. Wayne. *Unity and Culture: The United States, 1877–1900.* Baltimore: Penguin Books, Ltd., 1971.

Morgan, Keith N. *Charles A. Platt: The Artist as Architect.* New York: Architectural History Foundation, and Cambridge: MIT Press, 1985.

———. "Charles Adams Platt's Designs for the Corcoran Gallery Additions." In *The William A. Clark Collection.* Washington, D.C.: Corcoran Gallery of Art, 1978, 15–23.

Mullgardt, Louis Christian. "Architecture of the Panama-Pacific International Exposition." In *Art in California.* 1916. Reprint, Irvine, Calif.: Westphal Publishing, 1988, 151–58.

Mumford, Lewis. *The Brown Decades: A Study of the Arts in America, 1865–1895.* New York: Harcourt, Brace, 1931.

Murphy, C. F. "The Field Museum of Natural History, Chicago." *Architectural Forum* 42 (February 1925): 65–68.

Museum of Fine Arts, Boston. *Communications to the Trustees.* 4 vols. Boston: privately printed, 1904–6.

Museums of the Brooklyn Institute of Arts and Sciences. *Annual Reports.* Vol. 1, 1904–7. New York: Brooklyn Institute of Arts and Sciences, 1908.

National Gallery of Art. *John Russell Pope and the Building of the National Gallery of Art.* Washington, D.C.: National Gallery of Art, 1991.

"The New Building." *Toledo Museum of Art News* 2 (January 1909): 90–91.

The New Dayton Art Institute. Dayton, Ohio: Dayton Art Institute, 1930.

"The New Metropolitan Museum of Art." *Architectural Record* 12 (August 1902): 304–10.

Newport, E. E. "The New Corcoran Gallery at Washington." *Illustrated American* 20 (26 September 1896): 426–28.

Newton, Norman T. *Design on the Land: The Development of Landscape Architecture.* Cambridge: Belknap Press of Harvard University Press, 1971.

Nolen, John. "City Making." *American City* 1 (September 1909): 15–19.

———. "Getting Action in City Planning." In *Proceedings of the Thirteenth National Conference on City Planning.* Cambridge: [Harvard] University Press, 1921.

———. "The Place of the Beautiful in the City Plan." In *National Conference on City Planning, 1922,* n.p., 1922, 5–22.

———. *Montclair: The Preservation of Its Natural Beauty and Its Improvement as a Residence Town.* New York: Styles and Cash, 1909.

———. *New Ideals in the Planning of Cities, Towns and Villages.* New York: American City Bureau, 1919.

———. *Replanning Small Cities: Six Typical Studies.* New York: B. W. Huebsch, 1912.

Official Catalogue of Exhibits, World's Columbian Exposition, Department K, Fine Arts. Chicago: W. B. Gonkey, 1893.

Olmsted, Frederick Law, Sr. *A Consideration of the Justifying Value of a Public Park.* Boston: Tolman & White, Printers, 1881.

———. *Forty Years of Landscape Architecture: Central Park.* Edited by Frederick Law Olmsted, Jr. and Theodora Kimball. Reprint, Cambridge: MIT Press, 1973.

Olmsted, Frederick Law, Jr. "The Town Planning Movement in America." *Annals of the American Academy of Political and Social Science* 51 (January 1914): 172–81.

Olmsted, Frederick Law, Jr., and Theodora Kimball, eds. *Frederick Law Olmsted: Landscape Architect, 1822–1903.* 2 vols. New York: Benjamin Blom, 1970.

Opening of the Layton Art Gallery, Thursday, April 5th, 1888. Milwaukee, Wisc.: Layton Art Gallery, 1888.

Overby, Osmund. "The Saint Louis Art Museum: An Architectural History." *Saint Louis Art Museum Bulletin,* n.s., 18 (Fall 1987): 2–37.

Page, Walter H. "The Pan-American Exposition." *World's Work* 2 (August1901): 1014–48.

Palmer, Alice F. "Some Lasting Results of the World's Fair." *Forum* 16 (December 1893): 517–23.

Pan-American Art Handbook: Sculpture, Architecture, Painting. Buffalo, N.Y.: David Gray, 1901.

Pan-American Exposition, Buffalo: May 1st to November 1st, 1901. Buffalo, 1901.

Patton, N. S. "Expert Decisions of Competitions." *Inland Architect and News Record* 23 (March 1894): 13–15.

Peisch, Mark L. *The Chicago School of Architecture: Early Followers of Sullivan and Wright.* New York: Random House, 1964.

Perrin, Richard W. E. *Milwaukee Landmarks.* Milwaukee, Wisc.: Milwaukee Public Museum, 1979.

Peterson, Jon A. "The City Beautiful Movement: Forgotten Origins and Lost Meanings." *Journal of Urban History* 2 (1976): 415–34.

———. "The Nation's First Comprehensive City Plan." *Journal of the American Planning Association* 51 (Spring 1985): 134–50.

Pevsner, Nikolaus. *A History of Building Types.* Princeton, N.J.: Princeton University Press, 1976.

"The Philadelphia Museum of Art." *Atlantic Terra Cotta,* vol. 8 (February 1927).

Phipps, Linda S. "The 1893 Art Institute Building and the 'Paris ofAmerica': Aspirations of Patrons and Architects in Late Nineteenth-Century Chicago." *Art Institute of Chicago Museum Studies* 14 (1988): 28–45.

Physick, John. *The Victoria and Albert Museum: The History of Its Building.* Oxford: Phaidon-Christie's, 1982.

"Planning for the Future of Montclair." *American City* 3 (July 1910): 32–36.

Post, Robert C., ed. *1876: A Centennial Exhibition.* Washington, D.C.: National Museum of History and Technology, Smithsonian Institution, 1976.

"Preliminary Report of the Minneapolis Civic Commission." *Western Architect* 17 (January 1911): 17–19.

Presentation of the Carnegie Library to the People of Pittsburgh, with a Description of the Dedicatory Exercises, November 5th, 1895. Pittsburgh, Pa.: Corporation of the City of Pittsburgh, 1895.

Program of a Competition for the Selection of an Architect and the Procuring of a General Design for the Minneapolis Fine Arts Museum, Minneapolis, Minnesota. Minneapolis: Minneapolis Society of Fine Arts, 1911.

"Public Parks and Playgrounds: A Symposium." *Arena* 10 (1894): 274–88.

R., E. "The New Wing." *Bulletin of the Metropolitan Museum of Art, Supplement: The Wing of Decorative Arts* (March 1910): 5–7.

"Recent Brick and Terra-Cotta Work in American Cities." *Brickbuilder* 4 (July 1895): 156–57.

Reed, Henry Hope and Sophia Duckworth. *Central Park: A History and a Guide.* New York: Clarkson B. Potter, 1967.

Report of the Board of General Managers of the Exhibit of the State of New York at the Pan-American Exposition. Albany, N.Y.: J. B. Lyon, State Printers, 1902.

Reps, John W. *Monumental Washington: The Planning and Development of the Capital Center.* Princeton, N.J.: Princeton University Press, 1967.

"Restoration of the Fine Arts Building in Chicago." *Western Architect* 35 (October 1926): 133–34.

"A Review of the Engineering Exhibits at the St. Louis Exhibition." *Engineering News* 52 (11 August 1904): 127.

Rich, Lorimer. "Planning Art Museums." *Architectural Forum* 47 (December 1927): 553–78.

Riis, Jacob A. *How the Other Half Lives: Studies among the Tenements of New York.* 1890. Reprint, New York: Hill and Wang, 1957.

"Robert Dawson Evans Memorial Galleries for Paintings." *Museum of Fine Arts Bulletin* 10 (June 1912): 17–18.

Robinson, Charles Mulford. *City Planning.* New York: Putnam, 1916.

———. "The Improvement of Montclair." *Architectural Record* 28 (August 1910): 139–41.

———. *Modern Civic Art: or, The City Made Beautiful.* 4th ed. New York: Knickerbocker Press, 1918.

Rogers, Meyric R. "Modern Museum Design." *Architectural Forum* 47 (December 1927): 601–8.

———. "A Study in Museum Planning." *Architectural Record* 46 (December 1919): 518–28.

"Rome Prize in Architecture Awarded." *Pencil Points* 10 (July 1929): 485–89.

Roper, Laura Wood. *FLO: A Biography of Frederick Law Olmsted.* Baltimore, Md.: Johns Hopkins University Press, 1973.

Roth, Leland M. "McKim, Mead & White and The Brooklyn Museum, 1893–1934." In *A New Brooklyn Museum: The Master Plan Competition.* Edited by Joan Darragh. New York: Brooklyn Museum, 1988, 26–51.

———. *McKim, Mead & White, Architects.* New York: Harper & Row, 1983.

Ruskin, John. "A Museum or Picture Gallery." In *The Works of John Ruskin.* Edited by E. T. Cook and Alexander Wedderburn. London: George Allen, 1908, 34: 247–262.

Russell, Benjamin F. W. "The Works of Guy Lowell." *Architectural Review* 13 (February 1906): 13–40.

Sage, Cornelia Bentley. "Buffalo as an Art Center." *Art and Archaeology* 4 (September 1916): 135–60.

Sanford, John Douglas. *The Gallery Architects: Edward B. Green and Gordon Bunshaft.* Buffalo, N.Y.: Buffalo Fine Arts Academy, 1987.

Schuyler, Montgomery. "The Architecture of the St. Louis Fair." *Scribner's Magazine* 35 (April 1904): 385–94.

————. "The Art of City-Making." *Architectural Record* 12 (May 1902): 1–26.

————. "Last Words about the World's Fair." *Architectural Record* 3 (March 1894): 271–301.

————. "The Works of the Late Richard M. Hunt." *Architectural Record* 5 (December 1895): 97–180.

Scott, Mel. *American City Planning Since 1890*. Berkeley, Calif.: University of California Press, 1969.

Searing, Helen. *New American Art Museums*. New York: Whitney Museum of American Art, 1982.

A Selection of Photographs Illustrating the Work of Edw. B. Green & Sons, Architects. Buffalo, N.Y. 1924.

Sellstedt, Lars Gustaf. *Art in Buffalo*. Buffalo, N.Y.: Matthews-Northrup Works, 1910.

Simonson, Lee. "Museum Showmanship." *Architectural Forum* 47 (December 1927): 533–40.

"Sketches from the Premiated Designs for the Proposed Public Library, Boston, Mass." *American Architect and Building News* 17 (14 February 1885), Pl. 477.

Smith, Frances A. "Continued Care of Families." *Proceedings of the National Conference of Charities and Correction*. Boston: Press of Geo. H. Ellis, 1895.

Smith, Helen. "An Hour's Summary." *Corcoran Art Journal* 1 (August 1893): 5–6.

Solon, Leon V. "The Philadelphia Museum of Art, Fairmount Park, Philadelphia: A Revival of Polychrome Architecture and Sculpture." *Architectural Record* 60 (August 1926): 97–111.

Stein, Susan R., ed. *The Architecture of Richard Morris Hunt*. Chicago: University of Chicago Press, 1986.

Stoughton, Arthur A. "The Architectural Side of City Planning." In *Proceedings of the Seventh National Conference on City Planning, Detroit, MI, 1915*. Cambridge: [Harvard] University Press, 1915, 121–28.

Strong, Josiah. *The Twentieth Century City*. New York: Baker and Taylor, 1898.

Sturgis, R. Clipston. *Report on Plans Presented to the Building Committee*. Boston: Museum of Fine Arts, 1905.

Sturgis, Russell. "A Critique of the Works of Shepley, Rutan & Coolidge and Peabody & Stearns." *Architectural Record: Great American Architects Series*. Vol. 3. New York: Architectural Record Co., 1895–99.

————. "The Works of McKim, Mead & White." *Architectural Record: Great American Architects Series*. Vol. 1. New York: Architectural Record Co., 1895–99.

Swenarton, Mark. *Artisans and Architects: The Ruskinian Tradition in Architectural Thought*. London: Macmillan Press, 1989.

Taragin, Davira Spiro. *Corcoran*. Washington, D.C.: Corcoran Gallery of Art, 1976.

Terrell, Park. "Montclair Beautiful." *American City* 3 (July 1910): 29–31.

Toker, Franklin. *Pittsburgh: An Urban Portrait*. University Park, Pa.: Pennsylvania State University Press, 1986.

Toledo Museum of Art. *Dedication and Inaugural Addresses*. Toledo, Ohio: Toledo Museum of Art, 17 January 1912.

The Toledo Museum of Art: Its Plans and Purposes with Reference to the New Museum Building. Toledo, Ohio: Toledo Museum of Art, 1912.

"The Toledo, Ohio, Museum of Art." *American Architect* 101 (10 April 1912): 165–68.

Townsend, J. Benjamin. *100: The Buffalo Fine Arts Academy, 1862–1962*. Buffalo, N.Y.: Buffalo Fine Arts Academy, 1962.

Trachtenberg, Alan. *The Incorporation of America: Culture and Society in the Gilded Age*. New York: Hill and Wang, 1982.

Trask, J. E. D. "Baltimore as an Art Center." *News of the Baltimore Museum of Art* 1 (October 1923): 2–3.

Trustees of the Museum of Fine Arts. *Annual Reports 24–34 (1899–1909)*. Cambridge: [Harvard] University Press, 1900–1910.

Tselos, Dimitri. "The Chicago Fair and the Myth of the 'Lost Cause.'" *Journal of the Society of Architectural Historians* 26 (December 1967): 259–68.

Tucci, Douglas Shand. *Built in Boston: City and Suburb, 1800–1950*. Boston: New York Graphic Society, 1978.

Turner, Tran. "A Museum for Minneapolis." *Arts [Minneapolis Institute of Arts Bulletin]* 12 (December 1989): 12–15.

Van Brunt, Henry. "The Architectural Event of Our Times." *Engineering Magazine* 6 (January 1894): 430–41.

————. "Architecture at the World's Columbian Exposition." 1892. Reprinted in *Architecture and Society: Selected Essays of Henry Van Brunt.* Edited by William A. Coles. Cambridge: Belknap Press of Harvard University Press, 1969, 225–87.

————. *Richard Morris Hunt. A Memorial Address.* Washington, D.C.: American Institute of Architects, 1896.

Van Trump, James Denholm. *An American Palace of Culture: The Carnegie Institute and Library Building in Pittsburgh.* Pittsburgh, Pa.: Carnegie Institute and Pittsburgh History and Landmarks Foundation, 1970.

————. "The Past as Prelude: A Consideration of the Early Building History of the Carnegie Institute Complex." *Carnegie Magazine* 48 (October-November 1974): 346–60.

————. "'The Tenth Muse': Alexander Murals at Carnegie Institute." *Carnegie Magazine* 43 (February 1965): 63–67.

Van Zanten, David. "The Architecture of the Layton Art Gallery." In *1888: Frederick Layton and His World.* Milwaukee, Wisc.: Milwaukee Art Museum,1988.

Vinton, Arthur Dudley. "Morality and Environment." *Arena* 17 (April 1891): 567–77.

Wacker, Charles H. "The City Plan." In *The Child in the City: A Series of Papers Presented at the Conferences Held During the Chicago Child Welfare Exhibit, 1911.* Chicago: Department of Social Investigation, Chicago School of Civics and Philanthropy, 1912.

Walton, William. *World's Columbian Exposition, 1893: Art and Architecture.* 4 vols. Philadelphia: George Barrie, 1893.

Ward, Clarence. "The Dudley Peter Allen Memorial Art Building and the Department of Fine Arts at Oberlin College." *Bulletin of the Allen Memorial Art Museum* 4 (October 1947): 41–63.

Ware, William R. "Competitions." *American Architect and Building News* 66 (30 December 1899): 107–12.

Warren, Samuel D. "The Plans." *Museum of Fine Arts Bulletin Special Number: The New Museum* 4 (June 1907): 27–30.

Weber, Adna Ferrin. *The Growth of Cities in the Nineteenth Century: A Study in Statistics.* 1899. Reprint, Ithaca, N.Y.: Cornell University Press, 1968.

White, Theo B., ed. *Paul Philippe Cret: Architect and Teacher.* Philadelphia: Art Alliance Press, 1973.

Whitehill, Walter Muir. *Boston Public Library: A Centennial History.* Cambridge: Harvard University Press, 1956.

————. *Museum of Fine Arts, Boston: A Centennial History.* 2 vols. Cambridge: Belknap Press of Harvard University Press, 1970.

Wilcox, Delos F. *The American City: A Problem in Democracy.* New York: Macmillan Company, 1909.

Williams, William James. "John Russell Pope." *Apollo* 133 (March 1991): 166–70.

Wilson, Richard Guy. "International Style: The MoMA Exhibition." *Progressive Architecture* 63 (February 1982): 92–104.

————. *McKim, Mead & White, Architects.* New York: Rizzoli, 1983.

Wilson, William H. *The City Beautiful Movement.* Baltimore: Johns Hopkins University Press, 1989.

Winchell, Newton. "Museums and Their Purposes." *Science* 18 (July 24, 1891): 40–48.

"The Wing of Decorative Arts, Metropolitan Museum of Art." *Architects' and Builders' Magazine,* n.s., 11 (May 1910): 307–14.

Winkler, Franz K. [Montgomery Schuyler]. "The Architecture of the Louisiana Purchase Exposition." *Architectural Record* 15 (April 1904): 335–49.

Withey, Henry F., and Elsie Rathburn. *Biographical Dictionary of American Architects (Deceased).* Los Angeles: New Age Publishing, 1956.

Wittke, Carl. *The First Fifty Years: The Cleveland Museum of Art, 1916–1966.* Cleveland, Ohio: Cleveland Museum of Art, 1966.

"The World's Fair Art Palace a Memorial to Our Art Advancement." *Western Architect* 29 (July 1920): 61–62.

The World's Religious Congresses of 1893: General Programme. Chicago: Rand, McNally, 1892.

Wright, Carroll D., ed. *The Slums of Baltimore, Chicago, New York, and Philadelphia: Seventh Special Report of the Commissioner of Labor.* 1894. Reprint, New York: Negro Universities Press, 1969.

Zaitzevsky, Cynthia. *Frederick Law Olmsted and the Boston Park System.* Cambridge: Belknap Press of Harvard University Press, 1982.

Zimmermann, H. Russell. *Magnificent Milwaukee: Architectural Treasures, 1850–1920.* Milwaukee, Wisc.: Milwaukee Public Museum, 1987.

Zueblin, Charles. *American Municipal Progress: Chapters in Municipal Sociology.* New York: Macmillan, 1902.

———. *A Decade of Civic Development.* Chicago: University of Chicago Press, 1905.

Zukowsky, John. "The Art Institute of Chicago: Constructions, Concepts, and Queries." *Threshold* 3 (Autumn 1985): 60–74.

———. "Centennial Remembrances: The Early Art Institute Buildings." *Bulletin of the Art Institute of Chicago* 73 (January-February 1979): 2–4.

Theses and Dissertations

Ayres, William S. "The Domestic Museum in Manhattan: Major Private Art Installations in New York City, 1870–1920." Ph.D. diss., University of Delaware, 1993.

Grossman, Elizabeth. "Paul Philippe Cret." Ph.D. diss., Brown University, 1980.

Hancock, John L. "John Nolen and the American City Planning Movement: A History of Culture Change and Community Response, 1900–1940." Ph.D. diss., University of Pennsylvania, 1964.

Irish, Sharon Lee. "Cass Gilbert's Career in New York, 1899–1905." Ph.D. diss., Northwestern University, 1985.

Karlowicz, Titus Marion. "The Architecture of the World's Columbian Exposition." Ph.D. diss., Northwestern University, 1965.

Kihlstedt, Folke Tyko. "Formal and Structural Innovations in American Exposition Architecture: 1901–1939." Ph.D. diss., Northwestern University, 1973.

Lowell, Guy. "Design for an Art Museum and Reading Room in a Small Town." Thesis, M.I.T., 1894. [Photocopy in Archives, Museum of Fine Arts, Boston.]

Thompson, Joann Marie. "The Art and Architecture of the Pan-American Exposition." Ph.D. diss., Rutgers University, 1980.

Index

261